AIGA
GRAPHIC
DESIGN
USA:

The American Institute of Graphic Arts

Watson-Guptill Publications

New York

The Annual of The American Institute of Graphic Arts

Written by David R. Brown, Wylie Davis, Rose DeNeve

Designed by Miho

First published 1983
in New York by The
American Institute of
Graphic Arts, 1059 Third
Avenue, New York, N.Y.
10021 and Watson-
Guptill Publications, Inc.,
a division of Billboard
Publications, Inc., 1515
Broadway, New York,
N.Y. 10036

ISBN 0-8230-2102-4

Printed in Japan by Dai
Nippon Printing Co., Inc.
Set in Megaron by
Justified Type, Inc.
Bridgeport, Connecticut

First Printing, 1983

Distributed outside the
U.S.A. and Canada
by Fleetbooks, S.A.
c/o Feffer &
Simons, Inc.
100 Park Avenue
New York, New York
10017

Contents

Acknowledgments	4
The American Institute of Graphic Arts	5
Introduction	6
The AIGA Medal	7
AIGA Medalists, 1982	8
AIGA Design Leadership Award	30
California Graphic Design 1980-82	48
Just Type	168
The Mental Menagerie: A Five-Year Retrospective	204
The Book Show	252
Communication Graphics	300
Index	424

Acknowledgments

The encouragement, identification, and documentation of exemplary accomplishment in graphic design represents the heart of the Institute's program.

This publication is the culmination of the AIGA competitions program for the year 1982–1983, for which we relied on the expertise and generosity of a wide variety of individuals and organizations. The list of contributors represents an aggregate of combined talents which made this program possible.

The work reproduced on these pages was selected from almost 10,000 entries. To the individuals who participated in our competitions, and to the chairmen and juries who undertook the difficult process of selection, we owe our thanks.

We would also like to thank James Miho and Michael Vanderbyl, who designed the book and jacket, respectively, and the authors, David R. Brown, Wylie Davis, and Rose DeNeve.

This year, we are particularly grateful to Sophie McConnell, Associate Director, a publishing professional who made it possible for us to undertake the publication of this book ourselves, with the able assistance of Shelley Bance, Managing Editor, Nathan Gluck, and Glenngo King. Board members Ellen McNeilly and Paul Gottlieb provided counsel and advice along with our lawyer, Neale Albert, and Marc Weinstein of Watson-Guptill.

Under the care of our Membership Coordinator, Allison Schacter, membership is increasing and continues to provide the impetus and basic support for our growing programs. These, in turn, are prospering under the guidance of a concerned and energetic board, and our invaluable president, David R. Brown. To all, our thanks.

Caroline Hightower
Director

The American Institute of Graphic Arts

The American Institute of Graphic Arts is a national nonprofit organization of graphic design and graphic arts professionals. Founded in 1914, AIGA conducts an interrelated program of competitions, exhibitions, publications, educational activities, and public service efforts to promote excellence in, and the advancement of, graphic design.

Members of the Institute are involved in the design and production of books, magazines, and periodicals, as well as corporate, environmental, and promotional graphics. Their contribution of specialized skills and expertise provides the foundation for the Institute's program. Through the Institute, members form an effective, informal network of professional assistance that is a resource to the profession and to the public. This has been increased with the formation of national chapters over the past year.

The exhibition schedule at the Institute's Gallery now includes our annual competitive exhibitions. Of these, the Book Show and a Communication Graphics exhibition, which incorporates Advertising, are held each year. Two other exhibitions may include Illustration, Photography, Covers (book-jackets, magazines, periodicals, record albums), Insides (design of the printed page), Signage, and Packaging.

The exhibitions travel nationally and internationally. Each year, the Book Show is donated to the Rare Book and Manuscript Library of Columbia University, which houses the AIGA collection of award-winning books dating back to the 1920s. Other exhibitions are sent to the Popular and Applied Graphic Arts Department of the Library of Congress.

This year, the AIGA is completing a project grant from the National Endowment for the Arts to compile a listing of archival source materials on the history of graphic design.

AIGA publications include: a quarterly *Journal of Graphic Design;* a voluntary *Code of Ethics and Professional Conduct* for AIGA members; *Symbol Signs Repro Art,* a portfolio containing 50 passenger/pedestrian symbols and guidelines for their use; the guide *Graphic Design for Non-Profit Organizations;* and a *Graphic Design Education Directory.*

Introduction

To understand the value and quality of contemporary graphic design, it is important to involve and be involved with the process of criticism. Not carping or caviling, but criticism in the sense of examination of design and its merits from an inquisitive and informed point of view. Intellectually rigorous criticism is, obviously, not a new idea. Painters, sculptors, authors, architects, and others of the "aesthetic professions" routinely exult in, endure, and learn from public evaluation and criticism of their work.

Discerning, useful written criticism of graphic design is uncommon, although several books, articles, and papers have been published on the history and theoretical aspects of graphic design and the impact of graphic design on our culture.

We are not totally lacking in evaluative tools, however. The ongoing process of design competitions does provide a permanent record of work the profession currently considers to be the best. That record, a major and nationally significant part of which is contained in the pages of this book, bears critical testimony to the energy and impact of graphic design — and graphic designers — today. It is a record at once mute and eloquent.

The juried competition process is imperfect, of course. Most endeavors involving aesthetic judgment are. AIGA has taken a number of steps in the past year to ensure that the design competition process is as fair as it can be in providing each entry the same availability for scrutiny, in making sure the rules are understood, and in doing the utmost to attract as large and varied a body of work as possible for judging.

Last year, designers and firms submitted nearly 10,000 examples of their work to AIGA competitions. Presumably, entrants sent nothing less than what they considered to be their strongest work — a pre-screening step that is, in itself, quite useful in the critical process. There were five competitions held during the last program year. Two are annual events: Books and Communication Graphics. Just Type was just that. The Mental Menagerie was the sixth competition in the AIGA illustration series, "The Mental Picture." California Design, juried entirely by non-Californians, examined and evaluated the graphic design output of what is certainly one of the most vigorous and interesting parts of the country.

The AIGA Gold Medal has been awarded to Massimo and Lella Vignelli for "their expansion of the meaning and process of design." In addition to a body of work that seems almost too broad, too varied, and too uniformly good to have been the work of a team of two and an office, the Vignellis have participated in the dialogue about the function and value of design. "Theory! Documentation! History! Criticism!" says Massimo, citing the four essential fields of pursuit he believes are key to understanding design — both inside the profession and outside — beyond pure and purely suspect subjectivity.

The third AIGA Design Leadership Award has been made to Container Corporation of America, for its pioneering role in employing design and communications as a fundamental component of its business strategy. In this country, Container did it first, consistently and well.

Though the value and quality of graphic design might well be left to the inevitable judgment of history, it is a pleasure to publish design judged commendable by contemporary peers, both as a current celebration of the state of the art and as a record from which the inevitable judgments of history might be made.

The AIGA Medal

For sixty-two years, the Medal of the American Institute of Graphic Arts has been awarded to individuals in recognition of their distinguished achievements, services, or other contributions within the field of the graphic arts. Medalists are chosen by a committee, subject to approval by the Board of Directors. Past recipients have been:

Norman T. A. Munder, 1920
Daniel Berkeley Updike, 1922
John C. Agar, 1924
Stephen H. Horgan, 1924
Bruce Rogers, 1925
Burton Emmett, 1926
Timothy Cole, 1927
Frederic W. Goudy, 1927
William A. Dwiggins, 1929
Henry Watson Kent, 1930
Dard Hunter, 1931
Porter Garnett, 1932
Henry Lewis Bullen, 1934
J. Thompson Willing, 1935
Rudolph Ruzicka, 1936
William A. Kittredge, 1939
Thomas M. Cleland, 1940
Carl Purington Rollins, 1941
Edwin and Robert Grabhorn, 1942
Edward Epstean, 1944
Frederic G. Melcher, 1945
Stanley Morison, 1946
Elmer Adler, 1947
Lawrence C. Wroth, 1948
Earnest Elmo Calkins, 1950
Alfred A. Knopf, 1950
Harry L. Gage, 1951
Joseph Blumenthal, 1952
George Macy, 1953
Will Bradley, 1954
Jan Tschichold, 1954
P. J. Conkwright, 1955
Ray Nash, 1956
Dr. M. F. Agha, 1957
Ben Shahn, 1958
May Massee, 1959
Walter Paepcke, 1960
Paul A. Bennett, 1961
Willem Sandberg, 1962
Saul Steinberg, 1963
Josef Albers, 1964
Leonard Baskin, 1965
Paul Rand, 1966
Romana Javitz, 1967
Dr. Giovanni Mardersteig, 1968
Dr. Robert L. Leslie, 1969
Herbert Bayer, 1970
Will Burtin, 1971
Milton Glaser, 1972
Richard Avedon, 1973
Allen Hurlburt, 1973
Philip Johnson, 1973
Robert Rauschenberg, 1974
Bradbury Thompson, 1975
Henry Wolf, 1976
Jerome Snyder, 1976
Charles and Ray Eames, 1977
Lou Dorfsman, 1978
Ivan Chermayeff and Thomas Geismar, 1979
Herb Lubalin, 1980
Saul Bass, 1981
Massimo and Lella Vignelli, 1982

**The AIGA Medalists 1982:
Massimo and Lella Vignelli**

Chairman
Ivan Chermayeff
Principal
Chermayeff & Geismar

Committee
Saul Bass
Principal
Saul Bass/Herb Yager and Associates

Lou Dorfsman
Vice President/Creative Director
CBS, Inc.

Milton Glaser
Designer

William Lacy
President
The Cooper Union for the Advancement
of Science and Art

David Levy
President
Parsons School of Design

The Vignellis, Massimo and Lella, stand at the peak of their profession. During the past 20 years, their design output has been prodigious in quantity, far-ranging in media and scope, and consistent in excellence. Equally important is the influence they have had and the difference they have made. Their work has led by example. They have contributed to design as individuals. For their accomplishments, Massimo and Lella Vignelli have been chosen to receive the AIGA Gold Medal for 1982 — the sixty-second such award in a distinguished series that began in 1920.

Upon the occasion of the major retrospective of the Vignellis' work exhibited at Parsons in 1980, *The New York Times* critic Paul Goldberger characterized them as "total designers." They and their office have indeed done it all: industrial and product design, graphic design, book design, magazine and newspaper design, packaging design, interior and exhibit design, furniture design. Massimo and Lella work together in two ways: he concentrates on what they call the "2D"; she handles the "3D". He's the visionary: "I talk of feelings, possibilities, what a design *could* be." She's the realist: "I think of feasibility, planning, what a design *can* be."

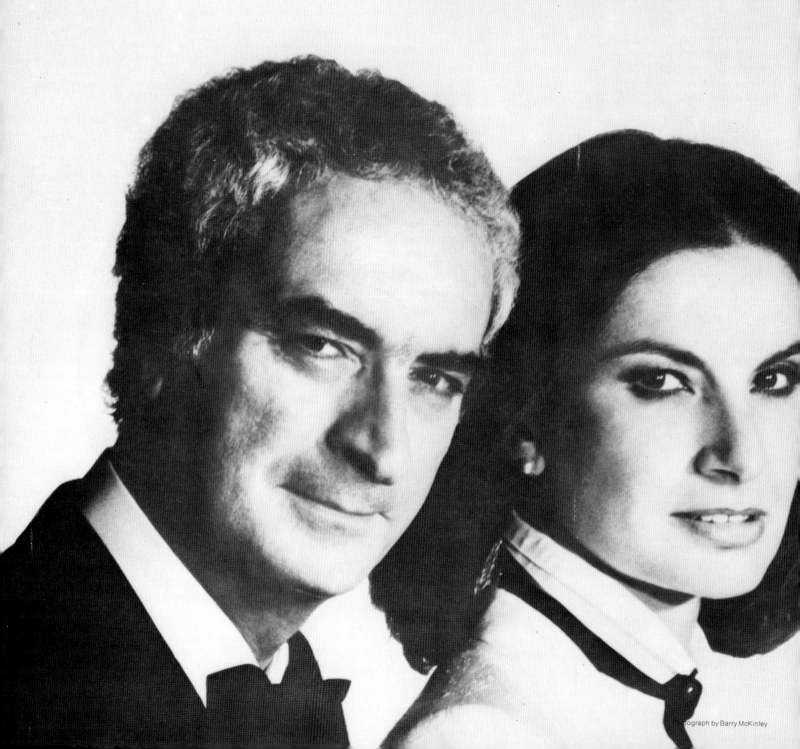

Photograph by Barry McKinley

The Vignellis were both born and educated in the industrial, more-European north of Italy, he in Milan and she in Udine, 90 miles away. Massimo's passion was "2D" — graphic design; Lella's family tradition and training were "3D" — architecture. They met at an architects' convention in Milan and were married in 1957. Three years later, they opened their first "office of design and architecture" in Milan and designed for Pirelli, Rank Xerox, Olivetti, and other design-conscious European firms. But their fascination with the United States, which took root during three years spent here after they were married, eventually grew strong enough to lure them away from Italy permanently. "There is diversity here, and energy, and possibility," recalls Massimo, "and the need for design." He cofounded Unimark in 1964, which ballooned and collapsed as the corporate identification boom of the late 1960s hyperventilated, then ran out of breath. In 1972, their present office was formed: Vignelli Associates for two-dimensional design, Vignelli Designs for furniture, objects, exhibitions, and interiors.

Not only do the Vignellis design exceedingly well, they also *think* about design. It is not enough that something — a chair, an exhibition, a book, a magazine — looks good and is well designed. The "why" and the "how," the very *process* of design itself, must be equally evident and quite beyond the tyranny of individual taste.

"There are three investigations in design," says Massimo. "The first is the search for structure. Its reward is *discipline.* The second is the search for specificity. This yields *appropriateness.* Finally, we search for fun, and we create *ambiguity.*

Vignelli design, in both three dimensions and two, is highly architectural in character. Massimo's posters, publications, and graphic designs seem to be built in stories, separated by the now-familiar, bold, horizontal rules. Basic geometry is respected. The investigative design process moves from the inside out: "The correct shape is the shape of the object's *meaning.*" The Vignelli commitment to the correctness of a design has taken their work beyond the mechanical exercise of devising a form best suited to a given function. They've always understood that design itself, in the abstract, could and should be an integral part of function. More than a process and a result, design — good design — is an imperative. "Everything has its own order," they've said. "You can't take a piece of music and scramble the notes. You can't take a piece of writing and scramble the words. You can't take a space and scramble the chairs around."

Both in the example set by their work and by their personal commitment of time and energy, design has no advocates more passionate or effective. Both teach, write, lecture, serve on juries and boards, contribute their talent and cast to worthy causes. Unabashedly urban and urbane, their participation in the world of design is enthusiastic, inquiring, generous. The Vignellis are true believers: "When we were young and naive, we thought we could transform society by providing a better, more designed environment. Naturally, we found that this was not possible. Now, we think more realistically: we see a choice between good design and poor or nondesign. Every society gets the design it deserves. It is our duty to develop a professional attitude in raising the standard of design."

That sounds serious, and the Vignellis are serious about design. But it is seriousness of purpose conveyed most often through exuberance. When either Massimo or Lella says the word, "design," it is pronounced with a capital "d": "Design." As individuals and professionals, their commitment to design and their accomplishments in design have rewarded them well. The Vignelli office continues to thrive and assignments come from an ever more diverse range of clients. Graduates of their firm have set out on their own and established well-respected practices. Only a few of the best and brightest are hired out of the schools each year. Their calendars are crammed; their pace formidable.

"The reward?" asks Massimo, paraphrasing the question. "Why, the reward is to *do* all this!"

THE AUDUBON SOCIETY BOOK OF WILDFLOWERS

by Les Line ... of Audubon magazine ... e Henricks Hodge

Andreas Feininger, Jerry Gentry,
Ray O. Green, Philip Hyde, Les Line, Yvona &
Momo Momatuk, David Muench, Charlie Ott,
Robert Perron, Willis Peterson, Eliot Porter,
Betty Randall, Bill Ratcliffe, Leonard Lee Rue III
Gordon Smith,
Charles Steinhacker, Kojo Tanaka,
James P. Valentine, Bradford Washburn,
Ralph Weiss, Larry West, Steven C. Wilson,
Don North, Michael Wotton

e Celebration of Unspoiled America

eWILD
LACES

Faces

A Narrative History
of the Portrait in Photography
by Ben Maddow

79 One D

The Mountains
of America From Alaska to the Great Smokies

A Journal for Ideas and
Criticism in Architecture

Published for The Institute
for Architecture and Urban Studies

By The MIT Press

OSITIONS SITIONS

SKYLINE

e Architecture and Design Review

May/L

Knoll au Louvre

Catalog of the Exhibition held at Pavillon de
Musée des Arts Décoratifs 107, rue de Rivo

January 12 to March 12, 1972

Eric Larrabee Massimo Vignelli

Knoll Design

RIZZOLI
NEW YORK

June/July 1979

AMERICAN HERITAGE

Nomination a
Election
of the Preside
Vice President
of the United S

Including the Manner of Selecting
Delegates to
National Political Conventions

Compiled by Thomas M. Durbin, Rita Ann Reimer,
Thomas B. Ripy, Congressional Research Service,
Library of Congress
for the United States Senate Library
under the direction of Francis R. Valeo,
Secretary of the Senate

March 1976
Printed for the use of the
Office of the Secretary of the Senate

U.S. Government Printing Office, Washington: 1

The Aud
Society F
to North A
Wildflowers

The
Society
to North Am
Butterflies

Peter Eisenman

HOUSE X

Graphic Design
for Non-Profit
Organizations

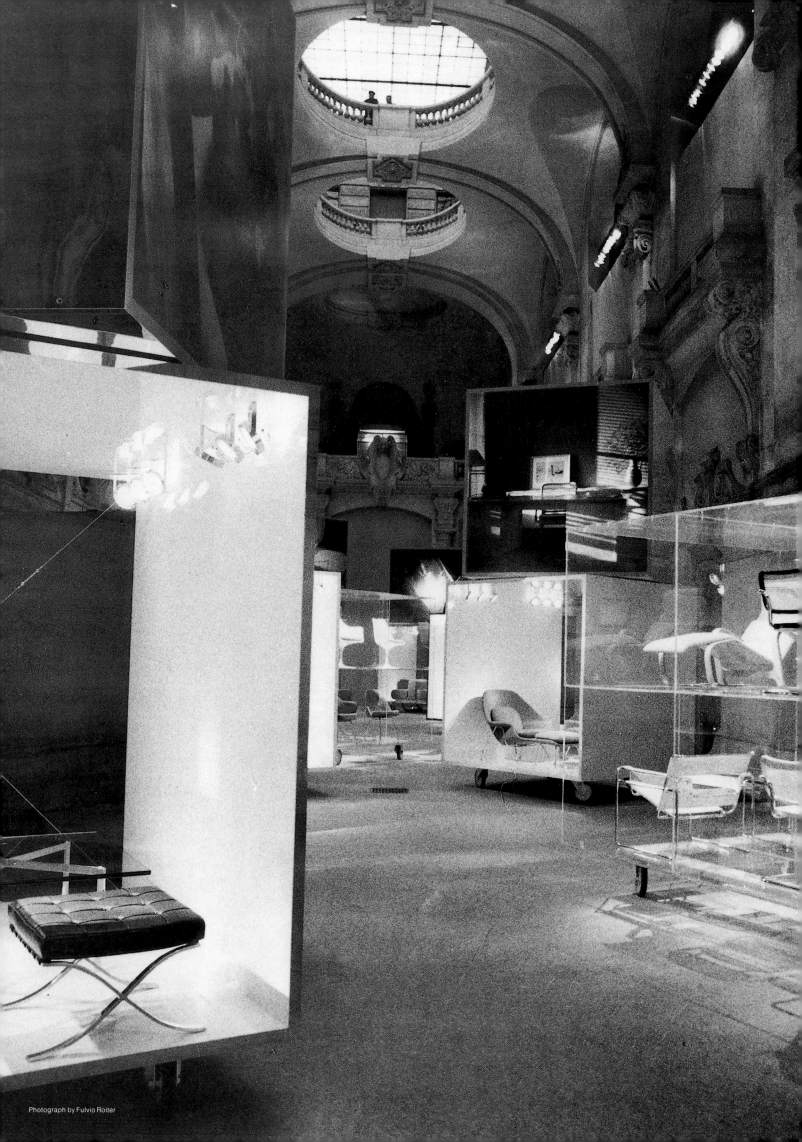

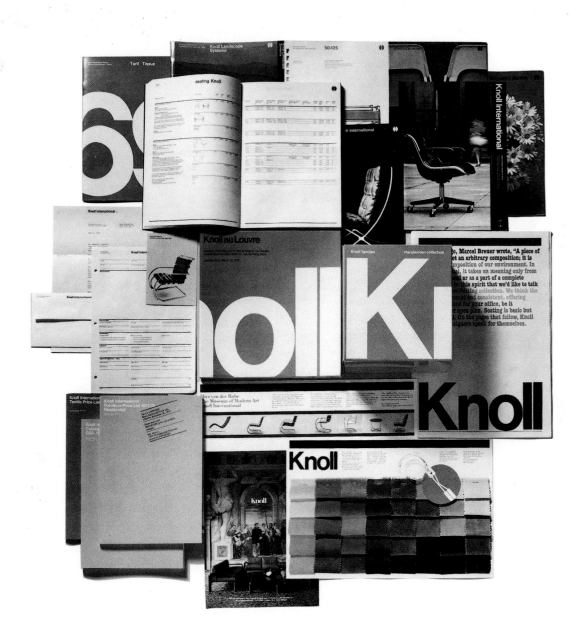

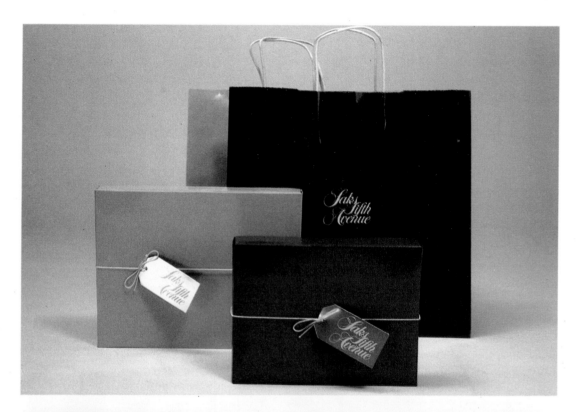

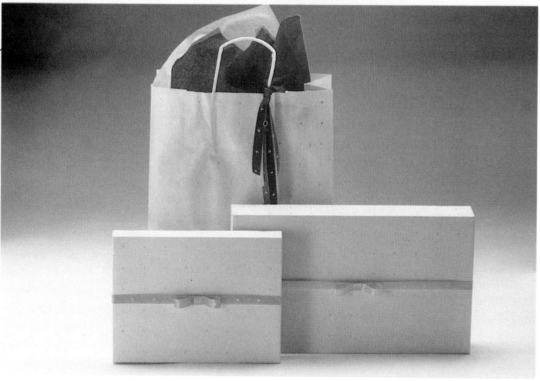

New York Subways

Client: New York City Transit Authority

Project: Sign system for New York Subways

Description: Identification, direction and information signs – black letters on white background.

Color coded discs, relating to station map, carry white letters or numerals.

Sign plate modulation for standard use of three sizes: 1´ x 1´; 1´ x 2´; 1´ x 4´; 1´ x 8´.

Typical train information sign on platforms: Direction of train; color coded disc for line identification; schedule.

For 23 St & 14 St
Mon-Fri
6:50 am to 10:05 am
3:30 pm to 6:55 pm
Take any train to 34 St
Change for ●

Downtown & Brooklyn

Broadway Nassau

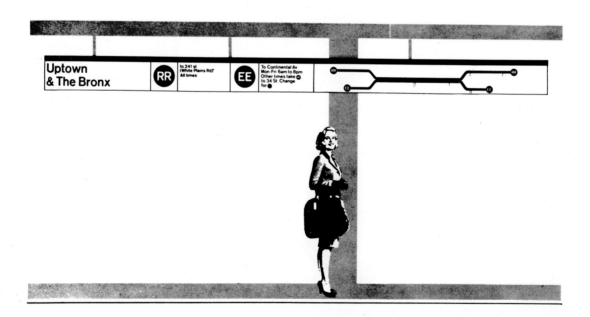

Uptown & The Bronx

RR | to 241 st (White Plains Rd) All times

EE | To Continental Av Mon-Fri 6am to 8pm Other times take ● to 34 St Change for ●

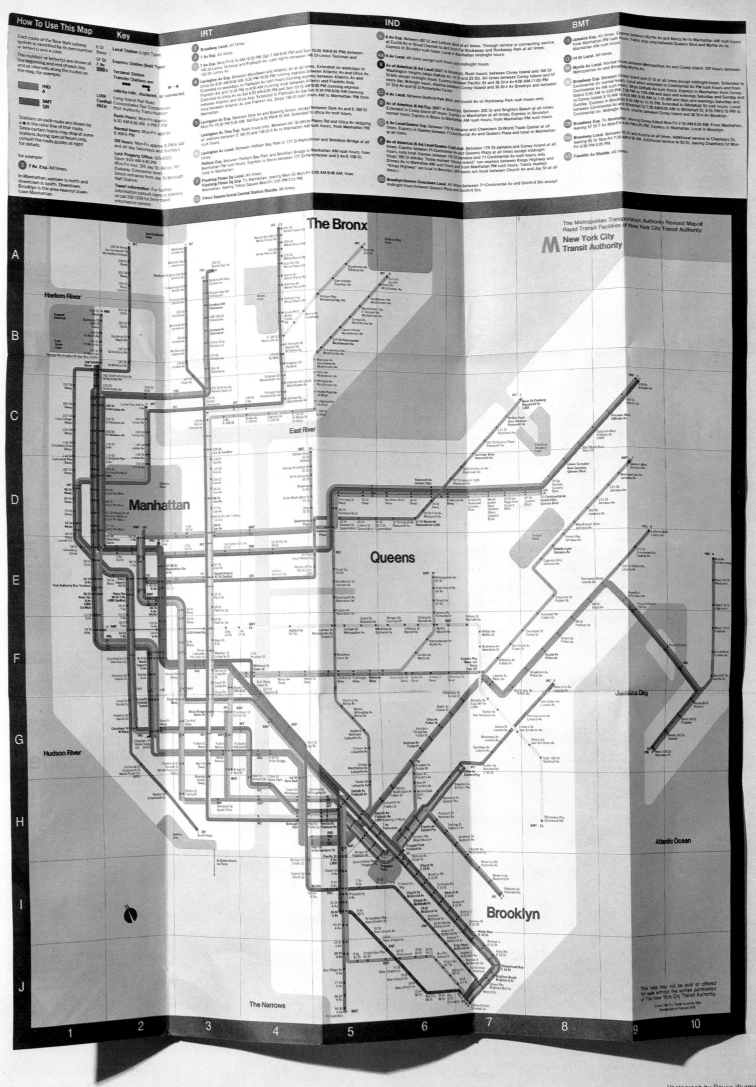

Photograph by Reven Wurman

Interior: Saint Peter's Church, New York, 1977

Photograph by George Cserna

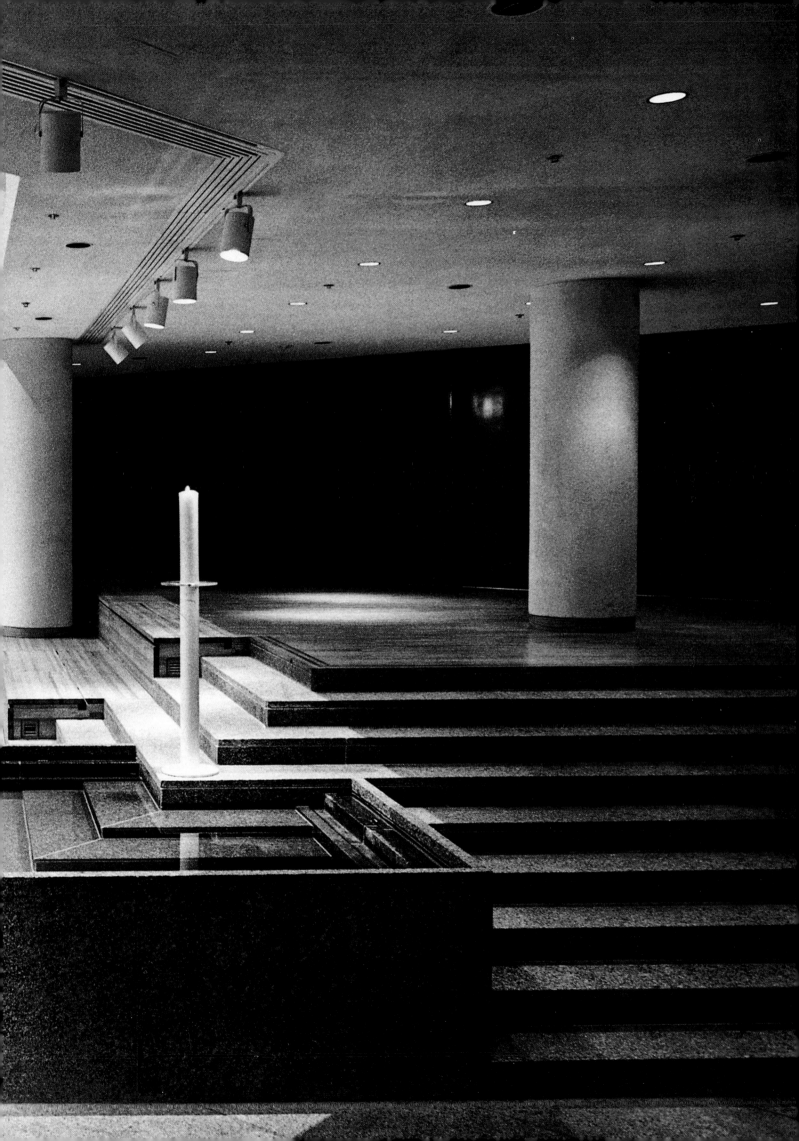

"Saratoga" Line: Poltronova, Italy, 1964

Table Lamp: Arteluce, Italy, 1962

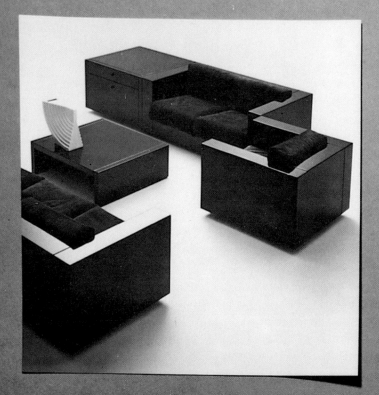

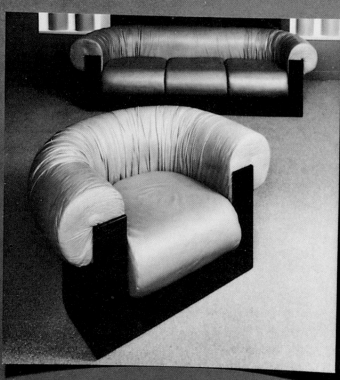

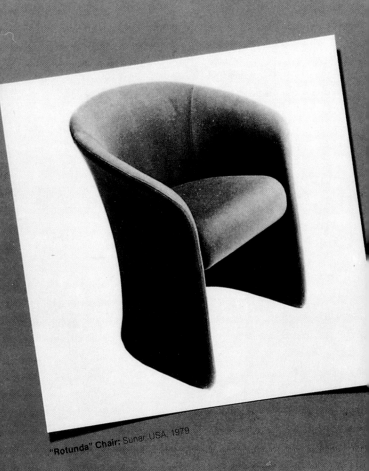

"Circolo" Chair: Sunar, USA, 1979

"Rotunda" Chair: Sunar, USA, 1979

air: Driade, Italy, 1973

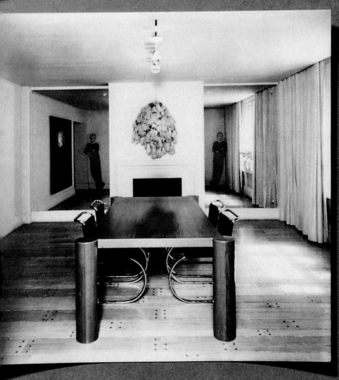

ble: Rosenthal, Germany, 1980

"Metafora" Coffee Table: Casigliani, Italy, 1979

Magazine: Architectural Record, New York, 1982
Showroom: ItalCenter, Chicago, 1982
Showroom: Hauserman, Los Angeles, 1982
Lighting installations by Dan Flavin

Vignelli for Italcenter

Photograph by Roberto Schezen

ARCHITECTURAL
RECORD

Business Design Engineering
A McGraw-Hill Publication, Six Dollars a Copy
September 1982

ls:

oom clothed in light

E.F. Hauserman Showroom
Pacific Design Center, Los Angeles
Designers: Vignelli Associates

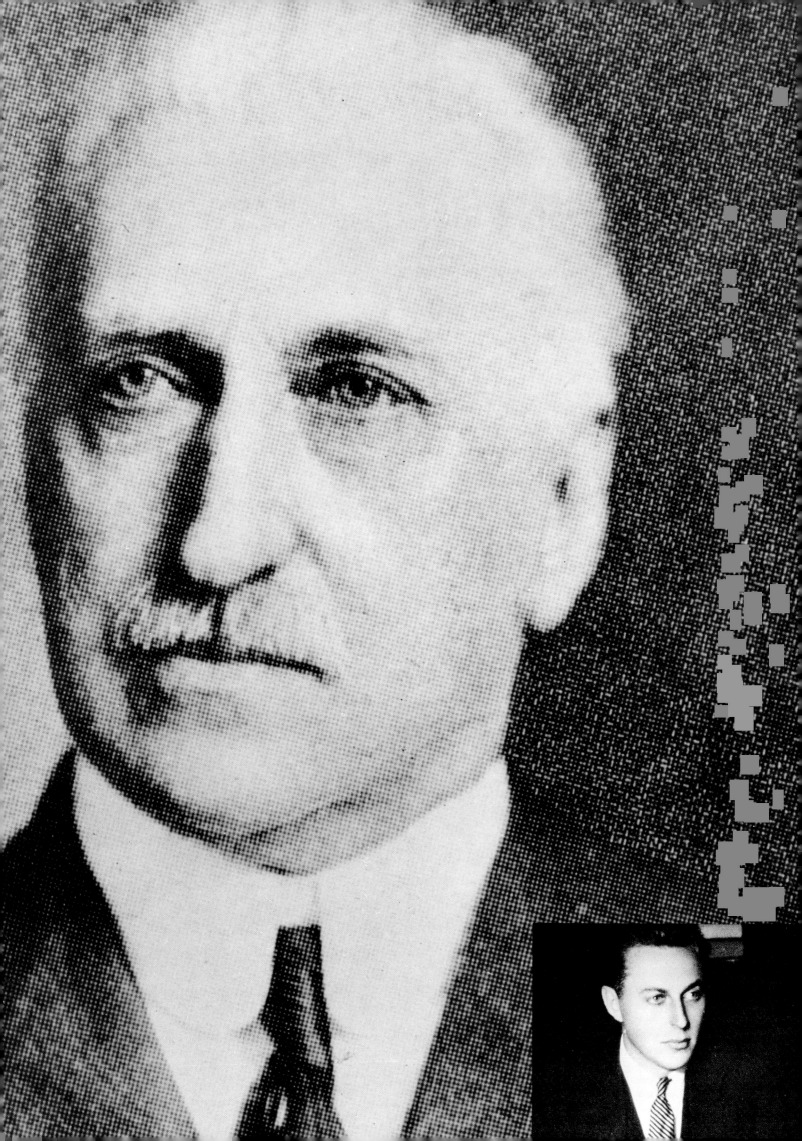

Hermann Paepcke

For nearly 50 years, Container Corporation of America has employed unique and sophisticated design and corporate communication as principal elements of its business strategy. In so doing, CCA has both proven the bottom-line worth of original design and earned for itself a pioneering, leadership position in American business. In design and communication, CCA had many great ideas first, the talent to implement them well, and the courage to stick with them. And as with most corporate success stories, the financial and intellectual wherewithal for CCA's achievement came from the top.

Walter P. Paepcke was a businessman of vision and fundamental optimism, whose career, both in business and beyond, seems to have been built upon a rare ability to see things as they could — and *should* — become. In 1926, at the age of 29, after four years of running the Chicago Mill & Lumber Company founded by his father, Paepcke changed his company's name to Container Corporation of America — presumptuous for an enterprise of 14 small box plants and mills dotted between Chicago and Philadelphia, but eventually right for the packaging giant CCA would become. In the 1920s and early 1930s, CCA was participating in a brand-new technology and a brand-new business: packaging products for shipping and selling in paperboard cartons and containers. Despite the newness of the product and CCA's position of dominance in the fledgling industry, Paepcke recognized very early that, soon enough, growing competition would change the fundamentals of the business. CCA's advantage of being first in paper packaging would be replaced by the realities of competing in a commodity business. So, in addition to managing CCA's assets and investments accordingly, Paepcke set out to distinguish his company from all others.

In 1936, CCA initiated what was quite likely the first, thoroughgoing corporate design program. Egbert Jacobson, a respected art director and authority on color, was hired to direct the effort. Jacobson started with CCA's factories, using color and interior design to express to CCA employees why and how the company they worked for was somehow different and special. Jacobson and Paepcke retained Bauhaus master Herbert Bayer as a consultant to CCA and, in 1937, launched an audacious advertising program that employed artists and designers, including Moholy-Nagy, Cassandre, Kepes, Leger, Man Ray, Matter, and others, to tell the CCA story with concise copy and powerful graphic images that would suggest the CCA personality by the quality and daring of their visual approach. Not everyone reacted favorably to this new kind of corporate advertising. In 1938, David Ogilvy, as well known in advertising circles then as he is today, characterized the CCA approach as "an exercise in amateurish pretension."

While they were, without doubt, toughminded about their business, Paepcke and his people also seemed able and eager to look beyond boxes to the broader implications and significance of packaging and its key role in the growth of a modern manufacturing economy. Between 1942 and 1944, CCA advertising focused on the role of paper packaging in shipping food and material for the war effort. Then, with peace, CCA ads turned to the role packaging played in countries around the world and utilized art made

Chairman
Eugene Grossman
Principal
Anspach Grossman Portugal

Committee
Bruce Blackburn
Principal
Danne & Blackburn

Thomas Geismar
Principal
Chermayeff & Geismar

Jim Miho
Designer

Arnold Saks
President
Arnold Saks, Inc.

Walter P. Paepcke, 1926

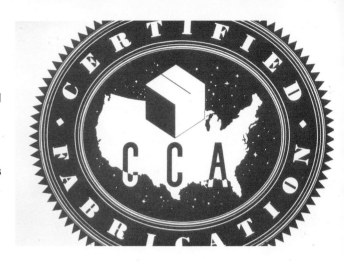

Certified Fabrication Seal:
1938
Designer:
Unknown

Corporate Symbol:
Original

Corporate Symbol:
1936
Design Director:
Egbert Jacobson

Corporate Symbol:
1958
Design Director:
Ralph Eckerstrom
Designers:
CCA Corporate Design Staff

by artists of the various countries featured. In concert with the United States' explosive post-war growth, CCA launched a series on each of the 48 states, once again commissioning artists native to the subject states. Then, around 1950, CCA took another pioneering step in advertising and launched the famed Great Ideas campaign, which would run at varying levels for the next 30 years, outliving the founder of the company by more than two decades. By 1968, even David Ogilvy's opinion had changed: "the best campaign in corporate advertising that has ever appeared in print."

Because of its high visibility, CCA corporate advertising tends to mask equally impressive accomplishments in other facets of corporate design and communication. Perhaps no other American company has done as good a job, over as long a stretch of time, of tending intelligently and persistently to the nuts-and-bolts of corporate identification, graphic design, and sales promotion. Organizationally, CCA was innovative in the establishment of its heralded Design Laboratory under Albert Kner in the late 1940s, and its experiment with the Center for Advanced Research in Design in the 1960s and early 1970s. Throughout a half-century of commitment to design, CCA has employed designers and design managers who stand in the forefront of modern graphic design and design communication: Ralph Eckerstrom, John Massey, John Rieben, Bill Lloyd, Bill Bonnell, Joe Hutchcroft. The challenge before each new CCA designer has been one of moving the CCA idea forward, not simply playing steward to a unique legacy — and all have succeeded.

There is more to Paepcke's impact on corporate design and communication, of course. Prominent among his many contributions was the founding and championing of the Aspen Institute for Humanistic Studies (a kind of "Great Ideas"-in-action for business executives), the Aspen Music School, and the International Design Conference. For his unequaled achievements, Paepcke was awarded the AIGA Gold Medal in 1960.

"But does it all sell *boxes*?" was and remains a question, both inside and outside CCA.

Though difficult to quantify, the answer is probably "yes." But it's the wrong question. What it all *has* done is set Container Corporation quite apart from the humdrum of corporate America — a position that few companies genuinely aspire to and fewer still achieve. CCA's position apart is just where Walter Paepcke must have been most comfortable. Paepcke believed that it was a businessman's obligation to keep his sights raised above the bottom line — not to ignore it, but to understand all the social, economic, and cultural forces that influenced it. Paepcke saw what business *could become* in our society, though it has yet to manifest it, and he insisted on such participation, both himself and his company. It speaks eloquently of the potential and the worth of design and communication that these were the tools of Paepcke's special choice.

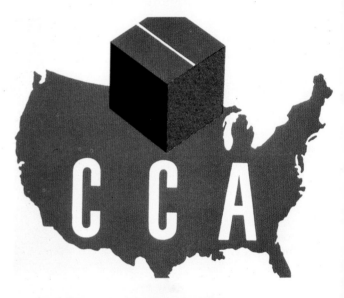

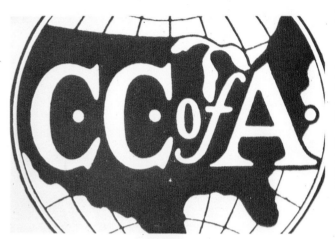

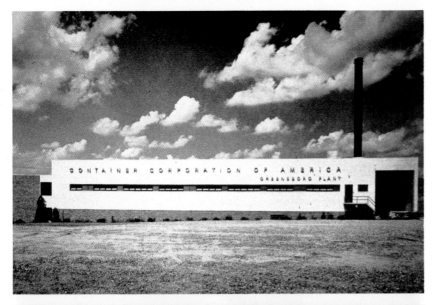

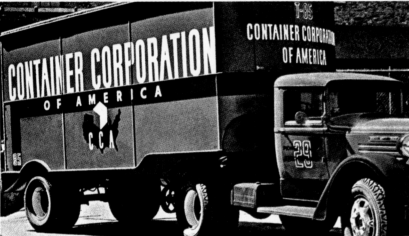

Corporate Identity:
Greensboro, North Carolina,
Carton Plant, 1947
Architect:
Walter Gropius

Corporate Identity:
Truck, 1936
Design Director:
Egbert Jacobson

Book:
World Geographic Atlas
Originally published, 1936
Revised, 1953
Design Director:
Herbert Bayer

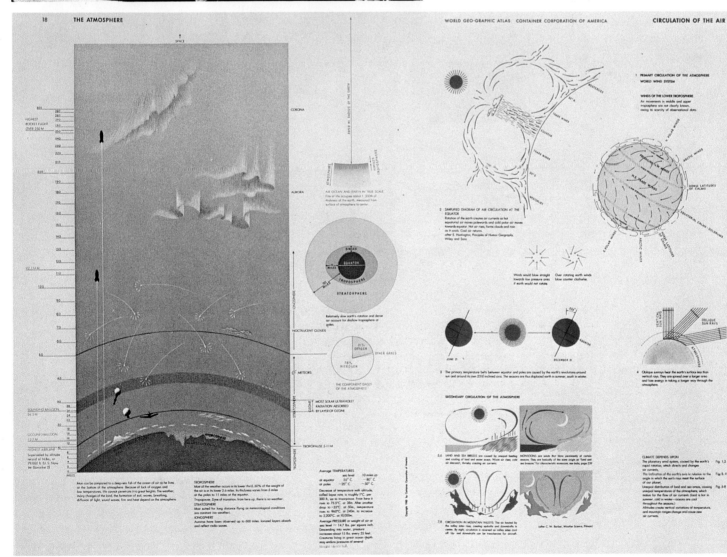

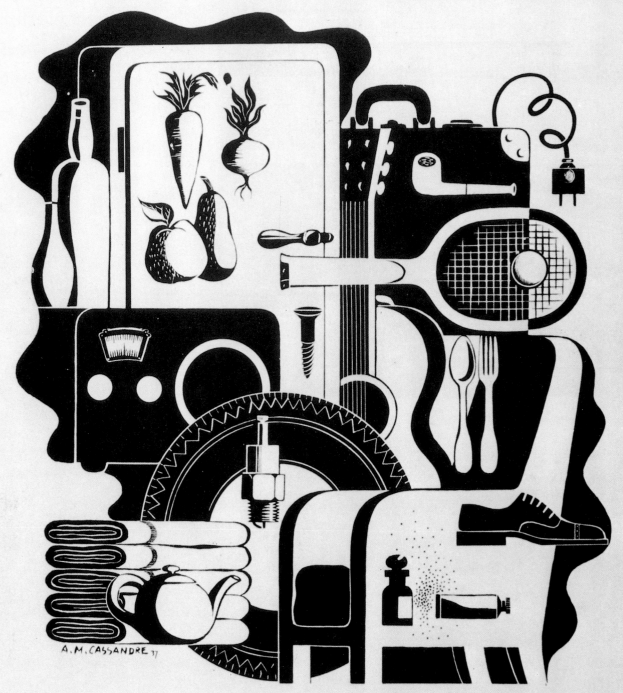

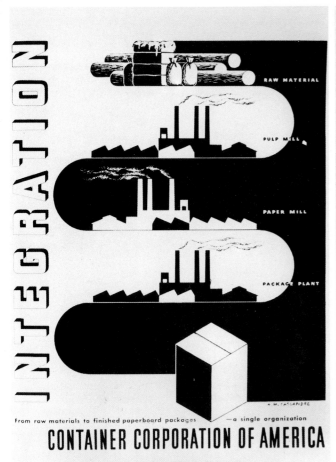

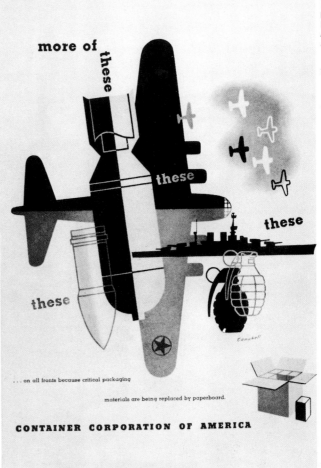

Advertisement:
Integration, 1939
Design Director:
Egbert Jacobson
Artist:
A. M. Cassandre

Advertisement:
World War II
Design Director:
Egbert Jacobson
Artist:
Campbell

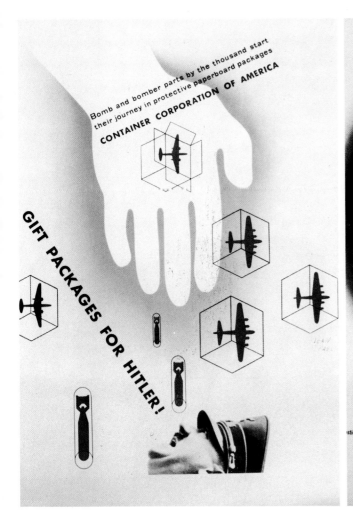

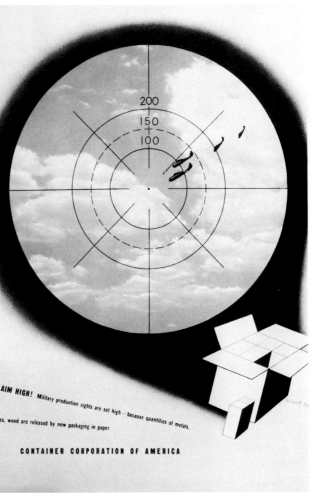

Advertisement:
World War II
Design Director:
Egbert Jacobson
Artist:
Jean Carlu

Advertisement:
World War II
Design Director:
Egbert Jacobson
Artist:
Herbert Bayer

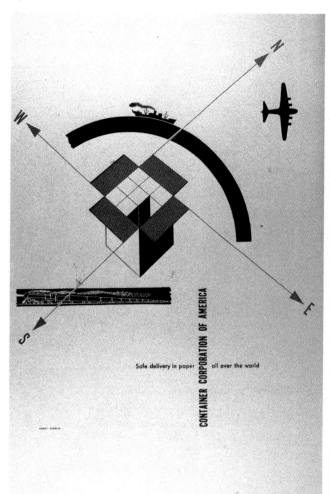

Safe delivery in paper all over the world

CONTAINER CORPORATION OF AMERICA

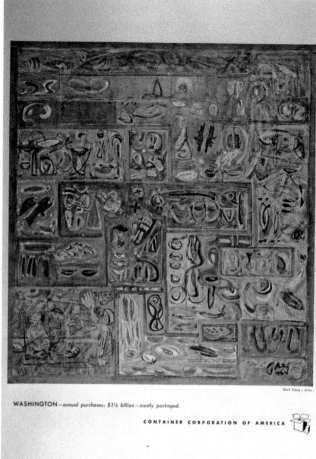

WASHINGTON—*annual purchases: $1½ billion—mostly packaged.*

CONTAINER CORPORATION OF AMERICA

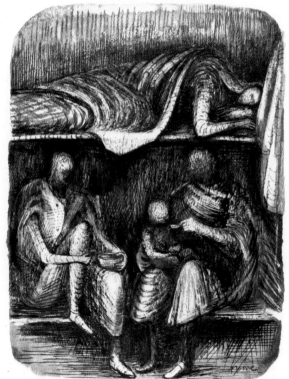

American foods in paper packages aid Britain.

CONTAINER CORPORATION OF AMERICA

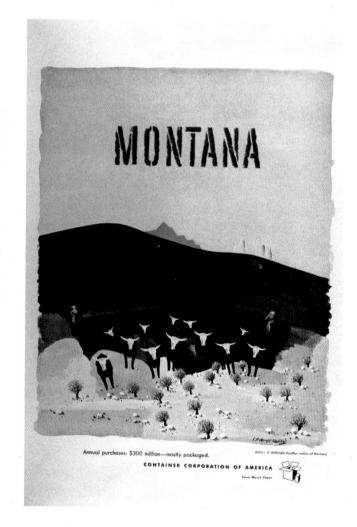

MONTANA

Annual purchases: $300 million—mostly packaged.

Artist—E. McKnight Kauffer, native of Montana

CONTAINER CORPORATION OF AMERICA

Save Waste Paper

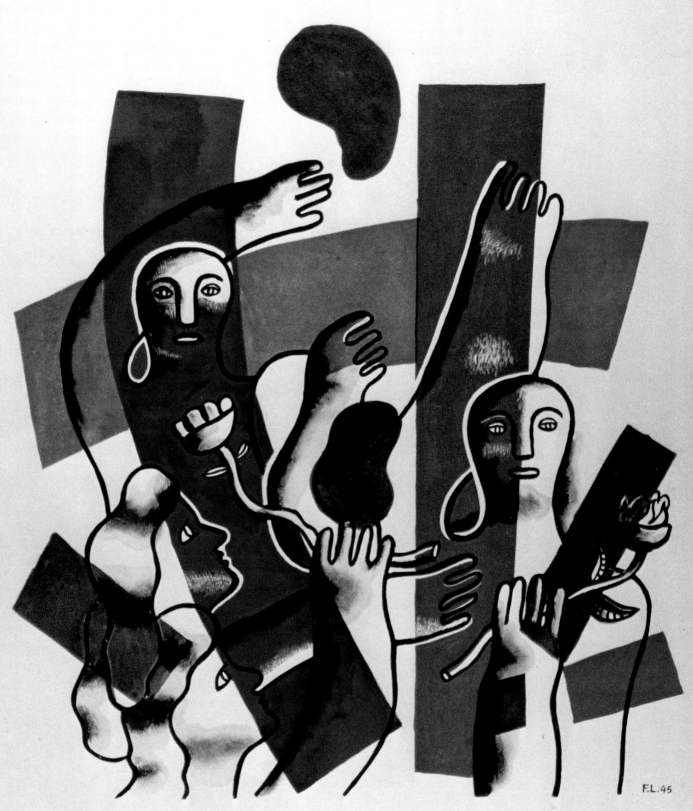

F.L.45

Artist: Fernand Leger, native of France

FRANCE REBORN *New lifeblood—supplies in paper packages.*

CONTAINER CORPORATION OF AMERICA

SAVE WASTE PAPER

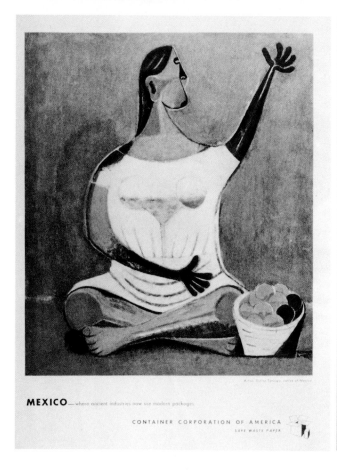

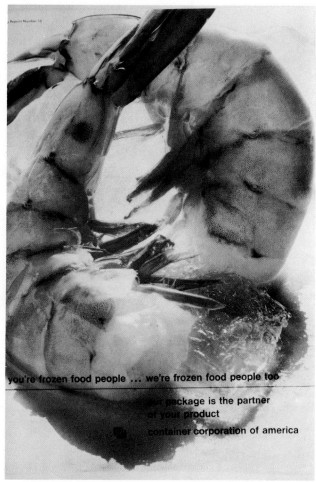

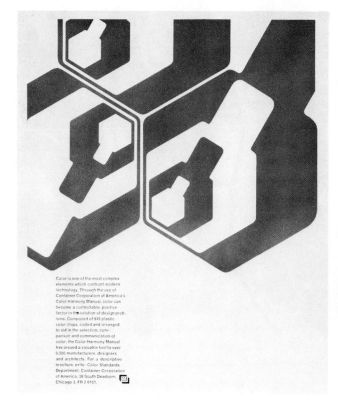

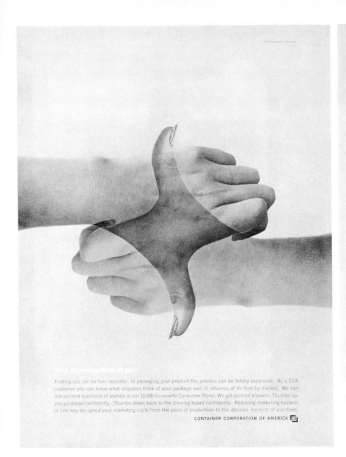

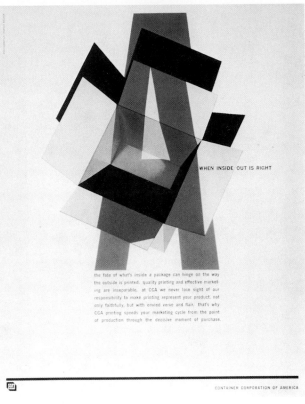

WHEN INSIDE OUT IS RIGHT

the fate of what's inside a package can hinge on the way the outside is printed. quality printing and effective marketing are inseparable. at CCA we never lose sight of our responsibility to make printing represent your product, not only faithfully, but with envied verve and flair. that's why CCA printing speeds your marketing cycle from the point of production through the decisive moment of purchase.

CONTAINER CORPORATION OF AMERICA

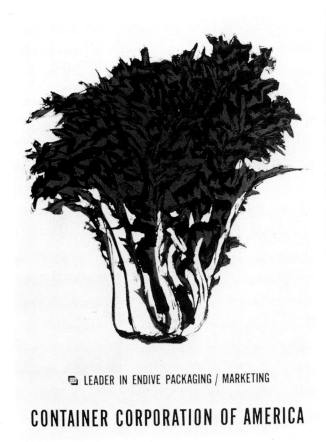

LEADER IN ENDIVE PACKAGING / MARKETING

CONTAINER CORPORATION OF AMERICA

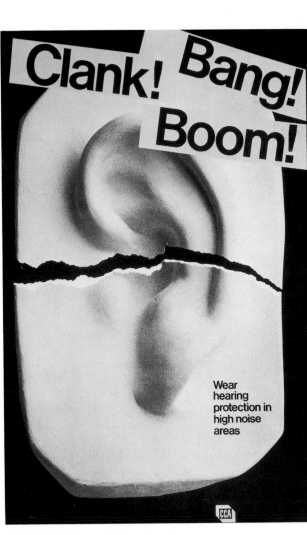

Manual:
Color Harmony
Design Director:
Walter Granville

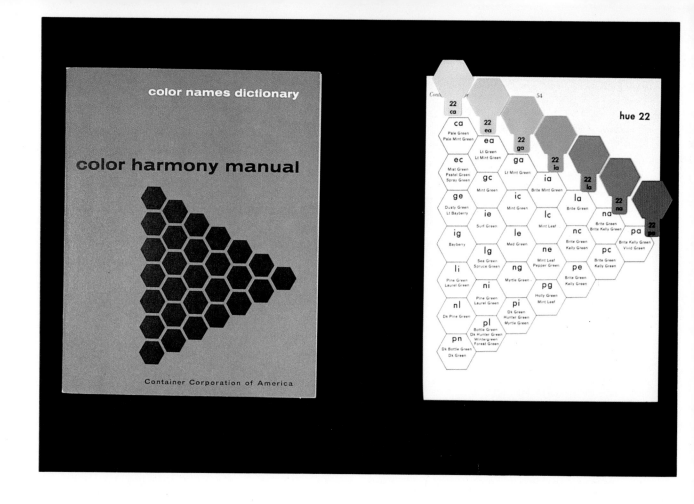

Book:
Color Harmony
Design Director:
Walter Granville
Designer:
Mort Goldsholl

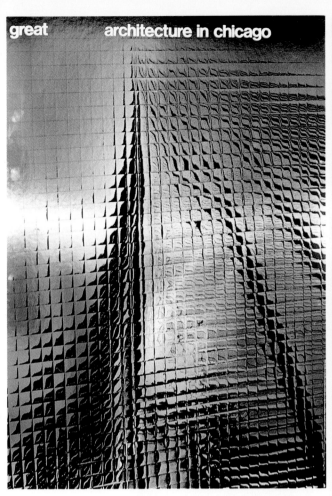

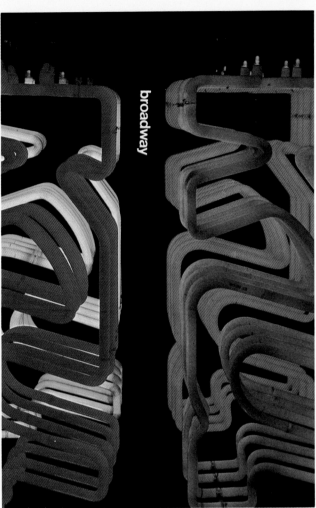

Poster:
Great architecture
in Chicago, 1967
Design Director:
John Massey
Designer:
Tomoko Miho

Poster:
Broadway, 1967
Design Director:
John Massey
Designer:
Tomoko Miho
Artist:
Chryssa

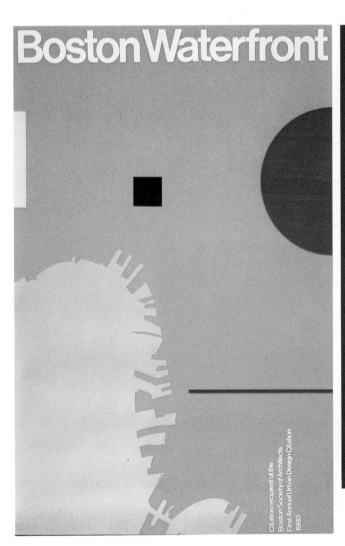

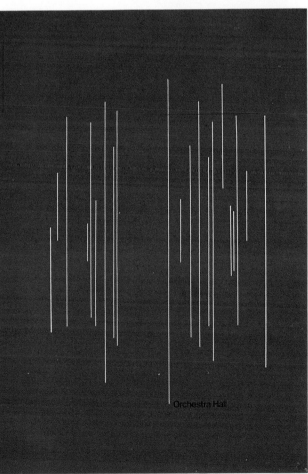

Poster:
Boston Waterfront, 1981
Design Director/Designer:
John Massey

Poster:
Orchestra Hall, Chicago
1967
Design Director:
John Massey
Designer:
Terry Westmacott

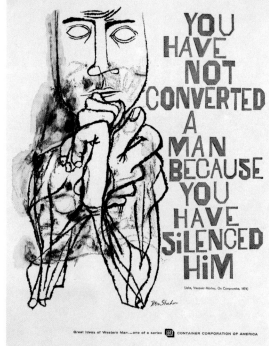

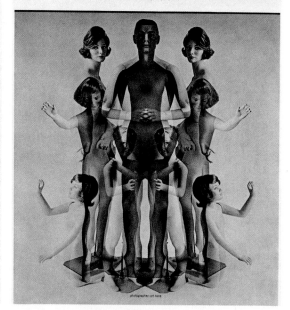

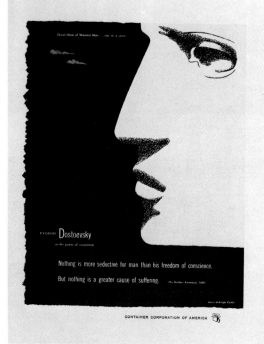

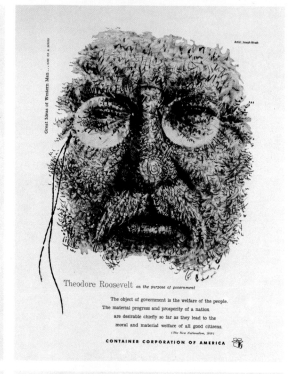

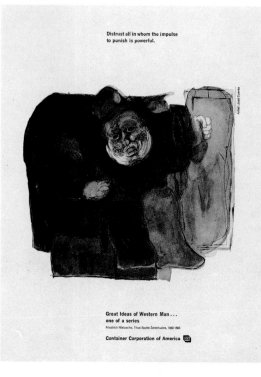

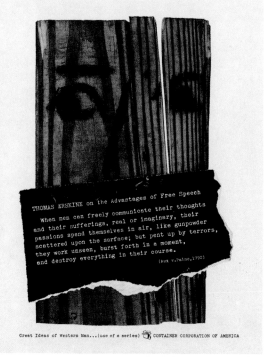

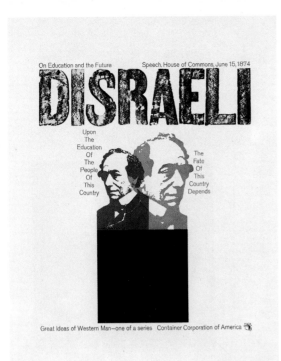

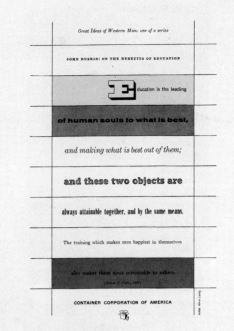

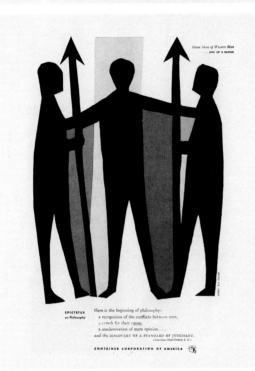

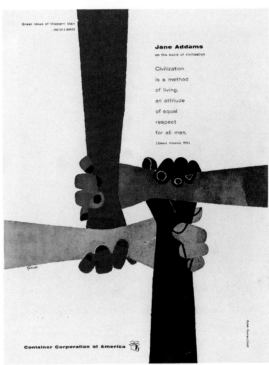

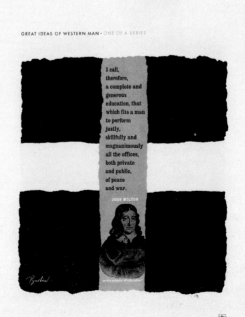

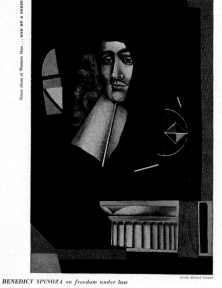

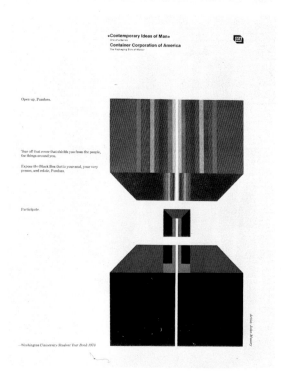

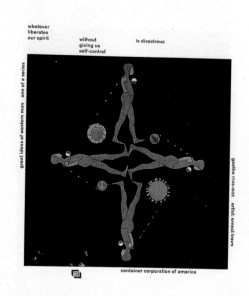

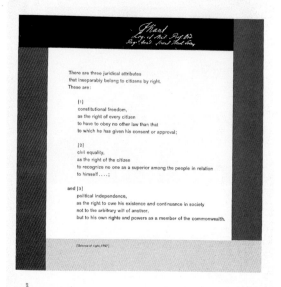

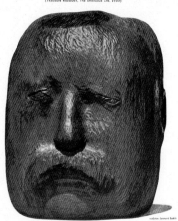

GREAT IDEAS OF WESTERN MAN...one of a series

No man is justified in doing evil on the ground of expediency

(Theodore Roosevelt, The Strenuous Life, 1900)

sculptor: Leonard Baskin

CONTAINER CORPORATION OF AMERICA

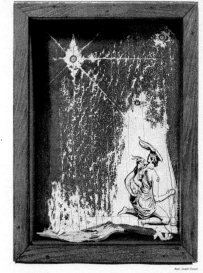

Artist: Joseph Cornell

Carl Schurz on Idealism

Ideals are like stars; you will not succeed in touching them with your hands. But like the seafaring man on the desert of waters, you choose them as your guides, and following them you will reach your destiny.

(Address, Faneuil Hall, Boston, April 18, 1859)

Great Ideas of Western Man... one of a series CONTAINER CORPORATION OF AMERICA

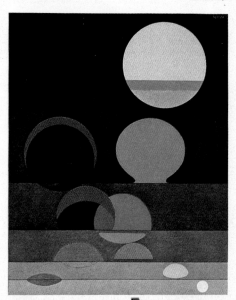

The art of progress is to preserve order amid change and to preserve change amid order

Alfred North Whitehead, 1861-1947 artist: herbert bayer

Great Ideas of Western Man one of a series Container Corporation of America

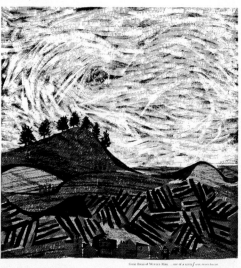

VICTOR HUGO on a measure of greatness

There is no such thing as a little country. The greatness of a people is no more determined by their number than the greatness of a man is determined by his height.

(Speech, November 17, 1862)

CONTAINER CORPORATION OF AMERICA

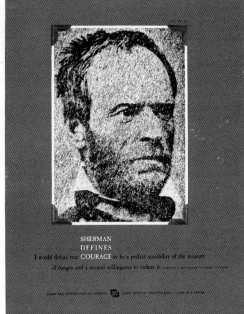

SHERMAN DEFINES COURAGE

I would define true courage to be a perfect sensibility of the measure of danger, and a mental willingness to endure it.

CONTAINER CORPORATION OF AMERICA GREAT IDEAS OF WESTERN MAN ONE OF A SERIES

those who cannot remember the past are condemned to repeat it

george santayana, the life of reason, great ideas of western man... one of a series container corporation of america

Artist: Man Ray

Sales Kit:
Formset
Design Director:
John Massey
Designer:
Bill Bonnell

Calendar:
1975
Design Director:
John Massey
Designer:
Bill Bonnell

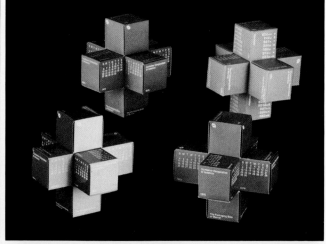

Calendar:
1972
Design Director:
John Massey
Designer:
John Massey

Calendar:
1973
Design Director:
John Massey
Designer:
Bill Lloyd

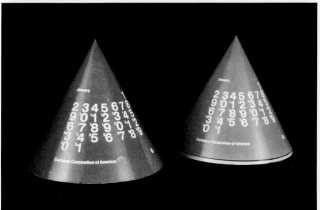

Calendar:
1983
Design Director:
John Massey
Designer:
Joe Hutchcroft

Sales Kit:
The Versaform Kit, 1979
Design Director:
John Massey
Designer:
Joe Hutchcroft

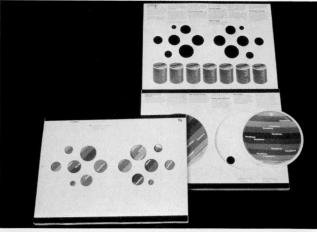

Exhibit:
Packaging Show
Design Director:
John Massey
Designers:
Bob and Bill Kaulfuss

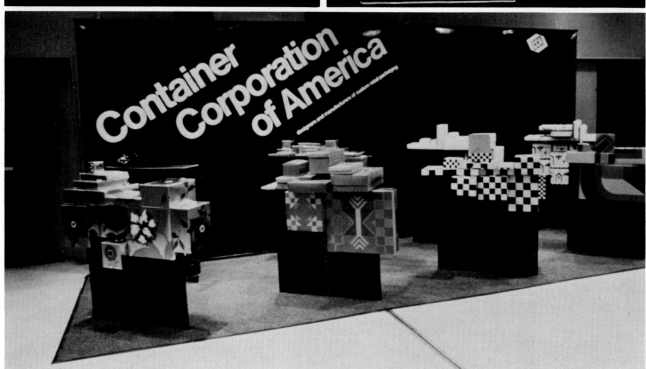

C A P E

Computer
Assisted
Packaging
Evaluation

Container Corporation
of America

Brochure:
CAPE: Computer Assisted
Packaging Evaluation
Design Director:
John Massey
Designer:
Bill Bonnell

Brochure:
Recycle Paper
Design Director:
John Massey
Designer:
Jeff Barnes

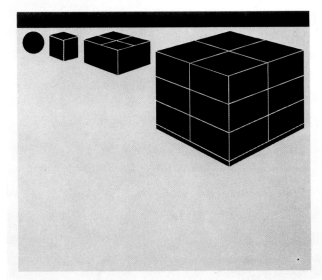

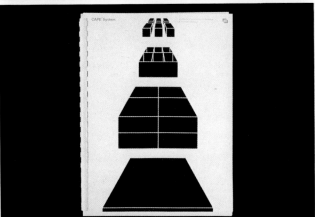

Binder:
CAPE System
Design Director:
John Massey
Designer:
Bill Bonnell

Corporate Identification:
Truck
Design Director:
John Massey
Designers:
CCA Staff

Exhibition:
Made With Paper
Design Director:
John Massey
Designers:
Bob and Bill Kaulfuss

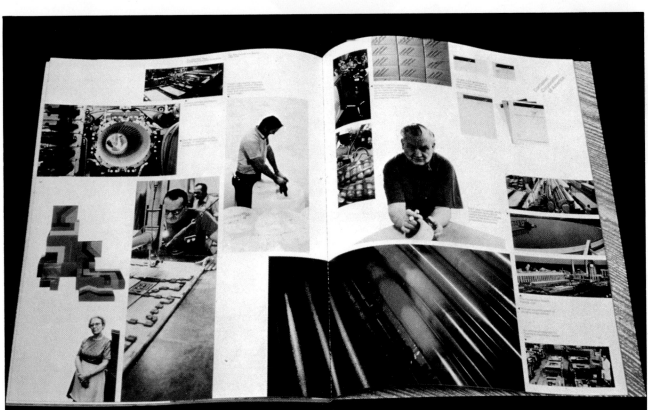

Book:
The First Fifty Years:
1926–1976
Design Director:
John Massey
Designer:
Bill Bonnell

Chairman
Kit Hinrichs
Partner
Jonson Pedersen Hinrichs & Shakery

Jury
Robert Cipriani
President
Robert Cipriani Associates

Alicia Landon
Designer
Alicia Landon Design

Stan Richards
President/Creative Director
The Richards Group

Paula Scher
Designer/Art Director
Columbia/CBS Records

Massimo Vignelli
President
Vignelli Associates

The AIGA California Graphic Design competition offers a unique opportunity to speculate on the presence of a regional style in American graphic design. As the golden land at the end of the Frontier, separated by a continent from the East Coast and its attachments to the cultural legacies of Europe, California has been the restless spawning ground for indigenous American styles, a place to try doing things in a different way. It would seem natural that a California style in graphic design would have emerged. At the invitation of the Stanford Design Conference, the AIGA held a competition to find out.

The poster announcing the competition, designed by Kit Hinrichs, foretold freewheeling movement and novelty with a touch of Hollywood nostalgia. In a photograph by Terry Heffernan, a panorama that reaches from the royal palms of Los Angeles to the Golden Gate over San Francisco Bay is reflected in the chrome grillwork of a 1947 Ford. The letters "DESIGN" are inscribed on the authentic vanity license plate borrowed from a California designer. The total effect attracted wide attention, and the poster was added to the collection of the Museum of Modern Art in New York. It also drew into the judging 2,600 entries covering a broad range of graphic design done over a 2½-year period by California designers. The exhibition of 402 pieces chosen by the judges opened in San Francisco, in Los Angeles, and in New York.

Commenting on the show as a whole, the jury (no members from California) made a distinction between work done for corporations and that created for more entrepreneurial clients. They agreed that the corporate style was essentially national and, except for a few light touches that might be considered too coy for New York, it resembled corporate work being done everywhere, impressive in its consistently high technical quality.

On the other hand, the graphic design representing smaller companies and organizations indicated signs of what the judges concurred might be a California style. Comparing this work to work done in the East, they observed that the *designer as artist* was much more visible in graphics done in California. The work appeared to be freer, less formally tied to tradition, and more experimental. There was a more vibrant use of color and a wider variety of media and printing possibilities. Frequently playful and humorous, it displayed what one judge described as "a joyful trendiness." It was noted that in New York or Boston, the photographer or illustrator is often depended on to carry the theme of a piece. In California, the designer's hand seemed much more apparent. And, unlike the East, where a designer is often labeled by a specialty, many California designers seemed to have successfully resisted categorization. The work of one of them may represent a wide variety of projects, from posters to promotional literature to identity programs, all of which maintain a uniformly high standard. The term *California Renaissance Designer* used by one of the judges seemed apropos.

The difference between Northern and Southern California, or more explicitly San Francisco and Los Angeles, was another classification used by the judges in describing the style of California graphics. The personalities of these two cities were said to have produced definitive styles of their own. The soft, decorative elegance of San Francisco, with its abundance of restaurants and boutiques, requires a quieter graphic expression than Los Angeles, with its sprawling tensions and fabled glamour. The energy- propelling New Wave design is generated in the Southern environment with its film, television and record industries. The judges considered the work of some California designers representative of one of these cities (such as Greiman in Los Angeles), while a few (Vanderbyl, Manwaring, and Ingles in San Francisco) were said to transcend the difference.

In tracing other cultural roots of the California style, the judges pointed to neighboring Mexico, with its brilliant colors, as a strong influence. Another was the Orient and its transcendental frame of mind, which removes California even further from the more tightly laced East Coast.

On a more practical level, the wide variety of production and printing possibilities noticed in the exhibition has been attributed to the rapidly expanding design services available in California, while the individualistic styles distinguishing some of the work may be evidence of a different client base. Large, multifaceted corporations, where designs must be sifted through a hierarchy of approval, are generally Eastern, whereas California clients tend to be smaller and can be represented by design that is specific and more personal.

In a time when telecommunications are shrinking the world, defining the characteristics of a regional style in American graphic design may seem beside the point. However, it is the point. In the increasing homogenization of world culture, understanding these remaining differences will enlighten our lives and enrich our work.

Promotional Brochure:
Harnessing Systems
Designer:
Greg Lee
Photographer:
Gary DiPalma
Design Firm:
Raychem Corp.
Menlo Park
Client:
Raychem Corp.
Typographer:
Drager & Mount
Printer:
Pacific Rotaprinting

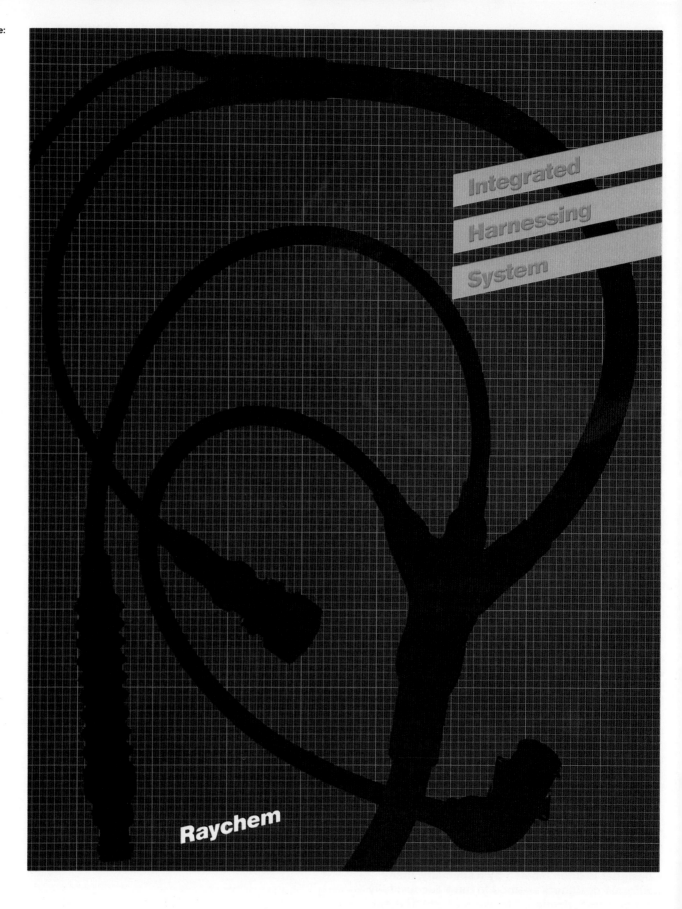

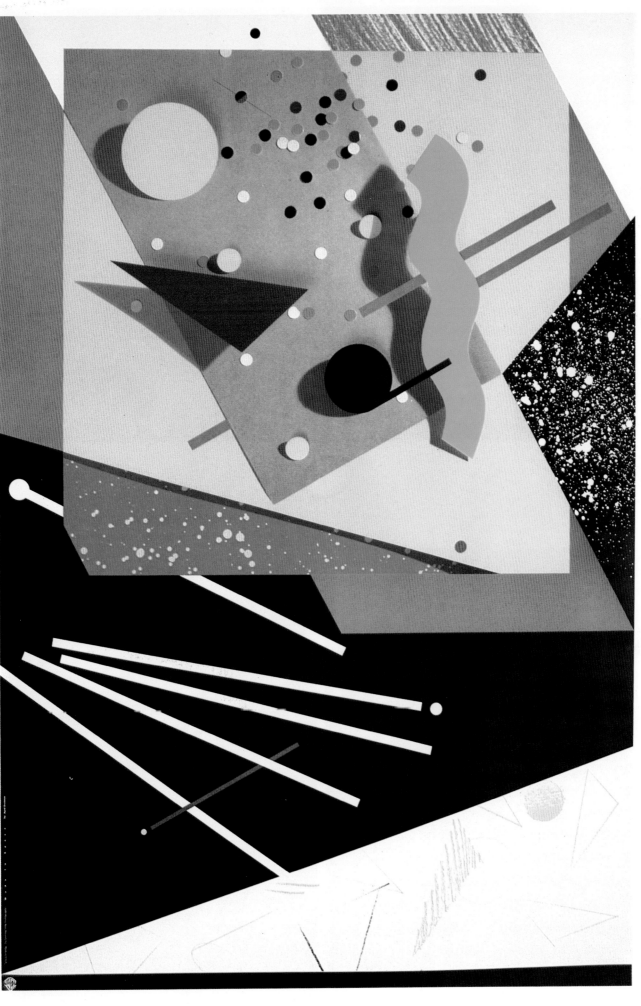

Poster:
Warner Records
Art Director:
April Greiman
Designer:
April Greiman
Artist:
April Greiman
Photographer:
April Greiman
Design Firm:
April Greiman Studio
Los Angeles
Publisher:
Warner Records
Printer:
Anderson Lithographic Co.

Poster:
Space Apple
Art Director:
Michael Vanderbyl
Designer:
Michael Vanderbyl
Artist:
Michael Vanderbyl
Design Firm:
Vanderbyl Design
San Francisco
Client:
Modern Mode, Inc.
Typographer:
Headliners/Identicolor
Printer:
LithoSmith

Poster:
Space Party
Designer:
Michael Vanderbyl
Artist:
Michael Vanderbyl
Design Firm:
Vanderbyl Design
San Francisco
Client:
Modern Mode, Inc.
Typographer:
Headliners/Identicolor
Printer:
LithoSmith

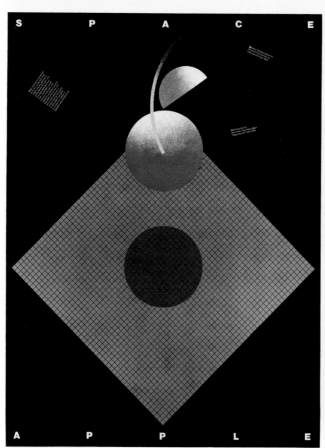

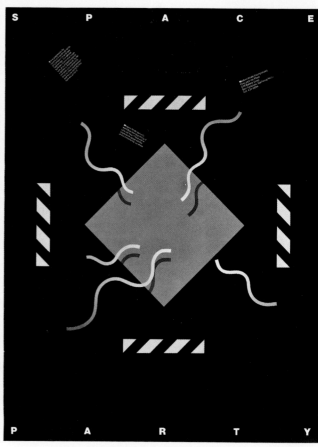

Poster:
The Windy Space
Art Director
Michael Vanderbyl
Designer:
Michael Vanderbyl
Artist:
Michael Vanderbyl
Design Firm:
Michael Vanderbyl
San Francisco
Client:
Modern Mode
Typographer:
Headliners/Identicolor
Printer:
LithoSmith

Poster:
Black &
Art Director:
Mark Anderson
Designers:
Michael Kunisaki,
Steven Tolleson
Artist:
Antony Milner
Photographer:
David Monley
Design Firm:
Anderson Griffin Assoc.
San Francisco
Client:
The National Press
Typographer:
Frank's Type, Inc.
Printer:
The National Press

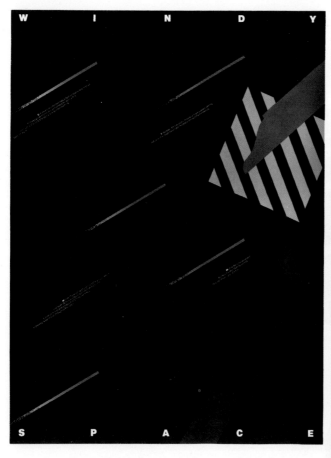

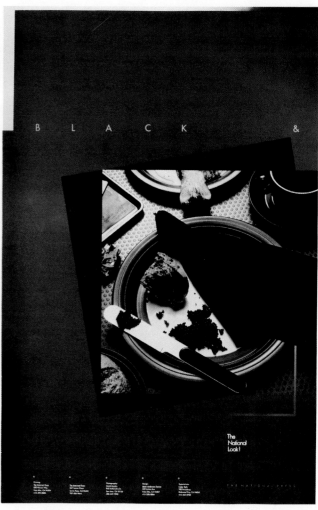

SIX DOES NOT EXIST ENVISION IT BEHIND THE RED SQUARE.

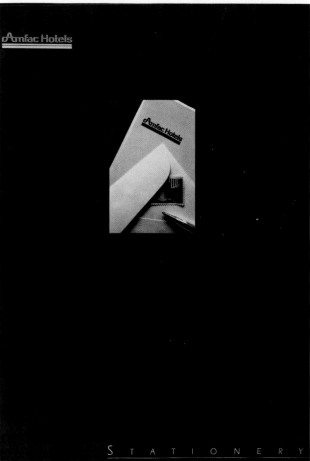

Poster:
Envision #6
Artist:
John Casado
Design Firm:
Casado Design
San Francisco
Client:
ADAC Sacramento
Typographer:
Reprotype

Promotional Folder:
Amfac Hotels
Art Director:
Mauricio Arias
Designers:
Mauricio Arias, Lee Beggs
Artist:
Lee Beggs
Photographer:
Light Language
Design Firm:
Arias & Sarraille
Palo Alto
Client:
Amfac Hotels
Typographer:
Spartan Typographers
Printer:
Color Graphics

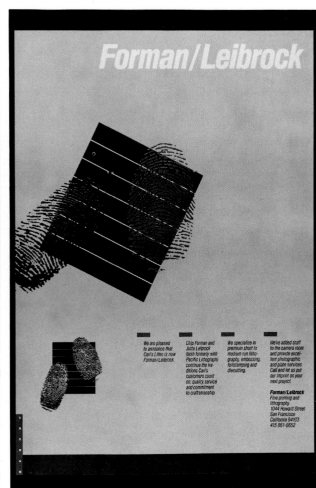

Poster:
Wedding Party
Art Director:
Craig Frazier
Designers:
Craig & Suzanne Frazier
Artist:
Craig Frazier
Design Firm:
Jorgensen/Frazier
San Francisco
Client:
The Fraziers
Typographer:
Drager & Mount
Printer:
Foundation 14, Aura Studios

Announcement:
Forman-Leibrock
Designer:
Michael Cronan
Design Firm:
Michael Patrick Cronan
San Francisco
Client:
Forman-Leibrock, Printer
Typographer:
Headliners/Identicolor
Printer:
Forman-Leibrock

Folder:
Eugene Lew + Assoc.
Art Director:
Michael Manwaring
Designer:
Michael Manwaring
Artists:
Debi Shimamoto,
Betty Barsamian
Design Firm:
The Office of Michael
Manwaring
San Francisco
Client:
Eugene Lew + Assoc.
Typographer:
Omnicomp
Printer:
Cannon Press

1980 MILL VALLEY FILM FESTIVAL

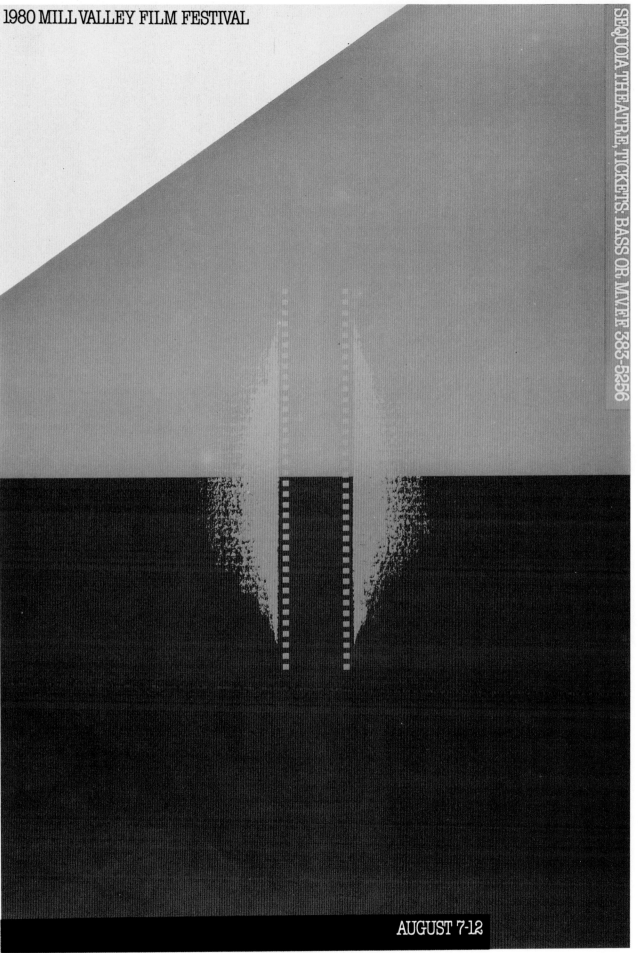

AUGUST 7-12

SEQUOIA THEATRE TICKETS: BASS OR, MVFF 383-5256

Poster:
Mill Valley Film Festival
Art Director:
John Casado
Designer:
John Casado
Artist:
John Casado
Design Firm:
Casado Design
San Francisco
Client:
Mill Valley Film Festival
Printer:
Clyde Engle

Menu:
Englander's
Art Director:
Bill Tom
Designer:
Bill Tom
Artist:
Bill Tom
Design Firm:
Dyer/Kahn
Los Angeles
Client:
Englander's Wine BA

Invitation:
Skidmore, Owings & Merrill
Christmas
Art Director:
Debra Nichols
Designers:
Paul Tsang/Debra Nichols
Artist:
Paul Tsang
Design Firm:
Skidmore, Owings & Merrill
Graphics
San Francisco
Client:
Skidmore, Owings & Merrill
Typographer:
Reardon & Krebs
Printer:
Lin Litho

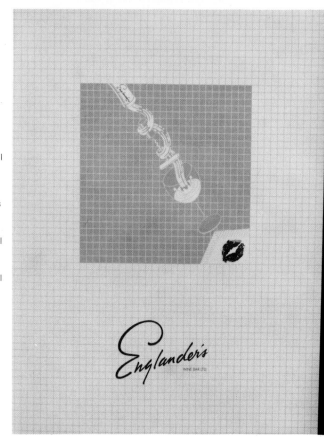

Announcement:
Kimonos
Art Director:
Russell Leong
Designer:
Russell Leong
Artist:
Michael Chikamura
Writers:
Linda Langston,
Candace Hathaway
Design Firm:
Russell Leong
Palo Alto
Client:
Palo Alto Cultural Center
Typographer:
Frank's Type, Inc.
Printer:
Walch Grafiks

Poster:
The W.O.R.K.S.
Art Directors:
Tom Kamifuji, June Vincent,
Alan Drucker
Designer:
Tom Kamifuji
Artist:
Tom Kamifuji
San Francisco
Client:
Drucker/Vincent, Inc.
Typographer:
Tom Kamifuji
Printer:
The W.O.R.K.S.

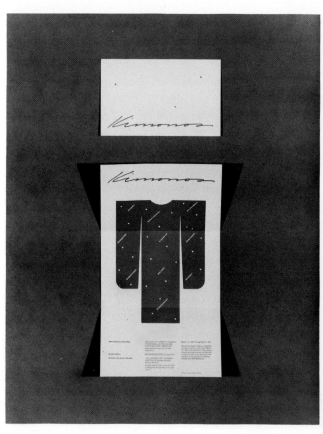

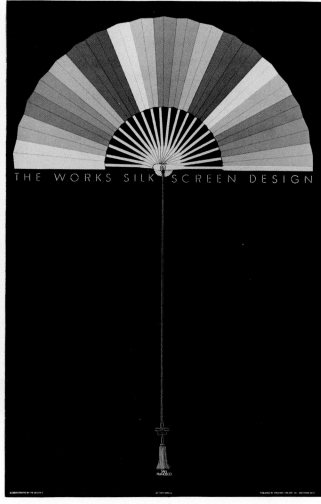

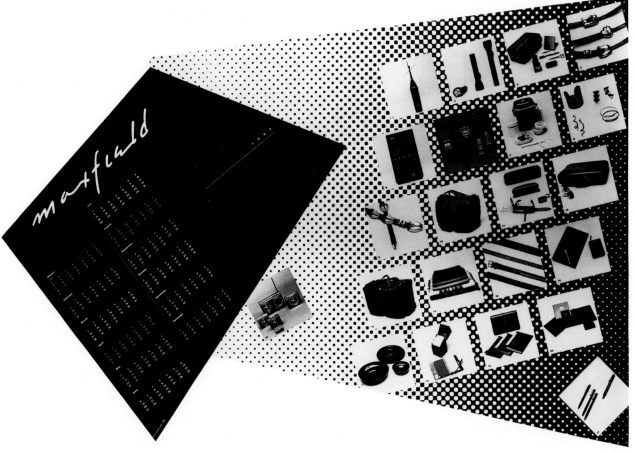

Calendar:
Maxfield
Art Director:
April Greiman
Designer:
April Greiman
Design Firm:
April Greiman
Los Angeles
Client:
Maxfields
Typographer:
Joe Malloy
Printer:
Anderson Lithographic Co.
Coordinator:
Anne Marie Dubois-Dumee

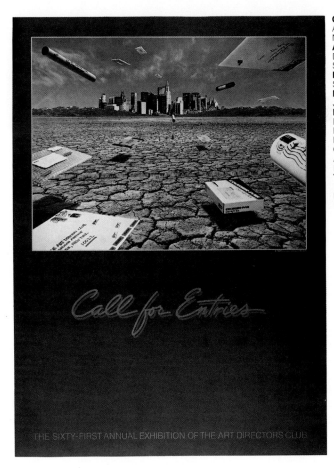

Call for Entry:
Art Directors Club of
New York
Art Directors:
Douglas Boyd,
Scott A. Mednick
Designer:
Scott A. Mednick
Photographer:
John Bilecky
Design Firm:
Douglas Boyd Design and
Marketing
Los Angeles
Client:
Art Directors Club of
New York
Typographer:
Phototype House
Printer:
Gore Graphics

Record Jacket:
Tommy Tutone
Art Director:
Tony Lane
Designer:
Tony Lane
Los Angeles
Photographer:
Bob Seidemann
Client:
CBS Records
Printer:
Shorewood Packaging
Corp.

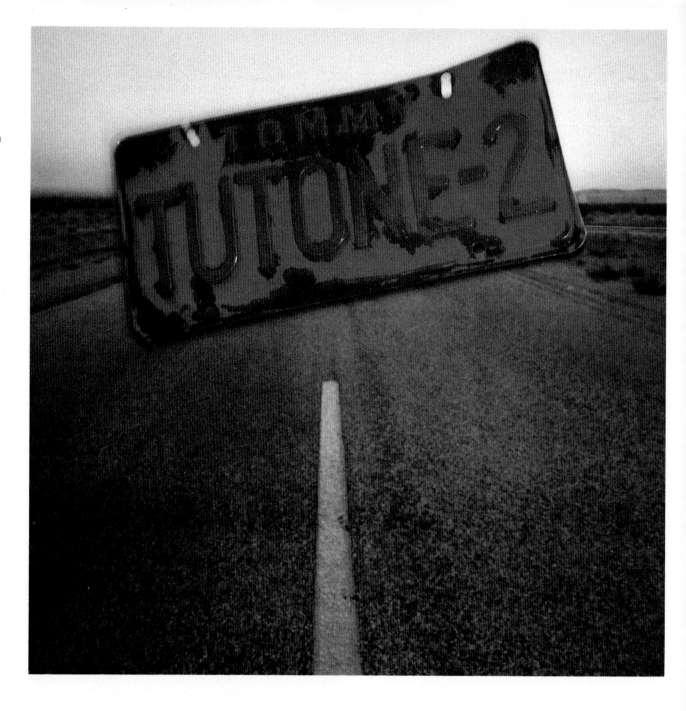

Poster:
Friedlander
Art Director:
Rory Phoenix
Designer:
Rory Phoenix
Photographer:
Ernie Friedlander
San Francisco
Client:
Ernie Friedlander
Printer:
Franciscan Graphics

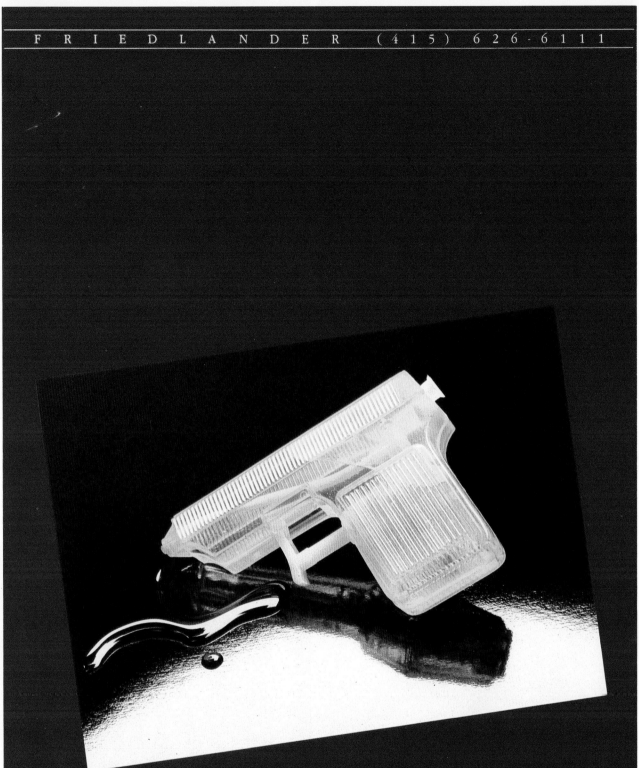

Magazine:
Apple
Art Director:
Mauricio Arias
Designer:
Mauricio Arias
Artist:
Various
Photographer:
Various
Design Firm:
Arias & Sarraille
Palo Alto
Client:
Apple Computer Inc.
Typographer:
Frank's Type, Inc.
Printer:
Color Graphics

Annual Report:
Financial Federation
Annual Report 1980
Art Directors:
Advertising Designers, Inc.,
Tom Ohmer
Designer:
Koji Takei
Artists:
Koji Takei, Don Oka
Design Firm:
Advertising Designers, Inc.
Los Angeles
Client:
Financial Federation, Inc.
Typographer:
Aldus Type Studio
Printer:
Anderson Lithographic Co.

Magazine:
Assets, Spring 1981
Art Director:
Kit Hinrichs
Designers:
Kit Hinrichs, Barbara Vick
Artist:
Ward Schumaker
Design Firm:
Jonson Pedersen Hinrichs
& Shakery
San Francisco
Client:
Crocker National Corp.
Typographer:
Crocker National Corp.
Printer:
Graphic Arts Center

Book Cover:
RSVP-7
Art Director:
Tom Nikosey
Designer:
Tom Nikosey
Artist:
Tom Nikosey
Design Firm:
Nikosey Design
Hollywood
Printer:
Wayne Graphics

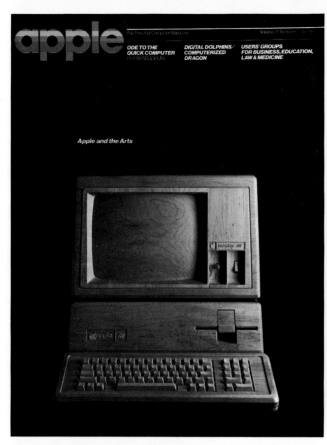

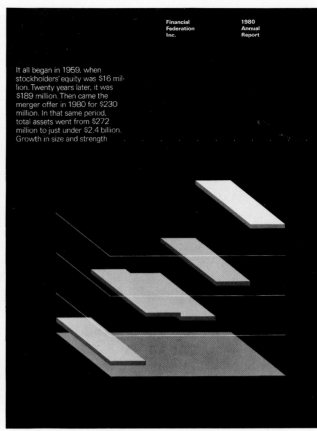

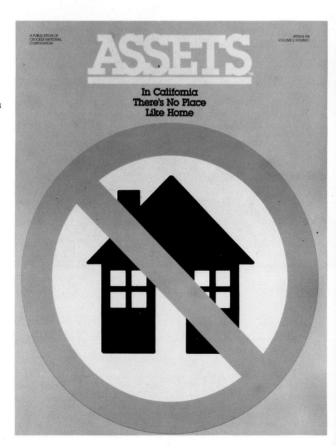

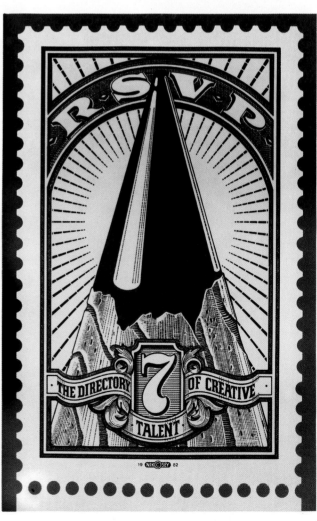

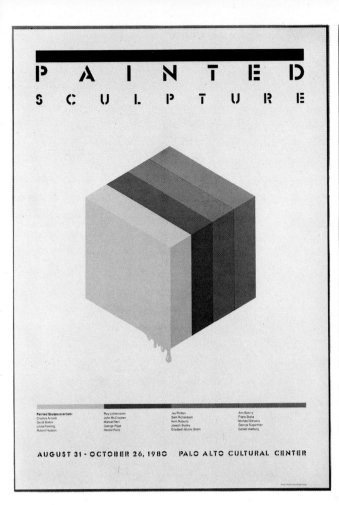

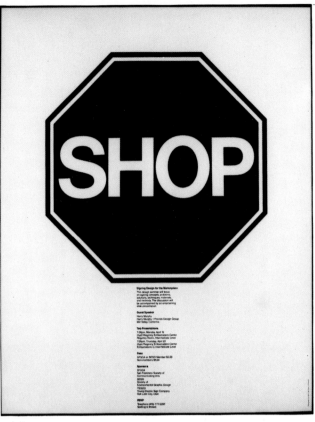

Poster:
Painted Sculpture
Art Director:
Russell Leong
Designer:
Russell Leong
Design Firm:
Russell Leong Design
Palo Alto
Client:
Palo Alto Cultural Center
Typographer:
Frank's Type, Inc.
Printer:
JEDA Publications

Poster:
"SHOP"
Art Director:
Harry Murphy
Designers:
Harry Murphy, Stan Klose,
John Gaccione
Design Firm:
Harry Murphy + Friends
Mill Valley
Client:
San Francisco Society of
Communicating Arts
Typographer:
Associates/San Rafael

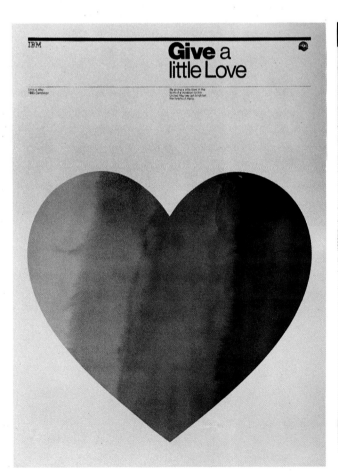

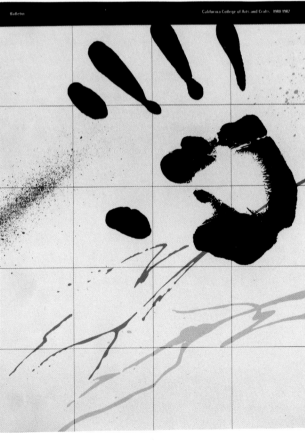

Poster:
United Way
Art Director:
Lee D. Green
Designer:
Lee D. Green
Artist:
Lee D. Green
Design Firm:
IBM, San Jose
San Jose
Client:
IBM, San Jose
Typographer:
Athertons
Printer:
B & C Litho.

Bulletin:
California College of Arts &
Crafts 1980-1982
Art Director:
Michael Manwaring
Designer:
Michael Manwaring
Artist:
Kathleen Weeks
Photographer:
Various
Design Firm:
The Office of Michael
Manwaring
San Francisco
Client:
California College of Arts
& Crafts
Typographer:
Abracadabra
Printer:
Interprint/Dai Nippon,
Japan

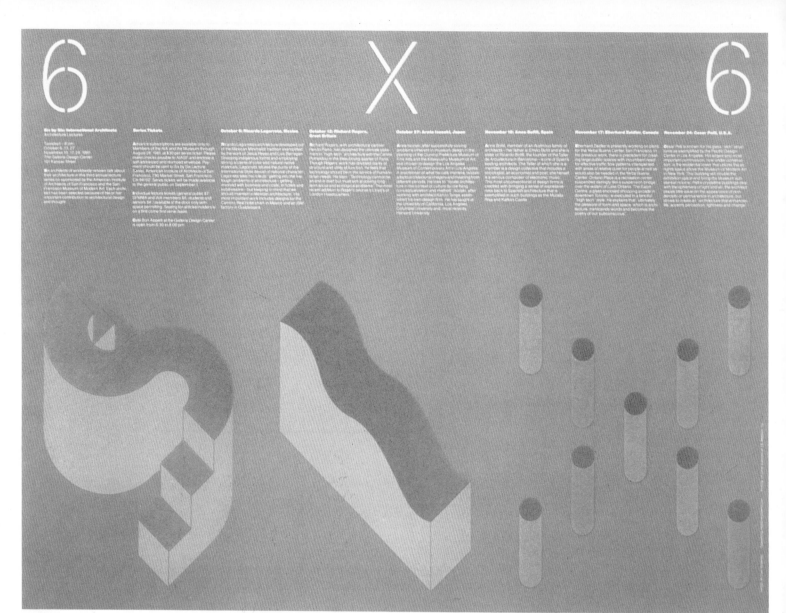

Poster:
Six by Six
Art Director:
Michael Vanderbyl
Designer:
Michael Vanderbyl
Artist:
Michael Vanderbyl
Design Firm:
Vanderbyl Design
San Francisco
Client:
American Institute of
Architects, San Francisco
Chapter
Typographer:
Headliners/Identicolor
Printer:
Venturegraphics

ART IN
LOS ANGELES

Los Angeles County
Museum of Art

in

Seventeen
Artists
in the Sixties

and

The Museum
as Site: Sixteen
Projects

21 July–
4 October
1 9 8 1

This exhibition was made possible
by a grant from the
James Irvine Foundation.

© 1981 by Museum Associates,
Los Angeles County Museum of Art.

Los Angeles County Museum of Art
5905 Wilshire Boulevard

Poster:
"Art in Los Angeles"
Art Director:
April Greiman
Designer:
April Greiman
Artist:
April Greiman
Design Firm:
April Greiman Studio
Los Angeles
Publisher:
Los Angeles County
Museum of Art
Typographer
RS Typographics
Printer:
Alan Litho

Book:
The Blimp Book
Art Director:
Neil Shakery
Designer:
Neil Shakery
Photographers:
George Hall, Baron Wolman
Design Firm:
Jonson Pedersen Hinrichs
& Shakery
San Francisco
Publisher:
Van Nostrand Reinhold Co.

Catalog:
Peterbilt Parts
Art Directors:
Doug Akagi, Steve Bragato
Designers:
Doug Akagi, Steve Bragato
Artists:
Sandy Short, Jim Gray,
Ken Andreotta
Photographers:
George Selland,
Bill Arbogast
Design Firm:
The GNU Group
Sausalito
Client:
Peterbilt Motors Co.
Typographer:
Spartan Typographers
Printer:
Continental Graphics

Greeting Card:
"California Freeway"
Art Director:
Roger Carpenter
Designer:
Linda Barton
Artist:
Stan Watts
Publisher:
Paper Moon
Culver City
Printer:
Angel Photocolor

Poster:
Eagles Aerobatic Flight
Team
Art Director:
Barry Deutsch
Designers:
Karen Tainaka,
Myland McRevey
Photographer:
Baron Wolman
Design Firm:
Steinhilber Deutsch & Gard
San Francisco
Client:
Christen Industries

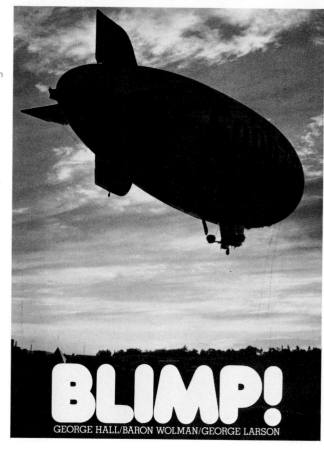

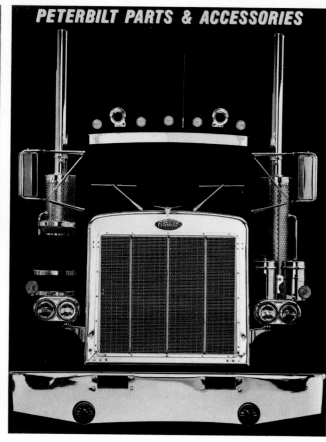

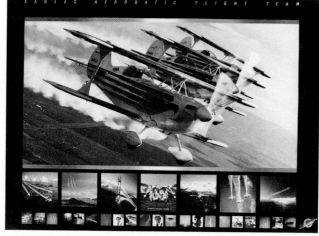

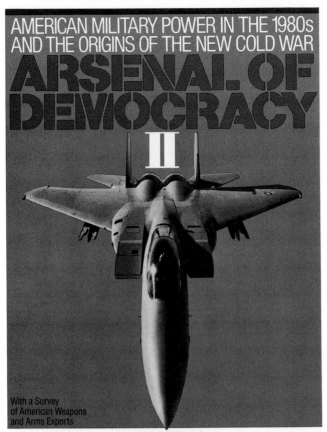

AMERICAN MILITARY POWER IN THE 1980s
AND THE ORIGINS OF THE NEW COLD WAR

ARSENAL OF DEMOCRACY
II

With a Survey
of American Weapons
and Arms Exports

BY TOM GERVASI

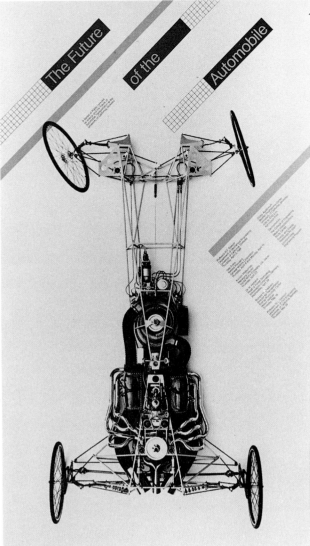

The Future of the Automobile

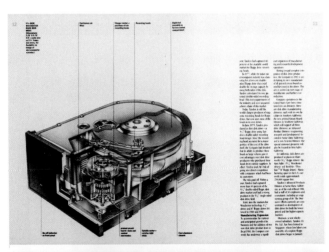

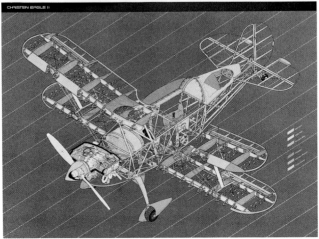

CHRISTEN EAGLE II

Book:
Arsenal of Democracy
Art Director:
Neil Shakery
Designer:
Neil Shakery
Design Firm:
Jonson Pedersen Hinrichs
& Shakery
San Francisco
Publisher:
Grove Press
Typographer:
Zimmering & Zinn/
U.S. Lithographic
Printer:
Murray Printing Co., Inc.

Poster:
Future of the Automobile
Art Director:
Greg Young
Designer:
Greg Young
Artist:
Don Potts
Photographer:
M. d'Hamer
Design Firm:
Berkeley Publications
Berkeley
Client:
University of California,
Berkeley
Typographer:
Reeder Type
Printer:
Cardinal Co.

Annual Report:
Tandon Corp.
Annual Report 1981
Art Director:
John Cleveland
Designers:
John Cleveland,
Michael Skjei
Artist:
David Kimble
Photographer:
Jay Freis
Design Firm:
John Cleveland, Inc.
Los Angeles
Client:
Tandon Corp.
Typographer:
Phototype House
Printer:
Southern California
Graphics

Poster:
Christen Eagle II
Art Director:
Barry Deutsch
Designers:
Karen Tainaka,
Myland McRevey
Artist:
Ivan Clede
Design Firm:
Steinhilber Deutsch & Gard
San Francisco
Client:
Christen Industries

Poster:
Happy GNU Year 1982
Art Directors:
Richard Burns, Doug Akagi
Sarah Nugent
Designers:
Jim Gray, Sandy Short
Artists:
Jim Gray, Sandy Short,
Ken Andreotta
Design Firm:
The GNU Group
Sausalito
Client:
The GNU Group
Printer:
Paragraphics

Bulletin:
California College of Arts
& Crafts Masters Degree
Program Bulletin
Art Director:
Michael Manwaring
Designer:
Michael Manwaring
Artist:
Betty Barsamian
Photographer:
Sharon Golden
Design Firm:
The Office of Michael
Manwaring
San Francisco
Client:
California College of
Arts & Crafts
Typographer:
Abracadabra
Printer:
Interprint/Warren's
Waller Press

Poster:
Baci
Art Directors:
Craig Frazier,
Conrad Jorgensen
Designers:
Craig Frazier,
Conrad Jorgensen
Artist:
Craig Frazier
Design Firm:
Jorgensen/Frazier
San Francisco
Client:
Baci Restaurant
Typographer:
Omnicomp
Printer:
James H. Barry Co.

Poster:
Legname
Art Director:
Craig Frazier
Designers:
Craig Frazier,
Conrad Jorgensen
Artist:
Rudi Legname
Photographer:
Rudi Legname
Design Firm:
Jorgensen/Frazier
San Francisco
Client:
Rudi Legname
Printer:
B&C Litho

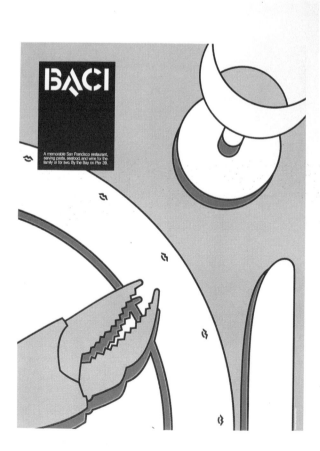

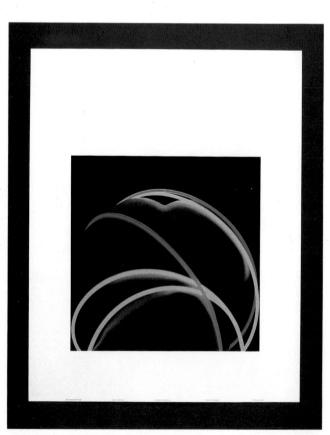

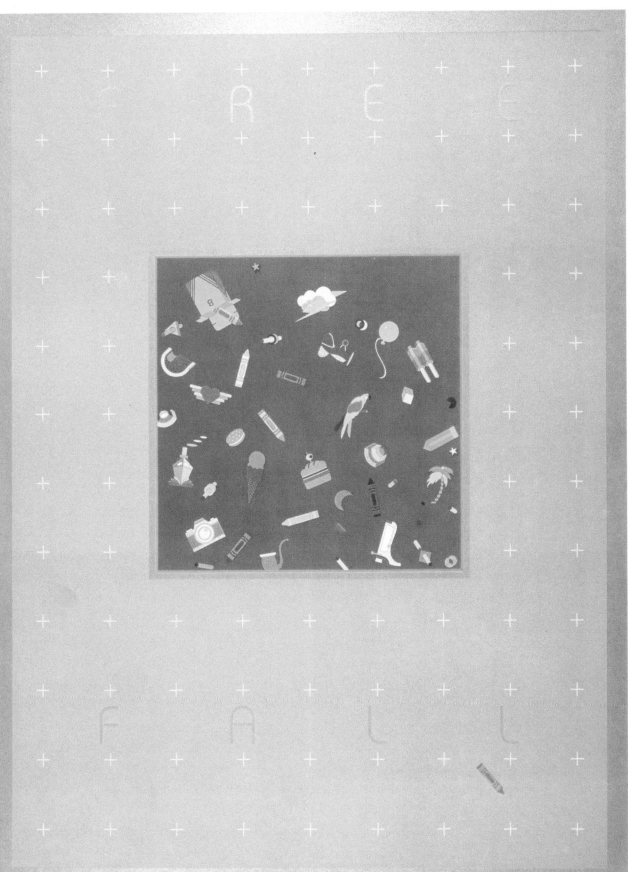

Poster:
"Free Fall"
Art Director:
Mark Anderson
Designers:
Mark Anderson,
Karen Emerson
Artist:
Karen Emerson
Design Firm:
Mark Anderson + Design
San Francisco
Client:
Mark Anderson + Design
Typographer:
Frank's Type, Inc.
Printer:
Riverside

Book:
Vanishing Creatures
Art Director:
Dugald Stermer
Designer:
Dugald Stermer
Artist:
Dugald Stermer
Design Firm:
Dugald Stermer
San Francisco
Client:
Lancaster-Miller
Typographer:
MacKenzie-Harris
Printer:
Publishers Press

Record Jacket:
Riggs
Art Director:
Richard Seireeni
Burbank
Artist:
Colin Self
Client:
Warner Bros. Records

Poster:
Rabbit
Art Director:
Jann Church
Designer:
Jann Church
Photographer:
John Lawder
Design Firm:
Jann Church Advertising
& Graphic Design
Newport Beach
Client:
George Rice & Sons
Typographer:
De-Lino-Type
Printer:
George Rice & Sons

Book:
Los Angeles Zoo
Art Director:
Tom Yerxa
Designer:
Russ Almquist
Photographer:
Various
Design Firm:
Atlantic Richfield
Design Services
Los Angeles
Client:
Los Angeles Zoo
Typographer:
Skil-Set Typographers
Printer:
Gardner Fulmer
Lithograph Co.

Book:
Cabrillo National Monument
Art Director:
McQuiston & Daughter, Inc.
Designer:
McQuiston & Daughter, Inc.
Artists:
Jennifer Dewey,
McQuiston & Daughter, Inc.
Photographers:
Marshall Harrington,
Gordon Menzie, Russ Finely,
San Diego Unified
Port District
Design Firm:
McQuiston & Daughter, Inc.
Del Mar
Client:
Cabrillo Historical Assoc.
U.S. Park Service
Typographer:
Boyer & Brass
Printer:
W. A. Krueger

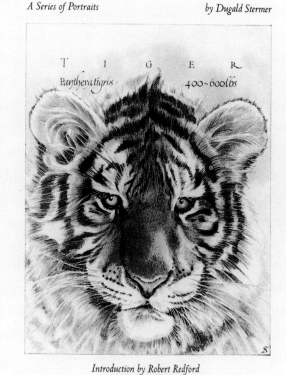

VANISHING CREATURES

A Series of Portraits *by Dugald Stermer*

TIGER
Panthera tigris 400~600 lbs

Introduction by Robert Redford

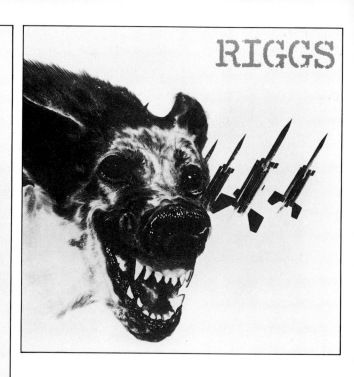

RIGGS

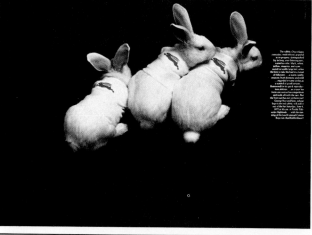

Early Spanish explorers called it, simply, "the Point of California." Sailing north against both prevailing wind and current along an uncharted coast, it was a welcome sight, one not soon forgotten. Certainly, it is one of present-day California's most prominent landmarks, a massive rock-and-sandstone, chaparral-covered headland extending eight miles southward from Mission Bay and rising to a height of 420 feet at its tip. Long before human record, surf pounded its western shore. Waves have chiseled and hewn that shoreline into new shapes and forms. On the east, by contrast, lies a quiet channel linking the Pacific Ocean to San Diego Bay. Only gentle waves lap here, except in a rare southerly storm, and the harbor has been a snug haven to mariners of many nations since Juan Rodriguez Cabrillo's arrival in 1542. This is San Diego's Point Loma peninsula, the scenic, dramatic physical setting for Cabrillo National Monument.

Point Loma

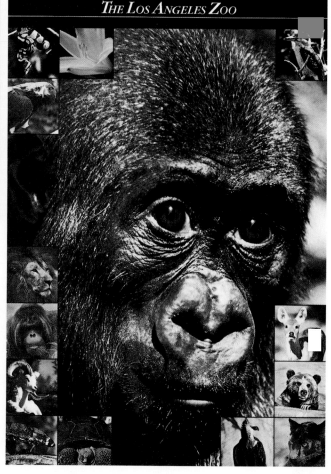

THE LOS ANGELES ZOO

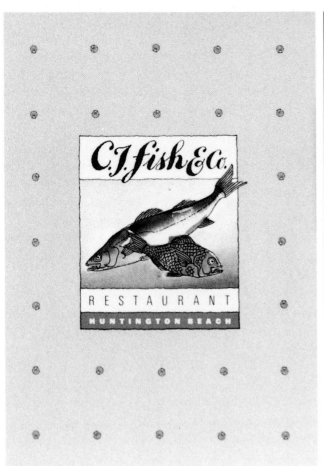

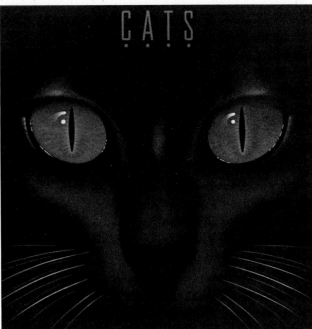

Menu:
C. J. Fish & Co.
Art Director:
Deborah Sussman
Designer:
Nancy Zaslavski
Artist:
Jim Simmons
Design Firm:
Sussman/Prejza & Co., Inc.
Santa Monica
Client:
C. J. Fish & Co.
Typographer:
Joe Molloy
Printer:
Lithographix

Record Jacket:
Cats
Art Directors:
Ron Coro, Johnny Lee
Designers:
Ron Coro, Johnny Lee
Los Angeles
Artist:
David Wilcox
Client:
Elektra/Asylum Records

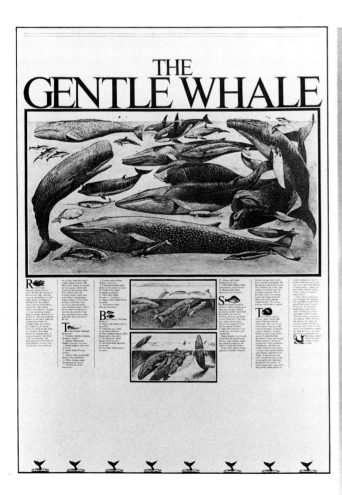

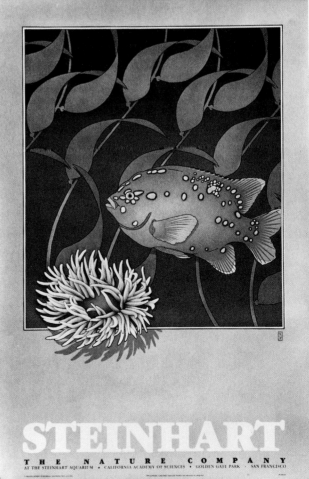

Poster:
The Gentle Whale
Art Director:
McQuiston & Daughter
Designer:
McQuiston & Daughter
Artist:
John Dawson
Design Firm:
McQuiston & Daughter, Inc.
Del Mar
Client:
Cabrillo Historical Assoc.
U.S. Park Service
Typographer:
Boyer & Brass, Inc.
Printer:
Russ Press

Poster:
Steinhart
Art Director:
Daniel Gilbert
Designer:
Daniel Gilbert
Artist:
Daniel Gilbert
Design Firm:
Miller/Gilbert Publishing
San Francisco
Client:
The Nature Co.
Typographer:
Reprotype
Printer:
PS Press

Magazine Cover:
Metro, November '81
Art Director:
Tom Ingalls
Designer:
Tom Ingalls
San Francisco
Artist:
Sudi McCollum
Client:
Metro Magazine
Publisher:
Metro Magazine
Printer:
Alonzo Press

Promotional Brochure:
Kinyon Memorial Art
Action Auction
Art Director:
Don Young
Designer:
Don Young
Artist:
Brian Lovell
Photographer:
Gordon Menzie
Design Firm:
The Design Quarter
San Diego
Client:
The Kinyon Memorial Fund
Typographer:
Slipshod Graphics
Printer:
Frye & Smith

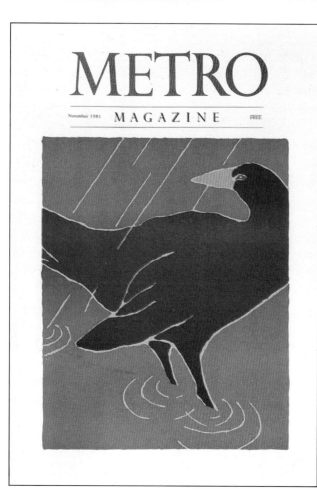

Environmental Graphics:
Oakville Grocery
Art Director:
Michael Manwaring
Designer:
Michael Manwaring
Design Firm:
The Office of Michael
Manwaring
San Francisco
Client:
Oakville Grocery Co.

Poster:
Alan Cober
Art Director:
Philip Hays
Designer:
John Hoernle
Los Angeles
Artist:
Alan Cober
Client:
Art Center College
of Design
Typographer:
Vernon Simpson
Printer:
Continental Graphics

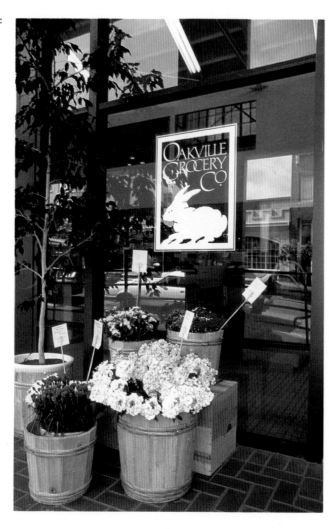

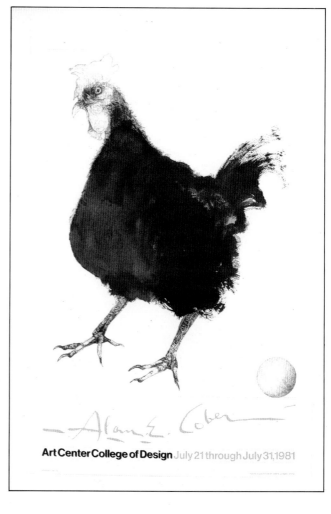

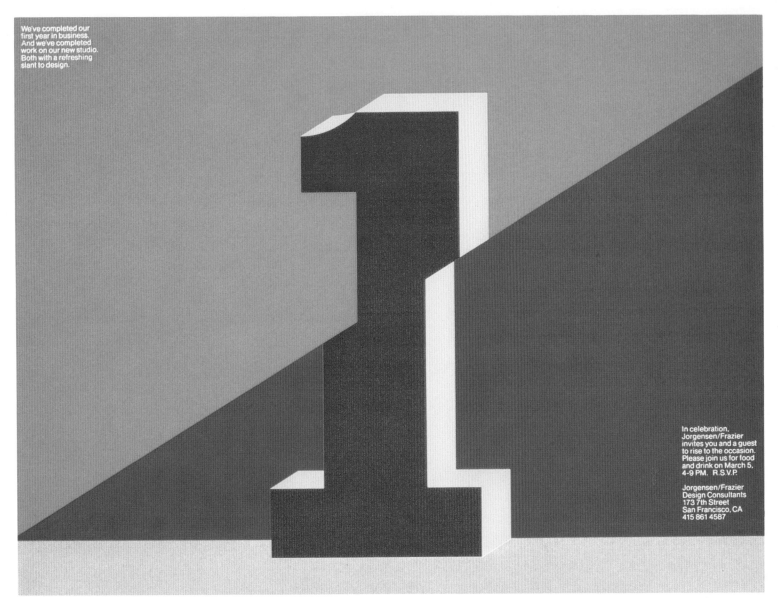

We've completed our first year in business. And we've completed work on our new studio. Both with a refreshing slant to design.

In celebration, Jorgensen/Frazier invites you and a guest to rise to the occasion. Please join us for food and drink on March 5, 4-9 PM. R.S.V.P.

Jorgensen/Frazier Design Consultants 173 7th Street San Francisco, CA 415 861 4587

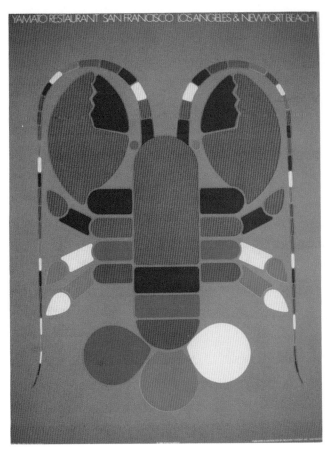

YAMATO RESTAURANT SAN FRANCISCO LOS ANGELES & NEWPORT BEACH

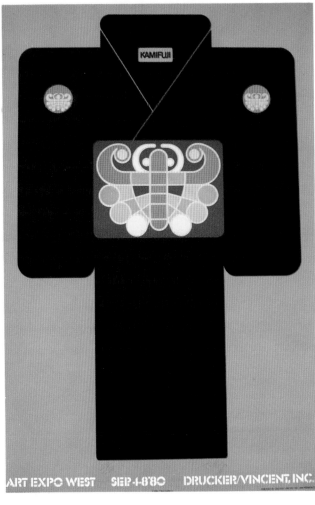

ART EXPO WEST SEP 4-8'80 DRUCKER/VINCENT, INC.

Announcement:
First Year Celebration
Art Director:
Conrad Jorgensen
Designers:
Craig Frazier,
Conrad Jorgensen
Artist:
Craig Frazier
Design Firm:
Jorgensen-Frazier
San Francisco
Client:
Jorgensen-Frazier
Typographer:
Omnicomp
Printer:
Serigraphics

Poster:
Yamato
Art Directors:
Tom Kamifuji, Alan Drucker
June Vincent
Designer:
Tom Kamifuji
Palo Alto
Artist:
Tom Kamifuji
Client:
Drucker/Vincent, Inc.
Typographer:
Tom Kamifuji
Printer:
The W.O.R.K.S.

Poster:
Kimono
Art Directors:
Tom Kamifuji, Alan Drucker,
June Vincent
Designer:
Tom Kamifuji
Artist:
Tom Kamifuji
San Francisco
Client:
Drucker/Vincent, Inc.
Typographer:
Tom Kamifuji
Printer:
The W.O.R.K.S.

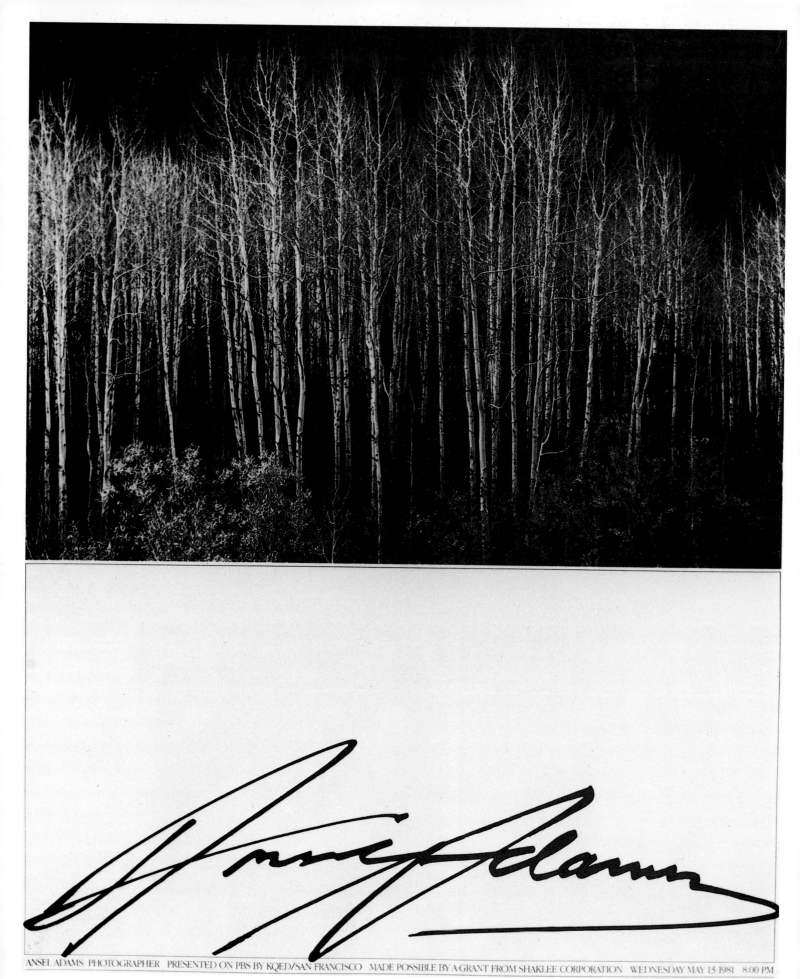

ANSEL ADAMS: PHOTOGRAPHER PRESENTED ON PBS BY KQED/SAN FRANCISCO MADE POSSIBLE BY A GRANT FROM SHAKLEE CORPORATION WEDNESDAY MAY 13 1981 8:00 PM

GXY-5141

Art Pepper

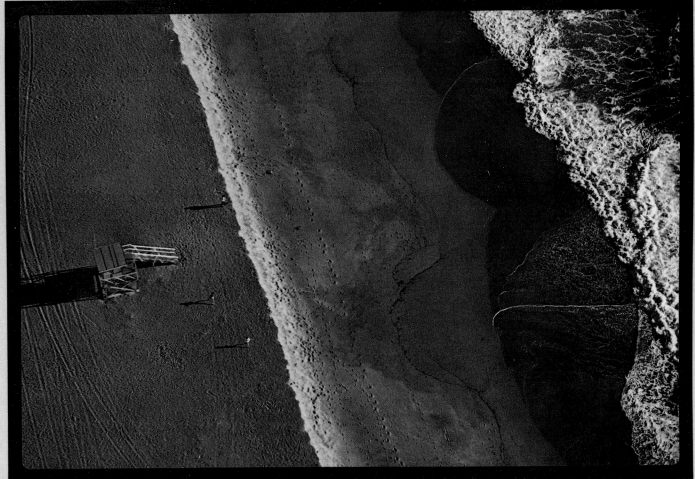

One September Afternoon

Record Jacket:
One September Afternoon
Art Director:
Phil Carroll
Designer:
Phil Carroll
Berkeley
Artist:
Phil Carroll
Photographer:
Baron Wolman
Client:
Fantasy Records

Poster:
Ansel Adams
Art Director:
Jennifer E. Morla
Designer:
Jennifer E. Morla
Photographer:
Ansel Adams
Design Firm:
KQEDesign
San Francisco
Client:
KQED-TV
Typographer:
Reprotype
Printer:
Warren's Waller Press

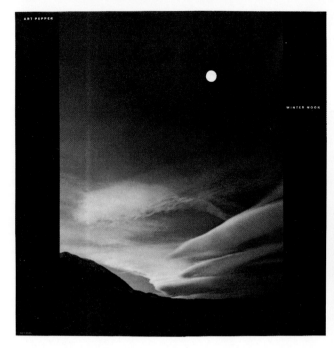

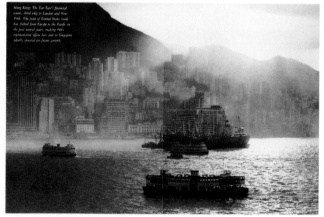

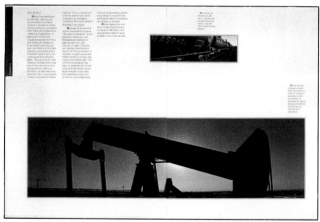

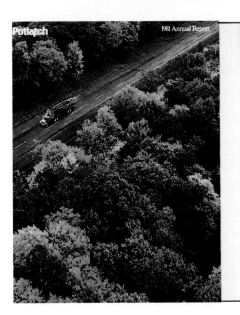

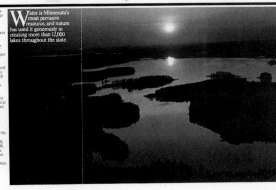

Annual Report:
Potlatch Annual
Report 1981
Art Director:
Kit Hinrichs
Designers:
Kit Hinrichs, Barbara Vick
Artist:
Colleen Quinn
Photographer:
Tom Tracy
Design Firm:
Jonson Pedersen Hinrichs
& Shakery
San Francisco
Client:
Potlatch Corp.
Typographer:
Reardon & Krebs
Printer:
Anderson Lithographic Co.

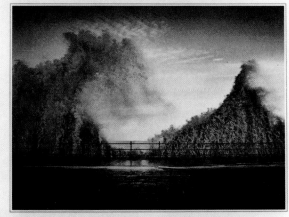

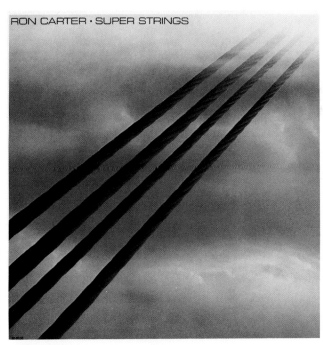

Record Jacket:
Billy Cobham — Billy
Cobham's Glass Menagerie
Art Directors:
Ron Coro, Norm Ung
Los Angeles
Designer:
John Barr
Photographer:
Michael Kenna
Client:
Elektra Musician Records

Record Jacket:
Superstrings
Art Director:
Phil Carroll
Designer:
Phil Carroll
Berkeley
Artist:
Phil Carroll
Photographer:
Phil Bray
Client:
Fantasy Records

Annual Report:
Crocker National Corp.
Annual Report 1981
Art Director:
Kit Hinrichs
Designers:
Kit Hinrichs/Leonore Bartz
Photographer:
John Blaustein/Image
Bank N.Y.
Design Firm:
Jonson Pedersen Hinrichs
& Shakery, San Francisco
Client:
Crocker National Corp.
Typographer:
Reardon & Krebs
Printer:
Graphic Arts Center

Annual Report:
Highlands Energy Corp.
Annual Report 1981
Art Director:
Sidjakov, Berman & Gomez
Designers:
Nicholas Sidjakov,
Michael Mabry
Artists:
Michael Mabry,
Karen Berndt
Design Firm:
Sidjakov, Berman & Gomez
San Francisco
Client:
Highlands Energy Corp.
Typographer:
Omnicomp
Printer:
California Printing

Annual Report:
Smith International
Annual Report 1981
Art Director:
James Cross
Designer:
Carl Seltzer
Artist:
Steve Jones
Photographer:
Michael Going
Design Firm:
Cross Associates
Los Angeles
Client:
Smith International
Typographer:
Central Typesetting Co.
Printer:
Anderson Lithographic Co.

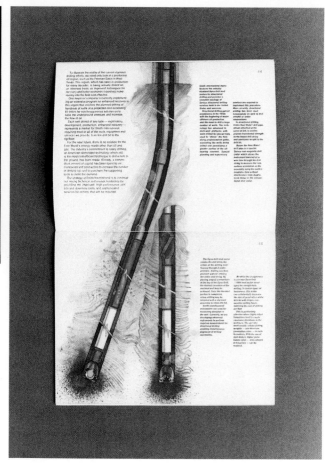

Annual Report:
Hexcel Corp. Annual
Report 1981
Art Director:
Stephen Stanley
Designer:
Stephen Stanley
Photographers:
Scott Solobodian,
Jon Brenneis
Design Firms:
Stephen Stanley Graphic
Design & Robert Conover
Graphic Design
San Francisco
Client:
Hexcel Corp.
Typographer:
Reardon & Krebs
Printer:
George Rice & Sons

Poster:
Seymour Duncan
Art Director:
Mark Oliver
Designer:
Mark Oliver
Photographer:
Peter D'Aprix
Design Firm:
Mark Oliver Assoc.
Santa Barbara
Client:
Seymour Duncan Pickups
Typographer:
Roger Graphics
Printer:
Graphic Press

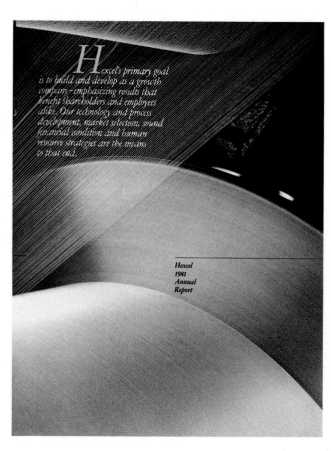

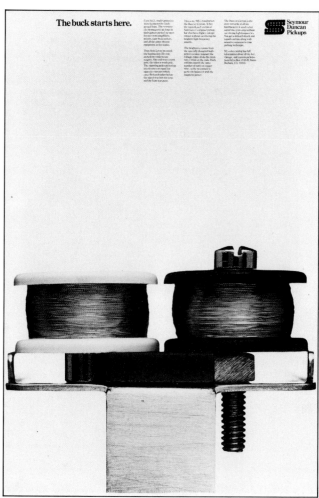

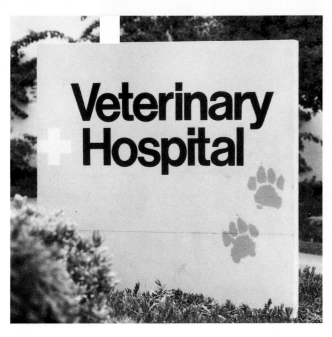

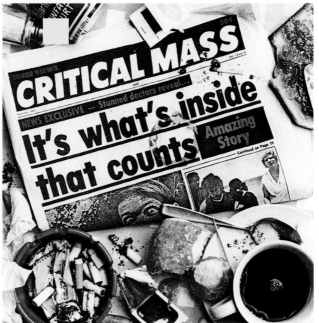

Environmental Graphics:
Miracle Mile Vet Hospital
Art Director:
Harry Murphy
Designers:
Harry Murphy,
Stanton Klose
Design Firm:
Harry Murphy + Friends
Mill Valley
Client:
Miracle Mile Vet Hospital

Record Jacket:
Critical Mass
Art Director:
George Osaki
Designer:
Hans Inauen
Artist:
Hans Inauen
Photographer:
Steve Sakai
Design Firm:
Dyer / Kahn
Los Angeles
Client:
MCA Records

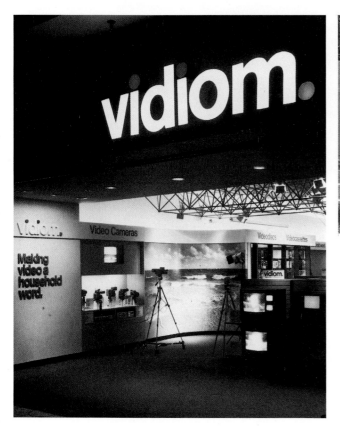

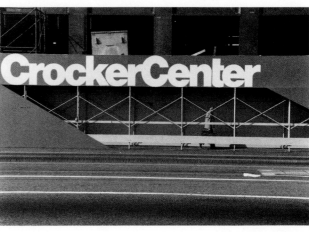

Environmental Graphics:
Vidiom Stores
Art Director:
Harry Murphy
Designers:
Harry Murphy,
Stanton Klose
Design Firm:
Harry Murphy + Friends
Mill Valley
Client:
Vidiom Stores

Environmental Graphics:
Crocker Center
Construction Barricade
Art Director:
Gary Hinsche
Designer:
John Tom
Santa Monica
Client:
Maguire Partners for
Crocker Center

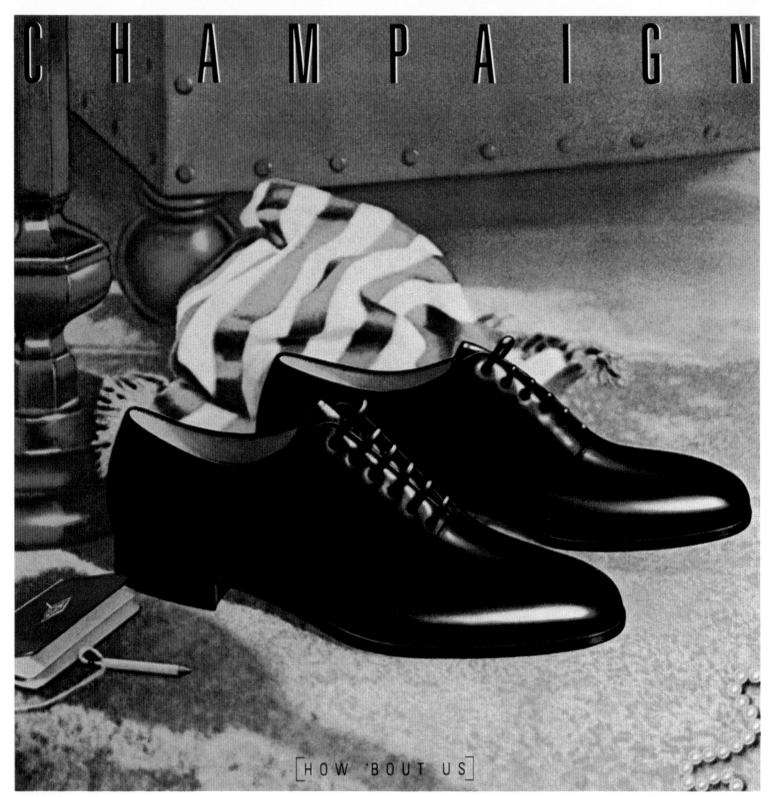

CHAMPAIGN

[HOW 'BOUT US]

Record Jacket:
Champaign
Art Director:
Nancy Donald
Designer:
Nancy Donald
Design Firm:
CBS Records
Los Angeles
Printer:
Shorewood Packaging
Corp.

Magazine Cover:
Metro
Art Directors:
Thomas Ingalls,
Michael Manwaring
Designer:
Michael Manwaring
Artist:
Michael Manwaring
Design Firm:
The Office of Michael
Manwaring
San Francisco
Client:
Metro Magazine
Typographer:
Ann McCue
Printer:
Alonzo Press

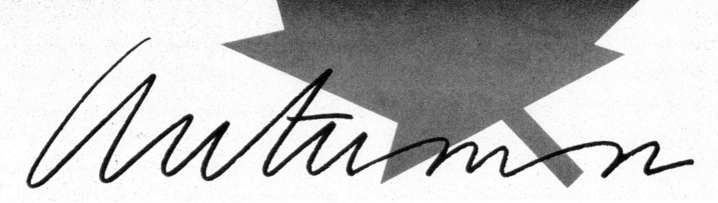

Calendar:
1981 Appointments
Art Director:
John Coy
Designers:
John Coy, Maryl Lavelle
Photographers:
Donald Hull,
Penelope Potter
Design Firm:
Coy, Los Angeles
Culver City
Client:
The J. Paul Getty Museum
Typographer:
Aldus Type Studio, Ltd.
Printer:
Alan Lithograph, Inc.

Calendar, Diary:
1982 Appointments
Art Director:
John Coy
Designer:
John Coy
Artists:
John Coy, Mary Lavelle
Photographers:
Donald Hull,
Penelope Potter
Design Firm:
Coy, Los Angeles
Culver City
Client:
The J. Paul Getty Museum
Printer:
Alan Lithograph, Inc.

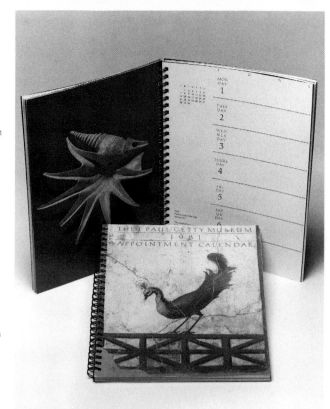

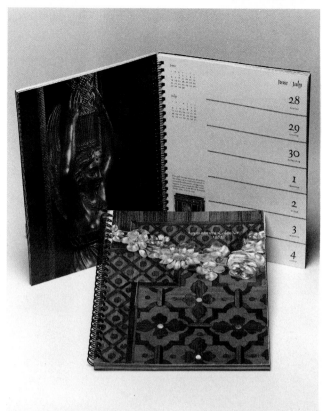

Address Book:
Decorative Arts
Art Director:
John Coy
Designer:
Maryl Lavelle
Photographer:
Donald Hull,
Penelope Potter
Design Firm:
Coy, Los Angeles
Culver City
Client:
The J. Paul Getty Museum
Printer:
Alan Lithograph, Inc.

Promotional Literature:
Great Chefs 1982
Art Director:
Michael Manwaring
Designer:
Michael Manwaring
Artist:
Betty Barsamian
Photographer:
Various
Design Firm:
The Office of Michael
Manwaring
San Francisco
Typographer:
Omnicomp
Printer:
Advanced Litho/Interprint
Illustrator:
Michael Manwaring

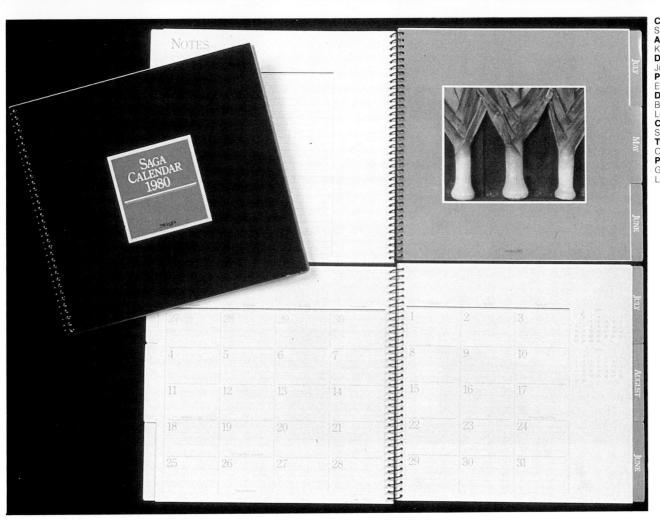

Calendar:
Saga 1980
Art Director:
Keith Bright
Designer:
Julie Riefler
Photographer:
Edward Weston
Design Firm:
Bright & Assoc.
Los Angeles
Client:
Saga Corp.
Typographer:
CAPCO
Printer:
Gardner Fulmer
Lithograph Co.

Calendar:
Saga 1981
Art Director:
Keith Bright
Designer:
Julie Riefler
Artist:
Wayne Thiebaud
Design Firm:
Bright & Assoc.
Los Angeles
Client:
Saga Corp.
Typographer:
Andresen Typographics
Printer:
George Rice & Sons

Dinner Program & Menu:
California Culinary
Academy
Art Director:
Michael Manwaring,
Anne Fox
Designer:
Michael Manwaring
Design Firm:
The Office of Michael
Manwaring
San Francisco
Publisher:
Foremost McKesson, Inc.
Printer:
Lee Design Associates

Brochure:
Third Creek
Art Director:
Sidjakov Berman & Gomez
Designers:
Jerry Berman,
Michael Mabry
Photographer:
David Muench
Design Firm:
Sidjakov Berman & Gomez
San Francisco
Client:
Third Creek Joint Venture
Typographer:
Omnicomp
Printer:
California Printing

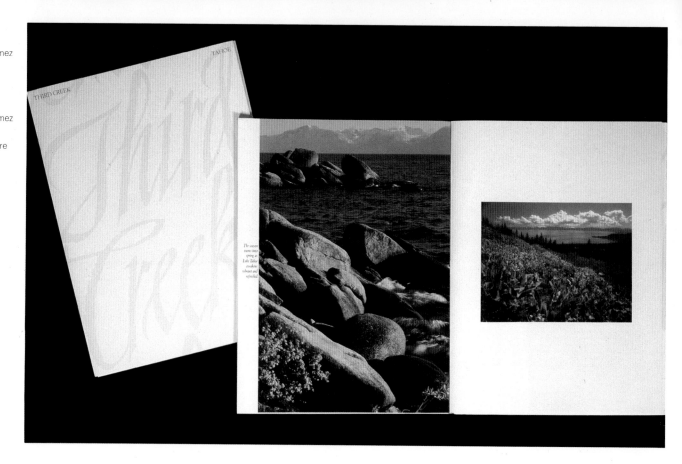

Poster:
NY in LA
Art Directors:
Douglas Boyd,
Scott A. Mednick
Designer:
Scott A. Mednick
Photographer:
Jayme Odgers
Design Firm:
Douglas Boyd Design and
Marketing
Los Angeles
Client:
Art Directors Club of
New York
Typographer:
Aldus Type
Printer:
Gore Graphics

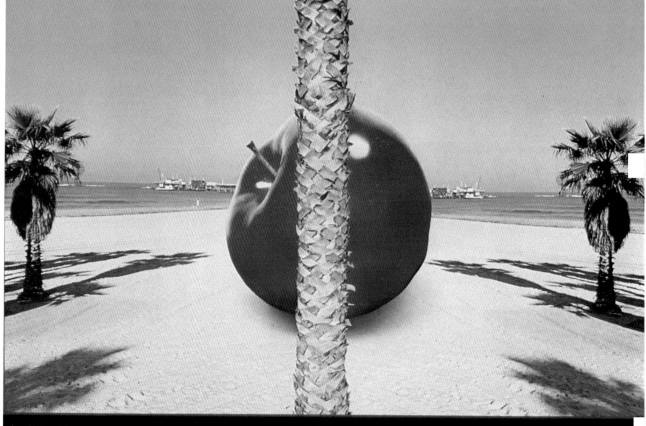

CLEAN BAY

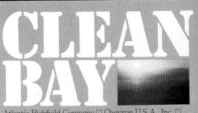

Atlantic Richfield Company ☐ Chevron U.S.A., Inc. ☐ Dow Chemical Company ☐ Exxon Company, U.S.A. ☐ Landsea Terminals, Inc. ☐ Mobil Oil Corporation ☐ Pacific Refining Company ☐ Pennzoil Company ☐ Shell Oil Company ☐ SPC Shipping, Inc. (SOHIO) ☐ Southern Pacific Pipe Lines, Inc. ☐ Texaco, Inc. ☐ Time Oil Company ☐ Tosco Corporation ☐ Union Oil Company of California ☐ Wickland Oil Terminals ☐

Thanks to carefully designed and rigidly enforced programs of spill prevention and control, oil spills don't happen very often. Yet even the most sophisticated prevention measures cannot eliminate entirely the possibility that a spill *could* happen. That's why Clean Bay was created.

This brochure describes the mission of this extraordinary "cooperative," a coalition of oil, chemical and pipeline companies that do business around San Francisco Bay.

Clean Bay is ready to respond quickly and effectively to virtually any situation involving spilled oil or oil products.

The cooperative's responsibility extends beyond San Francisco Bay and the entrance to the Golden Gate to cover 340 miles of California coastline — from as far north as Fort Bragg to Cape San Martin in the south.

Brochure:
Clean Bay
Art Director:
Kit Hinrichs
Designers:
Kit Hinrichs, Gillian Smith, Nancy Garrott
Photographer:
John Blaustein, Image Bank
Design Firm:
Jonson Pedersen Hinrichs & Shakery
San Francisco
Client:
Clean Bay
Typographer:
Spartan Typographers
Printer:
Graphic Arts Center

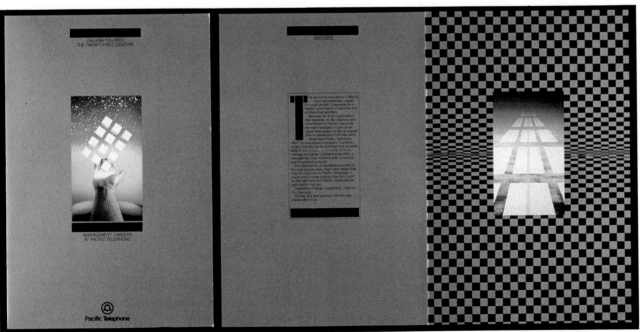

Brochure:
Pacific Telephone Recruitment
Art Director:
Neil Shakery
Designer:
Neil Shakery
Photographer:
Jayme Odgers
Design Firm:
Jonson Pedersen Hinrichs & Shakery
San Francisco
Client:
Peterson & Dodge
Typographer:
Reardon & Krebs
Printer:
Graphic Arts Center

Brochure:
Hills Brothers
Art Director:
Kit Hinrichs
Designers:
Kit Hinrichs, Gillian Smith
Photographers:
John Blaustein, Tom Tracy
Design Firm:
Jonson Pedersen Hinrichs
& Shakery
San Francisco
Client:
Russom & Leeper
Printer:
Pacific Rotoprinting

Packaging:
Delicato Wine
Art Director:
Robert Pease
Designer:
Robert Pease
Artist:
Terry Newman
Photographer:
George Selland
Design Firm:
Robert Pease & Co.
Alamo
Client:
Delicato Vineyards

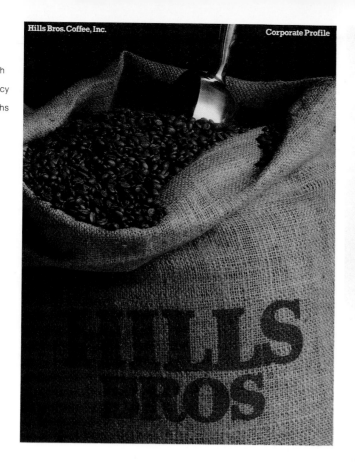

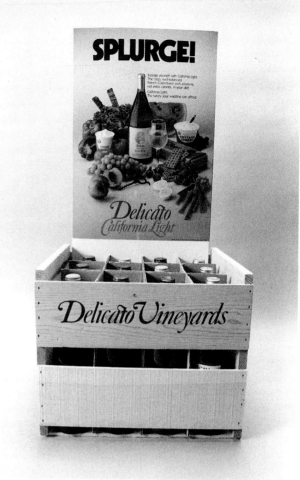

Poster:
"The Big Apple Opens
in Orange County"
Art Directors:
Jann Church, Lea Pascoe
Design Firm:
Jann Church Advertising
& Graphic Design, Inc.
Newport Beach
Client:
The New York Art
Directors Club
Printer:
Graphic Press

Book:
Sushi
Art Director:
Michael Cronan
Designer:
Michael Cronan
Photographer:
Kathryn Kleinman
Design Firm:
Michael Patrick Cronan
San Francisco
Publisher:
Chronicle Books
Typographers:
Robert Sibley, Abracadabra
Printer:
Dai Nippon Printing Co., Ltd.

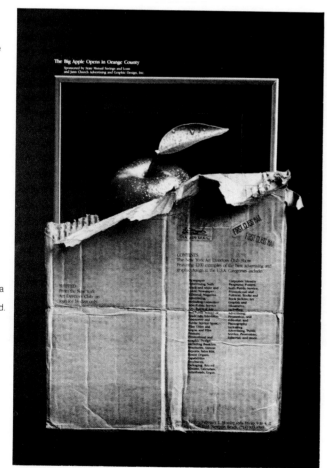

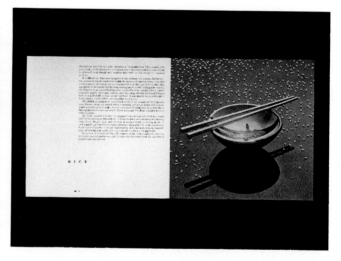

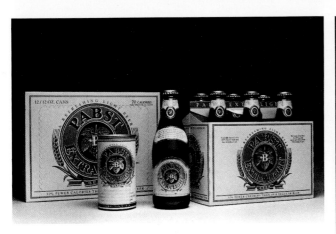

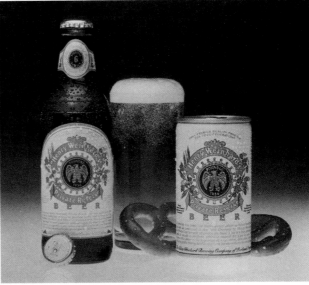

Package:
Pabst Beer
Art Directors:
Hal Riney, Gerald Andelin
Designers.
Barry Deutsch, Steinhilber
Deutsch & Gard
San Francisco
Artist:
James S. Schlesinger
Agency:
Ogilvy & Mather
Client:
Pabst Brewing Co.

Package:
Henry Weinhard
Art Directors:
Hal Riney, Jerry Andelin
Designer:
Primo Angeli
Artists:
Mark Jones, Renee Jung
Design Firm:
Primo Angeli Graphics
San Francisco
Agency:
Ogilvy & Mather
Client:
Pabst Brewing Co.
Typographer:
Reprotype

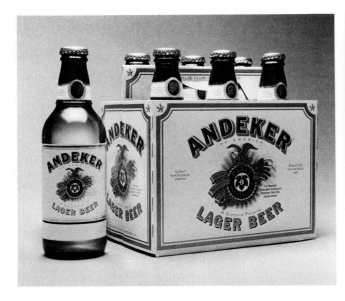

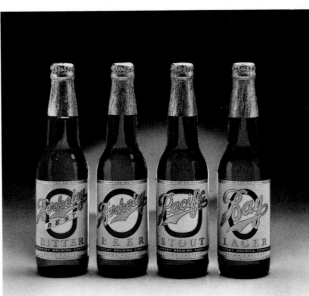

Package:
Andeker Beer
Art Directors:
Hal Riney, Gerald Andelin
Designer:
Barry Deutsch
Illustrator:
Larry Duke
Agency:
Ogilvy & Mather
San Francisco
Client:
Pabst Brewing Co.

Package:
Berkeley Beers
Art Director:
Tandy Belew
Designers:
Tandy Belew,
Anthony Chiumento,
George DeWoody
Artist:
Tandy Belew
Design Firm:
Image Development
San Francisco
Client:
Berkeley Brewing Co.
Typographer:
Solotype
Printer:
Color III

Package:
Can & Gift Box Line
Art Director:
Keith Bright
Designer:
Ray Wood
Design Firm:
Bright & Assoc.
Los Angeles
Client:
House of Almonds

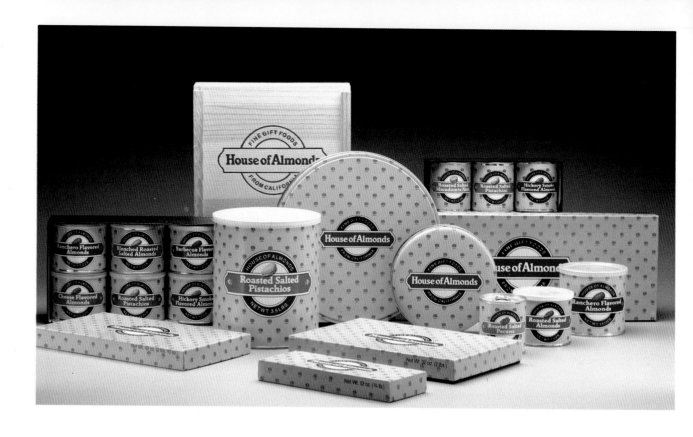

Packaging:
Robert Pecota 1981
French Colombard
Design Firm:
Colonna, Caldeway,
Farrel Design
Saint Helena
Client:
Robert Pecota Winery

Publication Spread:
California Wine
Art Director:
Kit Hinrichs
Designers:
Kit Hinrichs, Barbara Vick
Artist:
Kit Hinrichs
Photographer:
Armando Diaz
Design Firm:
Jonson Pedersen Hinrichs
& Shakery
San Francisco
Client:
Crocker National Corp.
Typographer:
Crocker National Corp.
Printer:
Graphic Arts Center

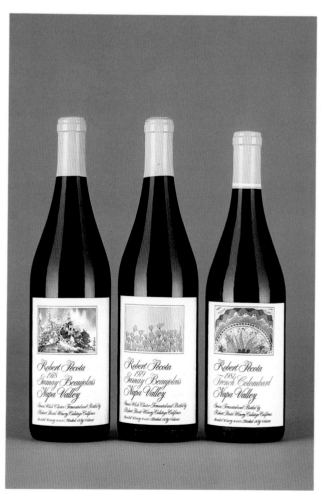

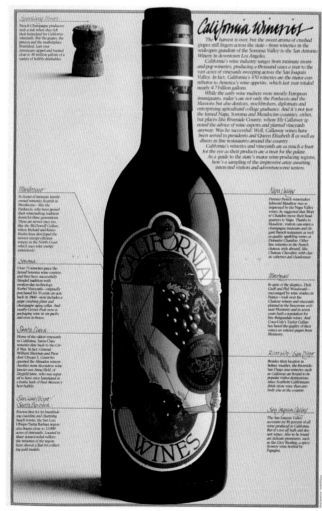

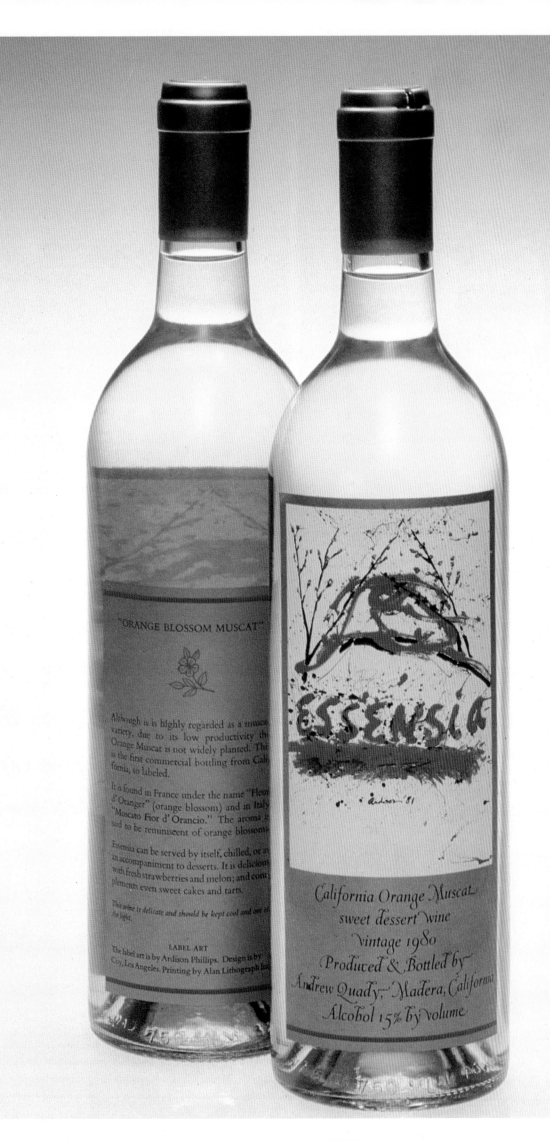

Label:
Essensia Wine
Art Director:
John Coy
Designer:
John Coy
Artist:
Ardison Phillips
Design Firm:
Coy, Los Angeles
Culver City
Client:
Andrew Quady
Typographer:
Vernon Simpson
Typographers
Printer:
Alan Lithograph, Inc.

Label:
Thos. Cooper & Sons
Art Director:
Rob Janoff
Designers:
Primo Angeli, Ray Honda,
Mark Jones
Artists:
Ray Honda, Mark Jones
Design Firm:
Primo Angeli Graphics
San Francisco
Typographer:
Reprotype

Promotional Item:
Cinco De Mayo Invitation
Art Director:
Carlos A. Huerta
Designer:
Carlos A. Huerta
Design Firm:
Huerta Design Assoc.
Los Angeles
Client:
Huerta Design Assoc.
Typographer:
Alpha Graphix
Printer:
Howard Krebbs

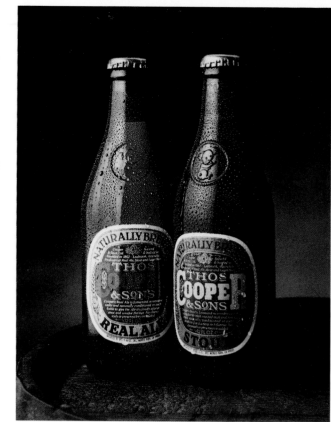

Poster:
"Can"
Art Director:
Al Fessler
Designer:
Al Fessler
Artist:
Barbara Bantheim
Photographer:
Ed Zak
Agency:
Ogilvy & Mather
San Francisco
Client:
Blitz-Weinhard Co.
Printer:
Pacific Lithograph

Label:
Molinari Designer Salame
Art Director:
Primo Angeli
Designer:
Primo Angeli
Artists:
Primo Angeli, Mark Jones
Design Firm:
Primo Angeli Graphics
San Francisco
Client:
Molinari
Typographer:
Sarah Waldron
Printer:
Williams Lithograph

Label:
Frog's Leap
Art Director:
Charles House
Designer:
Charles House
Artist:
Charles House
Design Firm:
Colonna, Caldeway, Farrell
Design
Saint Helena
Client:
Frog's Leap Winery
Typographer:
Werle's Instant Press
Printer:
Calistoga Press

WE RELUCTANTLY ANNOUNCE A CONVENIENT NEW PACKAGE

It has always been our belief that the only container which is appropriate to a true premium beer like Henry Weinhard's Private Reserve is a traditional glass bottle.

But bottles, unfortunately, are not appropriate to all the places where people like to drink Henry's. At the beach, for example. Or a softball game. Or on a backpacking trip.

Recognizing this, and in response to numerous requests from our customers and our friends in the retail trade, we have decided to make Henry's commercially available in the cans we originally intended only for service aboard airlines. While these cans lack the "bottling numbers" that distinguish the various limited brews of Henry Weinhard's Private Reserve, be assured that the product is identical in every respect to that offered in bottles and on draught.

THE BLITZ-WEINHARD BREWING COMPANY OF PORTLAND, OREGON

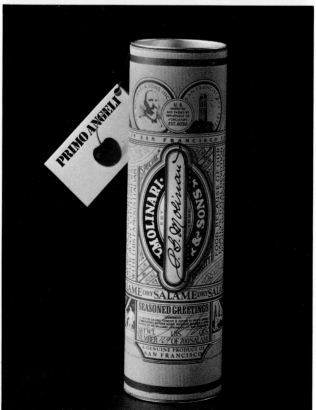

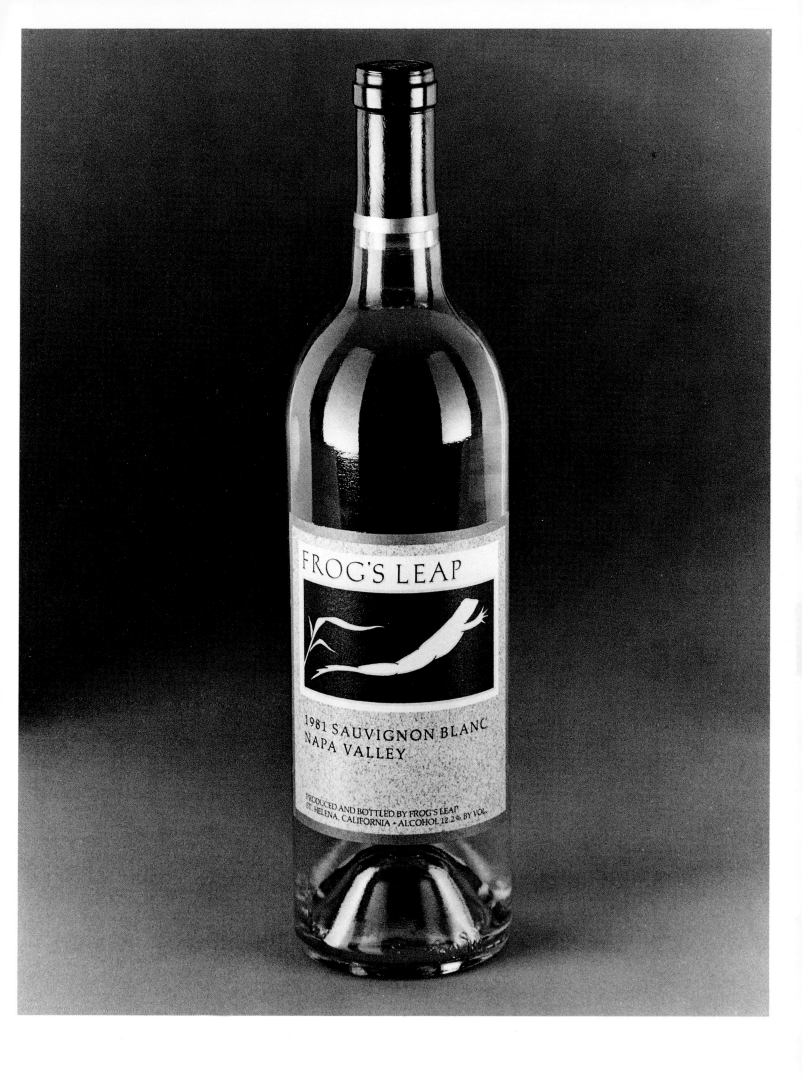

Label:
Beringer Vineyards
Art Director:
Ralph Colonna
Designer:
John Farrell
Design Firm:
Colonna, Caldeway, Farrell
Design
Saint Helena
Client:
Beringer Vineyards
Typographer:
Spartan Typographers
Printer:
Northwest Graphics

Package:
BFA
Art Directors:
Gary Hinsche, Edie Garrett
Designer:
Edie Garrett
Design Firm:
Hinsche & Assoc.
Santa Monica
Client:
BFA Educational Media
Typographer:
Cabco

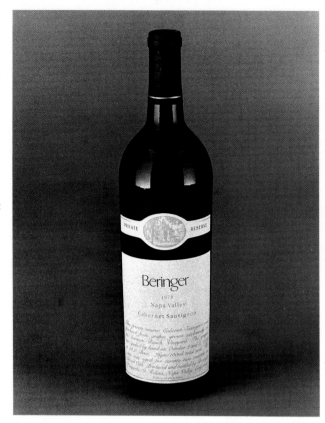

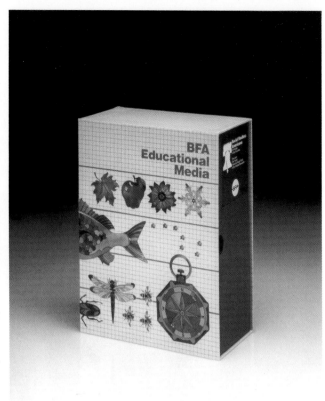

Package:
Greenlife Cosmetics
Art Director:
Paul Pruneau
Designer:
Paul Pruneau
Design Firm:
Design West
Santa Monica
Client:
William Randall / La Costa
Typographer:
De-Line-O-Type
Printer:
Wickman Screen Printing

Package:
The Small Things Co.
Art Director:
Harry Murphy
Designers:
Harry Murphy,
Stanton Klose
Design Firm:
Harry Murphy + Friends
Mill Valley
Client:
The Small Things Co.

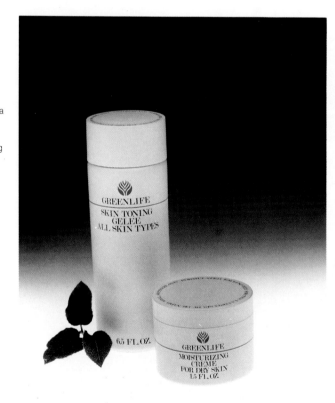

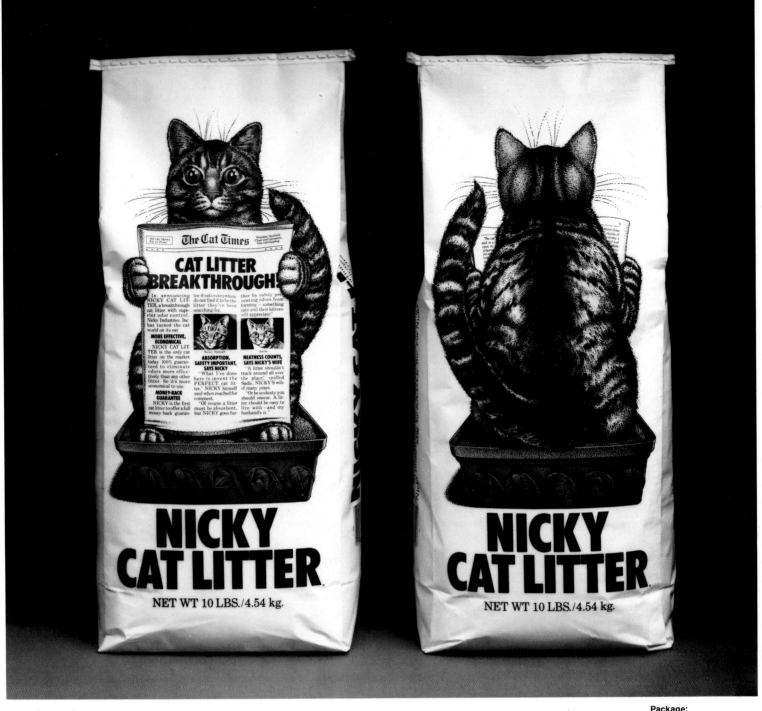

Package:
Nicky Cat Litter
Art Director:
Marilyn Katz
Designer:
Marilyn Katz
Artist:
Alex Murawski
Design Firm:
Marilyn Katz
Creative Consultant
Los Angeles
Client:
Nicky Industries, Inc.
Typographer:
Ryder Types, Inc.
Printer:
Westvaco Corp.

Label:
El Presidente Chili
Art Director:
Anne Cook
Designer:
Anne Cook
Artists:
Anne Cook, Rene Yung
Photographer:
Herb Anhaltzer
Design Firm:
DeVito Associates
San Anselmo
Client:
El Presidente Products
Typographer:
Reprotype
Printer:
Marier Engraving Co.

Package:
BurnNet
Art Director:
Marty Neumeier
Designer:
Byron Glaser,
Kathleen Trainor
Design Firm:
Neumeier Design Team
Santa Barbara
Client:
Western Medical, Ltd.
Typographer:
Roger Graphics
Printer:
J & S Graphix

Package:
Beach Street Bakery
Art Director:
Barry Deutsch
Designer:
Myland McRevey
Artist:
Myland McRevey
Design Firm:
Steinhilber Deutsch & Gard
San Francisco
Client:
Beach Street Baking Co.

Package:
Skincare & Hair Line
Art Director:
Ken Parkhurst
Designer:
Peter Sargent
Design Firm:
Bright & Assoc.
Los Angeles
Client:
Radiance Products

Package:
Olympia "Brand" Beer
Art Director:
Keith Bright
Designers:
Ray Wood, Peter Sargent
Design Firm:
Bright & Assoc.
Los Angeles
Client:
Olympia Brewing Co.

Package:
El Molino Salad Dressing
Art Director:
Ken Parkhurst
Designer:
Zengo Yoshida
Design Firm:
Bright & Assoc.
Los Angeles
Client:
Radiance/El Molino Div.

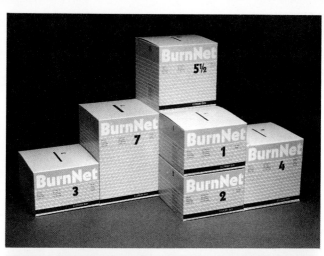

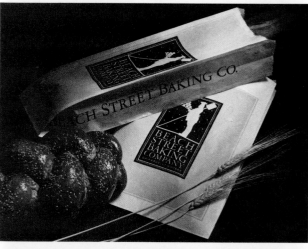

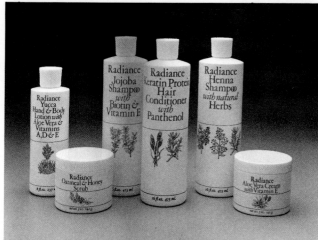

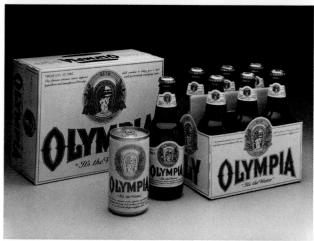

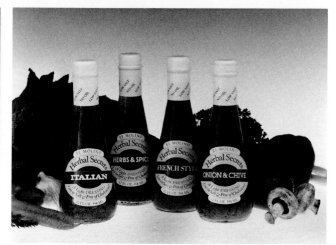

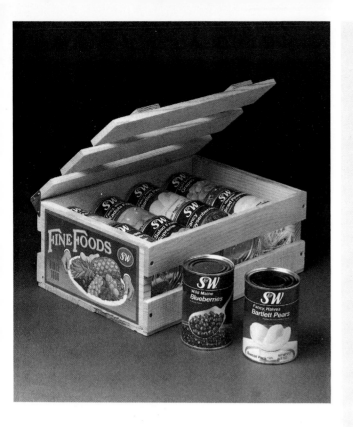

Package:
S&W Fruit
Art Director:
Anne Cook
Designer:
Anne Cook
Artist:
Nancy Wagstaff
Design Firm:
DeVito Assoc.
San Anselmo
Client:
S&W
Typographer:
Reprotype
Printer:
Louis Roesch

Package:
"Pipelite"
Art Director:
Hal Frazier
Designer:
Hal Frazier
Artist:
John Vince
Design Firm:
Frazier Design Consultancy
Los Angeles
Client:
Light Tubes, Inc.
Typographer:
Type West
Printer:
Container Corp.

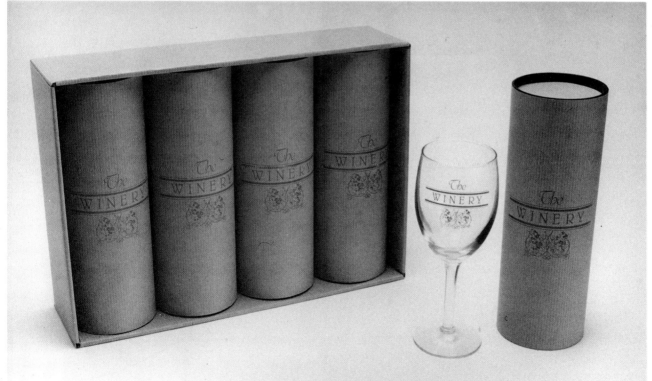

Package:
"Winery" Glass
Art Director:
Hal Frazier
Designer:
Hal Frazier
Artist:
John Vince
Design Firm:
Frazier Design Consultancy
Los Angeles
Client:
The Winery
Typographer:
John Vince

Package:
Victoria Pantry
Art Director:
Gerald Reis
Designers:
Gerald Reis, Wilson Ong
Design Firm:
Reis & Co.
San Francisco
Client:
Victoria Pantry

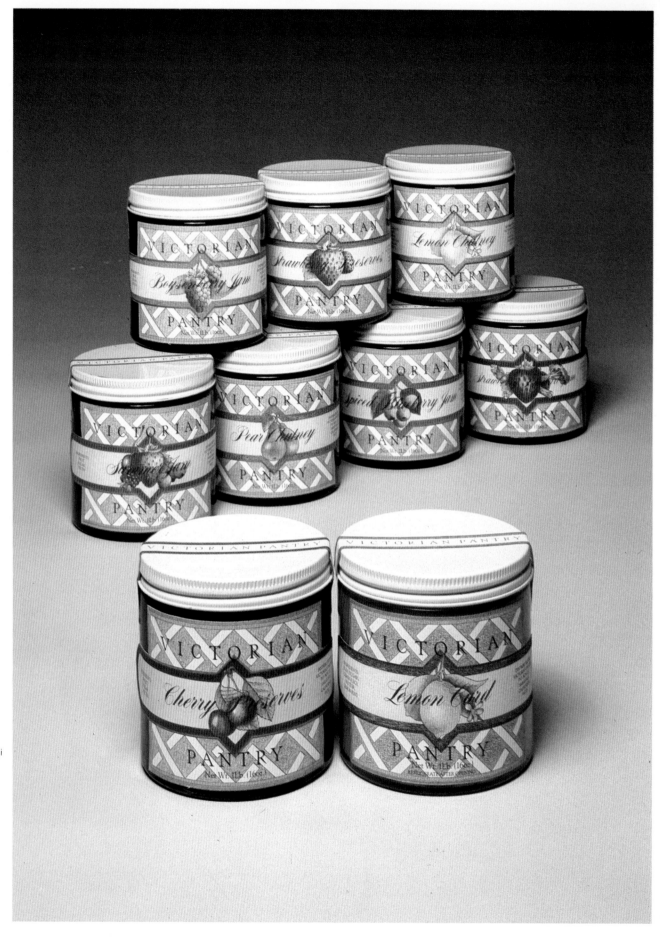

Promotional Item:
Irish Paperweight
Art Director:
Michael Dunlavey
Designers:
Michael & Lindy Dunlavey
Artist:
Lindy Dunlavey
Design Firm:
The Dunlavey Studio, Inc.
Sacramento
Client:
The Dunlavey Studio, Inc.
Typographer:
Ad Type Graphics
Printer:
Fleming ScreenPrint

Package:
Abercrombie Fitch
Art Director:
Richard Burns, Doug Akagi
Designers:
Doug Akagi, James Reed
Artists:
Susan Crutchfield,
Bruce Walker
Design Firm:
The GNU Group
Sausalito
Client:
Abercrombie Fitch & Co.

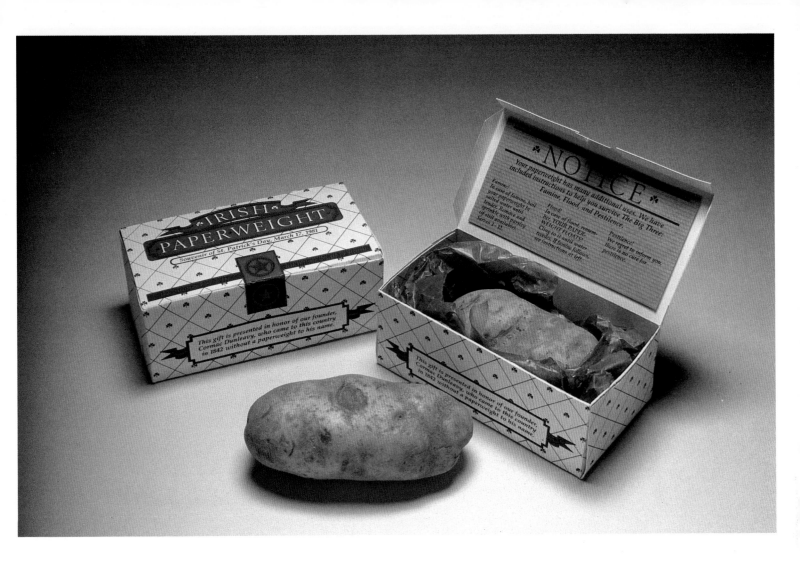

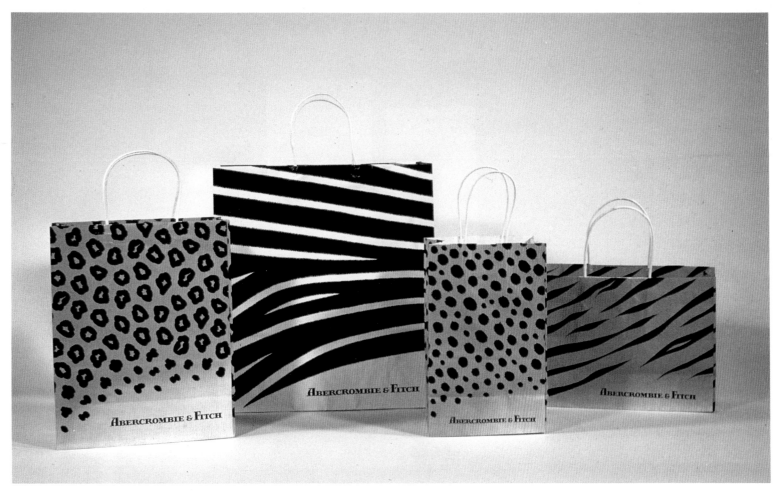

Package:
Prepair Personal Lubricant
Art Directors:
Ken Parkhurst, Keith Bright
Designer:
Peter Sargent
Design Firm:
Bright & Assoc.
Los Angeles
Client:
The Trimensa Co.

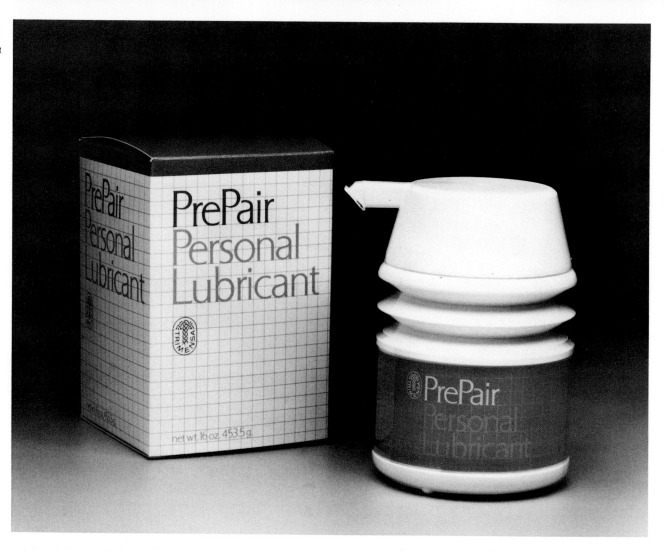

Package:
Robinsons Baby Food
Art Directors:
Jerome Gould, Ed Kysar
Designer:
Ed Kysar
Photographer:
Bob Walker
Design Firm:
Gould and Assoc., Inc.
Los Angeles
Client:
Coleman Foods, Ltd.
Typographer:
Andresen Typographics

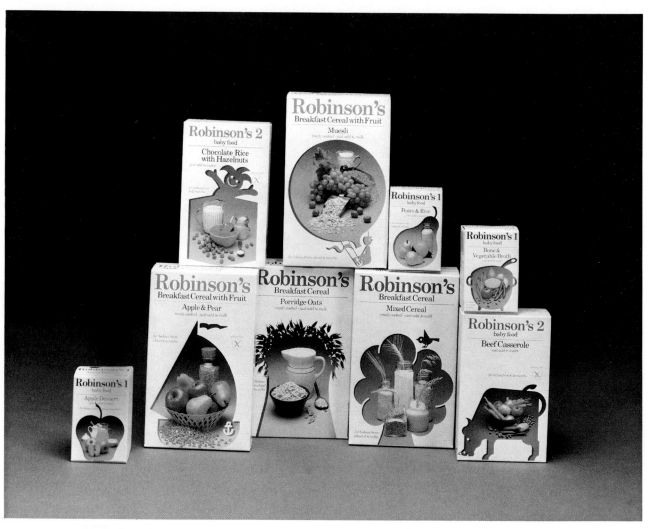

Package:
Leland Music Demotape
Art Director:
Don Weller
Designer:
Don Weller
Artist:
Don Weller
Design Firm:
The Weller Institute for the
Cure of Design
Los Angeles
Client:
Leland Music
Typographer:
Alpha Graphix
Printer:
Anderson Lithographic Co.

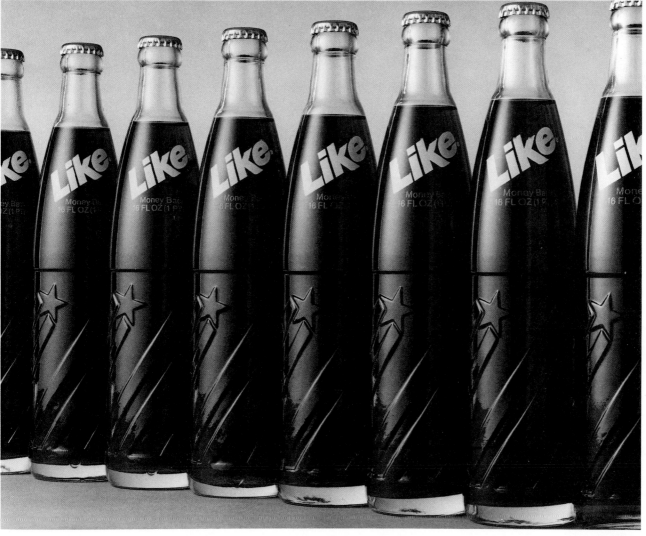

Package:
Like Cola
Art Director:
Chuck Krausie
Designer:
Margo Zucker
Design Firm:
Landor Assoc.
San Francisco
Client:
The Seven-Up Co.
Typographer:
Reprotype

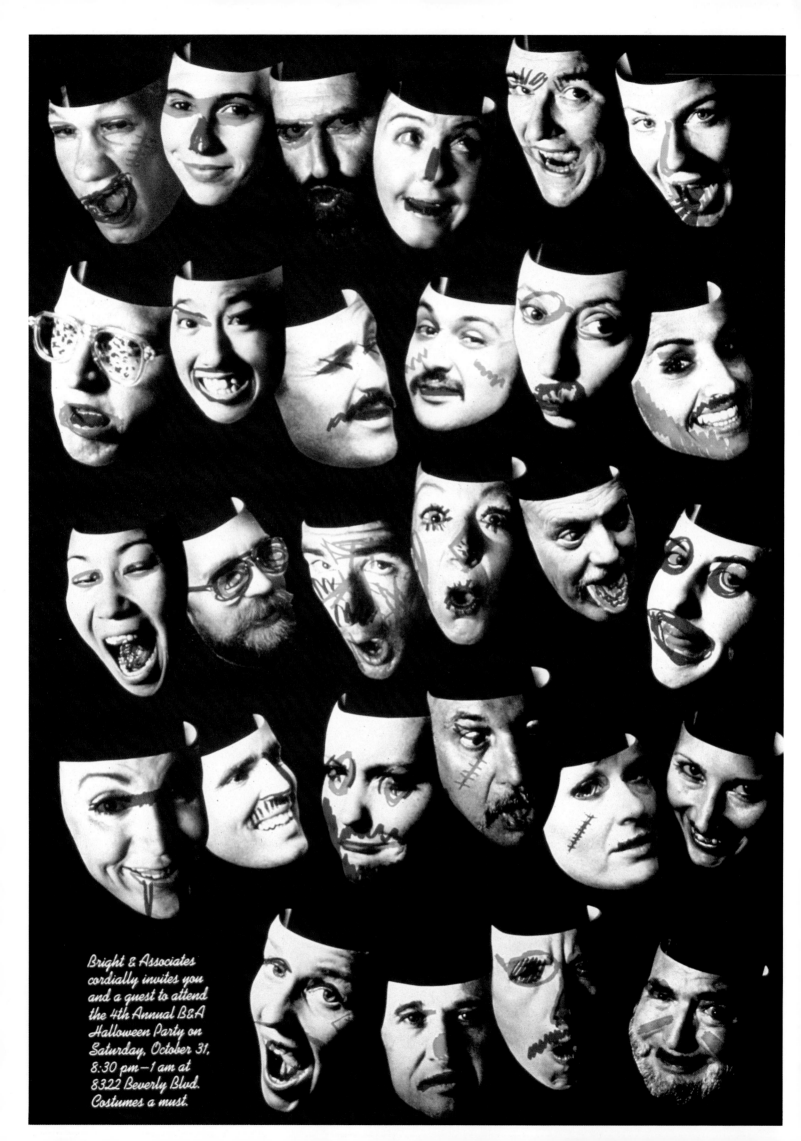

Bright & Associates cordially invites you and a guest to attend the 4th Annual B&A Halloween Party on Saturday, October 31, 8:30 pm—1 am at 8322 Beverly Blvd. Costumes a must.

Invitation:
1981 Halloween Party
Art Director:
Keith Bright
Designers:
Kara Blohm, Julie Riefler
Artist:
John Bright
Design Firm:
Bright & Assoc.
Los Angeles
Client:
Bright & Assoc.

Greeting Card:
"Nu Wave Girl"
Art Director:
Roger Carpenter
Designer:
Linda Barton
Photographer:
Stephen Harvey
Publisher:
Paper Moon
Culver City
Printer:
Angel Photocolor

Poster:
The "Swimmer"
Art Director:
Michael Schwab
Designer:
Michael Schwab
Artist:
Michael Schwab
Design Firm:
Michael Schwab Design
San Francisco
Client:
Michael Schwab
Typographer:
Reprotype

Poster:
Samurai
Art Director:
Tom Kamifuji
Designer:
Tom Kamifuji
Artist:
Tom Kamifuji
Palo Alto

Magazine:
SFSCA Quarterly #1
Art Director:
Kit Hinrichs
Designers:
Kit Hinrichs, Nancy Garrott
Artists:
Bruce Wolfe (Cover)
Various
Design Firm:
Jonson Pedersen Hinrichs
& Shakery
San Francisco
Client:
San Francisco Society of
Communicating Arts
Typographer:
Walker Graphics
Printer:
Alonzo Press

Poster:
Picasso
Art Director:
Russell Leong
Designer:
Russell Leong
Artist:
Barb Koehn, D. J. Simison
Design Firm:
Russell Leong Design
Palo Alto
Client:
Palo Alto Cultural Center

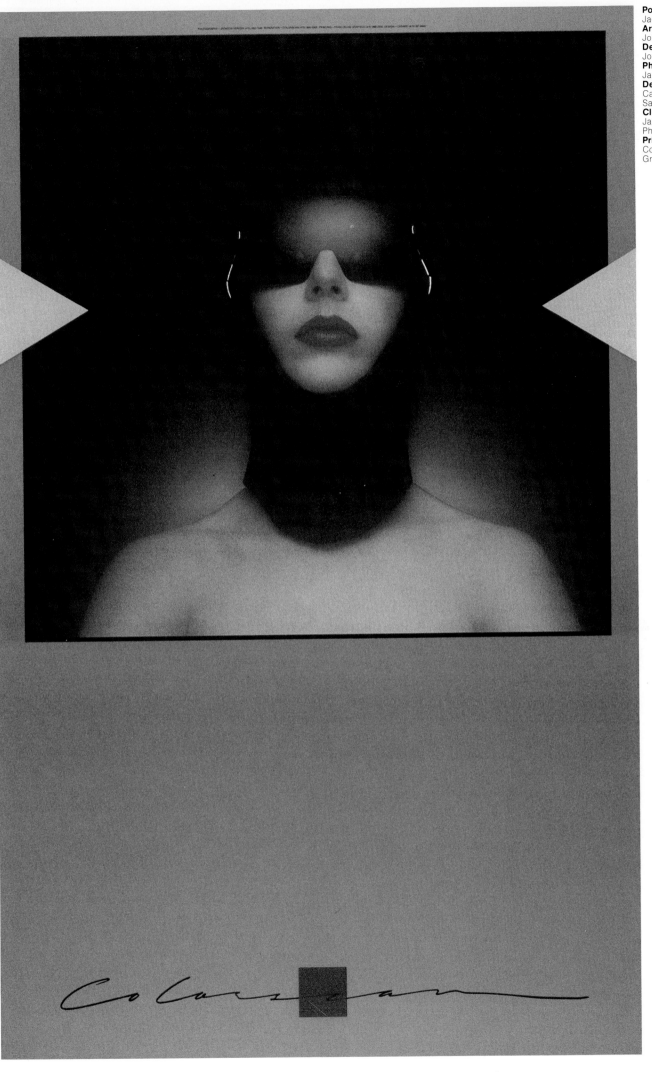

Poster:
Jackson Vereen
Art Director:
John Casado
Designer:
John Casado
Photographer:
Jackson Vereen
Design Firm:
Casado Design
San Francisco
Client:
Jackson Vereen
Photography
Printer:
Colorscan, Franciscan
Graphics

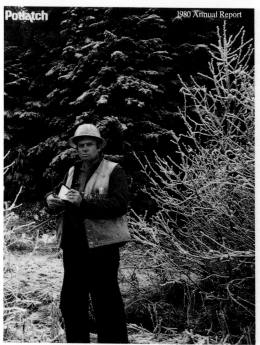

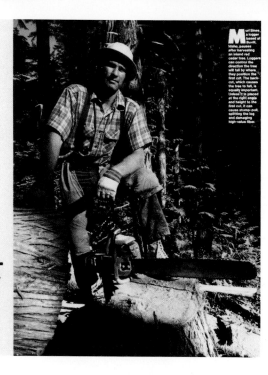

Skills:

From the forest to the corporate board-room, decisions are made affecting profit and loss. Earning a reasonable profit is a collective, cumulative effort. It depends as much on the skill and expertise of the employees who make and sell our products as it does on management's ability to set objectives and define strategies. Employees are called upon every day to make important decisions which add up to profit—or loss—for the company. This is the firing line, the point where the raw material is harvested, converted and sold. Without a highly trained and motivated work force, even the best growth plan would falter. This report takes a look at a few of the more readily illustrated skills performed by Potlatch employees, skills that directly affect our company's success. Regrettably, there is not enough space to salute either the whole range of critical jobs, or all the individuals throughout the country who perform them. Finally, this essay is only a part of the story on Potlatch skills. There is an equally essential contribution to the company's ongoing success from the sales, administration and management teams.

A cutting with desirable characteristics is inserted into a young pine that will serve as root stock in a seed orchard. After being sealed in place, this "scion" will supplant the natural leader, which is trimmed off in the grafting process. The scion will produce seeds earlier than a normal tree.

No two trees are alike, even when they come from carefully nurtured orchard-grown seeds and greenhouse seedlings. Time and conditions in the forest play a part in creating differences. Location, elevation, exposure to moisture, sunlight and wind, nearness to other trees and soil fertility are but a few of the factors that will determine speed and uniformity of growth, form, the number of limbs—the knots they create—and even the density and strength of the wood fiber. Each tree reacts to its environment individually. Each species displays its own unique traits and growing characteristics.

The production processes that convert trees into products have to take these differences into account. In the forest, the logger's first cut can affect fiber recovery and log quality. In the sawmill, decisions on where a saw makes its first cut on a log can affect the quantity and quality of lumber that the log provides. The amount and type of chemicals used in the manufacture of pulp can make a difference in recovery from wood chips, and

Scaler Ronald Blodgett uses a Scribner log rule and measuring tape to determine the net yield of a log at the St. Maries, Idaho, sawmill and plywood complex. The scaler's measurement is the basis for payment to timber owners and logging crews.

Since a logger pauses after harvesting an inland red cedar tree, Loggers can control the direction the tree will fall by where they position the first cut. The back-cut, which causes the tree to fall, is equally important. Unless it is placed at the right angle and height to the first cut, it can cause stump-pull, splitting the log and damaging high-value fiber.

Annual Report:
Potlatch Annual Report 1980
Art Director:
Kit Hinrichs
Designers:
Kit Hinrichs, Arlene Finger
Photographer:
Tom Tracy
Design Firm:
Jonson Pedersen Hinrichs
& Shakery
San Francisco
Client:
Potlatch Corp.
Typographer:
Reardon & Krebs
Printer:
Anderson Lithographic Co.

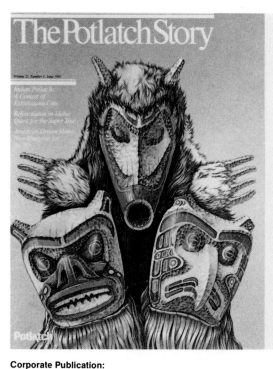

The Potlatch Story

Volume 21, Number 1, June 1981

Indian Potlatch: A Contest of Extravagant Gifts

Reforestation in Idaho: Quest for the Super Tree

American Dream Home: New Blueprint for Sales

he had not doubled the value of the original gift, he was shamed and demoted, and his rival's prestige was correspondingly enhanced. The contest continued throughout his life. If a man was successful, he played with increasingly formidable rivals.

Destruction of property was the most extreme form of wealth display. A man who was so rich he could afford to destroy valuable possessions (instead of giving them away with expectations that he would later receive return gifts of greater value) was indeed a great figure in the society. The most wanton display of wealth was the throwing away of copper, a metal which held tremendous value to the Northwest Indians.

Among some tribes, the worth of copper plaques was measured in terms of the number of blankets given away at the potlatch where they were exhibited. It was not unheard of to pay 6,000 blankets for a copper piece. Copper was formally purchased at potlatches and the seller had to distribute the proceeds to his tribe. Even after a price had been agreed upon, the buyer might say, "Do you think that is all I can afford? Here are another 300 blankets to add to those I have already paid." Thus, he raised his own status by showing he could afford more than the asking price. In time, copper plaques received names which often reflected their value: Making-the-House-Empty-of-Blankets, for example.

Despite the competitive nature of potlatches, the gift giving and destruction of property were rarely carried to extremes. A chief was not free to destroy property to the utter impoverishment of his people or to engage in contests that were ruinous to them. Good fortune, it was believed, abandoned the man who went too far, and he would be no longer supported by his followers.

Sometimes two chiefs who were under pressure to assert themselves would agree privately to throw a potlatch and counter-potlatch that would come out in a draw so that their tribes would be satisfied and they could save face.

The first white people to explore the territories where the potlatch was prac-

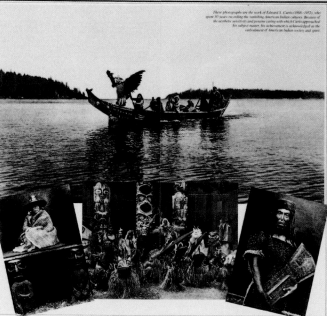

These photographs are the work of Edward S. Curtis (1868–1952), who spent 30 years recording the vanishing American Indian cultures. Because of the aesthetic sensitivity and genuine caring with which Curtis approached his subject matter, his achievement is acknowledged as the embodiment of American Indian society and spirit.

ticed must have judged this warfare of extravagant giving to be clearly insane, which is understandable given the civilized world's traditional view of warfare as one of bloodshed and plunder.

Nevertheless, when the British gained control of the land (about 1850), potlatches became even larger, and their sponsors rose even higher in rank. This was made possible partly because trade with the white man brought increased wealth to the tribes of the region. Another factor was the disease he brought with his trade. The fatal effects substantially reduced tribal populations and therefore the number of people to share the wealth.

The potlatch peaked in 1921, when the largest ever was thrown by the Kwakiutls, but the last of their kind was given in the 1930s, when the last of the Northwest tribes adopted the economic ways of their nation.

The bad name the potlatch has earned outside the Northwest Indian community, chiefly through its bragging, one-upmanship aspects, is changing thanks to more recent studies of the entire phenomenon. It is being seen more positively these days, as a sport, but with serious purpose, one that goes beyond ego gratification. The potlatch was a sophisticated and highly effective means of sharing wealth and giving power to those who were most likely to use it well.

But even in their worst sense, as aggression, potlatches were battles fought with oratory and property, not physical violence. Anthropologists agree, there's much to be said for a society in which a man gives his enemy a lavish gift instead of the business end of a spear.

Corporate Publication:
Potlatch Story-June 1981
Art Director:
Linda Hinrichs
Designer:
Linda Hinrichs
Artists:
John Hyatt,
Ward Schumaker,
Phillip Weisbecker
Photographer:
Paul Fusco
Design Firm:
Jonson Pedersen Hinrichs
& Shakery
San Francisco
Client:
Potlatch Corp.
Typographer:
Spartan Typographers
Printer:
George Rice & Sons

The Potlatch Story

MAINTAIN THE RIGHT

Volume 21, Number 2
November 1981

*Tweed Museum
Receives Mountie Art*

*Arkansas Reforestation:
Planning the 21st Century Forest*

*Wood Waste into Energy:
No Fuel Like an Old Fuel*

Mythical Beasts of the Timberlands

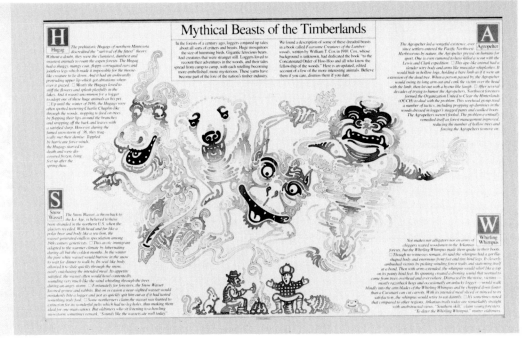

The Potlatch Story

MAINTAIN THE RIGHT

Volume 21, Number 2
November 1981

*Tweed Museum
Receives Mountie Art*

*Arkansas Reforestation:
Planning the 21st Century Forest*

*Wood Waste into Energy:
No Fuel Like an Old Fuel*

The Royal Canadian Mounted Police
Peace-keepers of the Canadian Frontier

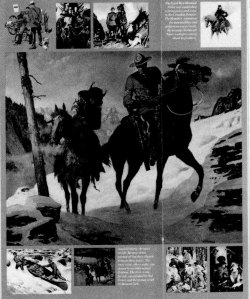

Corporate Publication:
The Potlatch Story,
Nov. 1981
Art Director:
Linda Hinrichs
Designer:
Linda Hinrichs
Artists:
Tim Lewis, Arnold Friberg,
Ward Schumaker
Photographers:
John Blaustein,
Dennis Gray
Design Firm:
Jonson Pedersen Hinrichs
& Shakery
San Francisco
Client:
Potlatch Corp.
Typographer:
Spartan Typographers
Printer:
George Rice & Sons

Annual Report:
Orthopaedic Hospital
Annual Report 1980
Art Director:
James Cross
Designer:
Doug Oliver
Photographer:
Robert Pacheco
Design Firm:
Cross Associates
Los Angeles
Client:
Los Angeles Orthopaedic
Hospital
Typographer:
Central Typesetting Co.
Printer:
Anderson Lithographic Co.

AFTER TWO AND A HALF WEEKS, Julia's half of her hospital room is overflowing with cards of all sizes and shapes, stuffed animals, games, Olivia Newton-John tapes, a tape machine, stamp books, and her needlework. She has developed a bantering friendship with her roommate and a friendly rapport with her nurses. She is visited frequently by Larry Apodaca, M.S.W., her social worker, and has added to her stamp collection some prizes brought to her by volunteer Otto Mason, a former school principal who shares her enthusiasm for stamp collecting.

After six weeks, Julia Kelly is going home.

During her hospitalization and surgeries, Julia Kelly presented a series of complex problems that required constant, careful decision-making by her physicians. This process will continue in the ambulatory care services department where she will return for follow-up treatment.

"Julia," says Gustafson, "is going to be limited because of her birth defect, but we have significant correction of her spinal deformity. She is a bright little girl who will be able to make her way in the world."

The sophisticated decision-making process, which has helped and will continue to help Julia, may be, after all, what is done best at Orthopaedic Hospital. The research and training that go on here, the skill and knowledge brought to bear by our expert medical and paramedical staff—these are the tools required to make and carry out those decisions that improve the life of each of our patients.

Welcome home, Julia.

Julia is preparing to go home. She is delighted to be returning to Whiskers, her cat, her brothers and many friends who call frequently and are eager to see her. After therapy, her student nurse and a volunteer help Julia with last minute details.

12. 13.

Annual Report:
Crocker National Corp.
Annual Report 1980
Art Director:
Kit Hinrichs
Designers:
Kit Hinrichs, Lenore Bartz
Photographer:
John Blaustein
Design Firm:
Jonson Pedersen Hinrichs
& Shakery
San Francisco
Client:
Crocker National Corp.
Typographer:
Reardon & Krebs
Printer:
Graphic Arts Center

The first year of the '80s tested bankers with volatile interest rates, a turbulent economy, the housing market in turmoil and the beginning of deregulation. While conditions will surely remain unsettled, the bold and imaginative will find opportunities where others see problems. Crocker's performance in 1980 resulted in record earnings, assets, loans and deposits. We also took steps to strengthen our future performance. We welcome the future despite its rigors. We believe that Crocker has the talent, the imagination and the stamina to compete with anyone.

CROCKER NATIONAL CORPORATION 1980 ANNUAL REPORT FROM MANAGEMENT

Significant growth in loans and services offered new opportunities to increase our deposit base. By year-end, the division's deposits had climbed 63 percent to $404 million. Those new funds provided significant resources as domestic money rates increased.

While moving to capitalize on 1980's profit potential, the International Division also took steps to assure strong future growth, especially important in light of Crocker's proposed alliance with Midland Bank.

Our own expansion plans for 1981 include two offices which will play important roles. A new representative office in Buenos Aires will help serve Argentina's business community. Plans are also underway to upgrade

our Seoul, Korea, office to branch status. This will enable us to take advantage of local lending opportunities and improve service to Crocker's many customers.

Project COPE (the Challenge of Profitability in the Eighties) continues to emphasize division operations, particularly in the area of credit administration. Negligible credit losses and COPE's tighter controls allowed us to begin to decentralize credit approval authority in 1980, an important process which will continue in 1981. With decentralization, we can respond much faster to credit needs around the globe.

The first of three phases of our international data automation project (IDA) concluded successfully in 1980, and IDA should be fully in place during 1981. When completed, IDA will provide us with an international financial communications network, a technological edge in processing our rapidly growing volume of international transactions.

Crocker's proposed alliance with Midland offers special opportunities for more growth and change within the International Division and its markets. Crocker's and Midland's customer bases, international installations and development plans tend to be complementary rather than overlapping. Affiliation holds the promise of measurable benefits for both banks.

1981 is shaping up as a year of challenges for us in the International Division, but its risks are sure to be outweighed by opportunities for sustained growth. Our seasoned international team of committed and experienced professionals is working around the world, tapping countless global sources for that growth.

The Merchant Banking/Corporate Finance Division continues to grow and expand its services as a financial advisor to corporations, governments and financial institutions in the United States and abroad. Our expertise as professionals and our importance in the affairs of our clients ideally position us to offer financial advisory services for mergers and acquisitions, valuations, complex project financings and long-term financings, including private placements, leveraged leases and industrial revenue bonds.

Our success is generating greater fee income in

1980 resulted from dramatic growth in both the Loan Syndications Group and the Specialized Financing Group, which concentrates on large-scale project financings.

In 1980, the Specialized Financing Group managed one dozen major project financing engagements

in seven countries on three continents. A proprietary computer-based financial model, and a cadre of professionals who are leaders in their field, helped distinguish Crocker's Specialized Financing Group as one of the leading financial advisors for projects in natural resources and other capital-intensive industries.

The Loan Syndications Group set new records in the volume of loans managed or comanaged by Crocker. By increasing selectivity, the group expanded volume and added to its complement of professionals.

Our Corporate Finance Group successfully originated a number of significant acquisition and divestiture transactions in 1980 that added to Crocker's reputation as a broad-gauged financial advisor. Additionally, despite tight credit markets, the group completed innovative tax-exempt financing between our clients and private lenders.

During the year we also took responsibility for the bank's leveraged lease function, formerly handled in the Commercial Services Division. These specialists arrange long-term lease financing for clients, placing debt and equity portions among a variety of financial institutions.

The scope of the division's activities will evolve in 1981 to include other non-banking financial services, some of which include subsidiaries of the bank's holding company. The combined talents of our professionals are being molded to provide the most profitable and respected mix of financial advisory services to round out Crocker's traditional banking services.

1980 was a memorable year for the financial markets in which our division operates. All modern records of high interest rates and interest rate volatility were easily shattered during those turbulent 12 months.

The year began with a prime interest rate of 15¾ percent, already very high by historical standards. During the first quarter, however, economic growth, credit demand and inflation combined to induce the Federal Reserve to adopt an even more stringent monetary policy, culminating in its policy course, full circle, toward aggressive ease. During a brief 10-week span beginning in mid-April, this combination of forces caused a dramatic plunge in money market rates, and by July the prime rate stood at 11 percent

In the atmosphere of most analysts, the economy responded with alacrity to the massive injection of credit, and by late summer it became apparent that many business sectors were recovering at an impressive pace. By early autumn, renewed economic strength and resulting credit demand, along with heavy government borrowing, again triggered

March program of credit rationing. The resulting money market pressures propelled the prime rate to an almost inconceivable level of 20 percent.

These high rates and credit conditions caused an abrupt decline in business activity, resulting in a record 9.9 percent annual rate of real economic decline in the spring quarter. In response to this precipitous fall, the Federal Reserve quickly changed

excessive monetary growth and inflation, forcing the Federal Reserve to react once more to a tight money market policy. By mid-December, the prime rate reached a new high of 21½ percent.

Charged with managing the bank's liquidity and, within this framework, minimizing the bank's cost of funds, our Liability Management Department funded most of the bank's asset

growth through the foreign and domestic money markets in 1980's inflationary environment, growth in the bank's loans again exceeded increases in demand deposits and consumer savings deposits subject to interest rate ceilings. Despite the extremely volatile money market conditions, we obtained the additional funds needed without strains on liquidity.

Broadly diversified sources of funds—by instrument, institution and market—coupled with the prudent structuring of liabilities by maturity, allowed the bank to service a broad spectrum of customers and markets with relative ease

Although liquidity was not a problem, the wide swings of money market rates provided ample opportunity to misjudge market movements to the detriment of the bank's net interest margin. But with this risk came greater potential rewards for astute participation in the markets.

10

11

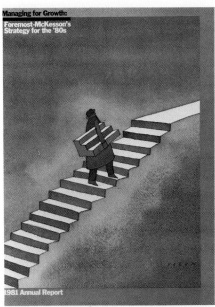

Managing for Growth:
Foremost-McKesson's
Strategy for the '80s

1981 Annual Report

and services consist of well-recognized brand names and established market franchises. They include Mueller pasta, Foremost dairy products, Sparkletts and other bottled water brands, Armor All protectant for automotive and home applications, Liquore Galliano, Mount Gay rums, a number of wine labels and the prescription claims services of Pharmaceutical Card System.

Our value-added distribution services distinguish our operations from those of most of our competitors by providing a range of values to our customers and suppliers far beyond the simple logistics of distribution. Buying from manufacturers and selling in smaller quantities to retailers, we make products available at the right time and place. At the same time, we provide valuable services such as marketing, planning, research, display and advertising support, computerized retail business systems and special packaging.

These core businesses — proprietary products and services and value-added distribution — will be the primary focus of our future growth.

Conceptually, our growth strategy can be thought of as a series of concentric circles built from these core businesses.

Our first priority in ensuring the future growth of the company is to continue to promote greater internal

efficiencies while increasing the market share of current operations. In this area we will commit additional resources to improving working capital efficiencies, developing computer systems, making productivity improvements and to the effective marketing of our current product lines.

We expect to achieve further important gains in efficiency by extending our present electronic data processing technology to all of our distribution systems. The Drug & Health Care Group pioneered this development, using computers to reduce its own operating costs and improving its retail customers' profitability through its Econmost, Econoscan and Econotone electronic order entry systems. About 80% of its business is now generated by these programs.

By adopting similar technology, the Chemical and Wine & Spirits groups offer attractive opportunities for more intensive computer use. The Chemical Group will incur start-up expenses of over $2 million in fiscal 1982 for an advanced marketing and product information system. A major computer expansion already under way in Wine & Spirits will provide that group with an advanced automated order system.

Given our capital resources, our diversity and the position of market leadership we enjoy in all of our major business segments, we have a wide choice of options as we pursue our goals.

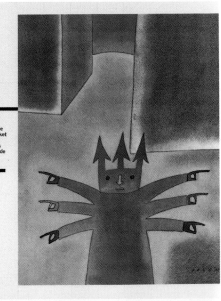

Annual Report:
Foremost-McKesson
Annual Report 1981
Art Director:
Neil Shakery
Designers:
Neil Shakery, Barbara Vick
Artist:
Jean Michel Folon
Design Firm:
Jonson Pedersen Hinrichs
& Shakery
San Francisco
Client:
Foremost-McKesson
Typographer:
Reardon & Krebs
Printer:
Graphic Arts Center

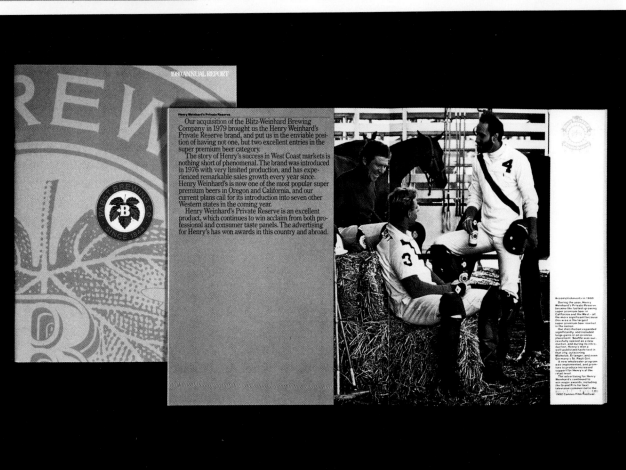

1980 ANNUAL REPORT

Henry Weinhard's Private Reserve

Our acquisition of the Blitz-Weinhard Brewing Company in 1979 brought us the Henry Weinhard's Private Reserve brand, and put us in the enviable position of having not one, but two excellent entries in the super premium beer category.

The story of Henry's success in West Coast markets is nothing short of phenomenal. The brand was introduced in 1976 with very limited production, and has experienced remarkable sales growth every year since. Henry Weinhard's is now one of the most popular super premium beers in Oregon and California, and our current plans call for its introduction into seven other Western states in the coming year.

Henry Weinhard's Private Reserve is an excellent product, which continues to win acclaim from both professional and consumer taste panels. The advertising for Henry's has won awards in this country and abroad.

Annual Report:
Pabst Brewing Co.
Annual Report 1981
Art Director:
Jerry Leonhart
Designers:
Nicolas Sidjakov,
Michael Mabry
Photographer:
Paul Fusco
Design Firm:
Sidjakov, Berman & Gomez
San Francisco
Agency:
Ogilvy & Mather
Client:
Pabst Brewing Co.
Typographer:
Omnicomp
Printer:
Wetzel Brothers, Inc.

Annual Report:
Brae Corp.
Annual Report 1980
Art Director:
Thom La Perle
Designer:
Thom La Perle
Artist:
Rick Von Holdt
Photographer:
Tom Tracy
Design Firm:
La Perle Assoc., Inc.
San Francisco
Client:
Brae Corp.
Typographer:
Spartan Typographers
Printer:
Anderson Lithographic Co.

Poster:
Moscow 1980
Art Director:
Paul Hauge
Designer:
Paul Hauge
Photographer:
Robert Stevens
Design Firm:
Hauge/Dasalle
Los Angeles

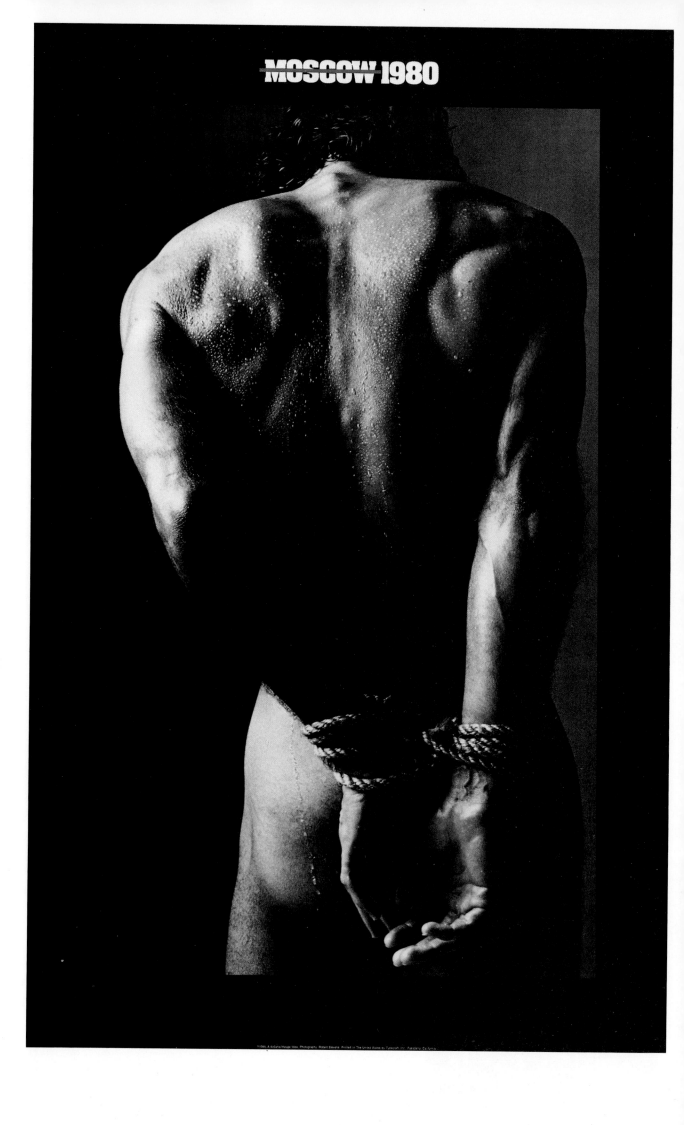

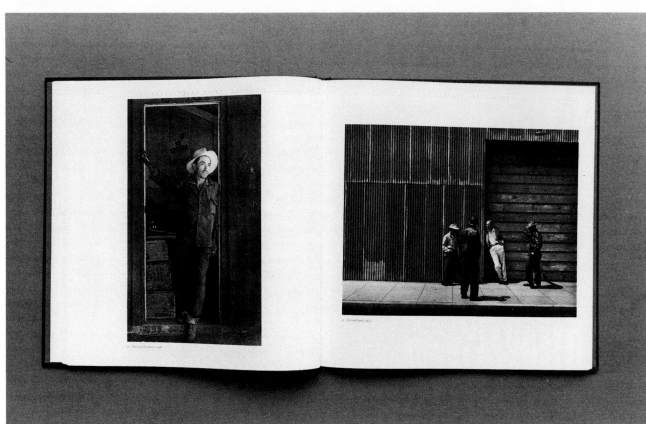

Book:
The Photography of
Max Yavno
Art Director:
Carl Seltzer
Designer:
Carl Seltzer
Photographer:
Max Yavno
Design Firm:
Cross Associates
Los Angeles
Publisher:
University of California
Press
Typographer:
Central Typesetting Co.
Printer:
Gardner Fulmer
Lithograph Co.

THE NEXT
The Decline and Rise of the United States
AMERICA

Michael Harrington/Photographs by Bob Adelman

Book:
The Next America
Art Director:
Neil Shakery
Designer:
Neil Shakery
Photographer:
Bob Adelman
Design Firm:
Jonson Pedersen Hinrichs
& Shakery
San Francisco
Publisher:
Holt, Rinehart and Winston
Typographer:
U.S. Lithographic, Inc.
Printer:
Rapoport Printing Corp.

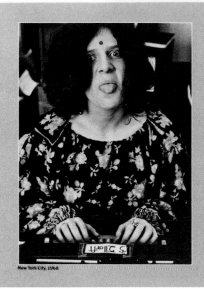

New York City, 1968

middle-class status) than among working people. One of the things that happened between Kinsey's studies in the forties and early fifties and Hunt's survey in the seventies is that the social class factors all but disappeared from the sex lives of the American people. Class differentials, as in Kinsey's oral-sex findings, no longer existed. And just as a change in sexual attitudes and practices thus moved from the cultural elite to the vast majority, so the consciousness of women's exploited position in the society and the demand for a redefinition of roles moved rapidly from vanguard to mass. The seventies, then, experienced two profound, contradictory revolutions, in sexuality and in sex roles. Each was sudden; each was ambiguous. Meanwhile, American politics were moving vigorously left, right and center. The people were disillusioned with politics in general, which was the source of a conservative mood; they were forced, by some of the same factors that had led them to a generalized disenchantment, to politicized, and even radical, attitudes about the particulars. Here again, dissonance was the dominant sound.

In the established academic theory of American politics in the post–World War II period, one could make a great deal of sense out of the nation's past. But as the seventies proceeded, that theory could not cope with the present and the immediate future, or rather, insofar as it did it saw only puzzling departures and uncertain outcomes. The average person in the street is not a political scientist, yet he or she participated viscerally in a breakdown of political loyalties which coincided, as will be seen, with a decline in religious faith. And that same person was simultaneously forced to become more political. According to the established theory, American politics are remarkably stable. Every forty or fifty

Poster:
Dead Men Don't Wear Plaid
Art Director:
Brian D. Fox
Designer:
Robert Biro
Artist:
Peter Greco
Photographer:
Aaron Rapaport
Design Firm:
B. D. Fox & Friends, Inc.
Los Angeles
Client:
Universal Pictures
Typographer:
Vernon Simpson
Printer:
Welsh Graphics

Magazine:
Frisco, March '82
Art Director:
Dugald Stermer
Designers:
Kirk Caldwell, Bill Prochnow,
Dugald Stermer
Artists:
Dugald Stermer, Bill
Prochnow, Kirk Caldwell,
Ron Chan, Dustin Kahn
Photographers:
Jim Marshall, Nicole
Bengiveno, Miguel Blanco,
Ted Pushingsky
Design Firm:
Dugald Stermer
San Francisco
Client:
Frisco Publishing Group
Typographer:
Color III, Daily Californian
Printer:
Quinn Graphics

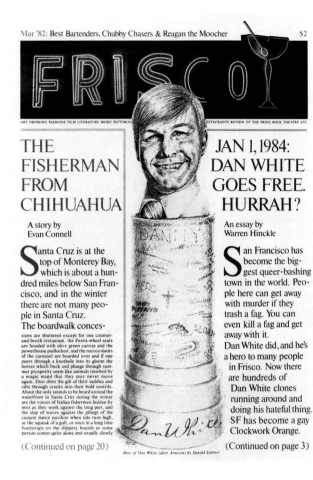

Promotional Brochure:
Blue Cross
Art Director:
Lynn Haywood
Designer:
Lynn Haywood
Artist:
Tina Tompson
Photographer:
George Takimori
Design Firm:
Sims Roberts Assoc., Inc.
Hermosa Beach
Client:
Blue Cross of So. California
Typographer:
Typographic Service
Printer:
Pro-Color

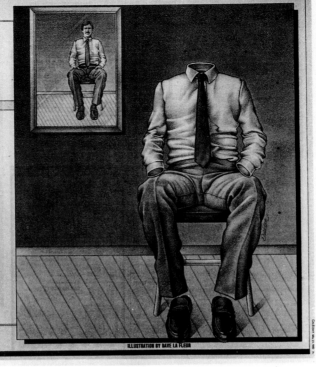

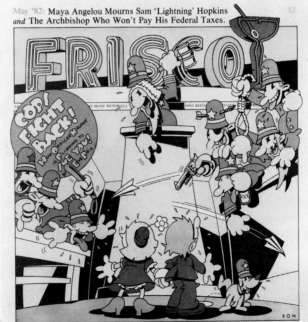

Editorial Spread:
"Missing"
Art Director:
Howard Shintaku
Designer:
Howard Shintaku
San Jose
Artist:
Dave La Fleur
Client:
San Jose Mercury News
Printer:
Alco Gravure

Poster:
The Solar Film
Art Director:
Saul Bass
Designer:
Saul Bass
Artist:
Saul Bass
Design Firm:
Saul Bass, Herb Yager & Assoc.
Los Angeles
Client:
Wildwood Enterprises, Inc.

Magazine:
Frisco, May '82
Art Director:
Dugald Stermer
Designers:
Dugald Stermer, Bill Prochnow, Kirk Caldwell, Ron Chan
Artists:
Ron Chan, Dugald Stermer, Bill Prochnow, Kirk Caldwell
Photographers:
Ted Pushinsky, Harry A. Smith
Design Firm:
Dugald Stermer
Client:
Frisco Publishing Group
San Francisco
Publisher:
Daily Californian
Printer:
Alonzo Press

Poster:
California Public Radio
Art Director:
Michael Vanderbyl
Designer:
Michael Vanderbyl
Artist:
Michael Vanderbyl
Design Firm:
Vanderbyl Design
San Francisco
Client:
California Public Radio
Typographer:
Headliners/Identicolor
Printer:
Fischoff Co.

Magazine:
SFSCA Quarterly #2
Art Director:
Kit Hinrichs
Designers:
Kit Hinrichs, Nancy Garrott
Artists:
Various
Photographer:
Dennis Gray
Design Firm:
Jonson Pedersen Hinrichs
& Shakery
San Francisco
Client:
San Francisco Society of
Communicating Arts
Typographer:
Walker Graphics
Printer:
Alonzo Press

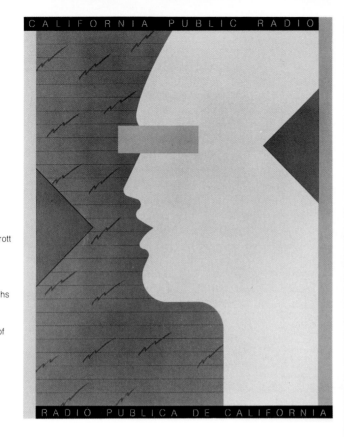

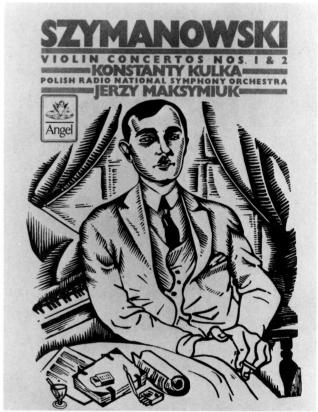

Promotional Brochure:
Richard Hixon
Promo Series
Designer:
Michael Cronan
Photographer:
Richard Hixon
Design Firm:
Michael Patrick Cronan
San Francisco
Client:
Richard Hixon,
Photographer
Typographer:
Headliners/Identicolor
Printer:
Paragraphics, Marin

Record Jacket:
Szymanowski
Art Director:
Marvin Schwartz
Designer:
Tri-Arts
Artist:
Tri-Arts
Design Firm:
Tri-Arts
Hollywood
Client:
Angel Records

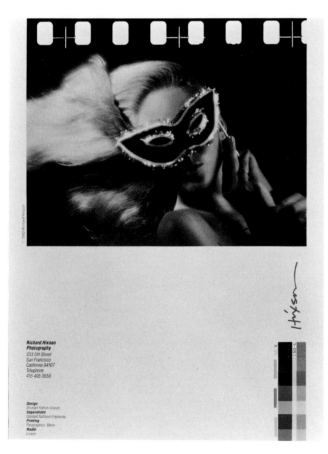

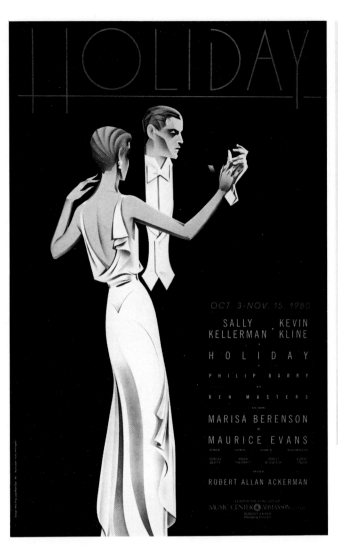

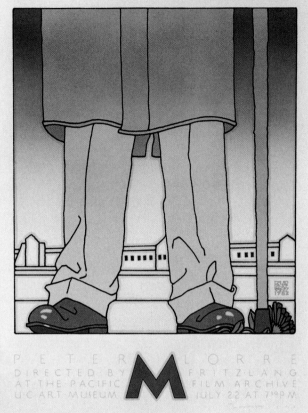

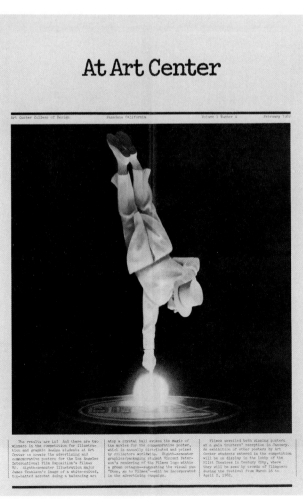

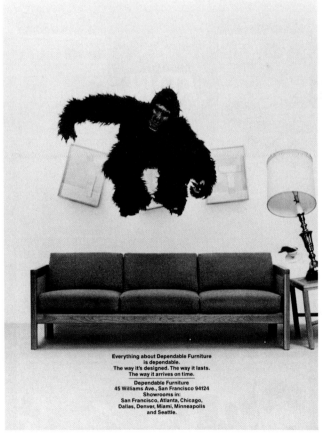

Poster:
Holiday
Art Director:
Hoi Ping Law
Designer:
Hoi Ping Law
Artist:
Holly Hollington
Design Firm:
Dyer/Kahn
Los Angeles
Client:
Ahmanson Theatre
Typographer:
Andresen Typographics
Printer:
No. Hollywood Printing

Poster:
"M"
Art Director:
D. L. Goines
Designer:
D. L. Goines
Artist:
D. L. Goines
Design Firm:
St. Heironymous Press, Inc.
Berkeley
Client:
Pacific Film Archive
Printer:
D. L. Goines

Newsletter:
At Art Center
Art Director:
Don Kubly
Designer:
John Hoernle
Design Firm:
Art Center College
of Design
Pasadena
Publisher:
Dolores Dils
Client:
Art Center College
of Design
Typographer:
Typecraft

Promotional Brochure:
Dependable Furniture '81
Art Director:
Sidjakov, Berman & Gomez
Designer:
Jerry Berman
Photographer:
Stone & Steccati
Design Firm:
Sidjakov, Berman & Gomez
San Francisco
Client:
Dependable Furniture
Typographer:
Petrographics
Printer:
Solzer & Hail
Agency:
Jolene Hammons Advg.

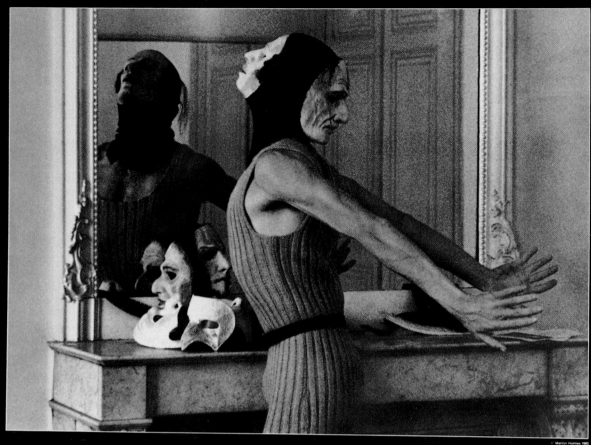

Marilyn Holmes Photographer

Photography: Marilyn Holmes
1261 Howard Street
San Francisco 94103
Telephone (415) 861-1093

Separation: Colorscan
Telephone (415) 969-5005

Lithography: JPP Graphic Arts Center
Telephone (415) 397-2233

© Marilyn Holmes 1980

Poster:
Marilyn Holmes
Art Director:
Harry Murphy
Designers:
Harry Murphy, Diane Levin
Photographer:
Marilyn Holmes
Design Firm:
Harry Murphy + Friends
Mill Valley
Client:
Marilyn Holmes
Typographer:
Colorscan/JPP
Graphic Arts
Printer:
JPP Graphic Arts

Promotional Brochure:
Desiree Goyette
Art Director:
Lee Beggs
Designer:
Lee Beggs
Artist:
Stephanie Langley
Photographer:
Paul Ambrose
Design Firm:
Paul Ambrose Studios
Palo Alto
Client:
Desiree Goyette
Typographer:
M & N
Printer:
Westwood Press

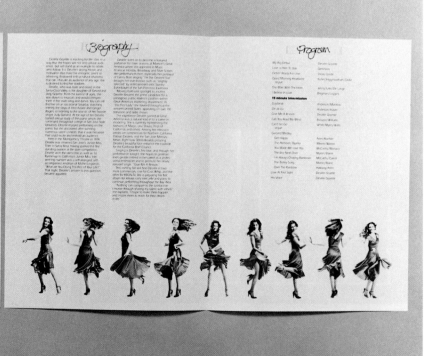

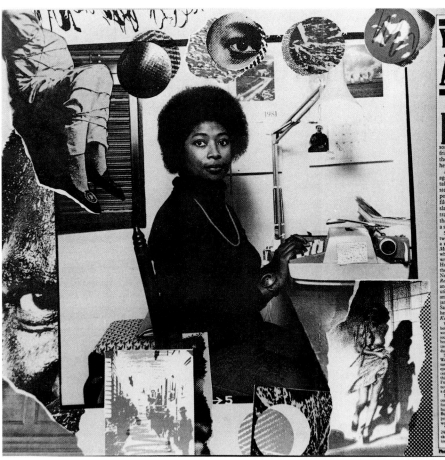

You Can't Keep Her Down
ALICE WALKER

by Evelyn Pine

IN HER NOVEL *MERIDIAN*, ALICE WALKER RECOUNTS the story of LouVinnie, a black slave who weaves terrifying tales so compellingly that the young son of a white plantation owner dies of fright upon hearing them. In revenge, the master rips the slave's tongue from her throat.

Meridian was published five years ago, and Alice Walker is still spinning tales that fascinate and horrify. The stories in her latest book rage against pornography, lynching, rape, whites filching black culture, sado-masochism, slavery, abortion and death. But in contrast to LouVinnie, Walker is lauded by the East Coast literary establishment as a storyteller of power and conviction.

She has published three volumes of poetry, two novels, two collections of short fiction and a number of essays ranging from a report in *Ms.* praising Castro's Cuba to a meditation on why a writer should have only one child. She wrote a biography of black poet Langston Hughes for children and edited an anthology of the writings of novelist and folklorist, Zora Neale Hurston. Her work has appeared in *Redbook, Essence, The Black Scholar, Harper's* and *The New York Times Magazine.* A contributing editor to *Ms.*, she has a loyal following among feminists. This spring, over 500 people jammed into the cavernous Ibsen Room in the San Francisco Women's Building to listen to her read stories from her new book, *You Can't Keep a Good Woman Down.*

Walker lives in San Francisco's Fillmore district with her 11-year-old daughter whom she encourages to read works by anarchist Emma Goldman and columnist/ journalist Agnes Smedley. Five years ago she divorced her child's father, a white lawyer with whom she occupied civil rights protests in Georgia and Mississippi during the sixties.

Settling into her carved wood rocker for an interview, Walker is engaging but reserved. She does not smile easily, but her laugh is blustery and audacious, her eyes penetrating. "If I were a slave in the 18th or 19th century," she explains, "I would be using every single thing at my disposal to free myself. In the 20th century, I'm doing exactly what I would be doing then. Only now, I'm doing it with a typewriter. It's the same thing: a direct line of revolt."

Nonetheless, political commitment and literary success are a dangerous combination. Walker's work argues for the destruction of a system which puts profits before human beings, merchandising people to sell its products. But as a black woman writer, Walker is that highly prized commodity: "the exception." Being black, being a woman, "she-one who overcame all odds and made it."

Walker has been a celebrated writer since the age of 24. One of eight children of Georgia sharecroppers who encouraged her to read, Walker left home and lost herself in stories, fantasies and her own poetry. Fol-

lowing in her sister Molly's footsteps (Walker once said Molly "collected scholarships like trading stamps"), Alice left the small town of Eatonton, Georgia, for college, first Spelman College in Atlanta, then the exclusive Sarah Lawrence near New York City.

During her senior year, Walker suffered a fit of suicidal depression. She scribbled poetry every night, slipping it under the door of her professor, activist-poet Muriel Rukeyser every morning. Undergraduate angst usually yields nothing more profound than incoherent song lyrics or love letters better left unmailed, but Rukeyser admired Walker's creations. She gave them to her literary agent who sold them to the first editor who read them. In 1968 her first book, *Once*, was published, thrusting her into the literary spotlight as the voice of young black women.

In 1974 *New York Times* reviewer Mel Watkins described her first book of stories as "perceptive miniatures, snapshots, that capture their subjects at crucial and revealing moments. In this collection, Ms. Walker is moving without being maudlin, ironic without being gimmicky." The *New Yorker's* Robert Coles hailed her as "a meditative poet and lyrical novelist."

Today Walker is ambivalent about fame, which she sees as corrupting even as it provides her livelihood. "The modern fame that black people have is really nothing," she asserts, "because you cannot be offended by people who you do not respect. Why should we respect white people? They're so devious. They sort of choose one to do this and you're supposed to follow that one. Joe Louis was so famous during the forties when he knocked out the German and he made lots and lots and lots of money. But how did Joe Louis end up? Joe Louis ended up as a sort of doorman at one of the Las Vegas nightclubs. Those white men gave him a job because they felt sorry for him, but also because it is like, 'We have bought the mighty Joe Louis and he shows you to your table.' That's treacherous stuff.

"I understand, too," she continues, "that a lot of what people say about me and what they write about me is really about themselves. It's good when it hits the mark, but I'd be an idiot to really believe, for instance, white men who write reviews in the *New York Times* about my work. What could they possibly know about my work that has any value at all? They don't know beans about my life or care about the lives of black women. Their reviews are good because they help you sell books, but on another level, I cannot be affirmed by those men because I don't respect them and I don't believe in them. And they don't respect and believe in me no matter what they write because if they did this would be an entirely different society. Entirely. You can look over the *New York Times* for the last 20 years or so, and you can really see their loyalties."

Another reason Walker can afford to be indifferent to the opinions of the main New York reviewers is that her audience is composed primarily of women. Her numerous stories and articles in *Ms.* magazine have gained her a significant audience, as the overflow crowd at her recent Women's Building reading also attests.

It's naive to assume, however, that this audience has liberated itself from the claws of American commercialism. In the late sixties, businessmen discovered that a large number of women loosely connected by a feminist identification could be consolidated as consumers. Like the teen market of the fifties, the shifting women's market needed new products, slogans and heroines. Freedom, independence and success in a man's world began to be used in promotions for everything from tampons to computer terminals. As feminists struggled to control their own businesses, presses and destinies, corporate publishers delighted in the discovery of a new market hungry for books about independent women proud of their intelligence and sexuality.

Photo & layout design: Marek A. Majewski.

continued on page 33

Publication Spread:
Alice Walker
Art Director:
Marek Majewski
Designer:
Marek Majewski
Artist:
Marek Majewski
Photographer:
Marek Majewski
Design Firm:
Quality Image
San Francisco
Client:
Artbeat

Promotional Literature:
Esprit Wholesale Catalog
Art Director:
John Casado
Designer:
John Casado
Photographer:
Olivero Toscani
Design Firm:
Casado Design
San Francisco
Client:
Esprit De Corp
Typographer:
Reprotype

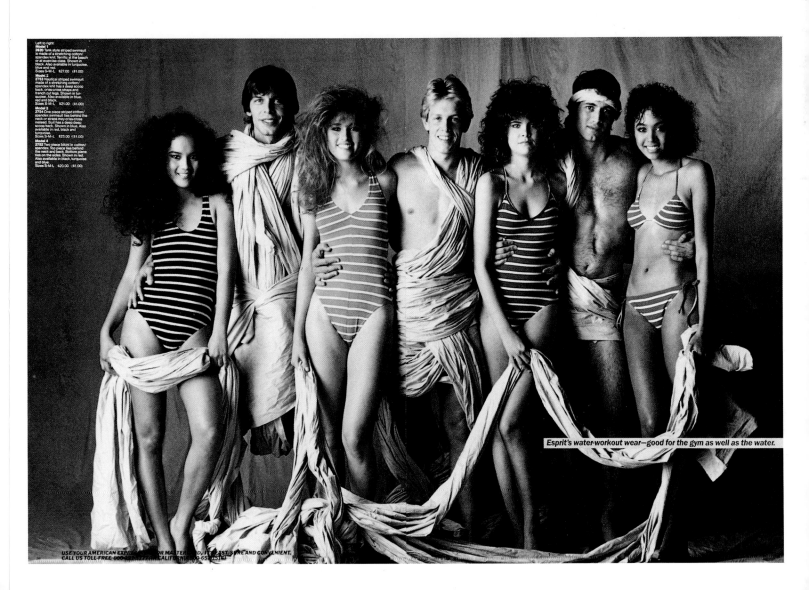

Left to right:
Model 1
2820 Tank style striped swimsuit is made of a stretching cotton/ spandex knit. Terrific at the beach or at exercise class. Shown in black. Also available in turquoise, blue and red.
Sizes S-M-L. $27.00 ($1.00)
Model 2
2753 Nautical striped swimsuit made of a stretching cotton/ spandex knit has a deep scoop back, criss-cross straps and french cut legs. Shown in turquoise. Also available in blue, red and black.
Sizes S-M-L. $21.00 ($1.00)
Model 3
2734 One piece striped cotton/ spandex swimsuit ties behind the neck or straps may criss-cross instead. Suit has a deep deep scoop back. Shown in red. Also available in red, black and turquoise.
Sizes S-M-L. $23.00 ($1.00)
Model 4
2752 Two piece bikini in cotton/ spandex. Top piece ties behind the neck and back. Bottom piece ties on the sides. Shown in red. Also available in black, turquoise and blue.
Sizes S-M-L. $20.00 ($1.00)

Esprit's water-workout wear—good for the gym as well as the water.

USE YOUR AMERICAN EXPRESS, VISA OR MASTERCARD. IT'S EASY, SAFE AND CONVENIENT. CALL US TOLL-FREE 800-227-2345 IN CALIFORNIA 800-652-1918.

Bulletin:
1983/84 Admissions
Art Director:
Keith Bright
Designer:
Julie Riefler
Artist:
Sherry Johannes
Photographer:
Ron Shuman
Design Firm:
Bright & Assoc.
Los Angeles
Client:
Calif. Inst. of the Arts
Typographer:
Andresen Typographics
Printer:
Jeffries Litho

Record Sleeve:
Billy Idol
Art Director:
Janet Levinson
Designer:
Janet Levinson
Los Angeles
Photographer:
Jules Bates
Client:
Chrysalis Records
Typographer:
Type West
Printer:
Shorewood Packaging
Corp.

Brochure:
Great Chefs 1981
Art Director:
Michael Manwaring
Designer:
Michael Manwaring
Artist:
Betty Barsamian
Photographer:
Various
Design Firm:
The Office of
Michael Manwaring
San Francisco
Publisher:
The Great Chefs of France
Typographer:
Omnicomp
Printer:
Interprint/Warren's
Waller Press
Illustrator:
Michael Manwaring

Editorial Spread:
"Divorce"
Art Director:
Howard Shintaku
Designer:
Howard Shintaku
San Jose
Artist:
Mitch Anthony
Client:
San Jose Mercury News
Printer:
Alco Gravure

Promotional Brochure:
Mt. Lid Woolens 1982
Art Director:
Michael Vanderbyl
Designer:
Michael Vanderbyl
Artist:
Michael Vanderbyl
Photographer:
Light Language
Design Firm:
Vanderbyl Design
San Francisco
Client:
Mt. Lid Woolens
Typographer:
Headliners/Indenticolor
Printer:
Interprint

Magazine:
Assets–Spring 1980
Art Director:
Kit Hinrichs
Designers:
Kit Hinrichs, Barbara Vick
Artist:
Michael Morgan
Photographers:
Tom Tracy, Suzanne Estelle,
John Blaustein
Design Firm:
Jonson Pedersen Hinrichs
& Shakery
San Francisco
Client:
Crocker National Corp.
Typographer:
Crocker National Corp.
Printer:
Graphic Arts Center

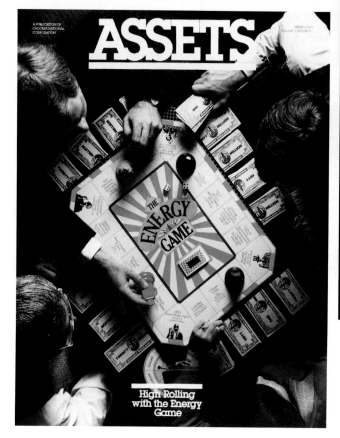

4002-H
Large nylon frame. Black, red, white or blue.

4002-D
Small nylon frame. Blue only.

4003-H
Large, double-bridge, nylon frame. Black, red, white or blue.

4003-D
Small, double-bridge, nylon frame. Blue only.

4008
Deluxe, barrel-hinged, double-bridge frame. Tortoise only.

4009
Large, barrel-hinged frame with wrap-around lenses. Brown only.

4017
Deluxe, barrel-hinged, double-bridge, nylon frame. Brown or blue.

4018
Deluxe, barrel-hinged, double-bridge frame. Laminated blue, white and red.

The original VUARNET sunglasses . . . named for the downhill gold medalist skier in the 1960 Winter Olympics. VUARNET sunglasses were first developed for sports professionals, like Jean Vuarnet, who could not permit the slightest doubt about their equipment.

Amateur sports enthusiasts discovered these glasses long after they had become the world standard of quality among professionals. Today VUARNET sunglasses are the obvious choice of everyone who demands optimum eye protection for any outdoor activity from the most active, like downhill skiing, to the most leisurely, like reading on the beach.

Made in 36 styles, VUARNETS are custom created for the differing conditions faced by sportsmen and women—specially filtered to protect the skier from reflected light, the driver and the tennis player from low-angle sun and glare, the high-altitude climber from raw sunlight at its brightest.

Common to all VUARNET sunglasses is the careful, secret process of the creation of the lens. Made from the highest-quality optical glass, VUARNET lenses are precision ground and polished on both surfaces to limit distortion. Heat treating, double gradient filters and metal oxide coatings offer abrasion and breakage resistance, complete ultraviolet absorption and 90% filter effectiveness against infrared rays and glare.

V U A R N E T

Promotional Brochure:
Vuarnet USA
Art Director:
Robert Miles Runyan
Designer:
Stephen Sieler
Photographer:
Jon Kubly
Design Firm:
Robert Miles Runyan & Assoc.
Playa del Rey
Client:
Vuarnet USA
Typographer:
Composition Type
Printer:
Lithographix

Los Angeles (213) 464-4106

Orange County (714) 540-7144

Advertisement:
Andresen
Art Director:
Keith Bright
Designer:
Peter Sargent
Design Firm:
Bright & Assoc.
Los Angeles
Client:
Andresen Typographics
Typographer:
Andresen Typographics

CURT McDOWELL

VOYEUR IN SEARCH OF A FIX.
BY RICHARD TRAINOR

Publication Spread:
Editorial
Art Director:
Curt McDowell
Designer:
Marek Majewski
Artist:
Marek Majewski
Photographer:
Marek Majewski
Design Firm:
Quality Image
San Francisco
Client:
Artbeat

Book:
Nexus Book
Art Director:
Carl Seltzer
Designer:
Carl Seltzer
Photographer:
Murray Smith
Design Firm:
Cross Assoc.
Los Angeles
Publisher:
Tiger Publishing
Typographer:
Vernon Simpson
Printer:
Gardner Fulmer
Lithograph Co.

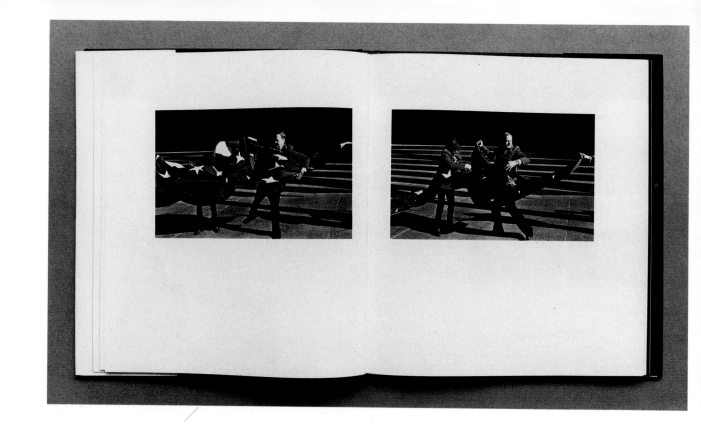

Annual Report:
Fluor Corporation 1979
Art Director:
Ron Jefferies
Designer:
Claudia Jefferies
Photographer:
William James Warren
Design Firm:
The Jefferies Association
Los Angeles
Client:
Fluor Corporation
Typographer:
CAPCO
Printer:
Anderson Lithographic Co.

Anniversary Brochure:
James H. Barry Co.
Art Director:
Thom LaPerle
Designer:
Thom LaPerle
Artist:
Rick Von Holdt
Photographer:
Tom Tracy
Design Firm:
LaPerle/Associates, Inc.
San Francisco
Client:
James H. Barry Co.
Typographer:
Mercury
Printer:
James H. Barry Co.

Record Jacket:
Billy Idol
Art Director:
Janet Levinson
Designer:
Janet Levinson
Los Angeles
Client:
Chrysalis Records
Typographer:
Type West
Printer:
Shorewood Packaging
Corp.

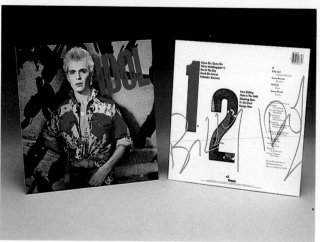

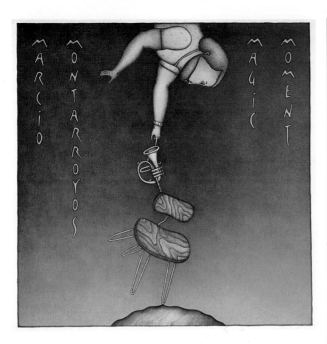

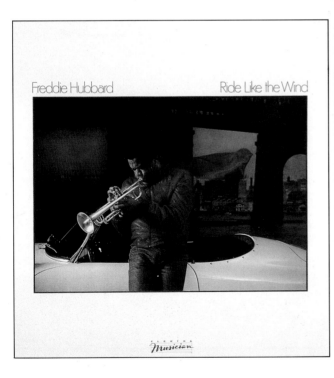

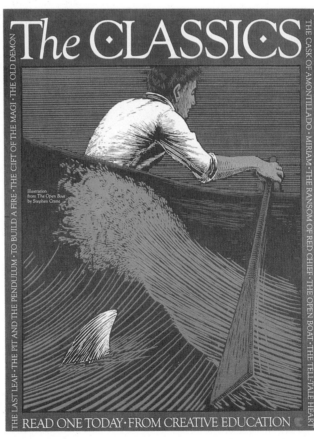

Record Jacket:
Marcio Montarroyos
Magic Moment
Art Director:
Tony Lane
Designer:
Tony Lane
Los Angeles
Artist:
Jerry McDonald
Client:
CBS Records
Printer:
Shorewood Packaging
Corp.

Announcement:
Atari
Art Director:
Barry Deutsch
Designer:
Myland McRevey
Artist:
Myland McRevey
Design Firm:
Steinhilber Deutsch
& Gard
San Francisco
Client:
Atari, Inc.

Record Jacket:
Freddie Hubbard –
Ride Like the Wind
Art Directors:
Ron Coro, Norm Ung
Designers:
Ron Coro, Norm Ung
Los Angeles
Photographer:
Ron Slenzak
Client:
Elektra Musician Records

Poster:
The Classics
Designers:
Marty Neumeier,
Bryan Glaser
Design Firm:
Neumeier Design Team
Santa Barbara
Client:
Creative Education, Inc.
Printer:
Worzalla Press

Calendar:
Saga 1982
Art Director:
Keith Bright
Designer:
Julie Riefler
Photographer:
Bret Lopez
Design Firm:
Bright & Assoc.
Los Angeles
Client:
Saga Corp.
Typographer:
Andresen Typographics
Printer:
George Rice & Sons

Calendar:
Fluor "Insight" 1981
Art Director:
James A. Cross
Designer:
Jay Beynon
Photographer:
Lonnie Duka
Design Firm:
Cross Assoc.
Los Angeles
Client:
Fluor Corp.
Typographer:
Central Typesetting Co.
Printer:
Gardner Fulmer
Lithograph Co.

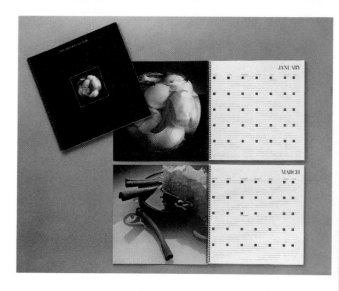

Promotional Brochure:
Herndon-Nelson
Art Director:
Joann Keahey
Designer:
Dave Stevenson
Artist:
Dave Stevenson
Photographer:
Meisels Photo
Design Firm:
The Rakela Co.
Sacramento
Client:
Herndon-Nelson
Typographer:
Litho
Printer:
American Graphics

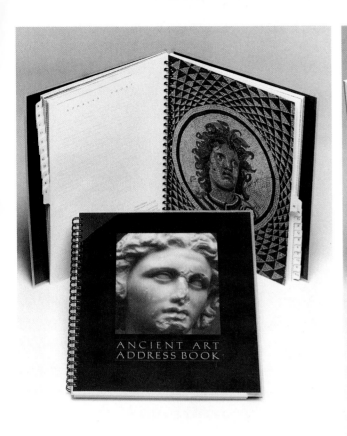

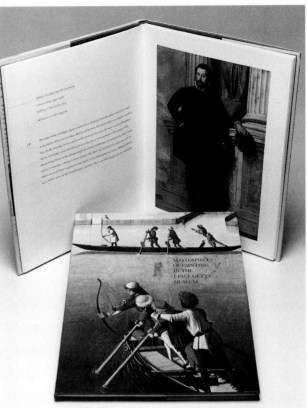

Address Book:
Ancient Art
Art Director:
John Coy
Designer:
Mary Lavelle
Photographers:
Donald Hull,
Penelope Potter
Design Firm:
Coy, Los Angeles
Culver City
Client:
The J. Paul Getty Museum
Printer:
Alan Lithograph, Inc.

Book:
Masterpieces of Painting
in the J. Paul Getty
Museum
Art Director:
John Coy
Designers:
John Coy, Maryl Lavelle
Photographer:
Donald Hull
Design Firm:
Coy, Los Angeles
Culver City
Client:
J. Paul Getty Museum
Typographer:
Vernon Simpson
Typographers
Printer:
Alan Lithograph, Inc.

58
Mes-i-ke-her
1900

Pencil, 11" x 8"

Collection of Edith Hamlin

59
Two Eagles
1932

Oil, 30" x 40"

Collection of Senator and Mrs. Barry Goldwater

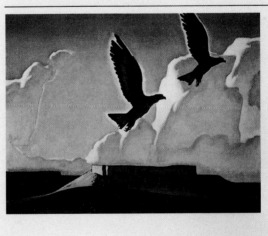

Book:
Maynard Dixon
Art Director:
Michael Vanderbyl
Designer:
Michael Vanderbyl
Artist:
Piper Murakami
Design Firm:
Vanderbyl Design
San Francisco
Client:
The California Academy
of Sciences
Typographer:
Mr. & Mrs. Peter Bedford
Printer:
Interprint/Dai Nippon

Brochure:
Student Union
Art Director:
Sam Smidt
Designer:
Sam Smidt
Photographer:
Sam Smidt
Design Firm:
Sam Smidt
Palo Alto
Client:
San Jose State University
Typographer:
Frank's Type, Inc.
Printer:
Globe Printing

Bulletin:
CCAC Summer Bulletin
Art Director:
Thomas Ingalls
Designers:
Thomas Ingalls,
David Holbrook
Design Firm:
Thomas Ingalls & Assoc.
San Francisco
Client:
California College of Arts
and Crafts
Typographer:
Abracadabra, Gestype
Printer:
Alonzo

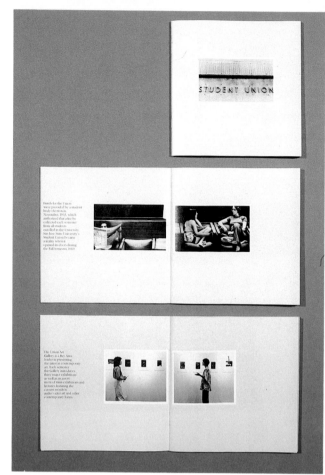

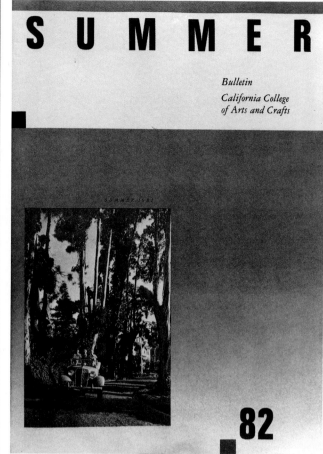

Announcement:
Sacramento Advertising
Club
Art Director:
Joann Keahey
Designer:
Dave Stevenson
Artist:
Dave Stevenson
Photographer:
Meisels Photography
Design Firm:
The Rakela Co.
Sacramento
Client:
Sacramento Advertising
Club
Typographer:
Lithographics
Printer:
Fong & Fong

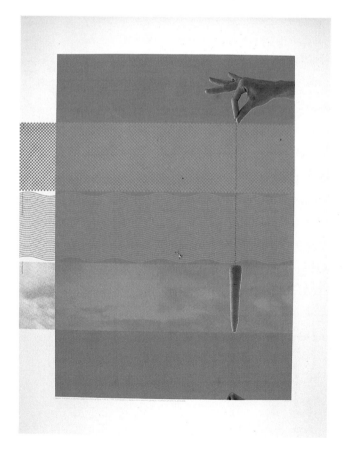

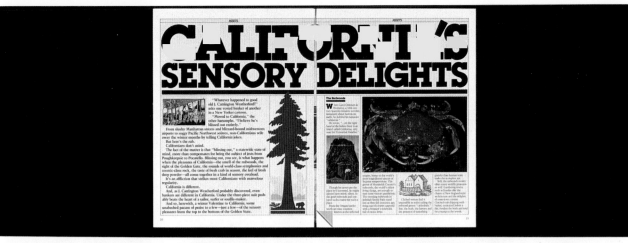

Publication Spread:
California Delights
Art Director:
Kit Hinrichs
Designers:
Kit Hinrichs, Barbara Vick
Artist:
Hank Osuna
Photographer:
Steve Gerber
Design Firm:
Jonson Pedersen Hinrichs
& Shakery
San Francisco
Client:
Crocker National Corp.
Typographer:
Crocker National Corp.
Printer:
Graphic Arts Center

Publication Spread:
Christmas A–Z
Art Directors:
Kit Hinrichs, Al Grossman
Designers:
Kit Hinrichs, Gillian Smith
Artists:
Lynne Dennis,
Ellen Blonder
Photographer:
Dennis Bettencourt
Design Firm:
Jonson Pedersen Hinrichs
& Shakery
San Francisco
Client:
McCall's Magazine

Poster:
'81 SWA Xmas
Art Director:
Sarah Nugent
Designers:
Sarah Nugent, Sandy Short
Artists:
Sandy Short, Peggy Kamei
Design Firm:
The GNU Group
Sausalito
Client:
The SWA Group
Printer:
Paragraphics

Call for Entry:
Illustration West
Art Director:
Leslie Tryon Tatoian
Designer:
Don Weller
Artist:
Don Weller
Design Firm:
The Weller Institute for the
Cure of Design
Los Angeles
Client:
Los Angeles Society of
Illustrators
Typographer:
Alpha Graphix
Printer:
Gardner Fulmer
Lithograph Co.

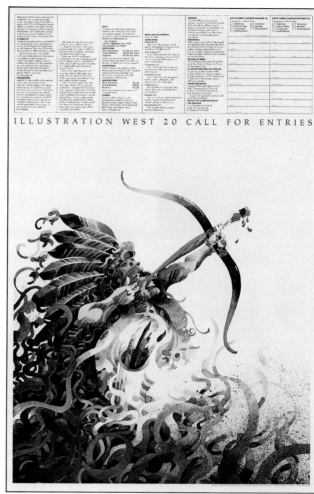

Poster:
Stanford
Art Director:
Michael Manwaring
Designer:
Michael Manwaring
Artists:
Michael Manwaring, Betty
Barsamian, Bill Chiaravalle,
Karen Fenlon
Design Firm:
The Office of
Michael Manwaring
San Francisco
Client:
Stanford Alumni Assoc.
Typographer:
Omnicomp
Printer:
Advanced Litho/Interprint

Poster:
Oakland Ballet
Art Director:
John Casado
Designer:
John Casado
Artist:
John Casado
Design Firm:
Casado Design
San Francisco
Client:
The Oakland Ballet
Typographer:
Omnicomp
Printer:
Clyde Engles Silkscreen

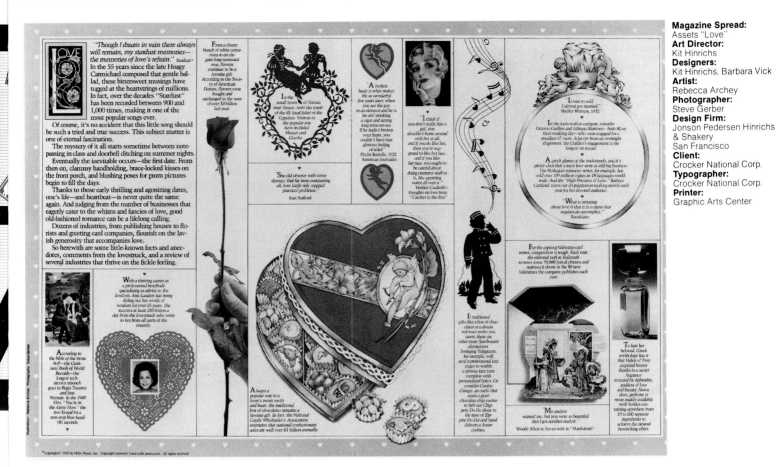

Magazine Spread:
Assets "Love"
Art Director:
Kit Hinrichs
Designers:
Kit Hinrichs, Barbara Vick
Artist:
Rebecca Archey
Photographer:
Steve Gerber
Design Firm:
Jonson Pedersen Hinrichs
& Shakery
San Francisco
Client:
Crocker National Corp.
Typographer:
Crocker National Corp.
Printer:
Graphic Arts Center

Magazine Spread:
Bauhaus
Art Director:
Tom Ingalls
Designer:
Tom Ingalls
San Francisco
Publisher:
Metro Magazine
Typographer:
Ann McCue
Printer:
Alonzo Press

Record J
Toto
Art Direc
Tony Lam
Designer
Tony Lam
Los Ange
Artist:
Tony Lam
Client:
CBS Rec
Printer:
Shorewo
Corp.

Record J
The Rome
Art Direc
Nancy Do
Designer
Nancy Do
Los Ange
Artist:
Eraldo Ca
Client:
CBS Rec
Printer:
Shorewo
Corp.

Record J
Stanley Cl
Art Direc
Nancy Do
Designer:
Nancy Do
Los Angel
Artist:
Robert Git
Client:
CBS Rec
Printer:
Shorewo
Corp.

Record Ja
Mickey Th
Alive Alon
Art Direct
Ron Coro
Los Angele
Artist:
Michael Br
Photograp
Leon La C
Client:
Elektra/As

Record Ja
Johannes
Complete S
Violin & Pia
Art Direct
Ron Coro,
Designer:
Norm Ung
Los Angele
Artist:
Norm Ung
Client:
Elektra/Asy
Records

Record Jac
Dollar Bran
Marketplac
Art Directo
Ron Coro, J
Designers:
Ron Coro, J
Los Angele
Artist:
James McM
Client:
Elektra/Asy

Catalog:
Art Center College
of Design
Art Director:
Don Kubly
Designer:
Sally Eager Kubly
Artists:
Various
Photographers:
Various
Client:
Art Center College
of Design
Pasadena
Typographer:
John G. Frank
& Vernon Simpson
Printer:
Graphic Press

Greeting Card:
Christmas
Art Director:
Russell Leong
Designer:
Russell Leong
Artist:
Russell Leong
Design Firm:
Russell Leong Design
Palo Alto
Client:
Apple Computer
Typographer:
Frank's Type, Inc.

Promotion Piece:
Michael Bull
Art Director:
Michael Bull
Designer:
Michael Bull
Artist:
Michael Bull
Design Firm:
Michael Bull
San Francisco
Client:
Michael Bull
Typographer:
Spartan Typographers

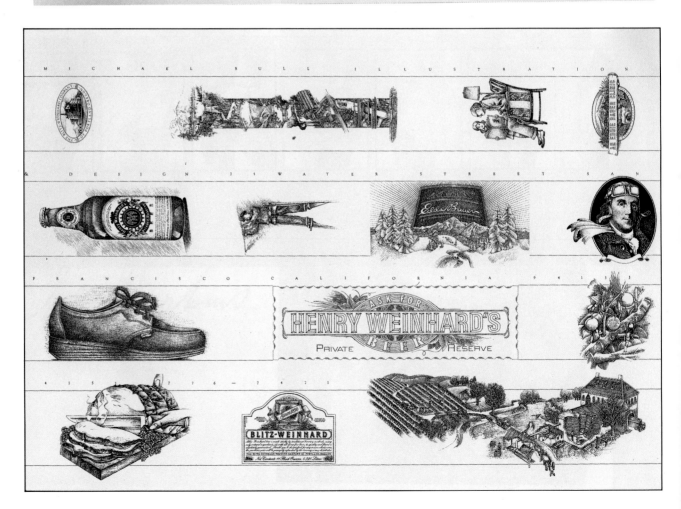

Catalog:
Modern Mode
Art Director:
Michael Vanderbyl
Designer:
Michael Vanderbyl
Artist:
Michael Vanderbyl
Photographers:
Stone + Stacatti
Design Firm:
Vanderbyl Design
San Francisco
Client:
Modern Mode
Typographer:
Headliners/Identicolor
Printer:
Interprint

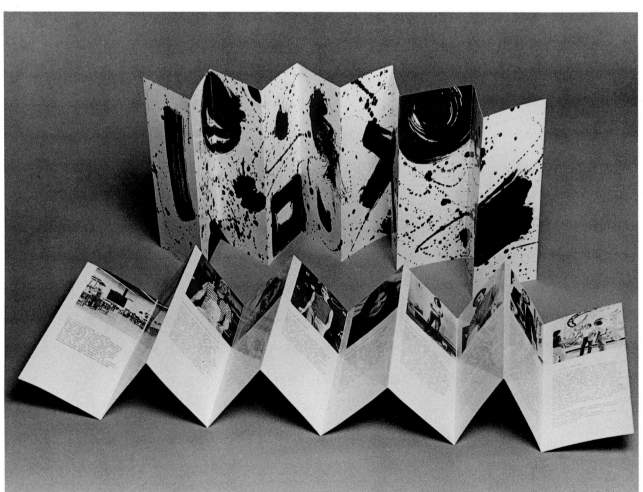

Promotional Brochure:
Fine Arts
Art Director:
Don Kubly
Designer:
Miguel Gamboa
Artists:
Various
Design Firm:
Art Center College
of Design
Los Angeles
Printer:
Typecraft

Poster:
Phil Toy
Art Directors:
Keilani Tom, Phil Toy
Designers:
Keilani Tom, Phil Toy
Artist:
Keilani Tom
Photographer:
Phil Toy
Design Firm:
Communikations
San Francisco
Client:
Phil Toy Photography
Typographer:
Petrographics
Printer:
Fong/Fong

Record Jacket:
Group 87
Art Director:
Nancy Donald
Designer:
Nancy Donald
Los Angeles
Photographer:
Steve Hiett
Client:
CBS Records
Printer:
Shorewood Packaging
Corp.

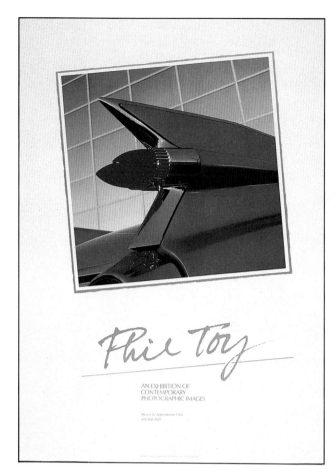

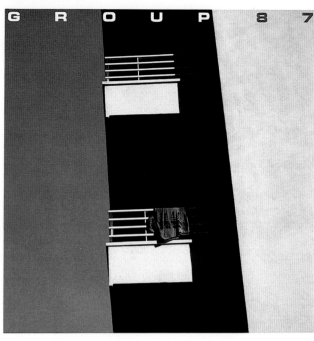

Poster:
Your Turn
Art Director:
Bill Tom
Designer:
Bill Tom
Artist:
Bill Tom
Design Firm:
Dyer/Kahn, Inc.
Los Angeles
Client:
Westweek

Catalog:
The Mead Library of Ideas
25th International Annual
Report Show
Art Directors:
Jann Church, Lea Pascoe
Designers:
Jann Church, Lea Pascoe
Photographers:
Walter Urie/Schwartz
Studios
Design Firm:
Jann Church Advertising
& Graphic Design
Newport Beach
Client:
The Mead Paper Co.
Typographer:
Headliners
of Orange County
Printer:
The Hennegan Co.

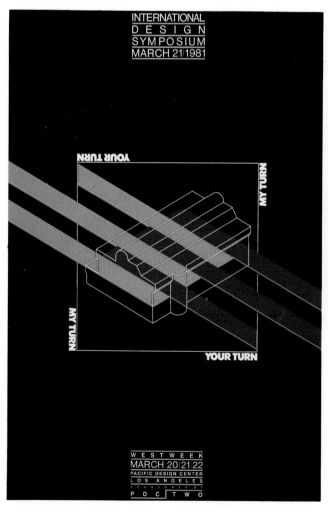

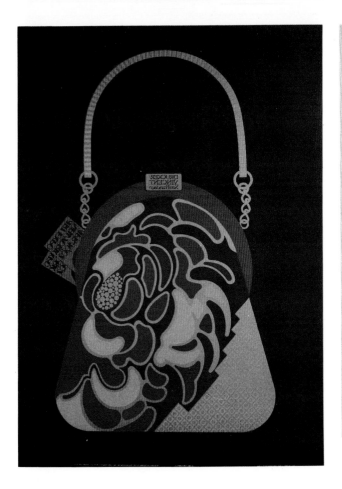

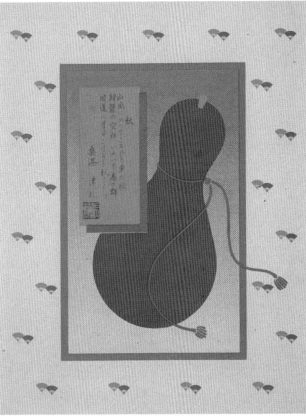

Poster:
Purse
Art Directors:
Tom Kamifuji, Alan Drucker,
June Vincent
Designer:
Tom Kamifuji
Artist:
Tom Kamifuji
San Francisco
Client:
Drucker/Vincent, Inc.
Typographer:
Tom Kamifuji
Printer:
Tea Lautrec

Poster:
Aki Matsuri
Art Director:
Doug Akagi
Designers:
Doug Akagi, Jim Gray
Artist:
Jim Gray
Design Firm:
The GNU Group
Sausalito
Client:
The GNU Group

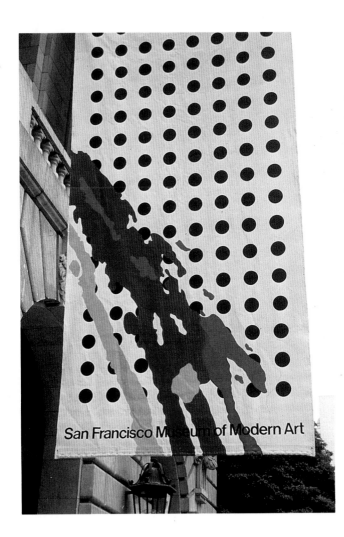

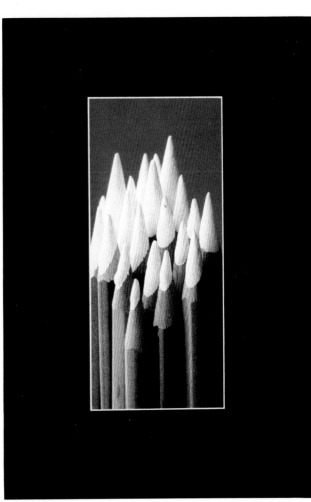

Banners:
San Francisco Museum
of Modern Art
Art Director:
Gerald Reis
Designers:
Gerald Reis, Wilson Ong
Design Firm:
Reis & Co.
San Francisco
Client:
San Francisco Museum
of Modern Art

Promotional Booklet:
Park City
Art Directors:
Jon Anderson, Mikio Osaki,
Don Weller
Designer:
Don Weller
Artist:
Everett Peck
Photographers:
Stan Caplan,
Mark Wagner
Design Firm:
The Weller Institute
for the Cure of Design
Los Angeles
Client:
TDCTIHTBIPC
Typographer:
Alphagraphix
Printer:
Gardner Fulmer
Lithograph Co.

Poster:
Clown
Art Director:
Patrick Soohoo
Designers:
Patrick Soohoo,
Paula Yamasaki
Artists:
Paula Yamasaki,
Philip Komai•
Design Firm:
Patrick Soohoo, Inc.
Los Angeles
Client:
Patrick Soohoo, Inc.
Typographer:
Fotoset
Printer:
Gardner Fulmer
Lithograph Co.

Invitation Poster:
Dolzen-Klotz Wedding
Art Director:
Jann Church
Designers:
Jann Church, Lea Pascoe
Illustrator:
Lea Pascoe
Design Firm:
Jann Church Advertising
and Graphic Design, Inc.
Client:
Dolzen-Klotz
Typographer:
Headliners of
Orange County
Printer:
M. D. Silkscreen

Annual Report:
National Semiconductor
Corp. Annual Report 1980
Art Director:
Ken Parkhurst
Designer:
Brad Donenfeld
Photographer:
William Warren
Design Firm:
Bright & Assoc.
Los Angeles
Client:
National Semiconductor
Corp.
Printer:
Anderson Lithographic Co.

Publication Spread:
Assets-Summer 1981
Art Director:
Kit Hinrichs
Designers:
Kit Hinrichs, Barbara Vick
Artist:
John Mattos
Design Firm:
Jonson Pedersen Hinrichs
& Shakery
San Francisco
Client:
Crocker National Corp.
Typographer:
Crocker National Corp.
Printer:
Graphic Arts Center

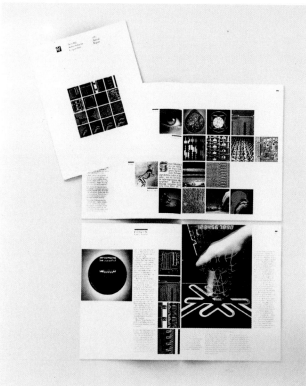

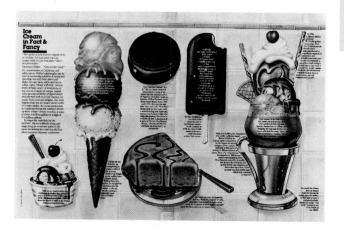

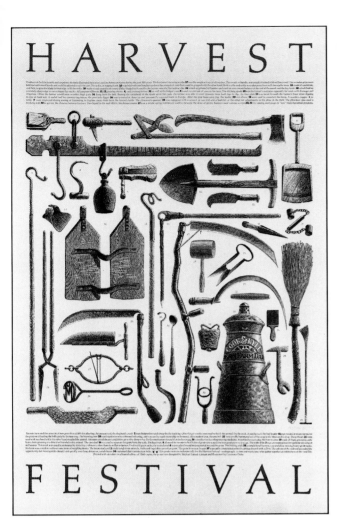

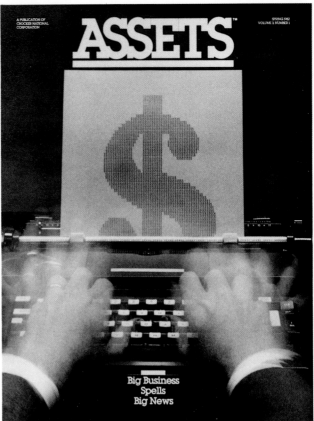

Poster:
Harvest Festival
Designer:
Michael Cronan
Artist:
Lawrence Duke
Design Firm:
Michael Patrick Cronan
San Francisco
Client:
General Exhibitions Corp.
Typographer:
Headliners/Identicolor
Printer:
Interprint

Magazine:
Assets - Spring 1982
Art Director:
Kit Hinrichs
Designers:
Kit Hinrichs, Barbara Vick
Artists:
Hank Osuna, John Hyatt
Photographers:
Tom Tracy, Nick Nichols
Design Firm:
Jonson Pedersen Hinrichs
& Shakery
San Francisco
Client:
Crocker National Corp.
Typographer:
Crocker National Corp.
Printer:
Graphic Arts Center

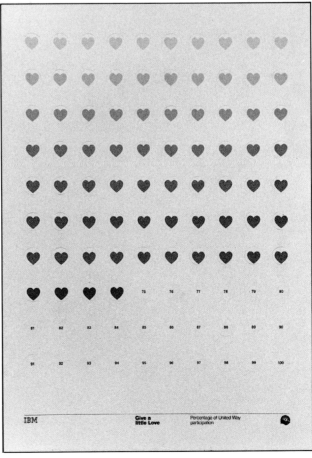

Logo:
All Occasions
Art Director:
Tandy Belew
Designers:
Tandy Belew,
Anthony Chiumento,
George DeWoody
Artist:
Tandy Belew
Design Firm:
Image Development
San Francisco
Client:
All Occasions

Poster:
United Way Heart
Art Director:
Lee Green
Designer:
Lee Green
Artist:
Lee Green
Design Firm:
IBM San Jose
San Jose
Client:
IBM San Jose
Typographer:
Athertons
Printer:
B & C Litho

Christmas Card:
Saul Bass/Herb Yager
1980
Art Director:
Saul Bass
Designer:
Saul Bass
Artist:
Art Goodman
Design Firm:
Saul Bass/Herb Yager
& Assoc.
Los Angeles
Client:
Saul Bass/Herb Yager
& Assoc.
Typographer:
Fotoset
Printer:
Alan Litho

Promotional Item:
Simpson Flower
Art Director:
Richard Cognata
Designer:
Richard Cognata
Artist:
Steve Reoutt
Design Firm:
Cognata Assoc., Inc.
San Francisco
Client:
Simpson Paper Co.
Typographer:
Omnicomp
Printer:
Master Craft Press

Annual Report:
Amfac Annual Report 1981
Art Director:
Neil Shakery
Designers:
Neil Shakery, Karen Berndt
Artist:
Daniel Schwartz
Design Firm:
Jonson Pedersen Hinrichs
& Shakery
San Francisco
Client:
Amfac
Typographer:
Spartan Typographers
Printer:
Graphic Arts Center

MAY THE NEW YEAR BRING PEACE & HAPPINESS

SAUL BASS/HERB YAGER & ASSOCIATES

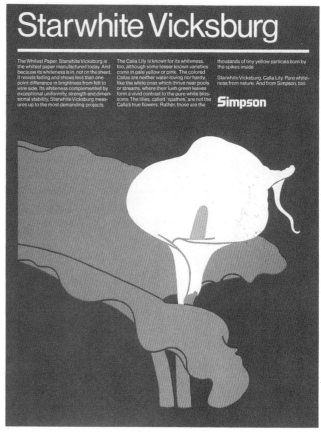

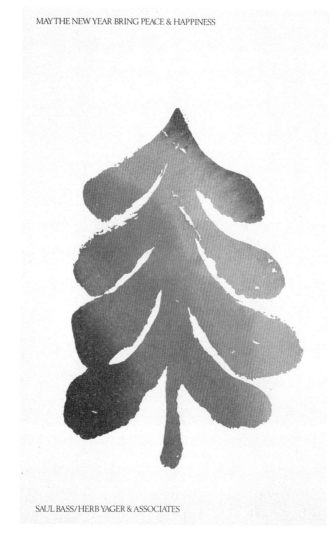

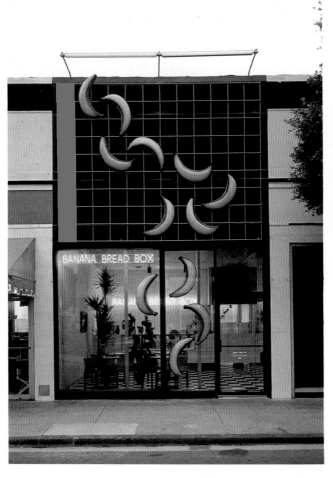

Poster:
EAT Chez Panisse
9th Birthday
Art Director:
D. L. Goines
Designer:
D. L. Goines
Artist:
D. L. Goines
Design Firm:
St. Heironymous Press, Inc.
Berkeley
Client:
Chez Panisse Restaurant
Printer:
D. L. Goines

Poster:
Sacramento
Designer:
Gwen Amos
Photographer:
Penina Meisels / Meisels
Photography
Design Firm:
Gwen Amos Design
Sacramento
Client:
The Sacramento
Metropolitan Arts
Commission
Printer:
Graphic Center

Environmental Graphics:
Banana Bread Store
Designers:
Jack & Susan Biesek
Artists:
Jack & Susan Biesek
Photographer:
Paul Bielenberg
Design Firm:
Biesek Design
San Luis Obispo

Package:
Golden Royal Pistachios
Art Director:
Cheryl Harrison
Designer:
Cheryl Harrison
Artist:
Cheryl Harrison
Design Firm:
Cheryl Harrison & Co.
San Francisco
Client:
Golden Royal / Brew Pac
Typographer:
Jim Wascoe Reprotype
Printer:
Scott Screen Printers

Promotional Brochure:
DHL Model III Sales
Art Director:
Michael Mabry
Designer:
Michael Mabry
Artist:
Margie Eng-Chu
Photographer:
Dennis Bettencourt
Design Firm:
Michael Mabry Design
Communications
San Francisco
Client:
DHL Business Systems
Corp.

Poster:
Le Petit Trianon
Art Director:
Sam Smidt
Designer:
Sam Smidt
Artist:
Sam Smidt
Design Firm:
Sam Smidt
Palo Alto
Client:
The S. F. Decorator
Showcase
Typographer:
Frank's Type, Inc.
Printer:
Jorgenson & Co.

Promotional Item:
Champion Laid Promotion
Art Director:
Neil Shakery
Designers:
Lenore Bartz, Neil Shakery
Artists:
Various & archival
Photographer:
Stock photography
Design Firm:
Jonson Pedersen Hinrichs
& Shakery
San Francisco
Client:
Champion International
Corp.
Typographer:
Reardon & Krebs
Printer:
Herlin Press

Poster:
Robert Long
Art Director:
Chris Blum
Designer:
Michael Manwaring
Artist:
Michael Manwaring
Design Firm:
The Office of
Michael Manwaring
San Francisco
Client:
Robert Long Lighting
Typographer:
Omnicomp

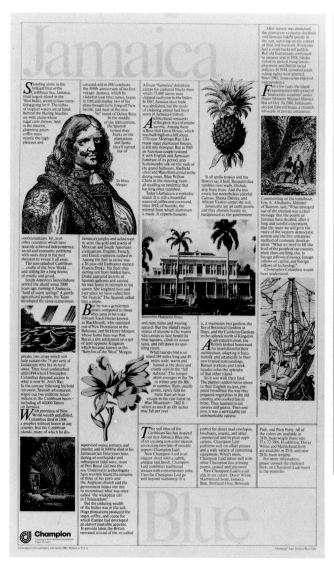

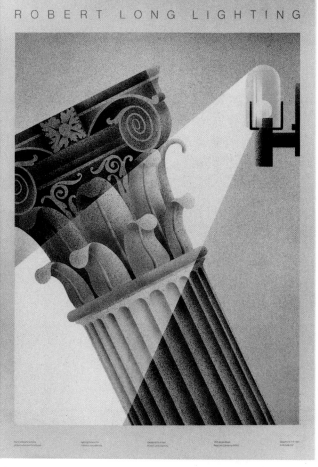

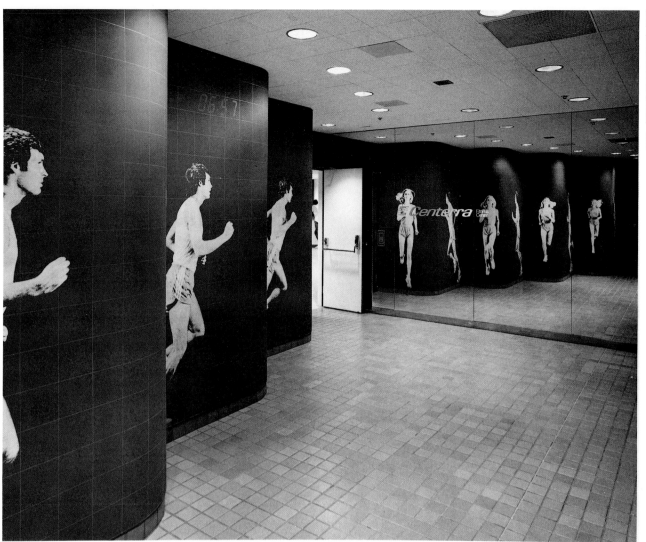

Wall Mural:
Shaklee Health Club
Art Director:
Craig Siegel
Photographer:
Steve Rahn
Design Firm:
Landor Assoc.
San Francisco
Client:
Shaklee
Printer:
The W.O.R.K.S.
Photographer:
Peter Aaron/ESTO

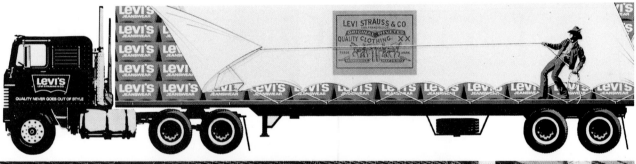

Vehicle Signage:
Levi Truck
Art Directors:
Chris Blum, FCB Nonig
Designer:
Michael Manwaring
Illustrator:
Michael Manwaring
Design Firm:
The Office of
Michael Manwaring
San Francisco
Client:
Levi Strauss & Co.

Vehicle Signage:
Levi's Truck
Art Director:
Chris Blum
Designer:
Michael Schwab
Artist:
Michael Schwab
Design Firm:
Michael Schwab Design
San Francisco
Client:
Levi Strauss & Co.

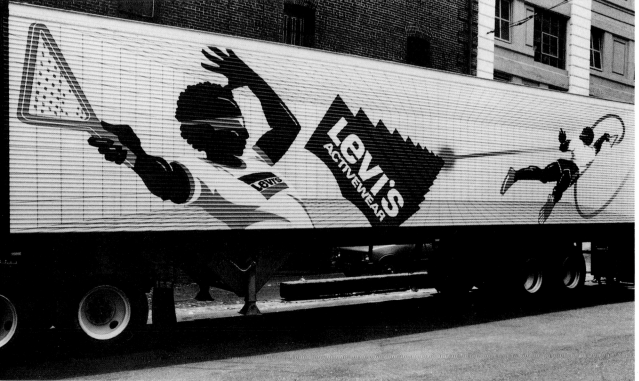

Poster:
Headline Type
Art Director:
Keith Bright
Designer:
Keith Bright
Design Firm:
Bright & Assoc.
Los Angeles
Client:
Andresen Typographics
Typographer:
Andresen Typographics

Announcement:
SJSU Design Mixer
Art Director:
Andrea Janetos
Designer:
Andrea Janetos
Artist:
Letraset
Design Firm:
Humpal, Leftwich & Sinn
Mountain View
Client:
San Jose State University
Typographer:
PM Typography

Poster:
Haagen
Designers:
Marty Neumeier/Byron
Glaser
Design Firm:
Neumeier Design Team
Santa Barbara
Client:
Haagen Printing
Printer:
Haagen Printing

Newsletter:
Art Directors Club
of Los Angeles
Art Director:
Gerry Rosentswieg
Designer:
Gerry Rosentswieg
Artist:
Gerry Rosentswieg
Design Firm:
The Graphics Studio
Los Angeles
Client:
Art Directors Club of L.A.

DOCUMENT Explicitly recording and efficiently servicing the agreement

Brochure:
RFC Brochure
Art Director:
Wes Keebler
Designer:
Wes Keebler, B. K. Hughes
Photographer:
Richard Clark
Design Firm:
Webb Silberg Co.
Los Angeles
Client:
RFC Intermediaries
Typographer:
Hi-Speed
Printer:
George Rice & Sons

Record Label:
Billy Idol
Campaign-12″ Label
on White Vinyl
Art Director:
Janet Levinson
Designer:
Janet Levinson
Los Angeles
Client:
Chrysalis Records
Typographer:
Type West

Record Label:
Billy Idol
Art Director:
Janet Levinson
Designer:
Janet Levinson
Los Angeles
Client:
Chrysalis Records
Typographer:
Type West

Announcement:
Moving
Art Director:
Michael Skjei
Designer:
Michael Skjei
Design Firm:
Michael Skjei Design
Los Angeles
Client:
Michael Skjei
Typographer:
Andresen Typographics
Printer:
Petersen Lithograph

Promotional Piece:
Change of Address
Art Director:
John Coy
Designer:
John Coy
Artist:
John Coy
Design Firm:
Coy, Los Angeles
Culver City
Client:
John Coy Design
Typographer:
Aldus Type Studio, Ltd.
Printer:
Alan Lithograph, Inc.

Promotional Item:
Legend of the Lone Ranger
Art Director:
Douglas Boyd,
Scott A. Mednick
Designers:
Gordon Tani,
Scott A. Mednick
Photographer:
Rick Wolin-Semple
Design Firm:
Douglas Boyd Design
& Marketing
Los Angeles
Client:
Associated Film Distributors
Printer:
Gore Graphics

Birth Announcement:
April White
Art Director:
Michael Kennedy
Designer:
Michael Kennedy
Design Firm:
Communications Design
Sacramento
Clients:
Tom and April White
Typographer:
Ad Type Graphics
Printer:
Printing Factory

148

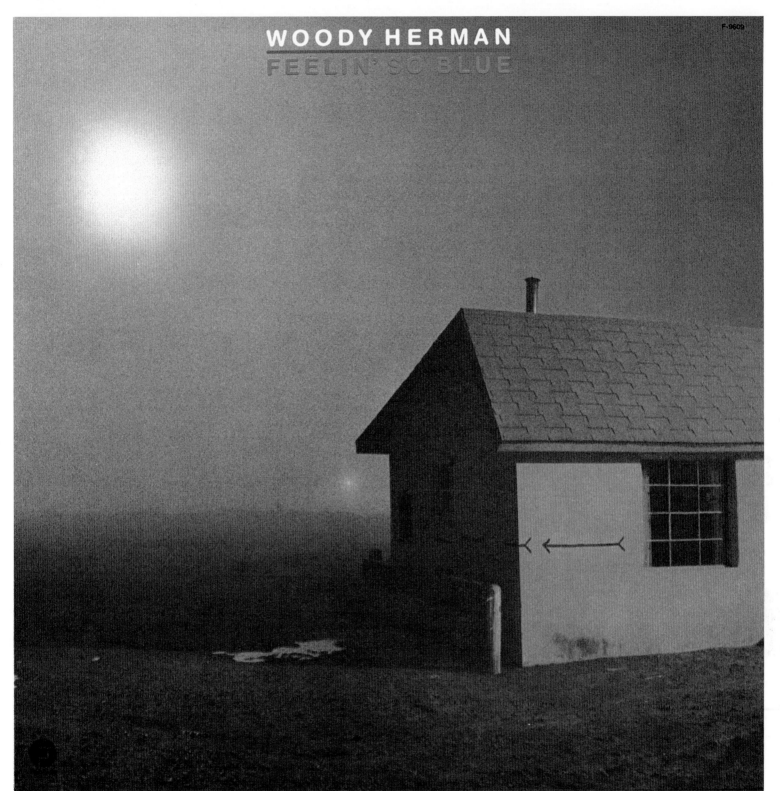

WOODY HERMAN
FEELIN' SO BLUE

F-9609

Record Jacket:
Feelin' Blue
Art Director:
Phil Carroll
Designer:
Phil Carroll
Berkeley
Photographer:
Theresa Weedy
Client:
Fantasy Records

Brochure:
Billy Cross
Art Director:
Michael Mahwaring
Designers:
Michael Manwaring,
Betty Barsamian
Artists:
Michael Manwaring,
Betty Barsamian
Photographer:
Faith Echtermeyer
Design Firm:
The Office of
Michael Manwaring
San Francisco
Client:
Billy Cross
Typographer:
Omnicomp
Printer:
Interprint/Warren's Waller
Press

Poster:
Music Center
Unified Fund 1981
Art Director:
Saul Bass
Designer:
Saul Bass
Artists:
Saul Bass, Art Goodman
Design Firm:
Saul Bass, Herb Yager
& Assoc.
Los Angeles
Printer:
Andersen Litho

Promotional Brochure:
San Francisco Symphony
Art Director:
Michael Cronan
Artists:
Michael Cronan,
Shannon Terry
Design Firm:
Michael Patrick Cronan
San Francisco
Client:
San Francisco Symphony
Typographer:
Design & Type
Printer:
Pisani Carlisle Graphics

Record Jacket:
Bach: Musical Offering
BWV 1039
Art Directors:
Ron Coro, Norm Ung
Designer:
Norm Ung
Los Angeles
Artist:
Norm Ung
Client:
Elektra/Asylum/Nonesuch
Records

Promotional Item:
Al Capone
Art Director:
Steven Jacobs
Designer:
Steven Jacobs
Artists:
John Mattos/Norman Orr
Design Firm:
Steven Jacobs, Inc.
Palo Alto
Client:
Simpson Paper Co.
Typographer:
Omnicomp
Printer:
Anderson Lithograph

Announcement:
Wedding Announcement
Art Director:
Paul Sinn
Designer:
Paul Sinn
Design Firm:
Galarneau, Deaver & Sinn
Palo Alto
Client:
Lisa Layne
Typographer:
PM Typography
Printer:
Craftsmen Printing

Menu:
Lion & Compass
Art Director:
Gerald Reis
Designers:
Gerald Reis, Wilson Ong.
Design Firm:
Reis & Co.
Los Angeles
Client:
Lion & Compass
Restaurant

Record Jacket:
Bill Evans/Eloquence
Art Director:
Phil Carroll
Designer:
Phil Carroll
Berkeley
Photographer:
Galen Rowell
Client:
Fantasy Records

Promotional Literature:
ATARI VCS Game
Art Director:
Kit Hinrichs
Designers:
Kit Hinrichs, Barbara Vick
Artists:
John Mattos,
Rebecca Archey,
Michael Schwab,
Tim Lewis
Photographers:
Tom Tracy, Armando Diaz
Design Firm:
Jonson Pedersen Hinrichs
& Shakery
San Francisco
Client:
ATARI, Inc.
Typographer:
Spartan Typographers
Printer:
Graphic Arts Center

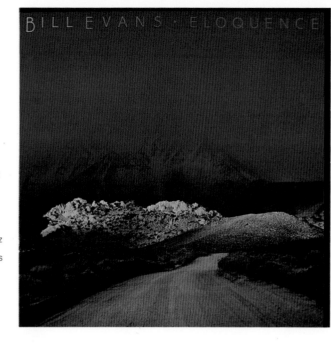

Promotional Brochure:
Billy Ball 1982
Art Director:
Richard Silverstein, Ogilvy
& Mather
Designers:
Betty Barsamian,
Michael Manwaring
Artist:
Betty Barsamian
Photographer:
Dennis Gray
Design Firm:
The Office of
Michael Manwaring
San Francisco
Client:
Oakland A's
Typographer:
Omnicomp
Printer:
James H. Barry Co.,
Network Graphics

Poster:
Carducci & Herman
Landscape Architects
Art Director:
D. L. Goines
Designer:
D. L. Goines
Artist:
D. L. Goines
Design Firm:
St. Heironymous Press, Inc.
Berkeley
Client:
Carducci & Herman
Printer:
D. L. Goines

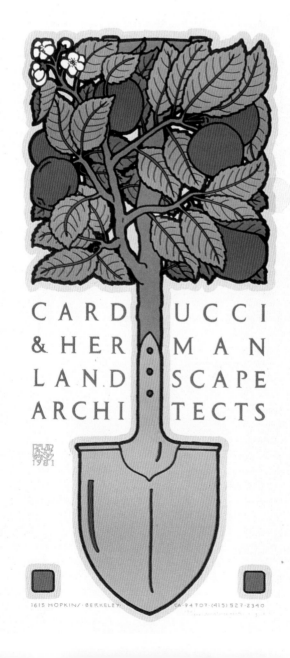

1982 MOTORCYCLE ACCESSORIES & APPAREL

Catalog:
Yamaha Parts
Distributors, Inc.
Art Director:
Diana Marshall
Designer:
Diana Marshall
Photographer:
Robert Stevens
Design Firm:
The Designory
Los Angeles
Client:
Yamaha Parts
Distributors, Inc.

Promotional Item:
Continental Graphics
Art Director:
Debra Valencia
Designer:
Debra Valencia
Photographer:
Kevin Burke
Design Firm:
Sussman/Prejza & Co., Inc.
Santa Monica
Client:
Continental Graphics
Typographer:
Continental Graphics
Printer:
Continental Graphics

Calendar:
PM Typography 1982
Art Directors:
Paul Sinn, Mark Galarneau
Designers:
Paul Sinn, Mark Galarneau
Artists:
Paul Sinn, Mark Galarneau
Design Firm:
Galarneau, Deaver & Sinn
Palo Alto
Client:
PM Typography
Typographer:
PM Typography
Printer:
Artcraft Printers, Inc.

PM TYPOGRAPHY 374-0743

Like it or not, the world of science and technology has become inseparable from the world of graphics. There is enormous potential for new design ideas based on the technological innovations.

The fact of the matter is, you really have no choice. Anyone involved in graphics in the '80's will have to keep up with the rapidly changing technology of the '80's. But while Mr Gutenberg, in his time, and the inventors of lasers and electronics of ours set a blistering pace, keep this in mind: The medium does not deliver the message. Designers do.

Regardless of the devices that are conjured up by the technicians, designers have the last word with the words. The job to entice, surprise, engage, entertain, inform, persuade—in short, communicate with readers—has been the burden of the artist from Day 1.

The technology of the '80's will be mind-boggling. But it is also mindless and powerless without the intelligence, talent, wit, innovation, esthetic sensibility, creativity and all those other sublime qualities that only human beings possess.

*—Vision '80, U&lc June 1980
Volume Seven, Number Two*

The main body consists of a glossary of typography and computing terms (A–Z) set in columns, with the large display letters O C T O B E R and calendar numerals 1–31 interspersed. Selected entries include:

Access. To locate an area of main or auxiliary memory for storing data at that location or retrieving stored data from it.

Access time. The time interval between the instant at which data is called for and the instant at which delivery is completed.

Alphanumeric. Construction of "alphabet and numeric." Refers to any system combining letters and numbers.

Analog. The characteristic of varying continuously along a scale.

Art. It is through Art, and through Art only that we can realize our perfection; through Art and Art only that we can shield ourselves from the sordid perils of actual existence. Oscar Wilde 1856-1900

ASCII. American Standard Code of Information Interchange established by the American Standards Association. The 7-bit code offers 128 characters.

Beauty. I am certain of nothing but the holiness of the heart's affections and the truth of imagination. John Keats 1795-1821

Binary code. In computer systems, a code that makes use of two distinct characters, usually 0 and 1.

Bit. In computer systems, the smallest units of information.

Byte. In computer systems, a group of adjacent bits operated on as a unit.

Cathode ray tube (CRT). In phototypesetting, electronic tube used to transmit letter images.

Central processing unit (CPU).

Character generation.

Characters-Per-Pica (CPP).

Code. A symbol or set of symbols used to represent data or instructions.

Core (Storage). The "memory" within a computer.

CPI. Characters Per Inch.

CPS. Characters Per Second.

Creativity.

Data.

Data base.

Data processing.

Data reduction.

Data transmission.

Demodulation.

Density.

Digital.

Digital computer.

Digitize.

Disc drive.

Display.

Editing Terminal.

End-Of-Line Decisions.

Esthetics.

Exception Dictionary.

Film Advances.

Floppy Disc.

Flying spot scanners.

Form.

Formatting.

Format storage.

Fortran.

Function code.

"Golf" ball.

Grid.

Hard copy.

Hardware.

Reader.

Mystery.

Kerning.

Key.

Keyboard.

Knowledge.

Light pen.

Line printer.

Lusters.

Main frame.

Matrix.

Merge.

Microcosmics.

Modem.

Modulation.

Multiplex.

Non-Causing Keyboard.

Novelty.

OCR. Optical Character Recognition.

Offline.

Online.

Opportunity.

Output.

Perforation.

Peripheral equipment.

Pi character.

Photocomposing.

Photocopy.

Photodisplay.

Photodisplay font.

Photodisplay unit.

Photoprint.

Photoproof.

Photosetting.

Phototypesetting.

Platesetter.

Processor.

Proofs.

Software. Computer programs, procedures, etc., as contrasted with the equipment itself, which is referred to as hardware.

Step And Repeat. Method of making multiple images from a master negative.

Storage.

Tape.

Tape editing.

Tape merging.

Unit System.

Use Value.

Universality.

Unjustified Tape.

Update.

Vacuum freeze.

Visual display.

Visual display terminal (VDT).

Vitality.

Weight.

Width.

Wit.

Wordspacing.

Xerography.

X-Height.

X-line.

Xenon Flash.

Zeal.

DESIGN: PAUL SINN, GALARNEAU, DEAVER & SINN. PRINTING: ARTCRAFT PRINTERS, INCORPORATED, CAMPBELL, CA. PAPER BY BECKETT.

The calendar grid with July and alphabet letters A-Z as typographic designs

J	U	L	Y	1	2	3
a					£	G
4	5	6	7	8	9	10
H	I	J	K	L	M	N
11	12	13	14	15	16	17
O	P	Q	R	S	T	U
18	19	20	21	22	23	24
V	W	X	Y	Z		PM Typography 2213 South Winchester Blvd. Campbell California 95008 408-374-0743
25	26	27	28	29	30	31

ITC ZAPF INTERNATIONAL HEAVY WITH MEDIUM

Geometry can produce legible letters, but art alone makes them beautiful. Art begins where geometry ends, and imparts to letters a character transcending mere measurement. Paul Standard

DESIGN: PAUL SINN / GALARNEAU, DEAVER & SINN PRINTING: ARTCRAFT PRINTERS, INCORPORATED, CAMPBELL, CA PAPER BY BECKETT

Calendar:
PM Typography 1982
Art Directors:
Paul Sinn, Mark Galarneau
Designers:
Paul Sinn, Mark Galarneau
Artists:
Paul Sinn, Mark Galarneau
Design Firm:
Galarneau, Deaver & Sinn
Palo Alto
Client:
PM Typography
Typographer:
PM Typography
Printer:
Artcraft Printers, Inc.

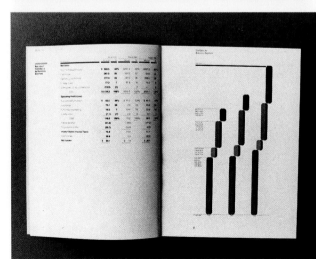

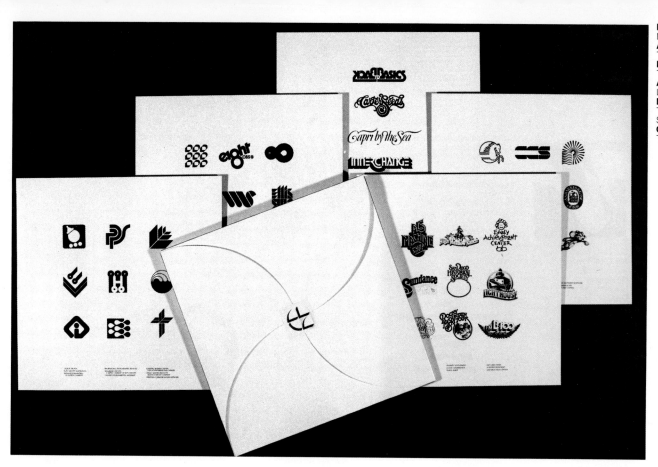

Promotional Brochure:
Design Quarter
Art Directors:
Tom Lewis, Don Young
Designers:
Tom Lewis, Don Young
Artist:
Linda Roberts
Design Firm:
The Design Quarter
San Diego
Client:
The Design Quarter

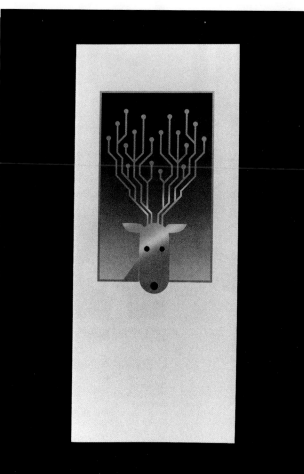

Annual Report:
Times Mirror Co. Annual
Report 1981
Art Director:
Robert Miles Runyan
Designer:
Jim Berté
Design Firm:
Robert Miles Runyan
& Assoc.
Playa del Rey
Client:
Times Mirror Co.
Typographer:
Composition Type
Printer:
George Rice & Sons

Greeting Card:
Intel Christmas
Art Director:
Barry Deutsch
Designer:
Karen Tainaka
Design Firm:
Steinhilber Deutsch & Gard
San Francisco
Client:
Intel Corp.

Wild Fibers
Art Director:
Bill Konersman
Designer:
Bill Konersman
Artist:
Bob Maile
Design Firm:
Bill Konersman Design
Los Angeles
Client:
Wild Fibers

First Nationwide Savings
Art Director:
Sidjakov Berman & Gomez
Designer:
Jerry Berman
Artist:
Karen Emerson
Design Firm:
Sidjakov Berman & Gomez
San Francisco
Client:
First Nationwide Savings
Typographer:
Petrographics

Kids Lids
Art Director:
Michael Vanderbyl
Designer:
Michael Vanderbyl
Artist:
Michael Vanderbyl
Design Firm:
Vanderbyl Design
San Francisco
Client:
Mountain Lid Woolens
Typographer:
Headliners/Identicolor

Top of the Trop
Art Director:
Mauricio Arias
Designers:
Mark Wallin, Mauricio Arias
Artist:
Mark Wallin
Design Firm:
Arias + Sarraille
Palo Alto
Client:
Tropicana Hotel,
Atlantic City

Suzanne West/Design
Art Director:
Suzanne West
Designer:
Suzanne West
Design Firm:
Suzanne West/Design
Palo Alto
Client:
Suzanne West/Design

WILSHIRE HOUSE

Wilshire House
Art Director:
Bill Tom
Designer:
Bill Tom
Artist:
Bill Tom
Design Firm:
Dyer/Kahn
Los Angeles
Client:
Wilshire House

THE
HUNTLEY HOTEL

The Huntley Hotel
Art Directors:
John Anselmo, Dan O'Mara
Designer:
Dan O'Mara
Artist:
Dan O'Mara
Design Firm:
John Anselmo
Design Assoc.
Santa Monica
Client:
The Huntley Hotel

Community Action Team
Art Directors:
Michael Vanderbyl, Frank
Rockwell, Ann Fox
Designer:
Michael Vanderbyl
Artist:
Michael Vanderbyl
Design Firm:
Vanderbyl Design
San Francisco
Client:
Foremost-McKesson

Marina Bay
Art Director
Michael Vanderbyl
Designer:
Michael Vanderbyl
Artist:
Michael Vanderbyl
Design Firm:
Vanderbyl Design
San Francisco
Client:
City of Richmond,
Tecon Realty

Marin Swim School
Art Director:
Harry Murphy
Designer:
Harry Murphy
Design Firm:
Harry Murphy + Friends
Mill Valley
Client:
Marin Swim School

greenhaus

Greenhaus
Art Director:
Jann Church
Designer:
Jann Church
Design Firm:
Jann Church Advertising
& Graphic Design, Inc.
Newport Beach
Client:
Greenhaus Interior Plant
Growers

Canyon Lakes
Art Director:
Michael Vanderbyl
Designer:
Michael Vanderbyl
Artist:
Michael Vanderbyl
Design Firm:
Vanderbyl Design
San Francisco
Client:
Brooks Resources,
Harold Thompson Real
Estate, Inc.

Beethoven
Designer:
Michael Cronan
Artist:
Michael Cronan
Design Firm:
Michael Patrick Cronan
San Francisco
Client:
San Francisco Symphony

Pabst Brewing Co.
Art Directors:
Hal Riney, Gerald Andelin
Designer:
Barry Deutsch
Design Firm:
Steinhilber, Deutsch
and Gard
San Francisco
Client:
Pabst Brewing Co.

Ariadne Clothing
Art Director:
Rebecca Martinez
Designer:
Rebecca Martinez
Design Firm:
Rebecca Martinez Design
Assoc.
San Francisco
Client:
Ariadne Clothing Mfg.

THE
COOKIE
PLACE

The Cookie Place
Art Director:
Sidjakov Berman & Gomez
Designer:
Nicolas Sidjakov
Artist:
Margie Eng
Design Firm:
Sidjakov Berman & Gomez
San Francisco
Client:
The Cookie Place
Typographer:
Omnicomp

Newport Balboa
Art Director:
Jann Church, Lea Pascoe
Designers:
Jann Church, Lea Pascoe
Artist:
Lea Pascoe
Design Firm:
Jann Church Advertising &
Graphic Design, Inc.
Newport Beach
Client:
Newport Balboa Savings
and Loan Assoc.

Mill Valley Film Festival
Art Director:
John Casado
Designer:
John Casado
Artist:
John Casado
Design Firm:
Casado Design
San Francisco
Client:
Mill Valley Film Festival

LA BOULANGERIE
A FRENCH BAKERY

La Boulangerie
Art Director:
Michael & Lindy Dunlavey
Designer:
Nancy Hansen
Artist:
Nancy Hansen
Design Firm:
Dunlavey Studio, Inc.
Sacramento
Client:
La Boulangerie
French Bakery

Calplans Agricultural
Fund-82
Art Director:
Tim Hartung
Designer:
Diane Higgins
Design Firm:
Hartung & Assoc. Ltd.
San Ramon
Client:
Calplans Securities, Inc.

Venture Graphics
Art Director:
Michael Vanderbyl
Designer:
Michael Vanderbyl
Artist:
Michael Vanderbyl
Design Firm:
Vanderbyl Design
San Francisco
Client:
Venture Graphics
Typographer:
Venture Graphics

The Breitman Co.
Art Director:
Barry Deutsch
Designer:
Karen Tainaka
Design Firm:
Steinhilber Deutsch
& Gard
San Francisco
Client:
The Breitman Co.

An Eddie Bauer Clinic
Art Director:
Rich Silverstein
Designer:
Rich Silverstein
Artist:
Michael Bull
San Francisco
Client:
Eddie Bauer

Jean Rene
Art Director:
Michael Manwaring
Designers:
Michael Manwaring,
Bill Chiaravalle
Artist:
Bill Chiaravalle
Design Firm:
The Office of Michael
Manwaring
San Francisco
Client:
Jean Rapaport
Typographer:
Omnicomp

Southern California Savings
& Loan
Art Director:
Robert Miles Runyan
Designer:
Robert Miles Runyan
Design Firm:
Robert Miles Runyan
& Assoc.
Playa del Rey
Client:
Southern California Savings
& Loan

Black Bull
Art Director:
Douglas Boyd
Designers:
Douglas Boyd, Gordon Tani
Artist:
Gordon Tani
Design Firm:
Douglas Boyd Design
and Marketing
Los Angeles
Client:
Black Bull

Kendra Downey
Art Director:
Harry Murphy
Designers:
Harry Murphy,
Sheldon Lewis
Design Firm:
Harry Murphy + Friends
Mill Valley
Client:
Kendra Downey

Narsai's
Designer:
Rebecca Martinez
Design Firm:
Rebecca Martinez
Design Assoc.
San Francisco
Client:
Narsai's

The Small Things Co.
Art Director:
Harry Murphy
Designers:
Harry Murphy, Stanton Klose
Design Firm:
Harry Murphy + Friends
Mill Valley
Client:
The Small Things Co.

Falluca Industries
Art Director:
Richard Holmes
Designer:
Ronald Morris
Design Firm:
Richard Holmes Advertising
& Design
Newport Beach
Client:
Falluca Industries

EASTVIEW

Eastview Mark
Art Directors:
Jann Church, Lea Pascoe
Designers:
Lea Pascoe, Jann Church
Artist:
Lea Pascoe
Design Firm:
Jann Church Advertising
& Graphic Design, Inc.
Newport Beach
Client:
AVCO Community
Developers

Ruggers
Art Director:
Sidjakov Berman & Gomez
Designer:
Michael Mabry
Artist:
Michael Mabry
Design Firm:
Sidjakov Berman & Gomez
San Francisco
Client:
S&A Restaurant Corp.

AIC
Art Director:
Michael Cronan
Designer:
Michael Cronan
Design Firm:
Michael Patrick Cronan
San Francisco
Client:
Art in Craft

OmniTox

Omnitox
Art Director:
Tets Yamashita
Designer:
Tets Yamashita
Artist:
George Fujino
Design Firm:
Harte Yamashita & Forest
Los Angeles
Client:
Omnitox
Typographer:
Headliners

Lantern Bay
Art Director:
Jann Church
Designers:
Jann Church, Lea Pascoe
Design Firm:
Jann Church Advertising
& Graphic Design, Inc.
Newport Beach
Client:
Lantern Bay Bird Preserve

FOUNDATION FOR
AMERICA'S SEXUALLY
EXPLOITED CHILDREN INC

Foundation for America's
Sexually Exploited Children
Art Director:
Hoi Ping Law
Designer:
Hoi Ping Law
Artist:
Hoi Ping Law
Design Firm:
Dyer/Kahn
Los Angeles
Client:
Foundation for America's
Sexually Exploited Children

The Complete Gourmet
Art Director:
Paul Pruneau
Designer:
Paul Pruneau
Artist:
Paul Pruneau
Design Firm:
Paul Pruneau Design
Santa Monica
Client:
Jan Strohm

SEGD
Art Directors:
Richard Burns, Doug Akagi,
Jeffry Corbin
Designers:
Doug Akagi, Jeffry Corbin
Artist:
Doug Akagi
Design Firm:
The GNU Group
Sausalito
Client:
Society of Environmental
Graphic Designers

Beach Street Baking Co.
Art Director:
Barry Deutsch
Designer:
Barry Deutsch
Artist:
Myland McRevey
Photographer:
Myland McRevey
Design Firm:
Steinhilber Deutsch
& Gard
San Francisco
Client:
Beach Street Baking Co.

Desiree Goyette
Art Director:
Lee Beggs
Designer:
Lee Beggs
Artist:
Lee Beggs
Design Firm:
Paul Ambrose Studios
Palo Alto
Client:
Desiree Goyette

BRANDS

Brands Stores
Art Director:
Harry Murphy
Designers:
Harry Murphy,
Stanton Klose
Artist:
Warren Welter
Design Firm:
Harry Murphy + Friends
Mill Valley
Client:
Brands Stores

INSIDE · OUT

Inside-Out
Designers:
Michael Cronan, Lon Clark
Artist:
Shannon Terry
Design Firm:
Michael Patrick Cronan
San Francisco
Client:
Inside-Out

EXCHANGE

Orange County Exchange
Art Director:
Karen Knecht
Designer:
Karen Knecht
Design Firm:
Karen Knecht/Graphic
Designer
Long Beach
Client:
Orange County Exchange
Typographer:
De-Line-O-Type

Knowledge and courage are required to achieve the best results in typography. It is as true in this field as in any other that one receives what one deserves and one deserves whatever one accepts. Fine typography is the result of nothing more than an attitude. Its appeal comes from the understanding used in its planning; the designer must care. Aaron Burns.

Typographers West **Marc Pupkin**

963 Commercial Street, Palo Alto, Calif. 94303
Telephone 415-494-9433

ERNEST E. HASKIN

Chairman of the Board

CALIFORNIA 269
 EIGHTH STREET
PRINTING SAN FRANCISCO, CA 94103

COMPANY 415 861-1600

Barrie Rokeach
Aerial Photography
32 Windsor
Kensington, CA 94708
Telephone
415/527-5376

Barrie Rokeach

S H A R O N · P O L S T E R

Edible Art For 848 26th Avenue Telephone
Catering San Francisco, Area Code 415
And Photography California 94121 751-2129

Chong Myong Kum The Small Things Company
 P.O. Box 16252
 San Francisco, Ca. 94116
 Telephone 415 564 9222

Robert W. Medearis
Managing General Partner

Third Creek Joint Venture
735 Live Oak
Menlo Park, CA 94025
415/327-6883

Pardee & Fleming **David S. Fleming**
Landscape Design

614 Palisades Avenue Residential
Santa Monica, CA 90402 Commercial
213 277-8044 Landscape
213 451-2470 Design
 Installation
 & Construction

JEAN MYERS ARCHITECTURAL GLASS
P.O. BOX AG • SOUTH LAKE TAHOE • CALIFORNIA • 95705 • (916) 541-7878

JEAN MYERS/DESIGNER

SEGD

is a Member through

Society of Environmental
Graphics Designers

ANTHONY J. AMENDOLA
PRESIDENT

PABST BREWING COMPANY
917 W. JUNEAU AVE. MILWAUKEE, WI 53201 (414) 347-7300

G. Robert Nease
Commercial Photography

130 East Union Street
Fullerton, California 92632
Tel: 714 525 1750

Robert Nease

D R E A M L A N D

Peter Fisk, Vice President
715 Harrison Street
San Francisco, California 94107
415 495 8660

Elaine Faris Keenan
Photographer
90 Natoma Street
San Francisco
California 94105
415.546.9246

Herrold
Associates

2090 Pacific Ave #502
San Francisco CA
94109

Irene L. Herrold

▸ Herrold

415.922.3072
▼

Michael Patrick Cronan
Graphic Designer
300 Broadway
San Francisco, 94133
Telephone 415/398 2368

Michael Patrick Cronan

Greenhaus
Art Director:
Jann Church
Designer:
Jann Church
Artist:
Jann Church
Design Firm:
Jann Church Advertising
& Graphic Design, Inc.
Newport Beach
Typographer:
De-Lino Type

greenhaus

This house cares for plants. With a thorough
understanding of color, texture and scale,
the Greenhaus provides varied services for
gardens in homes and offices. Plant services range
from initial design and consultation through
on-going plant care. Specimens are nurtured and
individually selected by our professionals.
The art of horticulture, when applied by the
Greenhaus system, will result in rich,
green, healthy environments. Showrooms and
growrooms are located at 17848 Sky Park Blvd.
Irvine, California 92714 (714) 751-4360.

Bill Poulton

The Office of
Michael Manwaring
Art Director:
Michael Manwaring
Designer:
Michael Manwaring
Artist:
Bill Chiaravalle
Design Firm:
The Office of
Michael Manwaring
San Francisco
Typographer:
Omnicomp
Printer:
Interprint; Phelps-Schaefer

The Office of
Michael Manwaring

1005 Sansome St
San Francisco
California 94111
415 421 3595

Dixie Wells

Forman/Leibrock
Designer:
Michael Cronan
Design Firm:
Michael Patrick Cronan
San Francisco
Typographer:
Headliners/Identicolor
Printer:
Forman/Leibrock

Forman/Leibrock

*Fine printing
and lithography.*

*1044 Howard St.
San Francisco
California 94103
415 861-6652*

Jutta Leibrock

Judi Keen
Art Director:
Robert Rakela
Designer:
Robert Rakela
Artist:
Robert Rakela
Design Firm:
The Rakela Co.
Sacramento
Typographer:
Ad Type
Printer:
Fong & Fong

JUDI KEEN

TAPESTRY ARTIST
DESIGNER

920 20TH STREET
SACRAMENTO CA
95814

916 446 4777

Dona Emerson
Art Director:
Harry Murphy
Designer:
Harry Murphy
Artist:
Sheldon Lewis
Design Firm:
Harry Murphy + Friends
Mill Valley

**Dona Emerson
Seamstress**

**622 Northern Avenue
Mill Valley, Ca. 94941**

**Telephone
415 383-2551**

Art in Craft
Designer:
Michael Cronan
Design Firm:
Michael Patrick Cronan
San Francisco
Typographer:
Headliners/Identicolor
Printer:
Creative Arts Printing

AIC

ART IN CRAFT

*A professional
association of
artists.*

*447 Sutter St.
Suite 425
San Francisco
CA 94108
Telephone
415 362 7238*

*Ellis Gold
Publisher*

Barrie Connolly & Associates

Interior Design

Space Planning

Barrie Connolly & Assoc.
Art Director:
Harry Murphy
Designer:
Harry Murphy
Artist:
Sheldon Lewis
Design Firm:
Harry Murphy + Friends
Mill Valley

BEACH
STREET
BAKING
COMPANY
GHIRARDELLI SQUARE

PASTRIES · COOKIES
FRENCH BREADS
900 NORTH POINT
SAN FRANCISCO 94109
415 · 771 · 6400

Beach Street Baking Co.
Art Director:
Barry Deutsch
Designer:
Myland McRevey
Artist:
Myland McRevey
Design Firm:
Steinhilber Deutsch & Gard
San Francisco

Heather Preston
Art Director:
Bruce Kortebein
Designer:
Bruce Kortebein
Artist:
Heather Preston
Design Firm:
Design Office
Bruce Kortebein
San Francisco
Typographer:
Spartan Typographers
Printer:
Techni-Graphics, Inc.

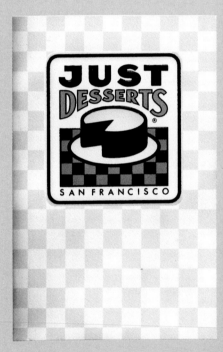

Just Desserts
Art Director:
Primo Angeli
Designer:
Primo Angeli
Artist:
Mark Jones
Design Firm:
Primo Angeli Graphics
San Francisco
Typographer:
Reprotype

C O Y

JOHN COY

8507 WASHINGTON BLVD
CULVER CITY, CA 90230
213 : 837 0173

Coy
Art Director:
John Coy
Designer:
John Coy
Design Firm:
Coy, Los Angeles
Culver City
Typographer:
Vernon Simpson
Typographers
Printer:
Alan Lithograph, Inc.

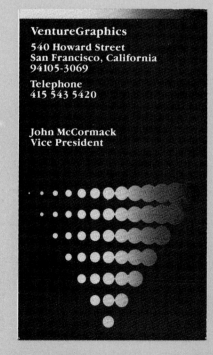

VentureGraphics
540 Howard Street
San Francisco, California
94105-3069

Telephone
415 543 5420

John McCormack
Vice President

VentureGraphics
Art Director:
Michael Vanderbyl
Designer:
Michael Vanderbyl
Artist:
Michael Vanderbyl
Design Firm:
Vanderbyl Design
San Francisco
Typographer:
Headliners/Identicolor
Printer:
VentureGraphics

GFT
Art Director:
Michael Vanderbyl
Designer:
Michael Vanderbyl
Artist:
Michael Vanderbyl
Design Firm:
Vanderbyl Design
San Francisco
Typographer:
Headliners/Identicolor
Printer:
The Printing House

PASS

Designer:
Michael Manwaring
Artist:
Betty Barsamian
Design Firm:
The Office of
Michael Manwaring
San Francisco
Typographer:
Omnicomp
Printer:
Golden Dragon Printing

Leslie Becker Design
Art Director:
Leslie Becker
Designer:
Leslie Becker
Artist:
Leslie Becker
Design Firm:
Leslie Becker Design
San Francisco
Typographer:
Custom Typography
Service
Printer:
Graphic Arts of Marin

Suzanne West/Design
Art Director:
Suzanne West
Designer:
Suzanne West
Design Firm:
Suzanne West/Design
Palo Alto
Typographer:
D. & J. Typography
Printer:
McCutchan Olds Co.

Graphics Ink Lithography
Art Director:
Don Young
Designers:
Don Young, Brian Lovell
Artist:
Brian Lovell
Design Firm:
The Design Quarter
San Diego
Typographer:
Boyer and Brass
Typesetting
Printer:
Graphics Ink Lithographers

San Jose State University
Programs of Design
Art Directors:
Andrea Janetos, Paul Sinn
Designers:
Andrea Janetos, Paul Sinn
Artist:
Paul Sinn
Design Firm:
Humpal, Leftwich & Sinn
Mountain View
Typographer:
PM Typography
Printer:
Craftsman Printing

La Boulangerie
Art Directors:
Michael & Lindy Dunlavey
Designer:
Nancy Hansen
Artist:
Nancy Hansen
Design Firm:
The Dunlavey Studio, Inc.
Sacramento

Stern + Mott, Ltd.
Art Director:
Gail Stern
Designer:
Dare Porter
Artist:
Dare Porter
Design Firm:
Dare Porter Graphic Design
San Francisco
Typographer:
Spartan Typographers
Printer:
First California Press

GFT Associates Inc.
Real Estate Investment

445 Bush Street
San Francisco.
California 94108

Telephone
415 397-4991

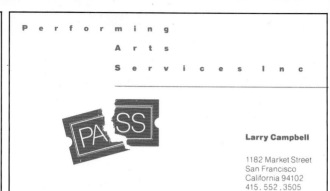

Performing Arts Services Inc

PASS

Larry Campbell

1182 Market Street
San Francisco
California 94102
415 . 552 . 3505

Leslie Becker
1736 Stockton
San Francisco
California 94133

Design

415 391-7374

Suzanne West / Design 415/324-8068

535 Ramona Street, Number 8, Palo Alto, California 94301

GRAPHICS INK
LITHOGRAPHY
2321 KETTNER BLVD • SAN
DIEGO. CA 92101 • 234-0747

ROBERT GRAVES

PROGRAMS OF DESIGN/GRAPHIC/INDUSTRIAL/INTERIOR
BRUCE HATCH/INDUSTRIAL DESIGN
SAN JOSE STATE / SAN CARLOS & 7TH
SAN JOSE CA 95192
408/277/2541

LA BOULANGERIE
~~~ A FRENCH BAKERY ~~~

1400  J STREET ■ SACRAMENTO, CA 95814 ■ 916-448-5233

Gail Stern • 33 Embarcadero Cove • Oakland • CA • 94606
(415) 436-0222
• STERN & MOTT • LIMITED •
(717) 253-3336
Rod Mott • PennCrest • RD#3 • Honesdale • PA • 18431

A Maguire Partners
Property

★

Helen M. Hawekotte
LEASING MANAGER

★

213-592 5539
714-846 4636

★

16400 Pacific Coast Highway
Huntington Beach
California 92647

Peter's Landing
**Art Director:**
Deborah Sussman
**Design Firm:**
Sussman/Prejza & Co., Inc.
Santa Monica
**Typographer:**
Vernon Simpson
**Printer:**
Alan Litho

Sanders Vogel

**High Quality Painting**

51 Bothin Avenue
Fairfax, Ca. 94930

Telephone
415  453-1184

High Quality Painting
**Art Director:**
Harry Murphy
**Designer:**
Harry Murphy
**Artist:**
Sheldon Lewis
**Design Firm:**
Harry Murphy + Friends
Mill Valley

———— Housel Precision Inc.

———— General Machining

———— 11782 Western Ave.

———— Number 15

———— Stanton, CA 90680

———— 714 898 1077

———— Home 714 828 8787

———— Ed Housel

Housel Precision, Inc.
**Art Director:**
Harold Burch
**Designer:**
Harold Burch
**Artist:**
Harold Burch
**Design Firm:**
Ken White Design
Office, Inc.
Los Angeles
**Typographer:**
Ad Compositors
**Printer:**
Toyo Printing

Paul M. Sheptow
Publisher

Sheptow Publishing
609 Mission Street
San Francisco, CA 94105
415 543-8020

Moving Image
**Art Director:**
Kit Hinrichs
**Designers:**
Kit Hinrichs, Lenore Bartz
**Design Firm:**
Jonson Pedersen Hinrichs
& Shakery
San Francisco
**Printer:**
Creative Arts Printing

BARBARA WINDOM
❧
THE CHARCUTERIE INC.
8706 SUNSET BOULEVARD
LOS ANGELES 90069
213 659 3048

The Charcuterie
**Art Director:**
Michael Manwaring
**Designer:**
Michael Manwaring
**Artist:**
Bill Chiaravalle
**Design Firm:**
The Office of
Michael Manwaring
San Francisco
**Typographer:**
Omnicomp
**Printer:**
Golden Dragon Printing

Marin Swim School

Post Office Box 3646
San Rafael, CA 94912
Phone 415 457-5455

Mary Mariani-O'Mara

Marin Swim School
**Art Director:**
Harry Murphy
**Designer:**
Harry Murphy
**Artist:**
Sheldon Lewis
**Design Firm:**
Harry Murphy + Friends
Mill Valley

**Promotional Literature:**
The Riviera Country Club
**Art Director:**
Dan Ashcraft
**Designers:**
Dan Ashcraft/Thom Collins
**Design Firm:**
Kaneko Metzgar
Ashcraft Design
Venice
**Client:**
The Riviera Country Club
**Typographer:**
CCI
**Printer:**
Vaughan Printing

**Stationery:**
Friends of Recreation
& Parks
**Art Directors:**
Dennis Thompson,
Jody Thompson
**Designers:**
Lori Wynn,
Dennis Thompson
**Artist:**
Lori Wynn
**Photographer:**
Robin Lew
**Design Firm:**
Coming Attractions
San Francisco
**Client:**
Friends of Recreation
& Parks
**Typographer:**
Reprotype
**Printer:**
Williams Lithograph Co.

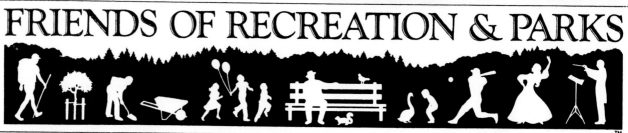

**Environmental Graphics:**
Crocker Barricade
**Art Director:**
Kit Hinrichs
**Designers:**
Lenore Bartz, Kit Hinrichs
**Photographer:**
Dennis Gray
**Design Firm:**
Jonson Pedersen Hinrichs
& Shakery
San Francisco
**Client:**
Crocker National Corp.
**Typographer:**
Omnicomp
**Printer:**
General Graphics &
Thomas Swan Signs

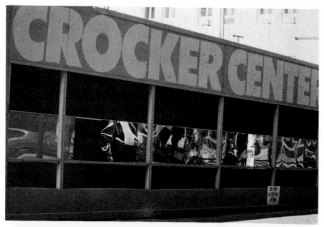

**Stationery:**
KGO-TV Creative SE
**Art Director:**
Jim Stringer
**Designer:**
Bunny Zaruba
**Artist:**
Bunny Zaruba
**Design Firm:**
KGO-TV Art Dept.
San Francisco
**Client:**
KGO-TV
**Typographer:**
KGO-TV Art Dept.
**Printer:**
Warren's Waller Press

**Brochure:**
WatersMark Leasing
**Art Directors:**
Michael Mabry, Donna Wolf
**Designer:**
Michael Mabry
**Artists:**
Larry Winborg,
Margie Eng-Chu
**Design Firm:**
Michael Mabry Design
Communications
San Francisco
**Client:**
Criswell Development Co.
GSD&M Austin
**Typographer:**
Petrographics
**Printer:**
Interprint

DICK WILSON
humorous illustrations

120 Belgrave Avenue
San Francisco ✳ California 94117
telephone 415·821 4818

**Stationery:**
Dick Wilson
**Art Director:**
Vita Otrubova
**Designer:**
Vita Otrubova
**Artist:**
Dick Wilson
**Design Firm:**
Vita Otrubova
San Francisco
**Client:**
Dick Wilson
**Printer:**
Golden Gate Embossing
Co. & McDougal Press

**Poster:**
Typography and Letterpress
Printing at U.C. Davis
**Art Director:**
Frances Butler
**Designer:**
Frances Butler
**Design Firm:**
Poltroon Press
Berkeley, CA
**Publisher:**
Design Group, U.C. Davis
**Typographer:**
Frances Butler
**Printer:**
Frances Butler

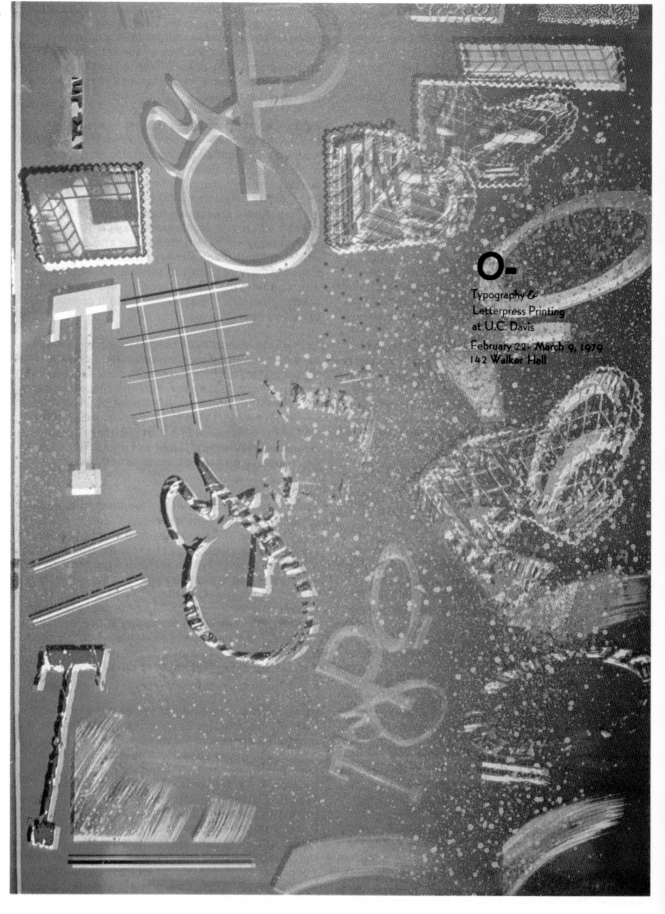

O-

Typography &
Letterpress Printing
at U.C. Davis

February 22- March 9, 1979
142 Walker Hall

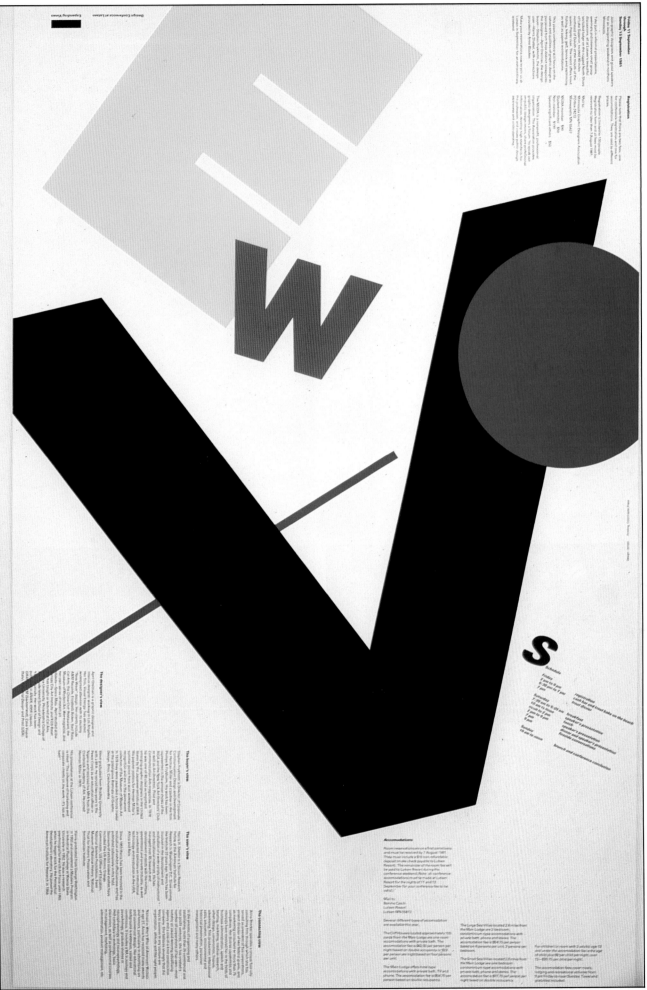

**Poster:**
Lutsen Design Conference:
Expanding Views
**Art Director:**
Robert Jensen
**Designer:**
Robert Jensen
**Design Firm:**
Robert Jensen Design
Minneapolis, MN
**Publisher:**
Minnesota Graphic
Designers Assn.
**Typographer:**
Merganthaler CRTronic
**Printer:**
Colormaster Press

**Promotional Brochure:**
Aldus Since 1972
**Art Directors:**
Harold Burch, Ken White
**Designer:**
Harold Burch
**Design Firm:**
Ken White Design
Office, Inc.
Los Angeles, CA
**Client:**
Aldus Type Studio
**Typographer:**
Aldus Type Studio
**Printer:**
McCullough Printing Co.

**Corporate Literature:**
Barron's Investor Kit
**Art Directors:**
Mark L. Handler, Mark Huie
**Designers:**
Mark Huie, Gail Rigelhaupt
**Design Firm:**
The Handler Group
New York, NY
**Client:**
Dow Jones & Co., Inc.
**Typographer:**
Haber Typographers
**Printer:**
Sterling Roman Press

**Greeting Card:**
Feliz 1980's
**Art Director:**
Jose Luis Ortiz
**Designer:**
Jose Luis Ortiz
**Design Firm:**
Jose Luis Ortiz Design
New York, NY
**Client:**
Jose Luis Ortiz

**Press Kit:**
WNJU TV47
Spanish Television
**Art Director:**
Mark Handler
**Designer:**
Thomas James Dolle
**Design Firm:**
The Handler Group
New York, NY
**Client:**
WNJU-TV
**Letterer:**
Thomas James Dolle
**Typographer:**
TypoGraphics
Communications, Inc.
**Printer:**
Sterling Roman Press

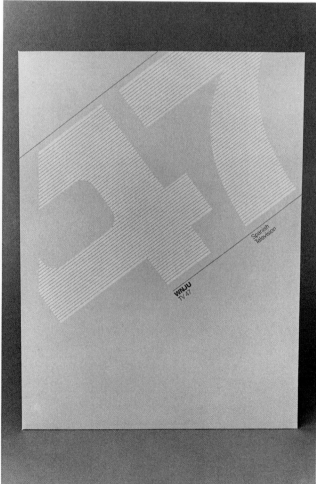

**Stationery:**
Bromley/Jacobsen
**Art Directors:**
Alyssia Lazin, Jak Katalan
**Designers:**
Alyssia Lazin, Jak Katalan
**Design Firm:**
Lazin & Katalan
New York, NY
**Client:**
Bromley/Jacobsen
**Printer:**
Dubin & Dubin

**T-Shirt:**
CCAC 75
**Art Director:**
Michael Vanderbyl
**Designer:**
Michael Vanderbyl
**Design Firm:**
Vanderbyl Design
San Francisco, CA
**Client:**
California College of
Arts and Crafts
**Typographer:**
Headliners/Identicolor

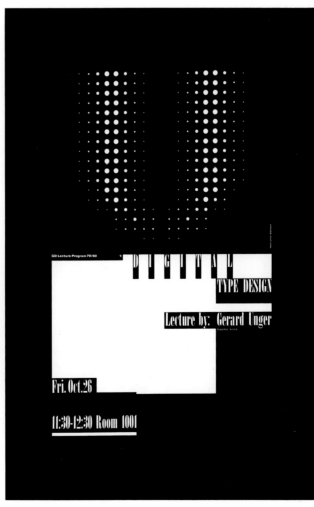

**Press Information Guides:**
Programs and Biographies
1982–1983
**Art Directors:**
David November
Marie-Christine Lawrence
**Designers:**
David November,
Toni Schowalter
**Design Firm:**
CBS Entertainment
Design Dept.
New York, NY
**Publisher:**
CBS Entertainment
**Letterer:**
Tom Carnase
**Typographer:**
TypoGraphics
Communications, Inc.
**Printer:**
Georgian Press
**Binder:**
Product Services, Inc.

**Poster:**
Digital Type Design
**Art Director:**
Hans-U Allemann
**Designer:**
Hans-U Allemann
**Design Firm:**
Hans-U Allemann
Philadelphia, PA
**Publisher:**
Philadelphia College of Art
**Typographer:**
Hans-U Allemann
**Printer:**
Smith McVaugh & Hutchon

**Poster:**
SWA Greetings
**Art Director:**
Doug Akagi
**Designer:**
Doug Akagi
**Design Firm:**
The GNU Group
Sausalito, CA
**Client:**
The SWA Group
**Typographer:**
Letraset
**Printer:**
Trend Graphics

**Stationery:**
Calypso
**Art Director:**
April Greiman
**Designer:**
April Greiman
**Design Firm:**
April Greiman Design
Los Angeles, CA
**Client:**
Calypso
Suzanne Harriton,
Matthew Schoenwald
**Typographer:**
Vernon Simpson
**Printer:**
Anderson Printing

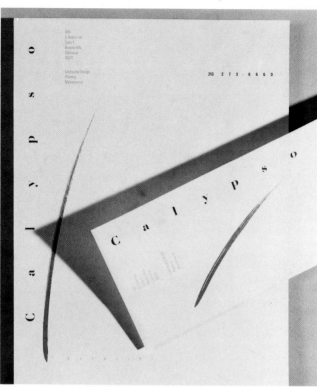

**Stationery:**
Judith Stockman
**Art Director:**
Bill Bonnell
**Designer:**
Bill Bonnell
**Artist:**
Sandro Franchini
**Design Firm:**
Bonnell Design Assoc., Inc.
New York, NY
**Client:**
Judith Stockman
and Assoc.
**Typographer:**
Pastore DePamphilis
Rampone, Inc.
**Printer:**
Rohner Printing Co.

**Corporate Brochure:**
Neuberger & Berman
**Art Director:**
Richard J. Whelan
**Designer:**
Richard J. Whelan
**Design Firm:**
The Whelan Design Office
New York, NY
**Client:**
Neuberger & Berman
**Typographer:**
Character Typographic
Services, Inc.
**Printer:**
Crafton Graphic Co.

**Poster:**
Big Drawings
**Art Director:**
Jacqueline S. Casey
**Designer:**
Jacqueline S. Casey
**Artist:**
Betsy Hacker
**Design Firm:**
MIT Design Services
Cambridge, MA
**Publisher:**
MIT Committee on the
Visual Arts
**Typographer:**
Jacqueline S. Casey
**Printer:**
Arlington Lithograph Co.

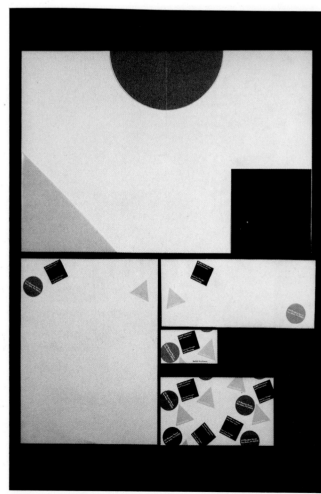

Great Big Drawings

Contemporary Works
on Paper

Hayden Gallery
Massachusetts Institute
of Technology

Hayden Memorial Library
Building
160 Memorial Drive
Cambridge. Massachusetts
02139

April 3-May 2. 1982
Public Preview
Friday. April 2
5-7 pm

Telephone
Gallery 253-4680
Office   253-4400

Organized by the MIT
Committee on the Visual Arts

**Announcement:**
Moving Announcement
**Art Director:**
Bart Crosby
**Designers:**
Bart Crosby, Susan Rogers
**Design Firm:**
Bonnell and Crosby, Inc.
Chicago, IL
**Client:**
Bonnell & Crosby, Inc.
**Typographer:**
Western Type
**Printer:**
Rohner Printing Co.

**Promotional Item:**
Sunar Cards
**Art Director:**
Bill Bonnell
**Designer:**
Bill Bonnell
**Design Firm:**
Bonnell Design Assoc., Inc.
New York, NY
**Publisher:**
Sunar

**Book Cover:**
Nicht Wahr Rosie?
**Art Director:**
Alastair Johnston
**Designers:**
Frances Butler,
Marilyn Perry
**Design Firm:**
Poltroon Press
Berkeley, CA
**Publisher:**
Poltroon Press
**Letterer:**
Arne Wolf
**Printer:**
West Coast Print Center

Stationery:
Hart Typography
**Art Director:**
Mark H. Hanger
**Designer:**
Mark H. Hanger
**Design Firm:**
Markham Design Office
Denver, CO
**Client:**
Hart Typography
**Typographer:**
Mel Typesetting
**Printer:**
Craftsmen Printing

**Logo:**
Image Development
**Art Director:**
Anthony Chiumento
**Designers:**
George DeWoody,
Tandy Belew
Anthony Chiumento
**Design Firm:**
Image Development
San Francisco, CA
**Client:**
Image Development

**Logo:**
Best
**Art Director:**
Tom Geismar
**Designer:**
Tom Geismar
**Design Firm:**
Chermayeff & Geismar
Assoc.
New York, NY
**Client:**
Best Products Co.

**Logo:**
Ace Chain Link Fence
**Art Director:**
Joseph M. Essex
**Designer:**
Joseph M. Essex
**Design Firm:**
Burson Marstellar
Design Dept.
Chicago, IL
**Client:**
Ace Chain Link Fence

**Invitation:**
PARTY
**Art Director:**
Lonn Beaudry
**Designer:**
Lonn Beaudry
**Design Firm:**
Design Machine
Kansas City, MO
**Client:**
Cibis & Crandall
**Typographer:**
Sharpgraphics
**Printer:**
Quality Lithographers

**Periodical Cover:**
Skyline, October 1981
**Art Director:**
Massimo Vignelli
**Designer:**
Michael Bierut
**Design Firm:**
Vignelli Assoc.
New York, NY
**Publisher:**
Skyline
**Typographer:**
Village Type & Graphics
**Printer:**
Trumbull Printing

**Brochure:**
Peter's Landing, 1979
**Art Director:**
Deborah Sussman
**Designer:**
Deborah Sussman
**Design Firm:**
Sussman/Prejza & Co.
Santa Monica, CA
**Client:**
Maguire Partners
**Typographer:**
Ad Compositors
**Printer:**
Alan Litho Co.

**Poster:**
Futurist Evening
**Art Director:**
Juanita Dugdale
**Designer:**
Juanita Dugdale
**Design Firm:**
Two Twelve Assoc.
New York, NY
**Client:**
Yale School of Art
**Typographer:**
Juanita Dugdale
**Printer:**
Century Blueprint

# Skyline          October 1981

The Architecture and Design Review                          $2.50

### Vidler on Jencks:                                        p.18
## Cooking up the Classics
### Eisenman and Wolfe:                                      p.12
## Our House and Bauhaus
### Stern on Frampton:                                       p.22
## Giedion's Ghost
### Peter Brooks:                                            p.30
## Prostitution and Paris
### Scully and Meier:                                        p.11
## Remembering Breuer
## Plus: Buildings, Books, Exhibits, Events, and The Insider's Guide to Architects' Offices

why × how = because

singularism + pluralism = peculiarism

futurist food

anti + neutral clothing required

Friday December 14

A+A 3rd floor conference room

1 multi-faceted drum + 5 wet rags = flat art

Futurist Evening

7:00 pm

! + ? × $ = &

**Stationery:**
Chromacolor
**Art Director:**
Robert Cipriani
**Designer:**
Robert Cipriani
**Design Firm:**
Robert Cipriani Assoc.
Boston, MA
**Client:**
Chromacolor
**Typographer:**
Typographic House
**Printer:**
Excelsior Process and
Engraving, Inc.

**Stationery:**
Grammar Game
Publishing Co.
**Designer:**
Mark Laughlin
**Design Firm:**
Shepard/Quraeshi, Inc.
Boston, MA
**Client:**
Richard Beaty
**Typographer:**
Don Dewsnap Publishing
**Printer:**
Draper Press

**Stationery:**
Skolos, Wedell + Raynor
**Art Director:**
Nancy Skolos
**Designer:**
Nancy Skolos
**Design Firm:**
Skolos, Wedell + Raynor
Charlestown, MA
**Client:**
Skolos, Wedell + Raynor
**Typographer:**
Berkeley Typographers
**Printer:**
Reynolds-DeWalt
Printing, Inc.

**Stationery:**
Pate International
**Art Director:**
Susan Roach Pate
**Designers:**
Hock Wah Yeo,
Susan Roach Pate
**Design Firm:**
Pate International
San Francisco, CA
**Client:**
Pate International
**Letterer:**
Hock Wah Yeo
**Typographer:**
Spartan
**Printer:**
Forman/Leibrock

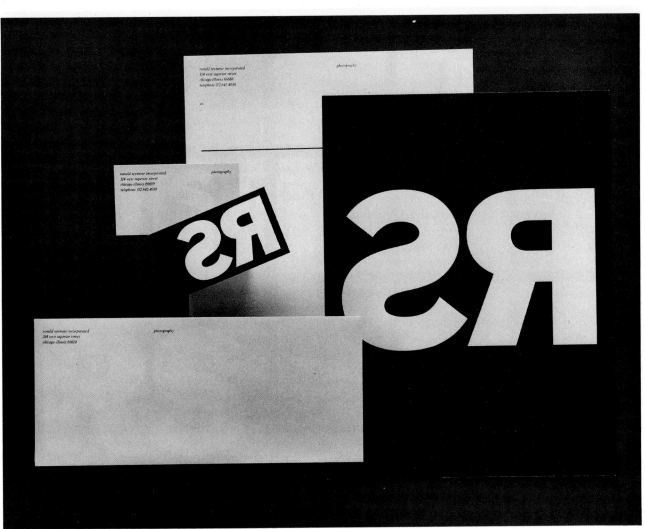

**Stationery:**
Ronald Seymour
**Art Director:**
Bart Crosby
**Designer:**
Bart Crosby
**Design Firm:**
Crosby Assoc., Inc.
Chicago, IL
**Client:**
Ronald Seymour, Inc.
**Letterer:**
Bart Crosby

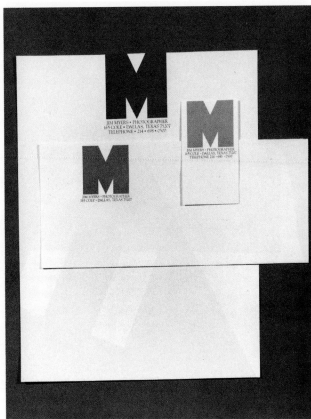

**Stationery:**
Berch & Berkman, CPA
**Art Director:**
Pat Hansen
**Designer:**
Pat Hansen
**Design Firm:**
Pat Hansen Design
Seattle, WA
**Client:**
Berch & Berkman
**Typographer:**
Type Gallery
**Printer:**
Printing Control Services

**Stationery:**
Jim Myers
**Art Director:**
Bob Young
**Designer:**
Bob Young
**Design Firm:**
Bob Young Design
Dallas, TX
**Client:**
Jim Myers
**Typographer:**
Chiles & Chiles
**Printer:**
Millett Printing Co.

**Book Cover:**
Think Metric
**Art Director:**
Willi Kunz
**Designer:**
Willi Kunz
**Design Firm:**
Willi Kunz Assoc., Inc.
New York, NY
**Publisher:**
W. H. Sadlier, Inc.
**Typographer:**
Johnson Ken-Ro, Inc.
**Printer:**
Clark Litho.

**Stationery:**
Cap Pannell & Co.
**Art Director:**
Cap Pannell
**Designer:**
Cap Pannell
**Artist:**
Cap Pannell
**Design Firm:**
Cap Pannell & Co.
Dallas, TX
**Client:**
Cap Pannell & Co.
**Typographer:**
Jaggars-Chiles-Stovall
**Printer:**
John A. Williams

**U.S. Tax Forms:**
1980 Intermediate Form
1981 Short Form
**Art Director:**
Ann Breaznell
**Designers:**
Ann Breaznell, John
Laughlin, Jean Taylor,
Ronald Manzke
**Design Firm:**
Siegel & Gale
New York, NY
**Client:**
U.S. Internal Revenue
Service
**Typographer:**
Carver Composition Co.

**Contents Page:**
Views, Spring 1981
**Art Director:**
Paul Souza
**Designer:**
Paul Souza
**Design Firm:**
WGBH Design Dept.
Boston, MA
**Publisher:**
Photographic
Resource Center
**Printer:**
Charles River
Publishing Co.

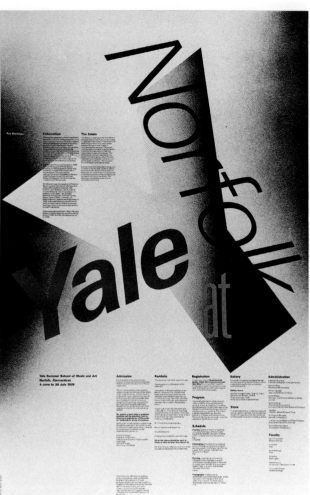

**Poster:**
Herman Miller Designers
**Art Director:**
Linda Powell
**Designer:**
Linda Powell
**Design Firm:**
Herman Miller, Inc.
Zeeland, MI
**Publisher:**
Herman Miller, Inc.
**Typographer:**
Typehouse, Inc.
**Printer:**
Kal-Blue

**Poster:**
Yale at Norfolk
**Art Director:**
Robert Jensen
**Designer:**
Robert Jensen
**Design Firm:**
Robert Jensen Design
Minneapolis, MN
**Publisher:**
Yale Summer School
of Music and Art
**Typographers:**
SNET, Robert Jensen
**Printer:**
Eastern Press

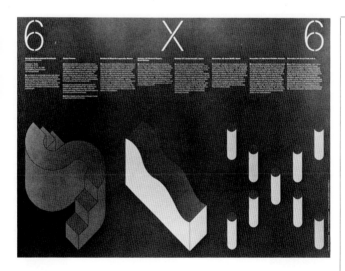

**Poster:**
Six by Six
**Art Director:**
Michael Vanderbyl
**Designer:**
Michael Vanderbyl
**Design Firm:**
Vanderbyl Design
San Francisco, CA
**Client:**
American Institute of
Architects,
San Francisco Chapter
**Typographer:**
Headliners/Identicolor
**Printer:**
VentureGraphics

**Poster:**
If We'd Been Around
in 1885
**Art Director:**
Stephen Frykholm
**Designer:**
Stephen Frykholm
**Design Firm:**
Herman Miller, Inc.
Zeeland, MI
**Publisher:**
Herman Miller, Inc.
**Typographer:**
Typehouse, Inc.
**Printer:**
Kal-Blue

**Promotional Brochures:**
Clinical Focus 1, 2, 3, 4
**Art Director:**
Bob Paganucci
**Designer:**
Bob Paganucci
**Design Firm:**
Bob Paganucci Design
Summit, NJ
**Client:**
CIBA-GEIGY Corp.
**Typographer:**
Royal Composing Room
**Printer:**
Colorpress

**Shopping Bag:**
J.C. Penney Co., Inc.
**Art Director:**
David Law
**Designer:**
Lawrence Wolfson
**Design Firm:**
J.C. Penney
Packaging Dept.
New York, NY
**Client:**
J.C. Penney Co., Inc.
**Printer:**
Continental Extrusion Corp.

**Promotional Brochure:**
McCoy & McCoy Assoc.
**Designers:**
Katherine McCoy
Michael McCoy
**Design Firm:**
McCoy & McCoy Assoc.
Bloomfield Hills, MI
**Client:**
McCoy & McCoy Assoc.
**Letterer:**
Katherine McCoy
**Typographer:**
American Center Studio
**Printer:**
Signet Printing Co., Inc.

**Promotional Item:**
Carnival Time
**Art Director:**
Bill Bonnell
**Designer:**
Elizabeth Cabana
**Design Firm:**
Bonnell Design Assoc., Inc.
**Publisher:**
Champion Papers
**Typographer:**
Pastore DePamphilis
Rampone, Inc.

**Poster:**
CCAC 75
**Art Director:**
Michael Vanderbyl
**Designer:**
Michael Vanderbyl
**Design Firm:**
Vanderbyl Design
San Francisco, CA
**Client:**
California College of
Arts and Crafts
**Typographer:**
Headliners/Identicolor
**Printer:**
LompaLithograph

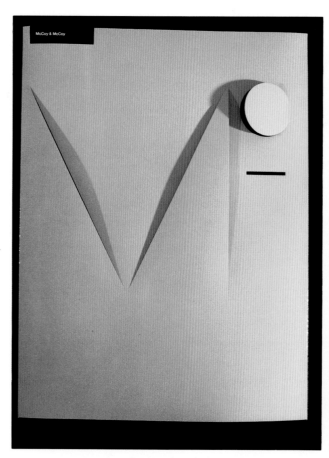

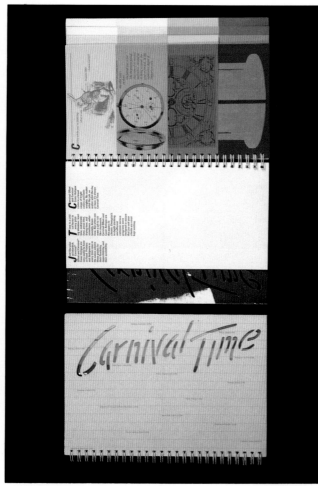

C C A C
1 9 0 7

The California College of Arts and Crafts was founded 75 years ago, opening its doors in the summer of 1907, one year after the great San Francisco earthquake and fire. The school started with 43 students, three classrooms and three teachers on the top floor of the Studio Building in

Berkeley. (The Studio Building has recently been declared a city landmark.) The school was originally named the School of the California Guild of Arts and Crafts. Then in 1908 it was renamed the California School of Arts and Crafts and finally, in 1936, became the California College of Arts and Crafts.

The College was founded by Frederick H. Meyer (1872–1961). Mr. Meyer had many talents; besides being a skilled craftsman, he was an excellent teacher, art historian and horticulturalist. Together with his wife, Laetitia Meyer, and dedicated faculty such as Perham Nahl, Isabelle Percy West and Xavier Martinez, a strong curricu-

lum of fine arts, crafts, design and humanities was established.

Mr. Meyer was deeply influenced by the arts and crafts movement that began in Europe in the latter part of the 19th century. He endeavored to establish a school in which the theory and practice of both the arts and crafts co-existed; his

unique vision still guides the college today.

CCAC is unique among art schools of its size because of the wide range of art instruction it offers. Based on Frederick Meyer's dream of a practical art school, CCAC has become an internationally known and respected institution drawing students from all 50 states and from over

50 countries throughout the world.

California College of Arts and Crafts
5212 Broadway at College Avenue
Oakland, CA 94618
415 653-8118

Degrees offered:
Bachelor of Fine Arts.

Master of Fine Arts.

Master of Art Education.

Three-year Certificate

Drawing
Painting
Printmaking
Sculpture
Photography
Film/Video
General Fine Arts
Ceramics
Glass
Metal Arts
Textiles
Wood Design
General Crafts
Graphic Design
Illustration
Interior Architectural Design
General Design
Art Education
Ethnic Studies.

**Stationery:**
Dot Baker
**Art Director:**
Dick Mitchell
**Designer:**
Dick Mitchell
**Design Firm:**
Richards, Sullivan,
Brock & Assoc.
Dallas, TX
**Client:**
Dot Baker
**Typographer:**
Chiles & Chiles
**Printer:**
Williamson Printing

**Promotional Spread:**
…the development of the
phonetic alphabet
**Art Director:**
Steve Jenkins
**Designer:**
Steve Jenkins
**Design Firm:**
Steve Jenkins Design
New York, NY
**Client:**
Steve Jenkins
**Typographer:**
North Carolina State
University
**Printer:**
North Carolina State
University

With the development of
the phonetic alphabet, the
individual symbol became
totally arbitrary. Meaning
was expressed solely by the
position of the symbol
within a sequence.

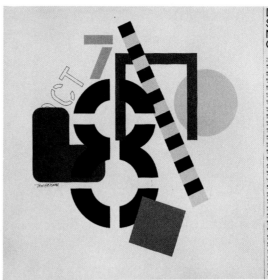

**Invitation:**
Come Celebrate,
We're Expanding
**Art Director:**
Phil Gips
**Designer:**
Steven Fabrizio
**Design Firm:**
Gips+Balkind+Assoc.
New York, NY
**Client:**
Gips+Balkind+Assoc.
**Typographer:**
Innovative Graphics
International
**Printer:**
Crafton Graphic Co., Inc.

**Poster:**
Designer's Saturday
**Art Director:**
Tom Geismar
**Designer:**
Tom Geismar
**Design Firm:**
Chermayeff &
Geismar Assoc.
New York, NY
**Client:**
Designer's Saturday
**Typographer:**
Typographic
Innovations, Inc.
**Printer:**
Sanders Printing Corp.

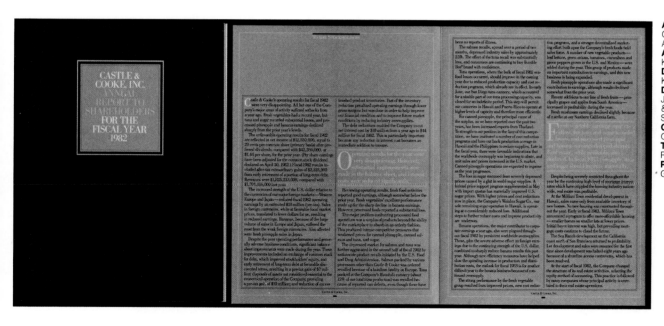

**Annual Report:**
Castle & Cooke
Annual Report 1982
**Art Director:**
Kit Hinrichs
**Designers:**
Kit Hinrichs, Barbara Vick
**Design Firm:**
Jonson Pedersen Hinrichs
& Shakery
San Francisco, CA
**Client:**
Castle & Cooke
**Typographer:**
Reardon & Krebs
**Printer:**
Graphic Arts Center

**Record Album:**
Nervous Eaters
**Art Directors:**
Ron Coro, Norm Ung
**Design Firm:**
Elektra/Asylum Art Dept.
Los Angeles, CA
**Publisher:**
Nervous Eaters
**Typographer:**
Norm Ung
**Printer:**
Album Graphics, Inc.

**Greeting Card:**
Joy
**Art Director:**
Rosalyn Eskind
**Designer:**
Malcolm Waddell
**Design Firm:**
Eskind Waddell
Toronto, CAN
**Client:**
Eskind Waddell
**Typographer:**
Trade Typesetting, Ltd.
**Printer:**
Mackinnon-Moncur, Ltd.

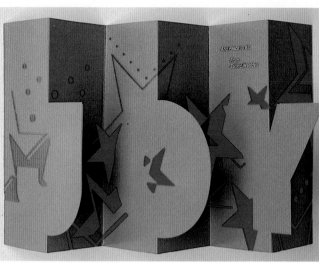

**Poster:**
Free Tuesday Evenings
**Art Director:**
Alan Peckolick
**Designer:**
Alan Peckolick
**Design Firm:**
Lubalin Peckolick Assoc.
New York, NY
**Client:**
Mobil Oil Corp.
**Letterer:**
Tony DiSpigna

**Invitation:**
Knoll Atlanta
**Art Director:**
Harold Matossian
**Designer:**
Steven Schnipper
**Design Firm:**
Knoll Graphics
New York, NY
**Client:**
Knoll International
**Typographer:**
Susan Schecter
**Printers:**
Schaedler Pinwheel
Kenner Printing

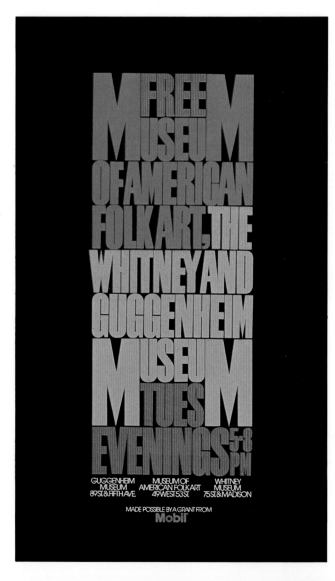

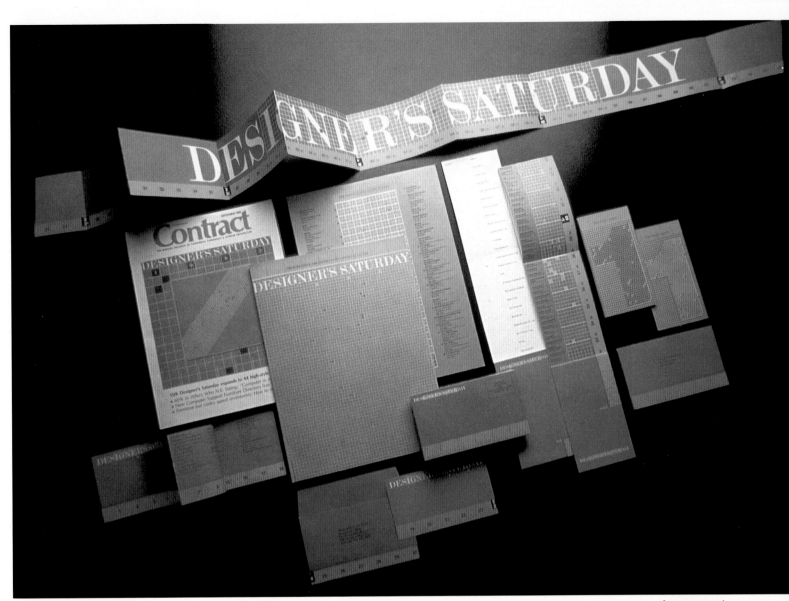

**Announcement:**
Designer's Saturday, 1982
**Art Directors:**
Michael Donovan,
Clement Mok
**Designer:**
Clement Mok
**Design Firm:**
Donovan & Green, Inc.
New York, NY
**Client:**
Designer's Saturday, Inc.
**Typographer:**
Concept Typographics
Services, Inc.
**Printer:**
Lebanon Valley Offset

**Poster:**
Bell Gallery, List Art Center
Brown University, 1982-83
**Art Director:**
Joseph Gilbert
**Designers:**
Joseph Gilbert,
Melissa Gilbert
**Design Firm:**
Gilbert Assoc.
Providence, RI
**Publisher:**
Brown University
**Letterer:**
Joseph Gilbert
**Printer:**
E. A. Johnson Co.

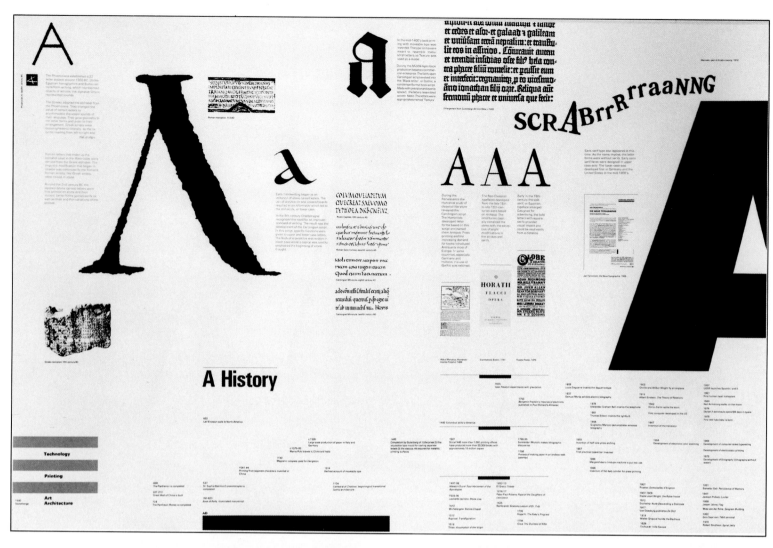

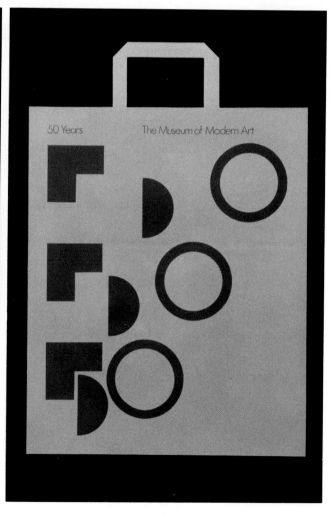

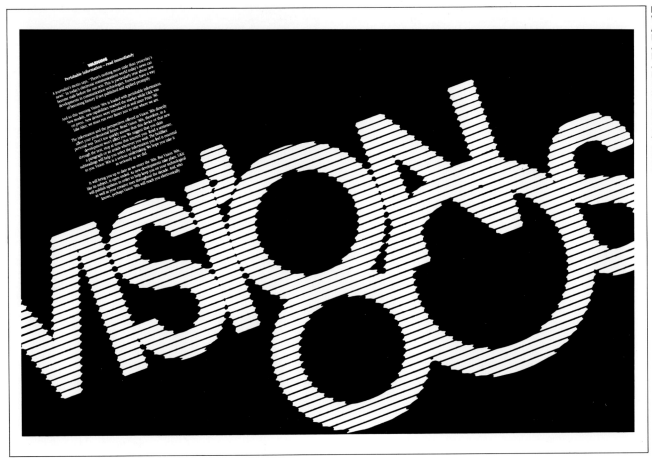

**Periodical Spread:**
Vision '80s
**Art Directors:**
Herb Lubalin,
Jurek Wajdowicz
**Designer:**
Jurek Wajdowicz
**Design Firm:**
Emerson, Wajdowicz
Studios, Inc.
New York, NY
**Publisher:**
International Typeface
Corp.
**Typographer:**
M.J. Baumwell Typography
**Printer:**
Lincoln Graphic Arts

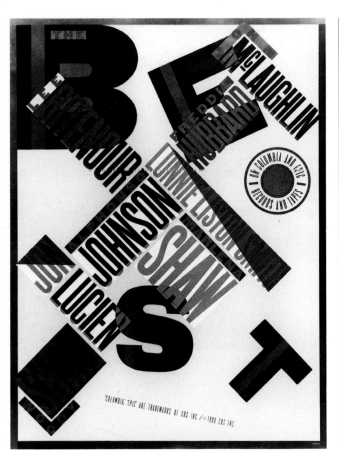

**Poster:**
The Best of…
**Art Director:**
Paula Scher
**Designer:**
Paula Scher
**Design Firm:**
CBS Records Design Dept.
New York, NY
**Publisher:**
CBS Records
**Typographer:**
Haber Typographers
**Printer:**
Shorewood Packaging
Corp.

**Stationery:**
67 Design/Construction,
Inc.
**Art Director:**
Roger Sametz
**Designer:**
Terry Swack
**Design Firm:**
Sametz Blackstone Assoc.
Boston, MA
**Client:**
67 Design/Construction,
Inc.
**Typographer:**
Monotype Composition Co.
**Printer:**
Ben Franklin Smith

**Poster:**
Envision 5
**Art Director:**
Michael Vanderbyl
**Designer:**
Michael Vanderbyl
**Design Firm:**
Vanderbyl Design
San Francisco, CA
**Publisher:**
Sacramento Art Directors
Club
**Typographer:**
Headliners/Identicolor
**Printer:**
Cal Central Press

**Poster:**
Body Language
**Art Director:**
Jacqueline S. Casey
**Designer:**
Jacqueline S. Casey
**Artist:**
Betsy Hacker
**Design Firm:**
MIT Design Services
Cambridge, MA
**Publisher:**
MIT Committee on the
Visual Arts
**Typographer:**
Jacqueline S. Casey
**Printer:**
Arlington Lithograph Co.

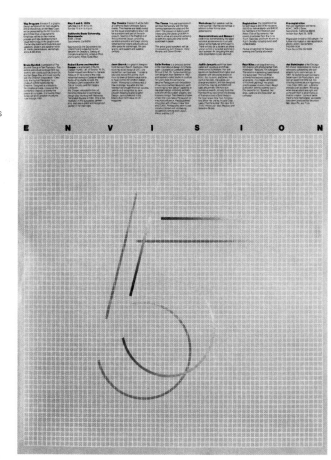

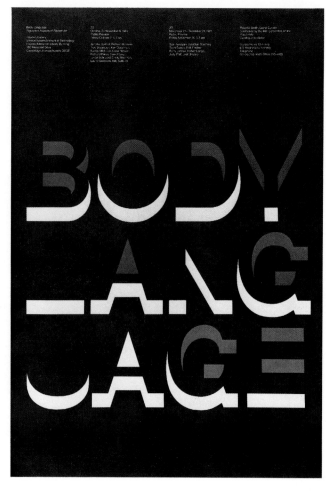

**Poster:**
The Best…
**Art Director:**
Paula Scher
**Designer:**
Paula Scher
**Design Firm:**
CBS Records Design Dept.
New York, NY
**Publisher:**
CBS Records
**Typographer:**
Haber Typographers
**Printer:**
Shorewood Packaging
Corp.

**Record Album:**
Bartok
**Art Director:**
Paula Scher
**Designer:**
Paula Scher
**Design Firm:**
CBS Records Design Dept.
New York, NY
**Publisher:**
CBS Records
**Typographer:**
Haber Typographers
**Printer:**
Shorewood Packaging
Corp.

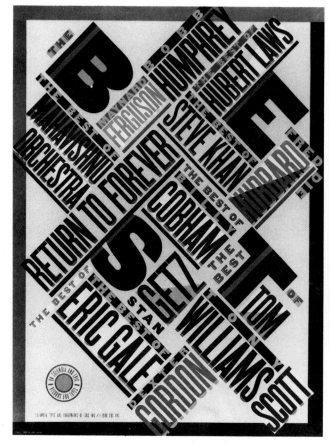

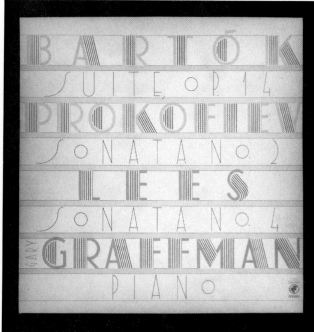

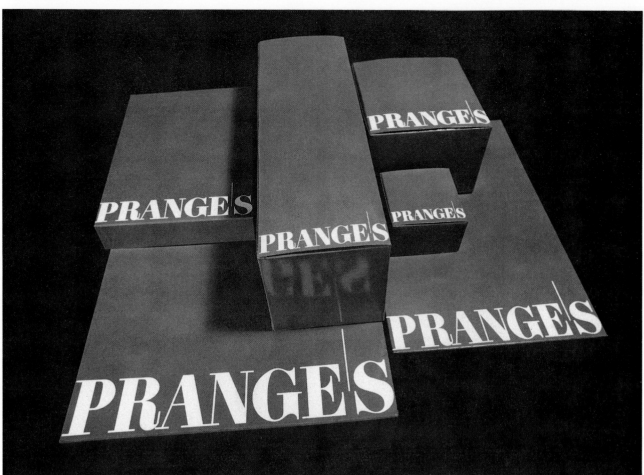

**Package:**
Prange Department Store
**Art Director:**
Eugene J. Grossman
**Designer:**
Kenneth D. Love
**Design Firm:**
Anspach Grossman
Portugal
New York, NY
**Client:**
H. C. Prange

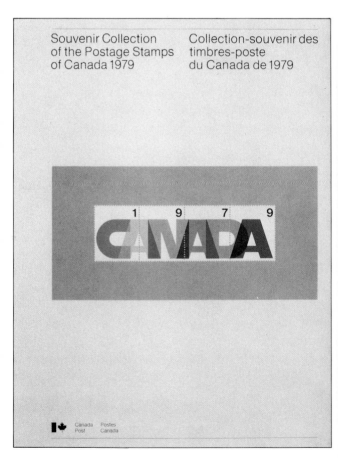

Souvenir Collection
of the Postage Stamps
of Canada 1979

Collection-souvenir des
timbres-poste
du Canada de 1979

1 9 7 9
CANADA

Canada   Postes
Post    Canada

**Brochure:**
Souvenir Collection of the
Postage Stamps of Canada
1979
**Art Director:**
Rolf Harder
**Designer:**
Rolf Harder
**Design Firm:**
Rolf Harder & Assoc.
Montreal, CAN
**Publisher:**
Canada Post
**Typographer:**
Compotronic, Inc.
**Printer:**
Philatelic Marketing Co.

**Invitation:**
An Evening With
Eric Sevareid
**Art Directors:**
Mark Falls, Tibor Kalman
**Designer:**
Mark Falls
**Design Firm:**
M & Co
New York, NY
**Client:**
Lippin & Grant
**Publisher:**
PolyGram Television

**Stationery:**
LITA
**Art Director:**
Robert Cipriani
**Designer:**
Robert Cipriani
**Design Firm:**
Robert Cipriani Assoc.
Boston, MA
**Client:**
Lita Cipriani
**Typographer:**
Typographic House
**Printer:**
Excelsior Process &
Engraving, Inc.

**Poster:**
Taking Things Apart…
**Art Director:**
Steff Geissbuhler
**Designer:**
Steff Geissbuhler
**Design Firm:**
Chermayeff & Geismar
Assoc.
New York, NY
**Publisher:**
American Chemical Society
**Printer:**
Crafton Graphic Co.

**Stationery:**
Evans Pre-School
Day Care Center
**Art Director:**
Joseph Bottoni
**Designer:**
Joseph Bottoni
**Design Firm:**
Bottoni & Hsiung
Cincinnati, OH
**Client:**
Evans Pre-School
Day Care Center
**Typographer:**
Typoset
**Printer:**
Ohio Valley Lithocolor

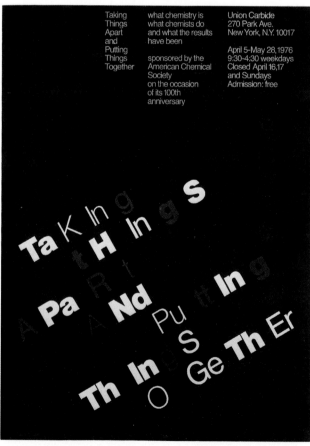

Taking
Things
Apart
and
Putting
Things
Together

what chemistry is
what chemists do
and what the results
have been

sponsored by the
American Chemical
Society
on the occasion
of its 100th
anniversary

Union Carbide
270 Park Ave.
New York, N.Y. 10017

April 5-May 28,1976
9:30-4:30 weekdays
Closed April 16,17
and Sundays
Admission: free

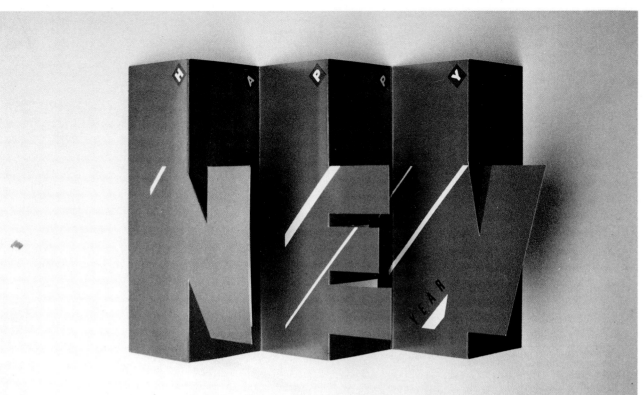

**Greeting Card:**
Happy New Year
**Art Director:**
Malcolm Waddell
**Designer:**
Brian Tsang
**Design Firm:**
Eskind Waddell
Toronto, CAN
**Client:**
Eskind Waddell
**Typographer:**
Cooper & Beatty, Ltd.
**Printer:**
Mackinnon-Moncur, Ltd.

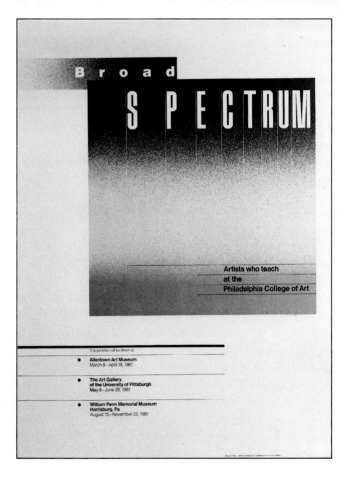

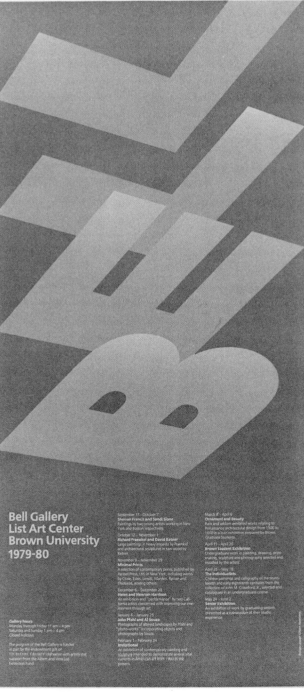

**Poster:**
Broad Spectrum
**Art Director:**
Hans-U Allemann
**Designer:**
Hans-U Allemann
**Design Firm:**
Hans-U Alleman Design
Philadelphia, PA
**Publisher:**
Philadelphia College of Art
**Typographer:**
Composing Room
**Printer:**
Consolidated/Drake Press

**Poster:**
Bell Gallery, List Art Center
Brown University, 1979–80
**Art Director:**
Joseph Gilbert
**Designer:**
Joseph Gilbert
**Design Firm:**
Gilbert Assoc.
Providence, RI
**Publisher:**
Brown University
**Letterer:**
Joseph Gilbert
**Printer:**
E.A. Johnson Co.

**Magazine Ad:**
A photographer focuses…
**Art Director:**
Rob Hugel
**Designers:**
Rob Hugel, Patti Levenburg
**Design Firm:**
Herman Miller Design Dept.
Zeeland, MI
**Client:**
Herman Miller, Inc.
**Typographer:**
Typehouse, Inc.
**Printer:**
West Michigan Magazine

**Research Journal:**
Visible Language: French
Currents of the Letter
**Art Director:**
Katherine McCoy
**Designers:**
Richard Kerr, Alice Hecht
Jane Kosstrin, Herbert
Thompson
**Design Firm:**
Cranbrook Academy of Art
Design Dept.
Bloomfield Hills, MI
**Publisher:**
Merald Wrolstad
Visible Language Magazine
**Typographer:**
Huron Valley Graphics

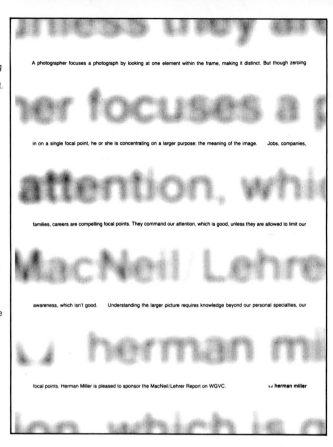

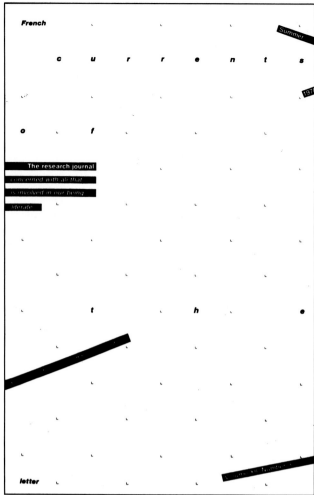

**Stationery:**
McCoy & McCoy
**Art Director:**
Katherine McCoy
**Designers:**
Katherine & Michael
McCoy
**Design Firm:**
McCoy & McCoy Assoc.
Bloomfield Hills, MI
**Client:**
McCoy & McCoy Assoc.
**Letterer:**
Katherine McCoy
**Typographer:**
Typehouse, Inc.
**Printer:**
Signet Printing Co., Inc.

**Announcement:**
China Club
**Art Director:**
April Greiman
**Designer:**
April Greiman
**Design Firm:**
April Greiman Design
Los Angeles, CA
**Client:**
China Club
**Typographer:**
Vernon Simpson
**Printer:**
Anderson Printing

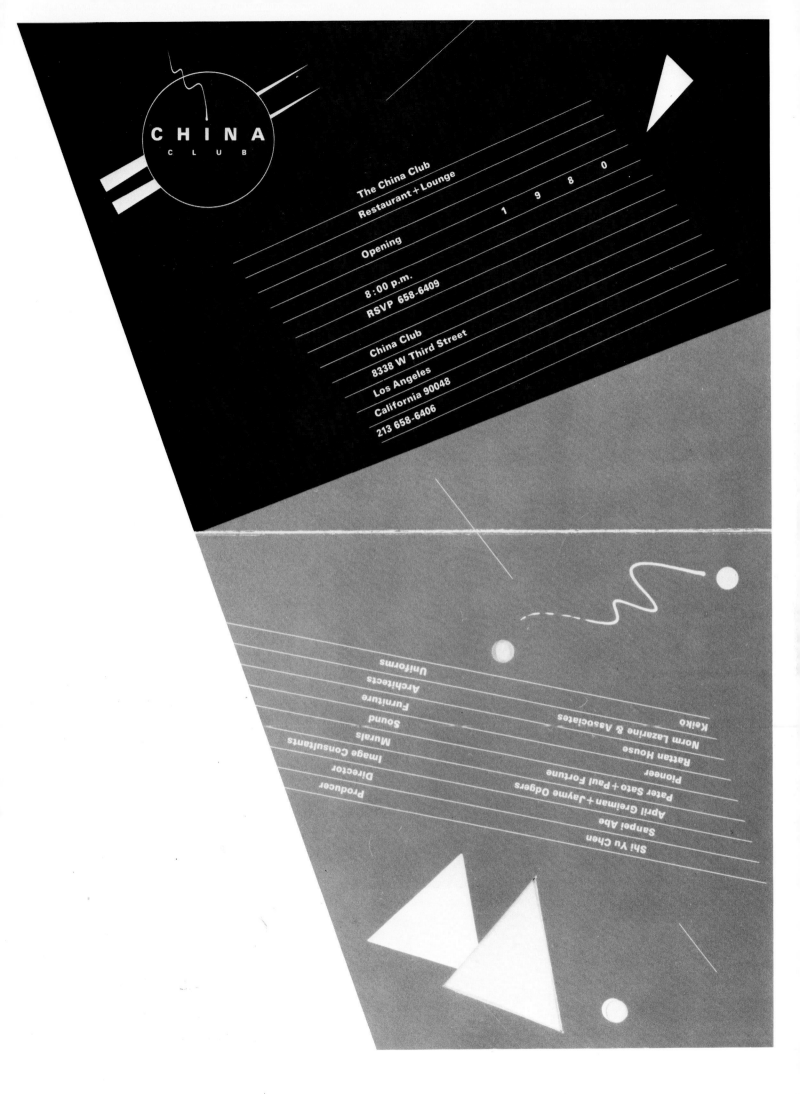

The China Club
Restaurant + Lounge

1 9 8 0

Opening

8:00 p.m.
RSVP 658-6409

China Club
8338 W Third Street
Los Angeles
California 90048
213 658-6406

Uniforms
Architects
Furniture
Sound
Murals
Image Consultants
Director
Producer

Keiko
Norm Lazarine & Associates
Rattan House
Pioneer
Pater Sato + Paul Fortune
April Greiman + Jayme Odgers
Sanpei Abe
Shi Yu Chen

**Stationery:**
California Drop Cloth Co.
**Art Director:**
April Greiman
**Designer:**
April Greiman
**Design Firm:**
April Greiman Design
Los Angeles, CA
**Client:**
California Drop Cloth Co.
Leonard Pollikof
Kate Altman
**Typographer:**
Vernon Simpson
**Printer:**
Anderson Printing

**Invitation:**
Orlando Diaz-Aczuy
**Art Directors:**
Harold Matossian
Takaaki Matsumoto
**Designer:**
Takaaki Matsumoto
**Design Firm:**
Knoll Graphics
New York, NY
**Client:**
Knoll International
**Typographer:**
Susan Schecter
**Printer:**
Schaedler Pinwheel

**Corporate Identity Manual:**
Searle Corporate Identification Standards Manual
**Art Director:**
Bart Crosby
**Designer:**
Bart Crosby
**Design Firm:**
Crosby Assoc., Inc.
Chicago, IL
**Client:**
G.D. Searle & Co.
**Typographer:**
Western Type
**Printer:**
Great Northern Design Printing

**Stationery:**
California Institute
of the Arts
**Art Director:**
April Greiman
**Designer:**
April Greiman
**Design Firm:**
April Greiman Design
Los Angeles, CA
**Client:**
California Institute
of the Arts
**Typographer:**
Vernon Simpson
**Printer:**
Alan Litho Co.

**Poster:**
Books+Books+Books
**Art Director:**
William Longhauser
**Designer:**
William Longhauser
**Design Firm:**
William Longhauser Design
Philadelphia, PA
**Client:**
Philadelphia College of Art

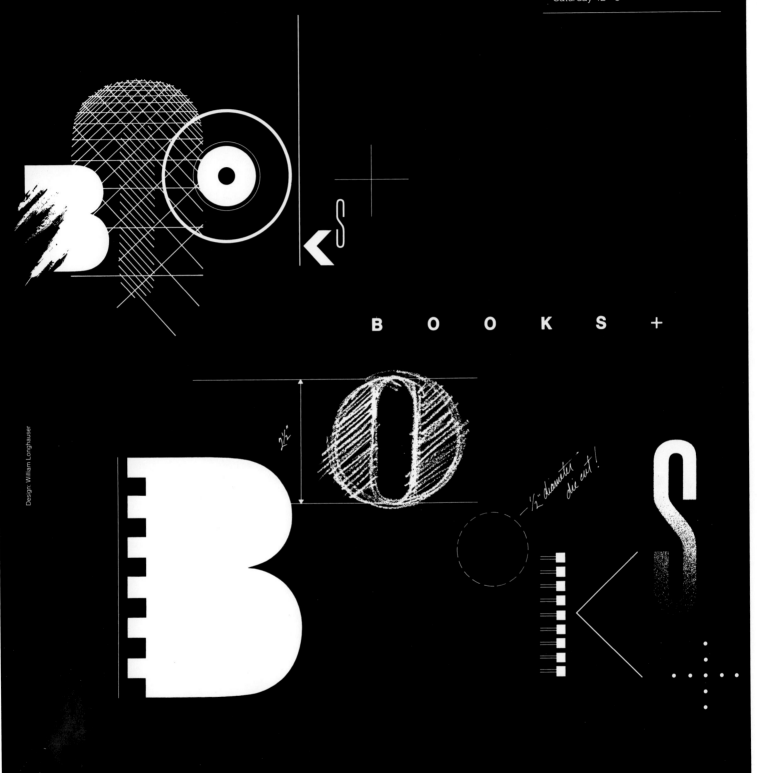

Design: William Longhauser

Recent production books
by leading Philadelphia
graphic designers,
printmakers and illustrators

Philadelphia College of Art
October 16 - November 11, 1978

● Opening 5 - 7 P.M. Friday,
October 13, 1978

Gallery Hours
Monday through Friday 10 - 5
Saturday 12 - 5

B    O    O    K    S    +

2½"

½" diameter
die cut!

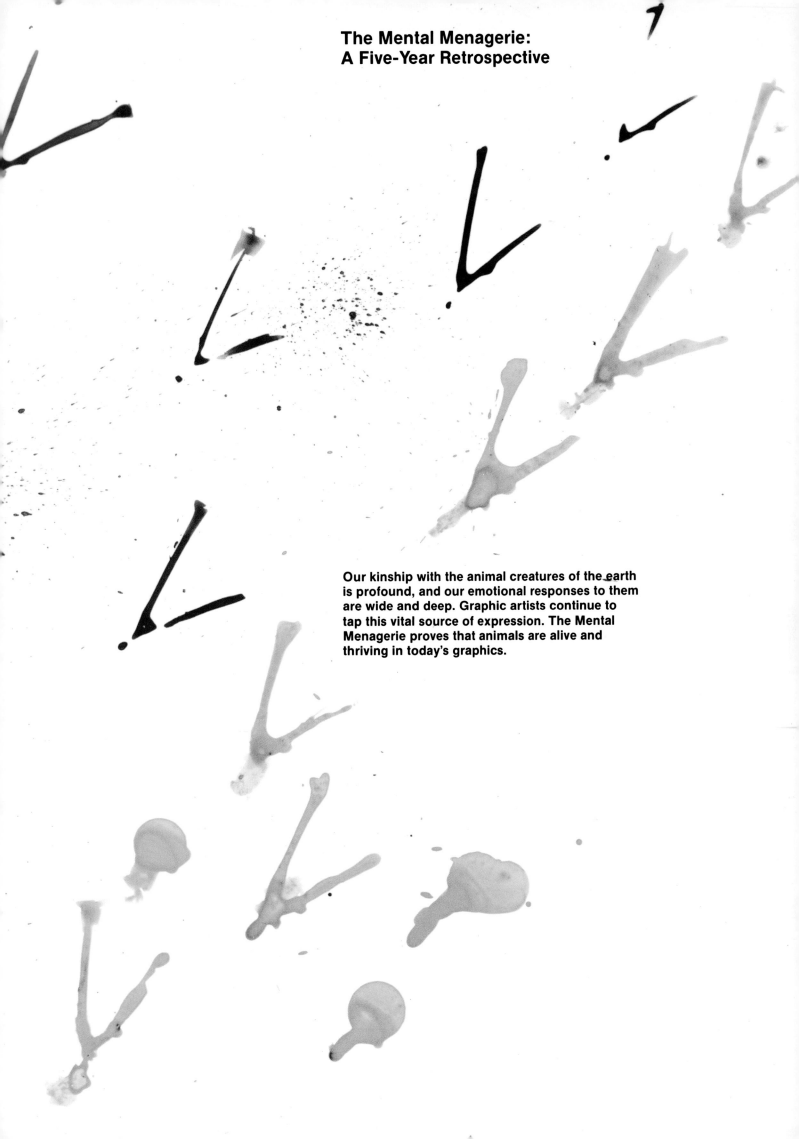

# The Mental Menagerie:
# A Five-Year Retrospective

Our kinship with the animal creatures of the earth is profound, and our emotional responses to them are wide and deep. Graphic artists continue to tap this vital source of expression. The Mental Menagerie proves that animals are alive and thriving in today's graphics.

**Chairman**
Doug Johnson
Principal
Performing Dogs

**Jury**
John Berg
Vice President
Art Packaging & Design
CBS Records

Walter Bernard
Art Director/Designer

Guy Billout
Illustrator

Paul Davis
Illustrator

Barbara Nessim
Illustrator

*The Mental Menagerie* is a collection of animal images from contemporary illustration, photography and design. It is sixth in the AIGA's Mental Picture series, a competition established to present the interpretive work of graphic artists in various media.

The animal theme of this competition was an innately appropriate choice. Since the first cavemen scratched on rock walls, and probably before that, human "artists" have been fascinated with animals. In prehistoric days, drawings of animals were associated with power and the will to survive, a drive as basic as life itself and an involvement that understandably took on mystical connotations. As civilization evolved, the record of visual forms based on the animal has provided a vast and rich strain in the history of art. In all their various and complex manifestations, these images reveal the continuing link between the artist and the animal kingdom, a connection as deeply rooted in the modern human psyche as it was in the mind of the primitive caveman.

It is apparent that the animal is still a potent symbol in modern urban society. Our kinship with the animal creatures of the earth is profound, and our emotional responses to them are wide and deep. Graphic artists continue to tap this vital source of expression.

*The Mental Menagerie* proves that animals are alive and thriving in today's graphics, though, according to the jury, there were few surprises. Much of the work was familiar. Over the past five years, it had been seen and remembered. This is important for two reasons. First, it underscores the frequency with which animals are used in today's photography, illustration and design. Secondly, the fact that these pieces stayed alive in the crowded visual memories of the judges is further proof of the strength and staying power of the animal image.

Except for several beautifully crafted, naturalistic renderings, most of the animal images in this show are used as metaphors to emotionally evoke the intricate facets of the human drama. Much of the work is, therefore, editorial. What is immediately noticeable is how incisively the animal serves as a symbol of communication and how broad is the range of possibilities. It extends from the lightest whimsy to the fiercest terror. For instance, pairs of rabbits on a record album, which seem to have increased in generative proportion, enliven a title — "Multiplication"— while, at the other end of the spectrum, an illustration showing a mad dog in the driver's seat of a truck involves us through an image of expressionist terror, like no human image could, in a story of the rabid Teamsters Union. Some of these symbols are so clear and immediate that they instantly bespeak a title. A poster presenting a dove with the variously shod feet of a broad spectrum of society says "Peace March" without the assistance of the words set in type.

The juxtaposition of one part of an animal on another, or the formation of one creature with both human and animal characteristics, is a device older than the ancient sphinxes, which continues to have infinite possibilities. The fragile head of a rabbit is placed on the lumbering body of a cow to amplify the message: "We do both small and large jobs."

The head of an avaricious tiger is attached to the body of a young executive, to represent the aggressively materialistic temper of the new generation.

There are also the rich possibilities of literary references. In this show, illustrators have made good use of the seemingly endless figures of speech in our language that employ animals. Cats leaping out of a bag instantly communicate the announcement: "We have let our secret out." Mythological creatures also abound. A unicorn provides a medieval flight of fantasy to a poster from an agricultural college, while flute-playing satyrs on a record album remind us of the hedonistic pleasures of music.

Images of animals have shaped the imaginations of modern adults since early childhood. We are conditioned by storybooks, fairytales, fables, cartoons, comic strips, puppets and toys to accept animals as imaginary human characters, many of whom can speak.

There is, then, the wide area of humor that seems so natural for animal imagery. Designers can always depend on animals to lighten their work. A team of roaches spells out "New York" as would a performing band at a football game. A rubber stamp designed to soften the demand of an overdue bill uses the head of a dog baring its teeth and the message: "We're putting the bite on you." In the category of environmental design, a drinking fountain at a zoo has been shaped in the form of a lion with the waterspout in its throat, inviting children to put their heads in the lion's mouth.

Animals have traditionally served as the recipients of feelings too difficult to express in the complex area of human relationships. As vessels of love that offer no threat or judgment, they have opened the floodgates of many human hearts. Not surprisingly, animals are now being used in "petting" programs in modern hospitals to reduce blood pressure and other effects of stress. Taking this instinct a step beyond the norm, photographs from an article entitled "The Objects of Their Affection" show a pet python being cuddled in a swimming pool and a buffalo standing patiently in its owner's livingroom.

Jim McMullan, an exhibitor in the show, said that animals have always intrigued him because they can't talk, and he can't figure out what they're really thinking. "They have a mysterious quality which allows us to imbue them with all kinds of characteristics," he said. "We make them mirrors of ourselves and what we're thinking and hoping." He also finds that whereas the natural movement of animals is a useful expressive tool, in human figures the same intensity of movement might seem overexaggerated.

Paul Davis, one of the judges, whose illustrations are equally filled with human as well as animal images, said that he didn't see a strong dividing line between human beings and animals: "After all, although we're in a different category; human beings are animals. It's an easy line to cross."

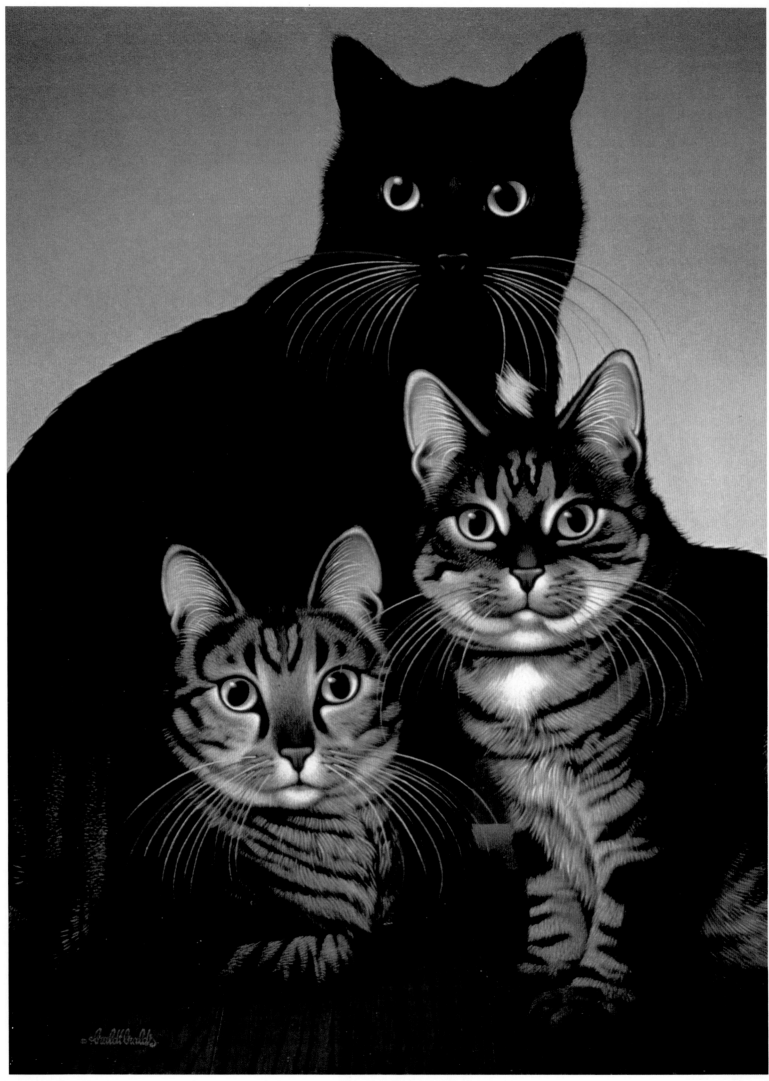

**Illustrator:**
James McMullan
New York, NY
**Cover Sketch:**
Graphis 213
**Publisher:**
Watson-Guptill
Publications

**Illustrator:**
Braldt Bralds
New York, NY
**Periodical Cover:**
Graphis 215
**Publisher:**
Walter Herdeg
Graphis Press Corp.

**Illustrator:**
Paul Davis
Sag Harbor, NY
**Greeting Card:**
Cat With Apples
**Publisher:**
The Museum of Modern Art

**Illustrator:**
Paul Davis
Sag Harbor, NY
**Catalogue Cover:**
Christmas Cat
**Client:**
Neiman-Marcus

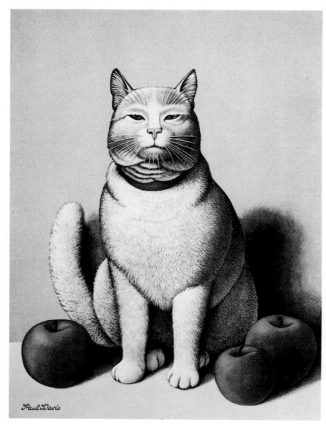 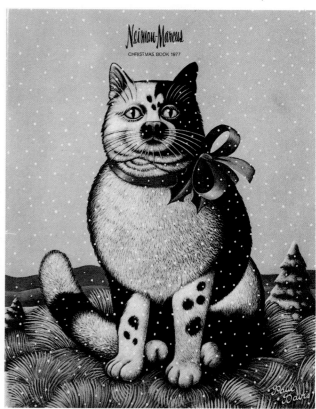

**Illustrator:**
Paul Davis
Sag Harbor, NY
**Periodical Cover:**
Communication Arts
March–April 1978
Matthew's Cat
**Publisher:**
Communication Arts

**Illustrator:**
Doug Johnson
New York, NY
**Poster:**
Pantherfoot
**Art Director:**
Terry Watson
**Agency:**
Gilmore Advertising
**Publisher:**
Upjohn Co.

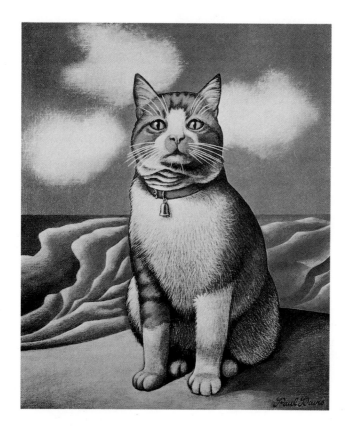

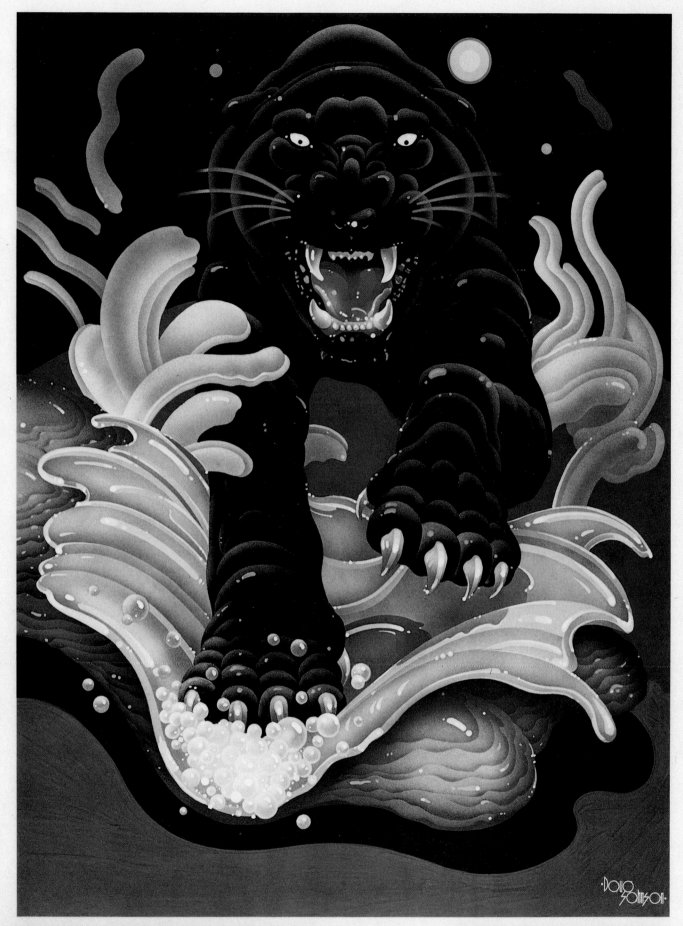

**PANTHERFOOT**

**ES KOMMT**

**Illustrator:**
Simms Taback
**Poster:**
What Could These Cats
Be Trying to Tell You?
**Art Director:**
Carol Carson
**Publisher:**
Scholastic Publications

**Illustrator:**
Ron Sullivan
Dallas, TX
**Advertisement:**
White Marsh Filled With
the Best of Surprises
**Art Director:**
Ron Sullivan
**Design Firm:**
Richards, Sullivan &
Brock, Assoc.
**Client:**
The Rouse Co.

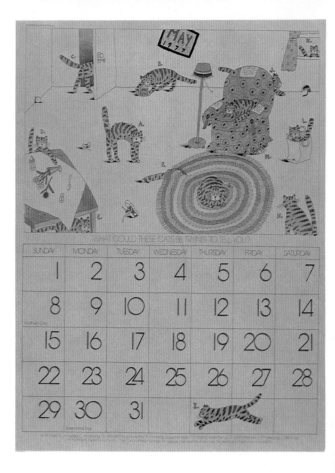

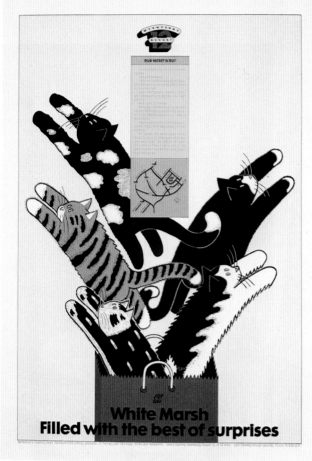

**Illustrator:**
Ivan Chermayeff
New York, NY
**Construction Barricade:**
Cat and Butterfly
**Art Director:**
Ivan Chermayeff

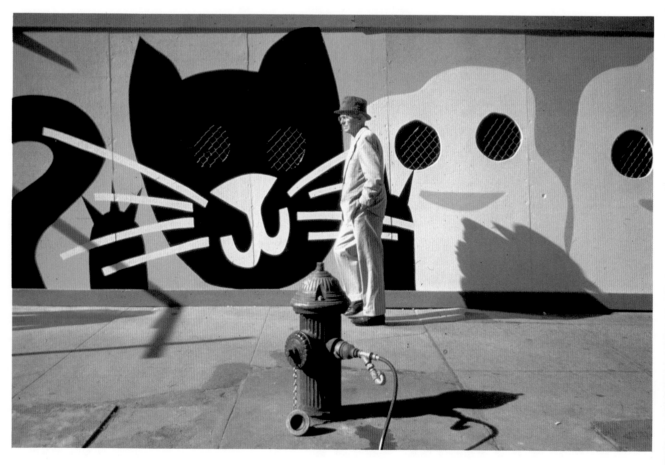

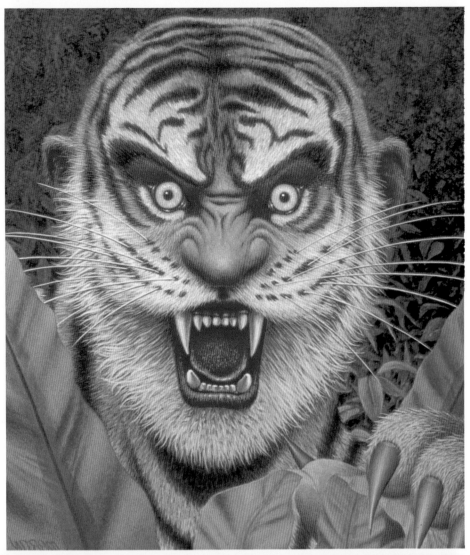

**Illustrator:**
John Martin
Toronto, CAN
**Book Cover:**
The Goat and The Tiger
**Art Director:**
Fifty Fingers
**Publisher:**
Paperjacks Books

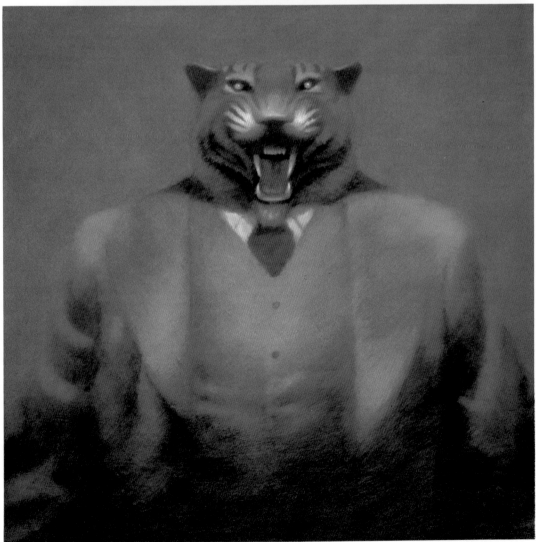

**Illustrator:**
Brad Holland
New York, NY
**Magazine Spread:**
Ruthless Mothers…
**Art Directors:**
Tom Staebler
Kerig Pope
**Publisher:**
Playboy Magazine

**Illustrator:**
Laszlo Kubinyi
New York, NY
**Book Illustration:**
The Town Cats
**Art Director:**
Riki Levinson
**Designer:**
Meri Shardon
**Publisher:**
E.P. Dutton, Inc.

**Illustrator:**
Brad Holland
New York, NY
**Periodical Cover:**
Idea, 1981 No. 9 Winter
Ninth Life
**Publisher:**
Illustration, Japan

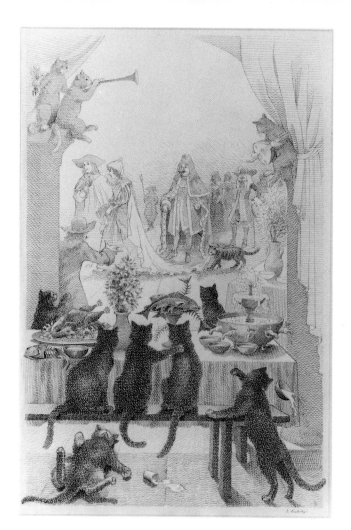

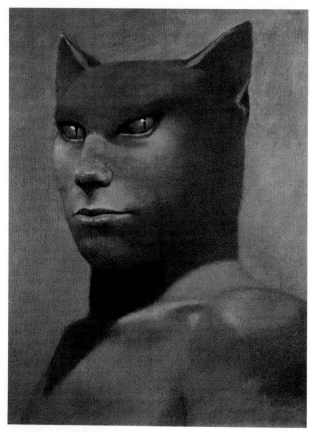

**Illustrator:**
James McMullan
New York, NY
**Poster:**
Revealing Illustrations
**Art Director:**
James McMullan
**Publisher:**
Society of Illustrators

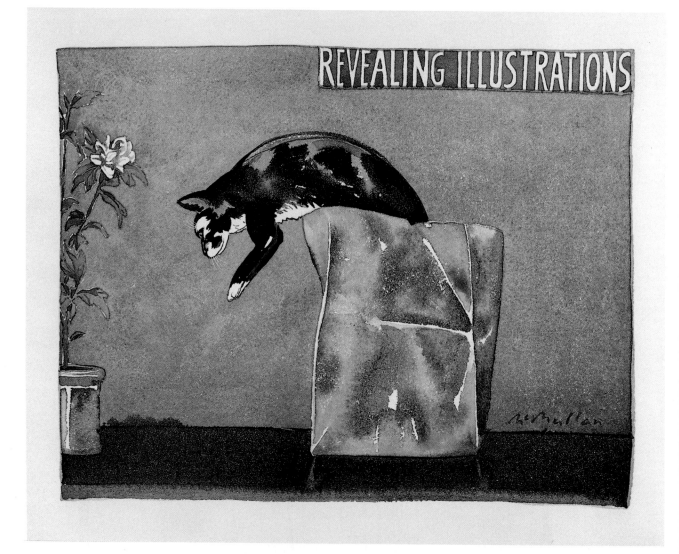

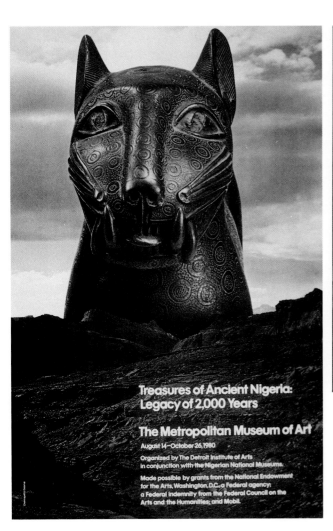

Treasures of Ancient Nigeria:
Legacy of 2,000 Years

The Metropolitan Museum of Art

August 14–October 26, 1980

Organized by The Detroit Institute of Arts
in conjunction with the Nigerian National Museums.

Made possible by grants from the National Endowment
for the Arts, Washington, D.C., a Federal agency;
a Federal indemnity from the Federal Council on the
Arts and the Humanities; and Mobil.

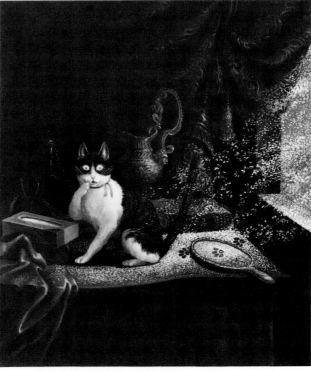

**Designer:**
Ivan Chermayeff
New York, NY
**Poster:**
Treasures of
Ancient Nigeria
**Art Director:**
Ivan Chermayeff
**Client:**
Mobil Corp.
**Publisher:**
The Metropolitan
Museum of Art

**Illustrator:**
Kinuko Y. Craft
Chicago, IL
**Magazine Page:**
Modern Manners
**Art Director:**
Mary Shanahan
**Publisher:**
Rolling Stone

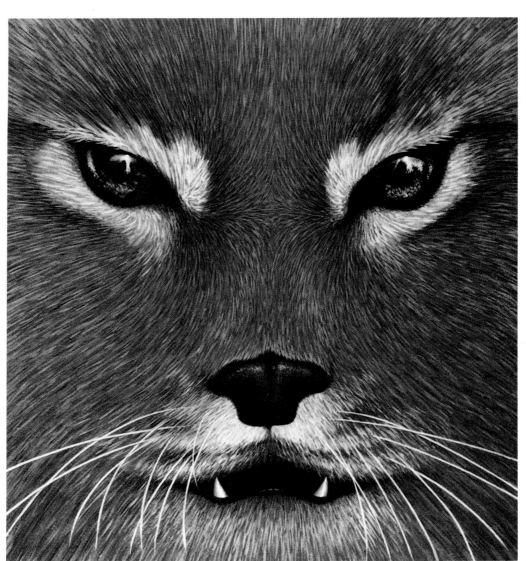

**Illustrator:**
John Martin
Toronto, CAN
**Album Cover:**
Lynx
**Art Director:**
David Wyman
**Design Firm:**
Fifty Fingers
**Publisher:**
Quality Records

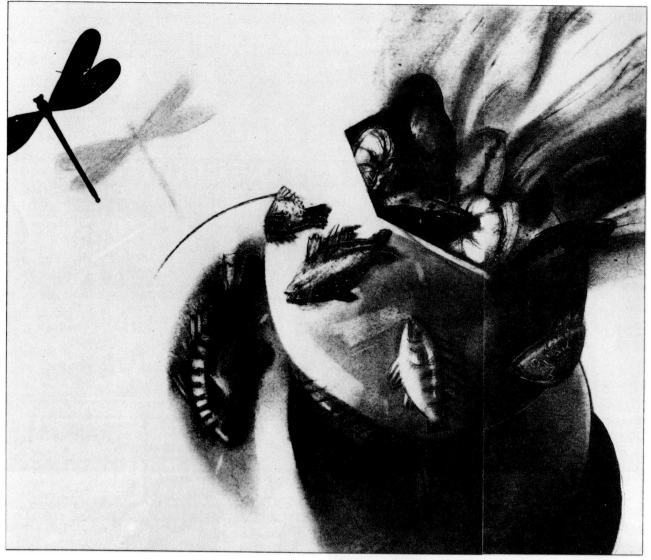

**Illustrator:**
Vivienne Flesher
New York, NY
**Newspaper Supplement Spread:**
Bouillabaisse
**Art Director:**
Katie Aldrich
**Publisher:**
The Boston Globe

**Illustrator:**
Mike Hicks
Austin, TX
**Rubber Stamp:**
Seal of Approval
**Art Director:**
Mike Hicks
**Publisher:**
Hixo, Inc.

**Photographer:**
Geri Murphy
National Geographic Soc.
Washington, DC
**Magazine Page:**
Arrow Crab
**Art Director:**
Jody Bolt
**Publisher:**
Special Publications
National Geographic
Society

218

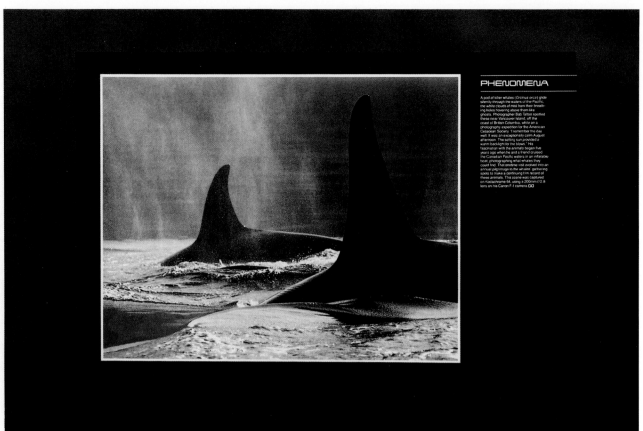

**Photographer:**
Bob Talbot
Redondo Beach, CA
**Magazine Spread:**
Phenomena
**Art Directors:**
Elizabeth Woodson
Elizabeth Siroka
**Publisher:**
Bob Guccione
Omni Magazine

### PHENOMENA

A pod of killer whales (Orcinus orca) glide silently through the waters of the Pacific, the white clouds of mist from their breathing holes hovering above them like ghosts. Photographer Bob Talbot spotted these near Vancouver Island, off the coast of British Columbia, while on a photography expedition for the American Cetacean Society. "I remember the day well. It was an exceptionally calm August afternoon. The setting sun provided a warm backlight for the blows." His fascination with the animals began five years ago when he and a friend cruised the Canadian Pacific waters in an inflatable boat, photographing what whales they could find. That onetime visit evolved into an annual pilgrimage to the whales, gathering spots to make a continuing film record of these animals. This scene was captured on Kodachrome 64, using a 200mm f/2.8 lens on his Canon F-1 camera. □□

**Illustrator:**
Simms Taback
New York, NY
**Poster:**
Fish
**Art Director:**
Carol Carson
**Publisher:**
Scholastic Publications

**Photographers:**
Various
**Book:**
Wildlife of the Polar
Regions
**Designer:**
Massimo Vignelli
**Publisher:**
Harry N. Abrams

G. Carleton Ray and M. G. McCormick-Ray

A Chanticleer Press Edition

# WILDLIFE OF THE POLAR REGIONS

HARRY N. ABRAMS, INC., PUBLISHERS, NEW YORK

**Photographer:**
Ned Seidler
National Geographic Soc.
Washington, DC
**Magazine Spread:**
Life in a Mountain Stream
**Art Director:**
Howard E. Paine
**Publisher:**
National Geographic
Society

**Illustrator:**
Paul Davis
Sag Harbor, NY
**Poster:**
Paul Davis/Art Center
College of Design
**Art Director:**
Rik Besser
**Publisher:**
Art Center College
of Design

**Illustrator:**
McRay Magleby
Provo, UT
**Poster:**
Shell Out
**Art Director:**
McRay Magleby
**Publisher:**
Art Directors Club
of Salt Lake City

**Illustrator:**
David Wilcox
New York, NY
**Record Album:**
Yardbirds Favorites
**Art Director:**
Paula Scher
**Publisher:**
CBS Records

**Illustrator:**
Heather Cooper
Toronto, CAN
**Record Album:**
Igor Stravinsky/Paul Hoffert
**Art Director:**
Heather Cooper
**Design Firm:**
Burns, Cooper, Hynes, Ltd.
**Publisher:**
SQN Records, Ltd.

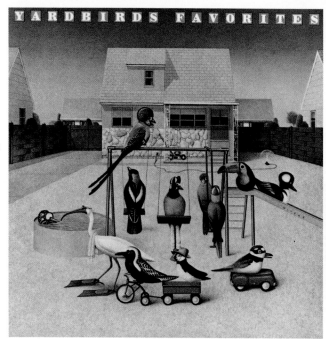

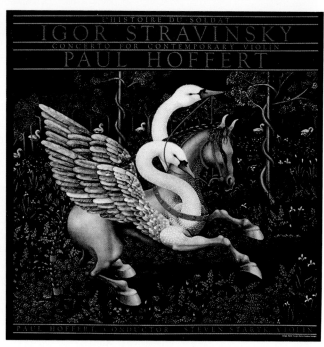

**Illustrator:**
Alex Murawski
Austin, TX
**Poster:**
Chickenman Returns
**Art Director:**
Pete Catrules
**Publisher:**
Radio Syndicate

**Photographer:**
Jim Brandenburg
National Geographic Soc.
Washington, DC
**Magazine Page:**
Squatters in Black Tie —
Jackass Penguins
**Art Director:**
H. Edward Kim
**Publisher:**
National Geographic
Society

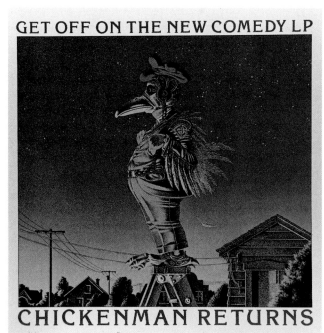

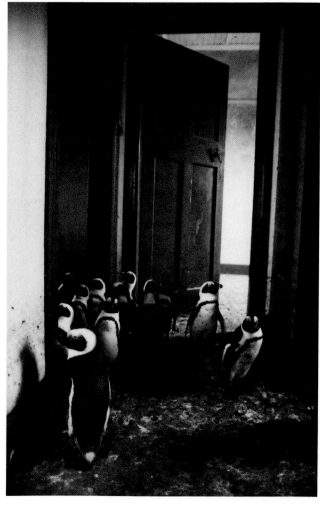

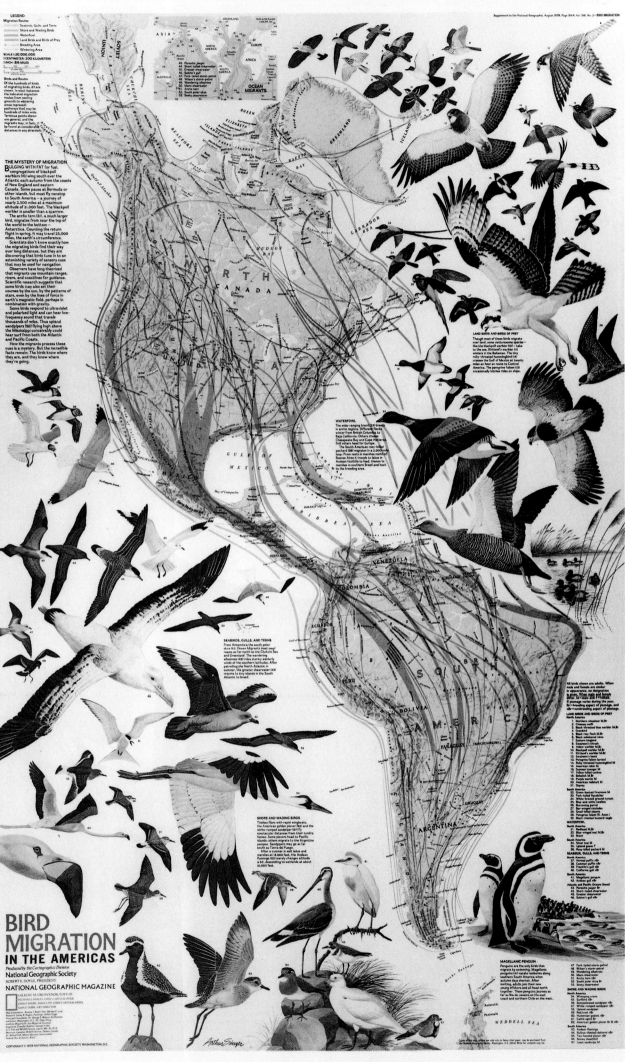

**Illustrator:**
Arthur Singer
Jericho, NY
**Poster:**
Bird Migration in the
Americas
**Art Director:**
Howard E. Paine
**Publisher:**
National Geographic
Society

**Photographers:**
Steven C. Wilson
and Karen C. Hayden
Bainbridge Island, WA
**Paperback Book:**
A Natural Collection
**Art Director:**
Les Meyers
**Publisher:**
Entheos Books

**Illustrator:**
Daniel Maffia
Englewood, NJ
**Calendar:**
April/Mockingbird
**Art Director:**
Herr Kulak
**Publisher:**
World Bank/Germany

**Illustrator:**
Dugald Stermer
San Francisco, CA
**Magazine Spread:**
New West, September 1981
Feather Madness
**Designers:**
Dugald Stermer,
Nancy Butkus
**Publisher:**
New West Magazine

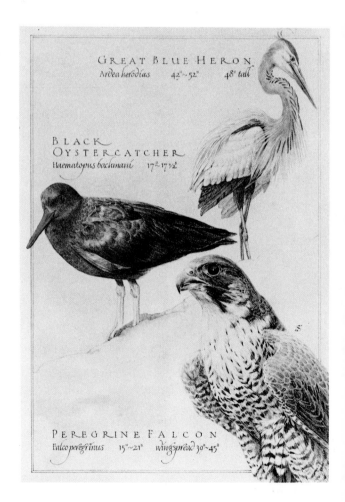

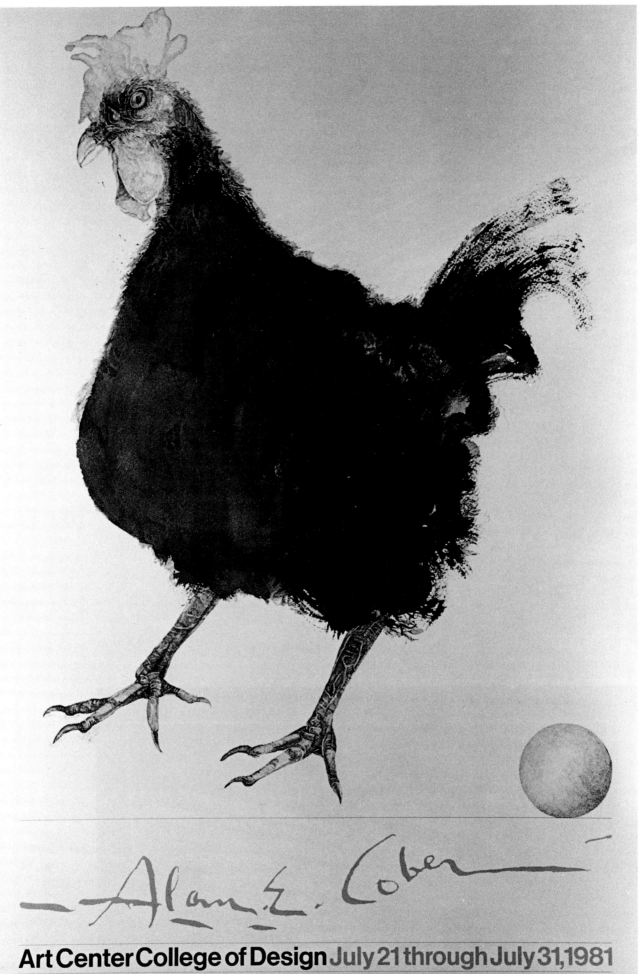

**Illustrator:**
Alan E. Cober
Ossining, NY
**Poster:**
Alan E. Cober/Art Center
College of Design
**Art Directors:**
Philip Hayes
John Hoernle
**Publisher:**
Art Center College
of Design

**Art Center College of Design** July 21 through July 31, 1981

**Illustrator:**
Richard Mantel
New York, NY
**Poster:**
Hampton Classic
**Art Director:**
Richard Mantel
**Publisher:**
Hampton Classic
Horse Show

**Illustrator:**
Richard Mantel
New York, NY
**Poster:**
The Racing Game
**Art Director:**
Sandra Ruch
**Agency:**
Push Pin Studios
**Client:**
Mobil Corp.

**Illustrator:**
Richard Mantel
New York, NY
**Poster:**
The Flame Trees
of Thika
**Art Director:**
Sandra Ruch
**Design Firm:**
Push Pin Studios
**Publisher:**
Mobil Corp.

**Illustrator:**
Seymour Chwast
New York, NY
**Advertisement:**
Forbes Jockey
**Art Director:**
John Garr
**Client:**
Doremus, Inc.

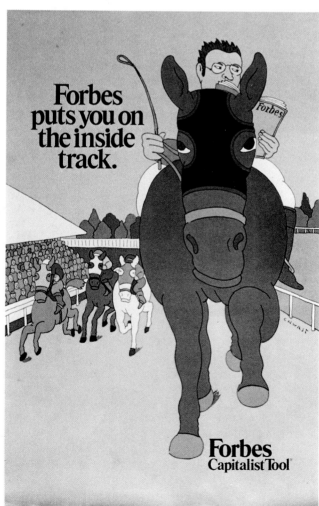

**Photographer:**
Cotton Coulson
National Geographic Soc.
Washington, DC
**Magazine Spread:**
A Horse in the Dining Room
**Art Director:**
Constance Phelps
**Publisher:**
National Geographic
Society

**Photographer:**
Robert Azzi
National Geographic Soc.
Washington, DC
**Magazine Spread:**
Ships of the Desert...
**Art Director:**
O. Louis Mazzatenta
**Publisher:**
National Geographic
Society

**Illustrator:**
Marvin Mattelson
New York, NY
**Poster:**
To Be Good Enough...
**Art Director:**
Silas H. Rhodes
**Designer:**
Bill Kobasz
**Publisher:**
School of Visual
Arts Press, Ltd.

To be good
is not enough,
when you dream
of being great.

# SCHOOL OF VISUAL ARTS

209 EAST 23RD STREET, NEW YORK, N.Y. 10010 (212) 683-0600. DEGREE AND NON-DEGREE PROGRAMS. EVENINGS AND WEEKENDS. FINE ARTS (PAINTING, SCULPTURE, PRINTMAKING), MEDIA ARTS (ADVERTISING, ART DIRECTION, COPYWRITING, DESIGN, ILLUSTRATION, FASHION), ADVERTISING BUSINESS, PRODUCTION, PHOTOGRAPHY, VIDEO TAPE, FILM, CRAFTS, ART HISTORY, HUMANITIES AND SCIENCES, PUBLIC RELATIONS AND ART EDUCATION.

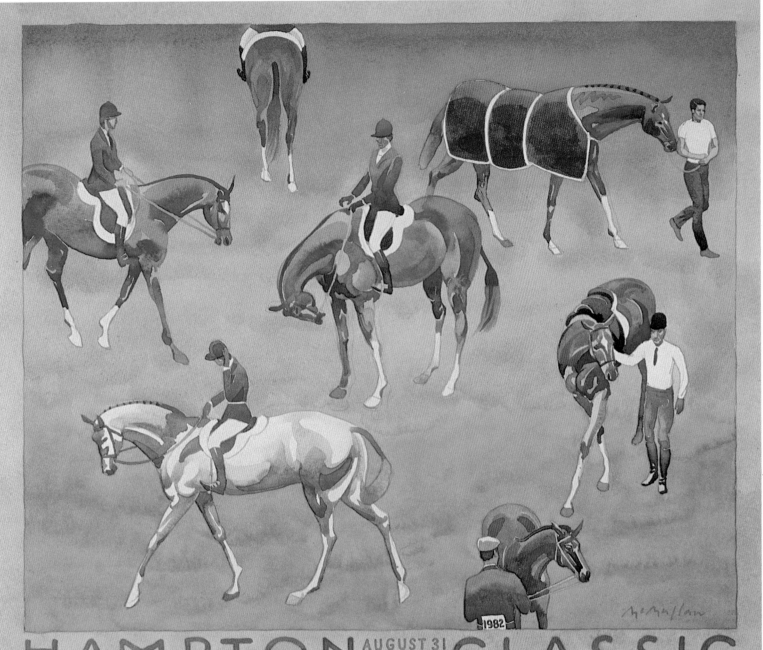

HAMPTON CLASSIC

AUGUST 31
SNAKE HOLLOW ROAD
BRIDGEHAMPTON N.Y.
SEPTEMBER 5

**Illustrator:**
James McMullan
New York, NY
**Poster:**
Hampton Classic
**Art Director:**
Tony Hitchcock
**Client:**
Hampton Classic
Horse Show

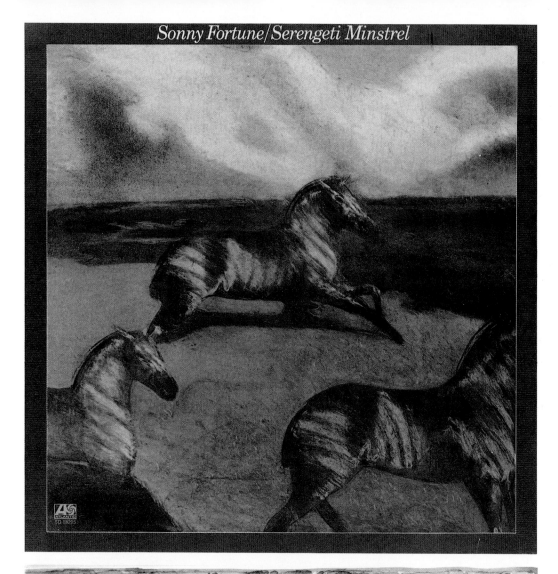

**Illustrator:**
John Collier
Pawling, NY
**Record Album:**
Sonny Fortune/
Serengeti Minstrel
**Art Director:**
Lynn Dreese Breslin
**Publisher:**
Atlantic Records

**Illustrator:**
James McMullan
New York, NY
**Record Album:**
Poco/The Songs of
Paul Cotton
**Art Director:**
Paula Scher
**Publisher:**
CBS Records

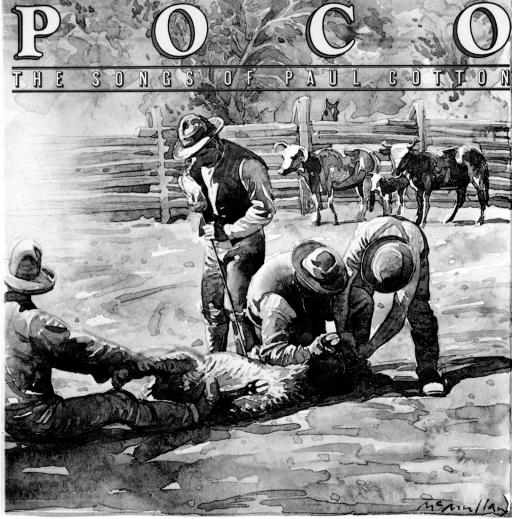

© 1979 *Paul Davis*

9 June 1982 The Greengrass Gallery in Macy's Cellar Celebrates the Publication of

# BOUQUET

Twelve Flower Fables by Myrna Davis
Paintings by Paul Davis

Clarkson N. Potter, Inc./Publishers    One Park Avenue, New York, New York 10016

Copyright 1982 Paul Davis   Distributed Exclusively by Herald Square Publications Inc. New York City

**Illustrator:**
Paul Davis
Sag Harbor, NY
**Poster:**
Bouquet
**Designer:**
Paul Davis
**Publisher:**
Herald Square
Publications, Inc.

**Illustrator:**
Braldt Bralds
New York, NY
**Magazine Spread:**
For Big and Small Jobs
**Art Director:**
Ton Giesbergen
**Agency:**
TBWA Advertising
**Publisher:**
Communication Arts

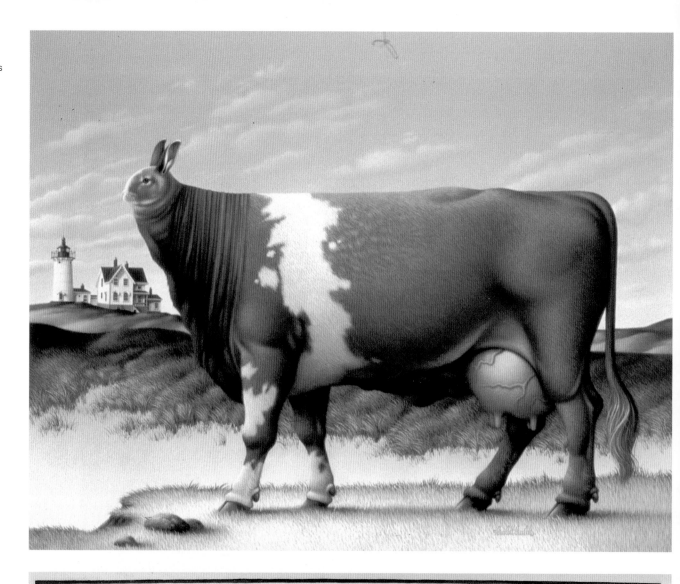

**Illustrator:**
James McMullan
New York, NY
**Poster:**
Cow
**Art Director:**
Carol Carson
**Publisher:**
Scholastic Publications

**Illustrator:**
Heather Cooper
Toronto, CAN
**Poster:**
The University of Guelph
**Art Director:**
Heather Cooper
**Design Firm:**
Burns, Cooper, Hynes Ltd.
**Publisher:**
University of Guelph

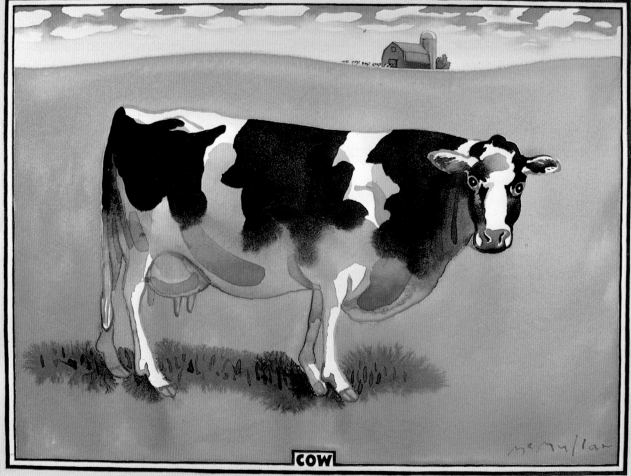

# THE UNIVERSITY OF GUELPH

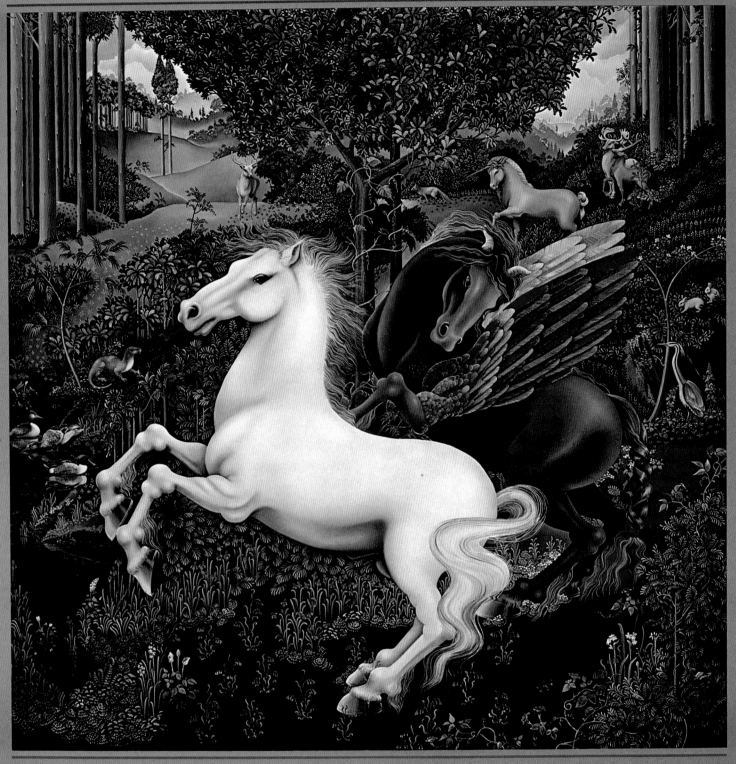

What darkens water
into history,
rings memory
inside young trees,
joins nature and mythology

in the beak of the heron,
the antelope's crown,
the hoof of the stallion,
the whorl of the horn,
wing, fur, claw and
the platinum voice
of the unicorn!

White answers blossom
in the garden of the dawn,
shade horizons with petals
of knowledge and imagination.

The journey begins
on an unbridled horse
by an ebony river
whose surface reflects
the rider's yesterdays
as well as the tomorrows.

The journey continues
toward a meeting
of water and earth,
earth and air.

The arrival begins
with a constellation
of river flowers.

*Janis Rapoport*

**Sculptor:**
David Sasala
Boulder, CO
**Mall Sculpture:**
Snail
**Designers:**
Richard Foy, Henry Beer
**Design Firm:**
Communication Arts, Inc.
**Client:**
City of Boulder, CO

**Sculptor:**
David Sasala
Boulder, CO
**Mall Sculpture:**
Beaver
**Designers:**
Richard Foy, Henry Beer
**Design Firm:**
Communication Arts, Inc.
**Client:**
City of Boulder, CO

**Illustrator:**
Tim Lewis
San Francisco, CA
**Periodical Spread:**
The Potlatch Story
**Art Director:**
Linda Hinrichs
Jonson Pedersen Hinrichs
& Shakery
**Client:**
Potlatch Co.

**Sculptor:**
David Sasala
Boulder, CO
**Mall Sculpture:**
Frog
**Designers:**
Richard Foy, Henry Beer
**Design Firm:**
Communication Arts, Inc.
**Client:**
City of Boulder, CO

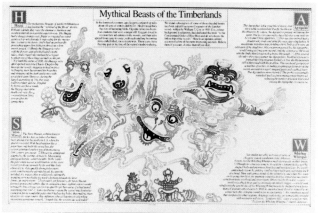

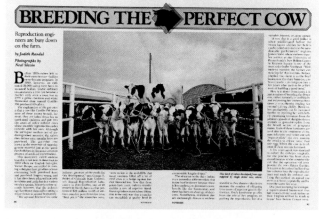

**Illustrator:**
Nigel Holmes
New York, NY
**Chart:**
Scapegoat for
a Volatile Problem
**Art Director:**
Rudolph Hoglund
**Publisher:**
Time, Inc.

**Photographer:**
Neal Slavin
New York, NY
**Magazine Spread:**
Breeding the Perfect Cow
**Art Director:**
Rodney C. Williams
**Publisher:**
Science 82 Magazine

**Illustrator:**
David Wilcox
New York, NY
**Record Album:**
Multiplication x Eric Gale
**Art Director:**
Paula Scher
**Publisher:**
CBS Records

**Illustrator:**
Milton Glaser
New York, NY
**Record Album:**
Ramsey Lewis/
Tequila Mockingbird
**Art Director:**
John Berg
**Publisher:**
CBS Records

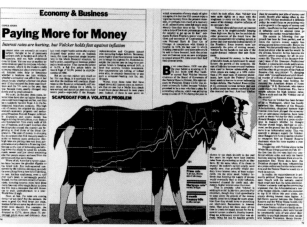

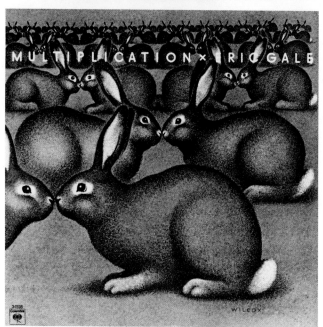

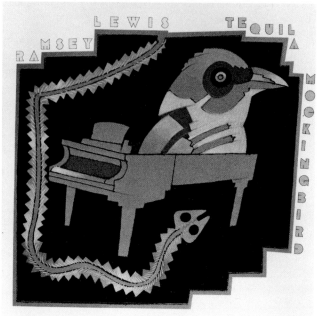

**Photographer:**
George F. Mobley
National Geographic
Washington, DC
**Magazine Spread:**
The Joy of Pigs
**Art Director:**
H. Edward Kim
**Publisher:**
National Geographic
Society

ATTENTION

Contains. Copper, zinc and small amounts of tin.
Metallic oxides, silica sand, cadmium, selenium,
cobalt, chromium, iron and copper. Nickle
sulphite, nickle chloride, boric acid, sulphuric
acid, sodium sulphite, sodium carbonate, sodium
cyanide, natural flavorings and preservatives.
With goodwill towards all people from Performing
Dogs. Doug Johnson and Anne Leigh.

**Photographer:**
Elliot Schneider
New York, NY
**Promotional Folder:**
Foto
**Designers:**
Elliot Schneider,
John Block
**Publisher:**
Alley Pie Publishing Co.

**Illustrator:**
Doug Johnson
New York, NY
**Promotional Item:**
Performing Dogs
Christmas Pin
**Designer:**
Doug Johnson
**Publisher:**
Performing Dogs

**Illustrator:**
Carol Bokuniewicz
New York, NY
**Promotional Item:**
M & Co. Chocolates
**Designers:**
Carol Bukuniewicz
Tibor Kalman
**Client:**
M & Co.

**Photographers:**
Steven C. Wilson and
Karen C. Hayden
National Geographic Soc.
Washington, DC
**Magazine Spread:**
Where Oil and
Wildlife Mix
**Art Director:**
Constance Phelps
**Publisher:**
National Geographic
Society

**Illustrator:**
Chris Rovillo
Dallas, TX
**Poster:**
Change
**Art Director:**
Chris Rovillo
**Publisher:**
Richards, Sullivan
Brock & Assoc.

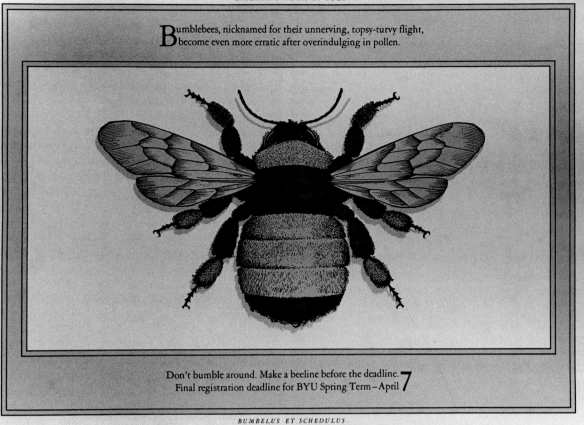

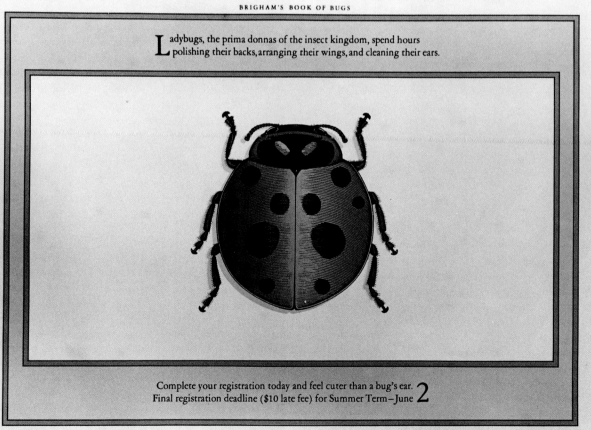

**Illustrator:**
McRay Magleby
Provo, UT
**Poster:**
Brigham's Book of Bugs
Bumblebees
**Art Director:**
McRay Magleby
**Publisher:**
Brigham Young University
Graphic Communications

**Illustrator:**
McRay Magleby
Provo, UT
**Poster:**
Brigham's Book of Bugs
Ladybugs
**Art Director:**
McRay Magleby
**Publisher:**
Brigham Young University
Graphic Communications

**Illustrator:**
Marshall Arisman
New York, NY
**Magazine Spread:**
Teamster Madness
**Art Director:**
Louise Kollenbaum
**Designer:**
Martha Geering
**Publisher:**
Mother Jones Magazine

**Illustrator:**
Dugald Stermer
San Francisco, CA
**Book:**
Vanishing Creatures
**Designer:**
Dugald Stermer
**Publisher:**
Lancaster-Miller Publishers

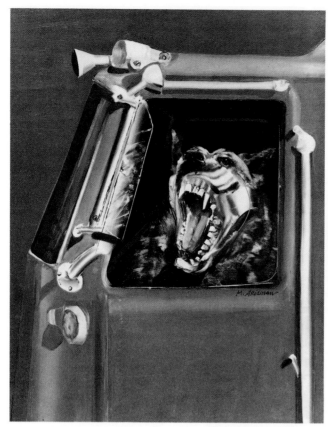

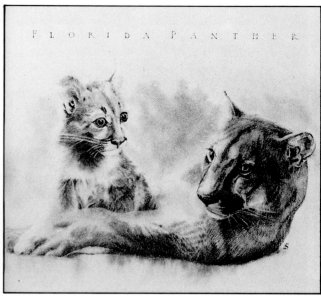

**Illustrator:**
Dan Kirk
New York, NY
**Magazine Spread:**
Bloodbath of the
Killer Fawns
**Art Director:**
Skip Johnston
**Publisher:**
National Lampoon

**Illustrator:**
Mike Hicks
Austin, TX
**Rubber Stamp:**
Past Due, Putting
the Bite on You
**Art Director:**
Mike Hicks
**Publisher:**
Hixo, Inc.

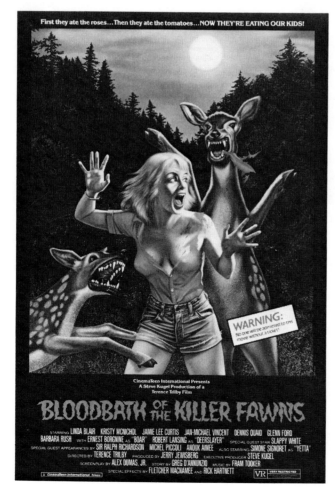

**Illustrator:**
John Collier
Pawling, NY
**Poster:**
Come. They're Waiting
for You
**Art Director:**
Brooke Kenney
**Agency:**
Duffy, Knutson
and Oberprillers
**Client:**
Minneapolis
Zoological Society

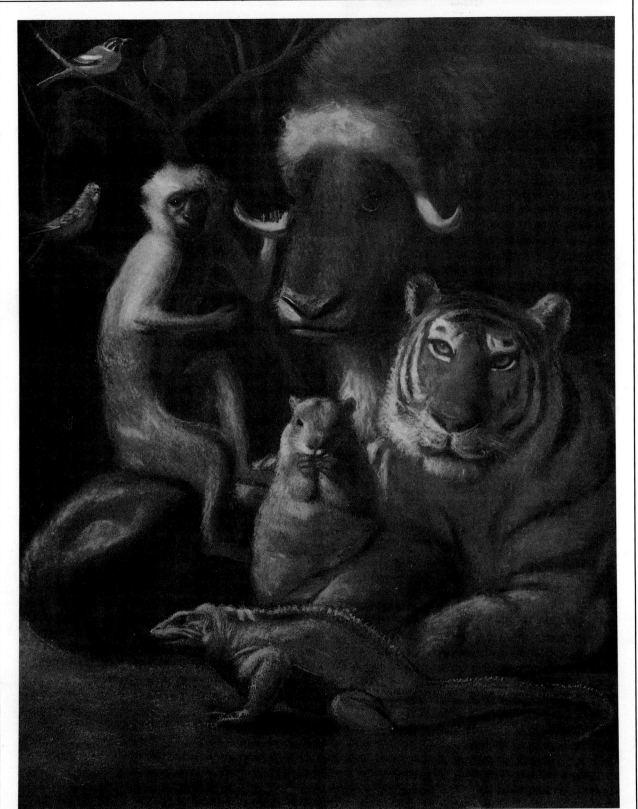

# COME. THEY'RE WAITING FOR YOU.
## JOIN THE FAMILY. THE MINNESOTA ZOOLOGICAL SOCIETY.

**Photographer:**
Corson Hirschfeld
Cincinnati, OH
**Book Spread:**
The Young Doctor's
Demesne.....
**Designer:**
Corson Hirschfeld
**Client:**
Rags 2 Riches

**Illustrator:**
Seymour Chwast
New York, NY
**Magazine Spread:**
Sitting In
**Designer:**
Mark Oliver
**Agency:**
Mark Oliver Assoc.
**Publisher:**
Santa Barbara Magazine

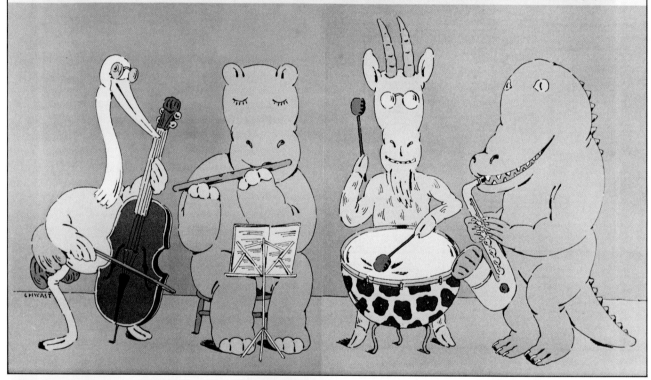

# sitting in

## leonard ("the mouse that roared") wibberley joins in with the santa barbara symphony

In my youth I had many ambitions, some of which turned out happily enough and some of which were doomed to failure from the very start and among the latter was the urge to play violin or viola or even the castanets with the Santa Barbara Symphony. I might have made it, now that I reflect on the matter, if I'd taken up the castanets at a tender age. But I didn't. I picked on the violin, which was one of the many cruelties visited on me unwittingly by my father.

My father was an amateur violinist of some ability. He taught himself, played entirely by ear and could not read a note of music. He played duets with Kreisler and with Heifetz and with Yehudi Menuhin, and my part in these performances was to keep the gramophone wound up, for you understand that these great artists were present only on records—the old 78 RPM records. Whenever he came to a difficult part, he just put his violin down and waited until the easy part turned up. My father

**Illustrator:**
Alex Murawski
Austin, TX
**Magazine Spread:**
Commercial Messengers
**Art Director:**
Robert Priest
**Publisher:**
Weekend Magazine
Toronto Star

'LA CUCARACHA'™ a new typeface and logo design from SketchPad Studio (817) 469-8151

**Illustrator:**
Chad Draper
Arlington, TX
**Promotional Piece:**
La Cucaracha, Logo
and Typeface
**Designer:**
Don Punchatz
**Publisher:**
SketchPad Studio

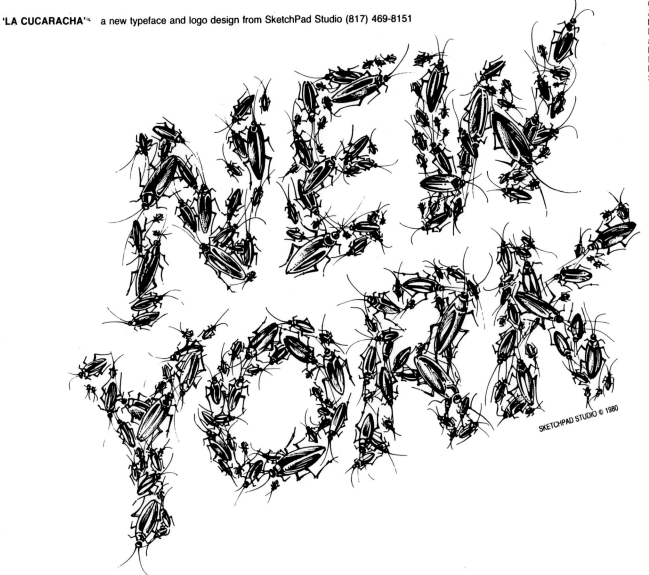

SKETCHPAD STUDIO © 1980

8                                    THE PUSH PIN GRAPHIC

**BESTIAL BOLD**

ABCDE
FGHIJK
LMNOP
QRSTU
VWXYZ
&

①Uncopyrighted 1980 by Push Pin Studios, Inc. Unauthorized use will be met with indifference.

**Illustrator:**
Seymour Chwast
New York, NY
**Type Specimen:**
Bestial Bold
**Designer:**
Seymour Chwast
**Publisher:**
Push Pin Graphic

Whatever its purpose, a book does what no other exercise in graphic design can do in quite the same way — it appeals to us as a complex, yet discreet object.

**Chairman**
Irwin Glusker
Principal
The Glusker Group, Inc.

**Jury**
Leslie Adams, Jr.
President and Publisher
Gryphon Editions, Inc.

Barbara Burn
Editor in Chief
Studio Books
The Viking Press

Judith Michael
Senior Designer
Harry N. Abrams, Inc.

Doris Palca
Head of Publications
The Whitney Museum of American Art

Cameron Poulter
Design and Production Manager
Assistant Director
The University of Chicago Press

Harlin Quist
Designer

A book is different things to different people: the combination of ink and paper; the wrapping in paper or cloth; the strivings of an author, at last made concrete. A book can be useful, entertaining, decorative, or any combination of these. But whatever its purpose, a book does what no other exercise in graphic design can do in quite the same way — it appeals to us as a complex, yet discreet object.

The appeal is a subtle one and, for this reason, judging a book design competition is not an easy task. When the jurors are designers with a particular fondness for the form, it is even more difficult. Add to this the sagging economy and a publishing industry woefully short of coin, and you have disappointed jurors looking in vain for some breathtakingly designed books which simply aren't there.

This was precisely the situation in this year's Book Show competition, in which only 73 of 695 entries surfaced as truly fine examples of the form. As might be expected, there were a few titles that the jurors felt were conspicuous by their absence. But there were no showstoppers, no dazzlers, no "wonder books," and several jurors agreed that the design of textbooks and children's books was particularly lacking. (Indeed, the latter category had by far the most entries, yet the fewest selected.)

Gazing upon any such assemblage of volumes raises its own ambiguities. Can a book of photographs really be judged separately from the photographs themselves? Or should its design make the object — the book itself — disappear? Despite the separation into their own category, can the precious little volumes from private presses be judged fairly, considering the innumerable impressions — good or bad — made by books in the trade category? Does a second color in a particular textbook clarify the material, or does its application confuse the student? And can a juror do justice to these considerations while looking at several hundred volumes in the space of eight hours?

Under such conditions, it becomes necessary to judge each entry, not against the others, but on its own terms — to somehow separate content from context and see if a proper balance has been struck between the two. It's a matter of appropriateness. As one juror observed, there are basically two ways to design a book: one is to let the design, or context, create the book's essential excitement, and the other is to let the design disappear, so to speak, and let the content reveal itself.

This year's Book Show judges were as critical of bindings and endpapers as they were of graphic expertise, and they rejected overproduced entries as readily as those that were poorly produced. Some of the former seemed competently designed from a graphics standpoint, but were, by their oddball formats, virtually unreadable — which made them not well designed at all. While this type of book was more apt to be from a limited edition by a private press, some trade houses were also guilty of overproduction.

Overproduction is, in itself, a curious phenomenon today. Surely, in an industry where economics are to be considered, materials and craftsmanship are likely the first aspects to suffer. In publishing, cloth bindings are replaced by nonwoven, synthetic substitutes; signatures are perfect-bound, rather than stitched and glued; paper is so thin, text can be read in a mirror. Book designers find themselves in conflict with marketing people whose hearts may be in the right place, but whose eyes are firmly fixed on the bottom line.

For publishers, it has become a matter of judging, as accurately as possible, the intersection of those two marketing curves — cost-plus-profit and consumer affordability. Will a parent really spend $15 for a hardcover storybook for his child, or $25 for a novel for himself? Which areas of production can be compromised, and how many, before value and marketability begin to suffer? At what point does less-expensive begin to look cheap?

As hard times in publishing assume the status quo, book publishers and designers are finding their own answers to these questions. Some, as noted earlier, are making expensive objects which also happen to be books; others are printing disposable entertainments to be consumed before they self-destruct.

Fortunately for the jurors, as well as for us, a number of houses are still opting for quality books that enliven, involve and inform. The Book Show includes books from old-line houses that still provide value for their upscale cover prices. There are classics of literature, handsomely designed and sturdily bound, and biographies sensitively tuned to the personas described. There are books for children and childish books for adults. There are softcover books that are every bit as appealing as their hardcover cousins, books as intimate as handbooks or as outsized as tabloids. They are the best the field has to offer and, as such, point to ways in which the publishing industry can, if not thrive, survive.

Communally, they attain that delicate balance between content and form. However simple or complex, they delight as objects, and as objects most will endure.

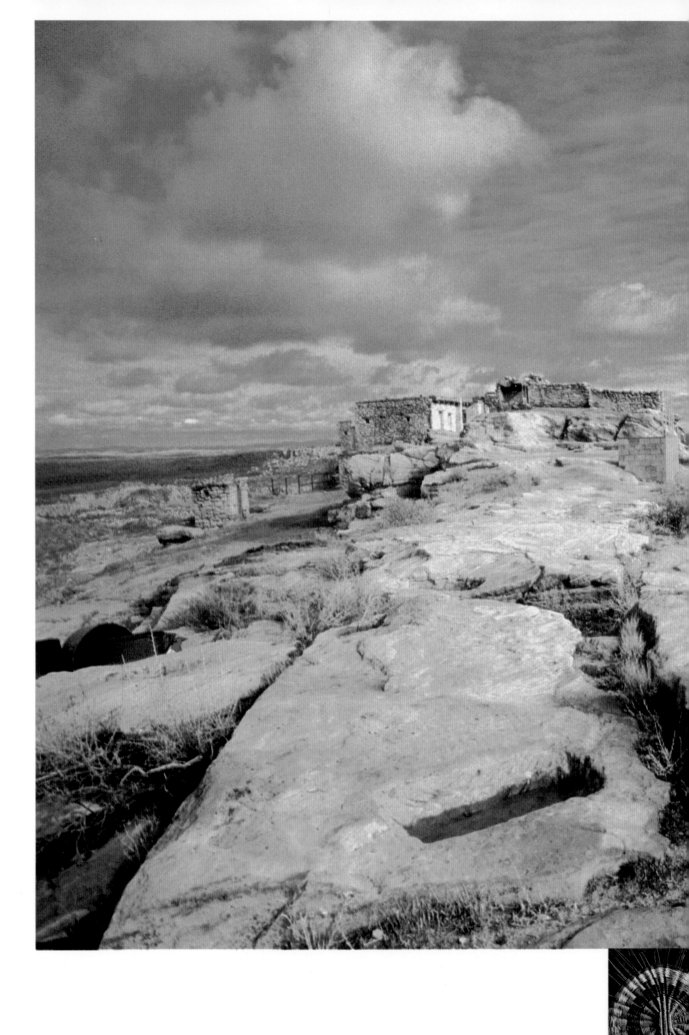

# HOPI

## BY SUSANNE AND JAKE PAGE

HARRY N. ABRAMS, INC., PUBLISHERS, NEW YORK

**Book Title:**
Hopi, The Eagle's Cry
**Authors:**
Susanne and Jake Page
**Editor:**
Robert Morton
**Art Director:**
Samuel N. Antupit
**Designer:**
Patrick Cunningham
**Photographers:**
Various
**Illustrators and
Cartographers:**
Various
**Publisher:**
Harry N. Abrams, Inc.
**Typographer:**
TGA Graphics, Inc.
**Printer:**
Toppan Printing Co., Ltd.
**Production Manager:**
Shun'ichi Yamamoto
**Paper:**
Utrillo Coated 157 g/m²
Kraftpaper 140 g/m²
**Binder:**
Toppan Printing Co., Ltd.
**Jacket Designer:**
Patrick Cunningham
**Jacket Photographer:**
Susanne Page

# HALSMAN
# PORTRAITS

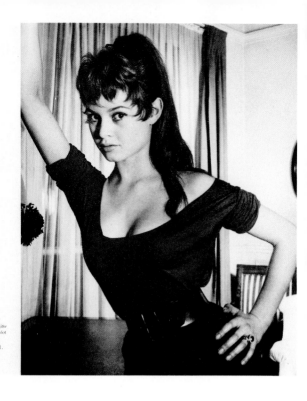

Shirley
Temple

50.

Brigitte
Bardot

51.

**Book Title:**
Halsman Portraits
**Author:**
Yvonne Halsman
**Editor:**
Ken Stuart, Jr.
**Art Directors:**
Bob Mitchell, Roberta Rezk
**Designer:**
Richard Hess
**Photographer:**
Philippe Halsman
**Publisher:**
McGraw-Hill Book Co.
**Typographer:**
Folio Graphics
**Printer:**
Sanders Printing Corp.
**Production Manager:**
Joyce Kaplan
**Paper:**
Warren's LOE #100
**Binder:**
A. Horowitz & Sons
**Jacket Designer:**
Richard Hess
**Jacket Illustrator:**
Philippe Halsman

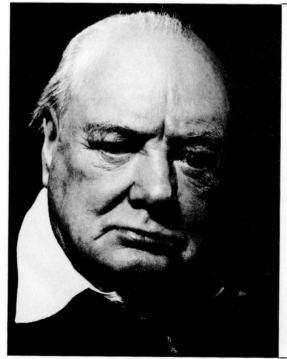

Winston
Churchill

4, 5.

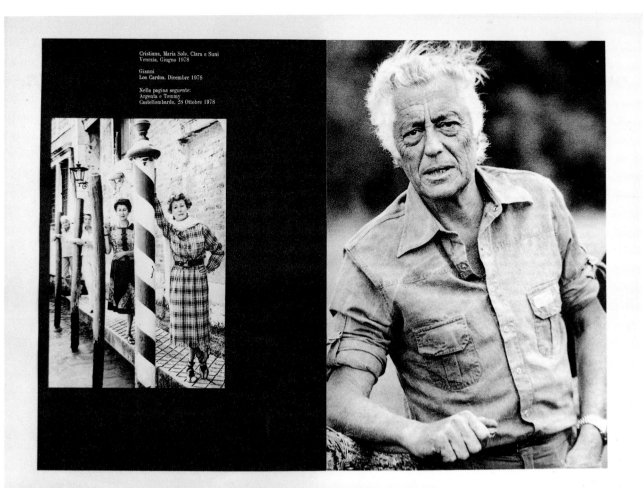

Cristiana, Maria Sole, Clara e Suni
Venezia, Giugno 1978

Gianni
Los Cardos, Dicembre 1978

Nella pagina seguente:
Argenta e Tommy
Castellombardo, 28 Ottobre 1978

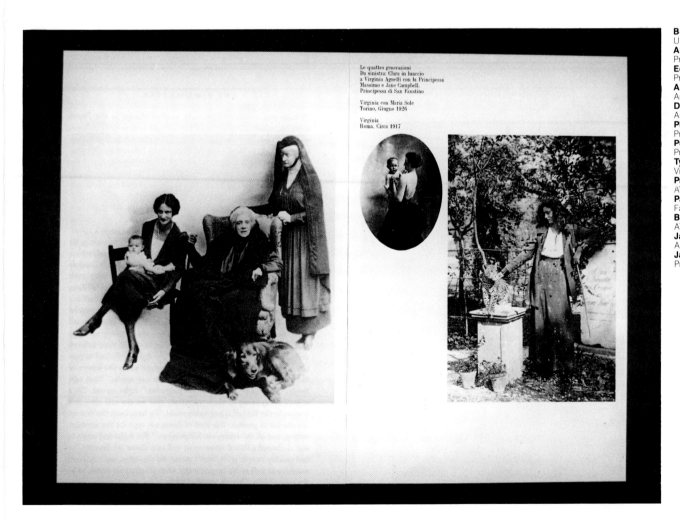

Le quattro generazioni
Da sinistra: Clara in braccio
a Virginia Agnelli con la Principessa
Massimo e Jane Campbell,
Principessa di San Faustino

Virginia con Maria Sole
Torino, Giugno 1926

Virginia
Roma, Circa 1917

**Book Title:**
Una Famiglia
**Author:**
Priscilla Rattazzi
**Editor:**
Priscilla Rattazzi
**Art Director:**
Armando Milani
**Designer:**
Armando Milani
**Photographer:**
Priscilla Rattazzi
**Publisher:**
Privately published
**Typographer:**
Videograf, Inc.
**Printer:**
ATR, Inc.
**Paper:**
Fabriano #150
**Binder:**
ATR, Inc.
**Jacket Designer:**
Armando Milani
**Jacket Photographer:**
Priscilla Rattazzi

**Book Title:**
American Decorative Arts
**Authors:**
Robert Bishop,
Patricia Coblentz
**Editors:**
Darlene Geis, Reginald Gay
**Art Director:**
Samuel N. Antupit
**Designer:**
Judith Michael
**Photographers:**
Various
**Motifs and Borders:**
Lydia Gershey
**Publisher:**
Harry N. Abrams, Inc.
**Typographer:**
Samwha Printing Co.
**Printer:**
Nissha Printing Co., Ltd.
**Production Manager:**
Shun'ichi Yamamoto
**Paper:**
Fukiage matte coated
157 g/m³
**Binder:**
Nissha Printing Co., Ltd.
**Jacket Designer:**
Judith Michael

210.

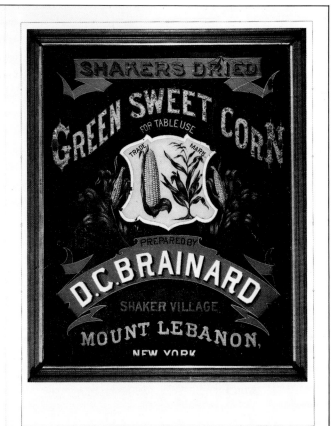

**Book Title:**
George Washington's
Chinaware
**Authors:**
Susan Gray Detweiler
Christine Meadows
**Editors:**
Margaret Kaplan, Louise
Haskett, Joanne Greenspun
**Art Director:**
Samuel N. Antupit
**Designer:**
Bob McKee
**Photographers:**
Will Brown and others
**Publisher:**
Harry N. Abrams, Inc.
**Typographer:**
U.S. Lithograph, Inc.
**Printer:**
Nissha Printing Co., Ltd.
**Production Manager:**
Shun'ichi Yamamoto
**Paper:**
Top coated 157 g/m²
**Binder:**
Nissha Printing Co., Ltd.
**Jacket Designer:**
Bob McKee
**Jacket Photographer:**
Will Brown

No 539.   EDWARD POLE, auctioneer.

## Sales of Elegant Furniture,

On Friday Next the 10th instant, at 10'clock, will be sold by public Auction, at the House of the late President of the United States, in Market street,

A QUANTITY of Valuable Household FURNITURE, belonging to General Washington, among which are, a number of Elegant Chairs with Sattin Bottoms, fattin Window Curtains, a Beautiful Cut Glafs Luftre, and a very compleat Mahogany Writing Defk, alfo, a Coach and Phaeton.

*Footman & Co. auctioneers.*

## 283 Art Deco smoking stand

**Description**
Ashtray on stand has doughnut-shaped receptacle with recesses for cigarettes, mounted on flat, circular tray with curved edge. Above this, an arched, tubular handle pierced in center, for knobbed plunger that opens slidelike trap, so ashes fall into hollow shaft (15–18" deep). Shaft terminates in round, molded base. Welded and screwed construction.

**Materials and Dimensions**
Stainless steel and aluminum. Steel may be enameled black, red, or white. Spring steel plunger device. Height: 25–27". Diameter at top: 16–17".

**Locality and Period**
Large factories in the East and Midwest. c. 1930–45.

**Comment**
The stand seen here was designed by Henry Dreyfuss and manufactured for use on the famous train, the *20th Century Limited*, but the type was widely made during the 1930s. The spring-loaded device for clearing the ashtray is an interesting 20th-century development, and the use of so-called industrial materials (steel and aluminum) is characteristic of design concepts emerging at the time.

**Hints for Collectors**
Ashtrays of this type are plentiful and can often be purchased for practically nothing at yard or church sales, or from secondhand-furniture dealers, although they may command much more at shops specializing in Art Deco furniture. If not damaged, they can usually be cleaned up quickly with a commercial metal cleaner and polisher. Damages to avoid include dents, corrosion, and scratched enamel.

## 284 Rustic smoking stand

**Description**
Stand with cabin-shaped box on square top that rests on tripod base. Top has slightly chamfered corners. At front of top, bent twigs shaped to hold 2 glasses or ashtrays; at rear, small, log-cabin-shaped box has peaked roof that lifts off, revealing storage well for cigarettes. Legs have rough branches with bark, reinforced by stick stretchers in triangular pattern. Coils of twig rise from stretchers, forming decorative loops below top. Other twigs secured to corners of top and joined together to form carrying handle. Nailed construction.

**Materials and Dimensions**
Ash, hickory, or other strong, flexible wood. Pine top and box. May be painted silver, gold, or other colors. Height: 25–28". Width: 13–15". Depth: 12–14".

**Locality and Period**
Small shops and hobbyists, primarily in New England, upstate New York, and northern Michigan. c. 1910–40.

**Comment**
Rustic, twig, or Adirondack furniture was intended primarily for use in mountain lodges and summer homes. It was made and sold locally in resort areas, although some pieces, like the smoking stands, were also sold through chain stores like Woolworth's.

**Hints for Collectors**
Although many people find rustic furnishings crude and unappealing, they are inexpensive and fairly easy to find. Some pieces are relatively plain and uninteresting, but others, like the one shown here, with its log-cabin cigarette box and bent twig decoration, are fine examples of 20th-century folk art.

Hardware

Escutcheons
*keyhole surround* — *oval plate* — *circular plate* — *diamond-shaped plate*

Pulls
*rosette knob* — *turned wooden knob* — *pressed glass knob*

*rosette with pendant ring* — *lion's-head mount with pendant ring* — *circular mount with pear-shaped handle* — *diamond-shaped mount with teardrop handle*

*rosette mounts with bail handle* — *rectangular mount with bail handle* — *batwing mount with bail handle* — *willow mount with bail handle*

*oval mount with bail handle* — *oblong mount with bail handle* — *fruit-carved wooden handle*

**Book Title:**
The Knopf Collectors' Guide to American Antiques Series
**Authors:**
Various
**Editor-in-Chief:**
Gudrun Buettner
**Senior Editor:**
Milton Rugoff
**Managing Editor:**
Susan Costello
**Project Editors:**
Mary Beth Brewer, Jane Opper, Michael Goldman
**Art Director:**
Carol Nehring
**Designer:**
Massimo Vignelli
**Photographers:**
Chun Y. Lai, Raymond Errett
**Illustrators:**
Various
**Publisher:**
Alfred A. Knopf, Inc.
**Producer:**
Paul Steiner, Chanticleer Press
**Typographer:**
Dix Type, Inc.
**Printers:**
Kingsport Press
Dai Nippon Printing Co., Ltd.
**Production Managers:**
Helga Lose, John Holliday
**Binders:**
Kingsport Press
Dai Nippon Printing Co., Ltd.

## Quilts

American quilts combine two ancient traditions— quilting and patchwork. No one knows when quilting began, but a small, carved ivory figure of an Egyptian pharaoh dating from 3400 B.C. wears what looks like a quilted garment. One of the earliest surviving quilted bedcovers, made in Sicily about 1400 A.D., depicts scenes from the legend of Tristan. The technique for making patchwork designs by sewing pieces of fabric together is thought by some historians to be of peasant origin.

**Piecing and Appliquéing**
The term "patchwork" includes two related techniques: piecing and appliquéing. In pieced quilts, many small, usually straight-edged pieces of fabric are sewn together to form a large cloth. In appliquéd quilts, small pieces of fabric are sewn to a single block or a large ground. Appliquéd quilts are predominantly representational, for complex designs can be cut out and stitched down more quickly than they can be pieced together. Often the two techniques are combined in a single quilt.
Because there are no American quilts remaining from the 17th century, we do not know whether the appliquéd or the pieced quilt developed first, but it seems likely that both evolved simultaneously. The earliest known American appliquéd quilts were created by sewing pieces of fabric cut from printed chintzes or imported calicoes onto white cotton or linen spreads, which were then quilted and embroidered. Popular throughout the 18th century, this technique, called broderie perse, enabled the housewife to salvage a worn coverlet or spread.

**Early American Quilts**
In England pieced quilts were fairly common by the end of the 18th century. The most popular form was probably the one-patch design, in which hundreds of identically shaped pieces of fabric were stitched together until an entire bedcover was created.

It is likely that the first settlers brought quilts with them to America. Since materials of all types were scarce in the New World in the late 17th and 18th centuries, and imports were available were very expensive, the creation of patchwork quilts was probably a necessity.
The majority of American pieced quilts were composed of sections known as blocks, each individually constructed by sewing, or "piecing," together pieces of cloth in a pattern that was set beforehand or worked out as the sewing progressed. The finished quilt was usually named after the overall design or, in some cases, for the design repeated in each block.
Quiltmaking in America reached the height of its popularity in the mid-19th century. During the peak period of creative quilting, from about 1775 to 1850, the repertoire of quilt designs expanded greatly. Starting in the East, quilt styles and techniques moved westward with the settlers. Since many of the same patterns were used in several regions, it is nearly impossible to identify a quilt's origin simply by its design or colors. Quilts made in the Amish and Mennonite communities of Pennsylvania and the Midwest are exceptions. These distinctive quilts can easily be recognized by their bold geometric patterns and striking juxtaposition of colors, which range from soft grays and browns to brilliant purples, blues, and pinks. Few Amish quilts made before 1900 survive; most Amish and Mennonite quilts found today date from the 1920s and 1930s.

**19th-century Quilting Bees**
During the 19th century, quiltmaking was an important part of social life. Traditionally, before a young woman was married, she was supposed to make thirteen quilts—twelve for everyday use and a special bridal quilt to be displayed only on important occasions. This thirteenth quilt would be either an elaborate,

*Detail of an appliquéd quilt. Courtesy America Hurrah Antiques, New York City.*

*Detail of an appliquéd quilt. Collection of Ellen Goodman.*

## Quilt Pattern Guide

There are thousands of quilt patterns, some unique and others variations on traditional designs. In many quilts, the same motif is repeated in each pattern block, while in others two or more motifs may be used. Sometimes a single pattern may cover the entire quilt surface; still other patterns are created by changing the fabric color within each block. For example, in Log Cabin quilts both the placement of light and dark fabrics within each block and the arrangement of the blocks determine the overall quilt design.

To help you recognize some of the most common pattern motifs, 36 block designs and 15 overall patterns are illustrated. To show how color arrangement affects the pattern, 5 Log Cabin patterns are shown as both individual blocks and overall designs. Because quilt patterns have had long and widespread popularity, the same design is often known by different names. The most common name appears here; alternate names are included in the text.

**Block Patterns**

| Whig Rose | Rose of Sharon | Rose Wreath | Foliage Wreath |
| North Carolina Lily | Tree of Life | Basket | Basket |
| Maple Leaf | Peony | Bear's Paw | Goose Tracks |
| Robbing Peter to Pay Paul | Flying Geese | Double Pinwheel | Pinwheel |

**Book Title:**
Perspecta 19
The Yale Architectural
Journal
**Authors:**
Various contributors
**Editors:**
Brian Healy, Nate McBride
**Art Director:**
Lorraine Wild
**Designer:**
Lorraine Wild
**Photographers:**
Various
**Publisher:**
The MIT Press
**Typographer:**
G & S Typesetters, Inc.
**Printer:**
Mercantile Printing Co.
**Production Manager:**
Christine Lamb
**Paper:**
Warren's Lustro #80
**Binder:**
Mercantile Printing Co.
**Cover Designer:**
Lorraine Wild

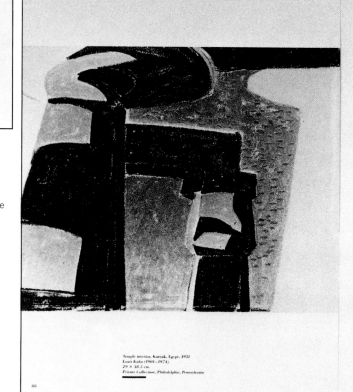

# 1973:

## Brooklyn, New York

LOUIS KAHN

I DISCOVERED SOMETHING ONE DAY. I was in Maryland getting another sort of honorary degree, and I had some prepared speech, which of course I wasn't going to read. I knew what I was going to say. They had a new building, the architects did. They had built a new building and it was there—I think the room was in the center—where the celebration, the degree giving, was held. The room was about a hundred and twenty feet or so long and maybe fifty feet wide and had a balcony. On two ends of the balcony there were musicians—brass instrument musicians on either end—and they played some baroque music of Venetian origin, and it was absolutely wonderful. Nobody played excellently. I heard little sounds that weren't really too good; but altogether, in the way it occupied the hall, this thing made me think of something to say which was not what I had intended, and I think that seeing you all puts me in the same frame of mind.

"I was going to show slides, but I'm not going to show any slides because I am bored with them, you see, myself. Maybe this is because I really don't think that telling you how I do things means very much.

I believe that a man's greatest worth is in the area where he can claim no ownership. The way I do things is private really, and when you copy you really die twenty deaths because you know that you wouldn't even go so far as to copy yourself, you see, because anything you do is quite incomplete. But the part that you do which doesn't belong to you is the most precious for you and it's the kind of thing that you really can offer, because it is a better part of you, actually. The premises anyone can use. Though you may be someone who thinks about them, you only think about them because they are part of a general commonality which really belongs to everybody.

And in getting up to speak, I had to say—after the music had been played, this great music—that it told me something that was terribly important to me. I felt, first of all, very joyous. I felt that which joy is made of.

Perspecta: The Yale Architectural Journal, Volume 19

**Book Title:**
The City Observed: Boston
**Author:**
Donlyn Lyndon
**Editor:**
Jonathan Galassi
**Art Director:**
Bernard Klein
**Designer:**
Carole Lowenstein
**Cartographer:**
David Lindroth
**Photographer:**
Alice Wingwall
**Publisher:**
Random House, Inc.
**Typographer:**
The Haddon Craftsmen, Inc.
**Printer:**
The Murray Printing Co.
**Jacket Designer:**
Adaptation by
Bob Silverman
based on an original design
by R. D. Scudellari
**Jacket Photographer:**
Alice Wingwall

*Palladian motif*

*muntins,* and the sections of metal or wood frame that divide the window into operating sections are called *mullions.* Recently very large windows have been made with single sheets of glass and have no muntins, and in some cases involving fixed glass there are not even mullions; rather, the sheets of glass are held together with clips and epoxy.

To make any window requires more than glass and frame. There must first be an opening in the wall, which requires an arch or a horizontal *header* or *lintel* spanning from side to side, and there must be a *sill* at the bottom to collect water running down the face of the window and throw it out away from the surface of the building. If the opening framed for the window is larger than the glass area, the solid section above and below the glass is termed a *spandrel.* Windows placed very high so that they let light in but do not afford views out are called *clerestory* windows. Windows surrounding a door are called *lights, fanlights* if they are above the door and their muntins are arranged in a radiating pattern, *sidelights* if they are beside the door.

*Quatrefoil* windows occur mostly in churches and are round openings inscribed with round windows in a pattern reminiscent of a four-leaf clover; a *trefoil* window is like a clover you can find. *Oriel* windows are miniature bay windows that bracket forward from the wall. *Palladian* windows consist of a large arched window in the center with smaller vertical windows on either side, the heads of which come only as high as the spring point of the arch for the center window. The frame is usually adorned with columns or pilasters and entablature. Windows of this sort are called *Serlian* by those who wish to demonstrate superior scholarship and *Venetian* by those who consider that neither Serlio nor Palladio can be said to have invented a form that was relatively common in the architecture of Venice and its dominions. In any case, the whole assembly is almost as potent an emblem of human presence as an aedicula.

xxxiv · A NOTE ON ARCHITECTURAL TERMS

I/THE
SYMBOLIC HUB

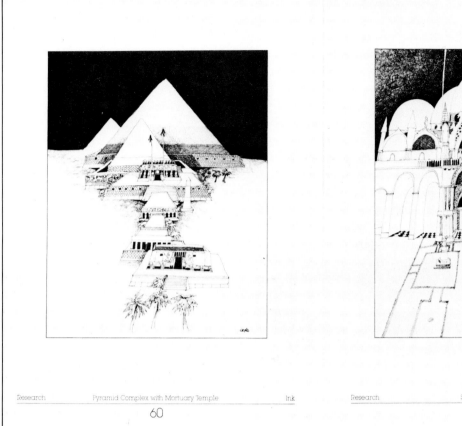

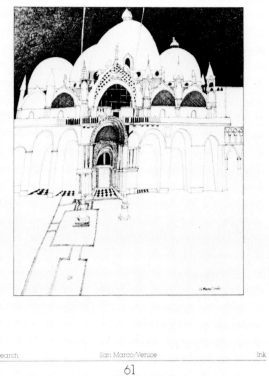

Research     Pyramid Complex with Mortuary Temple     Ink

60

Research     San Marco/Venice     Ink

61

**Book Title:**
The Great Human Race
John L. Doyle/
The Builders
**Editor:**
Roland Paska
**Art Director:**
Thomas E. Hall
**Designer:**
Thomas E. Hall
**Artist:**
John L. Doyle
**Publisher:**
Fishy Whale Press
**Typographer:**
Veras Type
**Printer:**
Reliable Reproductions, Inc.
**Production Manager:**
Thomas E. Hall
**Paper:**
Currency Cover 10pt
Patina Matte #100
**Binder:**
Reliable Reproductions, Inc.
**Jacket Designer:**
Thomas E. Hall
**Jacket Letterer:**
Thomas E. Hall

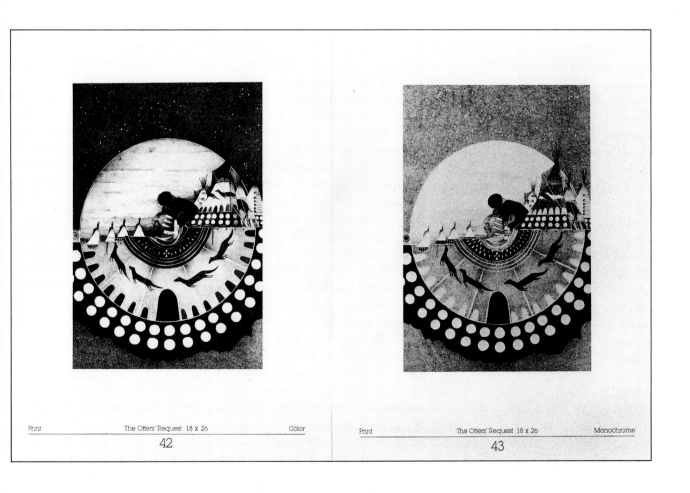

Print     The Otters' Request 18 x 26     Color

42

Print     The Otters' Request 18 x 26     Monochrome

43

**Book Title:**
Urban Romantic
**Author:**
George Tice
**Editor:**
David R. Godine
**Art Director:**
William F. Luckey
**Designer:**
Anne Chalmers
**Photographer:**
George Tice
**Publisher:**
David R. Godine, Publisher
**Typographer:**
Roy McCoy
**Printer:**
The Meriden Gravure Co.
**Production Manager:**
William F. Luckey
**Paper:**
Warren's LOE #100
**Binder:**
Publishers Book
Bindery, Inc.
**Jacket Designer:**
G. G. Laurens
**Jacket Letterer:**
G. G. Laurens

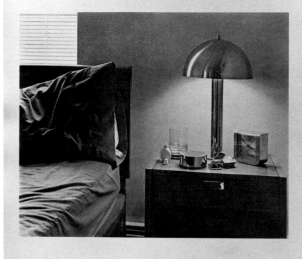

SELF-PORTRAIT · Carteret, New Jersey, 1975

ROCKPORT · Maine, 1978

OF MY PHOTOGRAPH *Self-Portrait, Carteret, New Jersey, 1975*, a reviewer once wrote '. . . there are his still lifes, mostly of ordinary scenes like his bedroom nightstand cluttered with a crushed cigarette pack, clock, lamp, an open bottle of nasal spray and a few other pieces of paraphernalia revealing much (but what?) about a man who seemingly doesn't reveal much about himself otherwise.' The purpose of this Introduction, then, is to reveal a bit more.

When I was about eleven or twelve, I lived for a time in a trailer camp in Lancaster, Pennsylvania. On one side was an Amish farm, on the other a Mennonite school. I used to watch the horse-drawn buggies go by as I waited for the school bus.

I came from a family of itinerant peddlers traveling the country in caravans of automobile-drawn trailers. We moved north in the summer and south in the winter – home was wherever we camped. We were called 'travelers' and had out own ethnic customs, traditions, and language (a mixture of English and Gaelic). Everyone else was 'country people.' My father was a country man. He wanted roots; my mother wanted wheels. I was raised by my mother. When we weren't on the road, New Jersey was home.

My father took pictures. Whenever my mother brought me to visit him, he'd take pictures. When he lived in the two-family house in Newark, he usually took them in the backyard or on the front porch. When he moved to the apartment house in Irvington, he'd take them on the roof or in the public parks. He pasted his pictures into albums, dating them in ink along the white borders, and managed to fill several albums in this fashion.

The first pictures I recall taking were with a Baby Brownie. I snapped my friends and relatives and brought the film to the drugstore for processing. After graduating from junior high school, I purchased a developing set and started processing my own photographs. It was more fun than making model airplanes or drawing pictures. I was never too happy with my drawings – they didn't look as real as photographs. And the model airplanes weren't so perfect either.

Before long, I grew dissatisfied with my little contact prints. I needed more sophisticated equipment, so I found a slide projector on sale for ten dollars and converted it into an enlarger by placing a cardboard diaphragm inside the lens. I bought a 35MM camera, a Kodak Pony. It didn't have a

[ 7 ]

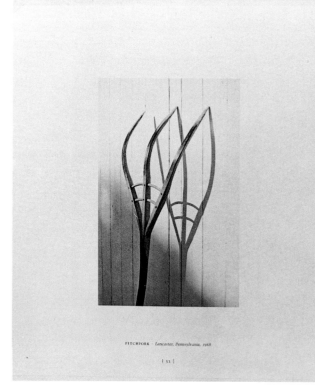

PITCHFORK · Lancaster, Pennsylvania, 1968

[ 32 ]

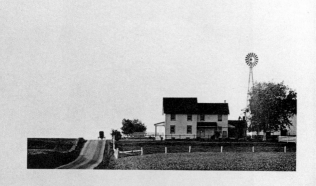

BUGGY AND FARMHOUSE WITH WINDMILL · Lancaster, Pennsylvania, 1965

[ 33 ]

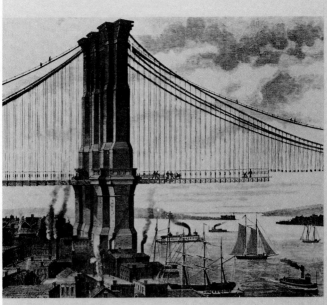

Floor beams being attached to the suspenders. Even this late in construction, the foot-bridge is still in use.

· 9 2 ·

Now Colonel Roebling had one last battle to fight. In 1881 he decided to add an additional 1000 tons of steel to the trusses. Although the additional steel would make the roadway strong and rigid enough to carry the weight of railroad trains, it would mean extra expense and extra time as well.

There was an instant reaction. Eleven years had passed since the bridge was begun, and everyone was outraged at the possibility of another delay. The cost was already well above the original estimate. Not only that, but twenty lives had been lost so far. More than half of the board of trustees of the New York Bridge Company had never even met Colonel Roebling, and of course he hadn't set foot near the bridge in almost nine years. The same old questions were raised again, both by the public and in the offices of the New York Bridge Company. Does the chief engineer know what he is doing? Has he gone insane? The board of trustees asked Colonel Roebling to appear before them.

His reply? "I am not well enough to attend the meetings of the Board, as I can talk for only a few moments at a time, and cannot listen to conversation if it is continued very long . . . I did not telegraph you before the last meeting that I was sick and could not come, because everyone knows I am sick, and they must be as tired as I am of hearing my health discussed in the newspapers."

Upon receiving Colonel Roebling's refusal, some of the newer and younger members of the board suggested that Colonel Roebling resign. When Colonel Roebling heard that, he had one answer. Never! His father was dead. His own health was ruined. For years he and his wife had lived only for the bridge. The struggle was almost over.

All right, then, the board ruled, if you won't resign, then we'll take a vote to decide whether you'll stay on. The board was pretty much split. The old-timers who had been with Colonel Roebling and his father before him wanted him to continue. The younger members were determined to make sweeping reforms in a period that was experiencing all kinds of political and social reforms. They wanted Colonel Roebling out. Word of the conflict leaked, and newspapers and the public took sides, too. Colonel Roebling stayed

· 9 3 ·

**Book Title:**
The Brooklyn Bridge
**Author:**
Judith St. George
**Editor:**
Margaret Frith
**Art Director:**
Margaret Frith
**Designer:**
Kathleen Westray
**Illustrators and Photographers:**
Various
**Publisher:**
G. P. Putnam's Sons
**Typographer:**
Maryland Linotype Composition Co., Inc.
**Printer:**
Halliday Lithograph Corp.
**Production Manager:**
John D'Avino
**Paper:**
Glatfelter #70
**Binder:**
Halliday Lithograph Corp.
**Jacket Designer:**
Kathleen Westray

38

Fig. 28. The Corcoran Gallery of Art. Atrium.

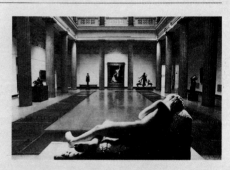

classicism. His building, its Georgia-marble walls rising resplendently above a granite base, its Grecian details extremely refined, its massing horizontal and stately, is in many ways a highly personal statement, but it established a standard for museum architecture that was immediately recognized by Flagg's contemporaries, who lauded his design for

> that massive dignity and grave imperiousness which so well become a building whose main object is at once to inspire by its very exterior reverence for beauty . . . and to preserve within . . . great objects of art.[15]

A purer Greek, without the French accent, is spoken by the Albright (today Albright-Knox) Art Gallery in Buffalo, of 1900–5 (Fig. 29) by Edward B. Green, Sr. (1855–1950), of the firm of Green and Wicks. The building, of white Maryland marble, was the first museum of the acropolis type in the United States. Set in a park overlooking a lake, it is an elegant Ionic collage with souvenirs of the Erechtheum overlaid by memories of the Glyptothek (Fig. 6) and the Altes Museum (Fig. 9). The Albright Art Gallery is another example of the collaborative spirit of the American Renaissance, for its caryatids, representing the arts, were designed by Augustus Saint-Gaudens. The organization departs from the more usual type seen in embryo at the Corcoran; the exhibition areas are all on one level and a lofty central entrance hall replaces the lateral courtyards as a sculpture gallery. However,

39

Fig. 29. Albright (-Knox) Art Gallery, Buffalo, New York. Edward B. Green, 1900–5. Perspective, plan, and elevations.

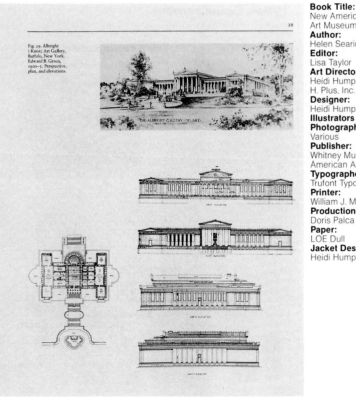

**Book Title:**
New American Art Museums
**Author:**
Helen Searing
**Editor:**
Lisa Taylor
**Art Director:**
Heidi Humphrey / H. Plus, Inc.
**Designer:**
Heidi Humphrey
**Illustrators and Photographers:**
Various
**Publisher:**
Whitney Museum of American Art
**Typographer:**
Trufont Typographers, Inc.
**Printer:**
William J. Mack Co.
**Production Manager:**
Doris Palca
**Paper:**
LOE Dull
**Jacket Designer:**
Heidi Humphrey

**BLUEPRINTS TWENTY-SIX**
EXTRAORDINARY STRUCTURES
WRITTEN AND COMPILED BY CHRISTOPHER GRAY
EDITORIAL COORDINATION BY PATRICIA BROWN
CONCEIVED AND CREATED BY JOHN BOSWELL
DESIGNED BY MARTIN MOSKOF AND ASSOCIATES

A FIRESIDE BOOK
PUBLISHED BY SIMON AND SCHUSTER · NEW YORK

**Book Title:**
Blueprints
**Authors:**
John Boswell
Christopher Gray
**Editor:**
Patricia Brown
**Art Director:**
Martin Moskof Assoc.
**Designer:**
Martin Moskof
**Illustrators:**
Various
**Letterer:**
Latent Lettering
**Publisher:**
Fireside Books/Simon &
Schuster, A Division of
Gulf & Western Corp.
**Typographer:**
Granite Graphics
**Printer:**
Kingsport Press
**Production Manager:**
Stephen F. Konopka
**Paper:**
Finch Opaque Vellum #70
**Binder:**
Kingsport Press
**Jacket Designer:**
Martin Moskof

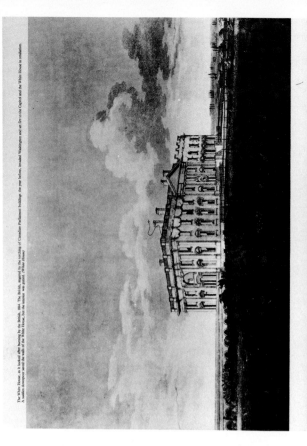

The White House, as it looked after burning by the British, 1814. The British, angered by the torching of Canadian Parliament buildings the year before, invaded Washington and set fire to the Capitol and the White House in retaliation. A sudden downpour saved the walls of the White House, but the interior was gutted. (White House)

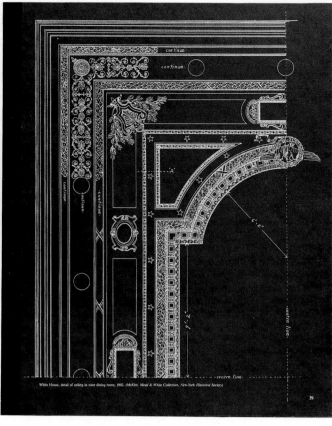

White House, detail of ceiling in state dining room, 1902. (McKim, Mead & White Collection, New-York Historical Society)

39

---

**CITIES**
THE FORCES THAT SHAPE THEM

Cities are more than open spaces, streets, buildings, and the people who inhabit them. They are, above all, the centers of word civilization. Why they look the way they do, how they function, how they affect us, and what we can do to reclaim them are urgent and critical concerns.

**Book Title:**
Cities
**Editor:**
Lisa Taylor
**Art Director:**
Heidi Humphrey/
H. Plus, Inc.
**Designers:**
Heidi Humphrey,
Amy Bernstein
**Illustrators and
Photographers:**
Various
**Publisher:**
The Cooper-Hewitt Museum
**Typographer:**
Cardinal Type Service, Inc.
**Printer:**
Interstate Book
Manufacturers, Inc.
**Production Manager:**
Peter Scherer
**Paper:**
Finch Opaque #70
**Binder:**
Interstate Book
Manufacturers, Inc.
**Cover Designer:**
Heidi Humphrey

## Urban Development

### It has been a long and complicated process.

By Dora P. Crouch

The word civilization literally refers to living in cities, suggesting that human history is inescapably tied up with the history of urban development. Complication may be the basic principle of both human life and urban history. The essential catalyst for the beginning of cities everywhere is variety. It is what makes urban civilization possible. Compared to non-urban life, urban life in any culture is always more varied and more complicated.

Within a city the people vary among themselves and vary more widely from the norm in their society than do those who live in the country. The extremes are found here: the feed singer the fastest pickpocket, the wizard of finance, the wasted drug addict. Such variety in the human contents of this city is reflected in the differing forms of urban architecture and in the special history of each city.

Most of the world's earliest cities grew up in the Middle East or the near the Mediterranean Sea. The oldest whose stone towers and walls come down to us is Jericho, dating back about eleven thousand years. This early date must be seen as the end of a long process of development. During the previous twenty thousand years, people learned to live in groups bigger than extended families and to build first with temporary and then with permanent materials. Jericho is now only a ruin, but some early cities are very much alive. Damascus, for one, is still inhabited after seven thousand years. Oasis gardens have always made life possible there, as they still do. The recent loosening of the compact form of the city, made possible by the automobile, changes the appearance but not the essence of Damascus. The change reveals a basic law of cities—that they grow by both extension and remodeling.

Extension and remodeling are the core of the history of Ostia, once the port of Rome. In the middle of the first millennium B.C. Ostia was founded as a river fortress to guard the approach to Rome. By the first century A.D. the original fort had long since been outgrown, and a busy port stretched out along the Tiber River. A century later the town had become so crowded that it was necessary to replace the one- and two-story dwellings with three- and four-story apartments. By the fourth century, the town had largely silted up, and Ostia's function as a port was over. The town found new life as a resort community for wealthy Romans. The once-crowded apartments were rebuilt into spacious single-family homes. Thus Ostia grew first outward, then upward, then inward. Its changing structures mirrored its changing functions and population.

During the same period, cities in different places vary greatly in their social structure and architectural equipment. Social structure has always been based on division of labor; beginning probably with simple divisions—hunter/nurse, shoemaker/pedestrian—but becoming increasingly sophisticated as more trades developed. Degree of complexity in occupation was reflected in the number of building types. A Greek city of the fourth century B.C. had more forms than a Persian one, because life in a Greek city was more complex. Where the Persians made do with temple, palace, house-workshop, and market, the Greeks added theaters, political and judicial meeting places, fountain houses, offices, schools, council chambers, health clubs, and racecourses.

Walls were a major feature of these traditional cities, excluding the non-urban world, but did not overtop the city. In Italian medieval cities, by contrast, the center was strongly emphasized. Here were the cathedral and the seat of government, each with a tower and each facing a large plaza. Ambitious citizens might challenge these two by erecting their own towers. As the town grew, by centrifugal action, neighborhoods turned around less-er church and plaza nodes. Venice is a good example, with its famous Piazza San Marco serving as a center for the whole city, and many smaller squares serving as focal points for their immediate neighborhoods.

Until the development of warfare based on gunpowder the city wall remained part of the composite urban image, a circle of wall overtopped by a church spire or dome and the other urban towers. Only in the nineteenth century were those walls razed and replaced by boulevards—the centrifugal forces winning at last.

These gradual processes of urban growth contrast with the deliberate and conscious creation of new cities. For the ancient Egyptians, only gods could found cities, but the Romans knew this as a human activity. They even had a precise date for the founding of Rome by Romulus and Remus—753 B.C.—beginning the customary link between history and urbanism.

Creation of new cities has been typical of many periods in history. The Greeks colonized the Mediterranean in the eighth century B.C. by building cities. Spaniards and Portuguese laid out over four hundred New World cities in three hundred years after Columbus. The urban frontier in the United States spread from east to west and then, particularly after World War II, from north to south. In most cases, new cities competed with older ones, sometimes thriving and sometimes fading away, depending on the number and variety of reasons for their existence at that particular place.

Aristotle said that people come to live in cities to be safe, and continue there in order to live well. Within the city, the one hundred years after Columbus. The urban frontier in the United States spread from east to west and then, particularly after World War II, from north to south. In most cases, new cities competed with older ones, sometimes thriving and sometimes fading away, depending on the number and variety of reasons for their existence at that particular place.

Whether in the ancient or the modern world, there are certain limits on urban growth. Ancient Rome may have had 1.2 million people, an exceptionally large population for that time. Medieval cities were much smaller, and even in the rich of the fifteenth century, there was scarcely a city in Europe of over eighty thousand people. Only about 30 percent of any society could live in urban centers before the Industrial Revolution. Today, 75 percent of the American people live in urban areas. In some countries, the concentration is even greater—in Greece today, half the people live in Athens—what a contrast to Aristotle's idea that a city could not exceed one hundred thousand people! Today, two cities stand at more than ten million people each.

What has happened to the traditional limits on urban growth? These are, first, the food supply; second, the invisible support system of water supply and sewerage; third, wealth; and fourth, time. The trip to work cannot comfortably take more than one hour each way. The hour can be spent on foot, as in the pre-industrial cities, on the steel wheels of railways, which expand the city along corridors, or on the rubber tires of the auto, the source of urban sprawl.

With cheap energy and technological innovation, the cities of the industrial era tended to gigantism. For a brief 150 years bigger was better. Brasilia, the new capital of Brazil begun in the 1950s, is a final-image of our infatuation with mechanization. As Brasilia struggles to incarnate itself as a place for human life and not merely as a set of propaganda gestures, that legacy of gigantism is more troublesome. Now in its third decade, the conflict between grand aspirations and pedestrian needs is being worked out bit by bit, as Brasilia fills in its empty superblocks.

We have grown accustomed to the spread of post-industrial cities, though we still prefer to visit compact Florence rather than expanded Detroit. But the energy crisis is forcing us to question whether urban gigantism is necessary or merely customary. How can we afford to maintain these megalopolises with their huge energy costs, up-keep costs, and human costs?

We have arrived at a point in history when we must re-examine the function of the city and the needs of its inhabitants. How large should cities be? What varieties of experience should they provide for their inhabitants? Is the ugliness of post-industrial cities essential, or can we learn to manipulate the rhythms of closed and open spaces of varying densities, of major architectural monuments and modest background buildings, to make cities more satisfactory places for humans to live? What can be done to treat a wider variety of people feel comfortable and happy in today's cities?

Dora P. Crouch teaches architectural and urban history at Rensselaer Polytechnic Institute and was the founding president of the Urban History Chapter of the Society of Architectural Historians.

Piazza San Marco, Venice.

Colosseum, Rome.

CITIES 7

## Urban Graveyards

### Our burial grounds reveal our attitude toward death.

By F. Andrus Burr

Graveyards are much like miniature cities; they are close packed communities of people, each in a private house, marked by a landscape of monuments that create the effect of a great metropolis. The urban graveyard, the city of the dead within the city of the living, has a long and important history in Western culture. The future of the urban burial ground, however, is uncertain, clouded by twentieth-century attitudes toward death and its symbols.

The Greeks created cemeteries and erected tombstones that would look familiar to twentieth-century Americans. They also built funerary structures, one of which, the immense tomb of Mausolos at Halicarnassus, gave us the word mausoleum. The Greeks even originated the concept of the garden cemetery, honoring the dead and at the same time creating an Elysian landscape for the enjoyment of the living. This type of cemetery was eventually forgotten, only to reappear in the nineteenth century.

The Romans, first in many cultures to appreciate the Greeks, adopted most aspects of Greek cemeteries and funerary architecture. Roman graveyards, however, which were rather linear in nature, were located on roads leading out of the cities and were intended to be places of high visibility. The great tombs of imperial Rome, like the mausoleum of Hadrian (now the Castel Sant'angelo), were among the most imposing and spectacular of all time. But it was the Romans, perhaps the first to face the problem of overcrowded cemeteries, who developed the idea of cremation and built the great Columbaria to store the ashes of the dead.

Later, the Christian church took on the role of guardian of the dead and used the catacombs for burial. Because of the belief in a material resurrection, cremation was forbidden by the church, and this unfortunate ban continued until the late nineteenth century. It would be interesting to read the argument claiming that the body would be more fit for judgment day after countless years underground than if transformed to ashes.

By the Middle Ages many people were actually being buried within the church itself; their interment within the sacred structure serving to recommend them for a favorable afterlife. But the main place of burial was in the churchyard, a small plot immediately adjacent to the church. In Europe the fees charged for these burials were an important source of income for the church. When urban churchyards became too crowded to accept more burials (and this occurred frequently in the days of the Great Plagues) the ground was dug up and the bones removed to a charnel house so that the graveyard could be reused and continue to provide income for the church.

With the coming of the Renaissance and new ideas of individualism, people began insisting on permanent burial places, and the reuse of cemeteries was looked on with increasing disapproval. The late eighteenth century graveyards had become rather forbidding places. The custom of cutting the grass and growing flowers by the grass was a nineteenth-century innovation. Grave stones were all rather similar, for their chief function was not as ornament, but as a marker and a record. Furthermore, the very function of the graveyard in society was different from what we now perceive it to be. It was a group monument to death. Located in the middle of the city (the dead center), without adornment of trees or bushes, it was a daily reminder of grim death and duty with no sweet sentiments or romance attached.

With the rapid growth of cities in Europe and America, churchyards had become overcrowded by the end of the eighteenth century. In many bodies were buried three and four deep, some barely underground. The result was a steamy miasma of evil humors and putrid stench. This repulsive situation, combined with social and cultural forces, led to sweeping changes in burial customs and ideas about what the graveyard should be.

The new nineteenth-century graveyard was called a cemetery, a reinvention of the Greek burial place. It was removed from the center of the city and it was removed from the control of the church. Mount Auburn, the first great American cemetery, was established by a nonprofit corporation and was located on the fringes of Cambridge, Massachusetts, well outside the city limits of Boston. These new cemeteries were elaborately landscaped and planted: no longer a grim "memento mori," they were great Arcadian landscapes, romantic and beautiful. Gravestones changed profoundly as well. They were no longer markers, but monumental symbols of the taste and aspirations of each individual. Statuary, draped urns, obelisks, and classical columns became common ornaments, which were both more imposing and more personal than eighteenth-century gravestones. And with these changes, the function of the cemetery itself changed. No longer a daily reminder of death, it became instead a special place to visit, a capsule of idealized nature where the living could seek inspiration and commune with the dead.

These cemeteries were received with enthusiasm in both Europe and America. In Paris it was the Père Lachaise Cemetery; in London, Highgate; in Glasgow, the Necropolis; and in New York, Greenwood. In all of them, the monument was not just the stone marker, but the whole environment. And with an environment a walk through any of these great burial grounds is a trip through the collective nineteenth-century mind. Sublime, awesome, maudlin, or even humorous, the experience is always rewarding. It is important to recognize that deeper certain resemblances, these great cemeteries are not parks. The cemetery serves a totally different but equally important function for society. Everyone likes a good softball game, but it would be a grave tragedy if, as some planners of the sixties suggested, we were to move all the gravestones out to the perimeter and use the space for recreation.

The twentieth-century edition of the landscaped cemetery is the "memorial park." These are vast fields of grass with bronze markers set just below the surface of the turf. Big golf course tractors with gang mowers can roam around and keep the whole place looking like someone's dream of the ideal suburban lawn. Add a couple of funeral chapels (these can do double duty for marriages), a few trees, a small formal garden, and that's it—simple and inexpensive. The perfectly logical development of twentieth-century life, the memorial park provides fast and efficient disposal of the corpse. No muss, no fuss. It is also a clear indication of our peculiar American fear of death and aversion to its symbols. It's easy to pretend that these big lawns are just that and no more, and maybe those little bronze plaques will be covered by the lush suburban grass, and we can just forget about the whole distasteful business.

Once again there is talk of overcrowding in urban cemeteries. The great nineteenth-century landscaped cemeteries have been engulfed by fast-growing cities, and the adjacent lands are far too marketable to be used for cemetery expansion. Likewise some of the older memorial parks are filled and unable to acquire new land. What are we to do with our dead? There are at least three perfectly good solutions, and all of them have been used in the past at various times. The first is cremation. Renewed interest in cremation started as far back as the mid-nineteenth century with reformers who were already concerned about the amount of land being used for conventional burials. Naturally one advantage of cremation is that you don't have to bury anything in the ground. You can have your ashes spread over a flower garden, strewn from an airplane, or blasted out of a twelve gauge shotgun—except, of course, in those states where the powerful funeral directors' lobby has persuaded the legislature to prohibit such unsavory practices. At any rate, even in those places your ashes can be kept in a nice little box on the mantel. The chief disadvantage of cremation is that it uses a lot of fuel and is therefore increasingly expensive and wasteful. Solar energy might provide a good answer to this, and further more it has a certain poetic touch—your body is placed in a solar furnace and incinerated by the great white light of the sun.

Another possible solution for urban burial is resepulchral structures—high rise cemeteries or vast catacombs laced into the networks of subway tunnels and underground utilities. These ideas appeal to many architects, and there is historical precedent, but they are not especially appealing to the general public. The unavoidable image is that of storing your departed relative in a filing drawer in the World Trade Center or in some disused part of the Fourth Street subway station. These solutions would have to be approached with a lot of architectural finesse and some very good public relations work.

Probably the best solution, and the soundest ecologically, is the old medieval method—burial in the ground with only a shroud to cover the body (or some quickly degradable container). This would insure rapid dissolution of the corpse and, after an appropriate passage of time, the burial plot could be reused. This is still the practice in some Paris cemeteries, notably Père Lachaise, where one buys a seventy- or one-hundred-year lease on a gravesite. This system is no wasteful of land, and it insures a constant income for the upkeep of a proper urban burial place.

The real cross associated with burial grounds is not the overcrowding problem, it is the low quality of design in twentieth-century funerary architecture. A culture is remembered by its monuments, and our endless rows of granite with banal soapblasted inscriptions tell a pretty boring and pathetic story as do our ersatz funeral chapels and crematoriums. We seem to have lost the ability to memorialize with architecture and sculpture. Building a new wing for a high school or naming the C.A.T. scanner for a notable deceased person just doesn't count for much in the great historical overview.

With a few exceptions—like Aldo Rossi's evocative cemetery project for Modena or Frederick Fisher's solar crematorium project—architects have not involved themselves with funerary architecture. But a current increase of interest in monumental architecture may indicate that it is once again appropriate to investigate the architecture of death. Perhaps our society will also examine, and re-discover, its relationship to the dead and the potential that cemeteries hold for the enrichment of life.

F. Andrus Burr is an architect who works in New York and teaches part time at Yale.

Graveyard, Bethlehem, Pennsylvania.

CITIES

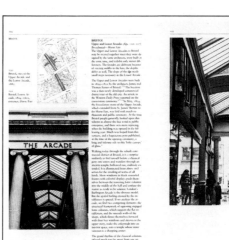

**Book Title:**
Arcades
**Author:**
Johann Friedrich Geist
**Editor:**
Cynthia Ware
**Designer:**
Diane Jaroch
**Diagrams, Illustrations
and Photographs:**
Various
**Publisher:**
The MIT Press
**Typographer:**
Achorn Graphic
Services, Inc.
**Printer:**
Halliday Lithograph Co.
**Production Manager:**
Dick Woelflein
**Paper:**
Mohawk MIT Special
**Binder:**
Halliday Lithograph Co.
**Jacket Designer:**
Diane Jaroch
**Jacket Illustrators
and Photographers:**
Various

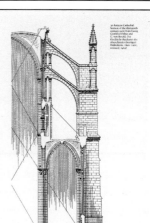

**Book Title:**
Experiments in
Gothic Structure
**Author:**
Robert Mark
**Editor:**
Robin Sweesy
**Designer:**
Celia Wilson
**Photographer:**
Robert Mark
**Publisher:**
The MIT Press
**Typographer:**
Village Typographers, Inc.
**Printers:**
Halliday Lithograph Co.
Mark Burton, Inc.
**Production Manager:**
Rachel Matthews
**Paper:**
Monadnock MIT Special
**Binder:**
Halliday Lithograph Co.
**Jacket Designer:**
Celia Wilson
**Jacket Photographer:**
Sepp Seitz

**Book Title:**
The ITC Typeface
Collection
**Author:**
Aaron Burns
**Editor:**
Aaron Burns
**Art Directors:**
Bob Farber, Ilene [...]
**Designer:**
Bob Farber
**Publisher:**
International Typef[...]
**Typographer:**
M. J. Baumwell Ty[...]
**Printer:**
Lithomart, Inc.
**Production Mana[...]**
John T. Prentki
**Binder:**
Publishers Book B[...]
**Jacket Designer:**
Bob Farber

---

THE
COLLECTED
STORIES
OF
ISAAC
BASHEVIS
SINGER

FARRAR · STRAUS · GIROUX
NEW YORK

**Book Title:**
The Collected Stories
of Isaac Bashevis Singer
**Author:**
Isaac Bashevis Singer
**Editor:**
Robert Giroux
**Art Director:**
Neal T. Jones
**Designers:**
Cynthia Krupat,
Herb Johnson
**Photographer:**
Peter J. Kaplan
**Publishers:**
Book-of-the-Month
Club, Inc.
Farrar Straus Giroux,
Licensee
**Typographer:**
Maryland Linotype
Composition Co., Inc.
**Printer:**
The Maple Press Co.
**Production Manager:**
Kenneth Milford
**Paper:**
Mohawk Ticonderoga
Text #60
**Binder:**
Tapley-Rutter Co., Inc.

---

380                    ISAAC BASHEVIS SINGER

heat. Esther kept reproaching me for wearing a stiff collar, a vest, and a hat in the hot weather. She saw me now and seemed embarrassed, like a provincial girl from Poland. We had never been together in public. We spent our time in the dark, like two bats. She made a move to leave, but my companion at the table called out to her. She approached unsteadily. She was wearing a white dress and a straw hat with a green ribbon. She was brown from the sun, and her black eyes had a girlish sparkle. She didn't look like a woman approaching forty, but slim and youthful. She came over and greeted me as if I were a stranger. In the European fashion, she shook my hand. She smiled self-consciously and said "you" to me instead of "thou."

"How are you? I haven't seen you for a long time," she said.

"He's hiding." The writer denounced me. "He's not doing anything about his visa and they'll send him back to Poland. The war is going to break out soon. I advised him to marry an American woman because he'd get a visa that way, but he won't listen."

"Why not?" Esther asked. Her cheeks were glowing. She smiled a loving, wistful smile. She sat down on the edge of a chair.

I would have liked to make a clever, sharp reply. Instead, I said sheepishly, "I wouldn't marry to get a visa."

The writer smiled and winked. "I'm not a matchmaker, but you two would make a fitting pair."

Esther looked at me questioningly, pleading and reproachful. I knew I had to answer right then, either seriously or with a joke, but not a word came out. I felt hot. My shirt was wet and I was stuck to my seat. I had the painful feeling that my chair was tipping over. The floor heaved up and the lights on the ceiling intertwined, elongated and foggy. The café began to circle like a carrousel.

Esther got up abruptly. "I have to meet someone," she said, and turned away. I watched her hurry toward the door. The writer smiled knowingly, nodded, and went over to another table to chat with a colleague. I remained sitting, baffled by the sudden shift in my luck. In my consternation I took the coins from my pocket and began to count and recount them, identifying more by touch than by sight, doing intricate calculations. Every time, the figures came out different. As my game with the powers on high stood now, I seemed to have won a dollar and some cents and to have lost refuge in America and a woman I really loved.

---

I · B · S

## *The Cabalist of East Broadway*

As happens so often in New York, the neighborhood changed. The synagogues became churches, the yeshivas restaurants or garages. Here and there one could still see a Jewish old people's home, a shop selling Hebrew books, a meeting place for *landsleit* from some village in Rumania or Hungary. I had to come downtown a few times a week, because the Yiddish newspaper to which I contributed was still there. In the cafeteria on the corner, in former times one could meet Yiddish writers, journalists, teachers, fund raisers for Israel, and the like. Blintzes, borscht, kreplech, chopped liver, rice pudding, and egg cookies were the standard dishes. Now the place catered mainly to Negroes and Puerto Ricans. The voices were different, the smells were different. Still, I used to go there occasionally to eat a quick lunch or to drink a cup of coffee. Each time I entered the cafeteria, I would immediately see a man I'll call Joel Yabloner, an old Yiddish writer who specialized in the Cabala. He had published books about Holy Isaac Luria, Rabbi Moshe of Cordova, the Baal Shem, Rabbi Nachman of Bratslav. Yabloner had translated part of the Zohar into Yiddish. He also wrote in Hebrew. According to my calculations, he must have been in his early seventies.

Joel Yabloner, tall, lean, his face sallow and wrinkled, had a shiny skull without a single hair, a sharp nose, sunken cheeks, a throat with a prominent Adam's apple. His eyes bulged and were the color of amber. He wore a shabby suit and an unbuttoned shirt that revealed the white hair on his chest. Yabloner had never married. In his youth he suffered from consumption, and the doctors had sent him to a santorium in Colorado. Someone told me that there he was forced to eat pork, and as a result he fell into melancholy. I seldom heard him utter a word. When

*Translated by Alma Singer and Herbert Lottman*

3 · 8 · 1

---

FREDERICK ASA[...]
Flannery O'C[...]
The Imagination of E[...]

**Book Title:**
Flannery O'Connor[...]
The Imagination of
Extremity
**Author:**
Frederick Asals
**Editor:**
Ellen Harris
**Art Directors:**
Charles East
Sandra Strother Hud[...]
**Designer:**
Sandra Strother Hud[...]
**Illustrator:**
Michael McCurdy
**Publisher:**
The University of
Georgia Press
**Typographer:**
G & S Typesetters, [...]
**Printer:**
Thomson-Shore, Inc[...]
**Production Manag[...]**
Sandra Strother Hud[...]
**Paper:**
Glatfelter B-31 #50[...]
**Binder:**
John H. Dekker & S[...]
**Jacket Designer:**
Sandra Strother Hud[...]
**Jacket Illustrator:**
Michael McCurdy

---

*My Sam*
A MEMOIR BY HIS WIFE
SAIDYE ROSNER
BRONFMAN

Privately Printed
1982

**Book Title:**
My Sam
**Author:**
Saidye Rosner Bronfman
**Designer:**
Glenn Goluska
**Photographers:**
Various
**Publisher:**
Privately published
**Typographer:**
Glenn Goluska,
The Nightshade Press
**Printer:**
The Porcupine's Quill, Inc.
**Production Manager:**
Glenn Goluska
**Paper:**
Mohawk Superfine
**Binder:**
T. H. Best Printing Co., Ltd.

---

## ADVENTS OF GOOD TOMORROWS

T HE GREATEST PLEASURE FOR ANY parent is to see the children settle into happy and productive lives of their own. This was certainly true for my Sam and me. In 1953 Edgar married a lovely girl, Ann Loeb, and that summer the young couple lived in our house in Tarrytown. My Sam and I were away on a business trip in England and Scotland and when we came back in September, Ann was pregnant with their first child.

One evening, as we were all sitting around the dinner table, Edgar suddenly said, 'Father, if our baby is a son, how would you feel if we named him after you?' My husband was well aware that in Orthodox Jewish tradition a child is not supposed to be named after a living person. He sat perfectly silent and he didn't say a word. Later, when we went upstairs to bed, he confessed that he was very pleased, but was so taken aback by what Edgar had proposed that he simply didn't know what to say.

[ 100 ]

He mulled it over and the next morning, with a twinkle in his eyes, he gave the children his consent.

October 23, 1953 – now that was a busy night! In Paris, Minda announced her engagement to Alain, Baron de Gunzburg, and in New York Ann went into labour. Edgar rushed her to the hospital. My Sam was in our suite at the St. Regis and I was in Montreal when Edgar called us both in the middle of the night. Mother and child were fine and the baby was a boy. His grandfather was extremely happy.

When Samuel II was just 10 days old, Edgar and Ann brought him to Montreal where they lived in a small apartment for nearly six months, while they redid a house on Aberdeen Avenue. As with his own children, my Sam was afraid to hold his first grandchild. He would just stand and look. Edgar and Ann had four more children: Edgar Miles Jr., Holly Dorothy, Matthew and Adam Rodgers.

Minda and Alain were married in Paris on December 1, 1953, in a ceremony at the home of his grandmother. They have a beautiful home there, and they have two fine sons, Jean François Charles and Charles Samuel. My Sam and I visited them as often as we could.

Edgar had always felt more comfortable in New York than in Montreal. In 1955 he moved to New York, and in 1957 my husband made him president of the American company. I frankly protested

[ 101 ]

---

## The Three Theban Plays (top spread)

**CHORUS**

Love, never conquered in battle
Love the plunderer laying waste the rich!                    880
Love standing the night-watch
        guarding a girl's soft cheek,
you range the seas, the shepherds' steadings off in the wilds—
not even the deathless gods can flee your onset,
nothing human born for a day—                                885
whoever feels your grip is driven mad.
                Love
you wrench the minds of the righteous into outrage,
swerve them to their ruin—you have ignited this,
this kindred strife, father and son at war
                and Love alone the victor—             890
warm glance of the bride triumphant, burning with desire!
Throned in power, side-by-side with the mighty laws!
Irresistible Aphrodite, never conquered—
Love, you mock us for your sport.

*Antigone is brought from the palace
under guard.*

But now, even I'd rebel against the king,                    895
I'd break all bounds when I see this—
I fill with tears, can't hold them back,
not any more . . . I see Antigone make her way
to the bridal vault where all are laid to rest.

**ANTIGONE**

Look at me, men of my fatherland,                            900
        setting out on the last road
looking into the last light of day
the last I'll ever see . . .
the god of death who puts us all to bed
takes me down to the banks of Acheron alive—               905
        denied my part in the wedding-songs,
no wedding-song in the dusk has crowned my marriage—
I go to wed the lord of the dark waters.

**CHORUS**

Not crowned with glory, crowned with a dirge,
you leave for the deep pit of the dead.                      910
No withering illness laid you low,
no strokes of the sword—a law to yourself,
alone, no mortal like you, ever, you go down
to the halls of Death alive and breathing.

**ANTIGONE**

But think of Niobe—well I know her story—                   915
        think what a living death she died,
Tantalus' daughter, stranger queen from the east:
there on the mountain heights, growing stone
binding as ivy, slowly walled her round
and the rains will never cease, the legends say             920
the snows will never leave her . . .
        wasting away, under her brows the tears
showering down her breasting ridge and slopes—
a rocky death like hers puts me to sleep.

**CHORUS**

But she was a god, born of gods,                             925
and we are only mortals born to die.
And yet, of course, it's a great thing
for a dying girl to hear, just hear
she shares a destiny equal to the gods,
during life and later, once she's dead.

**Book Title:**
The Three Theban Plays
**Author:**
Sophocles
**Translator:**
Robert Fagles
**Design Director:**
Beth Tondreau
**Designer:**
Ann Gold, after the design
of an earlier companion
volume by Barbara Knowles
**Illustrator:**
Ann Gold
**Publisher:**
The Viking Press
**Typographer:**
Vail-Ballou Press, Inc.
**Printer:**
Fairfield Graphics
**Production Manager:**
Anne Bass
**Paper:**
Glatfelter Offset #60
**Binder:**
Fairfield Graphics
**Jacket Designer:**
Ann Gold

---

## Daybook (bottom spread)

principles preclude my doing what would be in my own eyes venal. They set guidelines to which I try to be alert, not from any particular virtue, but to spare myself remorse.

So I end up in the position of a reasonably aspiring, reasonably ambitious man, no more and no less boundaried by my own character. This is lucky, because I cannot help doing the work I do, which feels to me as vital as my breath. I should not like to be in a position in which I could not breathe for fear of going against what I feel is right. But, were I a man, I would not have had laboriously to pick my way through such an obvious train of thought to such an obvious conclusion.

### 23 DECEMBER

Apparently there is green paint on the back of my hair. An acquaintance remarked on it, calling it "chartreuse"—to my eye a horrid color and not at all the glowing green, so multiple in its inflections, with which I have thought myself painting *17th Summer*. Once again I am brought face to face with the fact that I cannot gauge, except within a rough range, what other people see. For him, *17th Summer* would appear to be chartreuse, purple, and blue—of heaven knows what specificity. It takes a certain stubbornness to keep on making objects within the strict discipline of my senses. There is a taproot of selfishness. In narrow fact, I am making them only for my own perception.

### 24 DECEMBER

I feel a little pulled at the seams. Too much is happening too fast for me to integrate. Life unrolls like a Mack Sennett comedy. The film is so speeded up that events threaten to splinter into nonsense.

## 1975

### 1 JANUARY

The ground smells of spring. I am glad to be delivered once more from the dark solstice into the turn toward growth. January is my favorite month, when the light is plainest, least colored. And I like the feeling of beginnings.

### 3 JANUARY

In 1933, when I was twelve, the axe fell on the sunny progression of my days. The Depression, which temporarily annihilated my father's income and cut my mother's, laid waste to my childhood suddenly and unexpectedly. It seemed to me that one day all was as it had always been and the next both my parents were sick; our old nurse, retired; our cook, who had also been with us for years,

**Book Title:**
Daybook
**Author:**
Anne Truitt
**Editor:**
Nan Graham
**Designer:**
Elissa Ichiyasu
**Publisher:**
Pantheon Books
**Typographer:**
Maryland Linotype
Composition Co., Inc.
**Printer:**
The Haddon Craftsmen, Inc.
**Production Manager:**
Rebecca Woodruff
**Paper:**
S. D. Warren #50
**Binder:**
The Haddon Craftsmen, Inc.
**Jacket Designer:**
Louise Fili
**Jacket Letterer:**
Craig De Camps

**Book Title:**
Never Done

**Author:**
Susan Strasser

**Editors:**
Philip Pochoda,
Dan Guttenplan

**Art Director:**
Susan Mitchell

**Designer:**
Susan Mitchell

**Publisher:**
Pantheon Books

**Typographer:**
Maryland Linotype
Composition Co., Inc.

**Printer:**
R. R. Donnelley & Sons Co.

**Production Manager:**
Kathy Grosso

**Paper:**
Finch Opaque #60

**Binder:**
R. R. Donnelley & Sons Co.

**Jacket Designer:**
Susan Mitchell

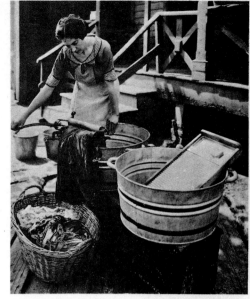

Wringing clothes—a task mechanized, then electrified, and finally eliminated. This is John Eshe's daughter, posing in 1923 for a home economics exhibit sponsored by the Agricultural Extension Division of International Harvester Corporation, Chicago.

to purchase a hand with their housework without hiring a full-time domestic servant.

Women who took in laundry had even more autonomy than those who worked in their employers' homes; working under their own supervision, they made independent decisions about starting, stopping, and timing their work and about the details of the work process, what kind of soap to

use or how hot the water should be. They could fit laundry work into their own household chores, or even—like Mary Mathews, a widow with a small child who made money teaching, sewing, and taking in laundry during the 1870s—into other paid employment. "I got up early every Monday morning," she later wrote, "and got my clothes all washed and boiled and in the rinsing water; then commenced my school at nine." At noon and after supper she sewed, often "till twelve and one o'clock at night. . . . Tuesday morning I had my clothes on the line by daylight, and my breakfast ready." She starched at noon Tuesday, ironed "as many of them as I could" after school, and finished the ironing at night. "Then I had the rest of the week to sew in. . . ." She used all the money she saved from this grueling schedule to invest in stock, and later in a boardinghouse, where she worked just as hard, doing laundry for twenty-six boarders, sewing sheets and pillowcases, and making repairs, again "working every night till twelve and one o'clock."

The individual laundress's autonomy eventually faded in the workplace

Farm woman washing clothes in her motor-driven washing machine, near Lincoln, Vermont, 1940. Farm Security Administration photo by Louise Rosskam.

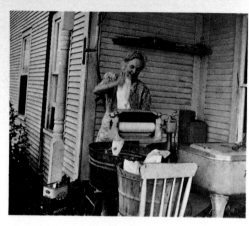

KEITH MONEY

## ANNA PAVLOVA

*Her Life and Art*

ALFRED A. KNOPF
New York 1982

**Book Title:**
Anna Pavlova,
Her Life and Art

**Author:**
Keith Money

**Editor:**
Robert Gottlieb

**Art Director:**
Betty Anderson

**Designer:**
Dorothy Schmiderer

**Photographers:**
Various

**Publisher:**
Alfred A. Knopf, Inc.

**Typographer:**
New England Typographic
Service, Inc.

**Printer:**
Rae Publishing Co., Inc.

**Production Manager:**
Ellen McNeilly

**Paper:**
Paloma #70

**Binder:**
American Book-Stratford
Press

**Jacket Designer:**
R. D. Scudellari

**Jacket Printer:**
Rapoport Printing Corp.

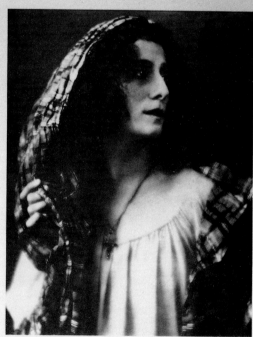

One of Eugene Hutchinson's many superb portraits of Pavlova in *The Dumb Girl of Portici*.

218

too. She had her own timekeeper, who maintained a detailed record of her work periods. It was his duty to find out from Universal when she was wanted, and to establish, in advance, what time she would be permitted to leave. This was quite contrary to normal practice—working hours tended to be open-ended—but Pavlova purchased a stopwatch (which she called her "Portici watch"), and her work was entirely governed by it.

Although the initial rushes dismayed her, Pavlova quickly learned about the techniques needed in working close to a camera. Her fellow performers were happy to give her tips, and before long her acting was quite as compelling as that of any experienced movie actor in the production. The part of the dumb girl Fenella was a purely dramatic role, but Lois Weber was conscious of the great risk she was taking in denying audiences a view of Pavlova the dancer, so she devised three interludes, in the manner of "visions," with Pavlova drifting around on pointe. One scene contained a bit of trickery with a male dancer clad totally in black velvet acting as an invisible partner, which enabled Pavlova to make an airy ascent that denied gravity. Elsewhere in the film she was given some gypsy dances with a tambourine, filmed later on location in California.

The action of *The Dumb Girl of Portici* was placed in the seventeenth century, during the uprising of the people against the Viceroy of Naples. The fisherman Masaniello was their leader in a revolt against persecution and the increasing taxation that went to support a profligate court. The Viceroy's son, Alphonso, was in the habit of moving about among the common people incognito, and it was thus that he wooed lightheartedly Masaniello's sister, the beautiful but congenitally dumb Fenella, who fell in love with this dashing admirer. Alphonso was actually engaged to Elvira, a Spanish princess, so the deceit inevitably led to anguish and confrontations, in the best *Giselle*-like traditions of blighted love. The great crowd scenes centered on the revolutionary populace, armed only with clubs, confronting the pikemen and armored horsemen of the Viceroy in hand-to-hand battles, and then overrunning the palace in an orgy of destruction. Side plots were rampant. Some of the film's scenario made breathless reading:

The Duke [i.e., the Viceroy] hears of his son's amour and by a subterfuge snares Fenella. In jail the Duke has her flogged because she will not answer his questions. [She cannot, of course.] When the guards get drunk on the wedding day of Alphonso, she escapes from the cell. Bewildered by her surroundings Fenella, in rags, her back torn from the strokes of the lash, runs headlong into the wedding party. The princess senses the relationship between the dumb girl and her husband. The princess sets her free but the Duke throws her into jail again. She is freed when the mob breaking into the castle opens the prison doors. Alphonso and the princess flee and the dumb girl saves their lives. Masaniello is poisoned by a neighbor who hoped to marry Fenella, and [Masaniello] goes mad. Alphonso returns to his father's power, overturns the rule of the people, which has become debased since Masaniello's madness, and he is saved from death by Masaniello's sword, as Fenella jumps between them and receives the weapon. Masaniello then falls on his own sword.

It was at this point that the white-robed spirit of Fenella was seen dancing its way up through the clouds to some Elysian Fields of perpetual happiness.[*]

Despite the stopwatch and her enormous salary, finance was still a recurring worry for Pavlova as the plans for the opera and ballet tour were consolidated. She actually accepted a "donation" of $5,000 from an ardent fan, wealthy attorney Charles Dickinson Stickney, who assured her that she need not repay him if her touring enterprise was not a success. Stickney was a fifty-eight-year-old bachelor who occupied a box near the stage every night that Pavlova danced in New York. At one period it was assessed that the flowers sent by him to the Century had cost over $500, so it was not surprising when he told the dancer, "I'm rich enough to put some money in your art!" Despite the openness of the loan, Pavlova signed a promissory note.

In the first week of September, while Pavlova was back on the West Coast completing the filming of beach scenes for the movie, Rabinoff was able to make his preliminary public announcements in New York. It was revealed that he had acquired the properties (and many of the artists) of the Boston Opera Company after it had fallen on hard times, and at this point it

[*] Having seen the entire and uncut version of this epic, I can testify that it is a genuinely remarkable opus for the times, with large-scale effects that would be the envy of many contemporary film makers. Pavlova displays a vivid personality, and her dramatic effects are really no more overblown than those of her fellow professionals; it was a time when styles of film (melo)drama, lyric romance, etc.) dictated the style of acting employed, and audiences knew which to expect. Some of the scenes in the film, such as the flogging and Fenella's incarceration in a cell swarming with very real rats, are quite disturbing. It is an exceptionally long film for the era.

219

ful parents. And then with the first drink, after which he could almost never stop, the wars would begin again.

Finally, when it all came to an end, she played her last scene with him. She arrived at the divorce court in a stunning white dress and hat (she had never worn a hat in her life before) and calmly asked for a divorce, demanding no alimony—nothing for her and nothing for the children. She got a job at The Grand Oriental Hotel, trained herself as a housekeeper-manager and supported us through schools by working in hotels in Ceylon and then England till she died. The easy life of the tea estate and the theatrical wars were over. They had come a long way in fourteen years from being the products of two of the best known and wealthiest families in Ceylon: my father now owning only a chicken farm at Rock Hill, my mother working in a hotel.

Before my mother left for England in 1949 she went to a fortune-teller who predicted that while she would continue to see each of her children often for the rest of her life, she would never see them all together again. This turned out to be true. Gillian stayed in Ceylon with me, Christopher and Janet went to England. I went to England, Christopher went to Canada, Gillian came to England, Janet went to America, Gillian returned to Ceylon, Janet returned to England, I went to Canada. Magnetic fields would go crazy in the presence of more than three Ondaatjes. And my father. Always separate until he died, away from us. The north pole.

172

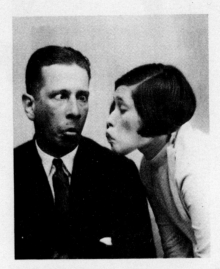

## WHAT WE THINK OF MARRIED LIFE

**Book Title:**
Running in the Family
**Author:**
Michael Ondaatje
**Editor:**
Star Lawrence
**Art Director:**
Antonina Krass
**Designer:**
Antonina Krass
**Photographers:**
Various
**Publisher:**
W. W. Norton & Co.
**Typographer:**
The Haddon Craftsmen, Inc.
**Printer:**
The Haddon Craftsmen, Inc.
**Production Manager:**
Andrew Marasia
**Paper:**
Sebago Antique #55
**Binder:**
The Haddon Craftsmen, Inc.
**Jacket Designer:**
Antonina Krass

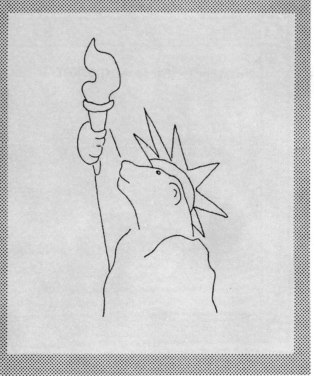

la Liberté

**Book Title:**
Bears & Theirs
**Author:**
Victoria Forrester
**Editor:**
Jean Karl
**Art Director:**
Mary Ahearn
**Designers:**
Victoria Forrester,
Mary Ahearn
**Illustrator:**
Victoria Forrester
**Publisher:**
Atheneum Publishers
**Typographer:**
Dix Typesetting Co.
**Printer:**
Kingsport Press
**Production Manager:**
Jin Lau
**Paper:**
P & S Offset #70
**Binder:**
Kingsport Press
**Jacket Designer:**
Victoria Forrester,
Mary Ahearn
**Jacket Illustrator:**
Victoria Forrester

**Book Title:**
Penguin's Penguins
**Author:**
Dennis Traut
**Editor:**
Martha Kinney
**Cover Designer:**
Neil Stewart
**Designer:**
Kathryn Parise
**Illustrator:**
Tom Calenberg
**Publisher:**
Penguin Books
**Typographer:**
Typographic Images
**Printer:**
Rae Publishing Co.
**Production Manager:**
Eileen Schwartz
**Paper:**
Glatfelter HiBrite #80
**Binder:**
A. Horowitz & Sons

"Something's fishy" is a penguin expression of endearment.

Great ideas usually come to penguins underwater.

**Book Title:**
The Tale of John Barleycorn
or From Barley to Beer
**Author:**
Mary Azarian
**Art Director:**
Sarah Saint-Onge
**Designer:**
George Laws,
Anne Chalmers
**Illustrator:**
Mary Azarian
**Calligrapher:**
George Laws
**Publisher:**
David R. Godine, Publisher
**Typographer:**
Wrightson Typographers
**Printer:**
Daamen, Inc.
**Production Manager:**
William F. Luckey
**Paper:**
Monadnock natural laid #80
**Binder:**
A. Horowitz & Sons
**Jacket Designer:**
George Laws,
Anne Chalmers
**Jacket Illustrator:**
Mary Azarian

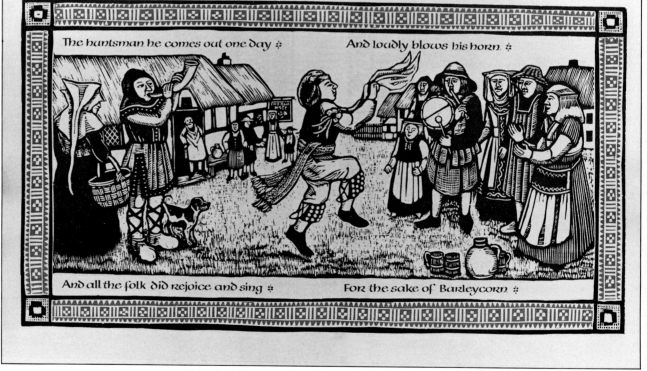

The huntsman he comes out one day ❖        And loudly blows his horn ❖

And all the folk did rejoice and sing ❖        For the sake of Barleycorn ❖

is beautiful

And to fall like a heavy handful of cloud
                    down
                        down rustling chaff
                    down
                            beautifully

        And to kill then ever so softly
        ripping out their sky vision
                    with hardness
                    with happiness

                is beautiful

        And on days. . days when the wind is right
    to dive like light into stone
and feel split-open briefly the auburn explode
                That is the body
                That is you  .
                Open on stone and. . open

                Open and broken:
    the head limp. . face dirt. . the laughter
        faded down the wind
            and the heart
            the heart bleeding

            bleeding rodents

**Book Title:**
Somata
**Author:**
Phillip Foss, Jr.
**Designer:**
Gerald Lange
**Illustrator:**
Gaylord Schanilec
**Publisher:**
The Bieler Press
**Typographers:**
Gerald Lange, Sue Rexford
**Printer:**
Gerald Lange
**Paper:**
Gutenberg Laid,
Papel de Amate
Dresden Ingres
**Binders:**
Sue Rexford, Gerald Lange

122

"You're a *very* poor *speaker*," said the King.

Here one of the guinea-pigs cheered, and was immediately suppressed by the officers of the court. (As that is rather a hard word, I will just explain to you how it was done. They had a large canvas bag, which tied up at the mouth with strings: into this they slipped the guinea-pig, head first, and then sat upon it.)

"I'm glad I've seen that done," thought Alice. "I've so often read in the newspapers, at the end of trials, 'There was some attempt at applause, which was immediately suppressed by the officers of the court,' and I never understood what it meant till now."

"If that's all you know about it, you may stand down," continued the King.

"I ca'n't go no lower," said the Hatter. "I'm on the floor, as it is."

"Then you may *sit* down," the King replied.

Here the other guinea-pig cheered, and was suppressed.

"Come, that finishes the guinea-pigs!" thought Alice. "Now we shall get on better."

"I'd rather finish my tea," said the Hatter, with an anxious look at the Queen, who was reading the list of singers.

"You may go," said the King; and the Hatter hurriedly left the court, without even waiting to put his shoes on.

"——and just take his head off outside," the Queen added to one of the officers; but the Hatter was out of sight before the officer could get to the door.

"Call the next witness!" said the King.

The next witness was the Duchess' cook. She carried the pepper-

box in her hand, and Alice guessed who it was, even before she got into the court, by the way the people near the door began sneezing all at once.

"Give your evidence," said the King.

"Sha'n't," said the cook.

The King looked anxiously at the White Rabbit, who said, in a low voice, "Your Majesty must cross-examine *this* witness."

"Well, if I must, I must," the King said with a melancholy air, and, after folding his arms and frowning at the cook till his eyes were nearly out of sight, he said, in a deep voice, "What are tarts made of?"

"Pepper, mostly," said the cook.

"Treacle," said a sleepy voice behind her.

"Collar that Dormouse!" the Queen shrieked out. "Behead that Dormouse! Turn that Dormouse out of court! Suppress him! Pinch him! Off with his whiskers!"

For some minutes the whole court was in confusion, getting the Dormouse turned out, and, by the time they had settled down again, the cook had disappeared.

"Never mind!" said the King, with an air of great relief. "Call the next witness." And, he added, in an undertone to the Queen, "Really, my dear, *you* must cross-examine the next witness. It quite makes my forehead ache!"

Alice watched the White Rabbit as he fumbled over the list, feeling very curious to see what the next witness would be like, "—for they haven't got much evidence *yet*," she said to herself. Imagine her surprise, when the White Rabbit read out, at the top of his shrill little voice, the name "Alice!"

123

**Book Title:**
Alice's Adventures
in Wonderland
**Author:**
Lewis Carroll
**Editors:**
James R. Kinkaid,
Selwyn H. Goodacre
**Art Director:**
Steve Renick
**Designer:**
Barry Moser
**Illustrator:**
Barry Moser
**Letterer:**
G. C. Laurens
**Publisher:**
University of California
Press
**Typographer:**
Winifred and Michael Bixler
**Printer:**
Southeastern Printing Co.
**Production Manager:**
Czeslaw Jan Grycz
**Paper:**
Glatfelter Offset #70
**Binder:**
Tapley-Rutter Co., Inc.
**Jacket Designer:**
Steve Renick
**Jacket Illustrator:**
Barry Moser
**Jacket Letterer:**
G. G. Laurens

**Book Title:**
A, B, See!
**Author:**
Tana Hoban
**Editor:**
Susan Hirschman
**Art Director:**
Ava Weiss
**Photograms:**
Tana Hoban
**Publisher:**
Greenwillow Books
**Typographer:**
Pastore DePamphilis
Rampone
**Printer:**
Rae Publishing Co.
**Production Manager:**
Eugene Sanchez
**Paper:**
Greenfield Opaque #70
**Binder:**
A. Horowitz & Sons
**Jacket Designer:**
Ava Weiss

ABCDEF**G**HIJKLMNOPQRSTUVWXYZ

ABCDEFG**H**IJKLMNOPQRSTUVWXYZ

**Book Title:**
The Circus of Dr. Lao
**Author:**
Charles G. Finney
**Introduction:**
Edward Hoagland
**Art Director:**
Claire Van Vliet
**Designer:**
Claire Van Vliet
**Illustrator:**
Claire Van Vliet
**Publisher:**
The Limited Editions Club
**Typographer:**
Claire Van Vliet
**Printer:**
The Stinehour Press
**Production Manager:**
Freeman Keith
**Paper:**
Mohawk Superfine #65
**Binder:**
The Stinehour Press
**Binding Designer:**
Claire Van Vliet
**Binding Illustrator:**
Susan Thatcher

'So that's the name of it,' thought Mr. Etaoin.

The tents were all black and glossy and shaped not like tents but like hard-boiled eggs standing on end. They started at the sidewalk and stretched back the finite length of the field, little pennants of heat boiling off the top of each. No pop-stands were in sight. No balloon peddlers. No noisemakers. No hay. No smell of elephants. No roustabouts washing themselves in battered buckets. No faded women frying hot dogs in fly-blown eating stands. No tent pegs springing up under one's feet every ninth step.

A few people stood desultorily about; a few more wafted in and around the rows of tents. But the tent doors all were closed; cocoon-like they secreted their mysterious pupæ; & the sun beat down on the circus grounds of Abalone, Arizona.

**26**

Then a gong clanged and brazenly shattered the hot silence. Its metallic screams rolled out in waves of irritating sound. Heat waves scorched the skin. Dust waves seared the eyes. Sound waves blasted the ears. The gong clanged and banged and rang; and one of the tents opened and a platform was thrust out and a Chinaman hopped on the platform and the gong's noise stopped and the man started to harangue the people; and the circus of Doctor Lao was on:

\* \* \* \* \* \* \* \* \* \* \* \* \* \* \* \* \* \* \*

'This is the circus of Doctor Lao.
We show you things that you don't know.
We tell you of places you'll never go.
We've searched the world both high and low
To capture the beasts for this marvelous show
From mountains where maddened winds did blow
To islands where zephyrs breathed sweet and slow.
Oh, we've spared no pains and we've spared no dough;
And we've dug at the secrets of long ago;
And we've risen to Heaven and plunged Below,
For we wanted to make it one hell of a show.
And the things you'll see in your brains will glow
Long past the time when the winter snow
Has frozen the summer's furbelow.
For this is the circus of Doctor Lao.
And youth may come and age may go;
But no more circuses like this show!'

\* \* \* \* \* \* \* \* \* \* \* \* \* \* \* \* \* \* \*

The little yellowed wrinkled dancing man hopped about on the platform sing-songing his slipshod dactyls and iambics; and the crowd of black, red, and white men stared up at him and marveled at his ecstasy.

The ballyhoo ceased. The old Chinaman disappeared. From all the tents banners were flung advertising that which they concealed and would reveal for a price. The crowd lost its identity; the individual regained his, each seeking what he thought would please him most. Mr. Etaoin wondered just where to go first. Over him fluttered a pennant crying, FORTUNES TOLD. 'I shall have my fortune told,' Mr. Etaoin confided to himself; and he scuttled into the tent.

**27**

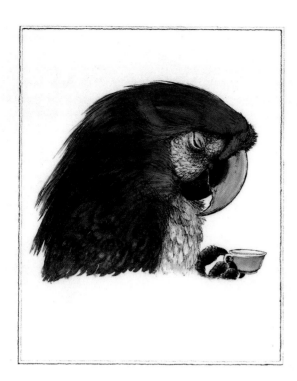

# THE PARROT
# IN THE GARRET

AND OTHER RHYMES ABOUT DWELLINGS

*Chosen by*
*Lenore Blegvad*

*Illustrated by*
*Erik Blegvad*

*A Margaret K. McElderry Book*
ATHENEUM 1982 NEW YORK

**Book Title:**
The Parrot in the Garret
**Author:**
Lenore Blegvad
**Editor:**
Margaret K. McElderry
**Art Director:**
Felicia Bond
**Designers:**
Felicia Bond, Erik Blegvad
**Illustrator:**
Erik Blegvad
**Publisher:**
Atheneum Publisher
**Typographer:**
Boro Typographers
**Printer:**
Dai Nippon Printing Co., Ltd.
**Production Manager:**
Jin Lau
**Paper:**
New Age #86
**Binder:**
Dai Nippon Printing Co., Ltd.
**Jacket Designer:**
Erik Blegvad
**Jacket Illustrator:**
Erik Blegvad

Nonetheless, he got in the ticket line behind a group of people who, earlier in the evening, had been waiting in line at the cheese distribution center.

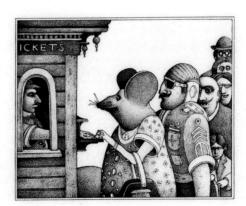

**Book Title:**
The Amusement Park
**Author:**
Dennis Corrigan
**Editor:**
Dennis Corrigan
**Art Director:**
Joe Scorsone
**Designer:**
Joe Scorsone
**Illustrator:**
Dennis Corrigan
**Publisher:**
The Tyler Offset Workshop
**Typographer:**
Advertising
Typographers, Inc.
**Printer:**
Michael Becotte
**Production Manager:**
Michael Becotte
**Paper:**
Mohawk Superfine
**Binder:**
Novelty Bookbinding Co.
**Jacket Designer:**
Joe Scorsone
**Jacket Illustrator:**
Dennis Corrigan

**Book Title:**
Bird's Eye
**Author:**
Judy Graham
**Editor:**
Harold Darling
**Art Director:**
Sandra Darling
**Designer:**
Judythe Sieck
**Illustrator:**
Michael Ansell
**Letterer:**
Judythe Sieck
**Publisher:**
The Green Tiger Press
**Printer:**
The Green Tiger Press
**Production Manager:**
Gerald Houck
**Binder:**
Automated Bindery
**Cover Designers:**
Sandra Darling,
Judythe Sieck
**Cover Illustrator:**
Michael Ansell
**Cover Calligrapher:**
Judythe Sieck

And indeed, the next day a new lady came to the park. She threw out some food for the birds, but as soon as they started eating, another newcomer arrived & sat down on the next bench. She had cats! Not only did they eat the bird food, but they tried to eat the birds as well.

"Thank goodness we can fly", said Stan to Flo, "or we'd be in quite a mess."

"That's right", answered Flo, "but we're in quite a mess already, without our friends. What do you think we should do?"

6

**Book Title:**
The Dragon Kite
**Author:**
Nancy Luenn
**Editor:**
Anna Bier
**Art Director:**
Barbara Knowles
**Designer:**
Barbara Knowles
**Illustrator:**
Michael Hague
**Publisher:**
Harcourt Brace Jovanovich
**Typographer:**
Book Composition
Services, Inc.
**Printer:**
Pearl Pressman Liberty
**Production Manager:**
Raymond G. Ferguson
**Paper:**
Glatco Matte #80
**Binder:**
A. Horowitz & Sons
**Jacket Designer:**
Barbara Knowles
**Jacket Illustrator:**
Michael Hague

said to Katsuta, "I have worked for four years now, honored one. Give me leave to go."

The old man nodded, his eyes as quiet as a pool in shadow.

Ishikawa returned home, stopping first to buy bamboo and paper, and the powder for paints. Beneath a blossoming cherry tree he began to build the giant kite. The work was as joyful as water leaping down the mountains. He felt sure that this kite would touch the heavens.

When it was finished, he went to find his three friends.

"Come and see the kite I have made," said Ishikawa. "Then you will know that my plan is a good one!" The three men shook their heads doubtfully as they followed Ishikawa back to the garden.

They stood amazed. A red and silver dragon coiled across the garden, its mighty wings a royal purple. Its eyes were the color of an autumn pool, mirroring the eyes of Katsuta.

"It is a well-made kite," Hayami murmured. The others nodded. A sea wind eddied through the garden, and the dragon kite stirred impatiently.

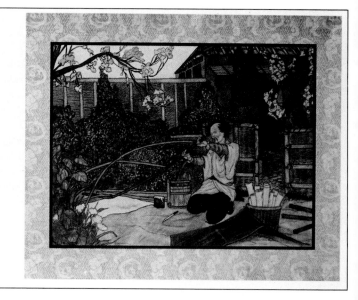

### BUTTERFLY

The Patchwork Admiral Butterfly
Likes to find some warm and dry
Parlour or drawing-room, and there
Settle. It hates the open air.
It does not waste its youthful powers
Fluttering over pretty flowers.
It would far prefer to rove
Round a gas-fire or a stove.
This may be why, as I am told,
Some live to be seventy-five years old.

**Book Title:**
People One Ought to Know
**Author:**
Christopher Isherwood
**Editor:**
Shaye Areheart
**Art Director:**
Douglas Bergstreser
**Designer:**
Wilma Robin
**Illustrator:**
Sylvain Mangeot
**Publisher:**
Doubleday & Co., Inc.
**Typographer:**
Doubleday & Co., Inc.
**Printer:**
Pearl Pressman Liberty
**Production Manager:**
Marie J. MacFarlane
**Paper:**
Cream Offset B-32 #80
**Binder:**
Doubleday & Co., Inc.
**Jacket Designer:**
Douglas Bergstresser
**Jacket Illustrator:**
Sylvain Mangeot
**Letterer:**
David Gatti

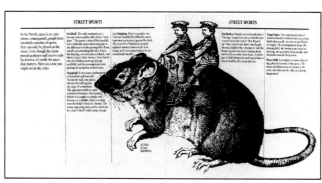

STREET SPORTS

STREET SPORTS

**Book Title:**
Yankees Made Simple/
The South Made Simple
**Author:**
Michael Hicks
**Editor:**
Daniel Okrent
**Art Directors:**
Tom Poth, David Shapiro,
Michael Hicks
**Designers:**
Tom Poth, Michael Hicks
**Illustrators:**
Various
**Publisher:**
Texas Monthly Press
**Typographer:**
G. & S. Typesetters
**Printer:**
McNaughton & Gunn, Inc.
**Production Manager:**
Cathy Berend
**Paper:**
Pinehurst #70
**Binder:**
McNaughton & Gunn, Inc.
**Jacket Designer:**
Michael Hicks
**Cover Photographer:**
Stence & Stence

STRANGE FOODS

STRANGE FOODS

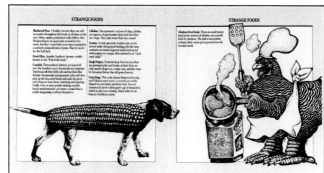

HOW TO BE A STAR

HOW TO BE A STAR

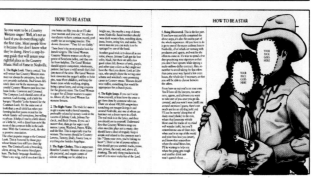

**Book Title:**
Let's Make Rabbits
**Author:**
Leo Lionni
**Editor:**
Frances Foster
**Art Director:**
Denise Cronin
**Designers:**
Denise Cronin, Leo Lionni
**Illustrator:**
Leo Lionni
**Publisher:**
Pantheon Books
**Typographer:**
Lincoln Typographers, Inc.
**Printer:**
Rae Publishing Co.
**Production Manager:**
Elaine Silber
**Paper:**
Moistrite Matte #80
**Binder:**
The Book Press
**Jacket Designer:**
Leo Lionni
**Jacket Illustrator:**
Leo Lionni

"Good morning," said the scissors to the pencil.
"What shall we do today?"
"Let's make rabbits," said the pencil.

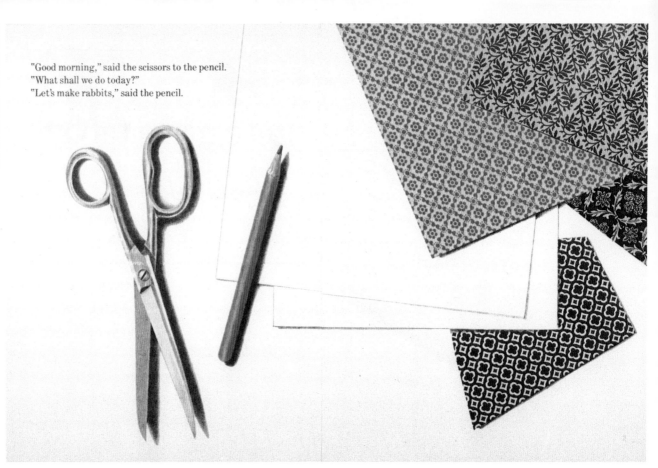

After looking in vain for something to eat, they called
the pencil and the scissors. "We're hungry," they said.

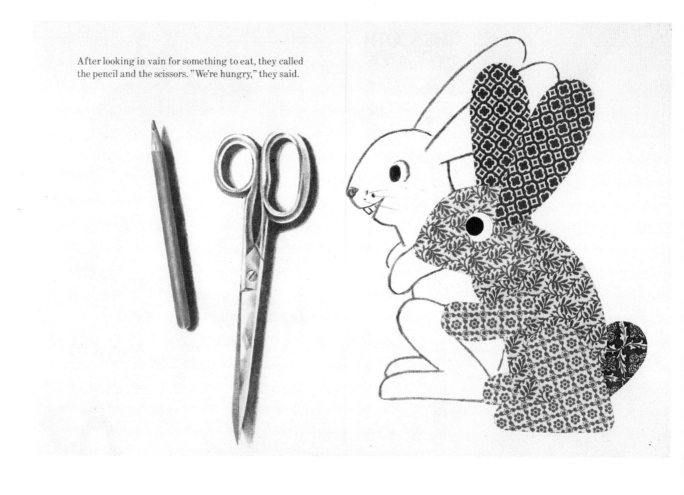

# THE INDESTRUCTIBLE CROCODILE

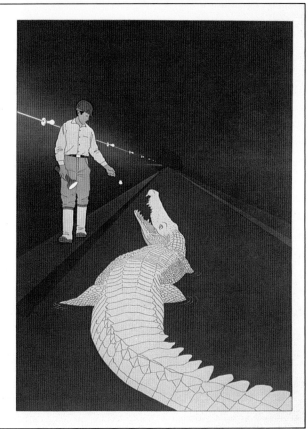

Descendants of the great reptiles that roamed the earth millions of years ago, crocodiles are true survivors (though contrary to popular opinion, they cannot survive being flushed into the sewer systems of large cities!).

Dramatic descriptions of crocodiles attacking humans are exaggerated. The carelessness of the victims is the main cause of accidents. But they never weep crocodile tears of false remorse, should such a meal occur.

A crocodile's teeth cannot cut or chew. Therefore, it crushes small prey and swallows it whole. To eat a large animal, the crocodile holds it and spins its own body around until it tears off a chunk it can gulp down. Crocodiles swallow stones to help digest their food. The stones also act as ballast when swimming. An adult can carry up to eleven pounds of stones in its stomach.

At night a crocodile's eyes have an eerie pale red glow. Legend says that this color reflects the beast's bloodthirsty nature. In fact, it is a pigment called rhodopsin that allows the crocodile to see in the dark.

**Book Title:**
Squid & Spider
A Look at the
Animal Kingdom
**Author:**
Guy Billout
**Editor:**
Carol Sarkin
**Art Director:**
Barbara Francis
**Designer:**
Carl Barile
**Illustrator:**
Guy Billout
**Publisher:**
Prentice-Hall, Inc.
**Typographer:**
Elizabeth Typesetting Co.
**Printer:**
Rae Publishing Co., Inc.
**Production Manager:**
Donna Sullivan
**Paper:**
Warren's Patino Matte #80
**Binder:**
Rae Publishing Co.
**Jacket Designer:**
Carl Barile
**Jacket Illustrator:**
Guy Billout

# THE TOUCHY SPIDER

A common misconception about spiders is that they are insects. In fact, they belong to the group of arachnids, which have eight legs instead of six. Among the 30,000 species of spiders, about half spin webs. This extraordinary ability is inherited. Parents do not teach their young how to build a web. A special gland in their bodies produces a liquid protein which, upon reaching the air, hardens into a silken thread of amazing strength.

Through its complex web, the spider interprets a world of touch and vibrations, never mistaking a dry leaf for a struggling insect. A starving spider will not even eat a fly placed next to its mouth if it has not caught it and identified it through the threads of the web.

Most spiders are true loners, willing to eat anything live that enters the web. So a male spider may bring a gift of prey to the female or may wrap her in silk himself to avoid ending up as her meal.

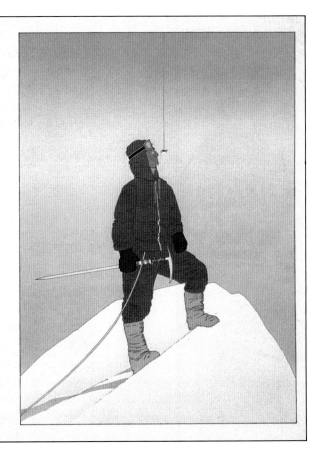

**Book Title:**
Chemistry, Fifth Edition
**Author:**
Charles E. Mortimer
**Editor:**
Jack Carey
**Art Director:**
Stephen Rapley
**Designer:**
Adriane Bosworth
**Illustrator:**
J. & S. Art Services
**Publisher:**
Wadsworth Publishing Co.
**Typographer:**
Syntax International
**Printer:**
R. R. Donnelley & Sons Co.
**Production Editor:**
Hal Humphrey
**Paper:**
Bookman Matter
**Binder:**
R. R. Donnelley & Sons Co.
**Jacket Designer:**
Adriane Bosworth
**Jacket Photographers:**
Various

$$EF = d \sin \theta$$

The expression

$$FG = d \sin \theta$$

can be derived in the same way. Therefore,

$$EF + FG = 2d \sin \theta$$

Since $EF + FG$ is equal to $n\lambda$,

$$n\lambda = 2d \sin \theta \qquad (9.6)$$

This equation, derived by William Henry Bragg and his son William Lawrence Bragg in 1913, is called the **Bragg equation**.

With X rays of a definite wavelength, reflections at various angles will be observed for a given set of planes separated by a given distance, $d$. These reflections correspond to $n = 1, 2, 3$, and so on, and are spoken of as first order, second order, third order, and so on. With each successive order, the angle $\theta$ increases, and the intensity of the reflected beam weakens.

Figure 9.18 is a schematic representation of an X-ray spectrometer. An X-ray beam defined by a slit system impinges upon a crystal that is mounted on a turntable. A detector (photographic plate, ionization chamber, or Geiger counter) is positioned as shown in the figure. As the crystal is rotated, strong signals flash out as angles are passed that satisfy the Bragg equation. Any set of regularly positioned atoms that contain atoms can give rise to reflections—not only those that form the faces of the unit cells. Thus, the value of $d$ is not necessarily the edge of the unit cell, although the two are always mathematically related.

**Figure 9.18** X-ray diffraction of crystals. (Schematic.)

**Example 9.4**

The diffraction of a crystal of barium with X radiation of wavelength 229 pm gives a first-order reflection at $27°8'$. What is the distance between the diffracted planes?

**Solution**

Substitution into the Bragg equation gives

$$n\lambda = 2d \sin \theta$$
$$1(229 \text{ pm}) = 2d(0.456)$$
$$d = 251 \text{ pm}$$

**9.14 Crystal Structure of Metals**

In the large majority of cases, metal crystals belong to one of three classifications: body-centered cubic (Figure 9.14), face-centered cubic (Figure 9.14), and hexagonal close-packed (Figure 9.19). The geometric arrangement of atoms in the face-centered cubic and the hexagonal close-packed crystals is such that each atom has a coordination number of 12 (each is surrounded by 12 other atoms at equal distances). If the atoms are viewed as spheres, there is a minimum of empty space in these two types of crystals (about 26%), and both of the crystal lattices are called **close-packed structures**. The body-centered cubic arrangement is slightly more open than either of the close-packed arrangements (about 32% empty space); each atom of a body-centered cubic crystal has a coordination number of 8.

The difference between the two close-packed structures may be derived from a consideration of Figure 9.20. The shaded circles of the diagram represent the first layer of spheres, which are placed as close together as possible. The second layer of spheres (open circles of Figure 9.20) are placed in the hollows formed by adjacent spheres of the first layer. The first two layers of both the face-centered cubic and the hexagonal close-packed arrangements are the same; the difference arises in the third and subsequent layers.

**Figure 9.19** Hexagonal close-packed structure

**Figure 9.20** Schematic representation of the first two layers of the close-packed arrangements

---

**Book Title:**
Contemporary Basic Mathematical Skills, Second Edition
**Author:**
Ignacio Bello
**Editor:**
Fred Henry
**Art Director:**
Lorraine Mullaney
**Designer:**
Frances Torbert Tilley
**Design Assistant:**
Dawn Stanley
**Art Studio:**
Vantage Art, Inc.
**Publisher:**
Harper & Row Publishers, Inc.
**Typographer:**
The Clarinda Co.
**Printer:**
The Murray Printing Co.
**Production Managers:**
Kewal K. Sharma,
Jacqui Brownstein
**Paper:**
Lindenweb Matte
**Binder:**
The Murray Printing Co.
**Jacket Designer:**
Frances Torbert Tilley
**Jacket Illustrator:**
Frances Torbert Tilley

In each product the number of decimal places is the **sum** of the number of places in the factors. For example, 0.3 has **one** decimal digit and 0.0007 has **four**; their product

$$0.3 \times 0.0007 = \frac{3}{10} \times \frac{7}{10,000} = \frac{21}{100,000} = \underbrace{0.00021}_{1 + 4 = 5 \text{ digits}}$$

has $1 + 4 = 5$ decimal digits. Here is the rule used to multiply decimals:

> **TO MULTIPLY DECIMALS**
> 1. **Multiply** the two decimal numbers **as if they were whole numbers.**
> 2. The **number of decimal places** in the product is the **sum** of the number of places in the factors.

Now let us find the price of 3.5 and 5 pounds of roast selling at $2.29 per pound. Following the rule given above, we have

**PRICE FOR 3.5 POUNDS**
```
    2.29   2 decimals
  × 3.5    1 decimal
   1145
    687
  8.015   Count 2 + 1 = 3
          decimal digits
          in the answer.
```
The price is $8.02.

**PRICE FOR 5 POUNDS**
```
    2.29   2 decimals
  ×    5   0 decimals
  11.45    Count 2 + 0 = 2
           decimal digits
           from the right
           in the answer.
```
The price is $11.45.

**Example 1.**

```
a.   2.31   2 decimals      b.  13.813   3 decimals
   × 4.2    1 decimal         ×   7.1    1 decimal
    462                        13813
    924                        96691
  9.702                       98.0723
     Count                        Count
   2 + 1 = 3                    3 + 1 = 4
   decimals.                    decimals.
```

Sometimes we need to **prefix** zeros to the product to obtain the required number of decimal places. For example:

```
0.005   3 decimals          0.016   3 decimals
×   3   0 decimals         × 0.23   2 decimals
.015    3 + 0 = 3 decimals    48
                              32
                           .00368   3 + 2 = 5
                                    decimals
```

This zero inserted here to obtain 3 decimal digits.

2 zeros inserted here to obtain 5 decimal digits.

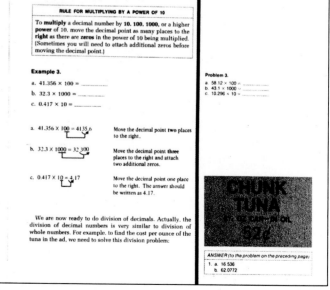

"Super-Right" Heavy Western Tender Beef

**BOTTOM ROUND**

**ROAST**

Boneless **$2.29** LB.

Courtesy of Tampa Tribune

**Problem 1.** a. 3.12   b. 12.172
    × 5.3     × 5.1

To **prefix** means to **write before.**

**Example 2.**

```
a.   5.102   3 decimals     b.   5.213   3 decimals
   × 21.03   2 decimals        × 0.0012   4 decimals
   15306                        10426
   5102                         5213
   10204                       .0062556   3 + 4 = 7 decimals
 107.29506   3 + 2 = 5
             decimals
```

In many cases we have to multiply decimals by **powers** of 10 (10, 100, 1000, etc.). The rules for doing this are very simple. See if you discover a pattern.

$$32.314 \times 10 = 323.14$$
$$32.314 \times 100 = 3231.4$$
$$32.314 \times 1000 = 32314.$$

Did you find the pattern?
Here is the general rule to multiply by powers of 10.

> **RULE FOR MULTIPLYING BY A POWER OF 10**
> To **multiply** a decimal number by **10, 100, 1000,** or a higher **power** of 10, move the decimal point as many places to the **right** as there are **zeros** in the power of 10 being multiplied. (Sometimes you will need to attach additional zeros before moving the decimal point.)

**Example 3.**

a. $41.356 \times 100 = $ _____

b. $32.3 \times 1000 = $ _____

c. $0.417 \times 10 = $ _____

a. $41.356 \times 100 = 4135.6$
   Move the decimal point two places to the right.

b. $32.3 \times 1000 = 32\ 300$
   Move the decimal point **three** places to the right and attach two additional zeros.

c. $0.417 \times 10 = 4.17$
   Move the decimal point one place to the right. The answer should be written as 4.17.

We are now ready to do division of decimals. Actually, the division of decimal numbers is very similar to division of whole numbers. For example, to find the cost per ounce of the tuna in the ad, we need to solve this division problem:

**Problem 2.** a. 3.201   b. 4.132
    × 31.02    × 0.0021

The powers of 10 are:
   10, 100, 1000, and so on.

**Problem 3.**
a. $58.12 \times 100 = $ _____
b. $43.1 \times 1000 = $ _____
c. $10.296 \times 10 = $ _____

**CHUNK TUNA** 52¢

> ANSWER (to the problem on the preceding page)
> 1. a. 16.536
>    b. 62.0772

Jack Addie and Joe Ludgate met quite by chance at a Methodist prayer meeting in London, Ontario. These two British immigrants shared more than evangelical inclinations, however, both having belonged to the zealous Salvation Army back home. So they decided to introduce their former religion to their new country. There was some violent opposition - but there was also hearty support, and from their first public service on 24 May 1882, their missionary movement and its accompanying good works rapidly spread from town to Canadian town.

It's not surprising. The principle upon which the Salvation Army was founded and has continued to thrive for over a century is disarmingly logical: needy souls cannot be saved for the Lord if their bodies are hungry and deprived. That is why founder William Booth began his spiritual mission among the poor of East London's slums with soup kitchens; and why his Christian Army of followers - now preaching in some 160 languages in nearly 70 countries - maintains a vast and varied

network of social services and welfare institutions around the world.

This emphasis on mercy and charitable works belies the aggressive stance the Army takes in its "warfare against evil." Messianically opposed to liquor, tobacco, promiscuity, and gambling, it has been called the world's largest temperance organization. A military form of dress and organization was adopted early to further endorse its highly self-disciplined approach to saving souls.

Left: Jack Addie (right) and Joe Ludgate began the work of the Salvation Army in Canada at London, Ontario, in 1882
Right: The flag of the Salvation Army
(The Salvation Army)

Jack Addie et Joe Ludgate se sont rencontrés tout à fait par hasard lors d'une séance de prière méthodiste à London, en Ontario. Ces deux immigrants britanniques, pourtant, avaient une plus grande foi dans les enseignements de la Bible, ayant tous deux été membres de l'Armée du Salut en Angleterre. Ils décident donc d'introduire leur ancienne religion dans leur nouveau pays. Bon nombre s'y opposent très fortement Addie, accusé d'avoir troublé la paix publique, est arrêté, tandis que d'autres donnent à l'Armée leur appui sincère. Dès le premier office religieux célébré le 24 mai 1882 à l'intention du public, le mouvement de prosélytisme gagne rapidement toutes les villes du Canada, en même temps que l'Armée du Salut poursuit son oeuvre humanitaire.

Le principe qui régit l'Armée du Salut depuis plus d'un siècle est d'une logique désarmante: il est impossible de sauver l'âme d'une personne qui souffre de la faim et de la pauvreté. C'est dans cette optique que William Booth, ministre méthodiste devenu évangélisateur, a entamé sa mission spirituelle en organisant des soupes populaires pour les nécessiteux des bas quartiers de Londres. C'est également pour cette raison que ses apôtres, qui prêchent aujourd'hui en quelque 160 langues dans près de 70 pays, entretiennent un vaste réseau de services sociaux et d'organisations de bienfaisance de toutes sortes dans le monde entier.

Ce grand déploiement d'indulgence et de générosité fait contrepoids à la position stricte adoptée par l'Armée du Salut dans sa "lutte contre le mal". S'opposant formellement à la consommation d'alcool et de tabac, à la promiscuité et au jeu, l'Armée est considérée comme la plus importante société de tempérance au monde. Même au temps où son fondateur exerçait un pouvoir absolu, l'Armée du Salut a toujours reconnu l'égalité des femmes membres de cette Église.

A gauche: Jack Addie (à droite) et Joe Ludgate ont fondé l'Armée du Salut à London, Ontario, en 1882.
A droite: Le drapeau de l'Armée du Salut
(l'Armée du Salut)

**Canada Day – Canadian Paintings**

The theme of this year's special Canada Day miniature sheet of twelve stamps is "Canada through the eyes of its artists." The works of Canadian painters illustrate the vivid and varied beauty with which Canada is so generously endowed. Each province and territory is represented by a painting. Their order of appearance has been determined solely by design requirements to give an overall sense of balance and harmony to the pane.

Jean Morin of Montreal, who designed this issue, has worked on a number of previous stamps, the most recent being the stamp commemorating Les Floralies de Montréal in 1981.

**Fête du Canada – Oeuvres canadiennes**

Cette année, le feuillet miniature de douze timbres produit spécialement pour la Fête du Canada a pour thème "Le Canada vu par ses artistes". Les oeuvres de peintres canadiens qui ont été choisies donnent en effet un aperçu des multiples splendeurs de notre pays. Les provinces et territoires ont fourni chacun le sujet d'un tableau. L'ordre de présentation des oeuvres n'étant déterminé que par un souci d'équilibre et d'harmonie.

Le Montréalais Jean Morin, qui a conçu l'ensemble, a déjà conçu d'autres vignettes, dont la plus récente est le timbre commémorant Les Floralies de Montréal en 1981.

**Book Title:**
Souvenir Collection of the Postage Stamps of Canada 1982
**Authors:**
Louise Ellis, Gloria Menard
Tom Masters
**Art Director:**
Iain Baines
**Designer:**
Rolf Harder, Leo Schweizer
**Artists and Photographers:**
Various
**Publisher:**
Canada Post Corp.
**Typographer:**
Compotronic, Inc.
**Printer:**
Ashton-Potter, Ltd.
**Production Manager:**
Dennis Tindale
**Paper:**
Rolland Renaissance 200m
**Binder:**
Bindery Services
**Jacket Designer:**
Rolf Harder
**Jacket Illustrator:**
Rolf Harder

22

### FISH: HOW TO CHOOSE

*Salmon*  Salmon, the nobleſt and richeſt fiſh taken in freſh water — the largeſt are the beſt. They are unlike almoſt every other fiſh, are ameliorated by being 3 or 4 days out of water, if kept from heat and the moon, which has much more injurious effect than the ſun.
In all great fiſh-markets, great fiſh-mongers ſtrictly examine the gills—if the bright redneſs is exchanged for a low brown, they are ſtale; but when live fiſh are bro't flouncing into market, you have only to elect the kind moſt agreeable to your palate and the ſeaſon.

*Shad*  Shad, contrary to the generally received opinion, are not ſo much richer flavored, as they are harder when firſt taken out of the water; opinions vary reſpecting them. I have taſted Shad thirty or forty miles from the place where caught, and really conceived that they had a richneſs of flavor, which did not appertain to thoſe taken freſh and cooked immediately, and

23

have proved both at the ſame table, and the truth may reſt here, that a Shad 36 or 48 hours out of water, may not cook ſo hard and ſolid, and be eſteemed ſo elegant, yet give a higher reliſhed flavor to the taſte.

*Salt Water Fiſh*  Every ſpecies generally of ſalt water Fiſh, are beſt freſh from the water, tho' the Hannah Hill, Black Fiſh, Lobſter, Oyſter, Flounder, Baſs, Cod, Haddock, and Eel, with many others, may be tranſported by land many miles, find a good market, and retain a good reliſh; but as generally, live ones are bought firſt, deceits are uſed to give them a freſhneſs of appearance, ſuch as peppering the gills, wetting the fins and tails, and even painting the gills, or wetting with animal blood. Experience and attention will dictate the choice of the beſt. Freſh gills, full bright eyes, moiſt fins and tails, are denotements of their being freſh caught; if they are ſoft, its certain they are ſtale but if deceits are uſed, your ſmell muſt approve or denounce them, and be your ſafeſt guide.

**Book Title:**
An Anthology of American Classics
Twenty-fifth Anniversary Edition
**Authors:**
John C. Callihan
and others
**Designer:**
Bradbury Thompson
**Illustrators:**
Various
**Publisher:**
Westvaco Corp.
**Typographer:**
Finn Typographic Service, Inc.
**Printer:**
The Meriden Gravure Co.
**Production Manager:**
Marie T. Raperto
**Paper:**
Clear Spring Vellum Offset #60
**Binder:**
Tapley-Rutter Co., Inc.

**Book Title:**
Sunar 82
**Editor:**
Christine Rae
**Designer:**
Wilburn Bonnell III
**Photographers:**
Various
**Publisher:**
Sunar
**Typographer:**
Pastore DePamphilis
Rampone
**Printer:**
Dai Nippon Printing Co., Ltd.
**Production Manager:**
Wilburn Bonnell III
**Binder:**
Dai Nippon Printing Co., Ltd.
**Jacket Designer:**
Wilburn Bonnell III

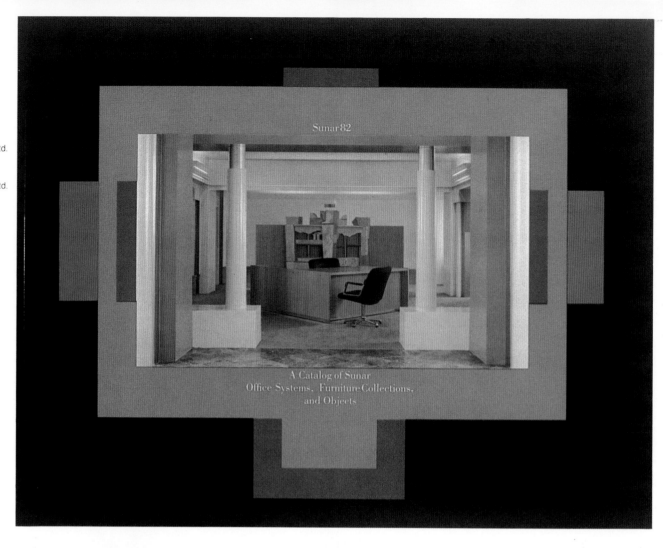

Sunar 82

A Catalog of Sunar
Office Systems, Furniture Collections,
and Objects

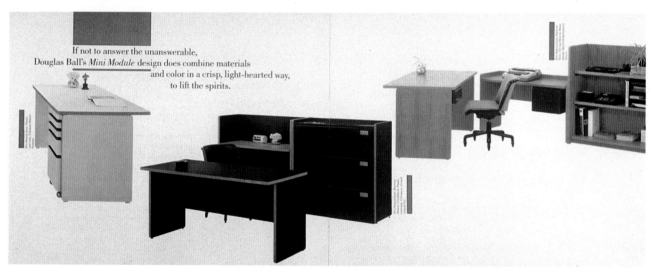

If not to answer the unanswerable,
Douglas Ball's *Mini Module* design does combine materials
and color in a crisp, light-hearted way,
to lift the spirits.

**Book Title:**
Kingswood: Study in Design
**Author/Editor:**
Martha Cross Neumann
**Art Director:**
Katherine McCoy
**Designer:**
Bonnie Detloff
**Photographers:**
Richard Hirneisen, George
Hance, Balthazar Korab,
Harvey Croze
**Publisher:**
Kingswood School
Cranbrook
**Typographer:**
Alpha 21
**Printer:**
Signet Printing
**Production Manager:**
Bonnie Detloff
**Paper:**
Black & White Dull #80,
#100 Text
**Binder:**
Star Bindery Co., Inc.
**Jacket Photographer:**
Richard Hirneisen

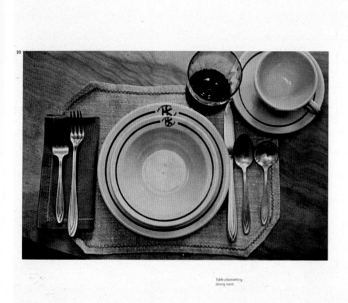

Table placesetting
dining room

Dining room floor lamps,
designed by Eero
Saarinen

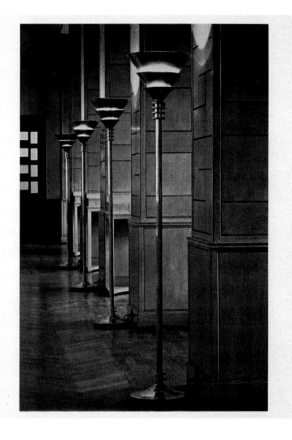

**Book Title:**
The Early Illustrated Book
**Editor:**
Sandra Hindman
**Art Director:**
Dana J. Pratt
**Designer:**
Adrianne Onderdonk
Dudden
**Illustrators:**
Various
**Publisher:**
Library of Congress
**Typographers:**
The Stinehour Press
The Haddon Craftsmen, Inc.
**Printer:**
Garamond/Pridemark
Press, Inc.
**Production Manager:**
Johanna T. Craig
**Paper:**
Mohawk Superfine Text #70
Warren's LOE #80 Text
**Binder:**
Nicholstone Book
Bindery, Inc.
**Jacket Designer:**
Adrianne Onderdonk
Dudden
**Jacket Illustrator:**
Adrianne Onderdonk
Dudden

companied Breydenbach on a pilgrimage with the specific purpose of making draw-ings of Jerusalem and major cities along the way in preparation for the eventual woodcuts. Considering the state of the art before he started, Reuwich's woodcuts are remarkably vivid representations of the places he saw, and they set a standard for the rest of the century. He devised a graphic style that was informative, clear, and well suited to the medium. The illustrations show the cities as encountered by the artist arriving by ship. The view of Corfu (fig. 1), for example, is taken from far enough offshore so that the whole city fits into the picture. The harbor is full of activity with ships being loaded or getting under way. The pictorial interest of this lively cityscape is a notable achievement in itself, but Reuwich did not lose sight of the fact that he was expected to portray a specific place known by name. To that end a fantastic banderole flutters over the entire city proclaiming its identity. How easily the artist's mind moved between the pictorial, topographical, and even cartographic aspects of his subject can be observed in the foldout view of the Holy Land, where a scenic mode of representation converts into a map at the outskirts of Jerusalem (fig. 2). The map portrays landscape in its territorial sense, outlining its shape and most prominent features, while the topographical view is well on its way to becoming a pictorial landscape.

Another instance of a landscape in woodcut having been motivated by topo-graphical concerns is the illustration identified as the Castle on the Gaisbühel (fig. 3) in Thomas Lirer's *Chronik von allen Königen und Kaisern*, called the *Swabian Chronicle*, which was published in Ulm by Dinckmut in 1486. In this case, however, the anonymous illustrator was no skilled topographical artist like Reuwich. The landscape looks like a conventionalized background with the usual foreground

*right:*
FIGURE 3. Castle on the "Gaisbühel,"
Thomas Lirer, *Chronik von allen
Königen und Kaisern*
(Ulm: Conrad Dinckmut, 1486),
Rosenwald Collection, no. 115.

*far right:*
FIGURE 4. St. Lucius with an Ox and
a Bear Harnessed to His Plow,
Thomas Lirer, *Chronik von allen
Königen und Kaisern*
(Ulm: Conrad Dinckmut, 1486),
Rosenwald Collection, no. 115.

FIGURE 5.
Landscape with Imperial Cities.
[Konrad Bote], *Cronecken der Sassen*
[Mainz: Peter Schoeffer, 1492],
Rosenwald Collection, no. 157.

subject simply eliminated. The normal relationship of landscape to figures can be seen in a similar woodcut from the same book, showing Saint Lucius, who has managed to harness a bear to his plow in place of the ox that the bear had killed (fig. 4). Whether or not the former view bore much similarity to the actual place, the castle and the terrain it dominated were given an illustration of their own without being upstaged by a narrative scene. The process of recasting the traditional land-scape background into the main subject occurred, it would seem, because of the political and historical rather than scenic interest of the site.

An illustration of a landscape especially constructed for a similar purpose appears in Konrad Bote's *Saxon Chronicle* (*Cronecken der Sassen*), published 1492 in Mainz by Peter Schoeffer (fig. 5). Set within a continuous, steeply rising landscape are clusters of late medieval buildings identified by inscriptions as German cities and estates, such as Magdeburg, Lüneburg, Salzwedel, and Harzburg. An imperial fig-ure, labeled Julius, oversees this terrain from a high, rocky place in the foreground. The telescoped arrangement of this political landscape did not have troubled a contemporary viewer who would have been accustomed to seeing paintings in which several episodes from one narrative were shown simultaneously within a single landscape, sometimes representing locations great distances apart.

---

**Book Title:**
Ben's Dream
**Author:**
Chris Van Allsburg
**Editor:**
Walter Lorraine
**Art Director:**
Carol Goldenberg
**Designers:**
Carol Goldenberg,
Chris Van Allsburg
**Illustrator:**
Chris Van Allsburg
**Publisher:**
Houghton Mifflin Co.
**Typographer:**
Roy McCoy
**Printer:**
The Murray Printing Co.
**Production Manager:**
Janice Pecararo
**Paper:**
Patina #80
**Binder:**
The Murray Printing Co.
**Jacket Designer:**
Carol Goldenberg
**Jacket Illustrator:**
Chris Van Allsburg

**Louis XV Revival
1845–1870**

By 1860 the balloon back had become the signature shape for its French-oriented age. Exposed-frame balloon-shaped frame appeared on upholstered and un-upholstered side chairs and armchairs.

This rosewood armchair with floral motifs carved on its frame, cabriole front legs, and reverse-curve rear legs, typifies the Louis XV Revival. It was one of a set designed for the Colonel Robert J. Milligan house in Saratoga, New York. Deep-tufted upholstered seats and balloon-shaped backs are also characteristic of the style, as is naturalistic carving.

Materials: Black walnut and, occasionally, mahogany were used in addition to rosewood.

Makers: This chair was made by Galusha Brothers of Troy, New York, around 1855. Other major makers of Louis XV Revival chairs include A. Eliaers of Boston; Joseph Meeks and Sons of New York; George J. Henkels of Philadelphia; S. J. John of Cincinnati; and John Jelliff of Newark, New Jersey.

**Rococo Revival—
John Henry Belter
1844–1863**

The elaborate and intricate open carving of Belter's chairs would not have with-stood normal wear had it not been for his laminating proc-ess. His method was to piece together layers of wood with the grain running at right angles, then to press the wood in steam molds to make it curve, and finally to pierce and carve it.

This typical Belter armchair has a laminated pierced-and-carved back comprising six to eight layers of veneer (see illustration above). Encir-cling the egg-shape tufted upholstered back of this Belter chair is pierced work in an oak-leaf pattern with an urn of flowers at the top. Elaborately carved cresting is in a floral-and-grape design above an ovolo molding in a scroll-and-cornucopia pat-tern. Finely executed carv-ing in floral-and-grape motifs are continuously varied in Belter's work.

Materials: Belter chairs are always of laminated rosewood.

Makers: The work of the German-born John Henry Belter is a distinct variation on the Louis XV Revival style. Belter, who operated in New York City from about 1844 until his death in 1863, invented a laminating proc-ess, which he used in making the backs of his chairs and sofas. Charles A. Baudouine of New York was his most successful competitor.

# The Wood Chair in America

**Book Title:**
The Wood Chair in America
**Authors:**
C. Ray Smith, Marian Page
Donovan & Green
**Editor:**
Nancye L. Green
**Art Directors:**
Michael Donovan,
Nancye L. Green
**Designer:**
Jane Zash
**Illustrators:**
Randall Lieu, Jim Silks
**Photographers:**
Amos T. S. Chan,
Michael Pateman
**Publishers:**
Estelle and Stephen Brickel
**Typographer:**
Concept Typographics
Service, Inc.
**Printer:**
Froelich/Green Litho Corp.
**Paper:**
Vintage Velvet Text #80
Vintage Velvet Cover #100
**Binder:**
E & M Bindery
**Jacket Designer:**
Jane Zash
**Jacket Photographer:**
Amos T.S. Chan

---

# COLONIAL KITS (1650–1800)

25

**Kit:** Nightstand
**Period:** Early nineteenth century
**Company:** The Bartley Collection, Ltd.
**Dimensions:** 20"W x 16"D x 29"H
**Woods:** Cherry; mahogany
**Number of parts:** 17
**Assembly time:** 3 hours
**Price:** $295.00 both woods
*This delicate nightstand is an adaptation of a nine-teenth-century painted washstand.*

**Kit:** Low bed with trundle
**Period:** Eighteenth century
**Company:** Cohasset Colonials
**Dimensions:** 69"W x 88"L x 35"H (bed); 34"W x 74 1/2"L x 9"H (trundle)
**Woods:** Pine/maple
**Number of parts:** 10 (bed); 13 (trundle)
**Assembly time:** 2 hours each
**Price:** $225.00 (full-size bed); $119.00 (trundle); $70.00 (foam rubber trundle mattress)
*The original of this attrac-tive low bed is in the Thomas Hart Room at the Metropolitan Museum of Art.*

**Kit:** Four-poster canopy bed
**Period:** Circa 1750
**Company:** Cohasset Colonials
**Dimensions:** (full size shown) 63"W x 80"L x 77"H
**Woods:** Pine/maple
**Number of parts:** 22
**Assembly time:** 1 1/2 hours
**Price:** $359.00
*Our favorite kit, and the most attractive and well-built bed for the price you'll find anywhere—I guarantee it. You can order the fishnet canopy separately ($190 for a full size). The canopy bed is also available in twin and queen sizes.*

**Kit:** Armoire
**Period:** Early eighteenth century (adaptation)
**Company:** American Forest Products Company
**Dimensions:** 30 9/16"W x 16 5/16"D x 54 3/16"H
**Wood:** Pine
**Number of parts:** 73
**Assembly time:** 8–9 hours
**Price:** $164.95

**Kit:** Dover china cupboard
**Period:** Circa 1750 (Queen Anne influence)
**Company:** Outer Banks Pine Products
**Dimensions:** 27 5/8"W x 17 1/2"D x 86 1/2"H
**Wood:** Pine
**Number of parts:** 18
**Assembly time:** 3 hours
**Price:** $250.00
*Raised panel doors, scal-loped-edge shelves, and a finished back are among the distinctive features of this finely crafted cabinet. Note the classic bonnet top with the urn final. The glass front is included in the kit.*

**Kit:** Hutch
**Period:** Early eighteenth century
**Company:** American Forest Products Company
**Dimensions:** 26 11/16"W x 15 5/16"D x 71 7/8"H
**Wood:** Pine
**Number of parts:** 50
**Assembly time:** 4–6 hours
**Price:** $139.95

**Kit:** Salem corner cupboard
**Period:** Circa 1775
**Company:** Outer Banks Pine Products
**Dimensions:** 37 5/8"W x 27 1/16"D x 82"H
**Wood:** Pine
**Number of parts:** 19
**Assembly time:** 3 hours
**Price:** $350.00

**Kit:** Corner cupboard
**Period:** Eighteenth century
**Company:** Yield House
**Dimensions:** 37 1/2"W x 16 3/4"D x 72"H
**Wood:** Pine
**Number of parts:** 40
**Assembly time:** 3–4 hours
**Price:** $279.00 ppd.
*A model of understated beauty and practicality, this functional cupboard fea-tures deep display shelves, which are grooved to hold plates upright.*

**Book Title:**
The Kit Furniture Book
**Author:**
Lynda Graham-Barber
**Editor:**
Betsy Amster
**Art Director:**
Susan Mitchell
**Designer:**
Sara Eisenman
**Photographers:**
Michel Legrou,
Marc Weinstein and others
**Publisher:**
Pantheon Books
**Typographer:**
Crane Typesetting
Service, Inc.
**Printer:**
The Murray Printing Co.
Coral Color Corp.
**Production Manager:**
Kathy Grasso
**Paper:**
Bookbinders Suede #70
**Binder:**
The Murray Printing Co.
**Cover Designer:**
Sara Eisenman
**Jacket Photographers:**
Michel Legrou,
Marc Weinstein

If there is any one element which unites these items
in their diversity, it is the ability to attract, to com-
mand attention. Even among the final selection,
where it seems the competition would be especially
keen, each speaks distinctly, at times eloquently,
so that even the casual viewer becomes involved,
surrendering to the process of communication.

**Chairman**
Henry Wolf
President
Henry Wolf Productions

**Jury**
Ivan Chermayeff
Partner
Chermayeff & Geismar Associates

Bridget DeSocio
Art Director
Stendig International

Arthur Einstein
Executive Vice President/
Creative Director
Lord, Geller, Federico, Einstein

Mike Salisbury
Designer
Mike Salisbury Communications

Lloyd Ziff
Art Director
Vanity Fair Magazine

Because of its eclectic nature, the Communication Graphics show has always attracted a relatively large number of entries — over 4000 this year, from 39 states (including Alaska and Hawaii), as well as Puerto Rico and Canada — producing a potpourri of graphic inspirations, witty ideas, lavish productions, and expensive gimmicks, sometimes all merging into a single winning entry. There are invitations to weddings and openings; calendars presenting (visually) the great landscapes of the American West and (conceptually) our ideas about time; boxes made from wood, aluminum, and board serving as promotion pieces, press kits, and a carpenter's rule. There are bags of sand from the Florida shore and soil from a developer's site, a T-shirt, and, of course, posters and brochures galore, nonetheless interesting for their more conventional, two-dimensional form.

If there is any one element which unites these items in their diversity, it is the ability to attract, to command attention. Even among the final selection, where it seems the competition would be especially keen, each speaks distinctly, at times eloquently, so that even the casual viewer becomes involved, surrendering to the process of communication.

For the jurors, who had to look at many more pieces than ultimately were selected, the job was more complex. The trend toward an increasing level of competence among entries continues, causing one juror to refer to the phenomenon as "a high level of boring." Good ideas are quickly imitated, for better or worse, and some entries seemed bent upon using up a generous production budget, whether the original concept called for it or not. "A lavish, varnished, six-color printing job can't make up for a lack of ideas," another juror bemoaned. "It's like buying a 16-cylinder Cadillac in 1934."

Among the more predictable forms entered — and selected — were some surprises. Two books, both in the New Wave mode, were trimmed off the square, bringing another novel, if somewhat disorienting, frame of reference to the page. There are several New Wave pieces in the show, suggesting that the style is gaining a wider acceptance among designers, and that a mastery of execution does much to validate the most reactionary of styles.

Other pieces were surprising in their incongruities — a restaurant menu, for example, with text set like poetry and illustrated with impressionistic drawings of food; a lavishly produced brochure with a cover of gray cardboard, embossed or hot-stamped as if it were a premium cover grade; a tall, thin, hardcover "book" which opened to a six-page flyer, printed on text-weight stock and folded accordion-style.

Also of interest were the selections from Texas, not only for their sheer numbers, but for the quality of their designs. At a time when the national economy is showing signs of recovery, the oil-based business of Texas continues to boom, supporting a flourishing graphic design industry admirably suited to this golden buckle of the Sun Belt. Many of these designs are both serious and sensitive, with muted and grainy color photographs set into wide margins and type set as a classical understatement. The effect is that of a visual *sotto voce*, the gentle movement of wind-borne sands across the wide open spaces.

Many of the Texan entries were pieces for developers, characterized by one juror as "real estate brochures to sell condominiums to millionaires with no taste." Speculating on the process of selecting well-designed pieces from among them, this juror continued: "We're probably choosing the least successful. We're judging on criteria having little to do with the purpose, and *our* criteria are of secondary importance to the client."

More disturbing was the observation of another that, in many entries, the design seemed to be at cross purposes with content — "a conflict between what's going to work and what will be art." The best of these were colorful, witty, or even elegant contrivances. In the worst — as in one New Wave piece whose variously sized lines of type were dovetailed into one another — the content was close to inaccessible.

The one place where New Wave solutions seemed to work the best was in the design of posters: here, in a medium of initial impact, a minimum of information is presented among flying color bars, floating squares, and type running at right angles to itself, with no loss of clarity. As a whole, the winning posters are a celebration of the form, with large areas of color, clean typography, appealing illustration, and strong photography. And the ads in the show are much like them: one idea, strongly put.

Among the rioting colors and opulent productions, there are a few selections bearing the hallmark of restraint. Obviously produced on smaller budgets, jobs like these — a fundraiser for a seminary, for example, or a catalog produced in black and white — allow for no compromising of concept, no glossing over of a weak idea with strong production. In an industry where we expect award-winners to dazzle us with technique, such simple, eloquent solutions are rare. And in a show with the breadth of scope such as this one, their presence is reassuring indeed.

**Billboard:**
1983/Stroh's Beer
**Art Director:**
Mark Hughes
**Designer:**
Mark Hughes
**Photographer:**
Gill Cope
**Agency:**
Doyle Dane Bernbach
New York, NY
**Writer:**
Steve Landsberg
**Client:**
Stroh's Brewery

**Magazine Ad:**
Artist/Designer
Ron Chereskin...
**Art Director:**
Susan Lloyd
**Photographer:**
Ulf Skogsbergh
**Design Firm:**
A.C. & R. Advertising
New York, NY
**Client:**
Ron Chereskin

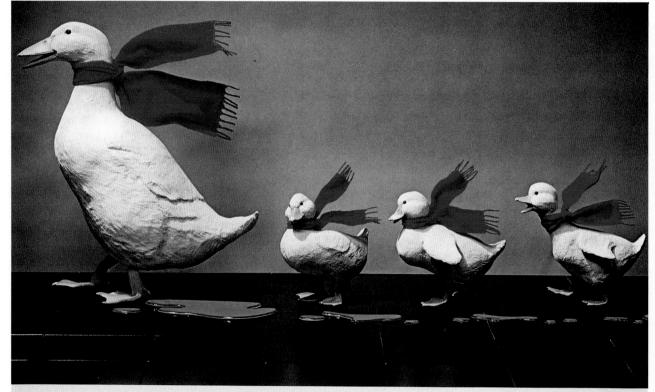

Artist/designer Ron Chereskin redefines rainwear and outerwear for men / 1290 Avenue of the Americas, Suite 1086, New York, New York 10104 (212) 977-2681

**Poster:**
AIGA California Design
80-82
**Art Director:**
Kit Hinrichs
**Designer:**
Kit Hinrichs
**Photographer:**
Terry Heffernan,
Light Language
**Design Firm:**
Jonson Pedersen Hinrichs
& Shakery
San Francisco, CA
**Publisher:**
The American Institute of
Graphic Arts
**Printer:**
Anderson Lithograph Co.

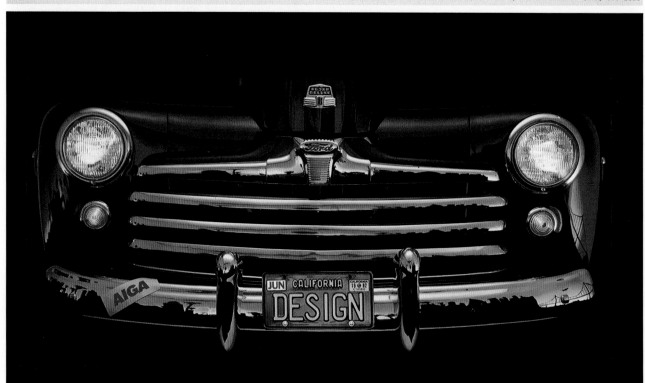

**Poster:**
TransConstructivism
**Designers:**
Steven Tolleson
Michael Kunisaki
**Design Firm:**
Mark Anderson Design
Palo Alto, CA
**Typographer:**
Abra Type
**Printer:**
The Works

**Poster:**
Innovative Furniture
in America
**Designers:**
Stephen Frykholm
Barbara Loveland
**Design Firm:**
Corporate Communication
Design & Development,
Herman Miller, Inc.
Zeeland, MI
**Client:**
Herman Miller
**Typographer:**
Type House, Inc.
**Printer:**
Continental Identification
Products

Innovative Furniture in America

The Saint Louis Art Museum

July 23 – September 5, 1982    Organized and circulated by the Smithsonian Institution Traveling Exhibition Service.

Sponsored in St. Louis by Interiors Unlimited and Herman Miller, Inc., with additional support from the Missouri Arts Council.

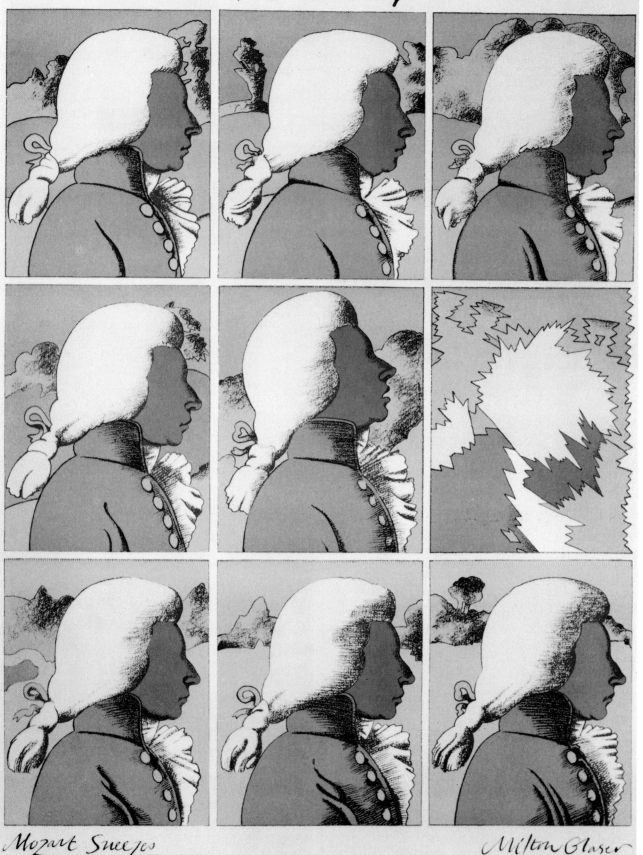

**Poster:**
Mostly Mozart Festival
Lincoln Center
**Art Director:**
Milton Glaser
**Designer:**
Milton Glaser
**Artist:**
Milton Glaser
**Design Firm:**
Milton Glaser, Inc.
New York, NY
**Publisher:**
Lincoln Center for the
Performing Arts
**Printer:**
Metropolitan Printing

**Poster:**
Hot Seat/Knoll
**Art Director:**
Woody Pirtle
**Designer:**
Woody Pirtle
**Artist:**
Woody Pirtle
**Design Firm:**
Woody Pirtle
Dallas, TX
**Publisher:**
Knoll International/Dallas
**Printer:**
Harvey DuPriest

**Greeting Card:**
Merry Christmas and
Happy New Year
**Art Directors:**
Luis Acevedo
Woody Pirtle
**Designer:**
Luis Acevedo
**Photographer:**
John Wong
**Design Firm:**
Pirtle Design
Dallas, TX
**Client:**
Heritage Press
**Typographer:**
Southwestern Typographics
**Printer:**
Heritage Press

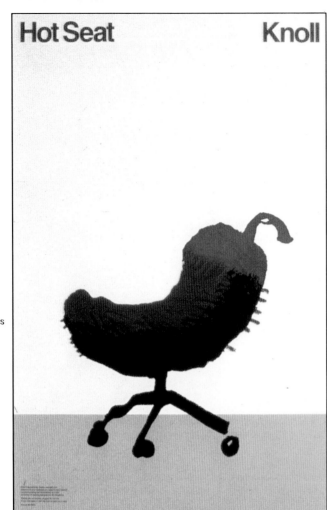

**Poster:**
A.M.
**Art Director:**
Woody Pirtle
**Designer:**
Woody Pirtle
**Photographer:**
Arthur Meyerson
**Design Firm:**
Pirtle Design
Dallas, TX
**Client:**
Arthur Meyerson
**Typographer:**
Southwestern Typographics
**Printer:**
Brodnax

**Poster:**
Shakespeare Festival
of Dallas
**Art Director:**
Woody Pirtle
**Designer:**
Woody Pirtle
**Artist:**
Woody Pirtle
**Design Firm:**
Pirtle Design
Dallas, TX
**Client:**
Shakespeare Festival
of Dallas
**Typographer:**
Southwestern Typographics
**Printer:**
Heritage Press

**Poster Invitation:**
Tchaikovsky 1812
Overture/Dallas Symphony
League Ball Celebration
**Art Director:**
Brian Boyd
**Designer:**
Brian Boyd
**Artist:**
Brian Boyd
**Design Firm:**
Richards, Sullivan, Brock
& Assoc.
Dallas, TX
**Client:**
Dallas Symphony Orchestra
**Typographer:**
Chiles & Chiles
**Printer:**
Heritage Press

**Poster:**
Columbia Travels
March 8, 1981, 6:00 A.M.
**Art Director:**
Richard Danne
**Designer:**
Richard Danne
**Photographer:**
Rene Burri
**Design Firm:**
Danne & Blackburn, Inc.
New York, NY
**Publisher:**
NASA
**Typographer:**
Typographic Images
**Printer:**
The Hennegan Co.

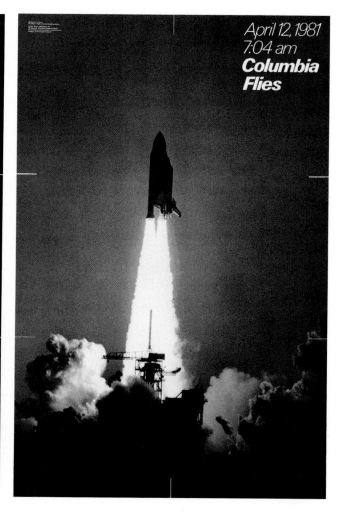

**Poster:**
Columbia Preps
Nov. 25, 1980, 11:30 A.M.
**Art Director:**
Richard Danne
**Designer:**
Richard Danne
**Photographer:**
Rene Burri
**Design Firm:**
Danne & Blackburn, Inc.
New York, NY
**Publisher:**
NASA
**Typographer:**
Typographic Images
**Printer:**
The Hennegan Co.

**Poster:**
Columbia Flies
April 12, 1981, 7:04 A.M.
**Art Director:**
Richard Danne
**Designer:**
Richard Danne
**Photographer:**
Rene Burri
**Design Firm:**
Danne & Blackburn, Inc.
New York, NY
**Publisher:**
NASA
**Typographer:**
Typographic Images
**Printer:**
The Hennegan Co.

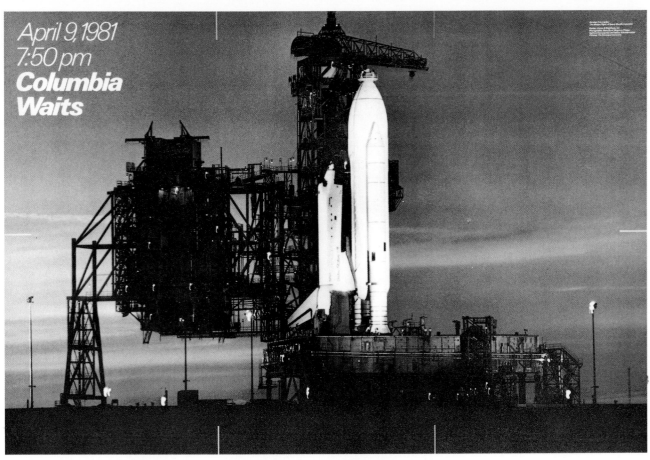

April 9, 1981
7:50 pm
*Columbia
Waits*

**Poster:**
Columbia Waits
April 9, 1981, 7:50 P.M.
**Art Director:**
Richard Danne
**Designer:**
Richard Danne
**Photographer:**
Rene Burri
**Design Firm:**
Danne & Blackburn, Inc.
New York, NY
**Publisher:**
NASA
**Typographer:**
Typographic Images
**Printer:**
The Hennegan Co.

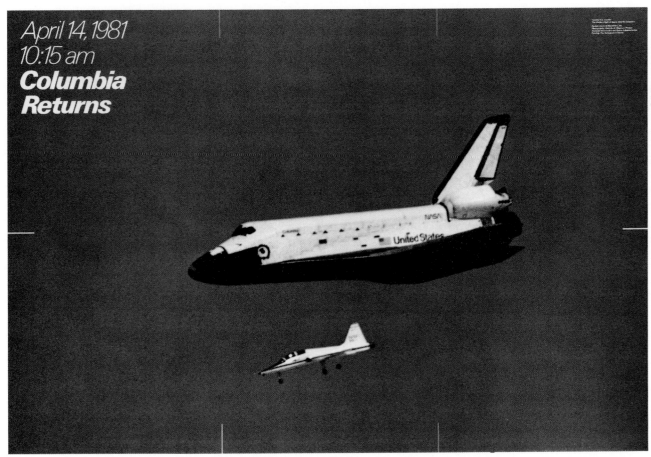

April 14, 1981
10:15 am
*Columbia
Returns*

**Poster:**
Columbia Returns
April 14, 1981, 10:15 A.M.
**Art Director:**
Richard Danne
**Designer:**
Richard Danne
**Photographer:**
Rene Burri
**Design Firm:**
Danne & Blackburn, Inc.
New York, NY
**Publisher:**
NASA
**Typographer:**
Typographic Images
**Printer:**
The Hennegan Co.

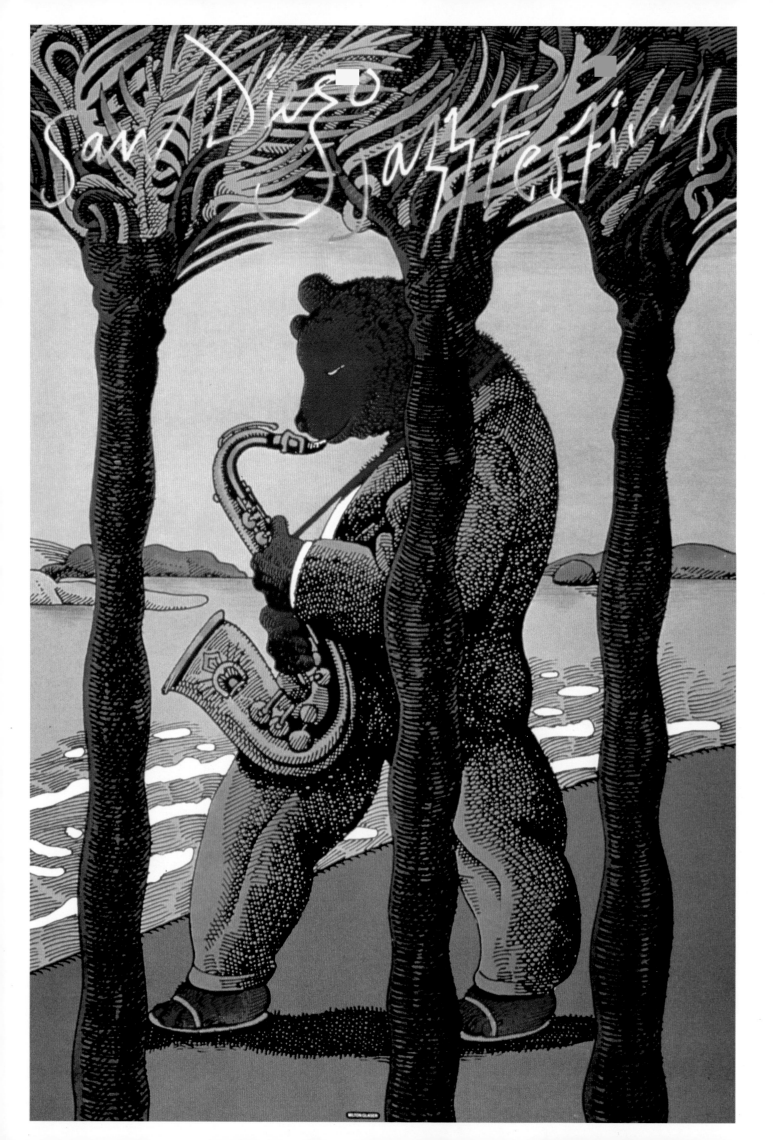

**Poster:**
California Portfolio Days
**Art Director:**
Michael Vanderbyl
**Designer:**
Michael Vanderbyl
**Design Firm:**
Vanderbyl Design
San Francisco, CA
**Publishers:**
California College of Arts
and Crafts, Otis Parsons
School of Design, California
Institute of the Arts, and
San Francisco Art Institute
**Typographer:**
CCAC Typographers
**Printer:**
California Central Press

**Poster:**
San Diego Jazz Festival
**Art Director:**
Milton Glaser
**Designer:**
Milton Glaser
**Artist:**
Milton Glaser
**Design Firm:**
Milton Glaser, Inc.
New York, NY
**Publisher:**
San Diego Jazz Festival
**Printer:**
Metropolitan Printing

**Poster:**
Ten Happy Summers
**Art Director:**
Theo Welti
**Designer:**
Jacqueline Rose
**Photographer:**
Jacqueline Rose
**Design Firm:**
20.20 Vision, Division of
Welti & Rose Advertising,
Inc.
New York, NY
**Client:**
20.20 Vision, Division of
Welti & Rose Advertising,
Inc.
**Typographer:**
Tri-Arts Press, Inc.
**Printer:**
Sanders Printing Corp.

ten happy summers
making art
making headlines
making deadlines

2o.2o vision
36 east 2o street
new york ny loo o3
212 674 788o
call any season

© 2o.2o Vision Division of Welti and Rose Advertising Inc.

314

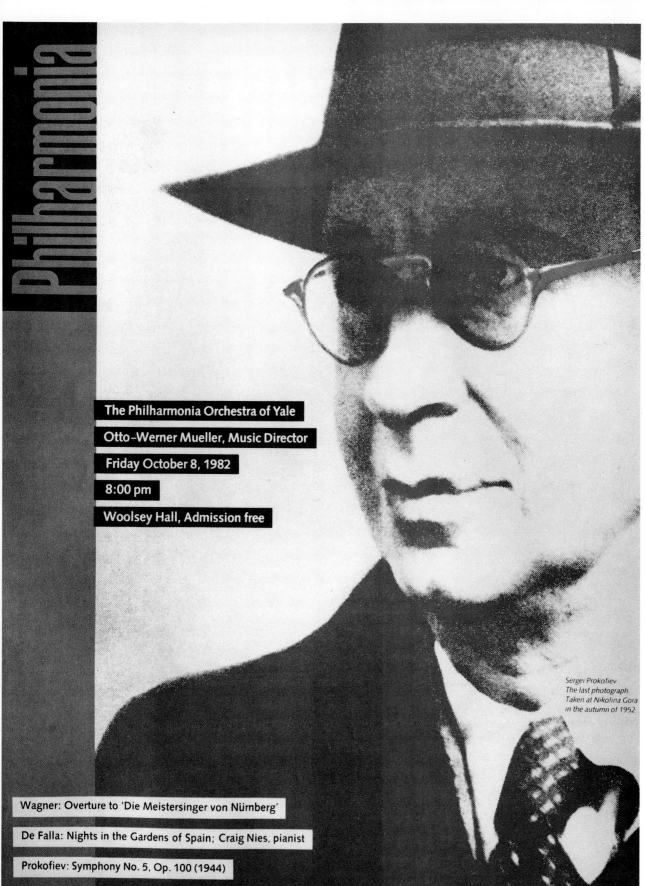

**Poster:**
Philharmonia
**Art Director:**
Richard Mehl
**Designer:**
Richard Mehl
New Haven, CT
**Client:**
Philharmonia of Yale
**Printer:**
Sirocco

Philharmonia

The Philharmonia Orchestra of Yale

Otto-Werner Mueller, Music Director

Friday October 8, 1982

8:00 pm

Woolsey Hall, Admission free

*Sergei Prokofiev.*
*The last photograph.*
*Taken at Nikolina Gora*
*in the autumn of 1952.*

Wagner: Overture to 'Die Meistersinger von Nürnberg'

De Falla: Nights in the Gardens of Spain; Craig Nies, pianist

Prokofiev: Symphony No. 5, Op. 100 (1944)

**Poster:**
Monet
**Art Director:**
Milton Glaser
**Designer:**
Milton Glaser
**Artist:**
Milton Glaser
**Design Firm:**
Milton Glaser, Inc.
New York, NY
**Publisher:**
Whiteprint Editions, Ltd.
**Typographer:**
Innovative Graphics
International
**Printer:**
Metropolitan Printing

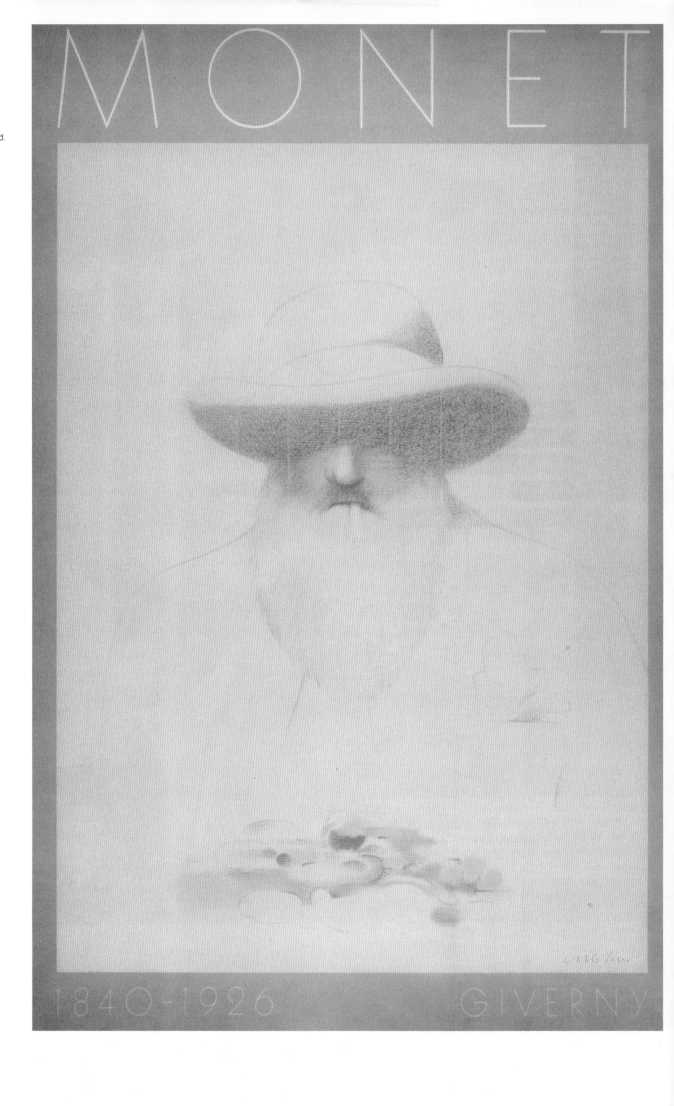

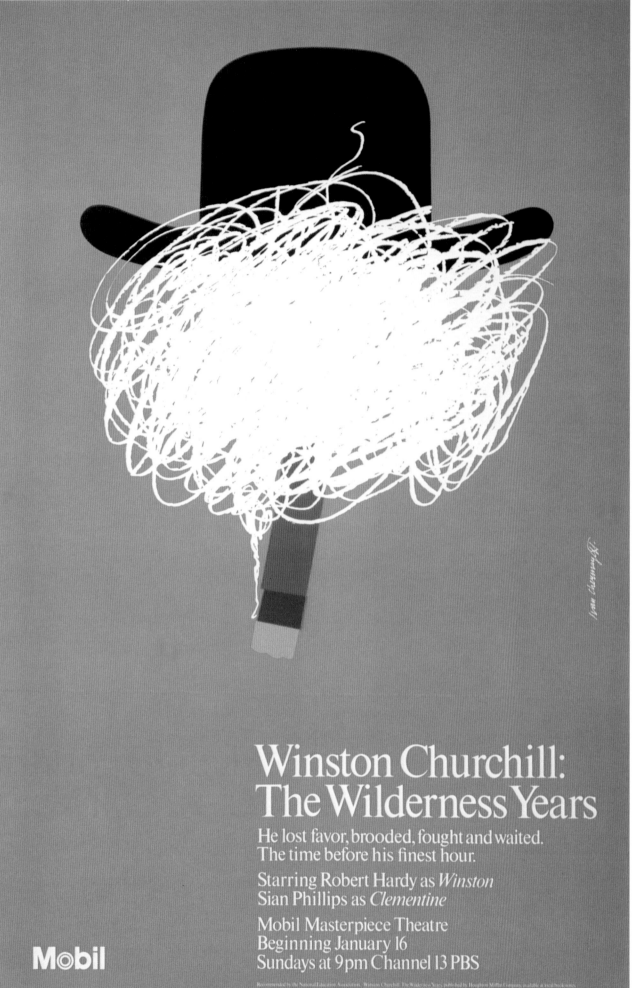

# Winston Churchill: The Wilderness Years

He lost favor, brooded, fought and waited. The time before his finest hour.

Starring Robert Hardy as *Winston*
Sian Phillips as *Clementine*

Mobil Masterpiece Theatre
Beginning January 16
Sundays at 9pm Channel 13 PBS

Mobil

**Poster:**
Winston Churchill:
The Wilderness Years
**Art Director:**
Ivan Chermayeff
**Designer:**
Ivan Chermayeff
**Artist:**
Ivan Chermayeff
**Design Firm:**
Chermayeff & Geismar
Assoc.
New York, NY
**Publisher:**
Mobil Masterpiece Theatre
**Typographer:**
Print & Design
**Printer:**
Tempo Communications,
Inc.

**Invitation:**
GroundBreaking Invitation
**Art Director:**
Dale Rushing
**Designer:**
Dale Rushing
**Photographer:**
King Douglas
**Design Firm:**
Eisenberg, Inc.
Dallas, TX
**Client:**
Rust Properties
**Typographer:**
JCS Typographers
**Printer:**
Padgett Printing

**Poster:**
Dory
**Art Director:**
McRay Magleby
**Designer:**
McRay Magleby
**Artist:**
McRay Magleby
**Design Firm:**
Brigham Young University
Graphic Communications
Provo, UT
**Publisher:**
Brigham Young University

**Poster:**
Free Tuesday Evenings
**Art Director:**
Alan Peckolick
**Designer:**
Alan Peckolick
**Design Firm:**
Pushpin Lubalin Peckolick
New York, NY
**Client:**
Mobil Oil Corp.
**Letterer:**
Tony DiSpigna

**Announcement:**
Culinary Workshop
**Art Directors:**
Tom Poth, David S. Shapiro
**Designers:**
Tom Poth, Mike Hicks
**Artist:**
Larry McEntire
**Design Firm:**
Hixo, Inc.
Austin, TX
**Client:**
Park St. David's Hospital
**Typographer:**
G & S Typesetters
**Printer:**
Printmakers, Inc.

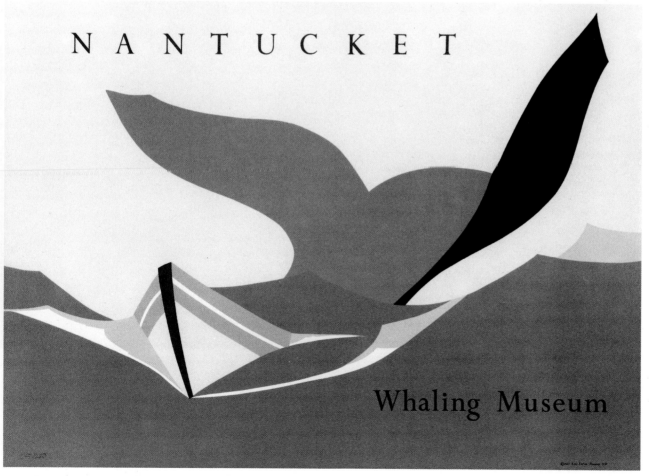

**Poster:**
Nantucket Whaling Museum
**Art Director:**
Kate Emlen
**Designer:**
Kate Emlen
**Artist:**
Kate Emlen
**Design Firm:**
Kate Emlen Graphic Design
Hanover, NH
**Client:**
Nantucket Historical Assn.
**Typography:**
Hand Set
**Printer:**
Sirocco Screenprints

**Poster:**
Profiles in American Art
**Art Directors:**
Walter King, Peggy Striegel
**Designer:**
Walter King
**Artist:**
Walter King
**Design Firm:**
Striegel Graphics
Broken Arrow, OK
**Client:**
Video Ventures
**Typographer:**
Tri-Graphics
**Printer:**
Tulsa Litho Co.

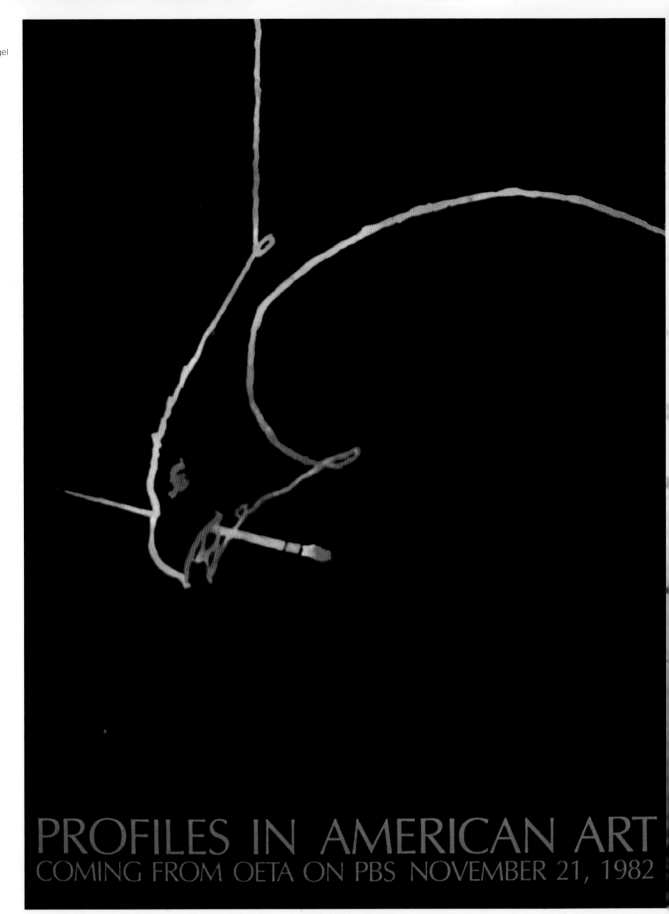

PROFILES IN AMERICAN ART
COMING FROM OETA ON PBS NOVEMBER 21, 1982

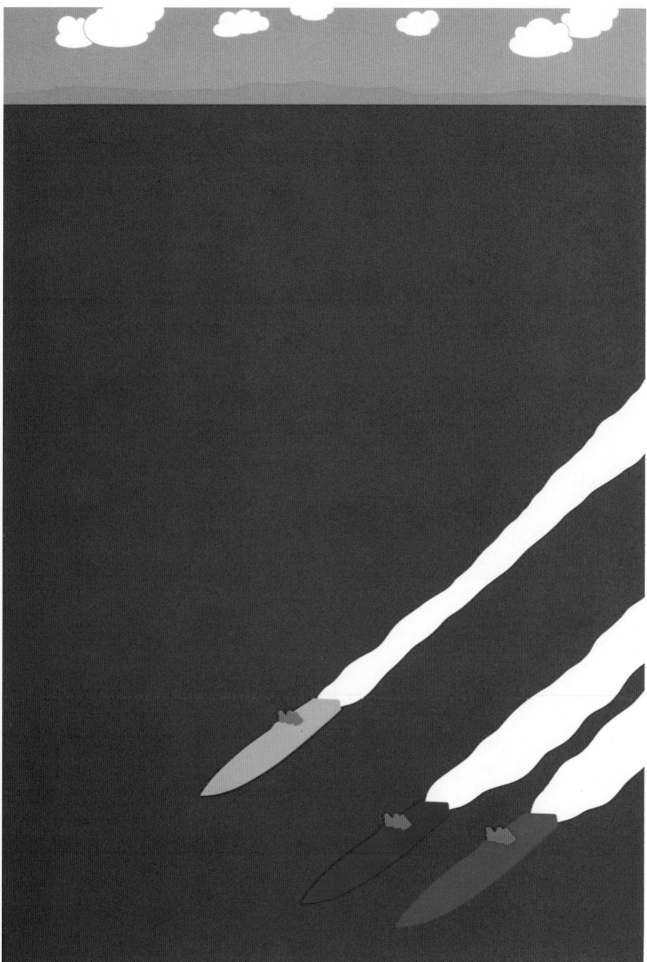

**Poster:**
National Offshore
Powerboat
**Art Director:**
Stephen Frykholm
**Designer:**
Stephen Frykholm
**Artist:**
Stephen Frykholm
**Design Firm:**
Phillips & Frykholm, Inc.
Belmont, MI
**Publisher:**
Ocean Promotions
**Typographer:**
Typehouse St. Joseph
**Printer:**
Continental Identification
Products

1982 RACING CIRCUIT

# NATIONAL OFFSHORE POWERBOAT

NEW ORLEANS   MIAMI   CAPE CORAL   DETROIT   POINT PLEASANT   SAUGATUCK   SAINT AUGUSTINE   FREEPORT, BAHAMAS   IMPERIAL WORLD CUP CHAMPIONSHIP

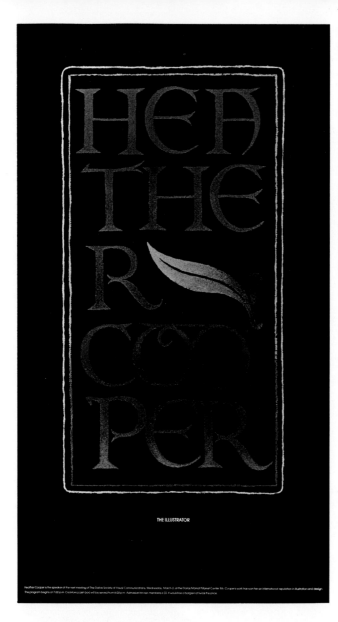

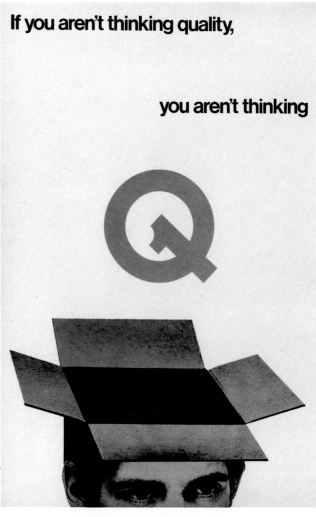

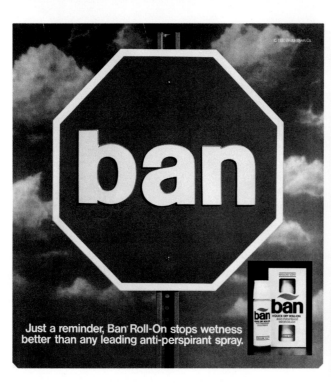

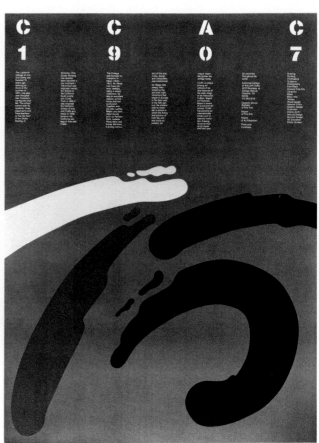

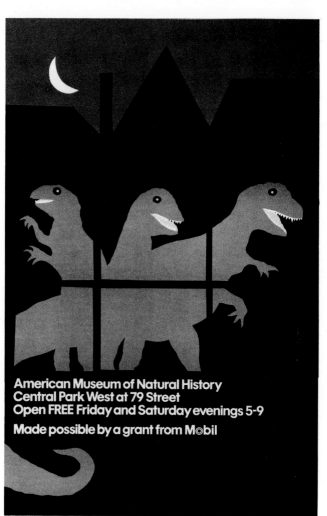

American Museum of Natural History
Central Park West at 79 Street
Open FREE Friday and Saturday evenings 5-9

Made possible by a grant from Mobil

To make sure you're buying 100% Colombian Coffee, read the fine print.

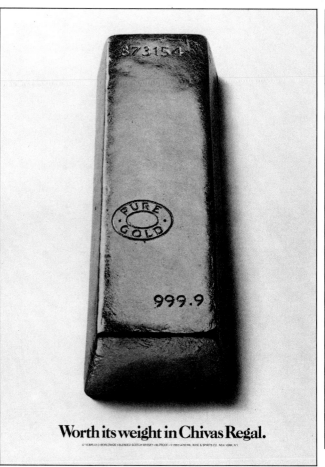

Worth its weight in Chivas Regal.

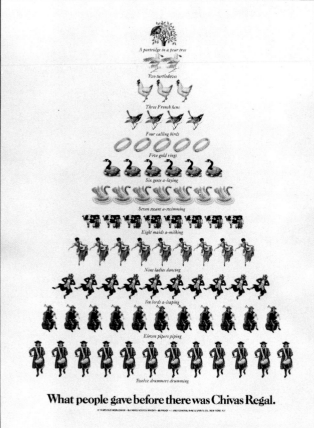

What people gave before there was Chivas Regal.

**Poster:**
Free Your Mind.
Use Your Library.
**Art Director:**
Robert Belinoff
**Designers:**
Robert Belinoff,
Shelley Doppelt
**Design Firm:**
Marketing by Design
New York, NY
**Publisher:**
American Library
Association
**Typographer:**
Innovative Graphics
International
**Printer:**
Congress Printing Co.

**Invitation:**
Construction Party Ahead
**Art Director:**
Woody Pirtle
**Designers:**
Woody Pirtle
Mike Shroeder
**Artists:**
David Neal, Mike Shroeder
**Design Firm:**
Pirtle Design
Dallas, TX
**Client:**
Gerald D. Hines Interests
**Typographer:**
Southwestern Typographics
**Printer:**
Allcraft Printing

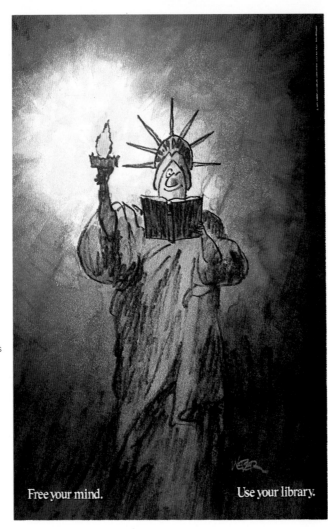

**Poster:**
The Better Way...
ITT Programming
**Art Director:**
Frank Armstrong
**Artist:**
Sally Andersen-Bruce
**Design Firm:**
Armstrong Design
Consultants
New Canaan, CT
**Client:**
ITT Programming
**Typographer:**
Set-to-Fit
**Printer:**
Herlin Press

**Logo/Poster:**
"C" Channel
**Art Director:**
Robert Burns
**Designer:**
Jennifer Gyles
**Artist:**
Al Pease
**Design Firm:**
Burns, Cooper, Hynes, Ltd.
Toronto, CAN
**Client:**
C Channel
**Typographer:**
M & H
**Printer:**
Arthur Jones Lithographers

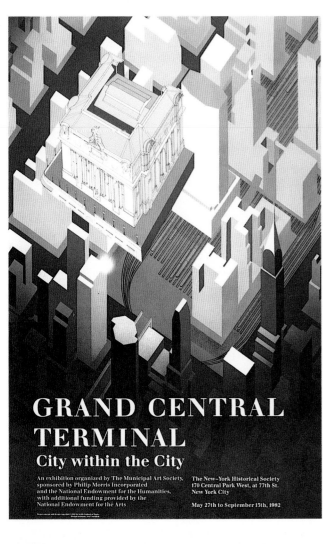

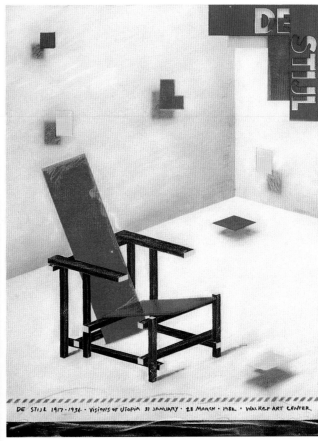

**Poster:**
Festival of Festivals
**Art Directors:**
Gary Ludwig, Paul Hodgson
**Designer:**
Gary Ludwig
**Artist:**
Jayme Odgers
**Design Firm:**
IVC, Inc.
Toronto, CAN
**Publisher:**
Festival of Festivals
**Printer:**
Phipps Reproduction

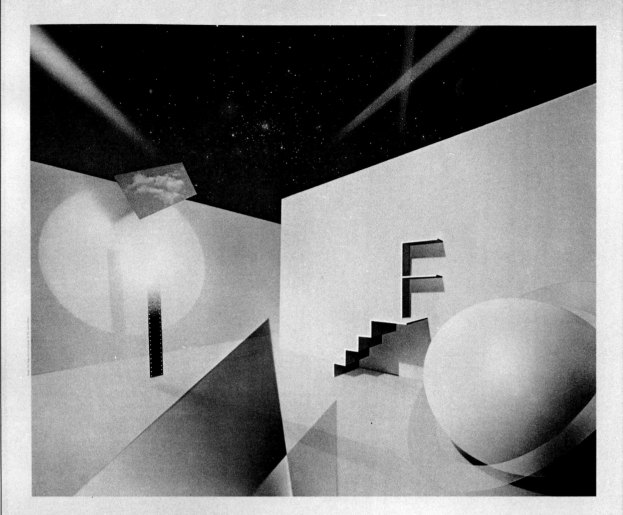

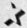

Yale Symphony 82|83 season
Orchestra

Halloween Concert

MIDNIGHT

October 31

Sunday

Woolsey Hall

Robert Kapilow

Music Director

**Poster:**
Halloween Concert
Midnight
**Art Director:**
Peter L. Levine
**Designer:**
Peter L. Levine
**Photographer:**
John T. Hill
**Design Firm:**
Peter L. Levine
New Haven, CT
**Publisher:**
Yale Symphony Orchestra
**Typographer:**
Peter L. Levine
**Printer:**
Screen Tek

▷

**Poster:**
Jazz
**Art Directors:**
Julius Friedman,
Walter McCord
**Designers:**
Julius Friedman,
Walter McCord
**Photographer:**
Jon Brown
**Design Firm:**
Images
Louisville, KY
**Publisher:**
Images
**Typographer:**
Adpro
**Printer:**
The Hennegan Co.

J                                          A

**Poster:**
Replace Damaged Clothing
**Art Director:**
Bob Ryf
**Designer:**
Bob Ryf
**Design Firm:**
IBM In-house
Kingston, NY
**Publisher:**
IBM Corp.
**Typographer:**
IBM In-house
**Printer:**
Regal Art Press

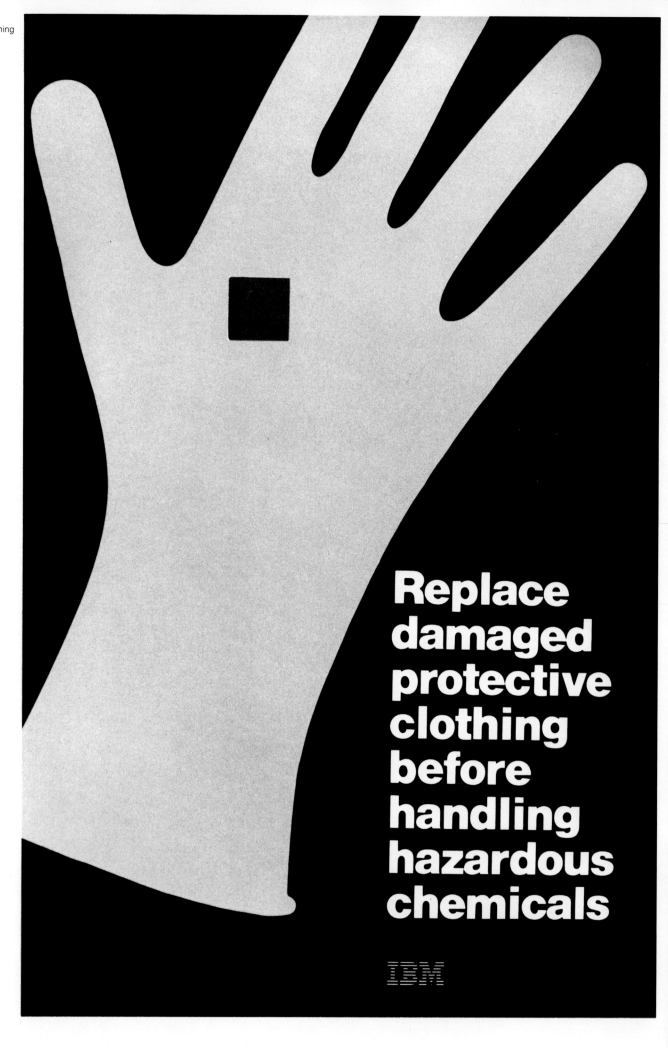

Replace
damaged
protective
clothing
before
handling
hazardous
chemicals

joseph bottoni

marcella k. hsiung

douglas wimmers

david martin

judy collins

terri falbikuffer

terry jent

best wishes from all of us at bottoni and hsiung, inc.

may all of your headaches be small ones in 1983

**Poster:**
May all your headaches
be small ones in 1983
**Designer:**
Joseph Bottoni
**Design Firm:**
Bottoni & Hsiung, Inc.
Cincinnati, OH
**Publisher:**
Bottoni & Hsiung, Inc.
**Typographer:**
Typoset, Inc.
**Printer:**
Ohio Valley Lithocolor

**Poster:**
Zonz
**Art Director:**
Joseph M. Essex
**Designer:**
Joseph M. Essex
**Artists:**
Michael Manwaring, Robert
Burns, Jerry Herring,
Gene Grossman
**Design Firm:**
Burson-Marsteller
Chicago, IL
**Publisher:**
Society of Typographic Arts
**Typographer:**
Master Typographers
**Printer:**
Nu-Tone Lithography

**Poster:**
Alan Lithograph, Inc.
**Art Director:**
John Coy
**Designer:**
John Coy
**Photographer:**
Grant Mudford
**Design Firm:**
Coy, Los Angeles
Culver City, CA
**Printer:**
Alan Lithograph, Inc.

**Poster:**
Chicago
**Art Director:**
Michael McGinn
**Designer:**
Michael McGinn
**Artist:**
Albert Lorenz,
Floral Park, NY
**Design Firm:**
Michael McGinn, Inc.
New York, NY
**Client:**
Citivues

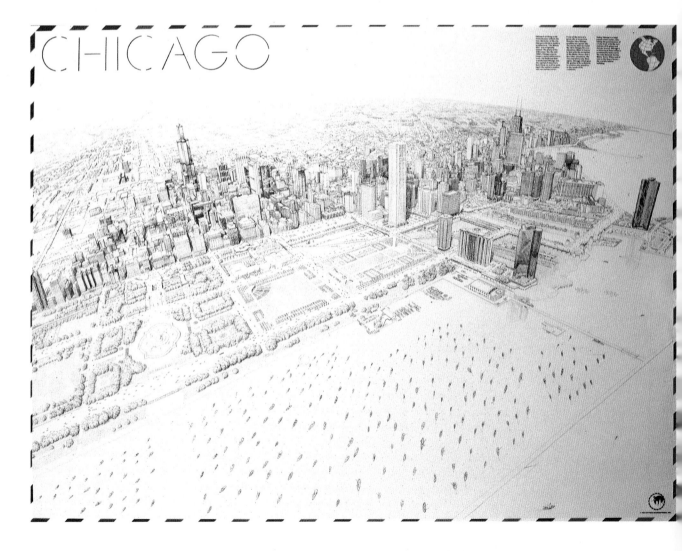

**Poster:**
Science '82 Infinity Poster
**Art Director:**
Henry Pujol
**Designer:**
Henry Pujol
**Photographer:**
Gary Levinson
**Design Firm:**
Mandala
Philadelphia, PA
**Publisher:**
Science '82/J.C. Crimmins
& Co.
**Typographer:**
Typo
**Printer:**
Pearl Pressman Liberty

**Poster/Mailer:**
Thank You
**Art Directors:**
Roger Cook, Don Shanosky
**Designers:**
Roger Cook, Don Shanosky
**Design Firm:**
Cook & Shanosky Assoc.,
Inc.
Princeton, NJ
**Client:**
Philadelphia College of Art
**Typographer:**
Typecraft
**Printer:**
Village Craftsmen

**Annual Report:**
Knudsen Corporation
1981 Annual Report
**Art Director:**
Robert Miles Runyan
**Designer:**
Rik Besser
**Photographer:**
Robert Stevens
**Design Firm:**
Robert Miles Runyan
& Assoc.
Playa del Rey, CA
**Client:**
Knudsen Corp.
**Typographer:**
Composition Type
**Printer:**
Lithographix

**Environmental Graphics:**
Pompeii-XIX Signage
**Art Director:**
Deborah Sussman
**Designer:**
Debra Valencia
**Artists:**
Debra Valencia
Susan Hancock
**Design Firm:**
Sussman/Prejza & Co.
Santa Monica, CA
**Client:**
J. Paul Getty Museum

**Poster:**
Tulip Time
**Art Director:**
Stephen Frykholm
**Designer:**
Stephen Frykholm
**Artist:**
Stephen Frykholm
**Design Firm:**
Corporate Communication
Design & Development,
Herman Miller, Inc.
Zeeland, MI
**Client:**
Herman Miller
**Typographers:**
Stephen Frykholm
Pam Van Dyken
**Printer:**
Continental Identification
Products

Bill Blass

**Magazine Ad:**
Bill Blass
**Art Director:**
Len Favara
**Photographer:**
Gideon Lewin
**Agency:**
Peter Rogers Assoc.
New York, NY

# Great Coats

**Promotional Booklet:**
Great Coats
**Art Director:**
James Miho
**Designer:**
James Miho
**Artists & Photographers:**
Various
**Design Firm:**
Miho
Redding, CT
**Publisher:**
Champion International
Corp.
**Typographer:**
Justified Type, Inc.
**Printer:**
Lasky Co.

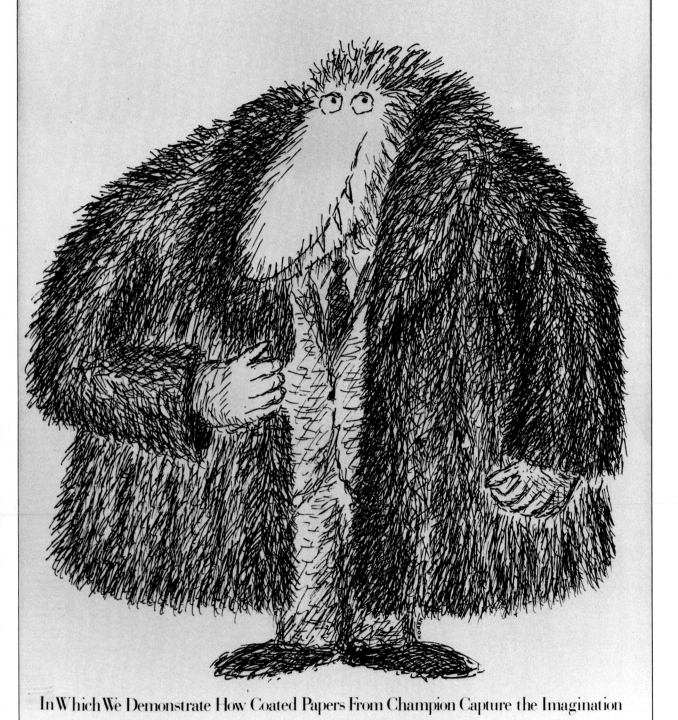

In Which We Demonstrate How Coated Papers From Champion Capture the Imagination

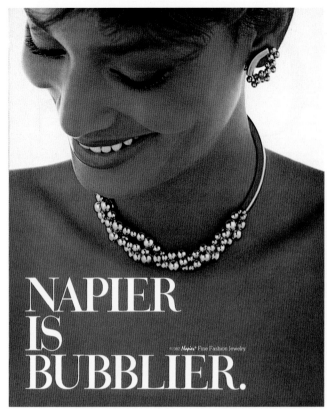

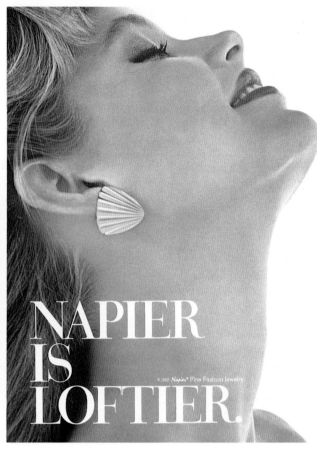

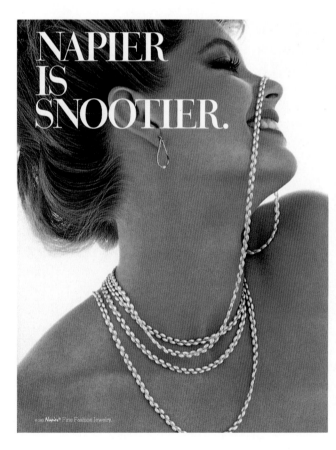

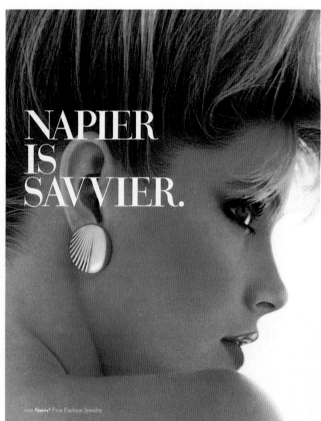

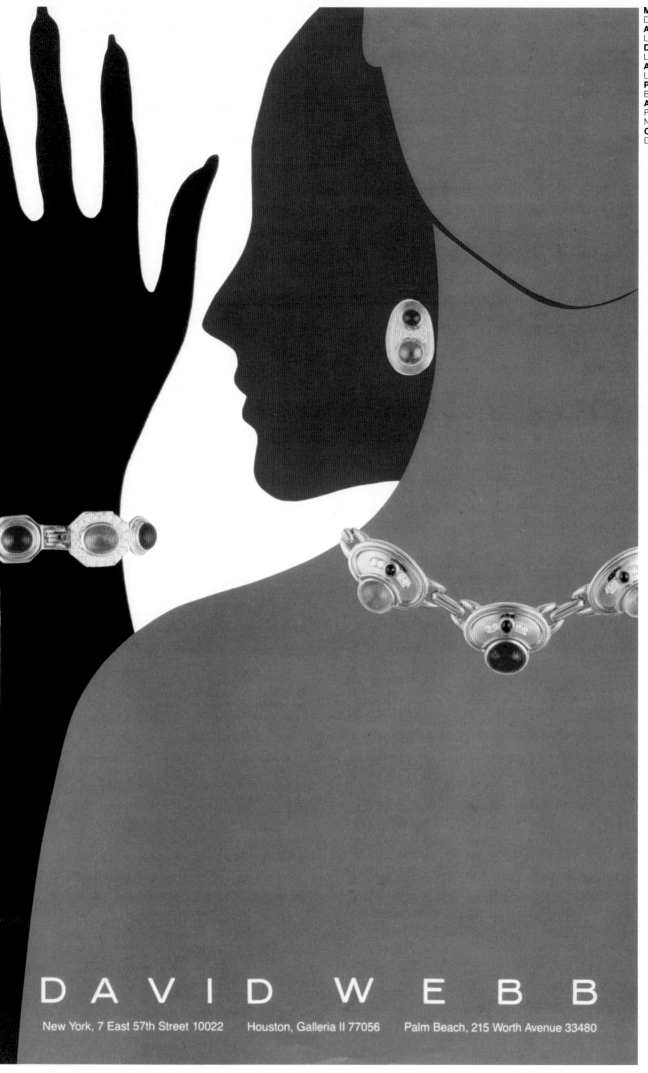

**Magazine Ad:**
David Webb
**Art Director:**
Len Favara
**Designer:**
Len Favara
**Artist:**
Len Favara
**Photographer:**
Bruce Fields
**Agency:**
Peter Rogers Assoc.
New York, NY
**Client:**
David Webb

# DAVID WEBB

New York, 7 East 57th Street 10022     Houston, Galleria II 77056     Palm Beach, 215 Worth Avenue 33480

## The life and death of a business deal.

We know that half of all business phone calls never reach the intended party.

The average memo takes a full three days simply to go from one mailroom to another.

IBM office systems can help.

Our computers. word processors. printers and copiers form a system. office-wide or world-wide. that can manage the information you need to manage your business.

They can create. file and retrieve documents electronically.

The IBM Audio Distribution System can even do the same for your voice: recording. storing and delivering phone messages. Using ordinary phone buttons. you indicate when you want the message delivered. where. and to whom.

No one knows better than we do where the office was. where it is now and where it will be in the future.

Where will you be? **IBM**

*For information on the IBM Audio Distribution System, call 1-800-241-2001. In Georgia, call 1-800-282-7994.*

---

By most measures. IBM is a rather large company.

But this ruler proves that IBM is a small computer company too. That is. we make a range of small computers.

Our IBM Personal Computer. for example. is just 19.6" wide. That's one dimension that can bring a new dimension to your business.

IBM's small computers are designed and priced for businesses of all sizes. They can handle word processing and data processing. The programs for our machines. easy to learn and easy to use. have been proved and refined in actual use.

Whether you're a large corporation or a one-person outfit. IBM has small computers that fit. Computers that bring to any business the same benefits our customers have always enjoyed: IBM experience. service and reliability.

However you choose to size up IBM. you'll find that we're very big on small computers.

And all the businesses that need them. **IBM**

# There was a time when all computers

were big. They were also costly and complex. Nevertheless, they were very well-suited to the jobs they had to do. But the average person rarely saw one of these computers and certainly didn't consider using one. At IBM, something has been happening to computers. They have been getting smaller. Their prices have been shrinking. And the special knowledge required to use one has been reduced dramatically. Our IBM Personal Computer, for example, is small enough to fit on a desk blotter but its power is equal to older computers many times its size. Today, small IBM computers can help businesses of all sizes manage their growth. Or families handle their bank accounts. Even very small people (kids for example) will find them just the right size. Of course, there is something else that's small about our small computers. The price: they start at under $1,600. You see, it always pays to read the small print.

**Magazine Ad:**
There was a time when all computers....
**Art Director:**
Jean Marcellino
**Designer:**
Jean Marcellino
**Agency:**
Lord Geller Federico & Einstein
New York, NY
**Client:**
IBM Corp.
**Typographer:**
George Abrams

**Magazine Ad:**
The life and death of a business deal
**Art Director:**
Seymon Ostilly
**Designer:**
Seymon Ostilly
**Photographer:**
Manuel Gonzalez
**Agency:**
Lord Geller Federico & Einstein
New York, NY
**Client:**
IBM Corp.
**Typographer:**
Royal Composing Room
**Engraver:**
Pioneer Moss

**Magazine Ad:**
IBM is a small computer company
**Art Director:**
Jean Marcellino
**Designer:**
Jean Marcellino
**Artist:**
David Heffernan
**Agency:**
Lord Geller Federico & Einstein
New York, NY
**Client:**
IBM Corp.
**Typographer:**
Royal Composing Room

**Poster:**
Connections
**Art Director:**
George Tscherny
**Designer:**
George Tscherny
**Illustrations:**
Antique Postal Cards
**Design Firm:**
George Tscherny, Inc.
New York, NY
**Publisher:**
Simpson Paper Co.
**Printer:**
S.D. Scott Printing Co.

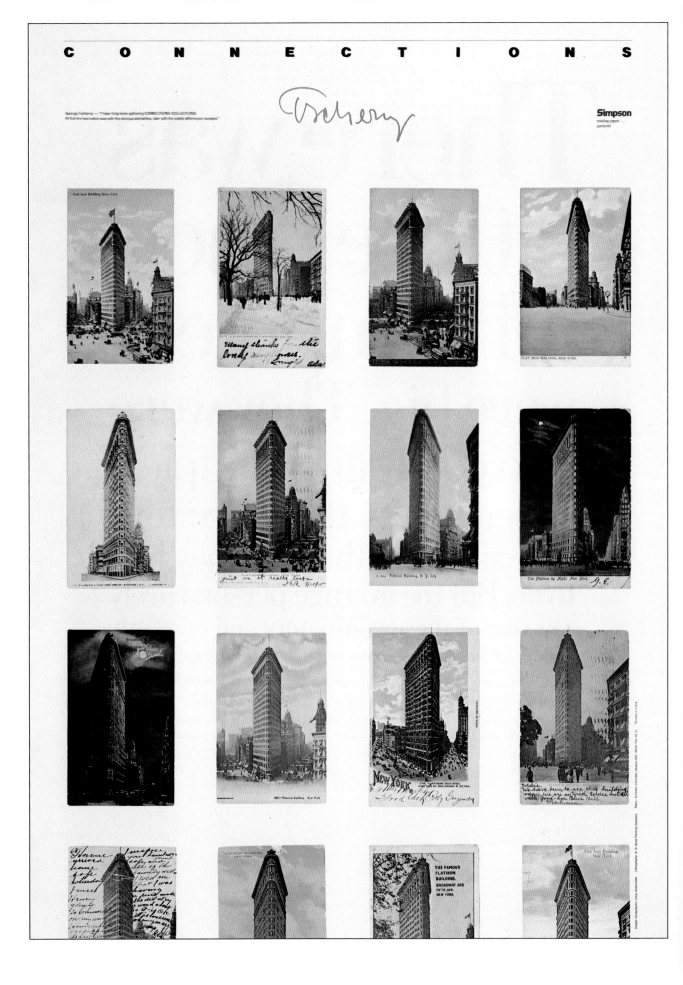

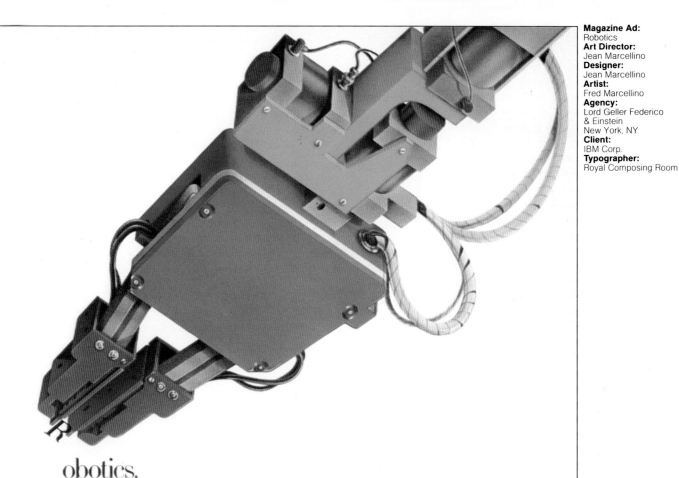

# obotics.

This story begins with the period at the end of this sentence.

The robotic arm above can locate a hole that size and accurately insert a pin. once or thousands of times.

Today. IBM robotic systems controlled by computers are doing precision work on complex. tedious or even hazardous tasks. Using special sensors in the "gripper." they are assembling complicated mechanisms. rejecting defective parts. testing completed units and keeping inventories.

Communication between the system and its computer is made possible by the most advanced robotic programming language yet reported. The language and the robotic systems it controls are part of our continuing commitment to research and development— a commitment funded with more than $8 billion over the past seven years.

IBM robotic systems can improve productivity. worker safety and product quality.

And that's precisely why we're in business. **IBM**

**Magazine Ad:**
Robotics
**Art Director:**
Jean Marcellino
**Designer:**
Jean Marcellino
**Artist:**
Fred Marcellino
**Agency:**
Lord Geller Federico
& Einstein
New York, NY
**Client:**
IBM Corp.
**Typographer:**
Royal Composing Room

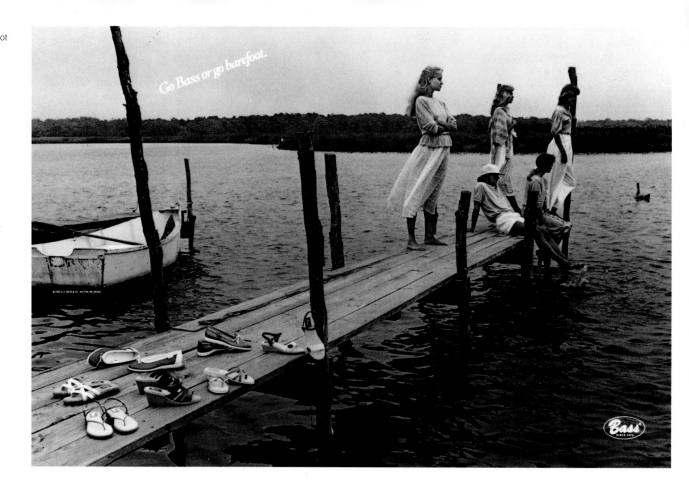

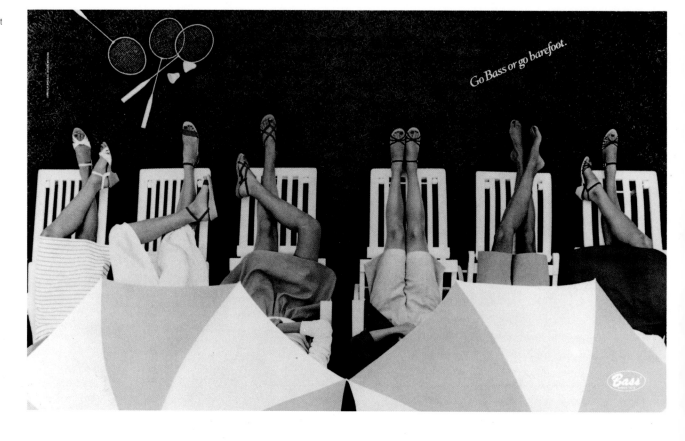

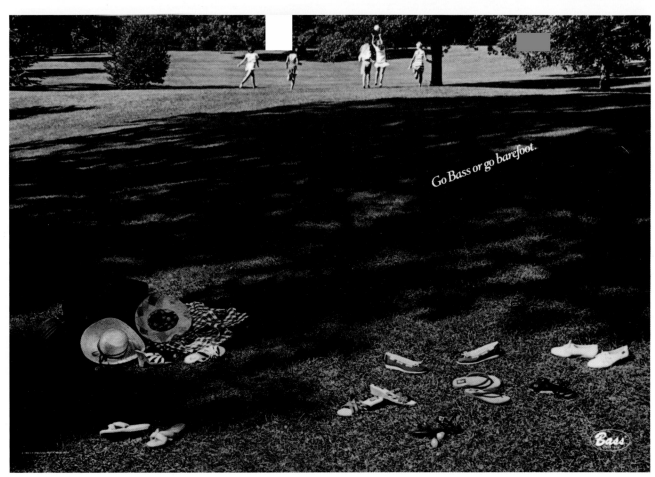

**Magazine Ad:**
Go Bass or go barefoot
**Art Director:**
Susan Casey
**Designer:**
Susan Casey
**Photographer:**
Barry Lategan
**Agency:**
Lord Geller Federico
& Einstein
New York, NY
**Client:**
G. H. Bass
**Typographer:**
Techni Process

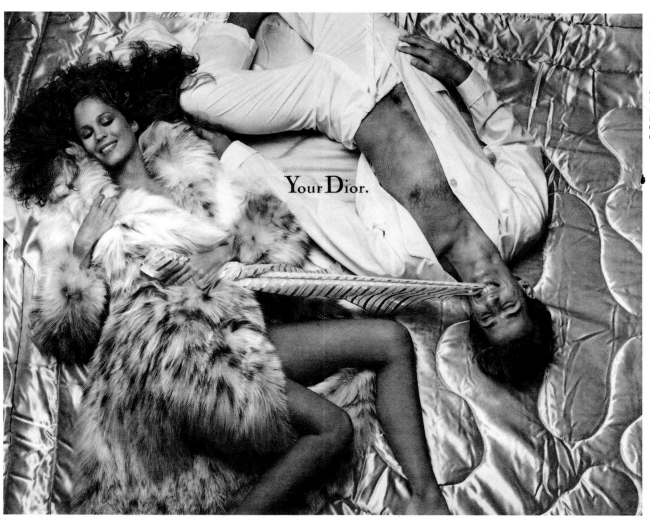

**Newspaper Ad:**
Your Dior
**Art Director:**
Gene Federico
**Designer:**
Gene Federico
**Photographer:**
Richard Avedon
**Agency:**
Lord Geller Federico
& Einstein
New York, NY
**Client:**
Christian Dior

**Advertisement:**
Guess who won more awards...
**Art Directors:**
Charles Hively,
Lyle Metzdorf
**Designer:**
Charles Hively
**Artist:**
Bill Wolfhagen
**Design Firm:**
Metzdorf Advertising
Houston, TX
**Typographer:**
Type Ink Type
**Printer:**
Printing Resources

**Magazine Ad:**
Jobs
**Art Director:**
Seymon Ostilly
**Designer:**
Seymon Ostilly
**Photographer:**
Hunter Freeman
**Agency:**
Lord Geller Federico
& Einstein
New York, NY
**Client:**
IBM Corp.
**Typographer:**
Royal Composing Room
**Engraver:**
Pioneer Moss

**Flyer:**
It took us twenty years.....
**Art Director:**
Jerry Berman
**Designer:**
Jerry Berman
**Photographer:**
John De Groot
**Design Firm:**
Sidjakov Berman & Gomez
San Francisco, CA
**Client:**
Sidjakov Berman & Gomez
**Typographer:**
Petrographics
**Printer:**
California Printing Co., Inc.

**Poster:**
The Nutcracker
**Art Directors:**
Henry Wolf,
David Blumenthal
**Designer:**
Henry Wolf
**Photographer:**
Henry Wolf
**Design Firm:**
Henry Wolf Productions
New York, NY
**Publisher:**
IBM Corp.
**Printer:**
Herlin Press

Jobs.
If you have the right skills, you might get one.
But for many people, getting those skills can seem like an impossible task.
Since 1968, in partnership with other companies and local community groups, IBM has supported a national job training program for the disadvantaged.
IBM provides equipment, supplies, and in some cases, people, to job training centers from New York to Los Angeles.
The results: more than 150,000 graduates have been trained for careers in office administration, computer operations, and computer programming.
This year, 11 new centers are scheduled to open.
They'll help even more people get the skills they need. And that helps open a lot of doors that used to be closed. **IBM**

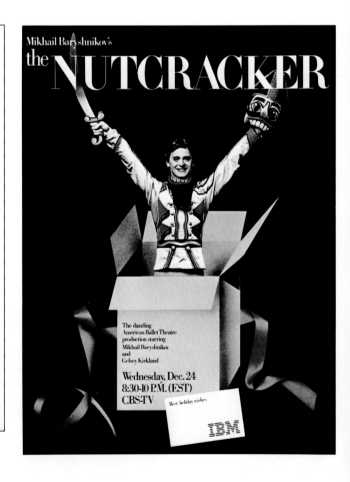

344

# In praise
# of the humble button.

Buttons [Start] things. [Stop] them. Even [MOVE] them.
[A] to [Z] begins a great novel. [1] through [1][0] creates
theories of the universe or [DELI] receipts. Buttons can find a [TOTAL]
Make a [Copy]. Record a [PAYMENT]. [PRINT] forms. [ENTER] data.

IBM makes more than 18.000 different buttons. Push one and

touch the technology behind it. Summon years of IBM experience

and research. The complex becomes simple. The time-consuming

takes no [TIME] at all. But making machines. from [TYPE] writers to

computers. includes concern about the people who will use them.

That's why we make buttons easy to [READ] and to reach.

We design [diagram] them to fit your fingers.

If you have a question. we even have a [HELP] button you can push.

All of which make the meetings between people [&] machines

a lot more friendly.

And that's a grand thing for a humble button to do. **IBM**®

**Magazine Ad:**
In praise of humble buttons
**Art Director:**
Seymon Ostilly
**Designer:**
Seymon Ostilly
**Photographer:**
Manuel Gonzalez
**Agency:**
Lord Geller Federico
& Einstein
New York, NY
**Client:**
IBM Corp.
**Typographer:**
Royal Composing Room
**Engraver:**
Pioneer Moss

Communication Graphics

**Newspaper Ad:**
Ansett: Top Connections
**Art Director:**
Raymond Lee
**Designer:**
Raymond Lee
**Photographer:**
Viktor Maderspach
**Design Firm:**
Raymond Lee & Assoc.
Toronto, CAN
**Client:**
Ansett Airlines of Australia
**Typographer:**
M & H Typographers, Ltd.

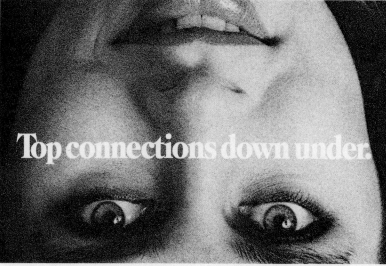

# Ansett.
## Airlines of Australia.

**Top connections down under.**

Be sure your clients
are well connected in
Australia.
Ansett connects with
all international flights,
and covers more of
Australia than any other
airline.
So the next time you're
booking an Australian
itinerary remember the
'AN' call sign and
make sure your clients
enjoy an international
standard of service.
And if you need more
information, please
call our N.Y. office at
(212) 697-7605 or L.A.
office at (213) 627-3429.

**Magazine Ad:**
Low Profile
**Art Director:**
William Wondriska
**Designer:**
William Wondriska
**Photographer:**
Jay Maisel
**Design Firm:**
William Wondriska Assoc.
Farmington, CT
**Client:**
United Technologies
**Typographer:**
Eastern Typesetting Co.
**Printer:**
N.Y. Times Magazine
Section

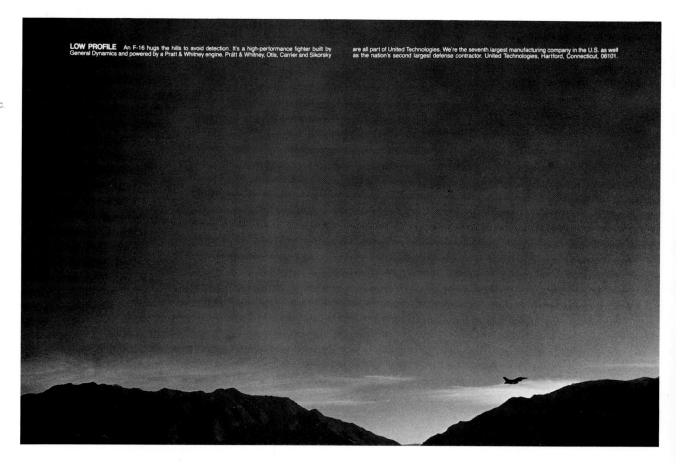

**LOW PROFILE** An F-16 hugs the hills to avoid detection. It's a high-performance fighter built by General Dynamics and powered by a Pratt & Whitney engine. Pratt & Whitney, Otis, Carrier and Sikorsky are all part of United Technologies. We're the seventh largest manufacturing company in the U.S. as well as the nation's second largest defense contractor. United Technologies, Hartford, Connecticut, 06101.

THE NEW YORKER

THE COUNTERPOINT OF E+A

Editorial + Advertising.
Separate melodies combined
to create a phenomenon;
that special energy between the covers
of The New Yorker—the same magical music
which keeps audiences and advertisers
coming back as no other magazine can.

YES, THE NEW YORKER

**Magazine Ad:**
The New Yorker
The Counterpoint of
E+A
**Art Director:**
Sven Mohr
**Designer:**
Sven Mohr
**Artist:**
Sven Mohr
**Agency:**
Lord Geller Federico
& Einstein
New York, NY
**Client:**
The New Yorker Magazine
**Typographer:**
Type Group

THE NEW YORKER

THE BALANCE OF E+A

Editorial + Advertising.
Together, they create a phenomenon:
that dynamic energy between
the covers of The New Yorker —
the same energy, the same exciting
attraction that keeps readers and
advertisers coming back as no other
magazine can.

YES, THE NEW YORKER.

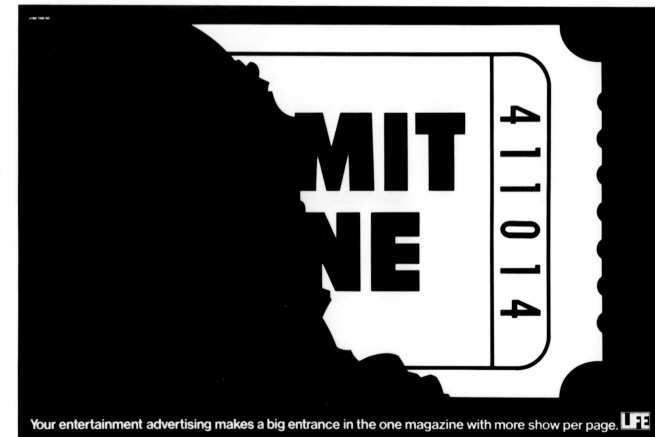

Your entertainment advertising makes a big entrance in the one magazine with more show per page. LIFE

# C H A M P I O N
# W E D G W O O D
captures the imagination of photographers Curtis and Running

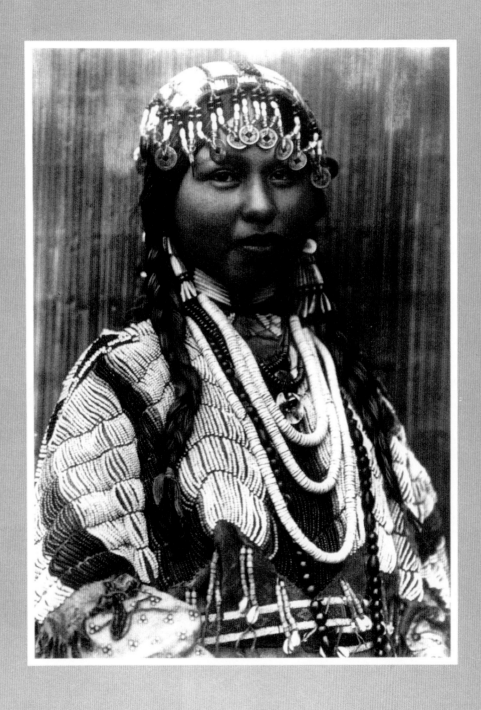

# C H A M P I O N
# W E D G W O O D

**Annual Report:**
Charles River Breeding
Laboratories, Inc.
Annual Report 1982
**Art Director:**
Steve Snider
**Design Firm:**
Arnold Design Team
Arnold & Co.
Boston, MA
**Client:**
Charles River Breeding
Laboratories
**Typographer:**
Typographic House
**Printer:**
Acme Printing Co.

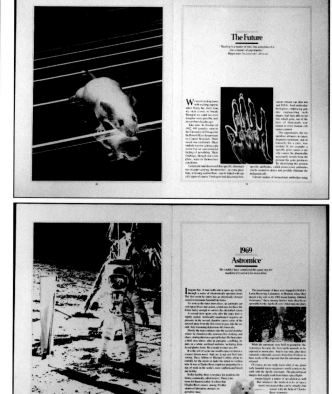

**Annual Report:**
Alco Standard Corporation
1982 Annual Report
**Art Director:**
Philip J. Eitzen
**Designer:**
Dale Strominger
**Photographer:**
Ed Eckstein
**Design Firm:**
The Creative Dept., Inc.
Philadelphia, PA
**Publisher:**
Alco Standard Corp.
**Typographer:**
PHP Typography
**Printer:**
Lebanon Valley Offset Co.

**Annual Report:**
Houston Metropolitan
Ministries Annual Report
1981
**Art Director:**
Jerry Herring
**Designer:**
Jerry Herring
**Photographer:**
Jim Sims
**Design Firm:**
Herring Design
Houston, TX
**Client:**
Houston Metropolitan
Ministries
**Typographer:**
Words & Things
**Printer:**
Fidelity Printing Co.

Weyerhaeuser Annual Report | 1981

**Annual Report:**
Weyerhaeuser Annual Report 1981
**Art Director:**
John Van Dyke
**Designer:**
John Van Dyke
**Photographers:**
Louis Bencze, David Watanabe, Steve Firebaugh
**Design Firm:**
Van Dyke McCarthy Co. Seattle, WA
**Client:**
Weyerhaueser Co.
**Typographer:**
Paul O. Giesey
**Printer:**
Graphic Arts Center

*Wood Products* The largest single market for wood-based building materials, for both United States and Canadian producers, is the new-housing construction industry in the United States.     Since 1979, that industry has been in the longest and deepest slump since the Great Depression, brought on by over-due efforts to control inflation through restricting growth in the national money supply. One result of this long-delayed action was increasing interest rates for home mort-gages to unheard-of levels.   Most Americans simply were unable to qualify financially for new home mortgages at these rates, even when mortgage funds were available.     1981 saw the lowest level of housing starts, and the lowest level of lumber pro-duction, in the United States since World War II. At the same time, two of the major export markets for lumber—Europe and Japan—also had declining markets.     As the world's largest lumber producer and one of the larger U.S. producers of plywood and composite panels, Weyerhaeuser was of course heavily impacted by the housing depression and the softness in the European and Japanese markets. Nevertheless, we kept our major facilities in operation most of the time, with operating rates much higher than those reported by the rest of the industry, and thus were able to soften the impact of the housing dis-aster for most of the skilled employees who operate our mills. How?     Our large amount of fee timber provides us with the lowest-cost raw material in the in-dustry. Our ownership of the resource permits us flexi-bility in matching wood qualities with market-mix requirements. The integration of our wood products and pulp and paper facilities (which use lumber and plywood manufacturing byproducts as raw materials), and our twenty-year program of developing export markets and distribution systems, also helped provide the answer. We simply have more options than do most

*The oldest manufactured wood product—lumber sawn from logs—remains the basic building ma-terial in the U.S. and many other nations. With new housing depressed, the do-it-yourself market has grown; the new deck, be-low, is an example.*

*Fiber Products*     Products made from pulped wood fibers — pulp, paperboard, paper, news-print, and packaging — were, in contrast to wood products and raw material — operating in strong markets until late in 1981. Although the general eco-nomic recession began to bring about softness in most of these markets late in the year, relatively high indus-try and company operating rates prevailed. It is in this sector of the forest products industry that the largest long-term growth opportunities exist, with world-wide consumption rising. And, the larger share of Weyerhaeuser's capital expenditures in 1981 was directed toward expansions in these product lines.     Our fiber business observed its 50th anniversary last November. Since making the decision, at the depth of the Great Depression, to enter this industry, the company has marketed 20 million tons of pulp alone.     In 1982 our production capacity for primary fiber products will reach 4.4 million tons per year.     In May 1981, our second newsprint machine began operating at Longview, Washington, doubling our manufacturing capacity for this product, sold in the Western U.S. and in Japan, to more than 400,000 tons per year. By next fall, two other major expansions will go into production — our new lightweight coated paper mill at Columbus, Mississippi, and the new lightweight linerboard machine at our Valliant, Oklahoma, mill. Like newsprint, an industry we entered in 1979, these will be new products for us, further diversifying and expanding our mar-keting mix. We have installed boiler capacity and are in-creasing pollution-control capacity at our Springfield, Oregon, linerboard mill to allow future ex-pansion of manufacturing; we also installed there the

*The Company doubled its news-print production in 1981 with startup of the new machine at the North Pacific mill at Longview, Wash-ington, opposite. Rising from the Mississippi forest, the new Columbus mill will bring us into the light-weight coated paper market for the first time, in 1982.*

**Announcement:**
1130 Dragon Street
**Art Director:**
Cap Pannell
**Designer:**
Cap Pannell
**Photographer:**
Phillip Branner
**Design Firm:**
Cap Pannell & Co.
Dallas, TX
**Client:**
John A. Williams, Printer
**Typographer:**
J.C.S.
**Printer:**
John A. Williams, Printer

You can now find John A. Williams, Printer in big, bright, beautiful new facilities.

At 1130 Dragon Street, Dallas, Texas 75207. Same phone number (742-5148). Same dedicated, quality-conscious people.

Ready to take on all monsters.

**Annual Report:**
H. J. Heinz Co.
Annual Report 1982
**Art Director:**
Bennett Robinson
**Designers:**
Bennett Robinson
Paula Zographos
**Artists and
Photographers:**
Various
**Design Firm:**
Corporate Graphics, Inc.
New York, NY
**Client:**
H. J. Heinz Co.
**Typographer:**
Tri-Arts Press
**Printer:**
George Rice & Sons

UNTITLED

The sun shines above the horizon,
Orange and yellow in hue.
The wind shimmers the trees,
Wafting unaware leaves
                        to the ground,
Unmindful of our love
Where it is also bound
Amid the dying others.

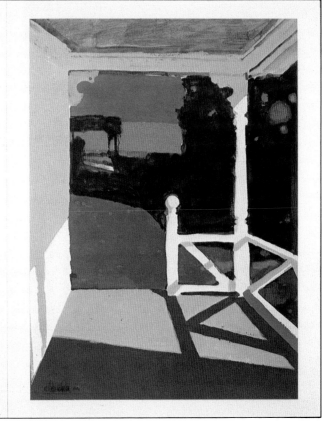

Carol Whitmore, data entry clerk, Heinz U.S.A.

THE SUGAR CANE FIELD
(Puerto Rico)

The flirting of sugar cane tops
with the undulating winds
Jungle entangled with climbing
itching vines
Burning fire enclosured INFERNO;
Concerto of roaring machetes;
Sugar Cane field
that swallows our JIBARO
Dying in the unconquerable
jungle;
Water boy;
Water boy;
Shout our JIBARO
Oh, GOD I'm burning

In the farness
the Sugar Mill
depicting the sky
with vomiting dark
smokes
Polluted balsams
that shortened our
lives;

The sun sets over the horizon
Retreat for our JIBARO
Oh, everlasting struggle;
The Man and the Sugar Cane Field;
Tomorrow;
The reward
A small bag of corn meal, black coffee
& trade mark "COLLINS" MACHETE

Day breaks, again
Brandishing & trembling Machetes;
Burning bodies
Imprisoned Souls;
Cruel destiny embalmed with sweats
in the Sugar Cane Field

Struggles ceased
Returning home
Face down, glancing over our
Mother Earth;
TOMORROW;
The same;

"JIBARO"
Till death
Knock on your door;
Cruel World;;

Milton Bonilla, plant superintendent, Star-Kist Caribe, Puerto Rico

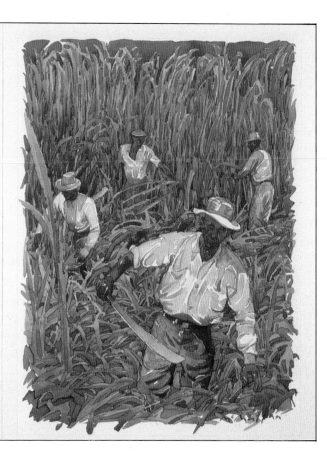

**Annual Report:**
Alco Standard Corporation
1982 Report to Employees
**Art Director:**
Philip J. Eitzen
**Designer:**
Dale Strominger
**Photographer:**
Ed Eckstein
**Design Firm:**
The Creative Dept., Inc.
**Publisher:**
Alco Standard Corp.
**Typographer:**
PHP Typography
**Printer:**
Lebanon Valley Offset Co.

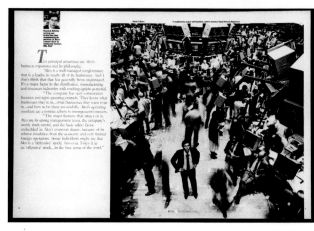

**Desk Calendar:**
Paramount Pictures
**Art Director:**
Rod Dyer
**Designers:**
Rod Dyer, Bill Tom
**Photographers:**
Various
**Design Firm:**
Dyer/Kahn, Inc.
Los Angeles, CA
**Client:**
Paramount Pictures
**Typographer:**
Andresen Typographics
**Printer:**
California Graphics

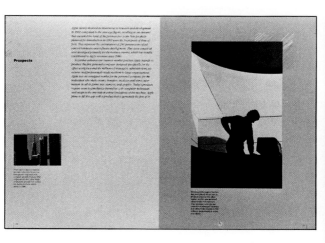

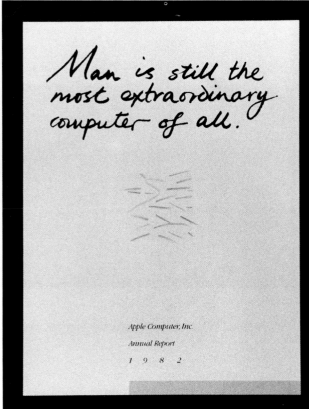

**Annual Report:**
Apple Computer, Inc.
Annual Report 1982
**Art Director:**
Mark Anderson
**Designers:**
Michael Kunisaki,
Steven Tolleson
**Photographer:**
Cheryl Rossum
**Artists:**
Antony Milner, Mitchell
Mauk, Sue Cretarolo
**Design Firm:**
Mark Anderson Design
Palo Alto, CA
**Publisher:**
Apple Computer, Inc.
**Typographer:**
Spartan Typographers
**Printer:**
Anderson Lithograph Co.

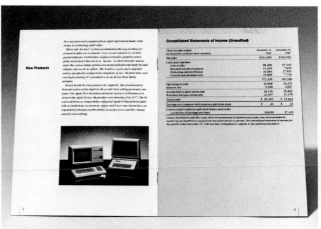

**Quarterly Report:**
Apple Computer
First Quarter Report
**Art Director:**
Phil Raymond
**Designer:**
Gary Maddocks
**Photographer:**
David Campbell
**Design Firm:**
Apple Computer, Inc.
Cupertino, CA
**Publisher:**
Apple Computer, Inc.
**Typographer:**
Vicki Dunn
**Printer:**
Anderson Lithograph Co.

**Calendar:**
1983 West
**Art Directors:**
Lou Fiorentino, Marc Passy
**Designers:**
Lou Fiorentino, Marc Passy
**Photographers:**
Lou Fiorentino,
Helen Fiorentino
**Design Firm:**
Lou Fiorentino, Visual
Communications
**Client:**
Tri-Arts Press
**Typographer:**
Tri-Arts Press
**Printer:**
Tri-Arts Press

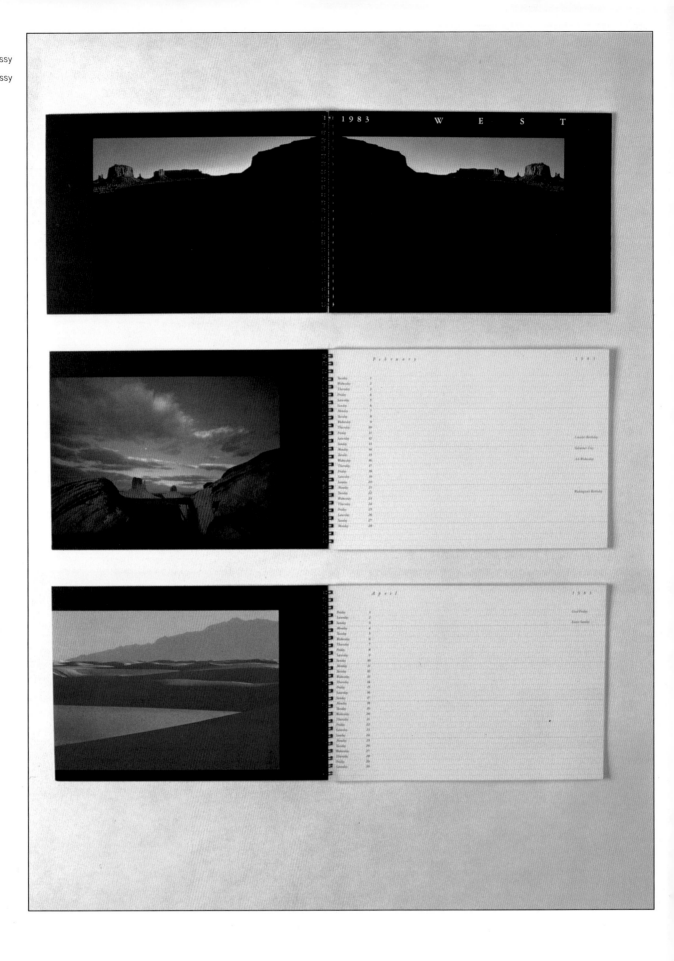

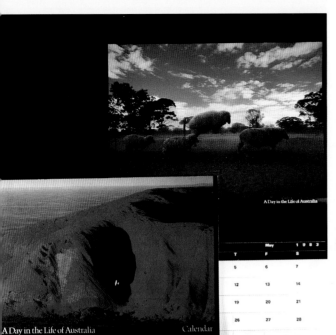

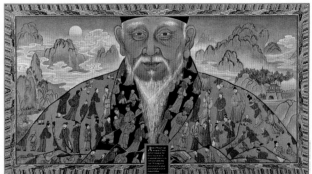

**Calendar:**
1983/A Day in the Life
of Australia
**Art Director:**
Leslie Smolan
**Designer:**
Steve Orant
**Photographers:**
Various
**Design Firm:**
Gottschalk & Ash, Int'l.
New York, NY
**Publisher:**
DITLA, Inc.
**Typographer:**
Concept Typographics
**Printer:**
Dai Nippon Printing Co., Ltd.

**Calendar:**
Champion, 1983 Calendar
Now is the Time
**Art Director:**
Kit Hinrichs
**Designers:**
Kit Hinrichs, Lenore Bartz
**Photographers:**
Various
**Design Firm:**
Jonson Pedersen Hinrichs
& Shakery
San Francisco, CA
**Publisher:**
Champion International
Corp.
**Printer:**
The Hennegan Co.

**Desk Calendar:**
Datebook, 1982
**Art Director:**
Matthew Watson
**Designer:**
Matthew Watson
**Artists:**
Jose Cruz, Louis Escobedo
David Griffin,
Matthew Watson
**Design Firm:**
Matthew Watson Design
Dallas, TX
**Publisher:**
Thompson Press
**Typographer:**
Southwestern Typographics
**Printer:**
Thompson Press

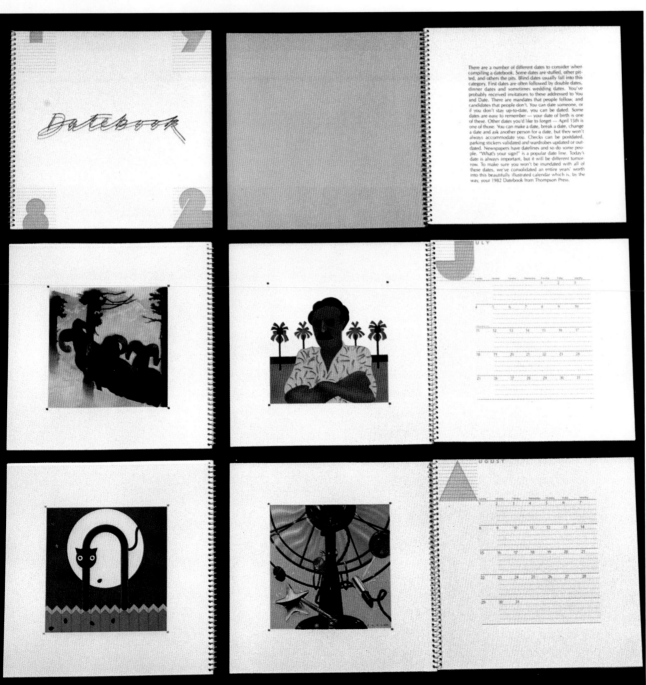

**Newspaper:**
Around the Globe #4
**Art Director:**
Terry Koppel
**Designer:**
Terry Koppel
**Artists:**
Patrick Blackwell
Jamie Hogan
**Design Firm:**
T. Ross Koppel Graphics,
Inc.,
New York, NY
**Publisher:**
The Boston Globe
**Typographer:**
The Composing Room
of N.E.
**Printer:**
The Boston Globe

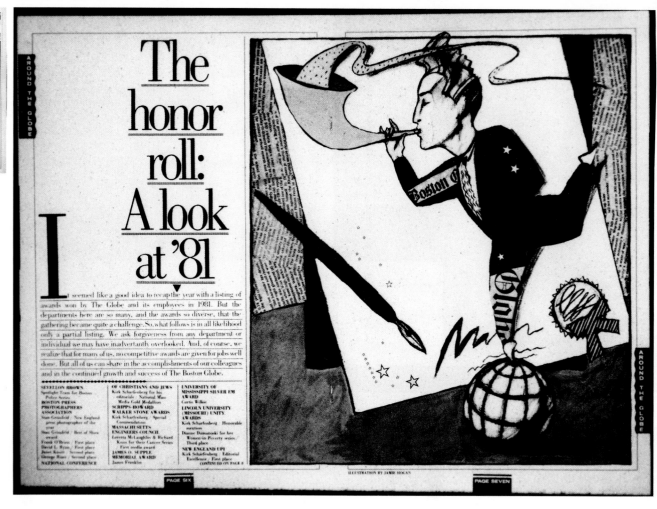

# The honor roll: A look at '81

It seemed like a good idea to recap the year with a listing of awards won by The Globe and its employees in 1981. But the departments here are so many, and the awards so diverse, that the gathering became quite a challenge. So, what follows is in all likelihood only a partial listing. We ask forgiveness from any department or individual we may have inadvertantly overlooked. And, of course, we realize that for many of us, no competitive awards are given for jobs well done. But all of us can share in the accomplishments of our colleagues and in the continued growth and success of The Boston Globe.

**SEVELLON BROWN**
Spotlight Team for Boston Police Series
**BOSTON PRESS PHOTOGRAPHERS ASSOCIATION**
Stan Grossfeld - New England press photographer of the year
Stan Grossfeld - Best of Show award
Frank O'Brien - First place
David L. Ryan - First place
Janet Knott - Second place
George Rizer - Second place
**NATIONAL CONFERENCE**

**OF CHRISTIANS AND JEWS**
Kirk Scharfenberg for his editorials - National Mass Media Gold Medallion
**SCRIPPS-HOWARD WALKER STONE AWARDS**
Kirk Scharfenberg - Special Commendation
**MASSACHUSETTS ENGINEERS COUNCIL**
Loretta McLaughlin & Richard Knox for their Cancer Series - First media award
**JAMES O. SUPPLE MEMORIAL AWARD**
James Franklin

**UNIVERSITY OF MISSISSIPPI SILVER EM AWARD**
Curtis Wilkie
**LINCOLN UNIVERSITY (MISSOURI) UNITY AWARDS**
Kirk Scharfenberg - Honorable mention
Dianne Dumanoski for her Women in Poverty series - Third place
**NEW ENGLAND UPI**
Kirk Scharfenberg - Editorial Excellence - First place
CONTINUED ON PAGE 8

ILLUSTRATION BY JAMIE HOGAN

PAGE SIX

PAGE SEVEN

**Exhibition Catalogue:**
Everest: As it has never
been seen
**Art Director:**
Linda Darnall
**Designer:**
Linda Darnall
**Photographers:**
Ned Gillette, Jan Reynolds
**Design Firm:**
R. J. Reynolds Graphic
Communications,
Winston-Salem, NC
**Client:**
R. J. Reynolds Tobacco Co.
**Publisher:**
The Asia Society
**Typographer:**
RJR Graphic Comm.
**Printer:**
Hunter Publishing Co.

EVEREST:
AS IT HAS NEVER BEEN SEEN

Photographs by Ned Gillette and Jan Reynolds

**Jan Reynolds,** of Stowe, Vermont, has combined a love of sports and the outdoors to become one of this country's preeminent women mountaineers. She is a veteran of three major expeditions. She set a new record for high altitude skiing for women when she skied from the top of China's 24,757-foot Mt. Muztagata in 1980.

Damche Bazaar - Nepal

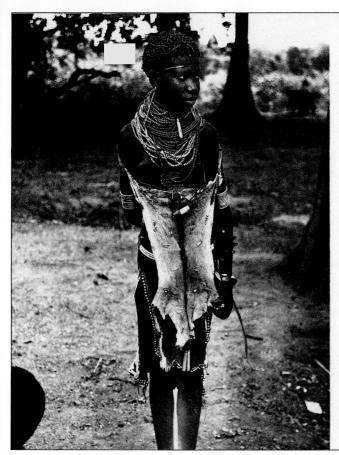

# AFRICA

**Catalogue:**
The Adventure Book
**Art Director:**
Michael Schwab
**Designer:**
Michael Schwab
**Photographer:**
Michael Nichols
**Design Firm:**
Michael Schwab Design
San Francisco, CA
**Client:**
Sobek Exploration Society
**Typographer:**
Reprotype

The Dark Continent still seems as mysterious and seductive as the 19th century explorers made it out to be. It is a variegated land no one man can know. Lavish cultures, vast populations of wildlife, lush vegetation, and a fierce beauty soak us up unnoticed. Emerging wide-eyed, mystified, we are no more knowing than when we went in, but palpably moved. The wildlife of the Tanzania bush, the thundering white sweep of Victoria Falls, the plunging canyons of the Zambezi River: visit these with Livingstone's reverence, and come home changed.

7

ETHIOPIAN GIRL   George Fuller                  AFRICA                  TANZANIA   Jим Slade

# OCEANIA

The land Down Under is so unique that it inspires its own adjectives to go with its peculiar fauna. Our one remaining frontier, its maps still show blank spaces marked Unexplored. Australia and New Zealand surprise us with out-of-place fjords and alpine ridges, grass plains and volcanoes, to be explored by bicycle, balloon, camel, or raft. Nearby, the juicy islands of the South Pacific promise our last chance of retreat from the twentieth century into a climate and society so colorful and hospitable as to make us wonder if we made it up.

39

PACIFIC ATOLL   Emanuel Valentin                  OCEANIA                  POLYNESIAN PLATE   Emanuel Valentin

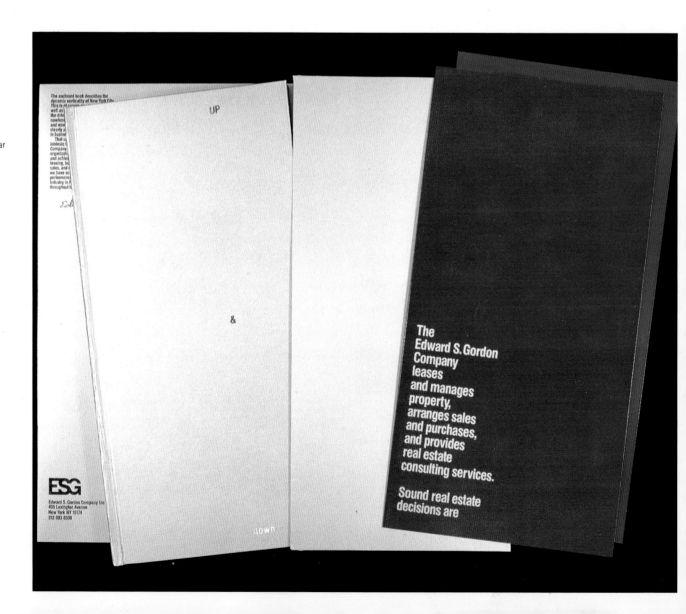

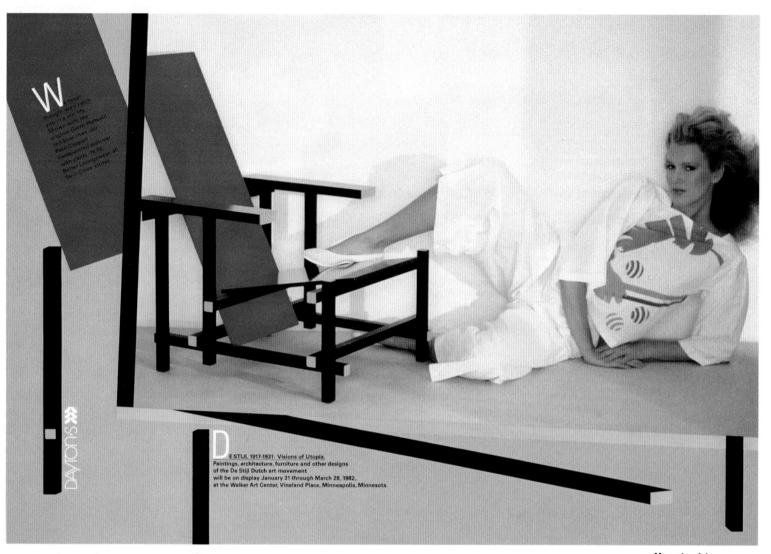

We never thought we'd catch you in a still life. Shown with the original Gerrit Rietveld red/blue chair, our Petti Crepsde hand painted pullover with pants, 76.00. Better Loungewear, all Twin Cities stores.

DE STIJL 1917-1931: Visions of Utopia.
Paintings, architecture, furniture and other designs
of the De Stijl Dutch art movement
will be on display January 31 through March 28, 1982,
at the Walker Art Center, Vineland Place, Minneapolis, Minnesota.

DAYTON'S

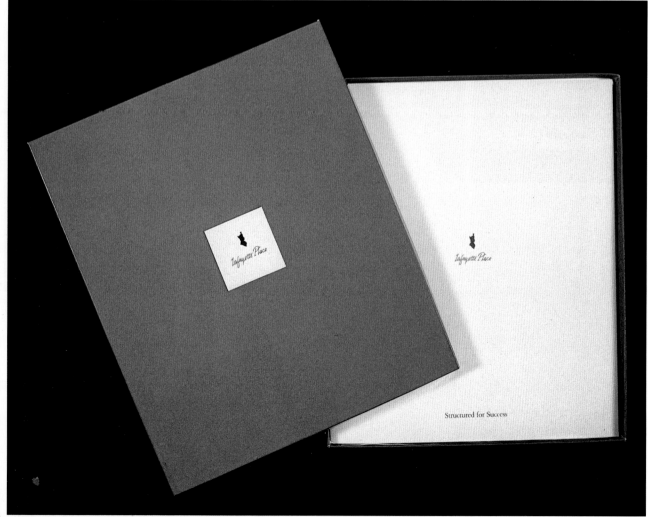

**Magazine Ad:**
De Stijl, 1917–1931
**Art Director:**
Karen Brown
**Designer:**
Karen Brown
**Photographer:**
Alex Chatelain
**Design Firm:**
Dayton's
Minneapolis, MN
**Publisher:**
Dayton's
**Typographer:**
Dahl & Curry
**Separator:**
Colour Graphics
**Printer:**
Minneapolis/St. Paul
Magazine

**Promotional Literature:**
Lafayette Place
**Art Director:**
Ivan Chermayeff
**Designer:**
Jill Rossi
**Design Firm:**
Chermayeff & Geismar
Assoc.,
New York, NY
**Photographer:**
Costa Manos/Magnum
**Publisher:**
Lafayette Place
**Typographer:**
CT Typografix
**Printer:**
Rapoport Printing Co.

Lafayette Place

Structured for Success

MOLITERNO

**Brochure:**
Moliterno
**Art Director:**
Malcolm Grear
**Designer:**
Malcolm Grear Designers
**Design Firm:**
Malcolm Grear Designers
Providence, RI
**Client:**
Moliterno Stone Sales
**Typographer:**
Dumar Typesetting
**Printer:**
Meridian Printing

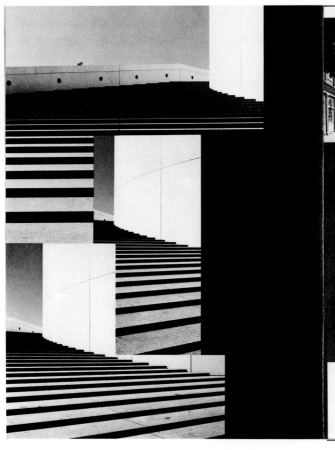

Landscapes that unearth the natural beauty of stone

Quincy Market Buildings
Faneuil Hall
Boston, Massachusetts

John F. Kennedy Library
Boston, Massachusetts

As a total stone company, Moliterno offers a number of specific services that go beyond traditional building exteriors and interiors.

For instance, we invented a cost-effective method of brick and concrete paving that lets you add a new dimension to courtyards, sidewalks and driveways.

You can also take advantage of our landscape design services. These can be used to accent a particular building or to tie together various buildings into a cohesive unit by defining the space and creating one environment out of a multitude of textures and shapes.

Moliterno has even provided the stone and installation expertise for a number of sculptures, fountains and carvings. It's all part of the capabilities of Moliterno craftsmen, and the quality of Moliterno stone.

the swa group

**Brochure:**
The SWA Group
**Art Directors:**
Richard Burns,
Sarah Nugent
**Designer:**
Sarah Nugent
**Artist:**
Sandra Short
**Photographers:**
Gerald Campbell, Dixi
Carrillo, Phillip M. James
**Design Firm:**
The GNU Group
Sausalito, CA
**Client:**
The SWA Group
**Typographer:**
Custom Typography Service
**Printer:**
Dai Nippon Printing Co., Ltd.

Security Pacific
National Bank World
Headquarters Building,
Los Angeles, California

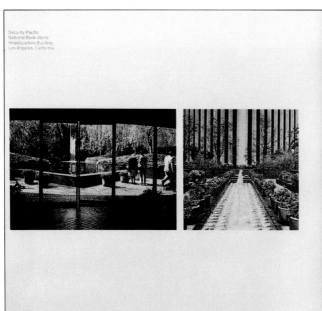

362

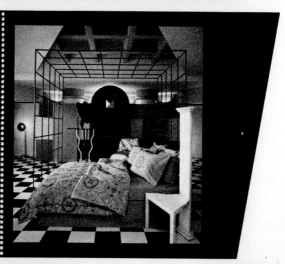

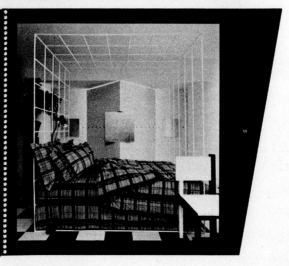

**Catalogue:**
Perspective
**Art Director:**
James Sebastian
**Designers:**
James Sebastian, Michael
McGinn, Jim Hinchee
**Photographer:**
Joe Standart
**Design Firm:**
Designframe, Inc.
New York, NY
**Publisher:**
Martex/West Point
Pepperell
**Typographer:**
Haber Typographers, Inc.
**Printer:**
Crafton Graphic Co., Inc.

**Delivery Envelope:**
John A. Williams, Printer
**Art Directors:**
Cerita Smith, Cap Pannell
**Designer:**
Cerita Smith
**Artist:**
Phil Prosen
**Design Firm:**
Cap Pannell & Co.
Dallas, TX
**Client:**
John A. Williams, Printer
**Typographer:**
J.C.S.

**Poster/Call for Entry:**
Surface & Ornament
**Art Director:**
Emilio Ambasz
**Designers:**
Emilio Ambasz
Karen Skelton
**Design Firm:**
Emilio Ambasz Design
Group, Ltd.
New York, NY
**Client:**
Formica Corp.
**Typographer:**
Innovative Graphics
International
**Printer:**
Barton Press, Inc.

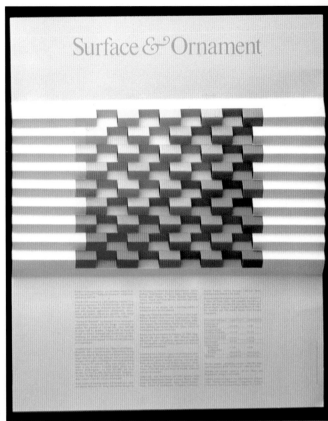

**Menu:**
T.G.I.Friday's Summer
Selections
**Art Director:**
Woody Pirtle
**Designer:**
Woody Pirtle
**Artist:**
Woody Pirtle
**Design Firm:**
Pirtle Design
Dallas, TX
**Client:**
T.G.I.Friday's, Inc.
**Typographer:**
Southwestern Typographics
**Printer:**
Allcraft Printing

**Menu:**
T.G.I.Friday's Main Menu
**Art Director:**
Woody Pirtle
**Designer:**
Woody Pirtle
**Artists:**
David Kampa, Ken Shafer
Mark Pirtle, Woody Pirtle
**Design Firm:**
Pirtle Design
Dallas, TX
**Client:**
T.G.I.Friday's, Inc.
**Typographer:**
Southwestern Typographics
**Printer:**
Allcraft Printing

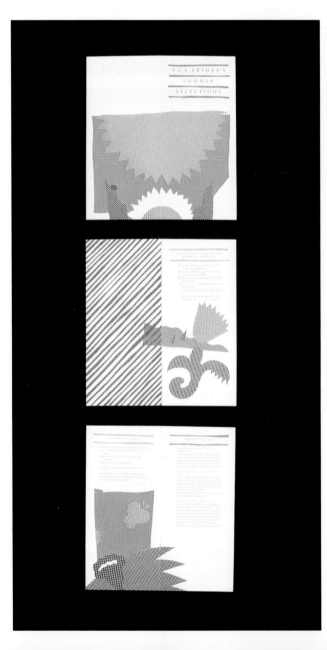

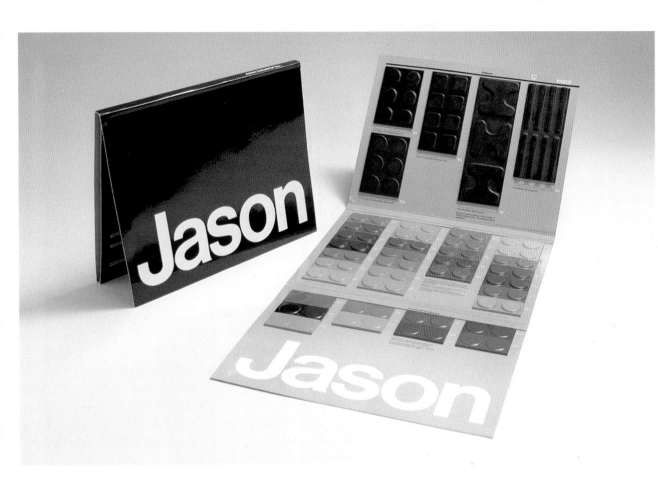

**Promotional Sampler:**
Jason
**Art Director:**
Michael R. Abramson
**Designer:**
Claire Hess
**Design Firm:**
Michael R. Abramson
& Assoc.
New York, NY
**Client:**
Jason Industrial, Inc.
Rubber Flooring Div.
**Typographers:**
Typogram
Concept Typographic
Services
**Printer:**
Vintage Lithographers, Inc.

**Promotional Item:**
Sunar Furniture Collection
Boxed Set
**Designer:**
Wilburn Bonnell III
**Design Firm:**
Bonnell Design Assoc., Inc.
New York, NY
**Client:**
Sunar
**Typographers:**
PDR, Inc.
**Printer:**
Dai Nippon Printing Co., Ltd.

**Promotional Brochure:**
Meier, Mercer, Riart
Collections
**Art Directors:**
Harold Matossian
Steven Schnipper
**Designer:**
Steven Schnipper
**Photographer:**
Mario Carrieri
**Design Firm:**
Knoll Graphics
New York, NY
**Publisher:**
Knoll International
**Printer:**
Rapoport Printing Co.

**Brochure:**
Gunlocke: Bridging
Imagination and Reality
**Art Director:**
April Greiman
**Designer:**
April Greiman
**Photographer:**
William Sharpe
**Design Firm:**
April Greiman Studio
Los Angeles, CA
**Client:**
Gunlocke Co.
**Typographer:**
Vernon Simpson
**Printer:**
Anderson Printing Co.

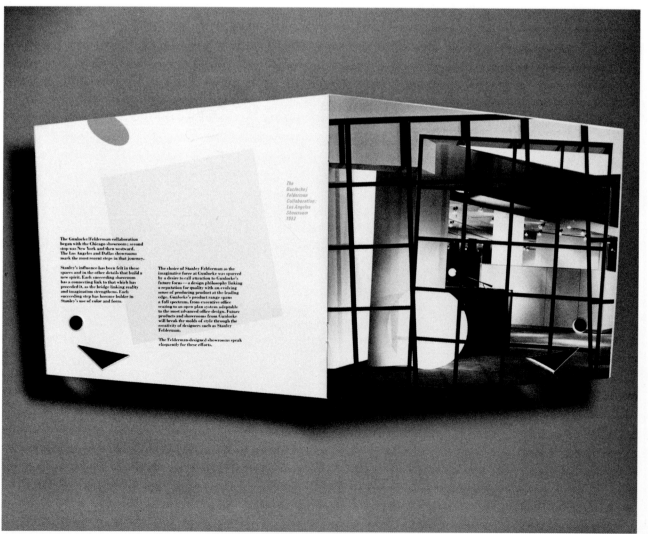

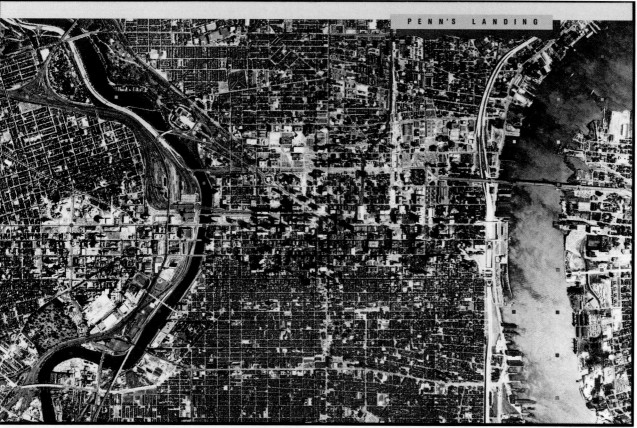

PENN'S LANDING

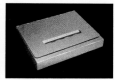

**Promotional Material:**
Penn's Landing
**Art Director:**
Joel Katz
**Designer:**
Joel Katz
**Photographers:**
George Adams Jones, Joe
Nettis, Michael Furman,
Edward F. Wheeler, Lewis
Portnoy/NBC Sports
Caesars Boardwalk
**Schematic Drawings:**
Cope Linder Assoc.
**Historical Materials:**
Library Company of
Philadelphia
Pennsylvania Hospital
University of Pennsylvania
**Design Firm:**
Katz Wheeler Design
Philadelphia, PA
**Client:**
Philadelphia Industrial
Development Corp, City of
Philadelphia
**Typographer:**
PHP Typography
**Printer:**
Consolidated/Drake Press

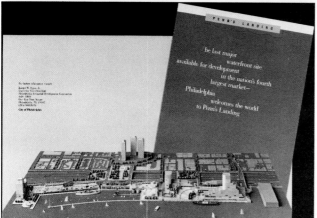

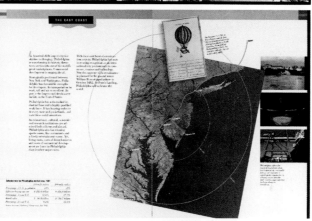

THE EAST COAST

THE REGION

| Effective buying income in the top 10 metropolitan markets, 1981 | |
|---|---|
| New York | $ 91.5 billion |
| Los Angeles | $ 74.7 billion |
| Chicago | $ 74.2 billion |
| Detroit | $ 44.8 billion |
| Philadelphia | $ 44.8 billion |
| San Francisco | $ 39.9 billion |
| Washington | $ 33.0 billion |
| Boston | $ 36.1 billion |
| Houston | $ 33.9 billion |
| Dallas | $ 32.7 billion |

Source: Sales and Marketing Management, July 1982.

Forty-five minutes from Philadelphia's City Hall, fox hunters ride to hounds. Andrew Wyeth paints along the Brandywine and, in Bucks County, James Michener writes bestsellers. In this same diverse region workers roll steel and refine oil, make helicopters, railcars, missile casings and steam turbines.

Philadelphia and its suburbs comprise the nation's fourth largest market with the third largest number of home-owner households. The region blends wide ranging job opportunities with an unusual mix of recreational options. Skiing, boating, camping and casino gambling are close at hand. Such treasures as Valley Forge, Washington's Crossing, Longwood Gardens, Winterthur and the Mercer Museum draw millions of tourists.

The city is an overnight truck drive away from half the U.S. population. The nation's busiest highway, Interstate 95, runs through Philadelphia and alongside both Penn's Landing and the recently expanded Philadelphia International Airport. Twelve commuter railroad lines link Philadelphia to its Pennsylvania suburbs. A fully automated high-speed line runs into downtown Philadelphia from New Jersey. One of the seven Delaware River highway bridges in the region connects the Pennsylvania and New Jersey Turnpikes. Such facilities, plus Amtrak trains, city subways, buses and trolleys provide quick and easy access to Penn's Landing.

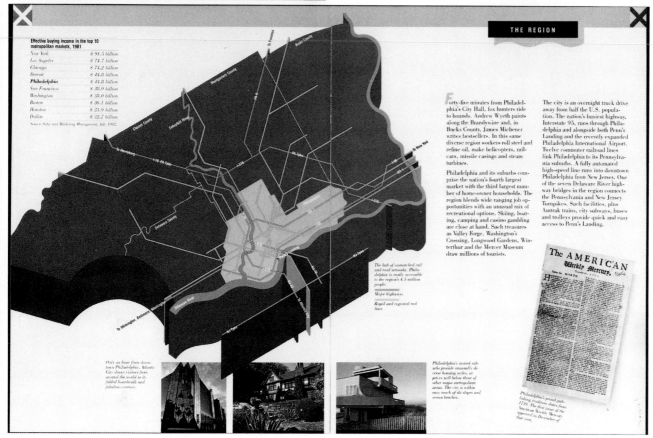

**Postage Stamp:**
Science and Industry
**Art Director:**
Saul Bass
**Designer:**
Saul Bass
**Design Firm:**
Saul Bass/Herb Yager
& Assoc.
Los Angeles, CA
**Client:**
U.S. Postal Service

**Poster:**
Hats Off
**Art Director:**
Cap Pannell
**Designer:**
Cap Pannell
**Artists:**
Cap Pannell, Cerita Smith
**Design Firm:**
Cap Pannell & Co.
Dallas, TX
**Publisher:**
Federated Stores
Realty, Inc.
**Typographer:**
J.C.S.
**Printer:**
Inky Fingers

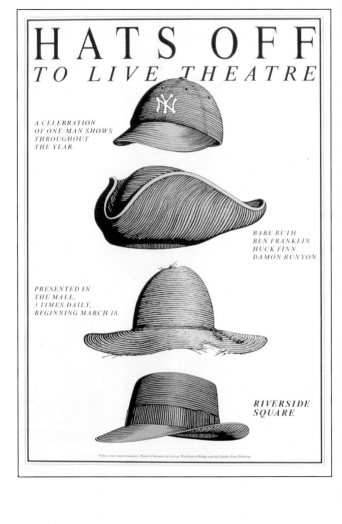

**Catalogue:**
Illustration Portfolio III
School of Visual Arts
**Art Director:**
Richard Wilde
**Designer:**
Bill Kobasz
**Artists:**
Various Students
**Design Firm:**
School of Visual Arts
New York, NY
**Typographer:**
Cardinal Type Service
**Printer:**
Pollack-Weir Graphics, Inc.

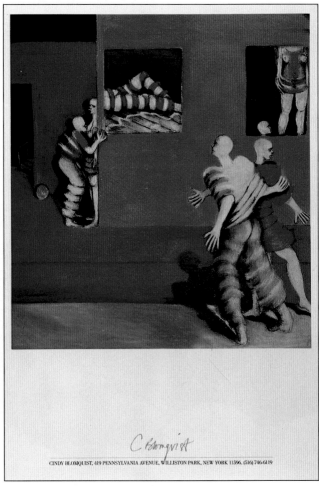

A Portfolio

**Promotional Brochure:**
Interprint/A Portfolio
**Art Director:**
Michael Patrick Cronan
**Designer:**
Michael Patrick Cronan
**Artist:**
Sudi McCollum
**Photographers:**
Barrie Rokeach, Keith Silva
Charles Kemper
**Design Firm:**
Michael Patrick Cronan
Graphic Design
San Francisco, CA
**Publisher:**
Interprint
**Typographer:**
Headliners
**Printer:**
Interprint

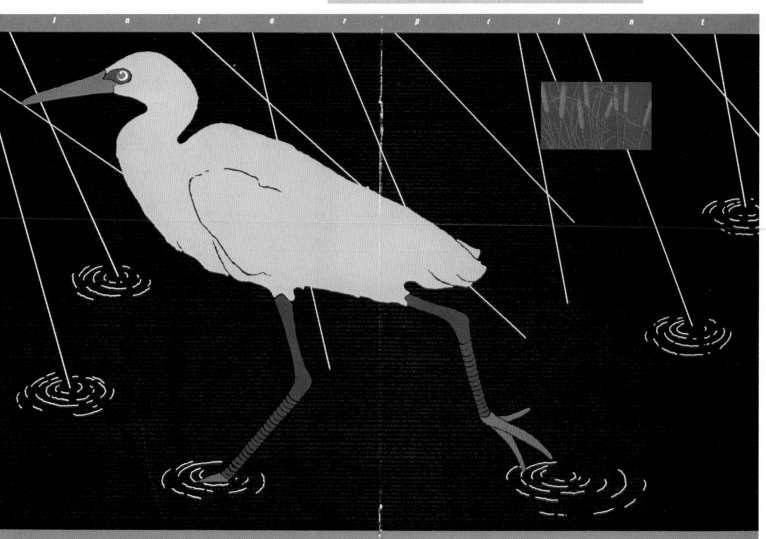

Sudi McCollum

Sudi McCollum said subtle was
what she wanted. Subtle tonali-
ties. Subtlety in the details:
"Hold the lines in the egret's
legs. That goes for the beak too.
Don't let them fill in. Think
subtle. Think Japanese. Think
muted. And would you mind
matching the colors from this
handful of fabrics, papers and
assorted odds and ends I've
found? I just couldn't find any

colors I really liked in the 1,774
PMS colors I've been looking at.
Matching these colors is really
important to me, Ken," said Sudi.
"And for heaven's sake don't let
those lovely, subtle lines fill in."

**Art Director:**
**Designer:**
**Artist:**
**Photographers:**
**Design Firm:**
**Publisher:**
**Typographer:**
**Printer:**

**Catalogue:**
Royal Robbins
**Art Director:**
John Casado
**Designer:**
John Casado
**Photographer:**
Will Mosgrove
**Design Firm:**
Casado Design
San Francisco, CA
**Client:**
Royal Robbins, Inc.
**Typographer:**
Display Lettering & Copy
**Printer:**
Gardner/Fulmer
Lithograph Co.

As an outdoorsman, Royal Robbins insists on "good style" in kayaking, skiing, and climbing, which means the purest approach to adventure, using no artificial aids or devices. The same philosophy applies to all Royal Robbins rugged wear. It carries a time-less, classic look of honest, functional clothing, consistent with the outdoor spirit.

**Invitational Booklet:**
River Visions
**Art Director:**
Danny Kamerath
**Designer:**
Danny Kamerath
**Artist:**
Danny Kamerath
**Design Firm:**
Richards, Sullivan, Brock
& Assoc.
Dallas, TX
**Client:**
Bedrock Development Corp.
**Typographer:**
Southwestern Typographics
**Printer:**
Williamson Printing

**Poster:**
HOME
**Art Director:**
Cap Pannell
**Designer:**
Cap Pannell
**Artists:**
Cap Pannell, Cerita Smith
**Design Firm:**
Cap Pannell & Co.
Dallas, TX
**Publisher:**
Texas Homes Magazine
**Typographer:**
J.C.S.
**Printer:**
P.M.Press

**Catalogue:**
Sunar '82
**Designer:**
Wilburn Bonnell III
**Photographers:**
Various
**Design Firm:**
Bonnell Design Assoc., Inc.
New York, NY
**Publisher:**
Sunar
**Typographer:**
Pastore DePamphilis
Rampone
**Printer:**
Dai Nippon Printing Co., Ltd.

HOME. What's inside it is important to your customers. And what's inside *Texas Homes* January-February issue is important to you.

Because in January, *Texas Homes* will publish its special market preview: the best new designs to debut at the January Homefurnishings Market in Dallas. This special section on furnishings, accessories, wall and floor coverings will not only reach our 100,000+ affluent homeowners, but

your best customers at the Dallas Homefurnishings Market.

AT HOME IN THE DALLAS MARKET CENTER. Three years ago, our editors developed a comprehensive, bi-annual report on the best new lines and products to be introduced at the Dallas market. Since then, our market preview has become a trusted reference for designers and buyers alike. Our market report has become a Texas institution. But more important, we see that it hits home.

WALL-TO-WALL COVERAGE. *Texas Homes* January-February issue will be delivered to every showroom in the Dallas Market Center during the January Homefurnishings Show. So your advertisement will be read by retailers and designers from all over the country.

What's more, the January-February issue of *Texas Homes* will be distributed to every room in the Loew's Anatole Dallas Hotel and the Marriott Hotel. Which means you'll

reach over 15,000 of your best customers at the January market, as well as our regular circulation of 100,000 affluent Texas homeowners.

ROOMS-FULL OF IMPACT. As a special service to advertisers who purchase ads ½ page or larger, *Texas Homes* will provide a slick counter card for use in market and retail showrooms. This will serve as an excellent reinforcement tool for your magazine advertising. And a timely reminder

that you deliver dealer support in regional publications.

RAISE HIGH THE ROOF BEAMS. If you want to reach your best customers at the Dallas Market and the most dynamic consumer readership in the U.S., join us for our January-February issue. Call advertising director Anita Middleton at (214) 741-4831 collect. But hurry, closing for the January-February issue of *Texas Homes* is November 12. Let us hear from you today!

**TEXAS HOMES**

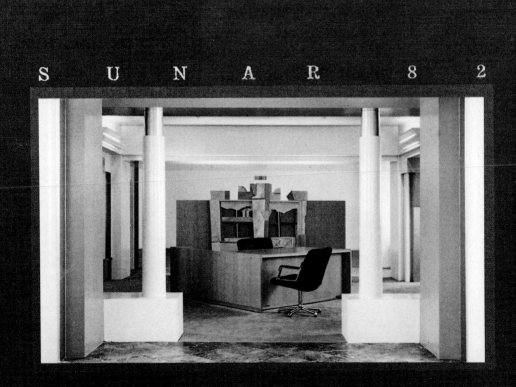

S U N A R 8 2

**Poster/Flyer:**
Preservation
& Urban Revitalization
**Art Director:**
Robert Rytter
**Designer:**
Robert Rytter
**Design Firm:**
R.S. Jensen, Inc.
Baltimore, MD
**Publisher:**
City of Roanoke, VA
**Typographer:**
Alpha Graphics
**Printer:**
Washburn Press

**Financial Booklet:**
Statement of Terms and
Conditions for Non-U.S.
Banks
**Art Director:**
Infield & D'Astolfo
**Designer:**
Infield & D'Astolfo
**Artist:**
Infield & D'Astolfo
**Design Firm:**
Infield & D'Astolfo
New York, NY
**Client:**
Citibank
**Typographer:**
Pro Type
**Printer:**
Crafton Graphic Co., Inc.

**Promotion Book:**
Transco Tower
**Art Director:**
Jerry Herring
**Designer:**
Jerry Herring
**Photographers:**
Joe Baraban, Heidrich
Blessing, Jim Sims,
Ron Scott
**Design Firm:**
Herring Design
Houston, TX
**Client:**
Gerald D. Hines Interests
**Typographer:**
Professional Typographers,
Inc.
**Printer:**
Heritage Press

**Invitation:**
Body Heat
**Art Director:**
Tonnie Chamblee
**Designer:**
Tonnie Chamblee
**Artist:**
Tonnie Chamblee
**Design Firm:**
Miller, Judson & Ford, Inc.
Houston, TX
**Client:**
Clampitt Paper Co.
**Typographer:**
Typeworks
**Printer:**
Treaty Oak Press

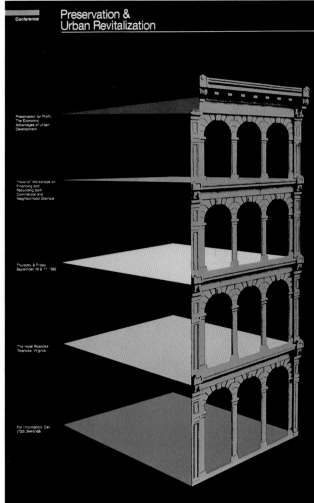

**Promotional Brochure:**
Hauserman/Isozaki
**Art Director:**
Massimo Vignelli
**Designer:**
Massimo Vignelli
**Artist:**
Arata Isozaki
**Design Firm:**
Vignelli Assoc.
New York, NY
**Client:**
Hauserman, Inc.
**Typographer:**
Pastore DePamphilis
Rampone

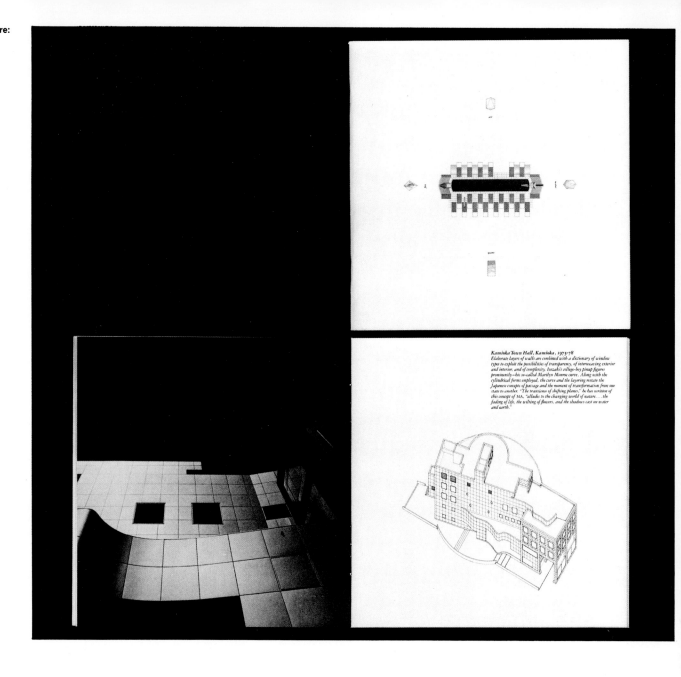

Kamioka Town Hall, Kamioka, 1975-78
Elaborate layers of walls are combined with a dictionary of window types to exploit the possibilities of transparency, of intersecting exterior and interior, and of complexity. Isozaki's college-boy pinup figures prominently—his so-called Marilyn Monroe curve. Along with the cylindrical forms employed, the curve and the layering restate the Japanese concepts of passage and the moment of transformation from one state to another. The transience of shifting planes, he has written of this concept of MA, "alludes to the changing world of nature . . . the fading of life, the wilting of flowers, and the shadows cast on water and earth."

**Promotional Booklet:**
Huntington Center
**Art Director:**
Lowell Williams
**Designer:**
Bill Carson
**Photographers:**
Jim Sims, Ron Scott
**Design Firm:**
Lowell Williams Design, Inc.
Houston, TX
**Client:**
Gerald D. Hines Interests
**Typographer:**
Typeworks, Inc.
**Printer:**
Heritage Press

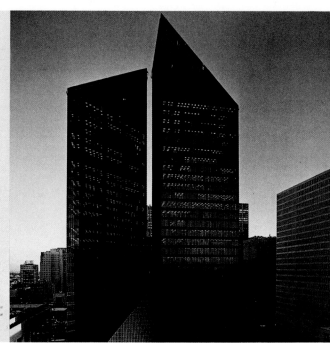

**E**xperienced in all phases of investment real estate development, Gerald D. Hines Interests is internationally recognized for its unyielding commitment to quality in architectural design, in construction, in project management.

Collaborating with some of the world's finest architects and designers, Hines Interests has been responsible for the development of such acclaimed projects as Pennzoil Place, the Galleria, Transco Tower, Post Oak Central and Texas Commerce Tower in United Energy Plaza, Houston; Central Trust Center, Cincinnati; 101 California, San Francisco; United Bank Center, Denver; and Seafirst Fifth Avenue Plaza, Seattle.

These and other projects have received architectural accolades from *The New York Times, Architectural Record, Texas Architecture,* The Urban Land Institute, the American Institute of Architects and the Texas Society of Architects.

Pennzoil Place
Houston

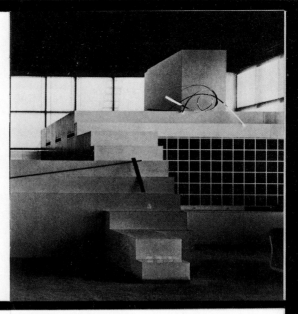

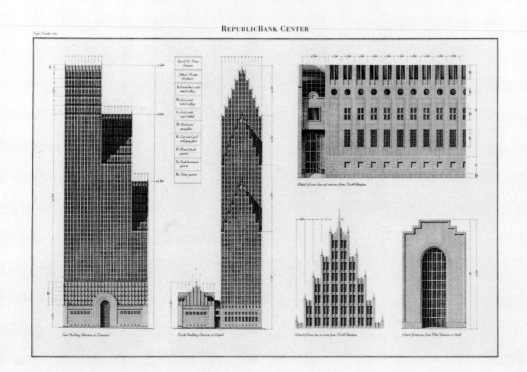

**Poster:**
Republic Bank Center
**Art Director:**
Lowell Williams
**Designers:**
Lowell Williams, Bill Carson
**Artist:**
Tom McNeff
**Design Firm:**
Lowell Williams Design, Inc.
Houston, TX
**Client:**
Gerald D. Hines Interests
**Typographer:**
Typeworks, Inc.
**Printer:**
Grover Printing Co.

**Promotional Brochure:**
The Turtle Creek Center
for the Arts
**Art Director:**
Danny Kamerath
**Designer:**
Danny Kamerath
**Photographer:**
Kent Kirkley
**Design Firm:**
Richards, Sullivan, Brock
& Assoc.
Dallas, TX
**Typographer:**
Southwestern Typographics
**Printer:**
Williamson Printing

**Annual Report:**
Lomas & Nettleton
Mortgage Investors
1982 Annual Report
**Art Director:**
Ron Sullivan
**Designer:**
Ron Sullivan
**Artist:**
McRay Magleby
**Photographer:**
Greg Booth
**Design Firm:**
Richards, Sullivan, Brock
& Assoc.
Dallas, TX
**Publisher:**
Lomas & Nettleton
Mortgage Investors
**Typographer:**
Chiles & Chiles
**Printer:**
Heritage Press

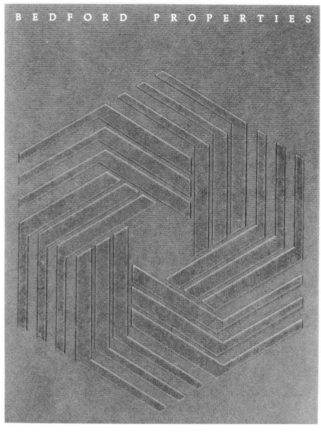

**Promotional Brochure:**
Bedford Properties
**Art Director:**
Michael Vanderbyl
**Designer:**
Michael Vanderbyl
**Photographers:**
Monica Lee, Rose Hodges
**Design Firm:**
Vanderbyl Design
San Francisco, CA
**Client:**
Bedford Properties
**Typographer:**
Headliners/Identicolor
**Printer:**
Interprint

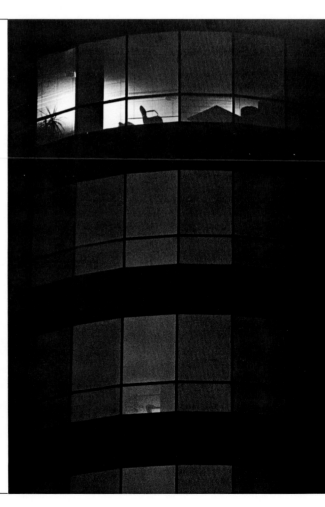

E ach project we undertake presents a unique
opportunity. So we look at each individually,
examine the options carefully, then select
the one that offers the greatest potential income
and return on investment for our clients.

DESIGN AND DEVELOPMENT. Whether the de-
velopment task is large or small, a single office
building or a major mixed-use complex, it begins
with a thorough evaluation of the alternatives:
assessing the potential of the property from both
a use and an investment standpoint, surveying
the market, analyzing development options, and
determining what type and size facility is right for
the site. Based on this research, we select the best
option and begin to build toward it, assembling
that development team—financial partners, archi-
tects, engineers, contractors, consultants—which
can bring the highest quality and integrity to
the project. Once that team has been formed,
we provide direction and supervise construction
throughout the development process.

PROJECT FINANCING. With the rising costs of
both money and construction, options for project
financing are increasing in number and complexity.

At Mark Lee & Associates, we are familiar with
current options, and with emerging ones. We have
the experience and the established relationships with
leading lending institutions to make financing a
smooth step in the investment building process,
instead of a major obstacle.

Short term, we arrange construction financing
through some of the nation's strongest commercial
banks, obtaining the most favorable terms on our
clients' behalf.

To secure long term financing, we prepare com-
prehensive loan packages, complete with financial
projections, architectural plans and scale models,
and sophisticated investment analyses. We then
approach prospective lenders and investors and
negotiate the most advantageous financial package,
ranging from a fixed-rate, nonparticipation loan
agreement, to a joint venture with the lender, and
a host of alternatives in between.

**Promotional Brochure:**
Mark Lee Associates
**Art Director:**
Lowell Williams
**Designer:**
Lance Brown
**Photographers:**
Jim Sims, Ron Scott
**Design Firm:**
Lowell Williams Design, Inc.
Houston, TX
**Publisher:**
Mark Lee & Assoc.
**Typographer:**
Typeworks, Inc.
**Printer:**
Williamson Printing

**Promotional Folder:**
Dunbar, The S/4 Series
**Art Directors:**
Michael R. Abramson
Lawrence Wolfson
**Designer:**
Lawrence Wolfson
**Photographers:**
Corson Hirschfeld
David Pruitt
**Design Firm:**
Michael R. Abramson
& Assoc.
New York, NY
**Client:**
Dunbar Furniture Corp.
**Typographer:**
Concept Typographical
Services
**Printer:**
Thorner-Sidney Press, Inc.

Power is brought to the top of cube storage units and work surfaces through surface access openings. Each cube storage unit and all primary and secondary work surfaces are manufactured in veneer or laminate.

## Work Surfaces

Each of the primary and secondary work surfaces has been shaped and scaled to improve space utilization. They facilitate the information-related activities of the office.

All primary work surfaces are designed for dual purposes. They function both as desk *and* conference table. By serving as an effective, comfortable meeting area, the need for additional conference rooms is reduced.

The secondary work surface can accommodate a full range of computer terminals and telecommunications equipment and can also function as an effective personal work area.

The varied shapes and sizes of the work surfaces function as connected units. In some cases, the programmed flexibility of the S/4 Series™ allows for free standing work surfaces.

An important feature of the S/4 Series is the orderly and functional management of power cables and lines. Wires pass through the primary access routes, under the secondary work surface, down the cube storage and into the recessed raceway of the Organizing Element™.

**Promotional Brochure:**
Stephens Office Seating
**Art Director:**
Harold Matossian
Steven Schnipper
**Designer:**
Steven Schnipper
**Photographer:**
Mario Carrieri
**Design Firm:**
Knoll Graphics
New York, NY
**Publisher:**
Knoll International
**Printer:**
CFK Press

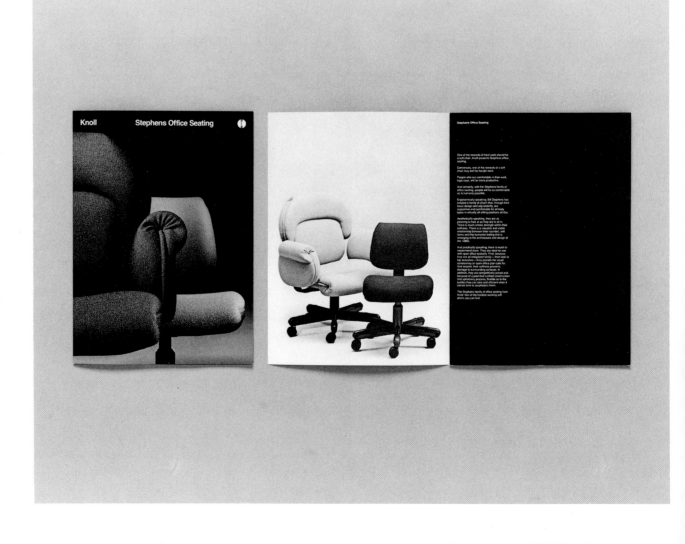

Knoll
Richard Meier Collection

**Poster:**
Richard Meier Collection
**Art Director:**
Harold Matossian
Steven Schnipper
**Designer:**
Steven Schnipper
**Photographer:**
Mario Carrieri
**Design Firm:**
Knoll Graphics
New York, NY
**Publisher:**
Knoll International
**Printer:**
Rapoport Printing Co.

**Promotional Magazine:**
Knoll News, June 1982
**Art Director:**
Harold Matossian
**Designers:**
Steven Schnipper
Leslee Ladds
**Photographers:**
Various
**Design Firm:**
Knoll Graphics
New York, NY
**Publisher:**
Knoll International
**Printer:**
Kenner Printing Co.

**Promotional Brochure:**
This year over 250,000
shoppers will spend
Christmas with us
**Art Director:**
Cerita Smith
**Designer:**
Cerita Smith
**Artist:**
Cerita Smith
**Design Firm:**
Cap Pannell & Co.
Dallas, TX
**Client:**
D Magazine
**Typographer:**
J.C.S.
**Printer:**
The Printery, Etc.

**Brochure:**
MAD Computer
**Designers:**
Steven Tolleson,
Michael Kunisaki
**Photographer:**
Jack Christianson
**Design Firm:**
Mark Anderson Design
Palo Alto, CA
**Client:**
MAD Corp.
**Typographer:**
Abra Type
**Printer:**
The National Press

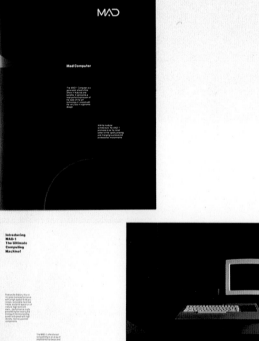

**Stationery:**
Interprint
**Art Director:**
Michael Patrick Cronan
**Designer:**
Michael Patrick Cronan
**Artist:**
Michael Patrick Cronan
**Design Firm:**
Michael Patrick Cronan
Graphic Design
San Francisco, CA
**Client:**
Interprint
**Typographer:**
Headliners
**Printer:**
Interprint

**Announcement Poster:**
Dallas Illustrators One
**Art Director:**
Jack Summerford
**Designer:**
Jack Summerford
**Artist:**
John Collier
**Design Firm:**
Summerford Design, Inc.
Dallas, TX
**Client:**
The Dallas Illustrators
**Typographer:**
Southwestern Typographics
**Printer:**
Thompson Press

**Brochure:**
Edwards & Angell
**Art Director:**
Malcolm Grear
**Designer:**
Malcolm Grear Designers
**Photographer:**
John T. Hill
**Design Firm:**
Malcolm Grear Designers
Providence, RI
**Client:**
Edwards & Angell
**Typographer:**
Dumar Typesetting
**Printer:**
National Bickford Foremost

When the defense of a client's rights calls for litigation, the trial attorneys of Edwards & Angell well earn their reputation for painstaking care. Because E & A lawyers have worked a full gamut of cases—antitrust, constitutional, discrimination, real estate, utility rate, as well as contracts and securities—we can apply a single expert to a client's case or a battery of them, whichever is appropriate. We can draw upon years of practical courtroom know-how to prove the old adage true: "The life of the law has not been logic—it has been experience."

It's evident, of course, that no one can predict the outcome of any given case. But this is equally evident: clients feel more secure with a firm known for doing its homework, known for paying attention, and known—a hundred years ago no less than this very afternoon—for being prepared.

**Promotional Brochure:**
Riverside
**Art Directors:**
Gary Templin, Ron Sullivan
**Designer:**
Gary Templin
**Photographer:**
Gary McCoy
**Design Firm:**
Richards, Sullivan, Brock & Assoc.
Dallas, TX
**Client:**
Bedrock Development Corp.
**Typographer:**
Chiles & Chiles
**Printer:**
Heritage Press

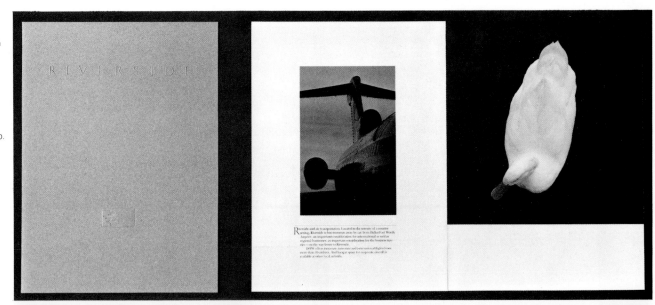

**Promotional Folder:**
Why did we redesign Architectural Record?
**Creative Director:**
John Rafferty
**Designer:**
Constance T. Doyle
**Design Firm:**
Rafferty Communicators, Inc.,
New York, NY
**Client:**
Architectural Record Magazine
**Printer:**
McGraw-Hill, Inc.

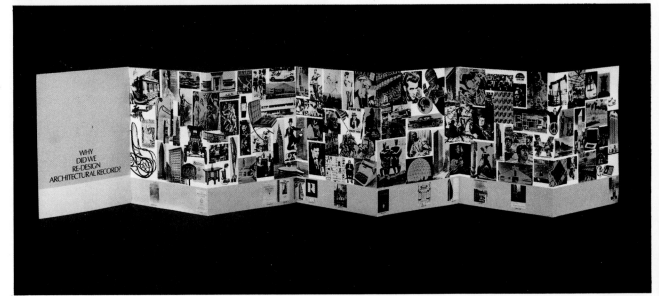

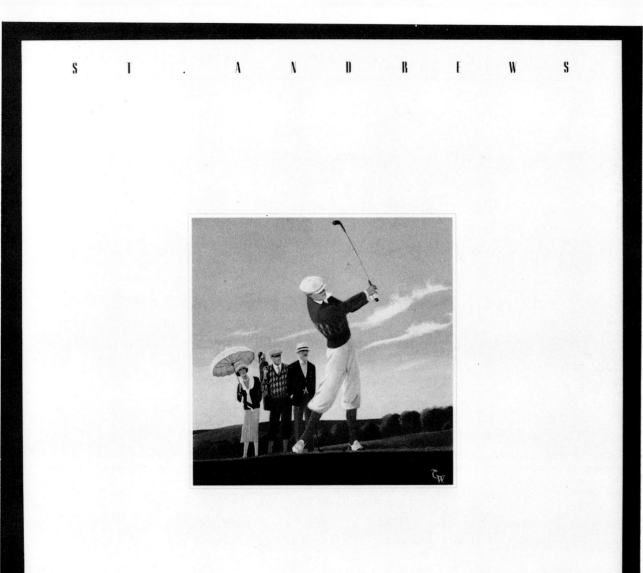

S T . A N D R E W S

B O C A · R A T O N

**Promotional Brochure:**
St. Andrews/Boca Raton
**Art Director:**
Ruth Ansel
**Designer:**
Philip Gips
**Artist:**
Chuck Wilkinson
**Design Firm:**
Gips+Balkind+Assoc.
New York, NY
**Client:**
St. Andrews/Boca Raton
**Typographer:**
Innovative Graphics
International
**Printer:**
Lebanon Valley Offset

Meet the Reverend Evelyn Kendall,
PSR alumna,
M.Div. Class of 1981.
Evelyn is a full-time member of the
ministerial staff of the Burlingame
United Methodist Church.

"Seminary for me was the way I
could respond to my call to a new
dimension of ministry. Beyond
what I had shared with my husband,
as minister's spouse, in the local
church, in Africa as a missionary
and as a lay director of a
church-related agency. My call
centered in wanting to share my
rich global experience, my
deep conviction in the unity of all
Christians and the importance
of Christ in today's world."

Hopes for people like Evelyn
graduating from PSR in the future
fade without support from
the alumni/ae. Alumni/ae gifts mean
more support from foundations,
churches and other friends because
it means our graduates affirm
the value of their education at PSR.

The timing of the call is not always
practical. If Evelyn had entered
PSR when she first felt her call, she
might have entered seminary
in 1950, the year after she graduated
from the University of California.
In 1950 the tuition was $180
per year. By 1980 it was $1,950.
The estimate of the entire cost to
educate a seminary student
in 1983 is over $14,502.

We must keep tuition low. Students
come to us with greater
indebtedness than ever before.
Your annual gift enables PSR
to increase funds
available for financial aid.

Give today.
Support the future.

**Promotional Folder:**
Meet the Reverend
Evelyn Kendall
**Art Director:**
Michael Mabry
**Designer:**
Michael Mabry
**Photographers:**
Michele Clement
Mark Schroeder
**Design Firm:**
Michael Mabry Design
San Francisco, CA
**Client:**
Pacific School of Religion
**Typographer:**
Petrographics
**Printer:**
Forman/Leibrock

THE HARLEY-DAVIDSON STORY

**Promotional Booklet:**
The Harley-Davidson Story
**Art Directors:**
Dan Donovan,
Jim Sendecke
**Designer:**
Dan Donovan
**Photographers and Archives:**
Various
**Design Firm:**
Reed Design Assoc.
Madison, WI
**Client:**
Harley-Davidson Co.
**Typographer:**
Landman Typographers
**Printer:**
Victory Graphics

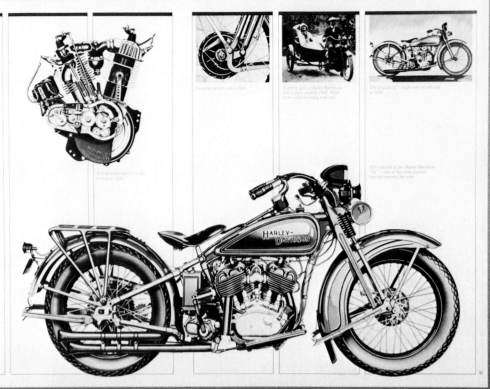

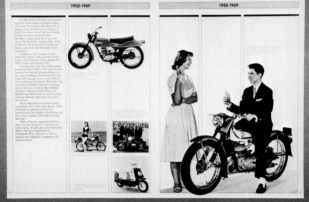

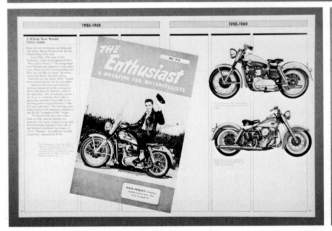

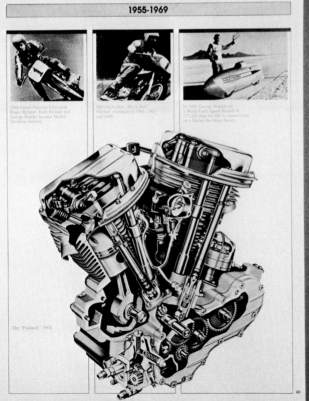

**Catalogue:**
Vuarnet USA, 1982
**Art Director:**
Robert Miles Runyan
**Designer:**
Robert Miles Runyan
& Assoc.
**Photographer:**
Jon Kubly
**Design Firm:**
Robert Miles Runyan
& Assoc.
Playa del Rey, CA
**Client:**
Vuarnet USA
**Typographer:**
Composition Type
**Printer:**
Lithographix

**1982**

**Promotional Brochure:**
Celica Supra by Toyota
**Art Director:**
Jim Doyle
**Designer:**
Jim Doyle
**Photographer:**
Mickey McGuire/Boulevard
**Illustrator:**
Konrad Kahl
**Agency:**
Dancer Fitzgerald Sample,
Inc/SCA
Torrance, CA
**Client:**
Toyota Motor Sales,
USA, Inc.
**Typographer:**
Aldus Type Studio
**Printer:**
Anderson Litho Co.

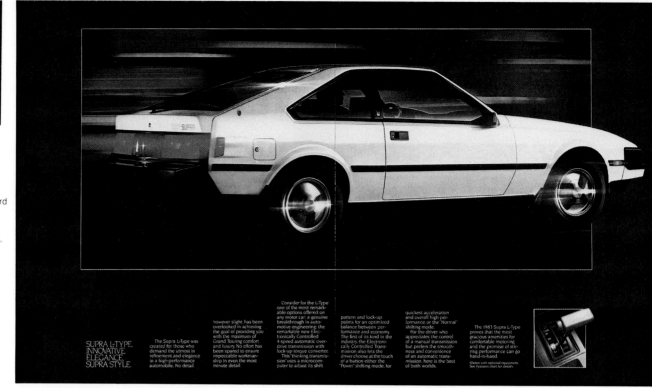

SUPRA L-TYPE.
INNOVATIVE
ELEGANCE.
SUPRA STYLE.

The Supra L-Type was created for those who demand the utmost in refinement and elegance in a high-performance automobile. No detail, however slight, has been overlooked in achieving the goal of providing you with the maximum of Grand Touring comfort and luxury. No effort has been spared to ensure impeccable workmanship in even the most minute detail.

Consider for the L-Type one of the most remarkable options offered on any motor car: a genuine breakthrough in automotive engineering: the remarkable new Electronically Controlled 4-speed automatic overdrive transmission with lock-up torque converter.

This "thinking transmission" uses a microcomputer to adjust its shift pattern and lock-up points for an optimized balance between performance and economy. The first of its kind in the industry, the Electronically Controlled Transmission also lets the driver choose at the touch of a button either the "Power" shifting mode, for quickest acceleration and overall high performance or the "Normal" shifting mode.

For the driver who appreciates the control of a manual transmission but prefers the smoothness and convenience of an automatic transmission, here is the best of both worlds.

The 1983 Supra L-Type proves that the most gracious amenities for comfortable motoring and the promise of stirring performance can go hand-in-hand.

Shown with optional equipment. See Features chart for details.

---

**Promotional Newspaper:**
U & lc/March 1982
**Art Director:**
Bob Farber
**Designer:**
B. Martin Pedersen
**Design Firm:**
International Typeface Corp.
New York, NY
**Publisher:**
International Typeface Corp.
**Typographer:**
M.J. Baumwell
**Printer:**
Lincoln Graphic Arts

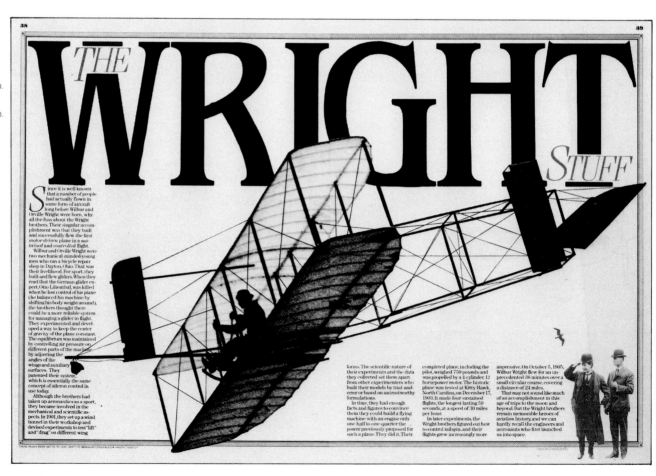

# THE WRIGHT STUFF

Since it is well known that a number of people had actually flown in some form of aircraft long before Wilbur and Orville Wright were born, why all the fuss about the Wright brothers. Their singular accomplishment was that they built and successfully flew the first *motor-driven* plane in a *sustained* and *controlled* flight.

Wilbur and Orville Wright were two mechanical-minded young men who ran a bicycle repair shop in Dayton, Ohio. That was their livelihood. For sport, they built and flew gliders. When they read that the German glider expert, Otto Lilienthal, was killed when he lost control of his plane (he balanced his machine by shifting his body weight around), the brothers thought there could be a more reliable system for managing a glider in flight. They experimented and developed a way to keep the center of gravity of the plane constant. The equilibrium was maintained by controlling air pressure on different parts of the machine by adjusting the angles of the wings and auxiliary surfaces. They patented their system, which is essentially the same concept of aileron control in use today.

Although the brothers had taken up aeronautics as a sport, they became involved in the mechanical and scientific aspects. In 1901, they set up a wind tunnel in their workshop and devised experiments to test "lift" and "drag" on different wing forms. The scientific nature of their experiments and the data they collected set them apart from other experimenters who built their models by trial-and-error or based on untrustworthy formulations.

In time, they had enough facts and figures to convince them they could build a flying machine with an engine only one-half to one-quarter the power previously proposed for such a plane. They did it. Their completed plane, including the pilot, weighed 750 pounds and was propelled by a 4-cylinder, 12 horsepower motor. The historic plane was tested at Kitty Hawk, North Carolina, on December 17, 1903. It made four sustained flights, the longest lasting 59 seconds, at a speed of 30 miles per hour.

In later experiments, the Wright brothers figured out how to control tailspin, and their flights grew increasingly more impressive. On October 5, 1905, Wilbur Wright flew for an unprecedented 38 minutes over a small circular course, covering a distance of 24 miles.

That may not sound like much of an accomplishment in this age of trips to the moon and beyond. But the Wright brothers remain memorable heroes of aviation history, and we can hardly recall the engineers and astronauts who first launched us into space.

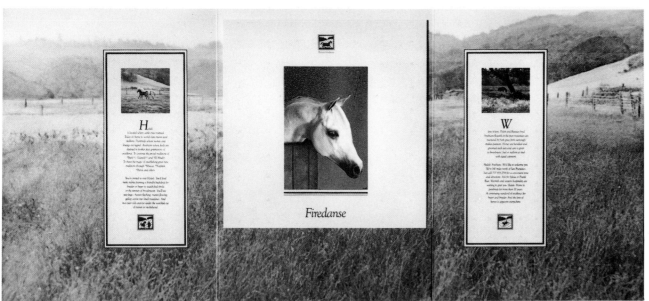

**Promotional Brochure:**
Halali Arabians
**Art Director:**
Clifton Lemon
**Designer:**
Clifton Lemon
**Photographer:**
Richard Lymburner
**Colorist:**
Anne Rhoney
**Design Firm:**
Lemon Design
San Francisco, CA
**Client:**
Halali Arabians
**Typographer:**
Display Lettering & Copy
**Printer:**
Joan Davis, Warren's Waller Press

# Moving mountains.

Firing Circuits is not a name that immediately springs to mind when you think of moving mountains. In fact we're the first to admit we're not exactly a household word. However, we feel the time has come to change all that. For twenty years Firing Circuits has been an integral part of the success of many of America's leading industrial giants. In that short time Firing Circuits has earned a reputation as an innovator in the field of power electronics.

One of our customers is Long-Airdox, a major supplier of belt and chain conveyors for underground coal mining. Over the years Long-Airdox has contributed to the technological advance of mining techniques in the coal industry. Working with coal industry experts they have produced a whole new generation of systems that will help double America's coal production by the end of the century.

That's where Firing Circuits comes in, supplying solid state electronic equipment to safely start and economically control the power that drives these systems. Used in a variety of industries, the solid state reduced voltage AC motor starters have digital gating of SCR's to give balanced firing, maximum torque and minimum motor heating. They are compact, ruggedly made and their plug-in construction minimizes downtime.

Firing Circuits also manufactures adjustable motor speed drives, power inverters for induction heating devices and rectifier units. In fact Firing Circuits' formation rectifiers give the initial charge to more than 200,000 batteries throughout the world every day. A recent Firing Circuits innovation resulted in a breakthrough product for industrial battery recharging. Using unique microprocessor technology, the charger delivers significant economies in labor, energy and battery life.

Whatever your needs in power electronics, Firing Circuits has the answer. If we don't we'll work with you until we do. That philosophy brought us this far and we've never liked standing still.

**FiringCircuits**
Innovators in power electronics
Muller Avenue
Norwalk, Connecticut 06852
203 846 1633

**Magazine Ad:**
Moving Mountains
**Art Director:**
Frank C. Lionetti
**Designers:**
Ann Clementino
Frank C. Lionetti
**Photographer:**
Bill Kuypendall
**Design Firm:**
Frank C. Lionetti Design
Old Greenwich, CT
**Client:**
Firing Circuits, Inc.
**Typographer:**
Southern New England Type

**Promotional Booklet:**
COPY/Herring Design
Quarterly #8
**Art Director:**
Jerry Herring
**Designer:**
Jerry Herring
**Artists:**
Various
**Design Firm:**
Herring Design
Houston, TX
**Publisher:**
Herring Design
**Typographer:**
Professional
Typographers, Inc.
**Printer:**
Wetmore & Co.

**Stationery:**
David Griffin & Co.
**Art Directors:**
David Kampa, Woody Pirtle
**Designer:**
David Kampa
**Artist:**
David Kampa
**Design Firm:**
Pirtle Design
Dallas, TX
**Client:**
David Griffin
**Typographer:**
Southwestern Typographics
**Printer:**
Fine Arts Engraving

**Promotional Brochure:**
The Horne Co., Realtors
**Art Director:**
Don Boswell, Inc.
**Designer:**
Wayne Ford
**Photographer:**
Jim Sims
**Design Firm:**
Miller, Judson & Ford, Inc.
Houston, TX
**Client:**
The Horne Co., Realtors
**Typographer:**
X-L Typographers
**Printer:**
Grover Printing Co.

**Catalogue:**
Sperry Top-sider 1983
**Art Director:**
Susan Adamson
**Designer:**
Susan Adamson
**Photographer:**
Myron
**Design Firm:**
Humphrey Browning
MacDougall Design Group
Boston, MA
**Client:**
Sperry
**Typographer:**
Typographic House
**Printer:**
Daniels Printing Co.

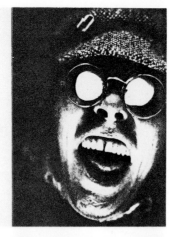

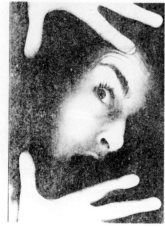

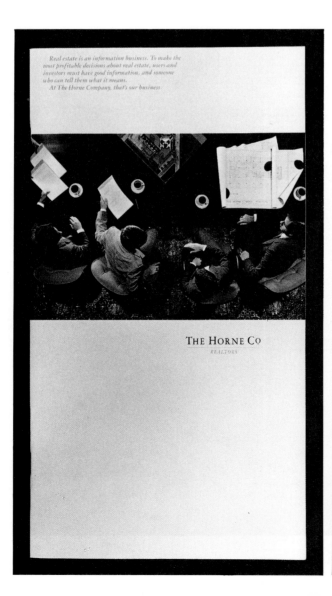

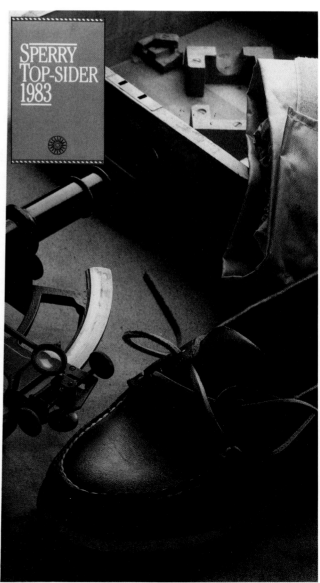

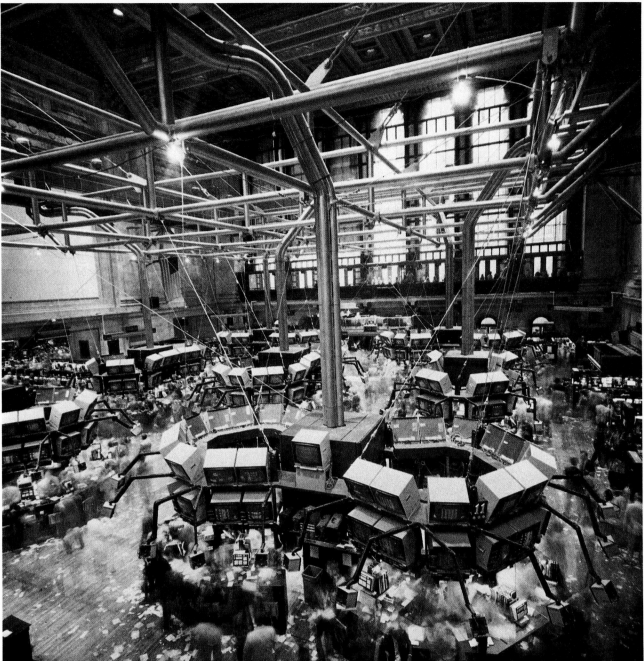

**Promotional Booklet:**
Marketplace/A Brief History
of The New York Stock
Exchange
**Art Director:**
Joan Charysyn
**Designer:**
Roberta Glasser
**Artists and
Photographers:**
Various
**Design Firm:**
Roberta Glasser
Graphic Design
New York, NY
**Publisher:**
The New York Stock
Exchange
**Typographer:**
CTT
**Printer:**
Sterling Roman Press

**Magazine Ad:**
With the right help....
**Art Directors:**
Gary Goldsmith,
Mark Hughes
**Designers:**
Gary Goldsmith,
Mark Hughes
**Agency:**
Doyle Dane Bernbach
New York, NY
**Client:**
Paine Webber, Inc.

With the right help your financial picture can change  colors rather quickly. Call Paine Webber. (212) 437-2731

**Promotional Newspaper:**
U & lc/June 1982
**Art Director:**
Bob Farber
**Designer:**
Bob Farber
**Artist:**
Bernard Durins
**Design Firm:**
International Typeface
Corp.
New York, NY
**Publisher:**
International Typeface
Corp.
**Typographer:**
M.J. Baumwell
**Printer:**
Lincoln Graphic Arts

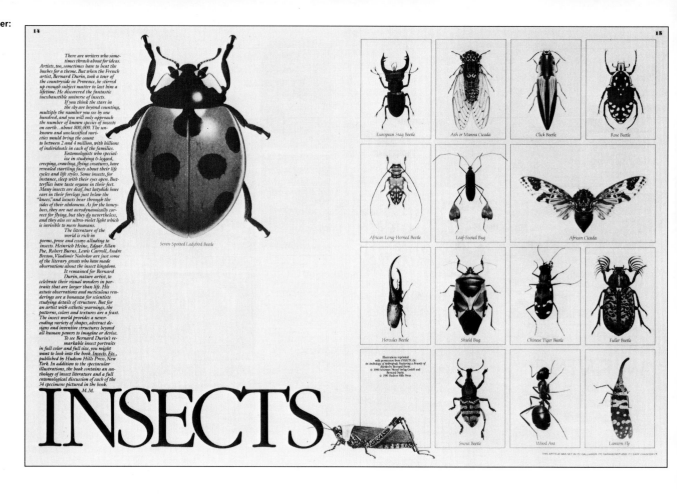

**Promotional Booklet:**
Tales of Colour
**Art Director:**
Neil Shakery
**Designer:**
Neil Shakery
**Artist:**
Dennis Ziemienski
**Design Firm:**
Jonson Pedersen Hinrichs
& Shakery
San Francisco, CA
**Client:**
California Printing Co., Inc.
**Typographer:**
Spartan Typographers
**Printer:**
California Printing Co., Inc.

**Annual Report:**
Potlatch 1981 Annual
Report
**Art Director:**
Kit Hinrichs
**Designer:**
Kit Hinrichs
**Artist:**
Colleen Quinn
**Photographer:**
Tom Tracy
**Design Firm:**
Jonson Pedersen Hinrichs
& Shakery
San Francisco, CA
**Client:**
Potlatch Corp.
**Typographer:**
Reardon & Krebs
**Printer:**
Anderson Lithograph Co.

**Promotional Booklet:**
Transformations
**Art Directors:**
Luis Acevedo, Woody Pirtle
**Designer:**
Luis Acevedo
**Photographer:**
Gary McCoy
**Design Firm:**
Pirtle Design
Dallas, TX
**Client:**
Roblee Corp.
**Typographer:**
Southwestern Typographics
**Printer:**
Padgett Printing

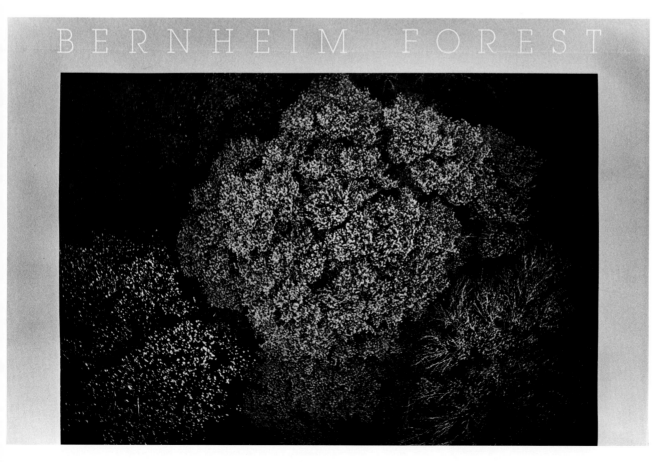

**Poster:**
Bernheim Forest
**Art Director:**
Julius Friedman
**Designer:**
Julius Friedman
**Photographer:**
Jon Webb
**Design Firm:**
Images
Louisville, KY
**Publisher:**
Bernheim Forest
**Typographer:**
Adpro
**Printer:**
The Hennegan Co.

**Catalogue:**
California Institute of
The Arts
**Art Director:**
Keith Bright
**Designers:**
Bright & Assoc., Inc.
**Photographers:**
Various
**Design Firm:**
Bright & Assoc., Inc.
Los Angeles, CA
**Publisher:**
California Institute of
The Arts
**Typographer:**
Andresen Typographics
**Printer:**
Jeffries Lithograph Co.

**Annual Report:**
Cenikor Foundation
1981 Annual Report
**Art Director:**
Jerry Herring
**Designer:**
Jerry Herring
**Photographer:**
Steve Brady
**Design Firm:**
Herring Design
Houston, TX
**Publisher:**
Cenikor Foundation
**Typographer:**
Typeworks, Inc.
**Printer:**
Gulf Printing

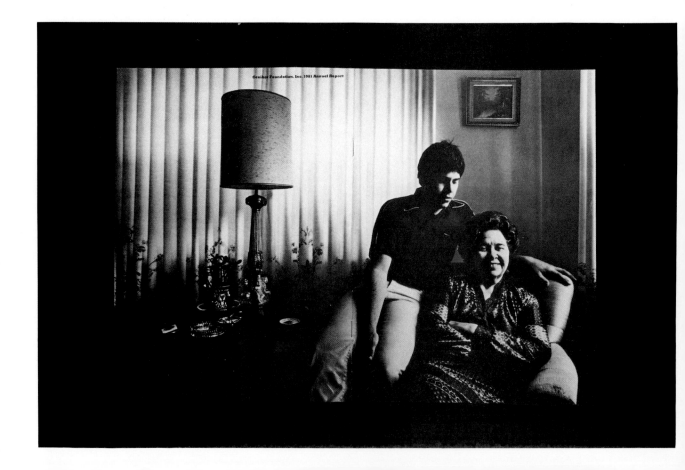

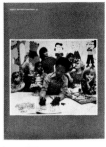

**Annual Report:**
Atlantic Richfield Foundation
Annual Report 1981
**Art Director:**
Lenore Tom
**Designer:**
Lenore Tom
**Photographer:**
Vic Luke
**Design Firm:**
Atlantic Richfield Co.
Los Angeles, CA
**Client:**
Atlantic Richfield Foundation
**Typographer:**
Atlantic Richfield Co.
**Printer:**
Gardner/Fulmer
Lithograph Co.

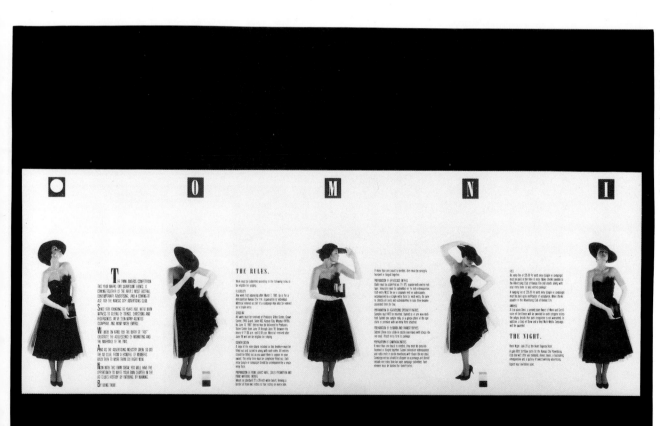

**Promotional Folder:**
Omni, July 29, 1982
**Art Director:**
John Muller
**Designer:**
John Muller
**Photographer:**
Hartzell Gray
**Design Firm:**
John Muller & Co.
Kansas City, MO
**Client:**
Kansas City Ad Club
**Typographer:**
Uppercase
**Printers:**
Boelte-Hall, Vile-Goller
Constable-Hodgins

**Menu:**
T.G.I. Friday's Culinary
Impressions
**Art Director:**
Woody Pirtle
**Designer:**
Woody Pirtle
**Artist:**
Woody Pirtle
**Design Firm:**
Pirtle Design
Dallas, TX
**Client:**
T.G.I. Friday's, Inc.
**Typographer:**
Southwestern Typographics
**Printer:**
Allcraft Printing

**Promotional Brochures:**
First Colony
**Art Director:**
Lowell Williams
**Designer:**
Lowell Williams
**Photographer:**
Jim Sims
**Design Firm:**
Lowell Williams Design, Inc.
Houston, TX
**Client:**
Gerald D. Hines Interests
**Typographer:**
Typeworks, Inc.
**Printer:**
Grover Printing Co.

**Promotional Brochure:**
Nursing at Stanford
University Hospital
**Art Director:**
Art Kirsch
**Designer:**
Art Kirsch
**Photographer:**
Mark Tuschman
**Design Firm:**
Art Kirsch Graphic Design
Palo Alto, CA
**Client:**
Stanford University Hospital
**Typographer:**
Frank's Type
**Printer:**
William H. Muller

**Poster:**
The new Suzuki 4x6
**Art Directors:**
Gary Priester,
Mike Salisbury
**Designers:**
Gary Priester,
Mike Salisbury
**Photographer:**
Mike Brown
**Agency:**
Young & Rubicam/Dentsu
Los Angeles, CA
**Client:**
Suzuki
**Typographer:**
Aldus Type Studio
**Printer:**
Anderson Printing Co.

**Invitation/Booklet:**
Bright & Associates.....
Halloween Party
**Art Director:**
Keith Bright
**Designers:**
Ray Wood, Peter Sargent
**Design Firm:**
Bright & Assoc., Inc.
Los Angeles, CA
**Printer:**
Jeffries Lithograph Co.

**Poster:**
Merry Christmas
**Art Director:**
Chris Hill
**Designers:**
Chris Hill, Joe Rattan
**Photographer:**
Jim Sims
**Design Firm:**
Hill/A Graphic Design
Group
Houston, TX
**Publisher:**
Hill/A Graphic Design
Group
**Typographer:**
Professional
Typographers, Inc.
**Printer:**
The Olivet Group

396

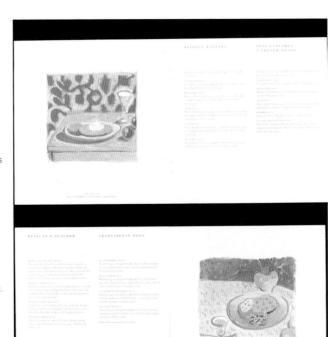

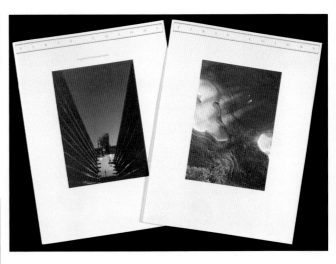

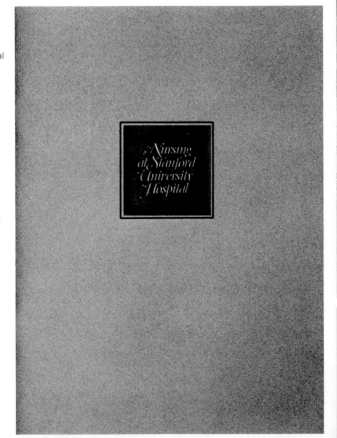

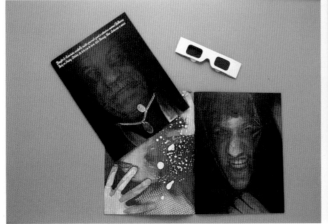

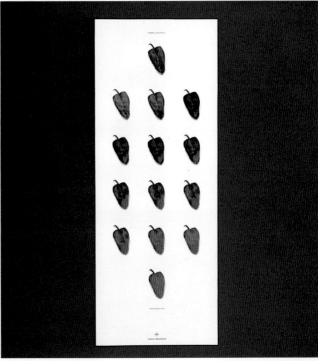

H     O     T

WE'RE INVITING OUR FRIENDS

IN THE GALLERIA TO JOIN US

WEDNESDAY, FEBRUARY 16,

FROM 4:30 UNTIL 6:30 PM

FOR COCKTAILS AND HORS D'OEUVRES

IN A CELEBRATION OF NEW BEGINNINGS.

WE'RE USHERING IN CHINESE NEW YEAR

WITH NEW FRIENDS AND OLD.

LEVEL THREE, THE GALLERIA

RSVP THE CHERRI OAKLEY COMPANY

(214) 742-5511

UNCLE TAI'S HUNAN CUISINE          HOUSTON, TWO POST OAK CENTRAL          DALLAS, GALLERIA LEVEL THREE

**Poster:**
HOT
**Art Directors:**
Linda Eissler
Arthur Eisenberg
**Designer:**
Linda Eissler
**Photographer:**
John Katz
**Design Firm:**
Eisenberg, Inc.
Dallas, TX
**Client:**
The Cherri Oakley Co.
**Typographer:**
JCS Typographers
**Printer:**
Padgett Printing

**Annual Report:**
Kansas City Art Institute
1981 Annual Report
**Art Director:**
John Muller
**Designer:**
John Muller
**Photographer:**
R. C. Nible
**Design Firm:**
John Muller & Co.
Kansas City, MO
**Client:**
Kansas City Art Institute
**Typographer:**
Fantastic
**Printer:**
Ashcraft Printing

Other qualitative objectives which, we believe, are essential to our success, and are met are: full-time access to professional studio and classroom facilities—we provide over 160 square feet of work space per student, properly sized classes for the nature of instruction—faculty/student ratio of 1:11.8 in 1979, 1:11.3 in 1980, and 1:11.4 in 1981; a diversity of curriculum which offers majors or electives in Ceramics, Fiber, Graphic Design, Industrial Design, Illustration, Painting, Photography/Film/Video, Printmaking and Sculpture; an outstanding freshman studio program—Foundation; and an excellent Liberal Arts and Art History curriculum. In addition, students have access to several additional learning opportunities at other institutions (free of extra charges) because of our participation in two educational consortia: the Kansas City Regional Council for Higher Education and the Union of Independent Colleges of Art.

Most important to the quality and diversity of instruction is the nature of the faculty. Fortunately, the Art Institute has been able to attract and retain an outstanding faculty of 43 full-time and 21 part-time artists, designers and scholars. Two-thirds of the faculty hold earned, terminal degrees (Ph.D's or M.F.A.'s) in their disciplines and at least nine are internationally acknowledged artists, designers or scholars.

An essential requirement when selecting and annually evaluating faculty for the Art Institute is that each is a practicing artist, designer or scholar who continues to pursue his or her professional interests. We believe the excellence in teaching is a direct result of two factors: the individual's interest in teaching and his/her timely, current personal activity as a practitioner. The number of commissions, exhibitions, publications, awards and fellowships received by our faculty indicate that we provide our students with the very finest.

A resultant quality of the Art Institute, perhaps the most important goal for our several audiences, is the performance of our alumni. The last six years we have worked hard to meet and know as many alumni as possible. Many of them are now assisting our Admissions staff in recruiting students and helping our Career Guidance and Placement Office in finding jobs or graduate school opportunities for our graduates. Research shows that more than 70% of the Art Institute graduates are still working in the discipline studied at the college after five years of professional life.

While the degree program appears to be meeting or exceeding objectives, the continuing education program needs further attention. There has been a 25% growth in Saturday and Summer high school course offerings and the basic evening program attracts good numbers and quality of students. However, we have the opportunity to offer many specialized courses for special interest groups such as art teachers, designers, publications managers, marketing professionals, pre-college art students, etc. This obvious market is not well-served in our community and this fact offers an opportunity to the Art Institute.

In other public service activities, the Charlotte Crosby Kemper Gallery provided the public with ten major exhibitions, including the Annual Graduating Class exhibition. The Student Gallery presented 15 exhibits of outstanding one-person or group works in painting, sculpture, drawing, design, photography, printmaking, ceramics and performance art.

Of the 57 visiting artists and scholars who visited the Art Institute during the year, 34 provided public lectures for students and the community. In addition to the 7,300 friends who attended activities on campus, more than 100,000 men and women enjoyed the Renaissance Festival, the Art Institute's annual recreation of an Elizabethan Harvest Festival which benefits the college.

It appears obvious that the college continues to achieve its objectives to provide diversified, high quality instruction and service to the community. If this goal were not met, none of the following information would be of any value.

Graphic and product designs take form on the drawing board.

**Design Manual:**
Anaconda Industries
Design Guide
**Art Director:**
Greg Cliff
**Designer:**
Greg Cliff
**Photographers:**
Bill Clark, Vic Luke
Lois Gervais
**Design Firm:**
Atlantic Richfield Design
Services
Los Angeles, CA
**Publisher:**
Anaconda Industries
Public Relations
**Typographer:**
Skilset
**Printer:**
Overland Printers

Design Guide
ANACONDA Industries

**Poster:**
Let's Be Friends
**Art Director:**
Chris Hill
**Designers:**
Chris Hill, Regan Dunnick
**Artist:**
Regan Dunnick
**Design Firm:**
Hill/A Graphic Design
Group
Houston, TX
**Client:**
Gwen Morgan
**Printer:**
Riverside Press

**Poster:**
Miles
**Art Director:**
John Berg
**Designer:**
John Berg
**Photographer:**
Gordon Parks
**Design Firm:**
CBS Records
New York, NY
**Publisher:**
CBS Records
**Typographer:**
Haber Typographers
**Printer:**
Progress Graphics

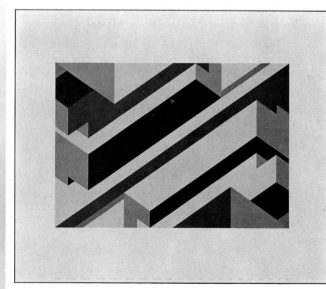

**Catalogue:**
Sparcraft Product Catalog
**Art Director:**
Gary Hinsche
**Designer:**
Edie Garrett
**Photographer:**
Bill Van Scoy
**Design Firm:**
Hinsche + Assoc.
Santa Monica, CA
**Client:**
Sparcraft Co.
**Typographer:**
Capco
**Printer:**
George Rice & Sons

**Poster:**
Corgan Associates
**Art Directors:**
Luis Acevedo
Woody Pirtle
**Designer:**
Luis Acevedo
**Artist:**
Luis Acevedo
**Design Firm:**
Pirtle Design
Dallas, TX
**Publisher:**
Corgan Assoc.
**Typographer:**
Southwestern Typographics
**Printer:**
Allcraft Printing

**Self-Promotional Item:**
Baxter + Korge, Inc.
25th Anniversary
Paperweight
**Art Director:**
Bruce Huninghake
**Designer:**
Bruce Huninghake
**Design Firm:**
Baxter + Korge, Inc.
Houston, TX
**Typographer:**
Professional Typographers
**Printer:**
American Embossing

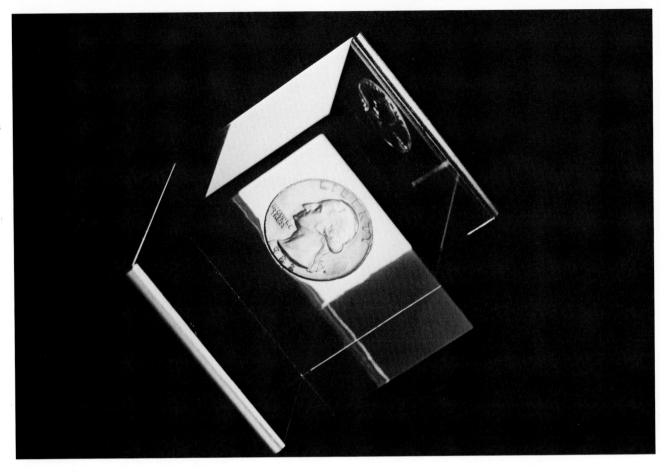

**Promotional Literature:**
Italian Show Center
Presentation
**Art Director:**
Ellen Woliner
**Designer:**
Martine Harmouch
**Design Firm:**
Corchia Woliner Assoc.
New York, NY
**Client:**
Gross & Assoc.
**Typographer:**
Trufont Typographers

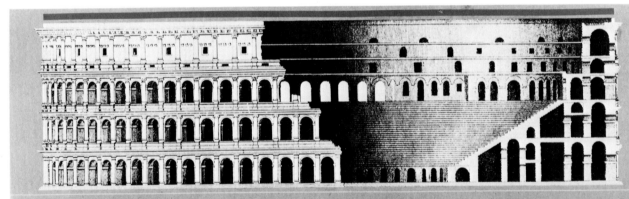

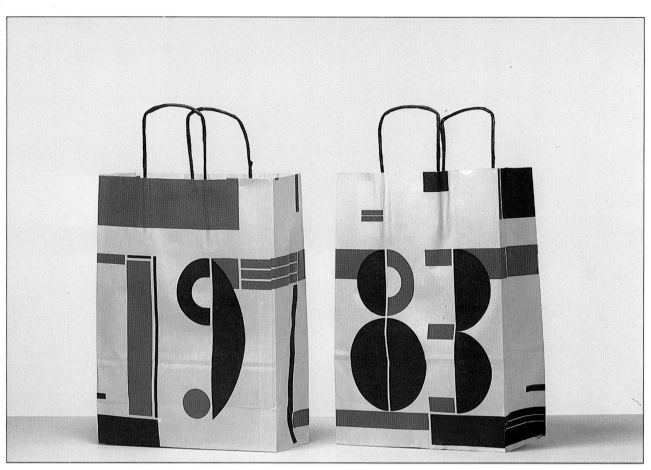

**Shopping Bag:**
Bloomingdales 1983
**Art Director:**
J. Richard Hsu
**Designer:**
Melanie Marder Parks
New York, NY
**Client:**
Bloomingdales

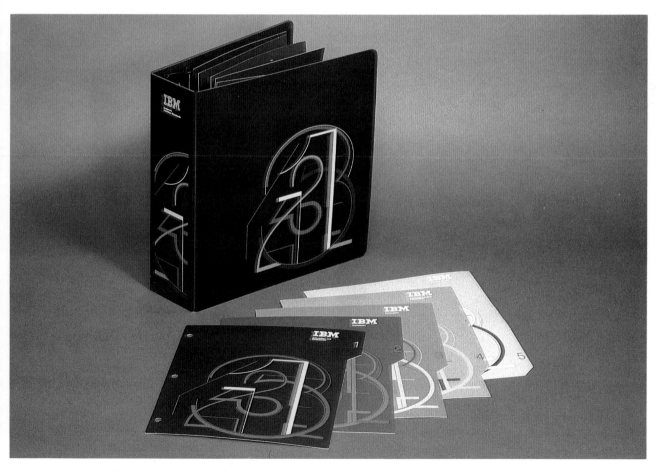

**Catalogue/Divider Sheets:**
IBM Corp. Furniture
Standards
**Art Director:**
Steff Geissbuhler
**Designer:**
Steff Geissbuhler
**Design Firm:**
Chermayeff & Geismar
Assoc.
New York, NY
**Client:**
IBM Corp.
**Printer:**
Crafton Graphic Co., Inc.

**Promotional Item:**
Imaginings
**Art Director:**
Robert Burns
**Designer:**
Joanna Kubicki
**Artist:**
Heather Cooper
**Design Firm:**
Burns, Cooper, Hynes,
Ltd..
Toronto, CAN
**Client:**
Ethos Cultural Development
Foundation
**Typographer:**
Typestudio
**Printer:**
Herzig-Somerville, Ltd.

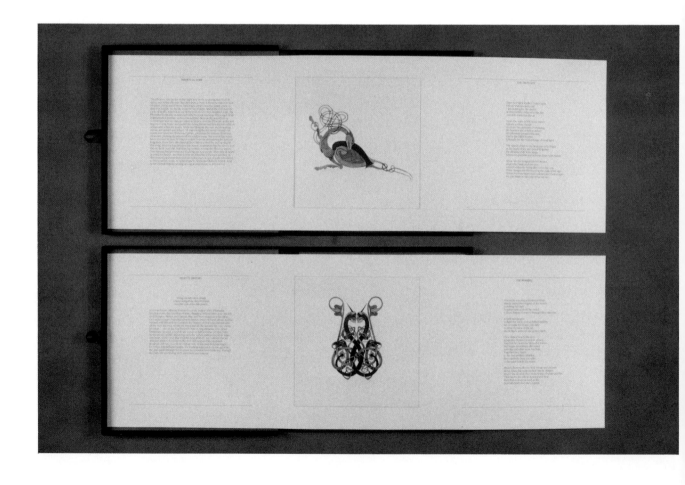

**Promotional Item:**
Free Florida vacation
package enclosed
**Art Director:**
Bob Cargill
**Designer:**
Dawn Fogler
**Copy:**
Ken Lewis
**Design Firm:**
Cargill & Assoc., Inc.
Atlanta, GA
**Client:**
Sawgrass, Arvida Resort
**Typographer:**
Phototype, Inc.
**Printer:**
Graphic Communications

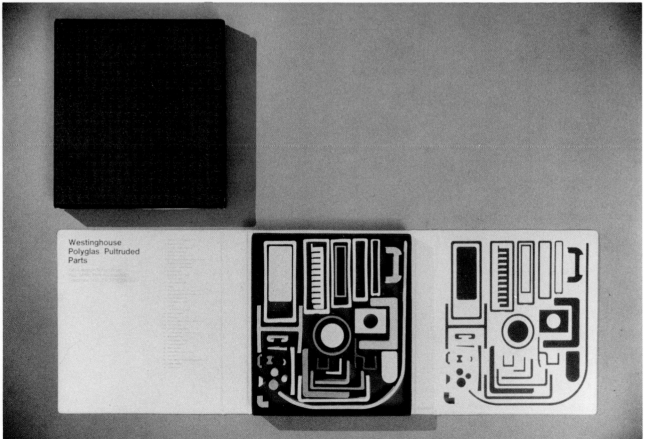

**Sales Kit:**
Polyglas Pultruded Parts
**Art Director:**
Edward X. Redings
**Designer:**
Edward X. Redings
**Creators:**
Westinghouse Model Shop
**Design Firm:**
Westinghouse Electric Corp.
Pittsburgh, PA
**Publisher:**
Westinghouse Electric Corp.
**Typographer:**
Herbick & Held
**Printer:**
Westinghouse Printing Div.

**Identity Manual:**
Company Identity
Manual/TRW
**Art Director:**
Don Ervin
**Designer:**
Don Ervin, Oliver Johnston
**Design Firm:**
Siegel & Gale
New York, NY
**Client:**
TRW, Inc.
**Typographer:**
Print & Design
**Printer:**
Lezius Hiles

**Promotional Brochure:**
The Last Large Piece…
**Art Directors:**
David Gauger, Bob Ankers
**Designers:**
Bob Ankers, David Gauger
Mark Decena
**Artists:**
Don Gentry, Bob Ankers
**Photographers:**
Barbeau Engh, Pacific Aeria
Survey, Eddie Hironaika
**Design Firm:**
Gauger Sparks Silva, Inc.
San Francisco, CA
**Client:**
Dividend Development
Corp.
**Typographer:**
Omnicomp
**Printers:**
VentureGraphics,
Solzer & Hall, Inc.

**Promotional Item:**
CCAC 75th Anniversary
T-Shirt
**Art Director:**
Michael Vanderbyl
**Designer:**
Michael Vanderbyl
**Design Firm:**
Vanderbyl Design
San Francisco, CA
**Client:**
California College of Arts
and Crafts
**Typographer:**
Headliners/Identicolor

**Bulletin/Annual Report:**
Rhode Island School of
Design Bulletin and 1981
Annual Report
**Art Director:**
Joseph Gilbert
**Designer:**
Joseph Gilbert
**Artists and
Photographers:**
Various
**Design Firm:**
Gilbert Assoc.
Providence, RI
**Client:**
Rhode Island School
of Design
**Typographer:**
Gilbert Assoc.
**Printer:**
Union Printing
Eastern Press

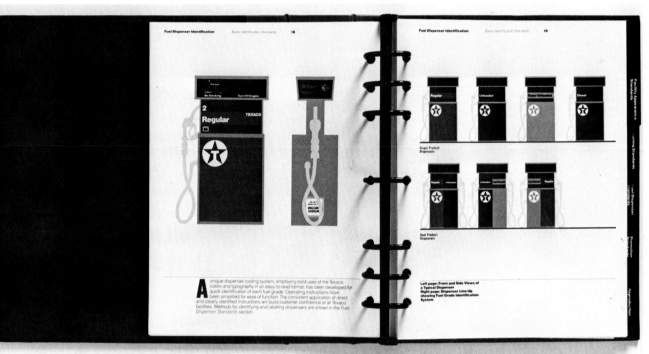

**Standards Manual:**
Texaco USA's Retail Facility
Standards Manual
**Art Director:**
Kenneth D. Love
**Designer:**
Don Kline
**Design Firm:**
Anspach Grossman
Portugal
New York, NY
**Client:**
Texaco, USA
**Typographer:**
Print & Design
**Printer:**
Sterling Roman Press, Inc.

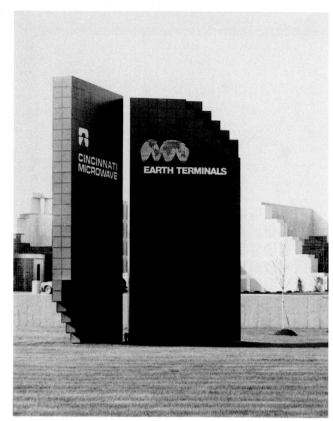

**Environmental Graphics:**
Cincinnati Microwave
Earth Terminals Signage
**Art Director:**
Jon Bentz
**Designer:**
Jon Bentz
**Artist:**
Jon Bentz
**Design Firm:**
Space Design
International, Inc.
Cincinnati, OH
**Client:**
Cincinnati Microwave, Inc.
**Fabricator:**
United Signs, Inc.

**Banquet Booklet:**
IBM Corporate Technical
Recognition Banquet
**Art Director:**
Richard Rogers
**Designer:**
Richard Rogers
**Photographers:**
Herb Levart and IBM Staff
**Design Firm:**
Richard Rogers, Inc.
New York, NY
**Publisher:**
IBM Corp.
**Typographer:**
Southern New England
Typographic Service, Inc.
**Printer:**
S.D. Scott Printing Co.

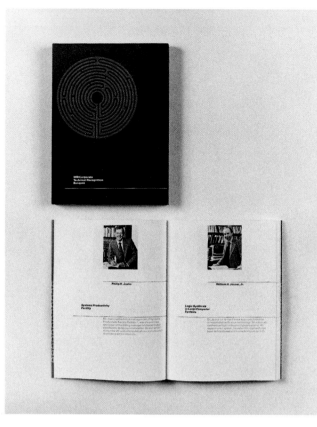

**Standards Manual:**
National Bank of Canada
**Art Director:**
Vasco Ceccon
**Designer:**
Francine Leger
**Design Firm:**
Vasco+Associes, Inc.
Outremont, Quebec, CAN
**Publisher:**
National Bank of Canada

**Environmental Graphics:**
Levi's Plaza Sign
**Art Director:**
Charles P. Reay
**Designer:**
Charles P. Reay
**Design Firm:**
Hellmuth, Obata &
Kassabaum
St. Louis, MO
**Client:**
Levi Strauss
**Typographer:**
National Typographers

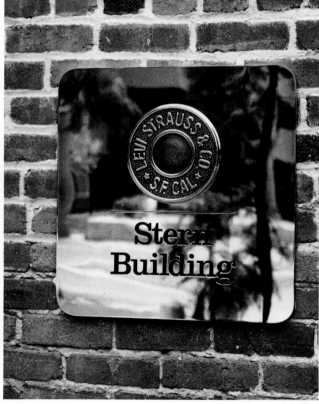

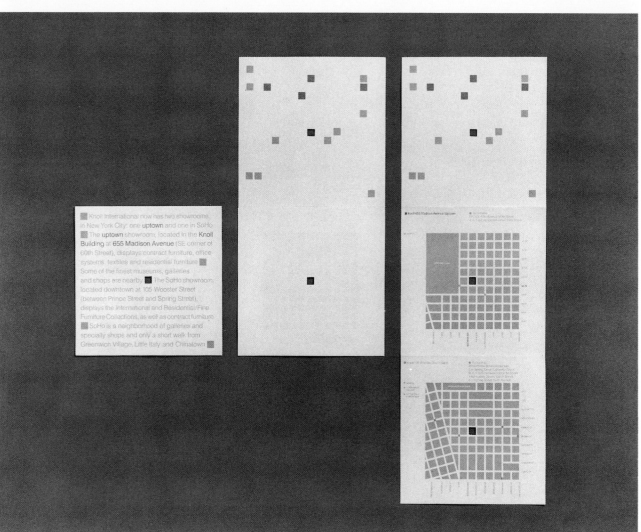

**Invitation/Announcement:**
Knoll Uptown/Downtown
**Art Directors:**
Takaaki Matsumoto
Harold Matossian
**Designers:**
Takaaki Matsumoto
Leslee Ladds
**Design Firm:**
Knoll Graphics
New York, NY
**Client:**
Knoll International
**Printer:**
C.G.S.

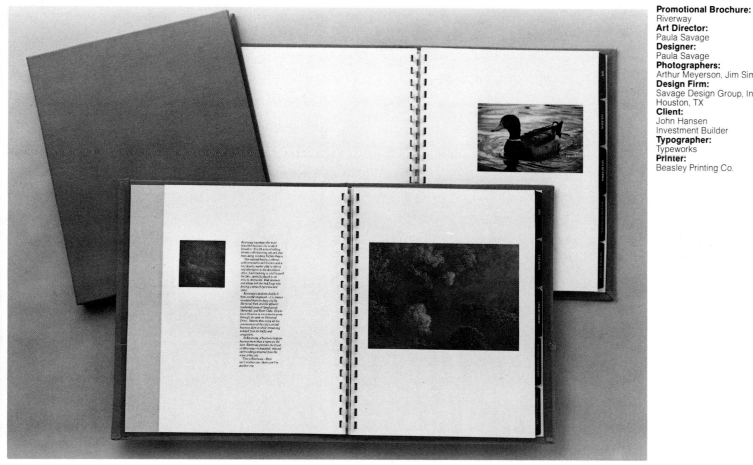

**Promotional Brochure:**
Riverway
**Art Director:**
Paula Savage
**Designer:**
Paula Savage
**Photographers:**
Arthur Meyerson, Jim Sims
**Design Firm:**
Savage Design Group, Inc.
Houston, TX
**Client:**
John Hansen
Investment Builder
**Typographer:**
Typeworks
**Printer:**
Beasley Printing Co.

**Program Booklet:**
MFA/Information
Graduate Design Program
**Art Directors:**
Meredith Davis,
Robert Meganck
**Designers:**
Meredith Davis,
Robert Meganck
**Design Firm:**
Communication Design, Inc.
Richmond, VA
**Publisher:**
Virginia Commonwealth
University
**Typographer:**
Virginia Commonwealth
University
**Printer:**
Carter Printing Co.

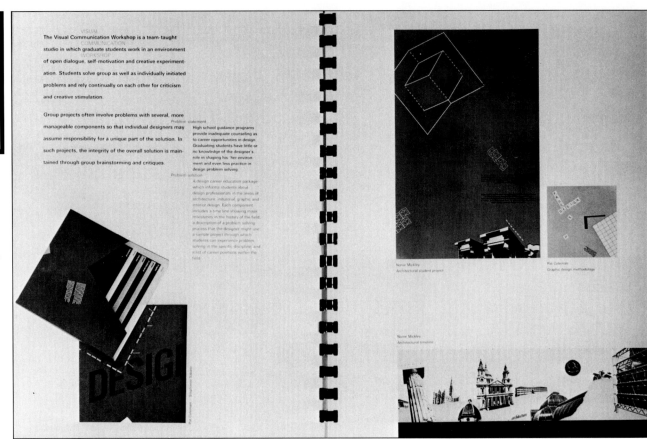

**Magazine Ad:**
Year after year.....
**Art Director:**
Janet Young
**Designer:**
Janet Young
**Artist:**
Dennis Mukai
**Agency:**
Winius Brandon Advertising
Bellaire, TX
**Client:**
McGinnis Cadillac
**Typographer:**
Professional Typographers

**Environmental Graphics:**
Crocker Construction
Barricade
**Art Director:**
Gary Hinsche
**Designer:**
John Tom
**Design Firm:**
Hinsche + Assoc.
Santa Monica, CA
**Client:**
Maguire Partners

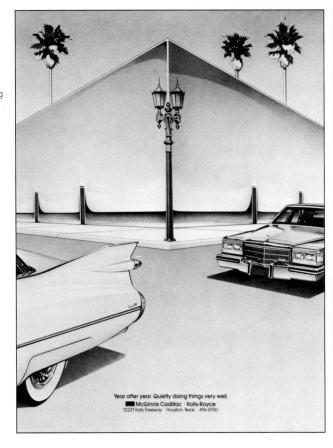

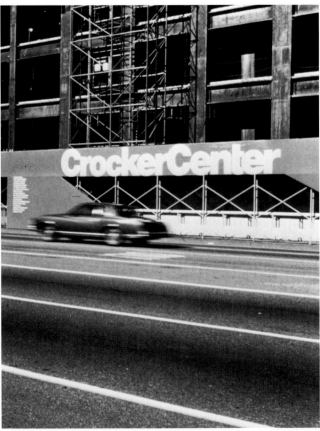

**Promotional Folio:**
Freedom of the Press
**Creative Director:**
Nathaniel Lande
**Art Directors:**
Robert Reid
Joseph Codiroli
**Design Firm:**
The Magazine Group
Time, Inc.
New York, NY
**Printer:**
Lakeland Press

**Boxed Textile Collection:**
Stendig Textiles
**Art Directors:**
Ursula Dayenian,
Tomoko Miho
**Designer:**
Tomoko Miho
**Design Firm:**
Tomoko Miho
New York, NY
**Client:**
Stendig Textiles, A Division
of Stendig International, Inc.
**Typographer:**
Typographic Images
**Fabricator:**
Piqua Paper Box Co.

**Folder:**
Precision, Inc.
Components for the
Aluminum Smelter Industry
**Art Director:**
Ivan Chermayeff
**Designer:**
Ivan Chermayeff
**Design Firm:**
Chermayeff & Geismar
Assoc.
New York, NY
**Client:**
Precision, Inc.
**Typographer:**
Print & Design
**Printer:**
Saunders Manufacturing

**Promotional Booklet:**
Superior Land and
Cattle Company
**Art Directors:**
Blake Miller, Wayne Ford
**Designers:**
Blake Miller, Wayne Ford
**Photographer:**
Jim Sims
**Design Firm:**
Miller, Judson & Ford, Inc.
Houston, TX
**Client:**
Superior Land & Cattle
Co., Inc.
**Typographer:**
X-L Typographer
**Printer:**
Simon Printing

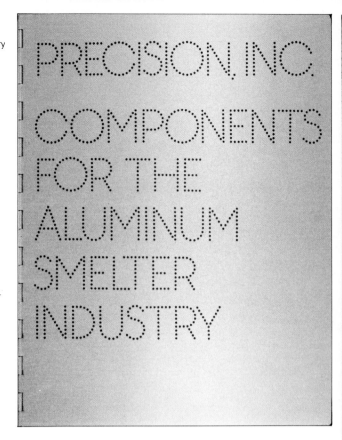

**Promotional Item:**
ColorCore
**Art Directors:**
Michael R. Abramson
Lawrence Wolfson
**Designers:**
Claire Hess, Lawrence
Wolfson, Cindy Steinberg
**Design Firm:**
Michael R. Abramson
& Assoc.
New York, NY
**Client:**
Formica Corp.
**Typographer:**
Concept Typographic
Services
**Printers:**
Glacuum Assoc.
Standard Folding Carton

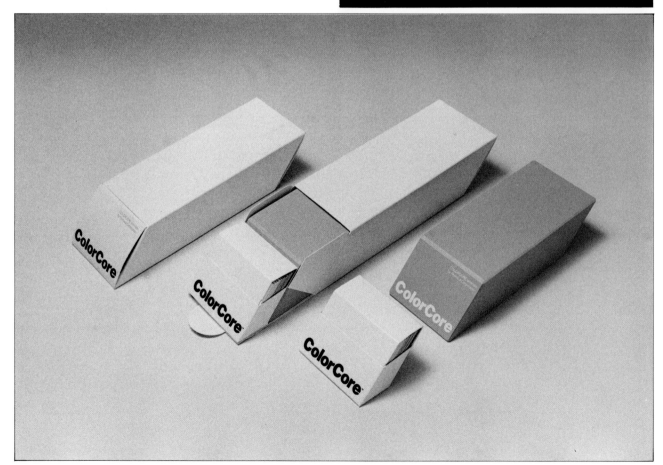

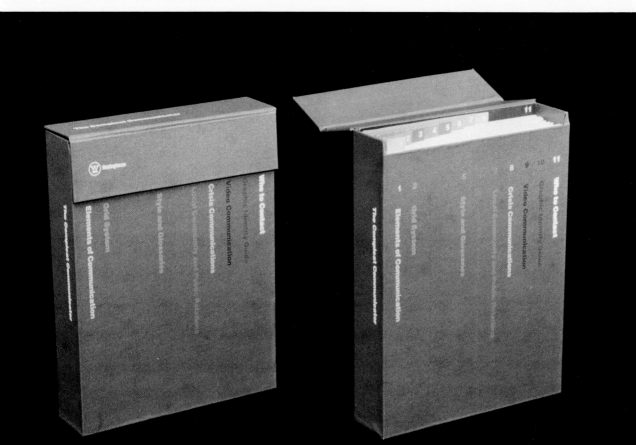

**Instruction Manual:**
The Complete
Communicator
**Art Director:**
Edward X. Redings
**Designer:**
Edward X. Redings
**Artist:**
Graphic Studio
**Design Firm:**
Westinghouse Electric Corp.
Pittsburgh, PA
**Publisher:**
Westinghouse Electric Corp.
**Typographer:**
InfoComp, Inc.
**Printer:**
Westinghouse Printing Div.

**Invitation:**
Atari Kids Library
Press Conference
**Art Directors:**
Kit Hinrichs, Neil Shakery
**Designers:**
Kit Hinrichs, Neil Shakery
Lenore Bartz
**Design Firm:**
Jonson Pedersen Hinrichs
& Shakery
San Francisco, CA
**Client:**
Atari, Inc.
**Printer:**
San Rafael Graphics

**Promotional Item:**
This Christmas more than 250,000 shoppers are in the bag.....
**Art Directors:**
Cerita Smith, Cap Pannell
**Designer:**
Cerita Smith
**Artist:**
Cerita Smith
**Design Firm:**
Cap Pannell & Co.
Dallas, TX
**Client:**
D Magazine
**Typographer:**
J.C.S.
**Printer:**
P.M.Press

**Shopping Bag:**
Galleria
**Art Director:**
Woody Pirtle
**Designer:**
Woody Pirtle
**Design Firm:**
Pirtle Design
Dallas, TX
**Client:**
Gerald D. Hines Interests
**Printer:**
Champion

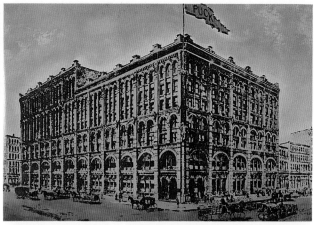

TO WHOM IT MAY CONCERN

CONCEPT

I am here. And I don't apologize for being here. I only hope my appearance will be as agreeable to you as it is to me. I have a mission to fulfill. Everybody has, but like almost everybody else I can't tell what that mission is until I have found out definitely myself. My name is PUCK, and I have been around for a very long time . . . as a myth, a magazine, and even a building . . . THE PUCK BUILD-ING. As a landmark of lower Manhattan The Puck Building is now undergoing a major restoration not only for the building but for the legend as well. Upon completion the building will be a commercial condominium having fifty to sixty spaces devoted to the arts . . . a place where groups and individuals can realize an ideal. There will be Work-shops, Environments, Schools, LEARNING; Architects, Photographers, Film Makers, Designers, DOING; Theater, Performances, Galleries, SHOWING. In short The Puck Project is a series of art working spaces and will house a cycle of creative activities within one structure. In Midsum-mer Night's Dream, Bottom's "most rare vision" was a dream . . . past the wit of men to say. The Puck Building was a dream and is now a reality. I have nearly eight acres in spic and span condition for your inspection and your own imagination. And having thus established my versa-tility and veracity, I remain

Faithfully yours

PUCK

**Self-Promotional Item:**
M & Co Pencil Box
**Art Director:**
Tibor Kalman
Carol Bokuniewicz
**Designer:**
Carol Bokuniewicz
**Artist:**
Carol Bokuniewicz
**Design Firm:**
M & Co.
New York, NY
**Typographer:**
Expertype
**Printer:**
Interstate Printing Corp.

**Promotional Brochure:**
Puck
**Art Director:**
Peter Gee
**Designer:**
Peter Gee
**Artists:**
Peter Gee, Olga Opsahl
**Photographers:**
Johann Spescha
Richard Barnes
**Design Firm:**
Peter Gee/307 Lafayette
Street Corp.
New York, NY
**Client:**
Puck Building
**Coordinator:**
Jocelyn Carlson
**Printer:**
Crafton Graphic Co., Inc.

**Promotional Literature:**
Alaska Brands
**Art Director:**
Keith Bright
**Designer:**
Doug Joseph
**Design Firm:**
Bright & Assoc., Inc.
Los Angeles, CA
**Client:**
Alaska Brands Frozen
Foods

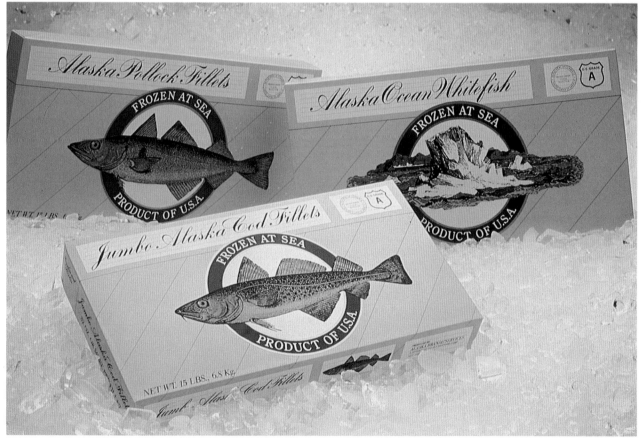

**Poster:**
Kamifuji, Hirouki
**Art Director:**
Tom Kamifuji
**Designer:**
Tom Kamifuji
**Artist:**
Tom Kamifuji
**Design Firm:**
Tom Kamifuji
Palo Alto, CA
**Publisher:**
Drucker/Vincent, Inc.
**Typographer:**
Tom Kamifuji
**Printer:**
The W.O.R.K.S.

**Promotional Folder:**
The IBM 3650
Programmable Store
System for Pharmacies
**Art Director:**
Jon Craine
**Designer:**
Don Kindschi
**Photographers:**
Various
**Design Firm:**
Jones Medinger Kindschi
Armonk, NY
**Client:**
IBM Corp.
**Typographers:**
Production Typographers
**Printer:**
L. P. Thebault

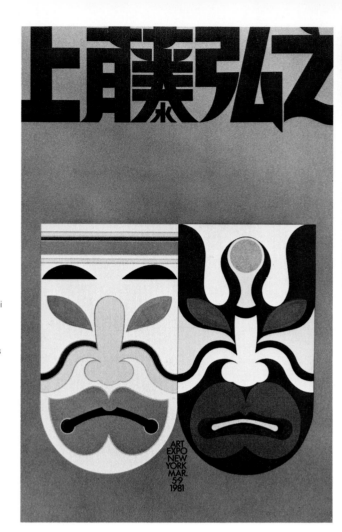

**Brochure:**
Pyro Energy
**Art Director:**
Jody L. Famuliner
**Designer:**
Jody L. Famuliner
**Photographer:**
Bruce Peterson
**Design Firm:**
Zeitgeist
Houston, TX
**Client:**
Pyro Energy Corp.
**Typographer:**
Dimensions
**Printer:**
Heritage Press

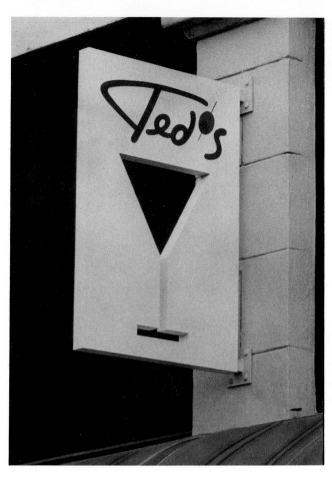

**Environmental Graphics:**
Ted's Sign
**Art Director:**
Harry Murphy
**Designers:**
Harry Murphy, Diane Levin
**Artists:**
Diane Levin, Sheldon Lewis
**Design Firm:**
Harry Murphy & Friends
Mill Valley, CA
**Client:**
Ted's

**Promotional Literature:**
Can You Keep a Secret?
**Art Director:**
Robert Cipriani
**Designer:**
Robert Cipriani
**Photographer:**
George Sakmanoff
**Design Firm:**
Robert Cipriani Assoc.
Boston, MA
**Client:**
Standard Duplicating
Machines Corp.
**Typographer:**
Typographic House
**Printer:**
Nimrod Press

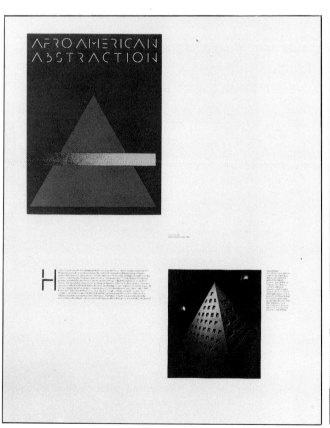

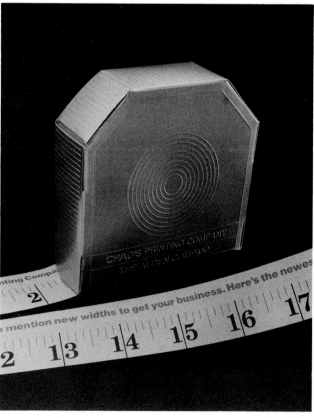

**Catalogue:**
Afro American Abstraction
**Art Director:**
Michael Vanderbyl
**Designer:**
Michael Vanderbyl
**Artists:**
Various
**Design Firm:**
Vanderbyl Design
San Francisco, CA
**Client:**
Art Museum Association
**Typographer:**
CCAC Typographers
**Printer:**
VentureGraphics

**Promotional Item:**
Chadis Printing Co.
Tape Measure
**Art Director:**
Robert Cipriani
**Designer:**
Robert Cipriani
**Design Firm:**
Robert Cipriani Assoc.
Boston, MA
**Client:**
Chadis Printing Co.
**Typographer:**
Typographic House
**Printer:**
Chadis Printing Co.

**Stationery:**
David Hunter
**Art Director:**
Michael Patrick Cronan
**Designer:**
Michael Patrick Cronan
**Design Firm:**
Michael Patrick Cronan
Graphic Design
San Francisco, CA
**Client:**
Levi Strauss & Co.
**Typographer:**
Headliners
**Printer:**
Interprint

**Stationery:**
Joel Harlib Associates
**Art Director:**
John Casado
**Designer:**
John Casado
**Artist:**
John Casado
**Design Firm:**
Casado Design
San Francisco, CA
**Client:**
Joel Harlib Assoc.
**Typographer:**
Omnicomp
**Printer:**
M. Boss

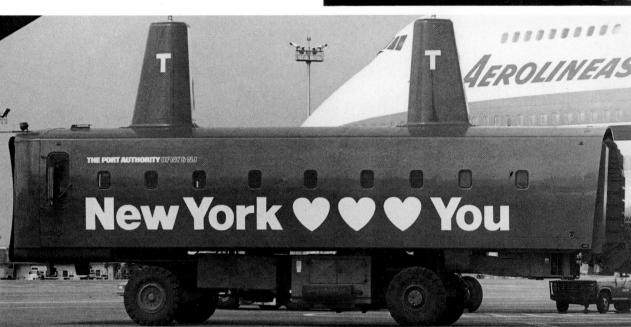

**Logo:**
Banner Life
**Art Director:**
John Lister
**Designer:**
David Uozimo
**Design Firm:**
Lister Butler, Inc.
New York, NY
**Client:**
Legal & General, Ltd.

**Christmas Card:**
Seasonings Greetings
**Art Directors:**
Tom Poth, David S. Shapiro
**Designer:**
Mike Hicks
**Artist:**
Laura Eisenhour
**Design Firm:**
Hixo, Inc.
Austin, TX
**Publisher:**
Hixo, Inc.
**Typographer:**
Capital Rubber Stamps
**Printer:**
Austin Screen Printing

**Vehicle Signage:**
New York Loves You
**Designer:**
Diane Whitebay
**Design Firm:**
Port Authority of N.Y. & N.J.
Engineering Dept.
New York, NY
**Client:**
Port Authority of N.Y. & N.J.

**Catalogue:**
The Lab Book
**Art Director:**
Lark Carrier
**Designer:**
Lark Carrier
**Design Firm:**
Lehman Millet, Inc.
Corning, NY
**Publisher:**
Corning Glass Works
**Typographer:**
Rochester Mono
**Printer:**
Herbick & Held

**Birth Announcement:**
COX
**Art Director:**
D.C. Stripp
**Designer:**
D.C. Stripp
**Artist:**
D.C. Stripp
**Design Firm:**
Richards, Sullivan, Brock
& Assoc.
Dallas, TX
**Client:**
Rita Cox
**Typographer:**
Chiles & Chiles
**Printer:**
Williamson Printing

**Name Change
Announcement:**
Booth & Associates
**Art Directors:**
D.C. Stripp, Ron Sullivan
**Designer:**
D.C. Stripp
**Design Firm:**
Richards, Sullivan, Brock
& Assoc.
Dallas, TX
**Client:**
Greg Booth & Assoc.
**Typographer:**
Chiles & Chiles
**Printer:**
Williamson Printing

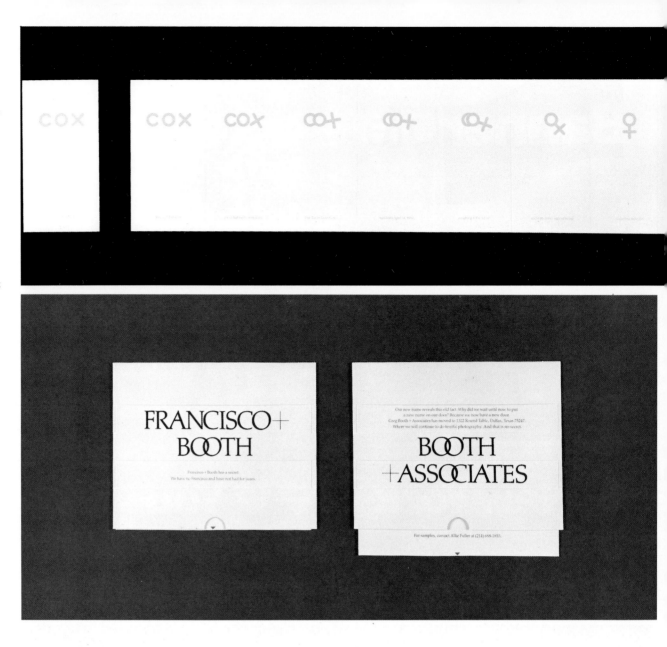

**Stationery:**
George Brown Photography
**Designer:**
Michael Mabry
**Design Firm:**
Michael Mabry Design
San Francisco, CA
**Client:**
George Brown Photography
**Typographer:**
Petrographics
**Printer:**
Forman/Leibrock

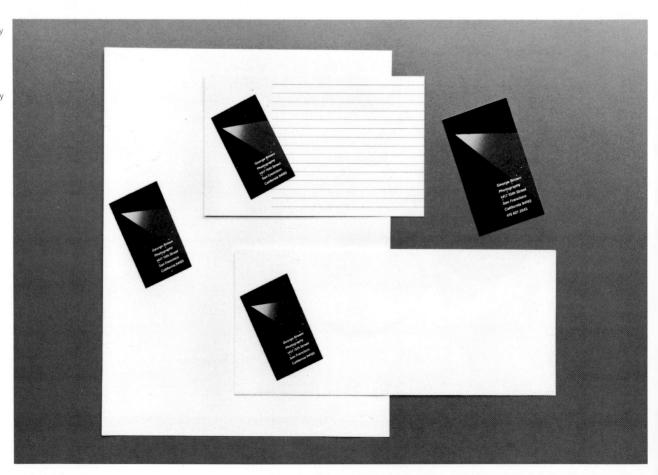

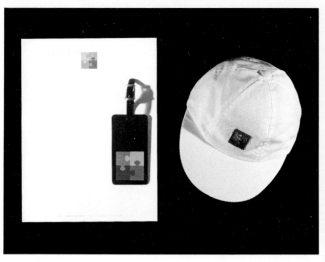

**Promotional Items:**
PEOPLE Sales Meeting
Luggage Tag, Stationery
and Patch
**Art Directors:**
Liza Green, Dick Martell
**Designer:**
Liza Greene
**Design Firm:**
PEOPLE Promotion
New York, NY
**Printer:**
Lakeland Press

**Invitation:**
David Hunter
**Art Director:**
Michael Patrick Cronan
**Designer:**
Michael Patrick Cronan
**Design Firm:**
Michael Patrick Cronan
Graphic Design
San Francisco, CA
**Client:**
Levi Strauss & Co.
**Typographer:**
Headliners
**Printer:**
Interprint

**Invitation:**
Forsythe-Gampfer Wedding
**Art Director:**
Kathy Forsythe
**Designer:**
Kathy Forsythe
**Paper Folding:**
Joyce Culkin
**Design Firm:**
Kathy Forsythe
Chicago, IL
**Clients:**
Kathy Forsythe and
David Gampfer
**Typographer:**
Ryder Types
**Printer:**
Bradley Printing Co.

**Promotional Material:**
Haycock Kienberger
Design Studio
**Art Directors:**
Tom Kienberger
Laurie Haycock
**Designers:**
Tom Kienberger
Laurie Haycock
**Design Firm:**
Haycock Kienberger
Santa Monica, CA
**Client:**
Haycock Kienberger
**Typographer:**
Tin Roof
**Printer:**
Grunfeld & Brandt, Inc.

*The poster was designed to reflect the client's desire to host the most energetic, magical, and unforgettable artists' ball of the year*

Poster
Craft and Folk Art Museum

Haycock/Kienberger is a design partnership providing clients with visual communications services in the area of corporate identity, package design, architectural signage,

*This six-part organizational tool was designed with simplicity and accessibility in mind for the uninitiated arts sponsor.*

Press Kit
Mid-America Arts Alliance

brochures, catalogs, and annual reports, as well as copywriting services. We commit ourselves to understanding the needs of our clients, bringing to each project an individual approach to

*Taking into consideration our client's highly competitive business, and the diverse applications required, this visual system was designed for its flexibility and distinctiveness.*

Identity Program
The Lirol Corporation

analysis, planning, design, and implementation. Our intention is to design innovatively and thoroughly, with effective communication results our foremost concerns. Ultimately, we

*The administration's objective in this case was to minimize copy and let student work speak for the direction of each department.*

Admissions Catalog
Kansas City Art Institute

gauge the success of our work by how well we have helped our clients verbalize their needs, and how well we have translated those needs into precise and creative visual terms.

**Promotional Newspaper:**
U & lc / Dec 1982
**Art Director:**
Bob Farber
**Designer:**
Bob Farber
**Artist:**
Mike Quon
**Design Firm:**
International Typeface Corp.
New York, NY
**Publisher:**
International Typeface Corp.
**Typographer:**
M.J. Baumwell
**Printer:**
Lincoln Graphic Arts

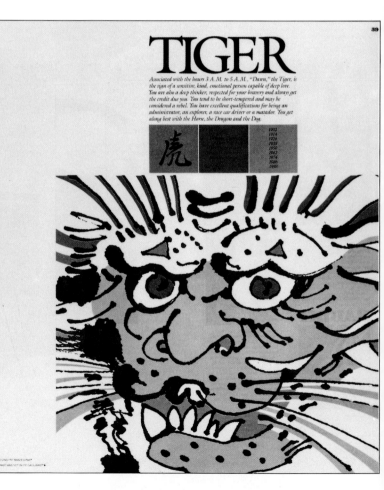

# RAT

# TIGER

# OX

Associated with the hours 3 A.M. to 5 A.M., "Dawn," the Tiger, is the sign of a sensitive, kind, emotional person capable of deep love. You are also a deep thinker, respected for your bravery and always get the credit due you. You tend to be short-tempered and may be considered a rebel. You have excellent qualifications for being an administrator, an explorer, a race car driver or a matador. You get along best with the Horse, the Dragon and the Dog.

As the name implies, you are sometimes as stubborn as your sign. However the sign of the Ox, corresponding to the hours 1 A.M. to 3 A.M., popularly known as the "Hour of the Crowing Rooster," holds promise of success. You are patient, quiet, methodical, trusting and often easy-going. But you must guard against being intensely chauvinistic and demanding your own way. You are alert in mind and body and determined to be successful. You might do well as a surgeon, a general or a hairdresser. You get along best with the Snake, the Rooster and the Rat.

The Rat is the official starting point of the circle of animals in the Chinese zodiac. It is also the sign for the start of the day—the hours from 11 P.M. to 1 A.M.—more accurately "Midnight." In the Chinese zodiac the Rat always faces North.

If you were born in the Year of the Rat, you are charming, imaginative, generous to those you love and attractive to the opposite sex. You are also thrifty, honest, highly organized and want everything to be "just so." Though you tend to be critical, quick tempered and easily angered, you manage to maintain a calm appearance. You are inclined to be an opportunist, but work hard to achieve your goals and possessions. You would be happy in a career in sales, or as a writer, critic or publicist. You get along best with the Snake and the Monkey, as well as the Ox.

**Famous Oxen:**
Napoleon Bonaparte
Vincent Van Gogh
Walt Disney
Clark Gable
Richard Nixon

**Famous Rats:**
William Shakespeare
Wolfgang Amadeus Mozart
Winston Churchill
George Washington
Truman Capote

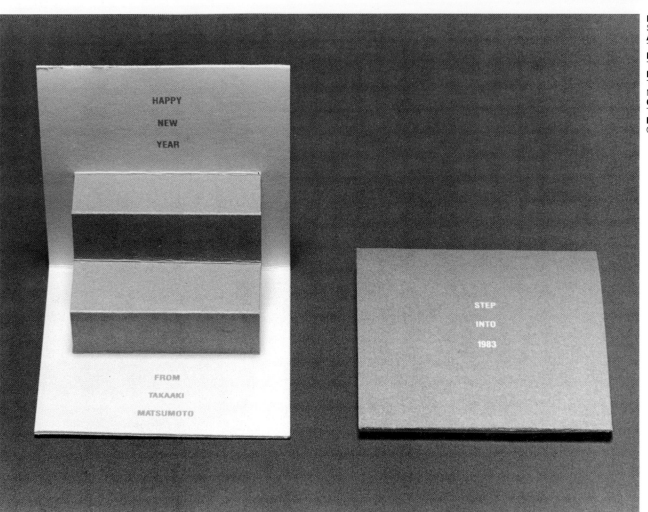

**New Year's Card:**
Step into 1983
**Art Director:**
Takaaki Matsumoto
**Designer:**
Takaaki Matsumoto
**Design Firm:**
Takaaki Matsumoto
New York, NY
**Client:**
Takaaki Matsumoto
**Printer:**
C.G.S.

**Stationery:**
M & Co.
**Art Director:**
Tibor Kalman
Carol Bokuniewicz
**Designer:**
Carol Bokuniewicz
**Design Firm:**
M & Co.
New York, NY
**Client:**
M & Co.
**Typographer:**
Expertype
**Printer:**
Goldplan Litho Co.

**Environmental Graphics:**
Talleyrand Office Park Sign
**Art Director:**
Kenneth Carbone
**Designer:**
Kenneth Carbone
**Design Firm:**
Gottschalk & Ash, Int'l.
New York, NY
**Client:**
Robert Martin Co.

**Logo:**
World's Largest Musical
Chairs Game
**Art Directors:**
Jane Kosstrin
David Sterling
**Designers:**
Jane Kosstrin
David Sterling
**Design Firm:**
Doublespace
New York, NY
**Client:**
Union Square Theatre

香山饭店
FRAGRANT HILL HOTEL

问讯处
Information

服务台
Service Station

**Environmental Graphics:**
Fragrant Hill Hotel
Beijing China Signage
**Designer:**
Tracy Turner
**Design Firm:**
I.M.Pei & Partners
New York, NY
**Client:**
Fragrant Hill Hotel, Beijing

# California Graphic Design '80-'82

## Art Directors, Illustrators
## Designers, Photographers

Adams, Ansel, 74
Adelman, Bob, 111
Advertising Designers, Inc., 62
Akagi, Doug, 66, 68, 97, 137, 159, 161
Almquist, Russ, 70
Altschuler, Franz, 121
Ambrose, Paul, 118
Amos, Gwen, 141
Andelin, Gerald, 87, 158, 161
Anderson, Jon, 137
Anderson, Mark, 54, 69
Anderson, Weldon, 117
Andreotta, Ken, 66, 68, 161
Angeli, Primo, 87, 90, 163
Anhaltzer, Herb, 94
Ankers, Bob, 156
Anselmo, John, 158
Anthony, Mitch, 122
Arbogast, Bill, 66
Archey, Rebecca, 116, 131, 152
Arias, Mauricio, 55, 62, 158
Arisman, Marshall, 120
Ashcraft, Dan, 166

Bane, Jeff, 156
Bantheim, Barbara, 90
Barile, Michael, 160
Barr, John, 77
Barsamian, Betty, 56, 68, 82, 120, 122, 150, 152, 164
Barton, Linda, 66, 101
Bartz, Lenore, 77, 108, 142, 165, 166
Bass, Saul, 133, 140, 150
Bates, Jules, 122
Becker, Leslie, 164
Beggs, Lee, 55, 118, 159
Belew, Tandy, 87, 139
Bender, Lawrence, 76
Bengiveno, Nicole, 102
Berman, Jerry, 84, 115, 158, 160
Berndt, Karen, 78, 140
Bernstein, Saul, 116
Berte, Jim, 157
Bettencourt, Dennis, 129, 142
Beynon, Jay, 126
Bielenberg, Paul, 141
Biesek, Jack, 141
Biesek, Susan, 141
Bilecky, John, 59
Biro, Robert, 112
Blaustein, John, 77, 85, 86, 107, 108, 122, 145
Blohm, Kara, 100
Blonder, Ellen, 129
Blum, Chris, 142, 143
Boss, David, 102
Boyd, Douglas, 59, 84, 148, 159
Bragato, Steve, 66
Brandon, Linda, 76
Bray, Phil, 77
Brenneis, Jon, 78
Bright, John, 100
Bright, Keith, 83, 88, 94, 98, 100, 122, 123, 126, 146
Britt, Maggi, 102
Bryan, Michael, 132
Bryant, Tim, 102
Bull, Michael, 134, 158
Burch, Harold, 161, 165
Burke, Kevin, 153
Burns, Richard, 68, 97, 159, 161
Butkus, Nancy, 103
Butler, Frances, 145

Caldwell, Kirk, 102, 113
Caplan, Stan, 137
Carroll, Phil, 75, 76, 77, 149, 152
Carpenter, Roger, 66, 101
Carugati, Eraldo, 121, 132
Casado, John, 55, 57, 105, 119, 130, 158
Chan, Ron, 102, 113
Chiaravalle, Bill, 130, 159, 161, 162, 165
Chikamura, Michael, 58
Chiumento, Anthony, 87, 139
Church, Jann, 70, 86, 136, 138, 158, 159, 162
Clark, Lon, 159
Clark, Richard, 147
Clede, Ivan, 67
Cleveland, John, 67
Cober, Alan, 72
Cognata, Richard, 140
Collins, Thom, 166
Colonna, Ralph, 92
Conover, Robert, 144
Cook, Anne, 94, 95
Corbin, Jeffry, 159
Coro, Ron, 71, 77, 120, 125, 132, 150
Coy, John, 82, 89, 127, 148, 163
Cronan, Michael, 55, 86, 114, 139, 150, 158, 159, 160, 161, 162
Cross, James, 78, 108, 126, 156
Crutchfield, Susan, 97

D'Aprix, Peter, 78
d'Hamer, M., 67
Davis, Pat, 116
Dawson, John, 71
Decena, Mark, 156
Dennis, Lynne, 129

Deutsch, Barry, 66, 67, 87, 94, 116, 125, 157, 158, 159, 163
Dewey, Jennifer, 70
DeWoody, George, 87, 139
Diaz, Armando, 88, 116, 152
DiPalma, Gary, 52
Donald, Nancy, 80, 132, 136
Donenfeld, Brad, 133, 138
Drucker, Alan, 58, 73, 137
Dubois-Dumee, Anne Marie, 59
Duka, Lonnie, 126
Duke, Lawrence, 87, 139
Dunlavey, Lindy, 97, 158, 164
Dunlavey, Michael, 97, 158, 164

Echtermeyer, Faith, 150
Emerson, Karen, 69, 158
Eng-Chu, Margie, 142, 145, 158, 166
Engh, Barbeau, 156
Estelle, Suzanne, 122
Farrell, John, 92
Fenlon, Karen, 130
Fessler, Al, 90
Finger, Arlene, 106, 145
Finely, Russ, 70
Folon, Jean Michael, 109
Fox, Ann, 83, 158
Fox, Brian D., 112
Frazier, Craig, 55, 68, 73
Frazier, Hal, 95
Frazier, Suzanne, 55
Freis, Jay, 67
Friberg, Arnold, 107
Friedlander, Ernie, 61
Fritz-Zavaki, Ron, 156
Fujino, George, 159
Fusco, Paul, 106, 109

Gaccione, John, 63
Galarneau, Mark, 154, 155, 156
Gamboa, Miguel, 135
Garnas, Richard, 160
Garrett, Edie, 92
Garrott, Nancy, 85, 104, 114
Gauger, David, 156
Gentry, Don, 156
Gerber, Steve, 129, 131
Gilbert, Daniel, 71
Gilbert, Eliot, 102
Girvin, Tim, 160
Giusti, Robert, 132
Glaser, Byron, 94, 125, 146
Goines, David Lance, 115, 116, 133, 141, 152
Going, Michael, 78
Golden, Sharon, 68
Golt, Rick, 76
Gomez, Ignacio, 121
Goodman, Art, 140, 150
Gould, Jerome, 98
Gray, Dennis, 107, 114, 152, 166
Gray, Jim, 66, 68, 137
Greco, Peter, 112, 160
Green, Lee D., 63, 139
Greiman, April, 53, 59, 65
Grossman, Al, 129

Hall, George, 66
Hansen, Nancy, 158, 164
Hauge, Paul, 110
Harrington, Marshall, 70
Harrison, Cheryl, 141
Hartung, Tim, 158
Harvey, Stephen, 101
Hathaway, Candace, 58
Hays, Philip, 72
Haywood, Lynn, 112
Hiett, Steve, 136
Higgins, Diane, 158
Hinrichs, Kit, 62, 77, 85, 86, 88, 104, 106, 108, 114, 116, 122, 129, 131, 138, 139, 145, 152, 161, 165, 166
Hinrichs, Linda, 106, 107
Hinsche, Gary, 79, 92
Hironaika, Eddie, 156
Hixon, Richard, 114
Hoernle, John, 72, 115
Holbrook, David, 128
Hollington, Holly, 115
Holmes, Marilyn, 118
Holmes, Richard, 159
Honda, Ray, 90
House, Charles, 91
Huerta, Carlos A., 90
Hughes, B.K., 147
Hull, Donald, 82, 127
Huyssen, Roger, 121
Hyatt, John, 106, 139

Imai, James, 161
Image Bank, 85
Inauen, Hans, 79
Ingalls, Thomas, 72, 81, 102, 128, 131
Inocencio, David, 133
Ison, Paul, 156

Jacobs, Steven, 151
Janetos, Andrea, 146, 164
Janoff, Rob, 90
Jefferies, Claudia, 124
Jefferies, Ron, 124
Johannes, Sherry, 122
Johnson, V. Courtlandt, 110
Jones, Mark, 87, 90, 163
Jones, Reginald, 145
Jones, Steve, 78
Jorgensen, Conrad, 68, 73

Jung, Renee, 87

Kahn, Dustin, 102
Kamei, Peggy, 130
Kamifuji, Tom, 58, 73, 104, 137
Katz, Marilyn, 93
Keahey, Joann, 126, 128
Keebler, Wes, 147
Kenna, Michael, 77
Kennedy, Michael, 148
Kessel, Bob, 102
Kimble, David, 67
King, David, 145
Kleinman, Kathryn, 86
Klose, Stanton, 63, 79, 92, 159, 160
Knecht, Karen, 159
Koehn, Barb, 104
Komai, Phillip, 138
Konersman, Bill, 158
Kortebein, Bruce, 163
Krausie, Chuck, 99
Kubly, Don, 115, 134, 135
Kubly, John, 123
Kubly, Sally Eager, 134
Kunisaki, Michael, 54
Kysar, Ed, 98

La Cash, Leon, 132
La Fleur, Dave, 113
La Perle, Thom, 109, 124, 160
Lane, Tony, 60, 117, 125, 132
Langley, Stephanie, 118
Langston, Linda, 58
Lavelle, Mary, 82, 127
Law, Hoi Ping, 115, 159
Lawder, John, 70
Lee, Greg, 52
Lee, Johnny, 71, 132
Legname, Rudi, 68
Leong, Russell, 58, 63, 104, 134
Leonhart, Jerry, 109
Letraset, 146
Levin, Diane, 118
Levinson, Janet, 122, 124, 147
Lew, Robin, 166
Lewis, Sheldon, 159, 162, 163, 165
Lewis, Tim, 107, 116, 152, 157
Light Language, 122, 133
Lopez, Bret, 126
Lovell, Brian, 72, 164
Lykes, John, 121

Mabry, Michael, 78, 84, 109, 142, 145, 159, 160, 166
Maile, Bob, 158
Majewski, Marek, 119, 123
Manwaring, Michael, 56, 63, 68, 72, 81, 82, 83, 122, 130, 142, 143, 150, 152, 159, 161, 162, 164, 165
Marshall, Diana, 153
Marshall, Jim, 102
Martinez, Rebecca, 158, 159
Mattos, John, 116, 138, 151, 152
Mayol, Carlos, 102
McCollum, Sudi, 72
McDonald, Jerry, 125
McDowell, Curt, 123
McLean, Wilson, 145
McMullan, James, 132
McQuiston & Daughter, 70, 71
McRevey, Myland, 66, 67, 94, 116, 125, 159, 163
Mednick, Scott, 59, 84, 148
Meisels, Penina, 141
Meisels Photography, 126, 128, 141
Menzie, Gordon, 70, 72
Milner, Antony, 54
Minobe, Denise, 120
Monley, David, 54
Morava, Emmett, 156
Morgan, Michael, 122
Morla, Jennifer E., 74
Mortensen, Christine, 121
Mortensen, Gordon, 121
Morris, Ronald, 159
Muench, David, 84
Murakami, Piper, 127
Murawski, Alex, 93
Murphy, Harry, 63, 79, 92, 118, 158, 159, 160, 162, 163, 165

Neumann, Marty, 94, 125, 146
Newman, Terry, 86
Newton, Helmut, 103
Nichols, Debra, 58
Nichols, Nick, 139
Nikosey, Tom, 62
Nonig, FCB, 143
Nugent, Sarah, 68, 130

Odgers, Jayme, 84, 85
Ogilvy & Mather, 152
Ohmer, Tom, 62
Oka, Don, 62
Oliver, Douglas, 76, 108
Oliver, Mark, 78
O'Mara, Dan, 158
Ong, Wilson, 96, 137, 151, 161
Orr, Norman, 151
Osaki, George, 79
Osaki, Mikio, 137
Osuna, Hank, 129, 139
Otrubova, Vita, 167

Pacheco, Robert, 108
Pacific Aeria Survey, 156
Parkhurst, Ken, 94, 97, 138
Pascoe, Lea, 86, 136, 138, 158, 159

Pease, Robert, 86
Peck, Everett, 137
Phillips, Ardison, 89
Phillips, Mike, 102
Phoenix, Rory, 61
Porter, Dare, 164
Potts, Don, 67
Potter, Penelope, 82, 127
Preston, Heather, 163
Price, Don, 116
Prochnow, Bill, 102, 113
Pruneau, Paul, 92, 159, 160
Pushinsky, Ted, 113

Quinn, Colleen, 77

Rahn, Steve, 143
Rakela, Robert, 162
Rapoport, Aaron, 112
Reed, James, 97
Reis, Gerald, 96, 137, 151, 161
Reoutt, Steve, 140
Riefler, Julie, 83, 100, 122, 126
Riney, Hal, 87, 158, 161
Roberts, Linda, 157
Rockwell, Frank, 158
Rosentswieg, Gerry, 147
Rowell, Galen, 76, 152
Runyan, Robert Miles, 76, 123, 157, 159, 160

Sakai, Steve, 79
San Diego Unified Port District, 70
Sargent, Peter, 94, 98, 123
Schlesinger, James S., 87
Schumaker, Ward, 62, 106, 107
Schwab, Michael, 104, 116, 143, 152
Schwartz, Daniel, 140
Schwartz, Marvin, 114
Schwartz Studios, 136
Schwortz, Barrie, 121
Seidemann, Bob, 60
Seireeni, Richard, 70
Self, Colin, 70
Selland, George, 66, 86
Seltzer, Carl, 78, 102, 111, 124
Shakery, Neil, 66, 67, 85, 109, 111, 140, 142
Shields, Charles, 121
Shimamoto, Debi, 56
Shintaku, Howard, 113, 122
Short, Sandy, 66, 68, 130
Shuman, Ron, 122
Sidjakov, Berman & Gomez, 78, 84, 115, 158, 159, 160
Sidjakov, Nichols, 78, 109, 158
Siegel, Craig, 143
Sieler, Stephen, 123, 160
Silverstein, Richard, 152, 158
Simison, D.J., 104
Simmons, Jim, 71
Sinn, Paul, 151, 154, 155, 160, 164
Skjei, Michael, 67, 148
Slenzak, Ron, 125
Slobodian, Scott, 78, 133
Smidt, Sam, 128, 142
Smith, Ellen, 145
Smith, Gillian, 85, 86, 129
Smith, Harry A., 113
Smith, Murray, 124
Soohoo, Patrick, 138, 156
Soyka, Ed, 121
Stanley, Stephen, 78
Stermer, Dugald, 70, 102, 113
Stern, Gail, 164
Stevens, Robert, 109, 153
Stevenson, Dave, 126, 128
Stimson, Fred, 145
Stone & Steccati, 115, 135
Stricklin, Patricia, 160
Stringer, Jim, 166
Sumichrast, Jozef, 121
Sussman, Deborah, 71, 165

Tainaka, Karen, 66, 67, 157, 158
Takei, Koji, 62
Takimori, George, 112
Tani, Gordon, 148, 159
Tatoian, Leslie Tryon, 130
Terry, Shannon, 150, 159, 160
Thiebaud, Wayne, 83
Thompson, Dennis, 166
Thompson, Jody, 166
Tolleson, Steven, 54
Tom, Bill, 58, 136, 158
Tom, John, 79
Tom, Keilani, 136
Tompson, Tina, 112
Toscani, Olivero, 119
Toy, Phil, 136
Tracy, Tom, 77, 86, 106, 109, 116, 122, 124, 139, 152
Trainor, Kathleen, 94
Treib, Marc, 145
Tri-Arts, 114
Tsang, Paul, 58, 161

Ung, Norm, 77, 125, 132, 150
Urie, Walter, 136

Valencia, Debra, 153
Vanderbyl, Michael, 54, 64, 114, 122, 127, 133, 135, 144, 158, 163, 164
Vereen, Jackson, 105
Vick, Barbara, 62, 77, 88, 109, 116, 122, 129, 131, 138, 139, 152, 161
Vince, John, 95
Vincent, June, 58, 73, 137
Von Holdt, Rick, 109, 124

Wagner, Mark, 137
Wagstaff, Nancy, 95
Walker, Bob, 98
Walker, Bruce, 97
Wallin, Mark, 158
Warren, William, 124, 138
Watts, Stan, 66
Weedy, Theresa, 76, 149
Weeks, Kathleen, 63
Weisbecker, Phillip, 106
Weller, Don, 99, 130, 137
Welter, Warren, 159
West, Suzanne, 158, 164
Weston, Edward, 83
Wilcox, David, 71
Wilson, Dick, 167
Winborg, Larry, 145, 166
Wing, Frank, 145
Wolf, Donna, 145, 166
Wolfe, Bruce, 104
Wolin-Semple, Rick, 148
Wolman, Baron, 66, 75
Wood, Ray, 94
Wynn, Lori, 166

Yamasaki, Paula, 138
Yamashita, Tets, 159
Yasui, Meredith, 156
Yavno, Max, 111
Yerxa, Tom, 70
Yoshida, Zengo, 94
Young, Don, 72, 157, 164
Young, Greg, 67
Young, Rene, 94

Zak, Ed, 90
Zaruba, Bunny, 166
Zaslavski, Nancy, 71
Zucker, Margo, 99

**Design Firms and Agencies**

Advertising Designers, Inc., 62
Paul Ambrose Studios, 118, 159
Gwen Amos Design, 141
Anderson Griffin Assoc., 54
Mark Anderson + Design, 69
Primo Angeli Graphics, 87, 90, 163
John Anselmo Design Office, 158
Arias & Sarraille, 55, 62, 158
Art Center College of Design, 115, 134, 135
Atlantic Richfield Design Services, 70

Barile/Garnas, 160
Saul Bass/Herb Yager & Assoc., 113, 140, 150
Leslie Becker Design, 164
Lawrence Bender Assoc., 76
Berkeley Publications, 67
Biesek Design, 141
Douglas Boyd Design & Marketing, 59, 84, 148, 159
Bright & Assoc., 83, 88, 94, 98, 100, 122, 123, 126, 138, 146
Michael Bull, 134, 158
Casado Design, 55, 57, 105, 119, 130, 158
CBS Records, 60, 80, 117, 125, 132, 136
Jann Church Advertising & Graphic Design, Inc., 70, 86, 136, 138, 158, 159, 162
John Cleveland, Inc., 67
Cognata Assoc., Inc., 140
Colonna, Caldeway, Farrell Design, 88, 91, 92
Coming Attractions, 166
Communications Design, 116, 148, 156
Communikations, 136
Robert Conover Graphic Design, 78, 144
Coy, Los Angeles, 82, 89, 127, 148, 163
Michael Patrick Cronan, 55, 86, 114, 139, 150, 158, 159, 160, 161, 162
Cross Assoc., 78, 102, 108, 111, 124, 126, 156

The Design Quarter, 72, 157, 164
Design West, 92
The Designory, 153
De Vito Assoc., 94, 95
Brad Donenfeld, 133
Drucker/Vincent, Inc., 58, 73, 137
The Dunlavey Studio, Inc., 97, 158, 164
Dyer/Kahn, Inc., 58, 79, 115, 136, 158, 159

Elektra Asylum Records, 70, 77, 120, 125, 132, 150

Fantasy Records, 75, 76, 77, 149, 152
B.D. Fox & Friends, Inc., 112
Frazier Design Consultancy, 95

Galarneau Deaver & Sinn, 151, 154, 155, 156
Gauger Sparks Silva, Inc., 156
The GNU Group, 66, 68, 97, 130, 137, 159, 161
Gould & Assoc., Inc., 98
The Graphics Studio, 147
April Greiman Studio, 53, 59, 65
Gribbitt, Ltd., 102

Cheryl Harrison & Co., 141
Harte Yamashita & Forest, 159
Hartung & Assoc., Ltd., 158
Hauge/Dasalle, 110
Hinsche & Assoc., 79, 92
Richard Holmes Advertising & Design, 159

Huerta Design Assoc., 90
Humpal Leftwich & Sinn, 146, 160, 164
IBM, San Jose, 63, 139
Image Development, 87, 139
Thomas Ingalls & Assoc., 72, 102, 128, 131
Steven Jacobs, Inc., 151
The Jefferies Assoc., 124
Jonson Pedersen Hinrichs & Shakery, 62, 66, 67, 77, 85, 86, 88, 104, 106, 107, 108, 109, 111, 114, 116, 122, 129, 131, 138, 139, 140, 142, 145, 152, 161, 165, 166
Jorgensen/Frazier, 55, 68, 73
KGO-TV Art Department, 166
KQED-TV, 74
Kaneko Metzgar Ashcraft Design, 166
Marilyn Katz Creative Consultant, 93
Karen Knecht/Graphic Designer, 159
Bill Konersman Design, 158
Bruce Kortebein Design Office, 163

Landor Assoc., 99, 143
La Perle Assoc., Inc., 109, 124, 160
Russell Leong, 58, 63, 104, 134
Janet Levinson, 122, 124, 147

Michael Mabry Design Communications, 142, 145, 166
Michael Manwaring, The Office of, 56, 63, 68, 72, 81, 82, 83, 122, 130, 142, 143, 150, 152, 159, 161, 162, 164, 165
Rebecca Martinez Design Assoc., 158, 159
McQuiston & Daughter, Inc., 70
Miller/Gilbert Publishing, 70
Mortensen Design, 121
Harry Murphy + Friends, 63, 79, 92, 118, 158, 159, 160, 162, 163, 165

Neumier Design Team, 94, 125, 146
Nikosey Design, 62

Ogilvy & Mather, 87, 90, 161
Mark Oliver Assoc., 78
Vita Otrobuva, 167

Robert Pease & Co., 86
Poltroon Press, 145
Dare Porter Graphic Design, 164
Paul Pruneau Design, 159, 160

Quality Image, 119, 123

The Rakela Co., 126, 128, 162
Raychem Corp., 52
Reis & Co., 96, 137, 151, 161
Robert Miles Runyan & Assoc., 76, 123, 157, 159

Michael Schwab Design, 104, 143
Sidjakov Berman & Gomez, 78, 84, 109, 115, 158, 159, 160
Sims Roberts Assoc., Inc., 112
Skidmore, Owings & Merrill Graphics, 58
Michael Skjei Design, 148
Sam Smidt, 128, 142
Patrick Soohoo, Inc., 138, 156
St. Heironymous Press, Inc., 115, 116, 132, 141, 152
Stephen Stanley Graphic Design, 78
Steinhilber Deutsch & Gard, 66, 67, 87, 94, 116, 125, 157, 158, 159, 163
Dugald Stermer, 70, 102, 112, 113
Sussman/Prejza & Co., Inc., 70, 153, 165

Tsang Design, 161
Tri-Arts, 114

Unigraphics, 145

Vanderbyl Design, 54, 64, 114, 122, 127, 135, 144, 158, 163, 164

Warner Bros. Records, 70
Webb Silberg Co., 147
The Weller Institute for the Cure of Design, 99, 130, 137
Suzanne West/Design, 158, 164
Ken White Design Office, Inc., 161, 165

**Publishers and Clients**

AVCO Community Developers, 159
Abercrombie Fitch & Co., 97
Ahmanson Theatre, 115
All Occasions, 139
American Institute of Architects, San Francisco Chapter, 64, 144
Amfac Hotels, 55, 140
Mark Anderson + Design, 69
Andresen Typographics, 123, 146
Angel Records, 114
Apple Computer, Inc., 62, 134
Ariadne Clothing Mfg., 158
Artbeat, 119, 123
Art Center College of Design, 71, 115, 134, 135
Art Directors Club of L.A., 147
Art Directors Club of N.Y.C., 59, 84, 86
Art Directors Club of Sacramento, 55, 116
Art in Craft, 159, 162
Associated Film Distributors, 148
Atari, Inc., 116, 125, 152

BFA Educational Media, 92
Baci Restaurant, 68
Banana Bread Store, 141
James H. Barry Co., 124

Saul Bass/Herb Yager & Assoc., 113, 140
Eddie Bauer, 97
Beach Street Baking Co., 94, 159, 163
Leslie Becker Design, 164
Beringer Vineyards, 92
Berkeley Brewing Co., 87
Black Bull, 159
Blackford High School, 156
Blitz-Weinhard Co., 90
Blue Cross of Southern California, 112
La Boulangerie French Bakery, 158, 164
Brae Corp., 109
Brands Stores, 159
The Breitman Co., 158
Bright & Assoc., 100
Brooks Resources, 158
Michael Bull, 134

CBS Records, 60, 80, 117, 125, 132, 136
Cabrillo Historical Assn., 70, 71
California Academy of Sciences, 127
California College of Arts & Crafts, 63, 68, 128
California Institute of the Arts, 122
California Printing Co., 160
California Public Radio, 114
Calplans Securities, Inc., 158
Carducci & Herman, 152
Cetus, 76
Champion International Corp., 142
The Charcuterie, 165
Chez Panisse Restaurant, 141
Christen Industries, 66, 67
Chronicle Books, 86
Chrysalis Records, 122, 124, 147
Clean Bay, 85
Coleman Foods, Ltd., 98
Barry Connolly & Assoc., 163
Continental Graphics, 153
Thomas Cooper & Sons, 90
The Cookie Place, 158
Coy, Los Angeles, 163
John Coy Design, 148
Creative Education, Inc., 125
Criswell Development Co., 145, 166
Crocker Center, 79
Crocker National Corp., 62, 77, 88, 108, 122, 129, 131, 138, 139, 166
Michael Patrick Cronan, 161
Billy Cross, 82, 150

DHL Business Systems Corp., 142
Delicato Vineyards, 86
Dependable Furniture, 115
The Design Conference That Just Happens to Be in Park City, 137
The Design Quarter, 157
Di Giorgio Corp., 145
Dividend Development Corp., 156
Dolzen-Klotz, 138
Kendra Downey, 159
Dreamland, 161
Drucker/Vincent, Inc., 58, 73, 137
Seymour Duncan Pickups, 78
The Dunlavey Studio, Inc., 97

East Bay Heritage Quilters, 133
Elektra Asylum Records, 71, 132
Elektra/Asylum/Nonesuch Records, 132, 150
Elektra Musician Records, 77, 120, 125
El Presidente Products, 94
Donna Emerson, 162
Englander's Wine BA, 58
Esprit de Corp, 119

Falluca Industries, 159
Fantasy Records, 76, 77, 149, 152
Financial Federation, Inc., 62
First Nationwide Savings, 158
C.J. Fish & Co., 71
Fluor Corp., 124, 126
Foremost-McKesson, Inc., 83, 109, 158
Forman/Leibrock, 55, 162
Foundation for America's Sexually Exploited Children, 159
The Fraziers, 55
Ernie Friedlander, 61
Friends of Recreation & Parks, 166
Frisco Publishing Group, 102, 112, 113
Frog's Leap Winery, 91

GFT Assoc., 164
Gardner-Fulmer Lithograph, 102
General Exhibitions Corp., 139
The J. Paul Getty Museum, 82, 127
The GNU Group, 68, 97, 137
Golden Royal/Brew Pac
Desiree Goyette, 118, 159
Graphics Ink Lithography, 164
The Great Chefs of France, 122
Greenhaus Interior Plant Growers, 158, 162
Grove Press, 67
GSD & M, Austin, 145, 166

Haagen Printing, 146
Herndon-Nelson, 126
Herrold Assoc., 161
Hexcel Corp., 78
Highlands Energy Corp., 78
High Quality Painting, 165
Richard Hixon, 114
Marilyn Holmes, 118
Holt Rinehart & Winston, 111, 144
House of Almonds, 88
Housel Precision, Inc., 165
Huerta Design Assoc., 90

Humpal, Leftwich & Sinn
The Huntley Hotel, 158
IBM, San Jose, 63, 139
Inside-Out, 159
Intel Corp., 157
Jorgensen-Frazier, 72
Just Desserts, 163
Justice & Assoc., Inc., 156

KGO-TV, 166
KQED-TV, 75
Judi Keen, 162
Elaine Faris Keenan, 161
The Kinyon Memorial Fund, 71

Lancaster-Miller, 70
Lantern Bay Bird Preserve, 159
Lisa Layne, 151
Rudi Legname, 68
Leland Music, 99
Levi Strauss & Co., 143
Eugene Lew + Assoc., 56
Lion & Compass Restaurant, 151
Light Tubes, Inc., 95
Robert Long Lighting, 142
Los Angeles County Museum of Art, 65
Los Angeles Orthopedic Hospital, 108
Los Angeles Society of Illustrators, 130
Los Angeles Zoo, 70

MCA Records, 79
Maguire Partners Properties, 79, 165
Michael Manwaring, The Office of, 162
Marin Swim School, 158, 165
Mattel, Inc., 156
Maxfields, 59
McCall's Magazine, 129
The Mead Paper Co., 136
Metro Magazine, 72, 81, 102, 131
Milton Meyer & Co., 145
Jean Meyers, 161
Mill Valley Film Festival, 57, 158
Miracle Mile Vet Hospital, 79
Mirage Gallery, 116
Modern Mode, Inc., 54, 135
Molinari, 90
Mortensen Design, 121
Mountain Lid Woolens, 122, 133, 158
The Moving Image, 165
Music Center Unified Fund, 150

Narsai's, 159
The National Press, 54
National Semiconductor Corp., 138
Naugles, Inc., 156
The Nature Co., 71
G. Robert Nease, 161
Newport Balboa Savings & Loan Assoc., 158
New West Magazine, 103
The New York Art Directors Club, 59, 84, 86
Nicky Industries, Inc., 93

Oakland A's, 152
The Oakland Ballet, 130
Oakville Grocery Co., 71
Olympia Brewing Co., 94
Omnitox, 159
Orange County Exchange, 159

PM Typography, 154, 155
Pabst Brewing Co., 87, 109, 158, 161
Pacific Film Archives, 115
Pacific Resources, Inc., 76
Palo Alto Cultural Center, 58, 63, 104
Paper Moon, 66, 101
Pardee & Fleming Landscape Design, 160
Robert Pecota Winery, 88
Performing Arts Services, Inc., 164
Peterbilt Motors Co., 66
Peter's Landing, 165
Peterson & Dodge, 85
Sharon Polster, 160
Poltroon Press, 145
Portal Publications, 116
Potlatch Corp., 77, 106, 107
Heather Preston, 163

Andrew Quady, 89

RFC Intermediaries, 147
RSVP, 62
Radiance/El Molino Div., 94
Radiance Products, 94
William Randall/La Costa, 92
Jean Rapoport, 159
Raychem Corp., 52
Richmond, City of, 158
George Rice & Sons, 70, 126
The Riviera Country Club, 166
Barrie Rokeach, 160
Robert Miles Runyan, 160
Russom & Leeper, 86

S & A Restaurant Corp., 159
S & W, 95
The SWA Group, 130
Sacramento Advertising Club, 128
The Sacramento Metropolitan Arts Commission, 141
Saga Corp., 83, 126
The San Francisco Decorators Showcase, 142
San Francisco Museum of Modern Art, 137
San Francisco Society of Communicating Arts, 63, 104, 114
San Francisco Symphony, 150, 158

San Jose Mercury News, 113, 122
San Jose State University, 128, 146, 164
Michael Schwab, 104
The Seven-Up Co., 99
Shaklee, 143
Simpson Paper Co., 140, 151
Skidmore, Owings & Merrill, 58
Michael Skjei, 148
Scott Slobodian, Inc., 133
The Small Things Co., 92, 159, 160
Smith International, 78
Society of Environmental Graphics
    Designers, 159, 161
Patrick Soohoo, Inc., 138
Southern California Savings
    & Loan, 159
Stanford Alumni Assoc., 130
Stern+Mott, Ltd., 164
Jan Sthrom, 159

Tandon Corp., 67
Tecon Realty, 158
Third Creek Joint Venture, 84, 160
Harold Thompson Real Estate, Inc., 158
Tiger Publishing, 124
Times Mirror Co., 157
Phil Toy Photography, 136
The Trimensa Co., 98
Tropicana Hotel, 158
Typographers West, 160

Universal Pictures, 112
University of California, Berkeley, 67
University of California Press, 111
U.S. Park Service, 70, 71

Van Nostrand Reinhold Co., 66
VentureGraphics, 158, 163
Jackson Vereen Photography, 105
Victoria Pantry, 96
Vidiom Stores, 79
Vuarnet USA, 123

Warner Bros. Records, 53, 70
Suzanne West/Design, 158, 164
Western Medical, Ltd., 94
Westweek, 136
White, Tom & April, 148
Wild Fibers, 158
Wilshire House, 158
Wilson, Dick, 167
Windsong Records, 102
The Winery, 95

Yamaha Parts Distributors, Inc., 153

**Typographers, Letterers and
Calligraphers**

Abracadabra, 63, 68, 86, 128
Ad Compositors, 165
Ad Type Graphics, 97, 116, 148, 156, 162
Aldus Type Studio, 62, 82, 84, 148, 161
Alpha Graphix, 90, 99, 130, 137, 156
Andresen Typographics, 83, 98, 115, 122,
    123, 126, 146, 148
Associates/San Rafael, 63
Athertons Type, 63, 139

Mr. & Mrs. Peter Bedford, 127
Boyer & Brass, Inc., 70, 71, 164

Cabco, 92
CAPCO, 83, 124
CCI, 166
Central Typesetting, 78, 102, 108, 111,
    126, 156
Color III, 112
Colorscan/JPP Graphic Art, 118
Composition Type, 76, 123, 157
Continental Graphics, 153
Crocker National Corp., 62, 88, 122, 129,
    131, 138, 139
Custom Typography Service, 164

D & J Typography, 164
Daily Californian, 112
De-Lino-Type, 70, 92, 159, 162
Design & Type, 150
Drager & Mount, 52, 55

Fotoset, 138, 140
John G. Frank, 134
Frank's Type, 54, 58, 62, 63, 69, 76,
    128, 142

Gestype, 128

Headliners, 159
Headliners/Identicolor, 54, 55, 64, 114,
    122, 133, 135, 139, 144, 158, 160, 161,
    162, 163, 164
Headliners of Orange County, 136, 138
Hi-Speed, 147
KGO-TV Art Dept., 166
Tom Kamifuji, 58, 73, 137

Lithographics, 126, 128

M & N, 118
MacKenzie-Harris, 70
McCluthen & Olds, 160
Ann McCue, 81, 102, 131
Mercury, 124
Joe Molloy, 59, 71

Omnicomp, 56, 68, 73, 78, 82, 84, 109,
    122, 130, 140, 142, 150, 151, 152, 156,
    158, 159, 160, 161, 162, 164, 165, 166

PM Typography, 146, 151, 154, 155, 156, 164
PTH, 102
Petrographics, 115, 136, 145, 158, 166
Phototype House, 59, 67

RS Typographics, 65
Rapid Typographers, 145
Reardon & Krebs, 58, 77, 85, 106, 108,
    109, 142, 161
Reeder Type, 67
Reprotype, 55, 71, 74, 90, 94, 95, 99, 104,
    163, 166
RogerGraphics, 78, 94, 121
Ryder Types, 93
Robert Sibley, 86

Vernon Simpson Typographers, Inc., 72,
    89, 112, 124, 127, 134, 163, 165
Skil-Set Typographers, 70
Slipshod Graphics, 72
Solotype, 87
Spartan Typographers, 55, 66, 85, 92, 106,
    107, 109, 116, 140, 145, 152, 160, 163, 164

Marc Treib, 145
Turnaround Type, 102
Turner, Brown & Yeoman, Inc., 144
Typecraft, 115
Type West, 95, 122, 124, 147
Typographic Service, 112

U.S. Lithographic Co., 67, 111

VentureGraphics, 158
John Vince, 95

Sarah Waldron, 90
Walker Graphics, 104, 114
Jim Wascoe Reprotype, 141
Werle's Instant Press, 91

Zimmering & Zinn, 67

**Printers, Binders and Engravers**

Advanced Litho, 82, 130
Alan Lithograph, Inc., 65, 82, 89, 126, 127,
    140, 148, 163, 165
Alco Gravure, 113, 122
Alonzo Press, 72, 81, 102, 104, 113, 114,
    128, 131
American Graphics, 126, 156
Anderson Lithographic Co., 53, 59, 62, 76,
    77, 78, 99, 106, 108, 109, 124, 138,
    151, 160
Andersen Litho, 150
Angel Photocolor, 66, 101
Artcraft Printers, Inc., 154, 155
Aura Studios, 55

B & C Litho., 63, 68, 139
James H. Barry Co., 68, 124, 152
Bench Mark Lithographers, 145

California Printing, 78, 84
Calistoga Press, 91
Cannon Press, 56, 161
Cardinal Co., 67
Pisani Carlisle Graphics, 150
Carl's Litho, 161
Color III, 87
Color Graphics, 55, 62
Colorscan, 105
Container Corp., 95
Continental Graphics, 66, 72, 153
Craftsman Printing, 164
Creative Arts Printing, 160, 162, 165

Dai Nippon Printing Co., Ltd., 63, 86,
    126, 127

Clyde Engles Silkscreen, 57, 130

First California Press, 164
Fischoff Co., 114
Fleming Screen Print, 97
Fong & Fong, 128, 136, 162
Forman-Leibrock, 55, 162
Foundation 14, 55
Franciscan Graphics, 61, 105
Frye & Smith, 72

Gardner-Fulmer Lithograph Co., 70, 83,
    102, 111, 124, 126, 130, 137, 138
General Graphics, 166
Globe Printing, 128
David Lance Goines, 115, 116, 133, 141, 152
Golden Dragon Printing, 164, 165
Golden Gate Embossing Co., 167
Golden State Embossing, 160, 161
Gore Graphics, 59, 84, 148
Graphic Arts Center, 62, 77, 85, 88, 108,
    109, 116, 122, 129, 131, 139, 141, 145, 152
Graphic Arts of Marin, 164
Graphic Center, 116, 140
Graphic Press, 78, 86, 134
Graphics Ink Lithographers, 164

Haagen Printing, 121, 146
The Hennegan Co., 136
Herlin Press, 142

Interprint, 63, 68, 82, 122, 126, 127, 130,
    133, 135, 139, 144, 145, 150, 162, 166

JEDA Publications, 63
JPP Graphic Arts, 118
J & S Graphix, 94
Jeffries Litho., 122
Jorgenson & Co., 142

Howard Krebbs, 90
W.A. Krueger, 70

Tea Lautrec, 137
Lee Design Assoc., 83
Lin Litho, 58
Lithographix, 71, 123
LithoSmith, 54

M.D., Silkscreen, 138

The Marier Engraving Co., 94, 160
Master Craft Press, 140
McCutchan Olds Co., 164
McDougal Press, 167
Murray Printing Co., Inc., 67

The National Press, 54
Network Graphics, 152
North Hollywood Printing, 115
Northwest Graphics, 92

OC Menu Printers, 156

Pacific Lithograph, 90
Pacific Press, 103
Pacific Rotoprinting, 52, 86
Paragraphics, 68, 114, 130
Pearl Pressman Liberty Printers, 144
Petersen Lithograph, 148
Phelps-Schaefer, 162
Printing Factory, 148
The Printing House, 164
Pro-Color, 112
PS Press, 71
Publishers Press, 70

Quinn Graphics, 112

Rapoport Printing Corp., 111
Reliable, Inc., 161
George Rice & Sons, 70, 76, 78, 83, 106,
    107, 126, 133, 145, 147, 156, 157
Riverside, 69
Russ Press, 71

Scott Screen Printers, 141
Serigraphics, 73
Shorewood Packaging Corp., 60, 80, 117,
    122, 124, 125, 132, 136
Solzer & Hail, Inc., 115, 156
Southern California Graphics, 67

Thomas Swan Signs, 166
T&J Graphics, 156
Techni-Graphics, Inc., 163
Toyo Printing, 161, 165
Typecraft, 135

Vaughan Printing, 166
VentureGraphics, 64, 156, 163

Walch Grafiks, 58
Warren's Waller Press, 68, 74, 122, 150, 166
Wayne Graphics, 62
Welsh Graphics, 112
Westvaco Corp., 93
Westwood Press, 118
Wetzel Brothers, Inc., 109
Wickman Screen Printing, 92
Williams Lithograph Co., 90, 166
The W.O.R.K.S., 58, 73
Worzalla Press, 125

# Just Type

## Art Directors and Designers

Akagi, Doug, 176
Allemann, Hans-U., 175, 199

Beaudry, Lonn, 180
Belew, Tandy, 179
Bergh, Don, 194
Bierut, Michael, 180
Bonnell, Bill, 176, 178, 188
Bottoni, Joseph, 198
Breaznell, Ann, 186
Burch, Harold, 174
Butler, Frances, 172, 178
Cabana, Elizabeth, 188
Casey, Jacqueline S., 177, 196
Chiumento, Anthony, 179
Chwast, Seymour, 185
Cipriani, Robert, 182, 198
Coro, Ron, 192
Crosby, Bart, 178, 183, 202

Dane, Brenda, 194
DeWoody, George, 179
Dolle, Thomas James, 174
Donovan, Michael, 193
Dugdale, Juanita, 181

Eskind, Rosalyn, 192
Essex, Joseph M., 179

Fabrizio, Steven, 191
Falls, Mark, 197
Fenlon, Karen, 184
Franchini, Sandro, 176
Frykholm, Stephen, 187

Geismar, Tom, 179, 191, 194
Geissbuhler, Steff, 198
Gilbert, Joseph, 193, 199
Gilbert, Melissa, 193
Gips, Phil, 191
Greiman, April, 176, 201, 202
Grossman, Eugene J., 197

Hacker, Betsy, 177, 196
Handler, Mark L., 174
Hanger, Mark H., 179
Hansen, Pat, 183
Harder, Rolf, 197
Hecht, Alice, 200
Hinrichs, Kit, 191
Hugel, Rob, 200
Huie, Mark, 175

Jenkins, Steve, 190
Jensen, Robert, 173, 187, 194
Johnston, Alastair, 178
Jorgensen, Conrad, 184

Kalman, Tibor, 197
Katalan, Jak, 175
Kerr, Richard, 200
Kosstrin, Jane, 200
Kunz, Willi, 186

Laughlin, John, 186
Laughlin, Mark, 182
Law, David, 188
Lawrence, Marie-Christine, 175
Lazin, Alyssia, 175
Levenburg, Patti, 200
Longhauser, William, 203
Love, Kenneth D., 197
Lubalin, Herb, 195

Manzke, Ronald, 186
Matossian, Harold, 202
Matsumoto, Taakaki, 202
McCoy, Katherine, 188, 200
McCoy, Michael, 188, 200
Meganck, Robert, 185
Mitchell, Dick, 190
Mok, Clement, 193

November, David, 175

Ortiz, Jose Luis, 174
Ozubko, Christopher, 185

Paganucci, Bob, 188
Pannell, Cap, 186
Pate, Susan Roach, 182
Perry, Marilyn, 178
Powell, Linda, 187

Rigelhaupt, Gail, 174
Rogers, Susan, 178

Sametz, Roger, 195
Scher, Paula, 195, 196
Schnipper, Steven, 2
Schowalter, Toni, 175
Skolos, Nancy, 182
Souza, Paul, 186
Sussman, Deborah, 180
Swack, Terry, 195

Tatro, Russell, 184
Taylor, Jean, 186
Thompson, Herbert, 200
Tsang, Brian, 199

Ung, Norm, 192

Vanderbyl, Michael, 175, 187, 189, 194, 196
Vick, Barbara, 191
Vignelli, Massimo, 180, 194

Waddell, Malcolm, 192, 199
Wajdowicz, Jurek, 195
Whelan, Richard J., 176
White, Ken, 174
Wolfson, Lawrence, 188

Young, Bob, 183
Yeo, Hock Wah, 182

## Design Firms and Agencies

Hans-U Allemann Design, 175, 199
Anspach Grossman Portugal, 197

Bonnell & Crosby, Inc., 178
Bonnell Design Assoc., Inc., 176, 178, 188
Bottoni & Hsiung, 198
Burson Marstellar Design Dept., 179

CBS Entertainment Design Dept., 175
CBS Records Design Dept., 195, 196
Chermayeff & Geismar Assoc., 179, 191,
    194, 198
Robert Cipriani Assoc., 182, 198
Cranbrook Academy of Art, 200
Crosby Assoc., Inc., 183, 202

Design Machine, 180
Donovan & Green, Inc., 193

Elektra/Asylum Art Dept., 192
Emerson, Wajdowicz Studios, Inc., 195
Eskind Waddell, 192, 199

Gilbert Assoc., 193, 199
Gips+Balkind+Assoc., 191
The GNU Group, 176
April Greiman Design, 176, 201, 202

The Handler Group, 174
Rolf Harder & Assoc., 197
Pat Hansen Design, 183

Image Development, 179

Steve Jenkins Design, 190
Robert Jensen Design, 173, 187
Jonson Pedersen Hinrichs & Shakery, 191
Conrad Jorgensen Design, 184
Knoll Graphics, 192, 202
Willi Kunz Assoc., Inc., 186

Lazin & Katalan, 175
William Longhauser Design, 203
Lubalin Peckolick Assoc., 192

M & Co., 197
MIT Design Services, 177, 196
Markham Design Office, 179
McCoy & McCoy Assoc., 188, 200
Meganck/Ozubko Design, 185
Herman Miller Design Dept., 187, 200
Minneapolis College of Art & Design,
    Students, 194
Muir Cornelius Moore, Inc., 184

Jose Luis Ortiz Design, 174

Bob Paganucci Design, 188
Cap Pannell & Co., 186

Pate International, 182
J.C. Penney Packaging Dept., 188
Poltroon Press, 172, 178
Pushpin Lubalin Peckolick, 185

Richards, Sullivan, Brock & Assoc., 190

Sametz Blackstone Assoc., 195
Shepard/Quraeshi, Inc., 182
Siegel & Gale, 186
Skolos, Wedell + Raynor, 182
Sussman/Prejza & Co., 180

Two Twelve Assoc., 181

Vanderbyl Design, 175, 187, 189, 196
Vignelli Assoc., 180, 194

WGBH Design Dept., 186
The Whalen Design Office, 176
Ken White Design Office Inc., 174

Bob Young Design, 183

**Publishers and Clients**

Ace Chain Link Fence, 179
Aldus Type Studio, 174
American Chemical Society, 198
American Institute of Architects, S.F.
    Chapter, 187

Baker, Dot, 190
Best Products Co., 179
Richard Beaty, 182
Berch & Berkman, 183
Bonnell & Crosby, Inc., 178
Bromley/Jacobsen, 175
Brown University, 193, 199

CBS Entertainment, 175
CBS Records, 195, 196
C K & C, 184
California College of Arts and Crafts,
    175, 189
California Drop Cloth Co., 202
California Institute of the Arts, 202
Calypso, 176
Canada Post, 197
Castle & Cooke, 191
Champion Papers, 188
China Club, 201
Chromacolor, 182
CIBA-GEIGY Corp., 188
Cibis and Crandall, 180
Cipriani, Lita, 198

Designer's Saturday, Inc., 191, 193
Dow Jones & Co., Inc., 174

Edmonton Jazz Society, 185
Eskind Waddell, 192, 199
Evans Pre-School Day Care Center, 198

Forbes, Peter, 194

Gips+Balkind+Assoc., 191

Hart Typography, 179

Image Development, 179
Information Science, Inc., 184
International Typeface Corp., 195

Jenkins, Steve, 190

Knoll International, 192, 202

Lippin/Grant, 197

MIT Committee on the Visual Arts, 177, 196
Maguire Partners, 180
McCoy & McCoy Assoc., 188, 200
Herman Miller, Inc., 187, 200
Minnesota Graphic Designers Assn., 173
Mobil Oil Corp., 192
The Museum of Modern Art, 194
Myers, Jim, 183

Nervous Eaters, 192
Neuberger & Berman, 176

Ortiz, Jose Luis, 174

Cap Pannell & Co., 186
Pate International, 182
J.C. Penney, Inc., 188
Philadelphia College of Art, 175, 199, 203
Photographic Resource Center, 186
Poltroon Press, 178
H.C. Prange, 197
Pushpinoff Productions, 185

Sacramento Art Directors Club, 196
W.H. Sadlier, Inc., 186
G.D. Searle & Co., 202
Ronald Seymour, Inc., 183
67/Design/Construction, Inc., 195
Skolos, Wedell + Raynor, 182
Skyline, 180
Judith Stockman & Assoc., 176
Sunar, 178
The SWA Group, 176

U.S. Internal Revenue Service, 186
University of California, Davis;
    Design Group, 172

Visible Language Magazine, 200

WNJU-TV, 74
Merald Wrolstad, 200

Yale School of Art, 181
Yale Summer School of Art & Music, 187

**Typographers, Letterers and
Calligraphers**

Ad Compositors, 180
Aldus Type Studio, 174
Hans-U Alleman, 175
American Center Studio, 188

M.J. Baumwell Typography, 195
Don Bergh, 194
Berkley Typographers, 182
Frances Butler, 172

Tom Carnase, 175
Carver Composition Co., 186
Casey, Jacqueline S., 177, 196
Character Typographic Services, Inc., 176
Chiles & Chiles, 183, 190
Compotronic, Inc., 197
Composing Room, 199
Concept Typographics Services, Inc., 193
Bart Crosby, 183

Brenda Dane, 194
Tony DiSpigna, 192
Thomas James Dolle, 174
Don Dewsnap Publishing, 182
Juanita Dugdale, 181

Tom Geismar, 194
Joseph Gilbert, 193, 199

Haber Typographers, 195, 196
Headliners/Identicolor, 175, 187, 189, 196
Huron Valley Graphics, 200

Innovative Graphics International, 191

Jaggars-Chiles-Stovall, 186
Robert Jensen, 187
Johnson Ken-Ro, Inc., 186

Letraset, 176

Katherine McCoy, 188, 201
Mel Typesetting, 179
Merganthaler CRTronic, 173
Monotype Composition Co., 195

North Carolina State University, 190

Pastore DePamphilis Rampone, 176, 188

Reardon & Krebs, 191
Royal Composing Room, 184, 188

SNET, 187
Susan Schechter, 192, 202
Sharpgraphics, 180
Vernon Simpson Typographers, Inc., 176,
    201, 202
Spartan, 182

Type Gallery, 183
Typehouse, Inc., 187, 200
Typographic House, 182, 198
Typographic Innovations, Inc., 191
TypoGraphics Communications, Inc.,
    174, 175
Typoset, 198

Norm Ung, 192
University of Alberta Type Laboratory, 185

Village Type & Graphics, 180

Western Type, 178, 202
Arne Wolf, 178
Margaret Wollenhaupt, 194

Hock Wah Yeo, 182

**Printers, Engravers and Binders**

Alan Litho Co., 180, 202
Album Graphics, Inc., 192
Anderson Printing, 176, 201, 202
Arlington Lithograph Co., 177, 196
Art Crafters, 194

Butler, Frances, 172

Cal Central Press, 196
Century Blueprint, 181
Charles River Publishing Co., 186
Clark Litho., 186
Colormaster Press, 173, 194
Colorpress, 188
Consolidated/Drake Press, 199
Continental Extrusion Corp., 188, 194
Crafton Graphic Co., Inc., 176, 191, 198
Craftsmen Printing, 179

Draper Press, 182
Dubin & Dubin, 175

Eastern Press, 187
Excelsior Processing & Engraving, Inc.,
    182, 198

Foreman/Leibrock, 182

Georgian Press, 175
Graphic Arts Center, 191
Great Northern Design Printing, 202

E.A. Johnson Co., 193, 199

Kal-Blue, 187
Kenner Printing, 192

Lasky Co., 184
Lebanon Valley Offset, 193
Lincoln Graphic Arts, 195
LompaLithograph, 189

Mackinnon-Moncur, Ltd., 192, 199
McCullough Printing Co., 174
Millett Printing Co., 183

North Carolina State University, 190

Ohio Valley Lithocolor, 198

Par Printing, 185
Philatelic Marketing Co., 197
PolyGram Television, 197
Printing Control Services, 183
Product Services, Inc., 175

Quality Lithographers, 180

Reynolds-DeWalt Printing, Inc., 182
Rohner Printing Co., 176, 178

Sanders Printing Corp., 191
Schaedler Pinwheel, 192, 202
Shorewood Packaging Corp., 195, 196
Signet Printing Co., Inc., 188, 200
Smith McVaugh & Hutchon, 175
Ben Franklin Smith, 195
Sterling Roman Press, 174

Trend Graphics, 176
Trumbull Printing, 180

VentureGraphics, 187

West Coast Print Center, 178
West Michigan Magazine, 200
John A. Williams, 186
Williamson Printing, 190

## The Mental Menagerie

**Illustrators, Designers and
Art Directors**

Andrea, Mary Pat, 240
Aldrich, Katie, 218
Arisman, Marshall, 246, 248
Azzi, Robert, 231

Beer, Henry, 238
Bennett, Martin, 240
Berg, John, 228, 238
Bernard, Walter, 249
Besser, Rik, 221
Billout, Guy, 244
Block, John, 239
Bokuniewicz, Carol, 239
Bolt, Jody, 218
Bralds, Braldt, 208, 225, 236, 248
Brandenburg, Jim, 222
Breslin, Lynn Dreese, 234, 241
Butkus, Nancy, 226

Carson, Carol, 212, 219, 236, 244
Catrules, Pete, 222
Chermayeff, Ivan, 212, 215, 217, 244
Chwast, Seymour, 224, 230, 250, 251
Cober, Alan E., 227
Collier, John, 234, 247
Cooper, Heather, 222, 237
Coulson, Cotton, 231
Craft, Kinuko Y., 215

Davis, Paul, 210, 221, 235
Devino, Frank, 248
Donald, Nancy, 229
Draper, Chad, 251

Endress, Buddy, 248

Fifty Fingers, 213
Flesher, Vivienne, 218, 229
Foy, Richard, 238

Gala, Tom, 244
Garr, John, 230
Geering, Martha, 246
Geisbergen, Ton, 236
Gilbert, Daniel, 228
Glaser, Milton, 238, 241
Grossman, Robert, 245
Guaranaccia, Steven, 216

Hayden, Karen C., 226, 242
Hayes, Philip, 227
Heller, Steve, 216
Hensley, Randall, 240
Hess, Mark, 241, 249
Hicks, Mike, 218, 246
Hinrichs, Linda, 238
Hirschfeld, Corson, 250
Hitchcock, Tony, 233
Hoglund, Rudolph, 238
Holland, Brad, 213
Holmes, Nigel, 238

Johnson, Doug, 211, 228, 239, 240
Johnston, Skip, 246

Kalman, Tibor, 239
Kenney, Brooke, 247
Kim, H. Edward, 222, 239
Kirk, Dan, 246
Kobasz, Bill, 217, 231
Kollenbaum, Louise, 246
Koppel, Terry, 229
Kubinyi, Laszlo, 214
Kulak, Herr, 226

Levinson, Riki, 214
Lewis, Tim, 238

Maffia, Daniel, 226
Magleby, McRay, 221, 243

Mantel, Richard, 230
Martin, John, 213, 215
Mattelson, Marvin, 232
Mazzatenta, O. Louis, 231
McMullan, James, 209, 214, 233, 234, 236
Metzner, Sheila, 241
Meyers, Les, 226
Miller, Teresa, 228
Mobley, George F., 239
Murawski, Alex, 222, 250
Murphy, Geri, 218

Oliver, Mark, 250

Paine, Howard E., 220, 223
Pavlov, Elena, 240
Phelps, Constance, 231, 242
Pope, Kerig, 213
Priest, Robert, 250
Punchatz, Don, 251

Rhodes, Silas H., 231
Rice, Nancy, 225
Richichi, Margaret, 248
Rongstad, Ellen, 244
Rothman, Frank, 248
Rovillo, Chris, 242
Ruch, Sandra, 230

Sasala, David, 238
Scher, Paula, 222, 234, 238, 245, 248
Schneider, Elliot, 239
Seidler, Ned, 220
Shaefer, Richard, 244
Shanahan, Mary, 215
Shardin, Meri, 214
Sherman, Whitney, 240
Singer, Arthur, 223
Siroka, Elizabeth, 219
Slavin, Neal, 216, 238
Smith, Elwood, 217
Staebler, Tom, 213
Steele, Tom, 229
Stermer, Dugald, 226, 229, 246
Sullivan, Ron, 212

Taback, Simms, 212, 219, 244
Talbot, Bob, 219

Van Hamersveld, John, 229
Vignelli, Massimo, 220

Wald, Carol, 241
Walsh, Susanne, 216
Watson, Terry, 211
Wilcox, David, 222, 238, 240
Williams, Rodney C., 238
Wilson, Steven C., 226, 242
Woodson, Elizabeth, 219
Wyman, David, 215

Zalon, Paul, 244
Zisk, Mary, 248

**Design Firms and Agencies**

Burns, Cooper, Hynes, Ltd., 222, 237

Chermayeff & Geismar Assoc., 217, 244
Communication Arts, Inc., 238

Duffy, Knutson & Oberprillers, 247

Fallon, McElligott & Rice, 225
Fifty Fingers, 215

Gilmore Advertising Co., 211

Hixo, 218

Jonson Pedersen Hinrichs & Shakery, 238

M & Co., 239
Mark Oliver Assoc., 250

Push Pin Studios, 230

Richards Sullivan Brock Assoc., 212

TBWA Advertising, 236

**Clients and Publishers**

A & W Publishers, 216
Harry N. Abrams, Inc., 220
Alley Pie Publishing Co., 239
The American Museum of Natural
    History, 244
Armour Co., 225
Art Center College of Design, 221, 227
Atlantic Records, 234, 241

The Boston Globe, 218, 229
Boulder, City of, 238
Brigham Young University Graphic
    Communications, 243

CBS Records, 222, 228, 229, 234, 238,
    240, 245, 248
Communication Arts, 210, 236
Coyne & Blanchard, Inc., 229

Doremus, Inc., 230

E.P. Dutton, Inc., 214

Entheos Books, 226

Geo Magazine, 216
Bob Guccione, 219, 248
Gold 'n Plump, 225
Graphis Press Corp., 208

Hampton Classic Horse Show, 230, 233
Hearst Magazines, 248
Herald Square Publications, Inc., 235

Walter Herdeg, 208
Hixo, Inc., 218, 246

Illustration/Japan, 214

Jack Frost Farms, 225
June 12 Rally Committee, 224

Lancaster-Miller Publishers, 246

M & Co., 239
The Metropolitan Museum of Art, 215
Miller-Gilbert, 228
Minneapolis Zoological Soc., 247
Mobil Corp., 230, 244
Mother Jones Magazine, 246
The Museum of Modern Art, 210

National Geographic Soc., 218, 220, 222, 223, 231, 239, 242
National Lampoon, 246
Neiman-Marcus, 210
New West Magazine, 226
North Charles Street Design Organization, 240

Omni Magazine, 219, 248

Paper Moon Graphics, Inc., 244
Paperjacks Books, 213
Performing Dogs, 239, 240
Philip Morris, 212
Playboy Magazine, 213
Popshots, Inc., 244
The Potlatch Co., 238
Push Pin Graphic, 251

Quality Records, 215

Radio Syndicate, 222
Rags 2 Riches, 250
Richards Sullivan Brock Assoc., 242
Rolling Stone, 215
The Rouse Co., 212

Salt Lake City, Art Directors Club of, 221
Santa Barbara Magazine, 250
Saratoga Performing Arts Center, 241
Scholastic Publications, 212, 219, 236, 244
School of Visual Arts Press, Ltd., 217, 232
Science Digest, 248
Science 82 Magazine, 238
Sketchpad Studio, 251
Society of Illustrators, 214
SQN Records Ltd., 222
St. Louis Zoo, 217

Time, Inc., 238, 248
Toronto Star, Weekend Magazine, 250

University of Guelph, 237
Upjohn Co., 211

Carol Wald, 241
Watson-Guptill Publications, 209
World Bank/Germany, 226

## The Book Show

### Art Directors, Illustrators, Photographers, Authors, Editors and Production Managers

Ahearn, Mary, 285
Amster, Betsy, 299
Anderson, Betty, 284
Ansell, Michael, 290
Antler & Baldwin, 262
Antupit, Samuel N., 256, 266, 267
Areheart, Shaye, 291
Asals, Frederick, 280
Asherman, Cheryl, 262
Ashton, Dore, 277
Azarian, Mary, 286

Baines, Iain, 295
Ball, John, 262
Barich, David, 261, 264
Barile, Carl, 293
Bass, Anne, 260, 283
Becotte, Michael, 289
Bello, Ignacio, 294
Berend, Cathy, 291
Bergstrasser, Douglas, 291
Bernstein, Amy, 274
Bier, Anna, 290
Billout, Guy, 293
Bishop, Robert, 266
Blegvad, Erik, 289
Blegvad, Lenore, 289
Bond, Felicia, 289
Bonnell III, Wilburn, 296
Boswell, John, 274
Bosworth, Adriane, 294
Brewer, Mary Beth, 266
Bronfman, Saidye Rosner, 282
Brown, Patricia, 274
Brown, Will, 267
Brownstein, Jacqui, 294
Bruin, Bill, 265
Buettner, Gudrun, 266
Burns, Aaron, 280
Butler, Tyler, 263

Cage, John, 277
Calenberg, Tom, 286
Call, William, 262
Callihan, John C., 295
Cameron, Angus, 264
Campbell, Bruce, 263
Caponigro, Eleanor, 269
Carey, Jack, 294
Carroll, Lewis, 287
Cash, Barbara L., 276

Chaitkin, William, 268
Chalmers, Anne, 277
Chan, Amos T.S., 299
Chatfield-Taylor, Joan, 261
Coblentz, Patricia, 266
Corrigan, Dennis, 289
Costello, Susan, 266
Craig, Johanna T., 298
Crane, Joan, 278
Cronin, Denise, 292
Croze, Harvey, 297
Cunningham, Patrick, 256

Darling, Harold, 290
Darling, Sandra, 290
D'Avino, John, 273
De Camps, Craig, 283
Del Mar Assoc., 262
Detloff, Bonnie, 297
Detweiler, Susan Gray, 267
Disraeli, Benjamin, 260
Donovan & Green, 299
Donovan, Michael, 299
Dorn, Peter, 260
Doyle, Kathleen, 279
Doyle, John L., 271
Dudden, Adreanne Onderdonk, 298

Eames, Stephen T., 265
East, Charles, 280
Eckersley, Richard, 278
Edlin, Gordon, 262
Eisdorfer, Sandra, 261
Eisenman, Sara, 299
Ellis, Louise, 295
Errett, Raymond, 266
Estrada, Jackie, 262
Evans, Catherine, 269

Fagles, Robert, 283
Farber, Bob, 280
Ferguson, Raymond G., 290
Fili, Louise, 283
Finney, Charles G., 288
Fischer, Gary, 265
Ford, David, 279
Forrester, Victoria, 285
Foss Jr., Phillip, 287
Foster, Frances, 292
Francis, Barbara, 293
Frith, Margaret, 273

Galassi, Jonathan, 270
Garland, Nathan, 277
Gay, Reginald, 266
Geis, Darlene, 266
Geist, Johann Friedrich, 275
Gershey, Lydia, 266
Giroux, Robert, 282
Godine, David R., 277
Goblitz, Pat, 262
Goines, David Lance, 276
Golanty, Eric, 262
Gold, Ann, 283
Goldenberg, Carol, 298
Goldman, Michael, 266
Goluska, Glenn, 282
Goodacre, Selwyn H., 287
Gottlieb, Robert, 284
Graham-Barber, Lynda, 299
Graham, Judy, 290
Graham, Nan, 283
Grasso, Kathy, 284, 299
Gray, Christopher, 274
Green, Christopher E., 269
Green, Nancye L., 299
Greene, Brad, 262
Greenspun, Joanne, 267
Griswold, Mac, 263
Grycz, Czeslaw Jan, 287
Guernsey, Bruce, 276
Gunn, J. A. W., 260
Guttenplan, Dan, 284

H. Plus, Inc., 273, 274
Hague, Michael, 290
Hall, Thomas E., 271
Halsman, Philippe, 258
Halsman, Yvonne, 258
Hamill, Sam, 281
Hance, George, 297
Harder, Rolf, 295
Harris, Ellen, 280
Haskett, Louise, 267
Hawthorne, Nathaniel, 263
Hayes, Susan, 279
Healy, Brian, 270
Hedrick, Joan, 261
Hendel, Richard, 261
Henry, Fred, 294
Hess, Richard, 258
Hicks, Michael, 291
Hilton-Putnam, Denise, 262
Hindman, Sandra, 298
Hirneisen, Richard, 297
Hirschman, Susan, 288
Hoagland, Edward, 288
Hoban, Tana, 288
Holliday, John, 266
Hornberger, Janet, 278
Houck, Gerald, 290
Hudson, Sandra Strother, 280
Humphrey, Hal, 294
Humphrey, Heidi, 273, 274
Hunter, Jefferson, 279

Ichiyassu, Elissa, 283
Isherwood, Christopher, 291

J & S Art Services, 294

Jacobsen, Howard, 261, 264
Jamison, Dan, 265
Jaroch, Diane, 275
Jencks, Charles, 268
Johnson, Dallas, 279
Johnson, Fridolf, 264
Johnson, Herb, 282
Johnson, Pauline, 260
Jones, Neal T., 282

Kalber, Werner, 262
Kaplan, Joyce, 258
Kaplan, Margaret, 267
Kaplan, Peter J., 282
Karl, Anita, 278
Karl, Jean, 285
Keith, Freeman, 288
Kelley, Gilbert, 278
Kemp, James, 278
Kent, Rockwell, 264
Kinkaid, James R., 287
Kinney, Martha, 286
Klein, Bernard, 270
Knowles, Barbara, 283, 290
Konopka, Stephen F., 274
Korab, Balthazar, 297
Krass, Antonina, 285
Krupat, Cynthia, 282

Lai, Chun Y., 266
Lamb, Christine, 270
Lambert, Phyllis, 269
Lange, Gerald, 287
LaPlante, Virginia, 279
Larson, Gun, 263
Lau, Jin 285, 289
Lavine, Eileen, 279
Lawrence, Star 285
Legrou, Michel, 299
Lieu, Randall, 299
Lindlof, Ed, 261
Lindroth, David, 270
Lionni, Leo, 292
London, Jack, 263
Lorraine, Walter, 298
Lose, Helga, 266
Lowell, Shelley, 263
Lowenstein, Carole, 270
Luckey, William F., 276, 277
Luenn, Nancy, 290
Lumiansky, R.M., 278
Lyndon, Donlyn, 270

MacFarlane, Marie J., 291
Mahon, Robert, 277
Mallarme, Stephane, 277
Mangeot, Sylvain, 291
Marasia, Andrew, 285
Mark, Robert, 275
Masters, Tom, 295
Matthews, John, 260
Matthews, Rachel, 275
Matyas, Andreas, 262
McBride, Nate, 270
McCoy, Katherine, 297
McCurdy, Michael, 280
McElderry, Margaret K., 289
McKee, Bob, 267
McNeilly, Ellen, 264, 284
Meadows, Christine, 267
Mehl, Ilene, 280
Melville, Herman, 263
Menard, Gloria, 295
Merritt, Carole, 263
Mezey, Gail, 264
Michael, Judith, 266
Milani, Armando, 259
Milford, Kenneth, 282
Miller, Henry, 264
Mitchell, Bob, 258
Mitchell, Susan, 284
Money, Keith, 284
Morgan, Frederick, 277
Mortimer, Charles E., 294
Morton, Robert, 256
Moser, Barry, 287
Martin Moskof Assoc., 274
Moskof, Martin, 274
Mullaney, Lorraine, 294
Munsterberg, Marjorie, 269

Nasser, Muriel, 278
Nehring, Carol, 266
Neiheisel, Louis, 262
Neilson, Ron, 265
Neumann, Martha Cross, 297
Newland, Joseph, 265
Nicholason, Karl, 262
Nowinski, Ira, 261

O'Connor, Flannery, 280
Okrent, Daniel, 291
Ondaatje, Michael, 285
Opper, Jane, 266
Osnos, Naomi, 264

Page, Jake, 256
Page, Marian, 299
Page, Susanne, 256
Palca, Doris, 273
Papadakis, Dr. Andreas, 268
Pare, Richard, 269
Parise, Kathryn, 286
Paska, Roland, 271
Pateman, Michael, 299
Pecararo, Janice, 298
Peck, Everett, 262
Pochoda, Philip, 284
Pollitzer, Eric, 277

Poth, Tom, 291
Pratt, Dana J., 298
Prentki, John T., 280

Quasha, George, 277
Quasha, Susan, 277

Rae, Christine, 296
Raperto, Marie T., 295
Rapley, Stephen, 294
Rattazzi, Priscilla, 259
Read, Jenny, 279
Reitt, Barbara, 263
Renick, Steve, 287
Rezk, Roberta, 258
Ritchie, Ward, 279
Robbins, Eugenia, 269
Robin, Wilma, 291
Royster, Paul, 263
Rugoff, Milton, 266
Russell, Frank, 268

Saint-Onge, Sarah, 286
Sanchez, Eugene, 288
Sargent, Rod, 265
Sarkin, Carol, 293
Schanilec, Gaylord, 287
Scherer, Peter, 274
Schmiderer, Dorothy, 284
Schurman, Donald M., 260
Schwartz, Eileen, 286
Schweizer, Leo, 295
Scorsone, Joe, 289
Scudellari, R.D., 263, 264, 270, 284
Searing, Helen, 273
Seebohm, Caroline, 260
Seitz, Sepp, 275
Shapiro, David, 291
Sharma, Kewal K., 294
Shelton, Richard, 281
Sieck, Judythe, 290
Silber, Elaine, 292
Silks, Jim, 299
Silverman, Bob, 270
Singer, Isaac Bashevis, 282
Sjoberg, Nancy, 262
Slick, Paul, 262
Smith, C. Ray, 299
Sophocles, 283
St. George, Judith, 273
Tom Stack & Assoc., 265
Stanley, Dawn, 294
Steiner, Paul, 266
Stence & Stence, 291
Stern, Bert, 262
Stewart, Neil, 286
Strasser, Susan, 284
Stuart Jr., Ken, 258
Sullivan, Donna, 293
Sweesy, Robin, 275
Swenson, Tree, 281

Taylor, Lisa, 273, 274
Thatcher, Susan, 288
Thompson, Bradbury, 295
Tibbits, Clark, 279
Tice, George, 277
Tilley, Frances Torbert, 294
Tindale, Dennis, 295
Tondreau, Beth, 260, 283
Traut, Dennis, 286
Truitt, Anne, 283
Turner, Debra K., 278
Twain, Mark, 263

Van Allsburg, Chris, 298
Vantage Art, Inc., 294
Van Vliet, Claire, 288
Vignelli, Massimo, 266
Von Schaewen, Deidi, 268

Ware, Cynthia, 275
Weinstein, Marc, 299
Weiss, Ava, 288
West, Harvey, 265
Westray, Kathleen, 273
Whitehill-Ward, John, 265
Whitman, Walt, 263
Wild, Lorraine, 270
Williams, Alan, 260
Wilmarth, Christopher, 277
Wilson, Celia, 275
Windsor, Kenneth R., 268
Wingwall, Alice, 270
Woelflein, Dick, 275
Woodruff, Rebecca, 283

Yamamoto, Shun'ichi, 256, 266, 267, 268
Young, Noel, 264

Zash, Jane, 299

### Publishers

Harry N. Abrams, Inc., 256, 266, 267, 268
African-American Family History Assn., 263
Antioch University, 279
Atheneum Publishers, 285, 289

The Bieler Press, 287
Book-of-the-Month Club, Inc., 282
Esther & Stephen Brickel, 299

Calloway Editions, 269
Barbara L. Cash/The Ives Street Press, 276
Canada Post Corp., 295
Celo Press, 279
Centre Canadien d'Architecture, 269

Chanticleer Press, 266
Chronicle Books, 261, 264
The Cooper-Hewitt Museum, 274
Copper Canyon Press, 281

Doubleday & Co., Inc., 291

Farrar Straus & Giroux, 282
Fireside Books, 274
Fishy Whale Press, 271

David R. Godine, Publisher, 276, 277
The Green Tiger Press, 290
Greenwillow Books, 288
Gulf & Western Corp., 274

Harcourt Brace Jovanovich, 290
Harper & Row Publishers, Inc., 294
Harvard University Press, 279
The Henry Art Gallery Assn., 265
Houghton Mifflin Co., 298

International Typeface Corp., 280

Kingswood School Cranbrook, 297
Alfred A. Knopf, Inc., 264, 266, 284

Library of Congress, 298
The Limited Editions Club, 288
Literary Classics of The United States, 263

McGraw-Hill Book Co., 258
The MIT Press, 273, 275
William Morrow & Co., Inc., 262

NavPress, 265
W.W. Norton & Co., 285

Pantheon Books, 283, 284, 292, 299
Penguin Books, 286
Perspecta, 270
Prentice-Hall, Inc., 293
G.P. Putnams Sons, 273

Random House, Inc., 270

Science Books International, 262
Charles Scribner's Sons, 278
Simon & Schuster, 274
Station Hill Press, 277
Sunar, 296

Texas Monthly Press, 291
The Tyler Offset Workshop, 289

University of California Press, 287
The University of Georgia Press, 280
University of Nebraska Press, 278
The University of North Carolina Press, 261
University of Toronto Press, 260
University of Washington, 265

The Viking Press, 260, 283

Wadsworth Publishing Co., 294
Westvaco Corp., 295
Whitney Museum of American Art, 273
Christopher Wilmarth, 277

Yale Architectural Journal, 270

**Typographers, Letterers and Calligraphers**

Achorn Graphic Services, Inc., 275
Advertising Typographers, Inc., 289
American Book-Stratford Press, 260
Alpha 21, 297
Gregory Atwood, 264

M.J. Baumwell Typography, 280
Michael Bixler, 276, 287
Winifred Bixler, 276, 287
Book Composition Services, Inc., 290
Boro Typographers, 289

Cambridge Press, Inc., 279
Cardinal Type Service, Inc., 274
Barbara L. Cash, 269
Chronicle Type & Design, 279
The Clarinda Co., 263, 264, 294
Compotronic, Inc., 295
Concept Typographics Service, Inc., 299
Crane Typesetting Service, Inc., 299

Dix Typesetting Co., 266, 285
Doubleday & Co., Inc., 291

Eastern Typesetting Co., 262
Elizabeth Typesetting Co., 293

Finn Typographic Service, Inc., 295
Folio Graphics, 258

G & S Typesetters, Inc., 270, 278, 280, 291
Gatti, David, 291
Glenn Goluska, 282
Granite Graphics, 274

The Haddon Craftsmen, Inc., 170, 263, 278, 285, 298
Howarth & Smith, Inc., 260

Gerald Lange, 287
G.G. Laurens, 287
Letraset, 263
Lincoln Typographers, Inc., 292
Latent Lettering, 274

Maryland Linotype Composition Co., Inc., 273, 282, 283, 284
Roy McCoy, 277, 298

New England Typographic Service, Inc., 284
The Nightshade Press, 282

Open Studio Design and Typography, 277

Pastore DePamphilis Rampone, 288, 296
Sue Rexford, 287

Samwha Printing Co., 266, 268
Judythe Sieck, 290
The Stinehour Press, 276, 277, 298
Tree Swenson, 281
Syntax International, 294

TGA Graphics, Inc., 256
Thomas & Kennedy, 265
Thompson Type, 262
Trufont Typographers, Inc., 273
Type by Design, 261, 264
Typographic Images, 286

The University of North Carolina Press, 261
University of Washington Printing Dept., 265
U.S. Lithograph, Inc., 267, 268

Vail-Ballou Press, Inc., 283
Claire Van Vliet, 288
Veras Type, 271
Videograf, Inc., 259
Village Typographers, Inc., 275

Word Graphics, Inc., 263

**Printers, Binders and Separators**

ATR, Inc., 259
American Book-Stratford Press, 264, 284
American Printers & Lithographers, 264
Ashton-Potter, Ltd., 295
Automated Bindery, 290

Michael Becotte, 289
T.H. Best Printing Co., Ltd., 282
Bindery Services, 295
The Book Press, 292
Mark Burton, Inc., 275

Barbara L. Cash, 276
Celo Press, 279
Color Assoc., 264

Daamen, Inc., 286
Dai Nippon Printing Co., Inc., 261, 264, 266, 289, 296
John H. Dekker & Sons, 278, 280
Delmar Printing Co., 279
R.R. Donnelley & Sons Co., 260, 263, 284, 294
Doubleday & Co., Inc., 291

E. & M. Bindery, 299

Fairfield Graphics, 283
Froelich/Green Litho Corp., 299

Garamond/Pridemark Press, Inc., 298
The Green Tiger Press, 290

The Haddon Craftsmen, Inc., 283, 285
Halliday Lithograph Corp., 261, 262, 273, 275, 278
Marsha Hollingsworth, 281
A. Horowitz & Sons, 258, 286, 288, 291
The Hunter Rose Co., Ltd., 260

Interstate Book Manufacturers, Inc., 274

Kingsport Press, 266, 274, 285

Lange, Gerald, 287
Lincoln & Allen, 265
Lithomart, Inc., 280

William J. Mack Co., 273
The Maple Press Co., 282
McNaughton & Gunn, Inc., 201
Mercantile Printing Co., 270
The Meriden Gravure Co., 269, 277, 295
Mondadori Pub. Co., 262
John M. Morgan, 279
The Murray Printing Co., 270, 279, 294, 298, 299

Nicholstone Book Bindery, Inc., 298
Nissha Printing Co., Ltd., 266, 267
Novelty Bookbinding Co., 289

Open Studio Bindery, 277
Open Studio Print Shop, 277

P & B Engraving Co., 276
Pearl Pressman Liberty, 290, 291
The Porcupine's Quill, Inc., 282
Princeton Polychrome Press, 278
Publishers Book Bindery, 269, 277, 280

Rae Publishing Co., Inc., 264, 284, 286, 288, 292, 293
Rapoport Printing Corp., 284
Reliable Reproductions, Inc., 271
Rexford, Sue, 287

Sanders Printing Co., 258
Signet Printing, 297
Southeastern Printing Co., 287
Star Bindery Co., Inc., 297
Stein Printing Co., 263
The Stinehour Press, 269, 276, 277, 288
Tree Swenson, 281

Tapley-Rutter Co., Inc., 282, 287, 295
Thomson-Shore, Inc., 278, 280
Toppan Printing Co., Ltd., 256, 268

University of Toronto Press, 260
University of Washington Printing Dept., 265

Williams Printing, 265

## Communication Graphics

### Art Directors, Designers, Illustrators, Artists, Photographers, Authors, Editors, Copywriters and Production Managers

Abramson, Michael R., 324, 365, 378, 410
Acevedo, Luis, 308, 393, 399
Adair, Jim, 348
Adamson, Susan, 390
Almquist, J.C., 389
Ambasz, Emilio, 364
Andersen-Bruce, Sally, 324
Anderson, Mark, 355
Ankers, Bob, 404
Ansel, Ruth, 383
Armstrong, Frank, 324
Avedon, Richard, 343

Baraban, Joe, 372, 388
Barnes, Richard, 413
Bartz, Lenore, 357, 411
Bass, Saul, 368
Belinoff, Robert, 324
Bennett, Sue, 349
Bentz, Jon, 406
Berg, John, 399
Berman, Jerry, 344
Besser, Rik, 349
Blackwell, Patrick, 358
Blessing, Heidrich, 372
Blevins, Burgess, 389
Blumenthal, David, 344
Bokuniewicz, Carol, 413, 421
Bonnell III, Wilburn, 365, 371
Booth, Greg, 376
Bottoni, Joseph, 331
Boulevard, 386
Boyd, Brian, 309, 311
Braasch, Gary, 388
Brady, Kerry, 322
Brady, Steve, 394
Branner, Phillip, 352
Bright & Assoc., Inc., 394, 413
Bright, Keith, 394, 396
Brosan, Roberto, 348
Brown, Jon, 328
Brown, Karen, 325, 361
Brown, Lance, 377
Brown, Mike, 396
Burns, Richard, 362
Burns, Robert, 324, 332, 402
Burri, Rene, 310
Butler, Wayne, 348

Caesars Boardwalk, 367
Campbell, David, 355
Campbell, Gerald, 362
Carbone, Kenneth, 422
Cargill, Bob, 403
Carlson, Jocelyn, 413
Carrier, Lark, 417
Carrieri, Mario, 378, 379
Carrillo, Dixi, 362
Carson, Bill, 377
Casado, John, 370, 416
Casey, Susan, 342, 343
Ceccon, Vasco, 406
Chamblee, Tonnie, 373
Charysyn, Joan, 391
Chatelain, Alex, 361
Chermayeff, Ivan, 317, 323, 360, 361, 410
Christianson, Jack, 380
Cipriani, Robert, 415
Clark, Bill, 398
Clement, Michele, 383
Clementino, Ann, 387
Cliff, Greg, 398
Codiroli, Joseph, 409
Collier, John, 381
Cook, Roger, 333
Cooper, Heather, 402
Cope, Gill, 304
Cope Linder Assoc., 367
Cosimo, 322
Coy, John, 332
Craine, Jon, 414
Cretarolo, Sue, 355
Cronan, Michael Patrick, 369, 381, 416, 419
Cruz, Jose, 357
Culkin, Joyce, 419
Curtis, E.S., 349

Danne, Richard, 310, 311
Darnall, Linda, 358
Davis, Meredith, 408
Dayenian, Ursula, 409
Decena, Mark, 404
De Groot, John, 344
Donovan, Dan, 384
Doppelt, Shelley, 324
Douglas, King, 318
Doyle, Constance T., 382
Doyle, Jim, 386
Dunnick, Regan, 399
Durins, Bernard, 392
Dyer, Rod, 354

Eckstein, Ed, 350, 354, 389
Eisenberg, Arthur, 397
Eisenhour, Laura, 417
Eissler, Linda, 397

Eitzen, Philip J., 350, 354
Emlen, Kate, 319
Engh, Barbeau, 404
Ervin, Don, 404
Escobedo, Louis, 357
Essex, Joseph M., 332

Famuliner, Jody L., 414
Farber, Bob, 386, 392, 420
Favara, Len, 325, 334, 337
Federico, Gene, 336, 343, 348, 389
Feldman, Marc, 388
Fields, Bruce, 337
Fiorentino, Helen, 356
Fiorentino, Lou, 356
Firebaugh, Steve, 351
Fogler, Dawn, 403
Ford, Wayne, 390, 410
Forsythe, Kathy, 419
Freeman, Hunter, 344
Friedman, Julius, 328, 393
Froelich, Jeri, 325
Frykholm, Stephen, 306, 321, 333
Furman, Michael, 367

Garrett, Edie, 399
Gauger, David, 404
Gee, Peter, 413
Geissbuhler, Steff, 360, 401
Gentry, Don, 404
Gervais, Lois, 398
Gilbert, Joseph, 405
Gillette, Ned, 358
Gips, Philip, 383
Glaser, Milton, 307, 312, 316
Glasser, Roberta, 391
Godard, Keith, 325
Goldsmith, Gary, 323, 391
Gonzalez, Manuel, 338, 345
Gray, Hartzell, 395
Grear, Malcolm, 362, 382
Green, Liza, 419
Greiman, April, 366
Griffin, David, 357
Grossman, Gene, 332
Gyles, Jennifer, 324

Hancock, Susan, 333
Harmouch, Martine, 400
Haycock, Laurie, 420
Haynes, Mike, 388
Heffernan, David, 338
Heffernan, Terry, 304
Helburn, William, 336
Herring, Jerry, 332, 350, 372, 390, 394
Hess, Claire, 365, 410
Hicks, Mike, 319, 417
Hill, Chris, 396
Hill, John T., 327, 381
Hinchee, Jim, 363
Hinrichs, Kit, 304, 357, 393, 411
Hinsche, Gary, 408
Hironaika, Eddie, 404
Hirschfeld, Corson, 378
Hively, Charles, 344
Hodges, Rose, 377
Hodgson, Paul, 326
Hogan, Jamie, 358
Hsu, Richard, 401
Hughes, Mark, 304, 323, 391
Huninghake, Bruce, 400

IBM Staff Photographers, 406
Infield & D'Astolfo, 372
Isozaki, Arata, 375

James, Phillip M., 362
Jarratt, James, 389
Jocis, Jay, 349
Johnston, Oliver, 404
Jones, George Adams, 367
Joseph, Doug, 413

Kahl, Konrad, 386
Kalman, Tibor, 413, 421
Kalyniuk, Jerry, 322
Kamerath, Danny, 322, 370, 376
Kamifuji, Tom, 414
Kampa, David, 364, 391
Katz, Joel, 367
Katz, John, 397
KaYeung, 388
Kemper, Charles, 369
Kennard, Ed, 408
Kienberger, Tom, 420
Kindschi, Don, 414
King, Walter, 320
Kirkley, Kent, 376
Kirsch, Art, 396
Kline, Don, 405
Kobasz, Bill, 368
Koppel, Terry, 358
Kosstrin, Jane, 422
Kubicki, Joanna, 402
Kubly, Jon, 385
Kunisaki, Michael, 305, 355, 380
Kuypendall, Bill, 387

Ladds, Leslie, 379, 407
Lande, Nathaniel, 409
Landsberg, Steve, 304, 323
Lategan, Barry, 342, 343
Laundy, Peter, 388
Lee, Monica, 377
Lee, Raymond, 346
Leger, Francine, 406
Lemon, Clifton, 387
Levart, Herb, 406

Levin, Diane, 415
Levine, Peter L., 327
Levinson, Gary, 333
Lewin, Gideon, 325, 334
Lewis, Ken, 403
Lewis, Sheldon, 415
Library Co. of Philadelphia, 367
Lionetti, Frank C., 387
Lister, John, 417
Lloyd, Susan, 304
Love, Kenneth D., 405
Loveland, Barbara, 306
Lorenz, Albert, 332
Ludwig, Gary, 326
Luke, Vic, 395, 398
Lymburner, Richard, 387

Mabry, Michael, 383, 418
Maddocks, Gary, 355
Maderspach, Viktor, 346
Magleby, McCray, 318, 376
Maisel, Jay, 346
Costa Manos/Magnum, 361
Manwaring, Michael, 332
Marcellino, Fred, 341
Marcellino, Jean, 338, 339, 341
Martell, Dick, 419
Matossian, Harold, 366, 378, 379, 407
Matsumoto, Takaaki, 407, 421
Mauk, Mitchell, 355
McCollum, Sudi, 369
McCord, Walter, 328
McCoy, Gary, 382, 393
McEntire, Larry, 319
McGinn, Michael, 332, 363
McGuire, Mickey, 386
McNeff,,Tom, 375
Meganck, Robert, 408
Mehl, Richard, 315
Metzdorf, Lyle, 344
Meyerson, Arthur, 308, 388, 407
Miho, James, 335, 349
Miho, Tomoko, 409
Miller, Blake, 410
Milner, Antony, 355
Mitchell, Dick, 322
Mohr, Sven, 347, 348
Morrell, Eric G., 360
Mosgrove, Will, 370
Mudford, Grant, 332
Mukai, Dennis, 408
Muller, John, 395, 398
Murphy, Harry, 415
Myron, 390

NBC Sports, 367
Neal, David, 324
Nettis, Joe, 367
Nible, R.C., 398
Nichols, Michael, 359
Nugent, Sarah, 362
Nyen, Arne, 388

Ochagavia, Carlos, 323
Odgers, Jayme, 326
Opsahl, Olga, 413
Orant, Steve, 357
Ostilly, Seymon, 338, 344, 345

Pacific Aeria Survey, 404
Pannell, Cap, 352, 364, 368, 371, 412
Parks, Gordon, 399
Parks, Melanie Marder, 401
Passy, Marc, 354
Pease, Al, 324
Peckolick, Alan, 318
Pedersen, B. Martin, 386
Pennsylvania Hospital, 367
Peterson, Bruce, 414
Pirtle, Mark, 364, 388
Pirtle, Woody, 308, 324, 364, 388, 391, 393,
    396, 399, 412
Pomeroy, Todd, 360
Portnoy, Lewis, 367
Poth, Tom, 319, 417
Priester, Gary, 396
Prosen, Phil, 364
Pruitt, David, 378
Pruzan, Michael, 323
Pujol, Henry, 333

Quinn, Colleen, 393
Quon, Mike, 420

Rafferty, John, 382
Rattan, Joe, 396
Raymond, Phil, 355
Reay, Charles P., 406
Redings, Edward X., 403, 411
Reid, Robert, 409
Reynolds, Jan, 358
Rhoney, Anne, 387
Richards, Micheal, 360
Rigsby, Lana, 325
Robinson, Bennett, 353
Rogers, Richard, 406
Rokeach, Barrie, 369
Rose, Jacqueline, 313
Rossi, Jill, 361
Rossum, Cheryl, 355
Running, J., 349
Runyan, Robert Miles, 333, 385
Rushing, Dale, 318
Ryf, Bob, 330
Rytter, Robert, 372

Sakahara, Dick, 348
Sakmanoff, George, 415
Salisbury, Mike, 396

Sargent, Peter, 396
Savage, Paula, 407
Scarlett, Nora, 389
Schnipper, Steven, 366, 378, 379
Schroeder, Mark, 383
Schwab, Michael, 359
Scott, Ron, 372, 377, 388
Sebastian, James, 363
Sellars, Joe, 325
Sendecke, Jim, 384
Shafer, Ken, 364
Shakery, Neil, 392, 411
Shanosky, Don, 333
Shapiro, David S., 319, 417
Sharpe, William, 366
Shevack, Brett, 322
Short, Sandra, 362
Shroeder, Mike, 324
Silva, Keith, 369
Sims, Jim, 350, 372, 377, 390, 396,
    407, 410
Skelton, Karen, 364
Skogsbergh, Ulf, 304
Smith, Cerita, 364, 368, 371, 380, 412
Smolan, Leslie, 357
Snider, Steve, 350
Spescha, Johann, 413
Standart, Joe, 363
Steinberg, Cindy, 410
Sterling, David, 422
Stevens, Robert, 333
Striegel, Peggy, 320
Stripp, D.C., 418
Strominger, Dale, 350, 354
Sullivan, Ron, 376, 382, 418
Summerford, Jack, 381
Sussman, Deborah, 333
Swenson, Bill, 360

Templin, Gary, 382
Tolleson, Steven, 305, 355, 380
Tom, Bill, 354
Tom, John, 408
Tom, Lenore, 395
Tracy, Tom, 393
Tscherny, George, 340
Turner, Tracy, 423
Tuschman, Mark, 396

University of Pennsylvania, 367
Uozimo, David, 417

Valencia, Debra, 333
Vanderbyl, Michael, 313, 322, 377, 404, 415
Van Dyke, John, 351
Van Scoy, Bill, 399
Vignelli, Lella, 388
Vignelli, Massimo, 375

Watanabe, David, 351
Waters, Catherine, 389
Watson, Matthew, 357
Webb, Jon, 393
Webster, D.J., 323
Welti, Theo, 313
Westinghouse Model Shop, 403
Wheeler, Edward F., 367
Whitebay, Diane, 417
Wilde, Richard, 368
Wilkinson, Chuck, 383
Williams, Lowell, 325, 377, 396
Wolf, Henry, 344
Wolfhagen, Bill, 344
Wolfson, Lawrence, 378, 410
Woliner, Ellen, 400
Wondriska, William, 346
Wong, John, 308
Wood, Ray, 396

Young, Janet, 408

Ziemienski, Dennis, 392
Zographos, Paula, 353

**Design Firms and Agencies**

A.C. & R. Advertising, 304
Michael R. Abramson & Assoc., 365,
    378, 410
Emilio Ambasz Design Group, Ltd., 364
Mark Anderson Design, 305, 355, 380
Anspach Grossman Portugal, 405
Apple Computer, Inc., 355
Armstrong Design Consultants, 324
Arnold Design Team, Arnold & Co., 350
Atlantic Richfield Co. Design Services,
    395, 398
Saul Bass/Herb Yager & Assoc., 368
Baxter+Korge, Inc., 400
Bonnell Design Assoc., Inc., 365, 371
Bottoni & Hsiung, Inc., 331
Bright & Assoc., Inc., 394, 396, 413
Burns, Cooper, Hynes, Ltd., 324, 402
Burson-Marsteller, 332

CBS Records, 399
Cargill & Assoc., Inc., 403
Casado Design, 370, 416
Chermayeff & Geismar Assoc., 317, 323,
    360, 361, 401, 410
Robert Cipriani Assoc., 415
Communication Design, Inc., 408
Container Corp. of America, 322
Cook & Shanosky Assoc., Inc., 333
Corchia Woliner Assoc., 400
Corporate Graphics, Inc., 353
Coy, Los Angeles, 332
The Creative Dept., Inc., 350, 354, 389

Creel Morrell, Inc., 360
Michael Patrick Cronan, 369, 381, 416, 419

Dancer Fitzgerald Sample, Inc./SCA, 386
Danne & Blackburn, Inc., 310, 311
Dayton's, 325, 361
Designframe, 363
Doublespace, 422
Doyle Dane Bernbach, 304, 323, 391
Dyer/Kahn, Inc., 354

Eisenberg, Inc., 318, 397
Kate Emlen Graphic Design, 319

Lou Fiorentino, Visual
    Communications, 356
Kathy Forsythe, 419

Gauger Sparks Silva, Inc., 404
Peter Gee, 413
Geer Dubois, 348
Gilbert Assoc., 405
Gips+Balkind+Assoc., 383
Milton Glaser, Inc., 307, 312, 316
Roberta Glasser Graphic Design, 391
The GNU Group, 362
Gottschalk & Ash, Int'l., 357, 422
Malcolm Grear Designers, 362, 382
April Greiman Studio, 366

Haycock Kienberger, 420
Hellmuth, Obata & Kassabaum, 406
Herring Design, 350, 372, 390, 394
Hill/A Graphic Design Group, 396, 399
Hinsche+Assoc., 399, 408
Hixo, Inc., 319, 417
Humphrey Browning MacDougall Design
    Group, 390

IBM/Kingston, 330
IVC, Inc., 326
Images, 328, 393
Infield & D'Astolfo, 372
International Typeface Corp., 386, 392, 420

R.S. Jensen, Inc., 372
Jonson Pedersen, Hinrichs & Shakery,
    304, 357, 392, 393, 411
Jones Medinger Kindschi, 414

Tom Kamifuji, 414
Katz Wheeler Design, 367
Art Kirsch Graphic Design, 396
Knoll Graphics, 366, 378, 379, 407
T. Ross Koppel Graphics, Inc., 358

Laurence, Charles & Free, 322
Raymond Lee & Assoc., 346
Lehman Millet, Inc., 417
Lemon Design, 387
Peter L. Levine, 327
Frank C. Lionetti Design, 387
Lister Butler, Inc., 417
Lord Geller Federico & Einstein, 336, 338,
    339, 341, 342, 343, 344, 345, 347,
    348, 389

M & Co., 413, 421
Michael Mabry Design, 383, 418
The Magazine Group, Time Inc., 409
Mandala, 333
Marketing by Design, 324
Takaaki Matsumoto, 421
Michael McGinn, Inc., 332
Richard Mehl, 315
Metzdorf Advertising, 344
Miho, 335, 349
Tomoko Miho, 409
Miller, Judson & Ford, Inc., 373, 390, 410
Herman Miller Corporate Communication
    & Design Dept., 306, 333
John Muller & Co., 395, 398
Harry Murphy & Friends, 415

Cap Pannell & Co., 352, 364, 368, 371,
    380, 412
Melanie Marder Parks, 401
I.M.Pei & Partners, 423
PEOPLE Promotion, 419
Phillips & Frykholm, Inc., 321
Pirtle Design, 308, 324, 364, 388, 391,
    393, 396, 399, 412
Port Authority of N.Y. & N.J. Engineering
    Dept., 417
Pushpin Lubalin Peckolick, 318

Rafferty Communicators, Inc., 382
Reed Design Assoc., 384
R. J. Reynolds Graphic
    Communications, 358
Richards, Sullivan, Brock & Assoc., 309,
    322, 370, 376, 382, 418
Peter Rogers Assoc., 325, 334, 337
Richard Rogers, Inc., 406
Robert Miles Runyan & Assoc., 333, 385

Savage Design Group, Inc., 407
School of Visual Arts, 368
Michael Schwab Design, 359
Sidjakov, Berman & Gomez, 344
Siegel & Gale, 404
Space Design International, Inc., 406
Striegel Graphics, 320
Summerford Design, Inc., 381
Sussman/Prejza & Co., 333

307 Lafayette St. Corp., 413
Time, Inc., 409
George Tscherny, Inc., 340
20/20 Vision, 314

University of Utah Graphic Design, 360

Vanderbyl Design, 313, 322, 377, 404, 415

Van Dyke McCarthy Co., 351
Vasco+Assoc., 406
Vignelli Assoc., 375, 388

Catherine Waters Design, 389
Matthew Watson Design, 357
Welti & Rose Advtg., Inc., 314
Westinghouse Electric Corp., 403, 411
Lowell Williams Design, Inc., 325, 377, 396
Winius Brandon Advtg., 396
Henry Wolf Productions, 344
William Wondriska Assoc., 346
Works, 325

Young & Rubicam/Dentsu, 396
Brigham Young University Graphic
    Communications, 318

Zeitgeist, 414

**Publishers and Clients**

Alan Lithograph, Inc., 332
Alaska Brands Frozen Foods, 413
Alco Standard Corp., 350, 354
The American Institute of Graphic
    Arts, 304
American Library Assn., 324
The American Museum of Natural
    History, 323
Anaconda Industries, 398
Ansett Airlines of Australia, 346
Apple Computer, Inc., 355
Architectural Record Magazine, 382
Art Museums Assn., 415
The Asia Society, 358
Atari, Inc., 411
Atlantic Richfield Foundation, 395

G.H. Bass, 342, 343
Baxter+Korge, Inc., 400
Bedrock Development Corp., 370, 382
Bedford Properties, 377
Bernheim Forest, 393
Bill Blass, 325, 384
Bloomingdales, 401
Greg Booth & Assoc., 418
The Boston Globe, 358
Bright & Assoc., 396
Bottoni & Hsiung, Inc., 331
Bristol-Myers, 322
George Brown Photography, 418

C Channel, 324
CBS Records, 399
California College of Arts & Crafts, 313,
    322, 404
California Institute of the Arts, 313, 394
California Printing Co., Inc., 392
Cenikor Foundation, 394
Chadis Printing Co., 415
Champion International Corp., 335,
    349, 357
Charles River Breeding Laboratories, 350
Ron Chereskin, 304
The Cherri Oakley Co., 397
Chivas Regal, 323
Cincinnati Microwave, Inc., 406
Citibank, 372
Citibank/Citicorp., 389
Citivues, 332
Clampitt Paper Co., 373
Colombian Coffee, 323
Container Corp. of America, 322
Corgan Assoc., 399
Corning Glass Works, 417
Rita Cox, 418
J.C. Crimmins & Co., 333

D Magazine, 380, 412
DITLA, Inc., 357
The Dallas Illustrators, 381
Dallas Society of Visual
    Communication, 322
Dallas Symphony Orchestra, 309
Dayton's, 325, 360
Christian Dior, 343
Dividend Development Corp., 404
Drucker/Vincent, Inc., 414
Dunbar Furniture Corp., 378

Edwards & Angell, 382
Ethos Cultural Development, 402

Federated Stores Realty, Inc., 368
Festival of Festivals, 326
Firing Circuits, 387
Formica Corp., 364, 410
Kathy Forsythe & David Gampfer, 419
Fragrant Hill Hotel, 423

J. Paul Getty Museum, 333
Edward S. Gordon, 360
David Griffin, 391
Gross & Assoc., 400
Gunlocke Co., 366

Halali Arabians, 387
John Hansen Investment Builder, 407
Harley-Davidson Co., 384
Joel Harlib Assoc., 416
Hauserman, Inc., 375
Haycock Kienberger, 420
H.J. Heinz Co., 353
Heritage Press, 308
Herring Design, 390
Gerald D. Hines Interests, 324, 372, 377,
    396, 412
Hill/A Graphic Design Group, 396, 399
Hixo, Inc., 417
The Horne Co., Realtors, 390

Houston Metropolitan Ministries, 350
IBM Corp., 330, 338, 339, 341, 344, 345,
  401, 406, 414
ITT Programming, 324
Images, 328
International Typeface Corp., 386, 392, 420
Interprint, 369, 381

Jason Industrial, Inc. Rubber Flooring
  Div., 365

Kansas City Ad Club, 395
Kansas City Art Inst., 396
Knoll International, 378, 379, 407
Knoll International/Dallas, 308, 366
Knudsen Corp., 333

Lafayette Place, 361
Mark Lee & Assoc., 377
Legal & General, Ltd., 417
Levi Strauss & Co., 406, 416, 419
Life Magazine, 348
Lincoln Center for the Performing Arts, 307
Lomas & Nettleton Mortgage
  Investors, 376

M & Co., 413, 421
MAD Corp., 380
Maguire Partners, 408
Martex, 363
Robert Martin Co., 422
Takaaki Matsumoto, 421
McGinnis Cadillac, 408
Metzdorf Advtg. Co., 344
Arthur Meyerson, 308
Herman Miller, 306, 333
Mobil Masterpiece Theatre, 317
Mobil Oil Corp., 317, 318, 323
Mohl Furs, 325
Moliterno Stone Sales, 362
Gwen Morgan, 399
Municipal Art Society, 325

NASA, 310, 311
Nantucket Historical Assn., 319
Napier, 336
National Bank of Canada, 406
The New Yorker Magazine, 347, 348
The N.Y. Stock Exchange, 391

Ocean Promotions, 321
Otis Parsons School of Design, 313

Pacific School of Religion, 383
Paine Webber, Inc., 391
Paramount Pictures, 354
Park St. David's Hospital, 319
People Magazine, 419
Philadelphia, City of, 367
Philadelphia College of Art, 333
Philadelphia Industrial Development
  Corp., 367
Philharmonia of Yale, 315
Port Authority of N.Y. & N.J., 417
Potlatch Corp., 393
Precision, Inc., 410
Puck Building, 413
Puritan Fashions Corp., 388
Pyro Energy Corp., 414

Reva, 389
R.J. Reynolds Tobacco Co., 358
Rhode Island School of Design, 405
Roanoke, Va., City of, 372
Roblee Corp., 393
Royal Robbins, Inc., 370
Rust Properties, 318

The SWA Group, 362
St. Andrews/Boca Raton, 383
San Diego Jazz Festival, 312
San Francisco Art Institute, 313
Sawgrass/Arvida Resort, 403
School of Visual Arts, 368
Science 82, 333
Shakespeare Festival of Dallas, 308
Sidjakov, Berman & Gomez, 344
Simpson Paper Co., 340
Sobek Exploration Soc., 359
Society of Typographic Arts, 332
Sparcraft Co., 399
Sperry, 390
Standard Duplicating Machine Corp., 415
Stanford University Hospital, 396
Stendig International, Inc., 409
Stendig Textiles, 409
Stroh's Brewery, 304
Sunar, 365, 371
Superior Land & Cattle Co., Inc., 410
Suzuki, 396

T.G.I.Friday's, Inc., 364, 396
TRW, Inc., 404
Ted's 415
Texaco, USA, 405
Texas Home Magazine, 371
Thompson Press, 357
Toyota Motor Sales USA, Inc., 386
The Trammell Crow Co., 360
Tri-Arts Press, 356
Turtle Creek Center for the Arts, 376
20/20 Vision, 314

U.S. Postal Service, 368
United Technologies, 346
University of St. Thomas, 325
University of Utah, Div. of Continuing
  Education, 360

Video Ventures, 320
Virginia Commonwealth University, 408
Vuarnet USA, 385

Wadsworth Atheneum, 389
David Webb, 337
Welti & Rose Advtg., Inc., 314
West Point Pepperell, 363
Westinghouse Electric Corp., 403, 411
Weyerhaeuser Co., 351
Whiteprint Editions, Ltd., 316
John A. Williams, Printer, 352, 364
Williamson Printing Co., 388

Yale Symphony Orchestra, 327
Brigham Young University, 318

## Typographers and Letterers

Abra Type, 305, 380
George Abrams, 339
Ad Agencies — Headliners, 348
Adpro, 328, 393
Aldus Type Studio, 386, 396
Alpha Graphics, 372
Andresen Typographics, 354, 394
Atlantic Richfield Co., 395

M.J. Baumwell, 386, 392, 420
Karen Brown, 325

CCAC Typographers, 313, 415
CTT, 391
CT Typografix, 361
Capco, 399
Capital Rubber Stamps, 417
Cardinal Type Service, 368
Chiles & Chiles, 309, 322, 376, 382, 418
The Composing Room of N.E., 358
Composition Type, 333, 385
Concept Typographic Services, 357,
  365, 378, 410
Custom Typography Service, 362

Dahl & Curry, 361
Dimensions, 414
Tony DiSpigna, 318
Display Lettering & Copy, 370, 387
Dumar Typesetting, 362, 382
Vicki Dunn, 355

Eastern Typesetting Co., 346
Expertype, 413, 421

Fantastic, 398
Frank's Type, 396
Stephen Frykholm, 333

G+S Typographers, 319, 360
Paul O. Giesy, 351
Gilbert Assoc., 405

Haber Typographers, 363, 399
Headliners, 369, 381, 416, 419
Headliners/Identicolor, 227, 377, 404
Herbick & Held, 403

IBM/Kingston, 330
IGI/Innovative Graphics International, 316,
  324, 364, 383
InfoComp, Inc., 411

JCS Typographers, 318, 352, 364, 368,
  371, 380, 397, 412
Justified Type, Inc., 335, 349

Tom Kamifuji, 414

Landman Typographers, 384
Peter L. Levine, 327

M & H Typographers, Ltd., 324, 346
Master Typographers, 332

National Typographers, 400

Omnicomp, 404, 416

PHP Typography, 350, 354, 365, 367, 389
Pastore DePamphilis Rampone, 371,
  375, 388
Petrographics, 344, 383, 418
Phototype, Inc., 403
Print & Design, 317, 323, 360, 404, 405, 410
Pro Type, 372
Production Typographers, 414
Professional Typographers, Inc., 372, 390,
  396, 400, 408

RJR Graphic Comm., 358
Reardon & Krebs, 393
Reprotype, 359
Rochester Mono, 417
Royal Composing Room, 336, 338, 341,
  344, 345
Ryder Types, 322, 419

Set-To-Fit, 324
Vernon Simpson Typographers, Inc., 366
Skilset, 398
Southern New England Typographic
  Service, Inc., 387, 406
Southwestern Typographics, 308, 324,
  357, 364, 370, 376, 381, 388, 391, 393,
  396, 399
Spartan Typographers, 355, 392

Techni Process, 322, 342, 343
Tin Roof, 417
Tri-Arts Press, 314, 353, 356
Tri-Graphics, 320
Trufont Typographers, 400
Twin Typographers, 360
Type Group, 347, 348
Type House, Inc., 306
Type Ink Type, 344
Typecraft, 333
Typehouse St. Joseph, 321
Typestudio, 402

Typeworks, Inc., 325, 373, 377, 394,
  396, 407
Typo, 333
Typographic House, 350, 390, 415
Typographic Images, 310, 311, 409
Typoset, Inc., 331

Uppercase, 395

Pan Van Dyken, 333
Virginia Commonwealth University, 408

Catherine Waters, 389
Words & Things, 350

X-L Typographers, 390, 410

## Printers, Binders, Separators
and Engravers

Accurate Silk Screen, 322
Acme Printing Co., 349, 350
Adams Group, 388
Alan Lithograph, Inc., 332
Allcraft Printing, 324, 364, 396, 399
American Embossing, 400
Anderson Lithograph Co., 304, 355,
  386, 393
Anderson Printing Co., 366, 396
Ashcraft Printing, 398
Austin Screen Printing, 417

Barton Press, Inc., 364
Beasley Printing Co., 407
Boelte-Hall, 395
M. Boss, 416
The Boston Globe, 358
Bradley Printing Co., 419
Corey Brixen, 360
Brodnax, 308

CFK Press, 378
C.G.S., 407, 421
California Central Press, 313
California Graphics, 354
California Printing Co., Inc., 344, 392
Carter Printing Co., 408
Chadis Printing Co., 415
Champion, 412
Colormaster Press, 325
Colour Graphics, 361
Congress Printing Co., 324
Consolidated/Drake Press, 367
Constable-Hodgins, 395
Continental Identification Products, 306,
  321, 333
Crafton Graphic Co., Inc., 323, 363, 372,
  401, 413

Dai Nippon Printing Co., Ltd., 357, 362,
  365, 371
Daniels Printing Co., 390
Joan Davis, 387
Harvey DuPriest, 308

Eastern Press, 405

Fidelity Printing Co., 350
Fine Arts Engraving, 391
Forman/Leibrock, 383, 418

Gardner/Fulmer Lithograph Co., 370, 395
Georgian Press, 325
Glacuum Assoc., 410
Goldplan Litho Co., 421
Graphic Arts Center, 351
Graphic Communications, 403
Grover Printing Co., 325, 375, 390, 396
Grunfeld & Brandt, Inc., 420
Gulf Printing, 394

HLH Seps., Inc., 322
The Hennegan Co., 310, 311, 328, 357, 393
Herbick & Held, 417
Heritage Press, 308, 309, 372, 376, 377,
  382, 414
Herlin Press, 324, 344
Herzig-Somerville, Ltd., 402
Lezius Hiles, 404
Horan Engraving Co., Inc., 348
Hunter Publishing Co., 358

Inky Fingers, 368
Interprint, 369, 377, 381, 416, 419
Interstate Printing Corp., 413

Jeffries Lithograph Co., 394, 396
Arthur Jones Lithographers, 324

Kenner Printing Co., 379

Lakeland Press, 409, 419
Lasky Co., 335
Lebanon Valley Offset Co., 350, 354, 383
Lincoln Graphic Arts, 386, 392, 420
Lithographix, 333, 385

McGraw-Hill, Inc., 382
Meridian Printing, 362
Metropolitan Printing, 307, 312, 316
Minneapolis/St. Paul Magazine, 361
William H. Muller, 396

National Bickford Foremost, 382
The National Press, 380
N.Y. Times Magazine Section, 346
Nimrod Press, 415
Nu-Tone Lithography, 332

Ohio Valley Lithocolor, 331
The Olivet Group, 396
Overland Printers, 253

P.M. Press, 371, 412
Padgett Printing, 318, 393, 397
Pearl Pressman Liberty, 333

Phipps Reproduction, 326
Pioneer Moss, 338, 344, 345
Piqua Paper Box Co., 409
Pollack-Weir Graphics, Inc., 368
The Printery, Etc., 380
Printing Resources, 344
Printmakers, Inc., 319
Progress Graphics, 399

Rapoport Printing Co., 360, 361, 366, 379
Regal Art Press, 330
George Rice & Sons, 353, 399
Riverside Press, 399

San Rafael Graphics, 411
Sanders Printing Corp., 314
Saunders Manufacturing, 410
S.D. Scott Printing Co., 340, 389, 406
Screen Tek, 327
Simon Printing, 410
Sirocco Screenprints, 315, 319, 389
Solzer & Hall, Inc., 404
Standard Folding Carton, 410
Sterling Roman Press, 391, 405

Tempo Creations, 317
L.P. Thebault, 414
Thompson Press, 357, 381
Thorner-Sidney Press, Inc., 378
Treaty Oak Press, 373
Tri-Arts Press, 314, 356
Tulsa Litho Co., 320

Union Printing, 405
United Signs, Inc., 406

VentureGraphics, 404, 415
Victory Graphics, 384
Vile-Goller, 395
Village Craftsmen, 333
Vintage Lithographers, Inc., 365

Warren's Waller Press, 387
Washburn Press, 372
Westinghouse Printing Div., 403, 411
Wetmore & Co., 390
John A. Williams, Printer, 352
Williamson Printing Co., 322, 370, 376,
  377, 388, 418
The W.O.R.K.S., 305, 414

J.F. Zimmerman & Sons, 360